THE RESEARCH INSTITUTE OF ART AND INDUSTRY, MOSCOW

FOLK ART
IN THE
SOVIET UNION

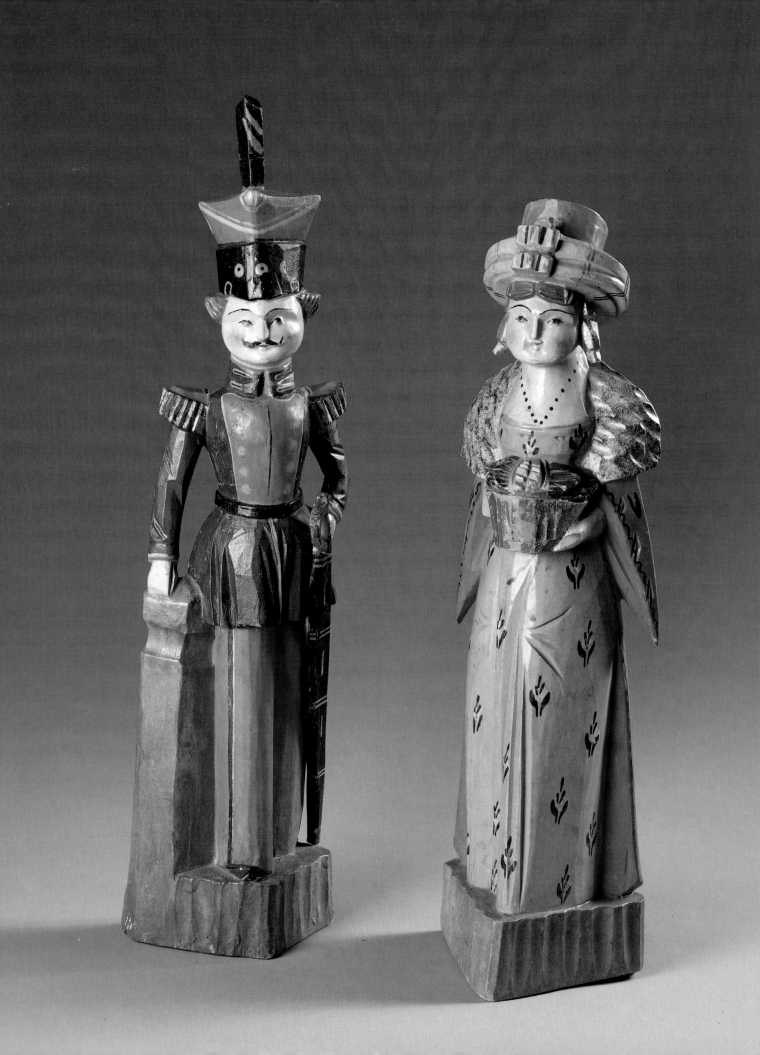

FOLK ART
IN THE
SOVIET UNION

Tatyana Razina

Natalia Cherkasova

Alexander Kantsedikas

HARRY N. ABRAMS, INC., PUBLISHERS, NEW YORK

AURORA ART PUBLISHERS, LENINGRAD

——————————————— ABRAMS ———————————————

PROJECT DIRECTOR
Andreas Landshoff

EDITOR
Nora Beeson

DESIGNER
Dirk Luykx

LAYOUTS BY
Amy Berniker, Gilda Hannah, and Steve Neuman

——————————————— AURORA ———————————————

EDITORS FOR THE ENGLISH LANGUAGE EDITION
Olga Akbulatova, Tamara Mazayeva, Marina Boiko, and Nora Andreyeva

DESIGN COORDINATOR
Irina Luzhina

CATALOGUE BY
G. Babanskaya, L. Dobrachova, R. Efendiyev, K. Galaupens, G. Gogia, E. Grishin, Z. Khakimova, N. Kostochkina, L. Lilchuk,
O. Makovetskaya, M. Malchenko, A. Mambetkadiyeva, N. Miakisheva, I. Mkrtychan, Kh. Nazik, K. Orlova, M. Peremena, B. Rozenberg,
E. Sakhuta, M. Tokareva, M. Tokhtabayeva, E. Torchinskaya, S. Sharanutsa, L. Uritskaya, and G. Yakovleva

TRANSLATED FROM THE RUSSIAN BY
Ruslan Smirnov

PHOTOGRAPHS OF FOLK ART BY
V. Barnev, R. Beniaminson, A. Ivanov, G. Khatin, B. Kocherov, F. Kuziumov, I. Nikolayev, S. Onanov,
N. Sapozhnikov, V. Savik, and I. Zakharova

LANDSCAPE AND GENRE PHOTOGRAPHS BY
N. Rakhmanov, pages 14, 94, 100, 162, 184, 208, 236, 300, 340, 352, and 372; V. Hippenreiter, pages 136, 438, 458, and 478;
V. Gaspariants, pages 258 and 318; F. Kuziumov, page 388; R. Ozersky and V. Yakobson, page 124; and L. Sherstennikov, page 422.

——————————————— NOTES TO THE CAPTIONS ———————————————

The reader should keep in mind that place names in the territories now making up the USSR have changed repeatedly over the centuries.
In each case, the name current at the time of the item's production is given. ASSR (Autonomous Soviet Socialist Republic), Province,
District, Territory, Region, and Area are geographical and administrative divisions. References to date, origin, and dimension are omitted
whenever these have been, for various reasons, impossible to establish. In cases where several items are illustrated, the descriptions are
given from left to right and from top to bottom. All dimensions are given in centimeters. Museum of the Ethnography of the Peoples of
the USSR, Leningrad, has been abbreviated to Ethnography Museum, Leningrad. Board of Exhibitions of the USSR Union of Artists,
Moscow, has been abbreviated to Union of Artists, Moscow. Main folk art centers are shown on respective maps.

Frontispiece:
Hussar and Lady, 19th century
Sergiyevsky Posad, Moscow Province
Wood, carved and painted. Height 40.5 and 36
Museum of Folk Art, Moscow

Library of Congress Cataloging-in-Publication Data
Razina, T.M. (Tatiana Mikhaïlovna)
Folk art in the Soviet Union.
Translated from Russian.
1. Folk art—Soviet Union. I. Cherkasova, N.V.
II. Kantsedikas, Alexander. III. Title.
NK975.R35 1990 745'.0947 86–26497
ISBN 0-8109-0944-8

Printed and bound in Italy

CONTENTS

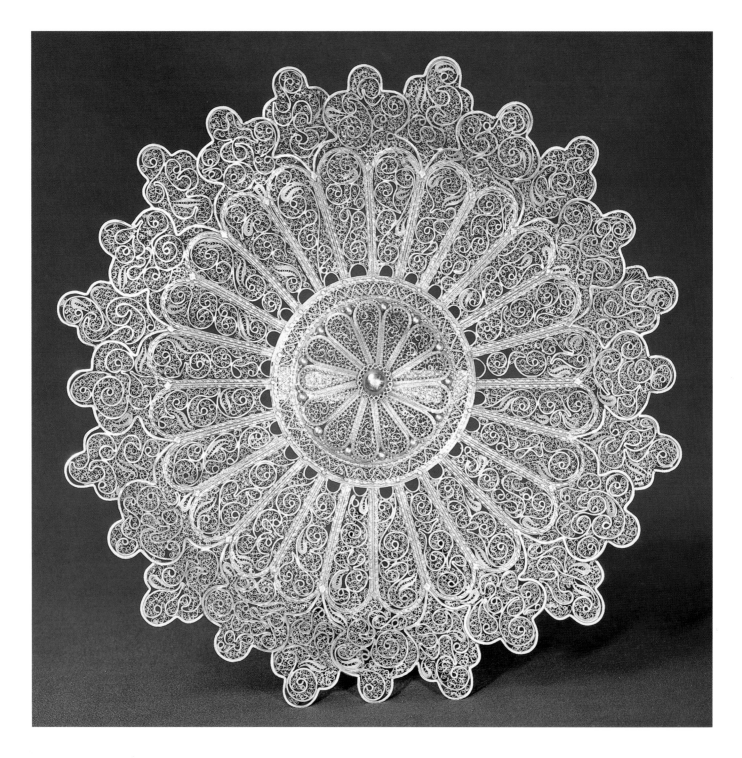

Tray. 1975
By R. Sarvazian
Yerevan
German silver, with filigree. Diameter 30
Union of Artists, Moscow

Preface

Like legends, ballads, or folk music, handicrafts constitute an essential element of a nation's culture. They originate from a community's customs and practical needs, and eventually develop into sophisticated arts with a rich spiritual content. Though they are concerned with objects for everyday use, these never look drab. Attractive handmade domestic utensils lend a touch of beauty and poetry to the surroundings in which people live.

Nature, particularly native scenery, is folk art's main inspiration since people are acutely aware of every feature of their land. It is for this reason that Russia's spired wooden churches seem akin to the forests dominating the northern landscape; that the round *yurta* tents of Central Asia seem inseparable from the vast expanses of the steppes and deserts; and that the austere mountain villages (*auls*), with their terraces of stone houses clinging to the slopes, recall the Great Caucasus Ridge.

Most of the diverse materials available, such as clay, wood, cotton, flax, straw, wool, fur, stone, freshwater pearls, and dye-containing grass, to name but a few, are used by the folk artist, who strives to bring out their most expressive qualities and to give his article a pleasing appearance and perfect finish.

In peasant handicrafts, which originated as ancillary, seasonal occupations centuries ago, traditions have been maintained and developed, and cer-

tain conventions have emerged. But they have not fettered the artist's individuality or impeded his imagination and skill.

The stability of folk art imagery stems from a culture's rigid pattern of customs, rituals, and festivals, which are closely connected to the people's occupations and influenced by such factors as climate and geographic location. Even to this day, some of the earliest ornamental motifs have survived in the art of certain communities although they have gradually undergone transformations and acquired new meaning in keeping with the altered conditions of life.

The folk artisan is a true guardian of traditional handicraft forms and styles, for it is he who absorbs from his ancestors and passes on to his descendants a wealth of carving, painting, weaving, and lace-making techniques. This legacy of skill and artistic tradition, coupled with improvisation, is a cultural force of great importance and is particularly valuable as a living link to the past. This is why the surviving traditional arts and crafts, spared by the mercy of history or by virtue of their geographic location, are so greatly appreciated. Folk art is always humanistic. It links the work of those who belong to different ethnic groups and races, possess different historical backgrounds, and even live on different continents.

The Soviet government pays great attention to the development of handicrafts in the USSR and has taken a number of steps to promote them. The USSR Union of Artists also actively assists and encourages folk artisans. The decorative arts, mainly of the nineteenth and twentieth centuries, of every region of the Soviet Union, are represented in this book, though a number of objects dating from an earlier period have been included where it was necessary to illustrate the evolvement of trends or traditions in a particular craft. The book is devoted to what may be regarded as the main type of folk art, namely, household items. It has been found possible, however, to include some works of nonutilitarian character, such as wooden statuary from Lithuania, folk paintings from the Ukraine, carved stones from Tuva, and ivories from the Chukchi Peninsula, for these works have such distinctive national flavors that they can be treated as folk crafts. This is particularly true today, when there are numerous interesting examples of native work in painting, drawing, and sculpture.

This present publication is the first survey of such scope aimed at providing a comprehensive, panoramic view of folk arts and crafts in the Soviet Union. What is represented here, however, is but a fraction of the wealth amassed in numerous Soviet museums all over the country.

The material selected comes from several major Soviet museums. Ac-

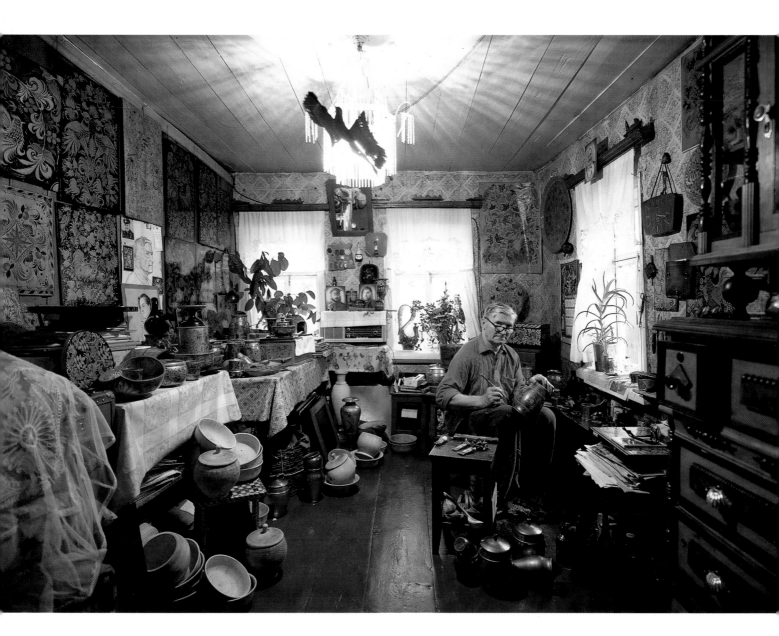

knowledgments are due to the Museum of Folk Art and the Museum of Oriental Art in Moscow; the Museum of the Ethnography of the Peoples of the USSR, the Hermitage, and the Russian Museum in Leningrad; the Museum of the History of Armenia in Yerevan; the Dzhanashia Museum of Georgia in Tbilisi; the Museum of the Uzbek SSR in Tashkent; the Museum of Ukrainian Folk Decorative Arts in Kiev; the Museum of Ethnography and Handicraft in Lvov; the Museum of the Byelorussian SSR in Minsk; the Museum of the Latvian SSR in Riga; and the Museum of Ethnography of the Estonian SSR in Tartu.

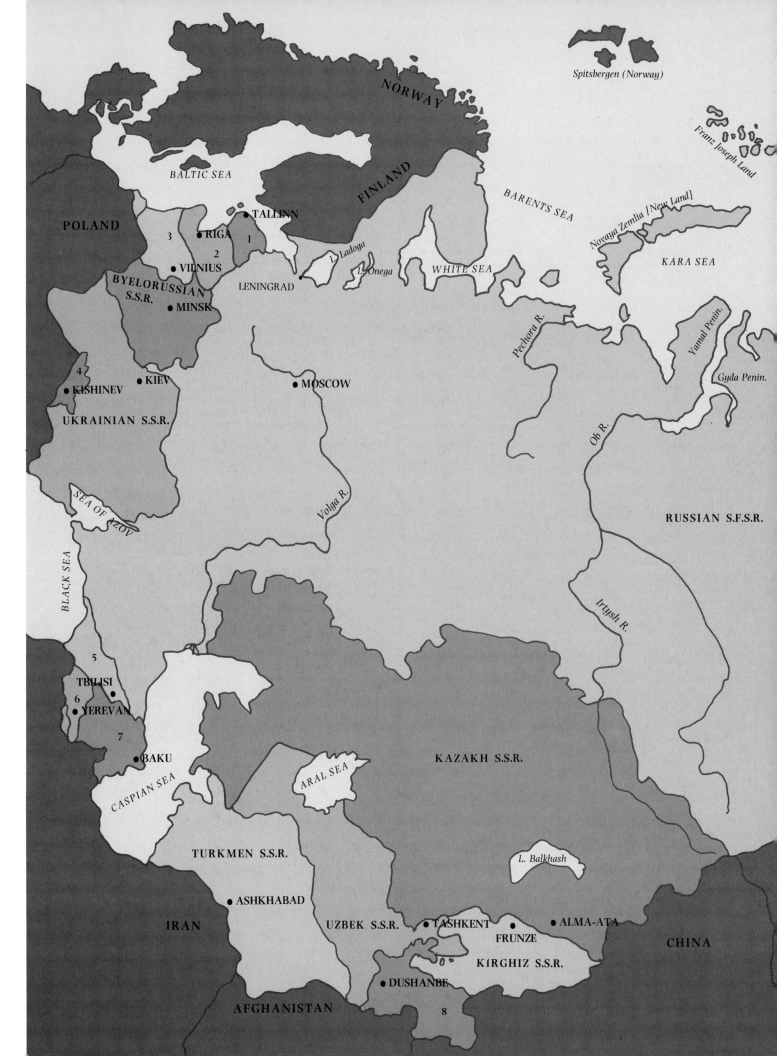

Spitsbergen (Norway)

Franz Joseph Land

NORWAY

BALTIC SEA

FINLAND

BARENTS SEA

Novaya Zemlia [New Land]

KARA SEA

POLAND

● TALLINN

● RIGA

3 2 1

● VILNIUS

BYELORUSSIAN
S.S.R.

● MINSK

L. Ladoga

L. Onega

WHITE SEA

LENINGRAD

Pechora R.

Yamal Penin.

Gyda Penin.

4

● KIEV

● KISHINEV

● MOSCOW

Ob R.

UKRAINIAN S.S.R.

SEA OF AZOV

Volga R.

RUSSIAN S.F.S.R.

BLACK SEA

Irtysh R.

5

TBILISI

6

● YEREVAN

7

● BAKU

KAZAKH S.S.R.

ARAL SEA

CASPIAN SEA

L. Balkhash

TURKMEN S.S.R.

● ASHKHABAD

IRAN

UZBEK S.S.R.

● TASHKENT

● ALMA-ATA

FRUNZE

CHINA

KIRGHIZ S.S.R.

● DUSHANBE

AFGHANISTAN

8

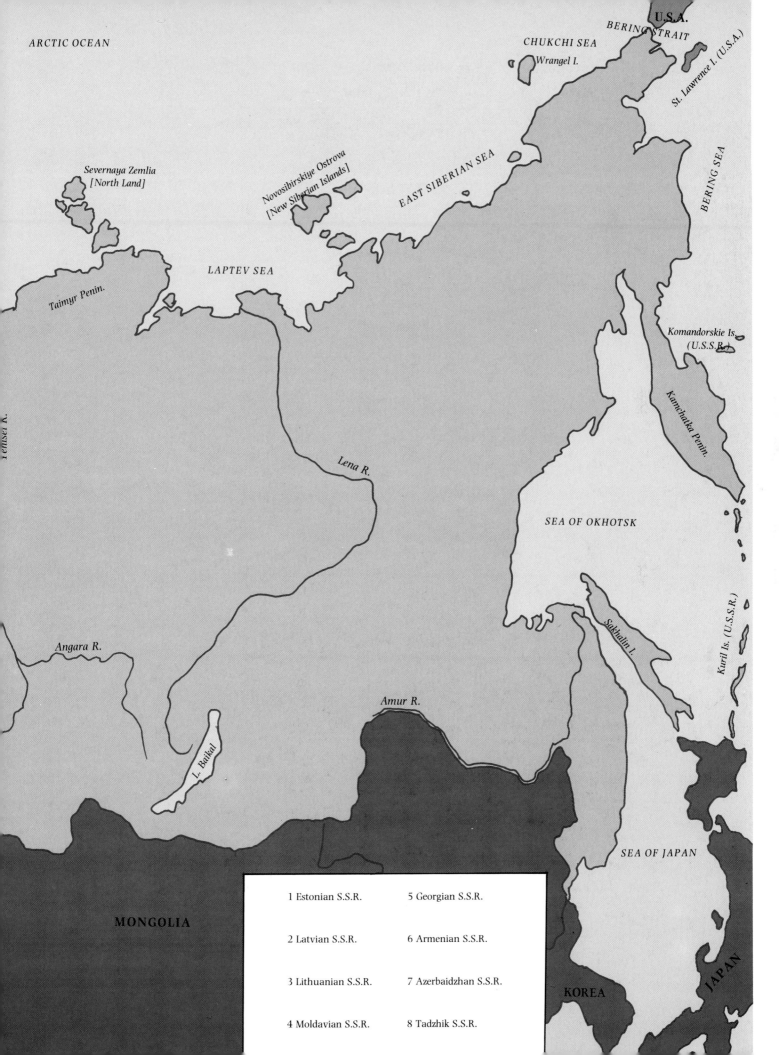

ARCTIC OCEAN

CHUKCHI SEA

U.S.A.

BERING STRAIT

Wrangel I.

St. Lawrence I. (U.S.A.)

BERING SEA

Severnaya Zemlia
[North Land]

Novosibirskiye Ostrova
[New Siberian Islands]

EAST SIBERIAN SEA

LAPTEV SEA

Taimyr Penin.

Komandorskie Is.
(U.S.S.R.)

Kamchatka Penin.

Yenisei R.

Lena R.

SEA OF OKHOTSK

Angara R.

Kuril Is. (U.S.S.R.)

Sakhalin I.

L. Baikal

Amur R.

SEA OF JAPAN

MONGOLIA

1 Estonian S.S.R.	5 Georgian S.S.R.
2 Latvian S.S.R.	6 Armenian S.S.R.
3 Lithuanian S.S.R.	7 Azerbaidzhan S.S.R.
4 Moldavian S.S.R.	8 Tadzhik S.S.R.

KOREA

JAPAN

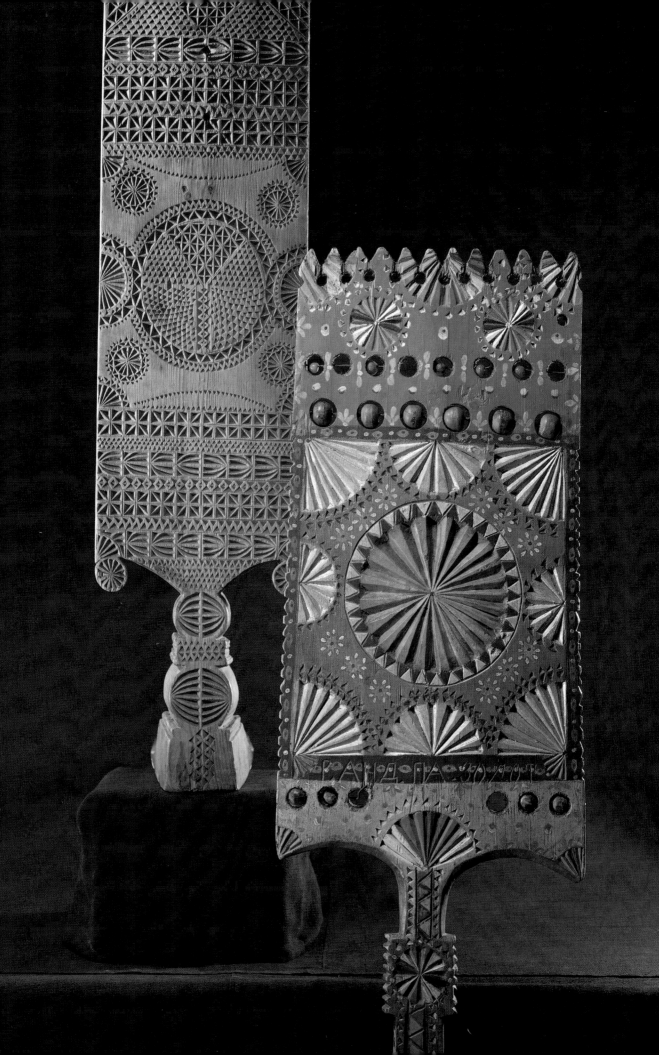

FOLK ART
IN THE
RUSSIAN SOVIET FEDERATED SOCIALIST REPUBLIC

The Russian Soviet Federated Socialist Republic (known in the Soviet Union by its abbreviated name, the RSFSR) is the USSR's largest constituent republic both in size and population. It stretches over vast territories, from the Arctic Ocean in the north to the Caucasus Mountains in the south, and from the Baltic Sea in the west to the Pacific Ocean in the east.

The scenery and vegetation of a land of such enormous extent naturally exhibit much variety, exemplified by lakes and forested rocks in Karelia; by the fields, coppices, and deep rivers of Central Russia; by the lush vegetation on the foothills of the Altai and the Urals; by the belt of tundra in the extreme north; by the hills of the Far East and the snows of the Chukot Peninsula. All these diverse conditions have given rise to highly original forms of folk art.

The art and culture of the RSFSR, a multinational republic, possess features peculiar to each of its peoples, of whom Russians are by far the most

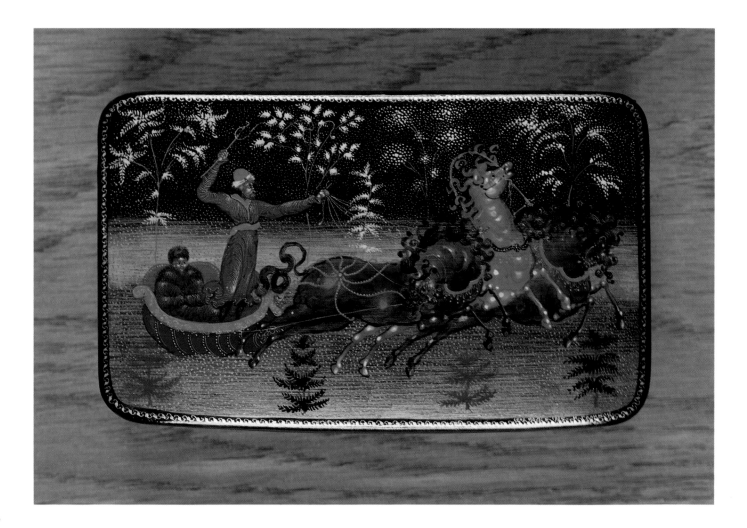

Snuffbox: *Troika.* 1925
Palekh, Ivanovo Region
Papier-mâché, painted and lacquered. 10.5 × 6.3
Museum of Folk Art, Moscow

numerous. Their art, which stems from the rich cultural legacy of Old Rus, is extraordinarily multifaceted. Owing to their rich traditions and favorable economic factors, the Russians have developed a multitude of arts and crafts, some of which are still thriving in their original locations.

Along the banks of the Volga River and in the Ural area, the inhabitants have maintained arts known for their splendid decorative qualities. The Mordvinians, Bashkirs, Tatars, Udmurts, Chuvashes, and Maris all have beautiful and original embroidery and national costumes.

The North Caucasus with its inimitable scenery has generated life-styles conducive to the flourishing of rare handicrafts that are practiced to this day by the national minorities living there. Fine examples of highly original work in such crafts as pottery, carpet-making, knitting, woodcarving, smithing, and goldsmithing are produced in nearly every village in this area.

In Siberia there are many national minorities, such as the Yakuts, Nentsy, Khants, Evenks, and Dolgans. Under almost identical conditions, these ethnical groups have developed handicrafts of a very similar character, yet the types and systems of ornamentation, and the trimming of fur costume and footwear vary vastly. Different materials have been employed as well. In some parts of Siberia and in the regions adjoining the Amur River, birch bast has been used ingeniously to make household utensils, and some communities (notably on the Chukchi Peninsula) have developed ivory and bone carving with great success. In southern Siberia the Buriats are famous as goldsmiths, particularly for their distinctive ornamental chasing, while the Tuvans are known as skillful bone carvers.

Folk decorative arts play an important role in the material and spiritual life of any nation, however small. A comprehensive panoramic survey of the RSFSR's folk arts brings into focus their rich aesthetic and spiritual values. These are evident in the splendid imagery and congruity of artistic expression, as well as in the perfection of their ornamentation and color scheme, which are demonstrated equally well by a peasant woman's costume from Riazan or a piece of embroidery from Chuvashia, a carpet from Daghestan or fur clothes from the Nenets National Area.

At present there is keen public interest in the traditional forms of folk art, therefore the handicrafts of all the regions and autonomous republics of the RSFSR receive much attention.

RUSSIAN
Folk Art

The Russian culture, arts, and crafts of the tenth to the seventeenth century are a foreword to the history of Russian folk art in the subsequent centuries. In the early eighteenth century, rapid economic growth, accompanied by the development of manufacturing industries, towns, and nationwide trade, gave an impetus to flourishing and very varied folk arts and crafts.

Peasant art, which is always closely connected to everyday life, was affected to some extent by modern urban culture. Still, a certain patriarchal character of the Russian life-style helped preserve the local traditions and flavor in folk art (as was the case with folk songs and Russian vernaculars). In northern Russia, particularly on the Pechora, Onega, Pinega, Mezen, and North Dvina Rivers (the territory of the present regions of Arkhangelsk and Vologda), the traditional way of life with its old-fashioned farming, age-old customs, and vestiges of heathen beliefs, survived the longest. Here the first recording of numerous legends, tales, wedding songs, and keens were made in the nineteenth century.

The famous Russian historian Vasily Kliuchevsky called the forest "a perennial setting for Russian life." In olden times the forest was the mainstay of the domestic economy, feeding the Russians and protecting them. Forts, houses, mills, wells, and other important structures were made of wood. Every peasant was well versed with the properties of different woods and used them astutely. Thus pine trees were felled for building houses and for making sledges, looms, and distaffs; birch was used for runners, skis, carts, and boats; kitchenware and toys were made of aspen.

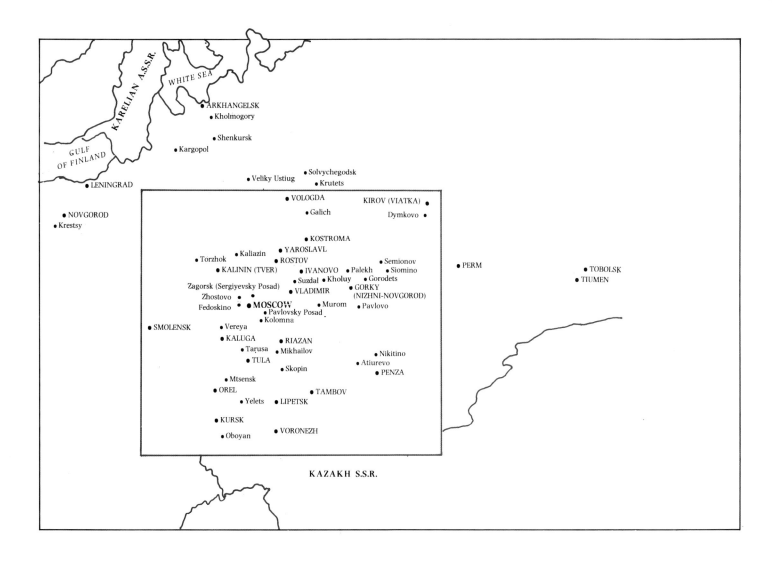

Russian villages were built entirely of wood. In the north the peasants preferred large houses that included sizable barns for livestock and that were big enough for a hay wagon to enter. The exterior decoration in the north was more restrained than that of the *izba* in the smart central Russian or Volga region; such houses, though smaller, were decorated with intricate carved and painted woodwork. It was also an old custom to decorate the *izba*'s interior with painted designs, which appeared on the floor, walls, furniture, and baby's crib.

Among the extant wooden objects once used in peasants' homes the distaff predominated. A whole tree was usually felled for just one distaff, which would often become a treasured heirloom. A distaff was a father's gift to his daughter, a young man's to his fiancée. The craftsman's ingenuity in decorating distaffs was truly boundless, for no other object was adorned with such painstaking care and affection. In northern Russia it was the vertical blade that carried the bulk of ornamentation. Distaffs from Yaroslavl Province were remarkable for their exquisite carving and elegant proportions: tall and slender, they resemble a tower with tiers of pierced arched openings and tiny twisted columns. Though they are typical of the eighteenth century and first half of the nineteenth, another type of distaff was also employed in the same area at that time, with the base formed by a

Plank (exterior decoration of a peasant house). Mid-19th century
Nizhni-Novgorod Province
Wood, carved and painted. 182 × 37
Ethnography Museum, Leningrad

Underside of a casket lid. 18th century
Veliky Ustiug, Vologda Province
Painted wood. 49 × 33
Ethnography Museum, Leningrad

Underside of a casket lid. 18th century
Veliky Ustiug, Vologda Province
Painted wood. 40 × 35
Ethnography Museum, Leningrad

Box. First half of the 18th century
Northern Russia
Painted wood. Height 40.5
The Russian Museum, Leningrad

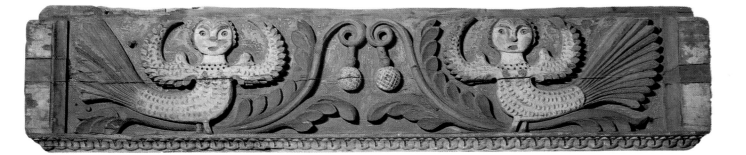

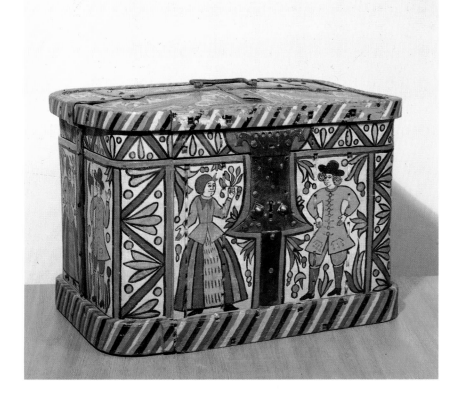

broad plank supporting a blade in the shape of a *kokoshnik* headgear carved in low relief, with clock towers, and festival and tea-drinking scenes.

Distaffs from Vologda are more solid in design and carved in high relief, sometimes in combination with painting. The ubiquitous large rosette in the center of the geometric ornamentation is an ancient symbol of the sun. The lower end of the blade is adorned with pendant decorations, also in the shape of rosettes.

Among distaffs from the north of Russia, those from the Mezen and Northern Dvina are particularly notable for their rich and varied painted decorations, in which exquisite silhouettes of horses, birds, and deer, drawn

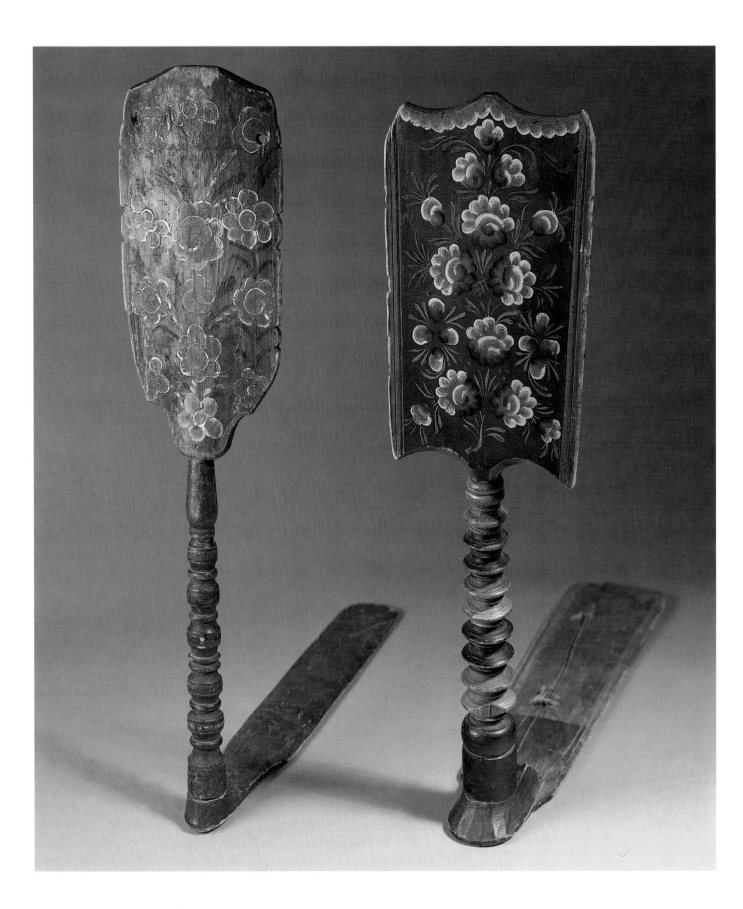

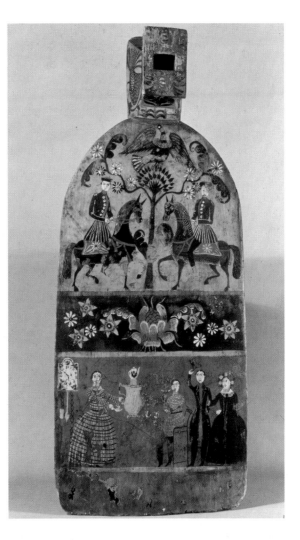

with calligraphic precision, alternate with rows of lines and scrolls. Soot and red clay from the river bank are used as pigments. The reverse side of the blade is painted with genre or hunting scenes. The painted compositions adorning distaffs made in the village of Borok follow the traditional pattern, with the lower part consisting of a picture within a rectangular frame, quite often a scene of sledging. The middle part usually consists of a tree or a flower within an arch, while the upper part is painted with symmetrically arranged windows. The bright vermillion and green of the painted decoration stand out boldly against the white or sometimes gold background.

In central Russia and along the Volga, distaffs with a decorated base were in common use. After work the spinner would detach the base from the staff and hang it on the wall as a decoration. Distaffs from the town of Gorodets on the Volga were particularly popular. They carried pictures of riders on rearing horses, hunters with dogs, or trees with birds. They were decorated by carving and with dark water-seasoned oak inlay. In the mid-nineteenth century, their subject matter became more diversified, and genre

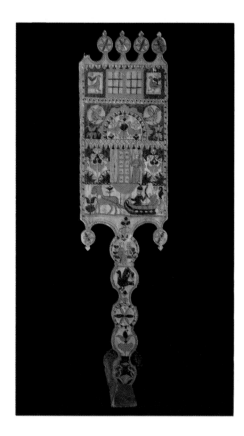
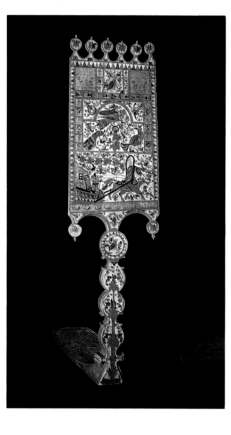
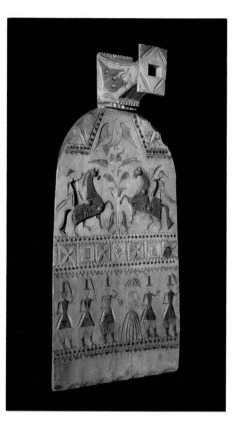
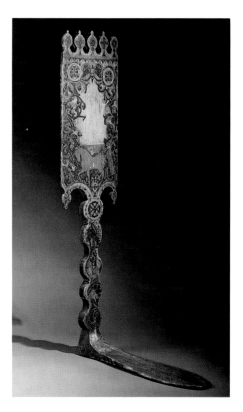
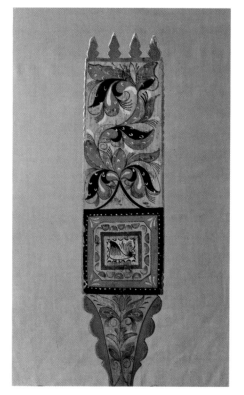
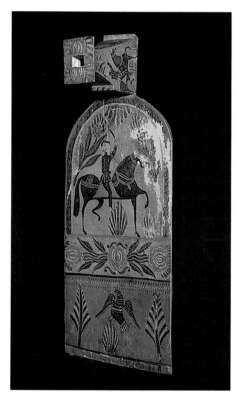

Distaff. Late 19th century
Village of Borok, Arkhangelsk Province
Wood, lathe-turned and painted. 92 × 23
Ethnography Museum, Leningrad

Distaff. Early 20th century
Village of Borok, Arkhangelsk Province
Wood, lathe-turned and painted. 90 × 25
Ethnography Museum, Leningrad

Distaff base. Mid-19th century
Vicinity of Gorodets, Nizhni-Novgorod Province
Wood, carved, inlaid with seasoned oak, and painted. 73 × 32
Ethnography Museum, Leningrad

Distaff. 19th century
Arkhangelsk Province
Wood, lathe-turned and painted. 90 × 21
Ethnography Museum, Leningrad

Detail of distaff. Early 20th century
Arkhangelsk Province
Wood, lathe-turned and painted. 88 × 24
The Russian Museum, Leningrad

Distaff base. Last quarter of the 19th century
Vicinity of Gorodets, Nizhni-Novgorod Province
Wood, lathe-turned and painted
Ethnography Museum, Leningrad

Laundry beetle. Late 18th or early 19th century
Nizhni-Novgorod Province
Carved wood. 39.5 × 12 × 3.5
Museum of Folk Art, Moscow

scenes from urban life, sumptuously bordered with draperies and festoons of flowers, began to predominate.

In the area adjoining the Volga, one of the most venerable crafts, over three hundred years old, is the production of lathe-turned wooden articles painted in the so-called Khokhloma style with grass, berries, and flowers in red, gold, and black. Named after the village trading center Khokhloma, it was one of Russia's most important handicraft industries in the late nineteenth century. Khokhloma ware was sold along the Volga, in Central Asia, in the Caucasus, and in the Near East. The technique is peculiar: first the unpainted wooden article is coated with special priming, then with drying oil and a thin layer of aluminum powder. The "silvered" object is then painted with heat-resistant oil, varnished, and fired. The characteristic gold color appears during this final stage, when the article is kept in a kiln at up to 90°C.

At present the production of Khokhloma ware is concentrated in the town of Semionov and the village of Siomino. The characteristic color range has been preserved, and the painting continues to be based on extemporaneous work without preliminary sketching.

Toy-making by folk artists plays an important role in the culture of any nation. This craft is linked with folklore, old beliefs, legends, and fairy tales,

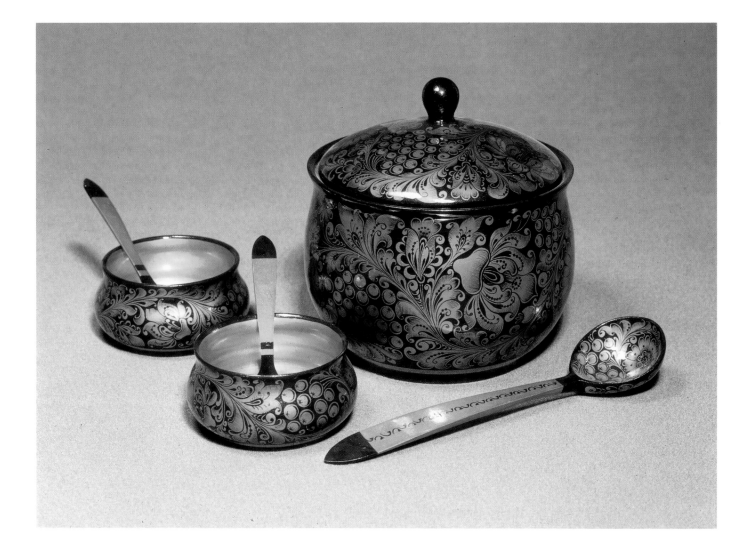

as well as with an insight into a child's inner world. There is always room for the artist to give free play to his fancy.

The main materials for toy-making were wood, pinecones, moss, straw, and clay. The most archaic types of imagery are shown in the extremely generalized wooden dolls and horses carved in the north of Russia. An entirely different approach is seen in the work of the Vladimir and Nizhni-Novgorod craftsmen, whose horses are painted with bright red lead. Nizhni-Novgorod's specialty was a carriage with two or three horses. By virtue of their elegant proportions, precise carving, and bold contrasting colors, these toys deserve the designation of works of art.

The village of Bogorodskoye in the vicinity of Moscow is a large toy center. The industry is connected with the history of Zagorsk (formerly the trading quarter of the Trinity-Sergius Monastery), where painted figurines of ladies and hussars, as well as scenes modelled on *lubok* folk pictures were

Honey set. 1969
By E. Dospalova
Semionov, Gorky Region
Wood, lathe-turned and painted. Height 18
The Russian Museum, Leningrad

Saltcellar and bowl. 1981
Village of Siomino, Gorky Region
Wood, lathe-turned, painted, and varnished. Height 14
 (saltcellar) and 7.5 (bowl); diameter 20 (saltcellar)
Private collection

Keg. 1945
By M. Chigrova
Village of Siomino, Gorky Region
Wood, lathe-turned and painted. 21 × 17
Museum of Folk Art, Moscow

Bowl. 1981
Village of Siomino, Gorky Region
Wood, lathe-turned, painted, and varnished. Diameter 22
Private collection

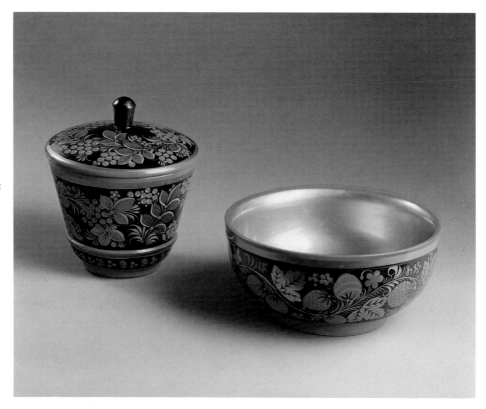

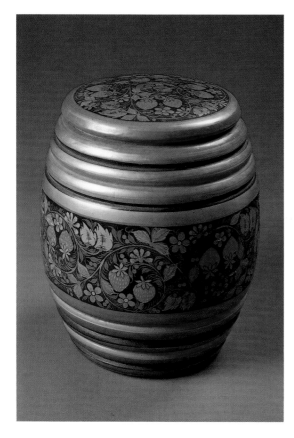

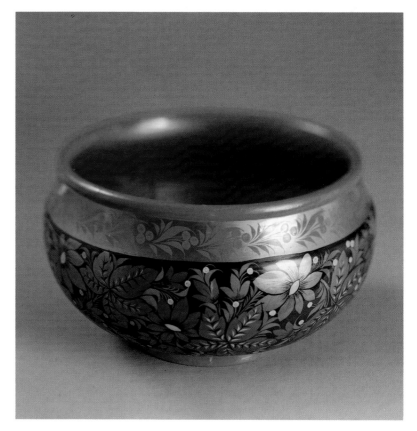

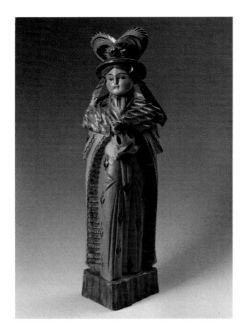
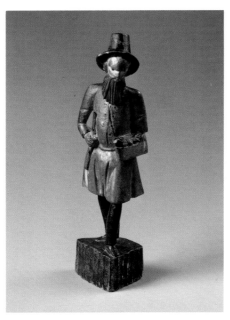
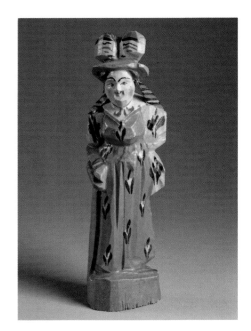

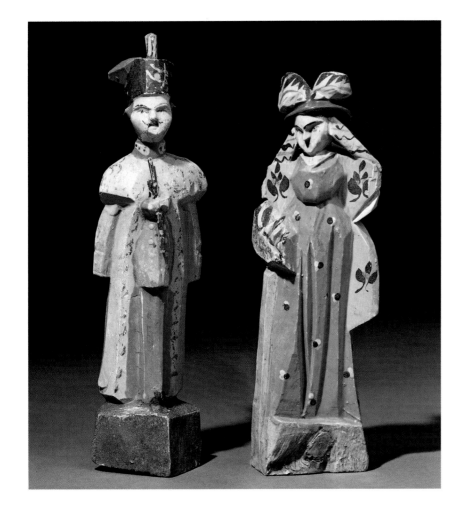

Lady. 19th century
Sergiyevsky Posad, Moscow Province
Wood, carved and painted. Height 37
Museum of Folk Art, Moscow

Peasant with a Bast Basket. 19th century
Village of Bogorodskoye, Vladimir Province
Wood, carved and painted. Height 24
Museum of Folk Art, Moscow

Lady. 19th century
Sergiyevsky Posad, Moscow Province
Wood, carved and painted. Height 21.2
Museum of Folk Art, Moscow

Hussar and Young Lady. Second half of the 19th century
Sergiyevsky Posad, Moscow Province
Wood, carved and painted. Height 24.5
Ethnography Museum, Leningrad

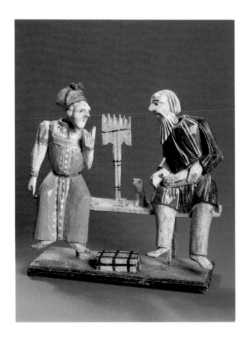

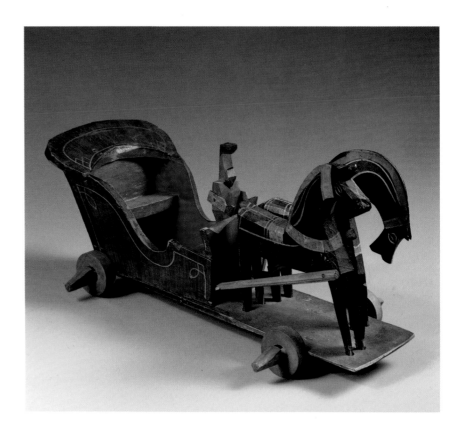

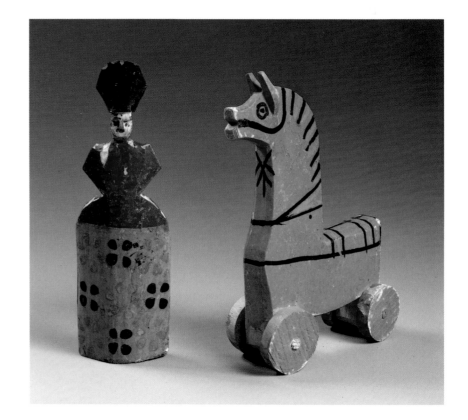

Old Man and His Wife. 19th century
Village of Bogorodskoye, Vladimir Province
Wood, carved and painted. 19.5 × 19 × 6.5
Museum of Folk Art, Moscow

Doll carriage. 19th century
Gorodets, Nizhni-Novgorod Province
Wood, carved and painted. 19 × 31 × 17
Museum of Folk Art, Moscow

Doll and toy horse. 19th century
Vladimir Province
Wood, carved and painted. Height 19 and 18.5
Museum of Folk Art, Moscow

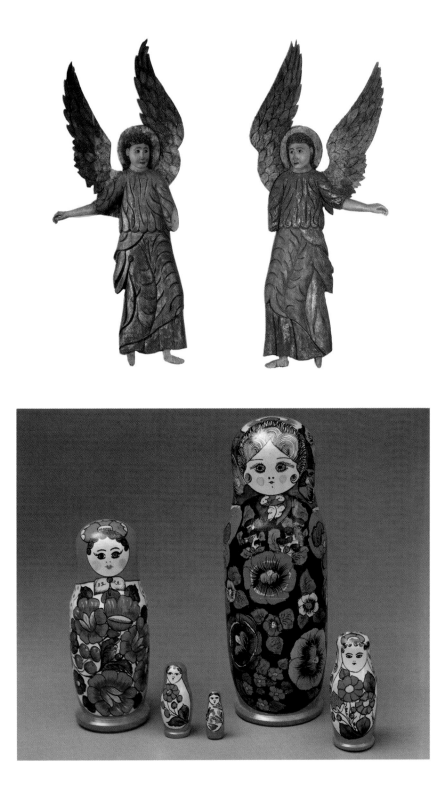

turned out. One of the favorite characters was the bear, which often figured as the peasant's friend and helper. Many of the toys could be set in motion by means of simple devices, such as springs or strings. Present-day toys from Bogorodskoye are made in the same generalized fashion, which brings out the expressive qualities of the wood's texture and color.

By far the best-known Russian souvenir is the *matrioshka* wooden doll, which contains several progressively smaller dolls inside, each consisting of two detachable parts. The first doll of this kind was made in the late nineteenth century to the design of the artist Sergei Maliutin in the trading

Angels. Late 17th century
Northern Russia
Wood, carved and painted. Height 273 and 272
The Russian Museum, Leningrad

Matrioshka **dolls.** 1979
By M. Masiagina and A. Subbotina
Krutets, Gorky Region
Wood, lathe-turned and painted. Height 22, 7.5, 4.5, 32,
 and 12
Museum of Folk Art, Moscow

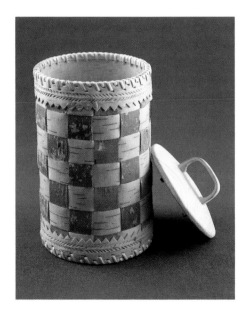

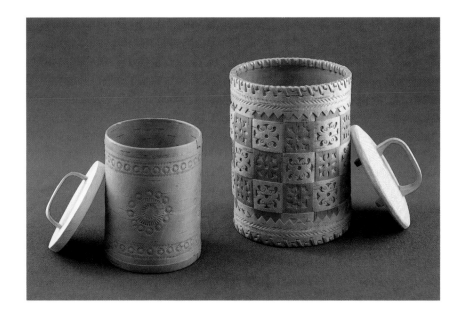

Container. 1978
By V. Petukhov
Arkhangelsk Region
Birch bark, carved, stamped, and painted. Height 32
Union of Artists, Moscow

Containers. 1978–79
By V. Petukhov
Arkhangelsk Region
Carved wood and stamped and painted birch bark.
 Height 23 and 19
Union of Artists, Moscow

quarter of the Trinity-Sergius Monastery. Today's most famous *matrioshkas* come from the town of Polkhov-Maidan in the Gorky Region, as well as other gaily painted wooden articles such as money boxes with naive landscapes on the lid, mushroom-shaped needle cases, painted eggs, apples, and whistles in the form of birds. Contrasting scarlet, green, and violet coloring (in aniline dye) over starch priming, with outlines delicately drawn in pen or brush, are the most characteristic features of the Polkhov-Maidan articles.

In the eighteenth and nineteenth centuries, apart from making figurines and toys, folk carvers produced statues in the round, which were sometimes painted, for churches and chapels. The standard of execution varied a great deal, yet most of the images carved by peasant artists bear the stamp of sincerity and even drama.

Birch bark, or, rather, its outer layer, was widely used in Russia from the dawn of its history. Letters written on bark that date back to the eleventh–fourteenth centuries survive to this day. In peasant homes, cylindrical *tuyes* vessels made of birch bark with lids were commonly used to contain sour cream, milk, flour, and groats or for soaking cloudberries and cranberries in water. These vessels were decorated with stamped or cursorily painted designs. In the nineteenth century, a center for this industry emerged on the Shemoksa River, where these traditional birch-bark vessels, boxes, and dishes are still produced as souvenirs.

Skill was also required to make boards for stamping designs on cakes (*prianiks*), which were baked for Christmas feasts, given as presents to guests at wedding celebrations, and dispensed at funerals. It was customary to bake a particular type of cake for each important occasion. Thus, for example, rye cakes in the shape of birds, cows, and sheep were prepared for

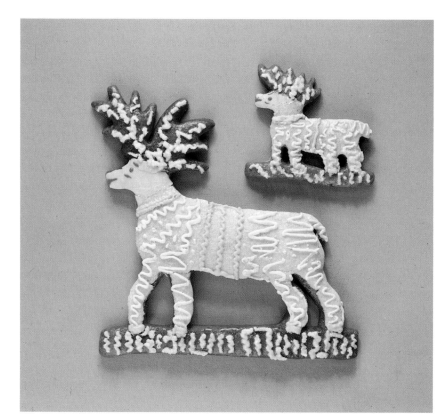

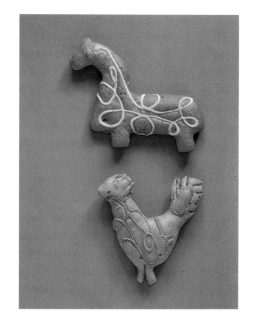

Figured cakes. 1971
Arkhangelsk
Baked dough and icing
Ethnography Museum, Leningrad

Cakes with stamped designs. 1920s; 1960s
Tver Province; Tula Region
Baked dough
Ethnography Museum, Leningrad

Figured cakes. 1927
Kolomna, Moscow Region
Dough, baked and painted
Ethnography Museum, Leningrad

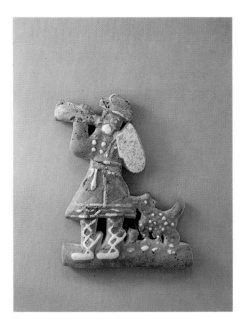

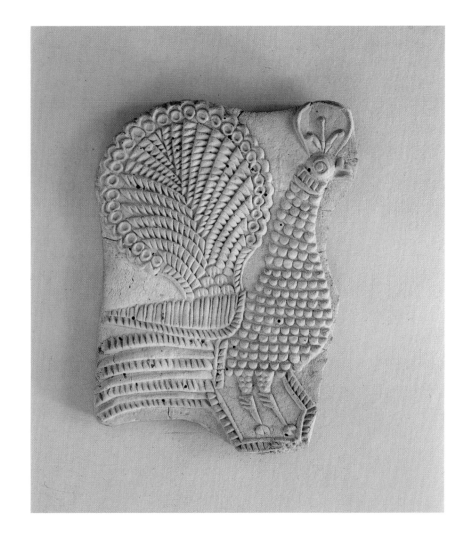

the day when domestic animals were pastured for the first time in spring, whereas for the winter solstice the form of deer was recommended. Even as recently as the beginning of the twentieth century, enormous quantities of cakes were sold at Russian fairs. Boards for making them sometimes contained up to nine different designs and measured up to a meter and a half in length. Quite often the carver's name and the place of manufacture, as well as a witty proverb or message with good wishes, were also incised into the wood. Owing to the eye-catching designs, boards were often kept at home for interior decoration.

The carving on stamping boards is similar to that of molds for tiles with raised patterns and of textile printing blocks. Production of the last two was a widespread craft, which catered to the textile dyeing and printing trade current in many Russian provinces. Dyers travelled throughout the countryside to collect orders for dyeing and printing homespun cottons and to sell their wares. Their fabric-printing methods were simple: the block with a carved design was covered with a thin layer of dye and pressed to the fabric. To ensure a good print, the block was beaten with a heavy cast-iron

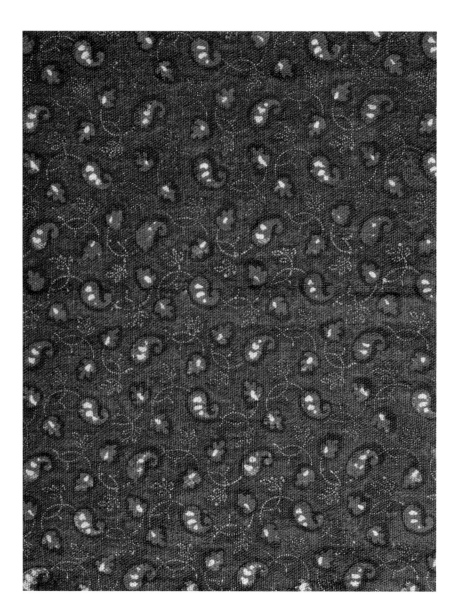

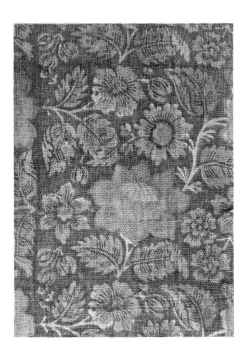

hammer. Most rustic prints were in one color, but if more than one was desired, it was either applied by hand, or additional blocks were made for the purpose. Cotton prints were used for making clothes, such as women's sleeveless dresses with shoulder straps (*sarafans*), men's caftans, and padded body warmers, as well as for curtains, tablecloths, ecclesiastic vestments, and in bookbinding. Cotton fabrics often rivalled expensive cloths in beauty. Old prints are distinguished for their austere geometric ornamentation and measured rhythm reminiscent of wood carvings. Plant designs in two colors are characteristic of seventeenth-century cotton prints. In the eighteenth century, they were replaced by large flowers and foliage in red and brown tones, at times with pale blue buds or berries on a light-toned background. Blue cotton prints with a bird surrounded by plants were widely used in Russian peasant homes throughout the nineteenth century.

Folk art tradition was further developed in machine-printing, which was introduced in the 1830s. In the second half of the same century, textile mill fabrics were already superseding hand-printed homespun cloths. Even

Fragment of printed cloth. Late 19th century
Kostroma Province
Linen (natural dyes). 33 × 42
Museum of Folk Art, Moscow

Fragment of printed cloth. 18th century
Central Russia
Linen (natural dyes). 26 × 31
Museum of Folk Art, Moscow

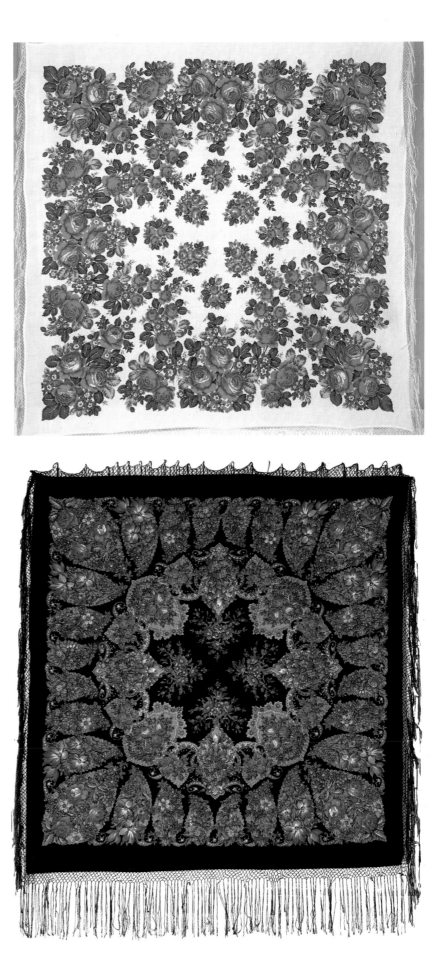

Kerchief. 1978
Pavlovsky Posad, Moscow Region
Printed wool. 100 × 100
Union of Artists, Moscow

Kerchief. 1979
Pavlovsky Posad, Moscow Region
Printed wool. 110 × 110
Union of Artists, Moscow

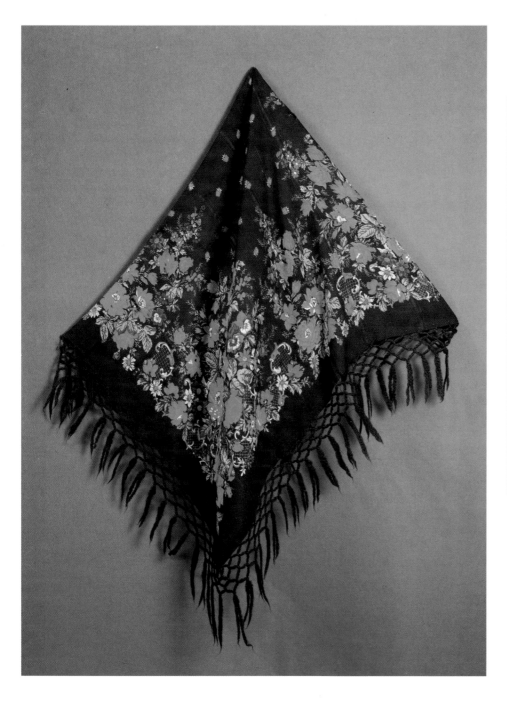

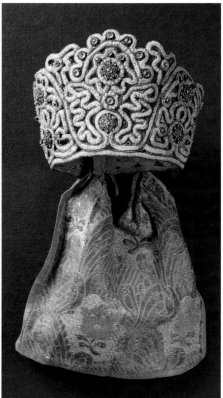

then, however, some hand-loom industries survived, especially those engaged in the production of shawls and kerchiefs.

In the 1860s, Pavlovsky Posad, a small town near Moscow, became the center of a thriving industry producing woollen shawls decorated with printed floral designs, sometimes in combination with other motifs. Local dyers and print-block carvers based their compositions on masterful combinations of large and small plant elements and on harmonious red and green colors placed against a black, white, or red background, imparting to the shawls a particularly festive aspect.

Nowadays shawls from Pavlovsky Posad are worn all over the country—in the Caucasus, Central Asia, the Ukraine, and Moldavia. They

Shawl. Second half of the 19th century
Pavlovsky Posad, Bogorodsk District, Moscow Province
Printed wool. 100 × 105
Museum of Folk Art, Moscow

Peasant woman's headdress. 19th century
Novgorod Province
Cardboard, embroidered with freshwater pearls and glass.
47 × 13.5
The Russian Museum, Leningrad

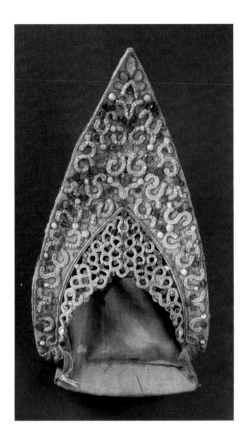

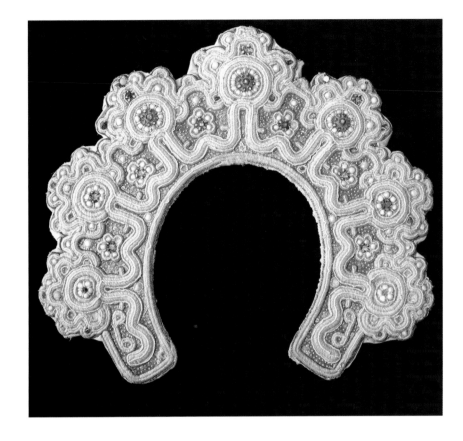

Peasant woman's headdress. 18th century
Kostroma Province
Cardboard, embroidered with freshwater pearls and glass.
 45 × 26
The Russian Museum, Leningrad

Young peasant girl's headdress. Mid-19th century
Arkhangelsk Province
Cardboard, decorated with spangles, mother-of-pearl, beads,
 and glass. 39 × 41
Museum of Folk Art, Moscow

blend well both with traditional national costumes and with modern urban clothing.

Peasant costumes retained their traditional indigenous features until the late nineteenth century. At that time it was customary for women to cover their hair with a fairly intricate headdress. In the southern provinces of Russia it was usually a *kika*, a horned headpiece with bright embroidery; in the north it was a *kokoshnik*, a diadem-like piece embroidered in gold, silver, and pearls, which was kept in peasant families as heirlooms and handed down from mother to daughter for generations.

Shawls and kerchiefs embroidered in gold thread were much sought after, especially those made in Kargopol and Nizhni-Novgorod. They were worked in satin stitch with gilded, silver, and copper threads. The violet-carmine, carmine-rose, terra verde, or ocher colors of velvet or silk set off the soft texture of gold embroidery with its muted light-and-shade effects. In one of the shawl's corners a large design was embroidered, filling about three-quarters of the whole shawl. Covering the head down to the shoulders, such a shawl, worn with a satin *sarafan* dress or a gold-embroidered vest, formed a beautiful ensemble.

A predilection for intense colors and bold designs is characteristic of traditional peasant dress, especially women's, in which even crude home-

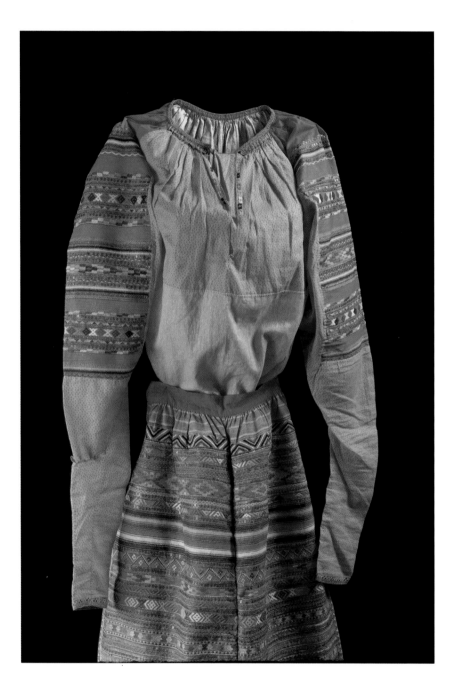

spun cloth was beautified by means of various embroidered decorations, sewn-on ribbons, and gilt galloons.

Folk costumes remained almost unaltered for a very long time, each province or district adhering to its regional style. Nevertheless, the variety of distinctive local features can be divided into two basic types: the northern and the southern styles of costume. In the north, women wore linen straightly cut chemises with wide embroidered sleeves, over which they donned sleeveless *sarafan* dresses up to six meters wide at the hemline. In

Peasant chemise and apron. 19th century
Vereya District, Moscow Province
Homespun cotton, with red calico trimmings, spangles, braid, ribbons, and fringes. 211 × 67; 98 × 59
Museum of Folk Art, Moscow

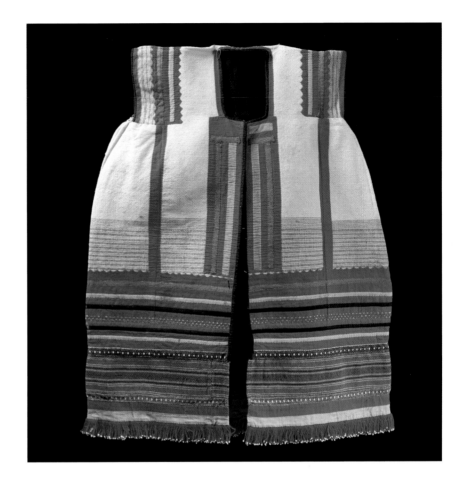

Peasant girl's sleeveless dress. 19th century
Mikhailov District, Riazan Province
Homespun linen, with red calico trimmings, braid, fringes,
 and beads. 69 × 60
Museum of Folk Art, Moscow

Tobacco pouch. First third of the 19th century
Linen, with beadwork. 17 × 25
The Russian Museum, Leningrad

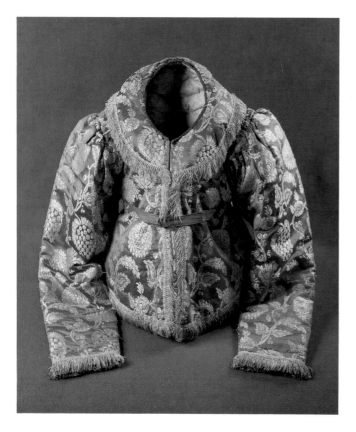

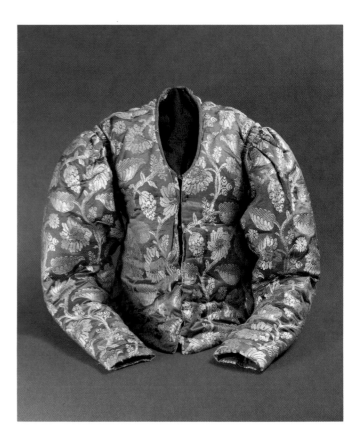

central and southern provinces, Russian women favored homespun skirts (*paniovas*), which consisted of several widths of woollen material, stitched together and wrapped around the body. Skirts were usually dark blue, black, or red with stripes or checks. Aprons decorated with embroidery, silk ribbons, and lace were a requisite accessory. There were numerous variations within each of these two basic styles, but the general effect was a strikingly elaborate whole and its details.

It would hardly be fair to give preference to only one regional costume for its artistic merits because there are so many other superb examples. Peasant women's chemises of the Tambov Province are remarkable for the exquisite graphic quality of the black geometric designs embroidered on their sleeves; dresses of Tula peasant women, with their wide sleeves and large aprons, stand out for their rhythmic freedom in the arrangement of large and small red designs; flared white and blue cotton-print sleeveless dresses worn by peasant women of Arkhangelsk Province vied with costumes of the Vereya District of Moscow Province, distinguished by their crimson-red iridescence and lovely small embroidered decorations; outstanding in their beauty are peasant costumes from Riazan Province, in the embroidery and laces of which red tones predominate; mosaic-like patterns of dress yokes is the most imposing feature of peasant women's costumes from the Kargopol District of Olonets Province.

Woman's jacket. 18th or early 19th century
Northern Russia
Brocade. 158 × 55
Museum of Folk Art, Moscow

Woman's jacket. 19th century
Northern Russia
Brocade. 164 × 55
Museum of Folk Art, Moscow

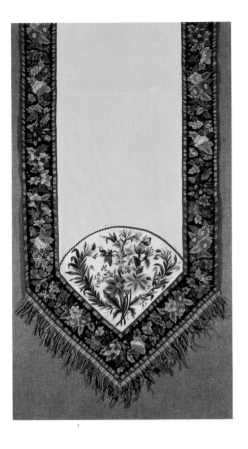

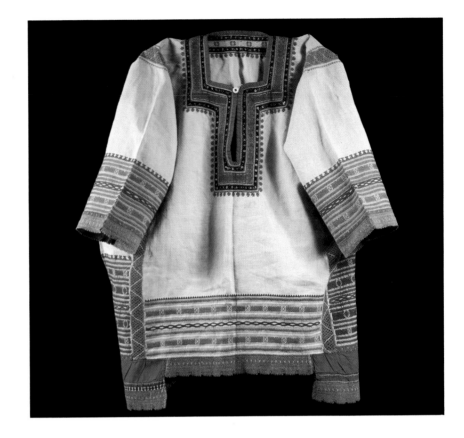

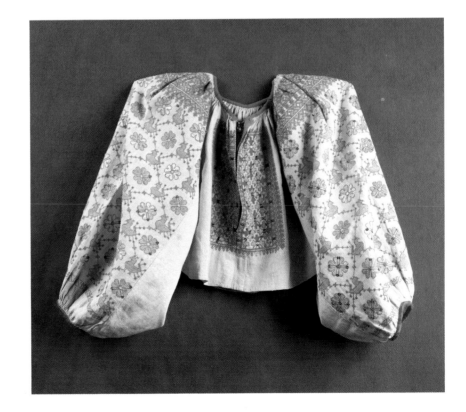

Detail of scarf. 1830s and mid-19th century
Homespun goat's down (border) and embroidered silk
The Russian Museum, Leningrad

Woman's blouse. 19th century
Riazan Province
Homespun linen, with red calico trimmings and embroidery.
 74 × 96
Museum of Folk Art, Moscow

Sleeves of a woman's chemise. 19th century
Olonets Province
Homespun linen, with red calico trimmings and embroidery.
 130 × 42
Museum of Folk Art, Moscow

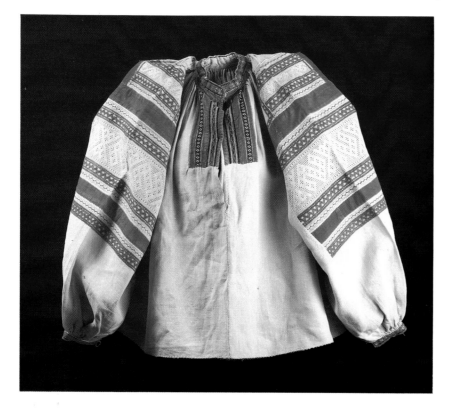

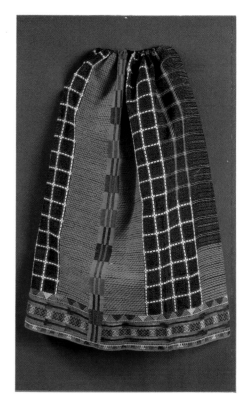

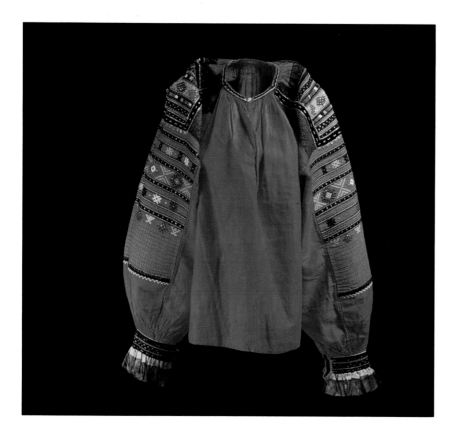

Peasant woman's chemise. 19th century
Voronezh Province
Homespun linen, with embroidery. 156 × 63
Museum of Folk Art, Moscow

Peasant woman's chemise. Late 19th century
Voronezh Province
Homespun cotton, with embroidery, spangles, and lace.
59 × 161
Museum of Folk Art, Moscow

Skirt. Late 19th century
Voronezh Province
Homespun wool, with embroidery. 84 × 88
Museum of Folk Art, Moscow

All of these costumes demonstrate precious facets of national talent. Woven patterns and embroidered designs complemented each other, although in certain regions one of these predominated, thus determining the general style of costume.

The embroidery of northern Russia (Arkhangelsk, Vologda, and Olonets Provinces) and of Tver Province is rich in archaic pictorial motifs formerly associated with the cult of fertility and magical protection of hearth. Variations of tripartite compositions, dominated by the figure of a goddess flanked by horses, riders, trees, or birds, often occur on the sleeves and hems

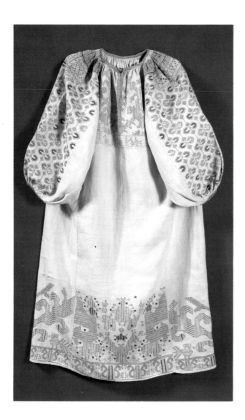

Peasant woman's chemise. 19th century
Olonets Province
Homespun linen, with braid, lace, and embroidery. 70 × 124
Museum of Folk Art, Moscow

Petticoat for festive occasions. 19th century
Arkhangelsk Province
Homespun linen, with embroidery and fringes. 83 × 91
Museum of Folk Art, Moscow

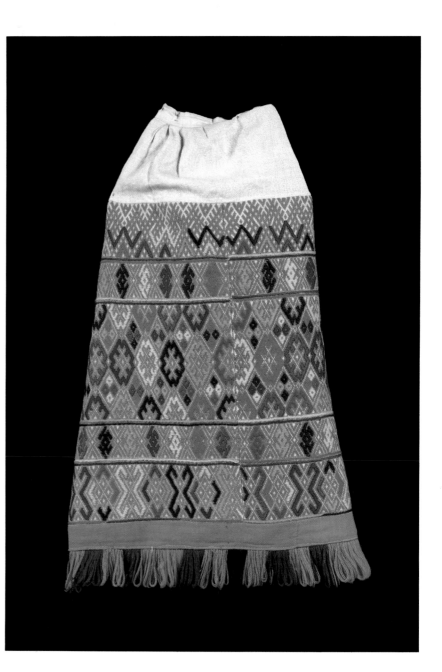

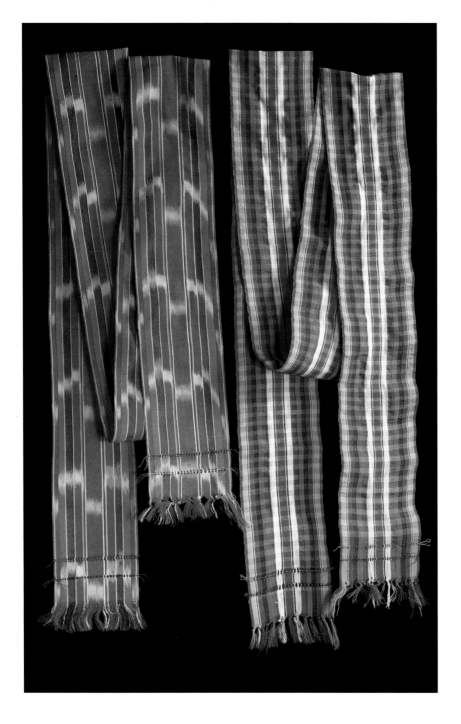

Waistbands. 1910s
Oboyan District, Kursk Province
Homespun wool. 17 × 342; 16.5 × 336
Museum of Folk Art, Moscow

Towel. 19th century
Northern Russia
Embroidered linen. 235 × 36
Museum of Folk Art, Moscow

Border of towel. 19th century
Olonets Province
Linen, with red calico trimmings, lace, and embroidery.
 Width 34
Museum of Folk Art, Moscow

Border of an apron. First half of the 19th century
Torzhok, Tver Province
Homespun linen, with lace and silk ribbons. Width 42
Museum of Folk Art, Moscow

Border of towel. Early 19th century
Galich, Kostroma Province
Linen, with lace and silk ribbons. Width 28.5
Museum of Folk Art, Moscow

of women's chemises and on the borders of homespun towels. Birds were among the favorite images of Russian folklore. Ornaments with representations of birds, either in a generalized form or depicted in a life-like manner, were often combined to form compositions of varying complexity. Other popular zoomorphic motifs in embroidery were horses, deer, dogs, frogs, serpents, and various fantastic creatures. As their magical significance was

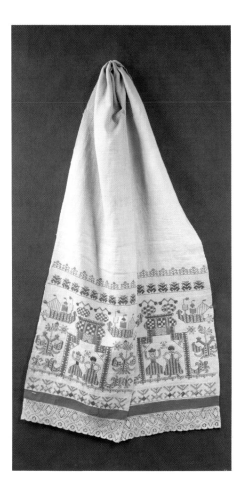

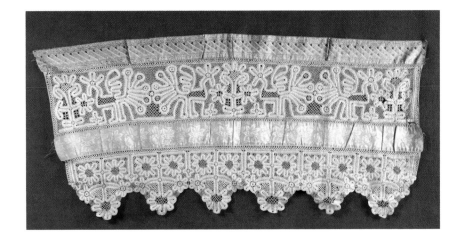

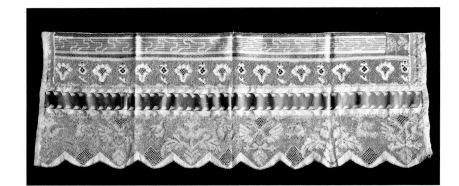

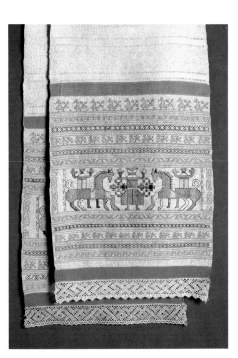

gradually forgotten, they became associated with the poetic world of fairy tales.

Throughout the centuries, the following principles have been observed in the art of embroidery: two-dimensional representation, an emphasis on the most essential forms, and a concise mode of expression. Not infrequently, compositions of rich decorative effect were worked entirely in red over light-colored homespun cloth. In the north, the sleeves and hems of women's chemises were embroidered with red and occasionally blue thread. These chemises were an indispensable part of a Russian woman's trousseau. The most beautiful of them were worn on such occasions as wedding celebrations and the first day of hay-making or harvesting. The function of embroidered towels was more diverse. They decorated the icon corner in a peasant hut, and they were also hung on "sacred" trees and on roadside and graveyard crosses; newborn babies were laid on them; they also served to lower coffins into the grave. This is why their characteristic motifs were a Tree of Life and various auspicious symbols.

Vestiges of ancient symbolism are reflected in embroidered geometric designs commonly found on various articles of southern Russian origin. A

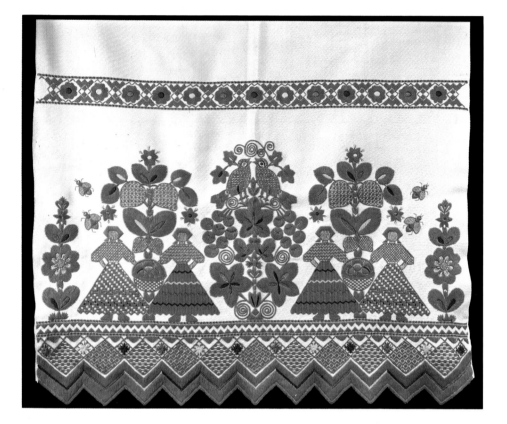

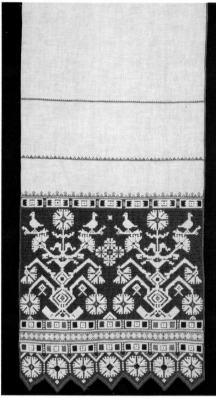

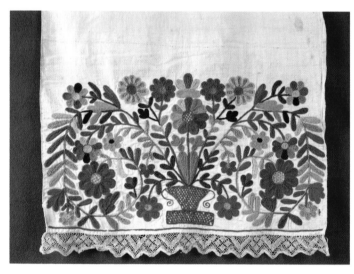

Border of towel. 1950s
Mstiora, Vladimir Region
Embroidered tussore. Width 72
Museum of Folk Art, Moscow

Border of towel. 19th century
Nizhni-Novgorod Province
Cotton, with tambour embroidery and bobbin lace.
 Width 20.3
Museum of Folk Art, Moscow

Border of towel. 1977
Tarusa, Kaluga Region
Linen, embroidered in mouliné. Width 55
Union of Artists, Moscow

Border of towel. 1967
By D. Smirnova
Mikhailov, Riazan Region
Linen, with lace and embroidery. Width 43
Museum of Folk Art, Moscow

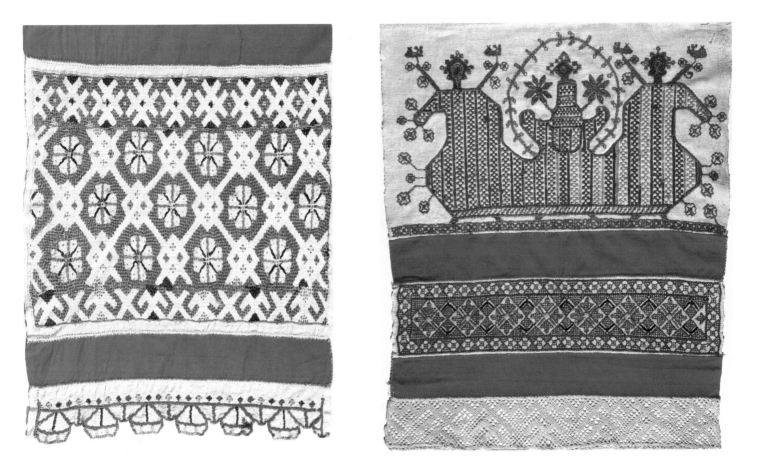

Border of towel. Early 20th Century
Northern Russia
Embroidered linen. Width 40
The Russian Museum, Leningrad

Border of towel. 1910s
Northern Russia
Embroidered linen. Width 40
The Russian Museum, Leningrad

virtually infinite number of compositions are made up of lozenges, crosses, roundels, and rosettes, which used to symbolize fertility, fire, and the sun. The bright costume of the south is embroidered in multicolored worsted, with orange tones predominating. Beautiful and bold color combinations are found in checked skirts from Orel, Voronezh, Riazan, and Kursk Provinces, decorated along the sides and hemline with raised embroidered patterns and with spangles and tapes. In the costumes worn in Kaluga and Tula Provinces, wide use is made of embroidery in colored threads.

Embroidery was more in contact with urban culture than weaving, which resulted in very interesting articles of folk handicraft such as broad bed valances made in Vologda Province. Resembling a frieze, they carried scenes from the life of the country gentry, or depicted architectural splendors, ships, and smartly dressed town people. Urban influence was responsible for the widespread use of satin stitch in white thread, hem stitch, and colored cross stitch. Such articles were in great demand in the towns, causing centers for their production to appear in many parts of Russia. Thus, Mstiora was famous for its satin-stitch embroidery in white thread, Novgorod Province for various types of hem-stitch work, Riazan for its multico-

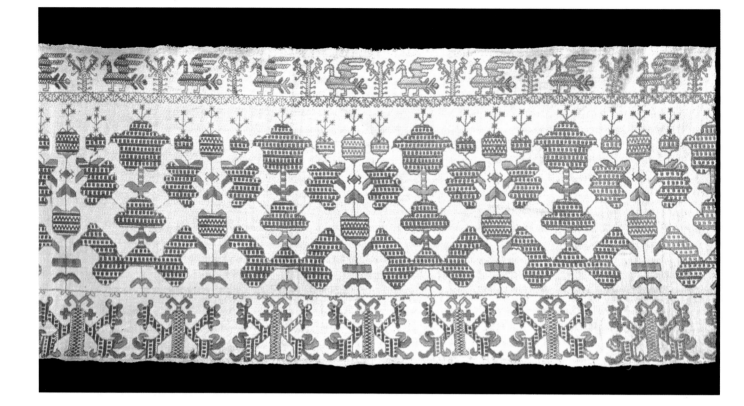

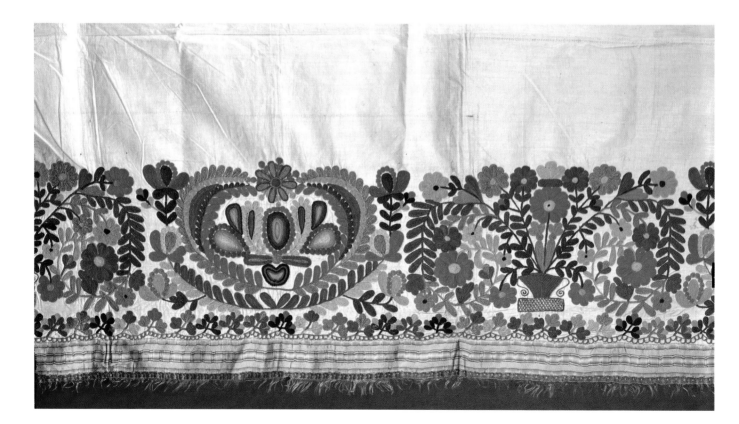

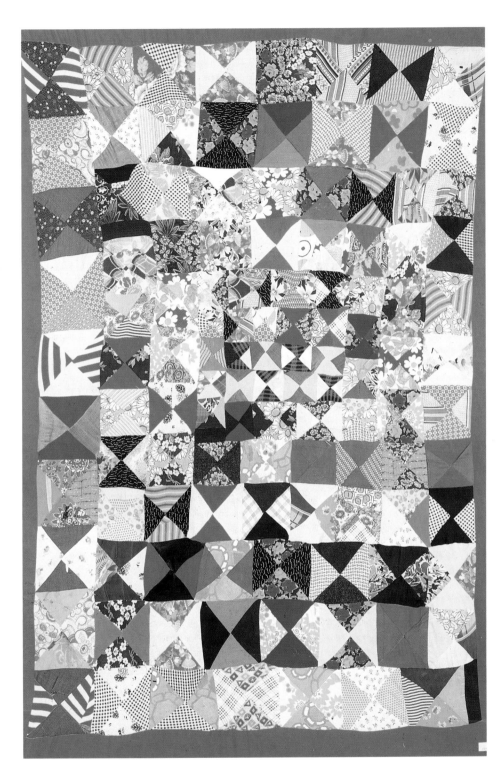

Fragment of bed valance. 19th century
Arkhangelsk Province
Embroidered linen. 160 × 37
Museum of Folk Art, Moscow

Fragment of bed valance. Late 19th century
Nizhni-Novgorod Province
Cotton, with tambour embroidery and silk ribbons. 200 × 90.5
Museum of Folk Art, Moscow

Bedspread. 1972
By A. Abakumova
Arkhangelsk Region
Patchwork
Union of Artists, Moscow

Runner. 1969
By A. Pogosheva
Vologda Region
Patchwork
Union of Artists, Moscow

Detail of door mat. 1978
Central Russia
Homespun cotton. Width 70
Union of Artists, Moscow

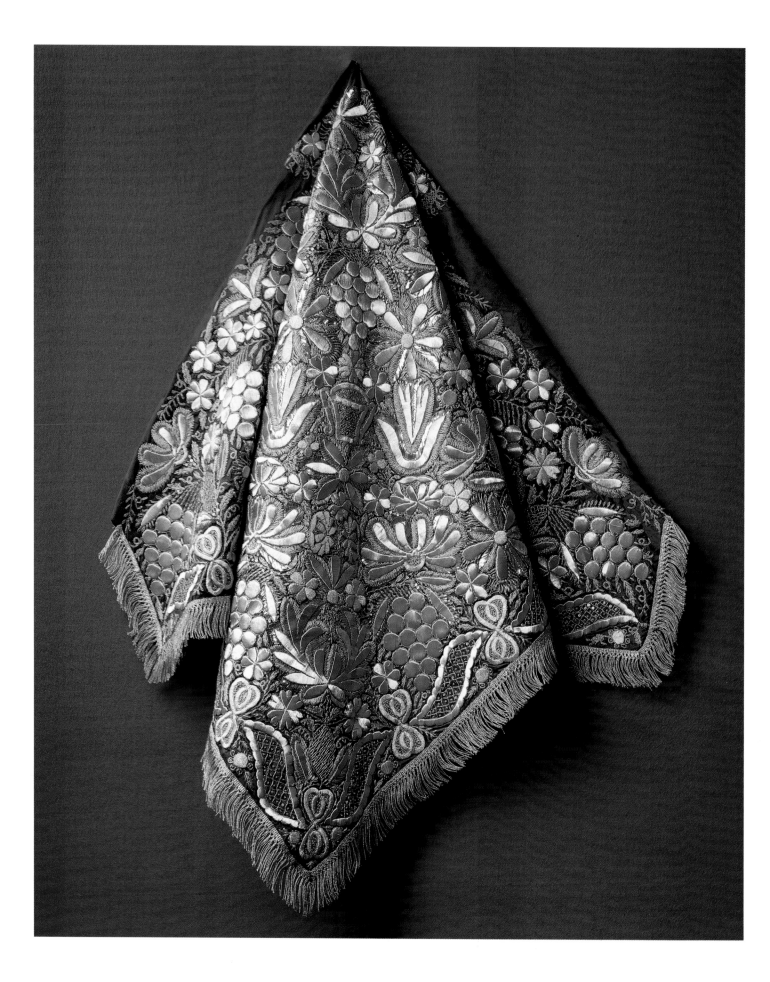

Kerchief. Early 19th century
Kargopol, Olonets Province
Silk, with embroidery in couched gold work. 92 × 95
Museum of Folk Art, Moscow

Woman's headdress. 19th century
Tver Province
Brocade, embroidered in gold thread, with mother-of-pearl.
 Height 22, diameter 17.5
The Russian Museum, Leningrad

Kerchief. First half of the 19th century
Nizhni-Novgorod Province
Silk, embroidered in gold thread. 68 × 140
Museum of Folk Art, Moscow

Women's headdresses. 19th century
Orel Province
Velvet, embroidered in gold thread, with freshwater pearls and
 glass. 19 × 20 × 15; 21 × 20.5 × 18.5
The Russian Museum, Leningrad

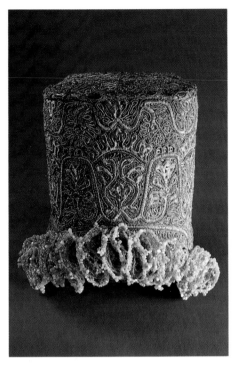

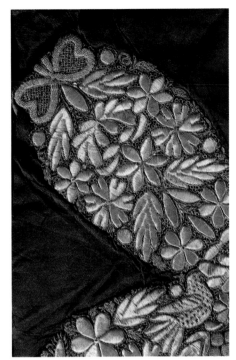

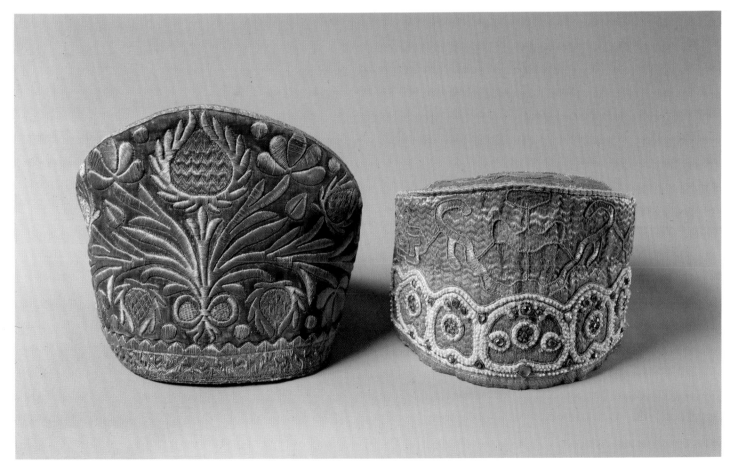

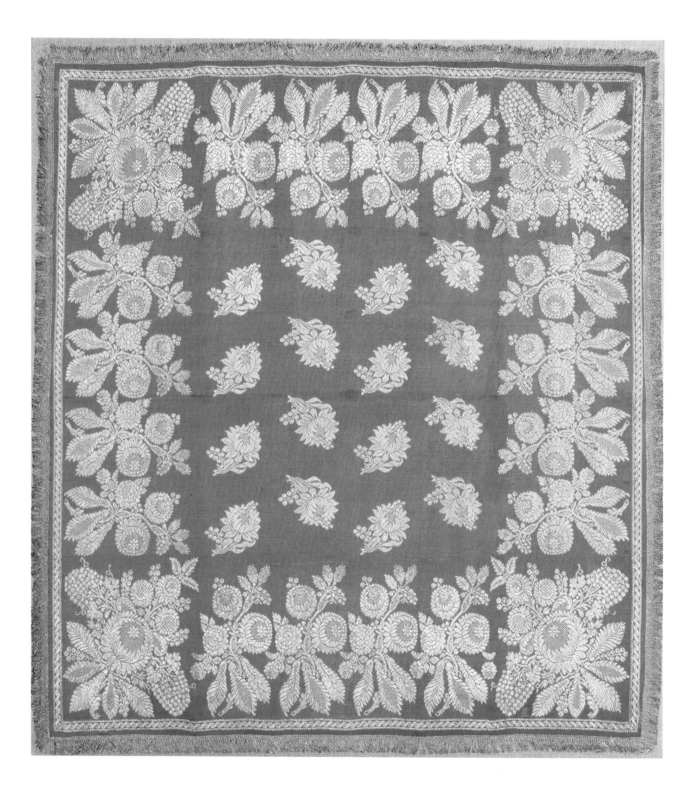

lored needlework, Torzhok for its embroidery in gold thread, and Kaluga for its embroidery in colored threads with drawn-thread work. Even now, hand-embroidered decorations are widely used as trimmings for clothes, tablecloths, napkins, and other articles.

Kerchief. First half of the 19th century
Silk, embroidered in gold thread. 107 × 98
The Russian Museum, Leningrad

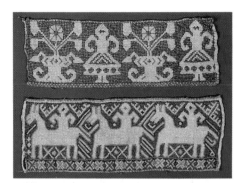

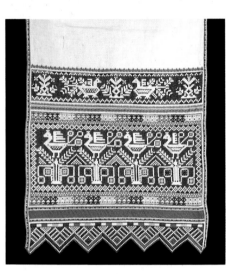

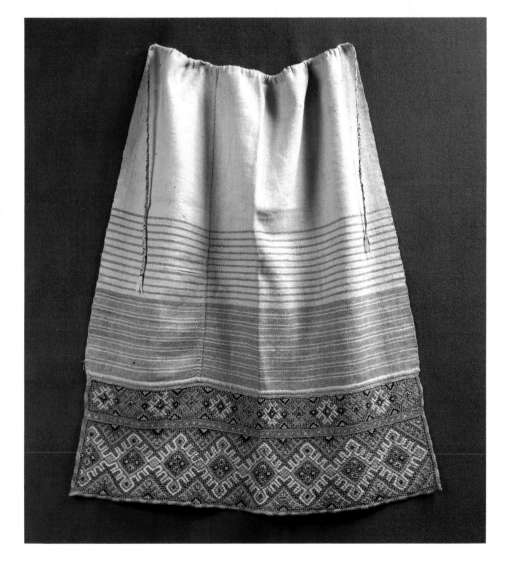

Corner of tablecloth. 1977
Tarusa, Kaluga Region
Embroidered linen
Museum of Folk Art, Moscow

Towel insertions. 19th century
Kaluga Province
Embroidered linen. 12 × 35; 13 × 37
Museum of Folk Art, Moscow

Border of towel. 1975
Tarusa, Kaluga Region
Embroidered linen. Width 50
Museum of Folk Art, Moscow

Border of towel: *Peahens.* 1956
Tarusa, Kaluga Region
Embroidered linen. Width 50
Museum of Folk Art, Moscow

Apron. Late 19th century
Smolensk Province
Homespun linen, with embroidery. 61 × 70
Museum of Folk Art, Moscow

Russian carpet-making has been connected with the textile-weaving trade. Peasants from the southern provinces wove thick woollen bedspreads with striped or geometric ornaments. Flat-handwoven rugs with large floral designs were made in Kursk and Voronezh Provinces in the nineteenth cen-

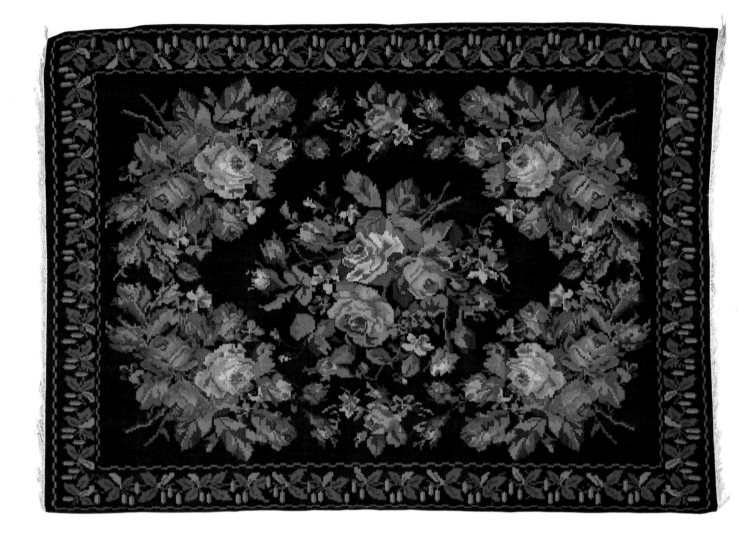

tury as coverings for benches, chairs, or sledges. Similarly patterned pile rugs were woven in the Urals and in Siberia. Carpet-making continues in its traditional centers even today, except for Voronezh, where checked plaids in attractive original colors are produced instead.

Like many other European countries, Russia had a well-established lace-making trade. The oldest surviving lace of gold or silver thread dates back to the fourteenth century. Old records contain evidence that lace was used for decorative purposes even earlier. Gold and silver lace was woven with a weft of silk threads entwined with very thin gilded or silvered copper wire. In the eighteenth century, Russian lacemakers also used flattened wire of different hues, creating a type of lace for trimming fine clothes and headdresses. Later, the ornamental motifs of gold and silver lace were employed in bobbin lace made of white linen thread, large quantities of which were produced in many old towns and country estates. Colored threads

Rug. 1979
Voronezh Region
Handwoven wool. 150 × 220
Union of Artists, Moscow

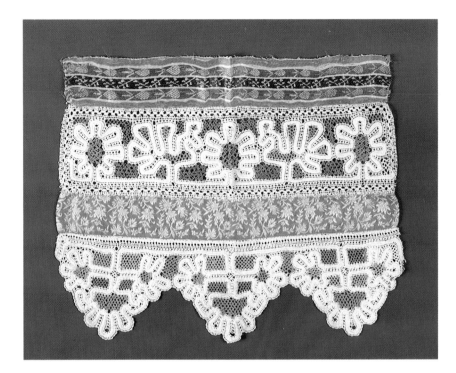

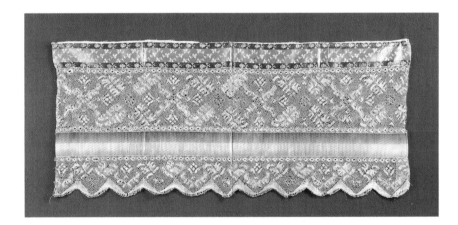

Border of towel. 18th or early 19th century
Torzhok, Tver Province
Linen, with colored lace and silk ribbons. Width 32
Museum of Folk Art, Moscow

Border of towel. Early 19th century
Galich, Kostroma Province
Linen, with lace and silk ribbons. Width 37.5
Museum of Folk Art, Moscow

Border of towel. Late 18th or early 19th century
Galich, Kostroma Province
Linen, with colored lace and silk ribbons. Width 29
Museum of Folk Art, Moscow

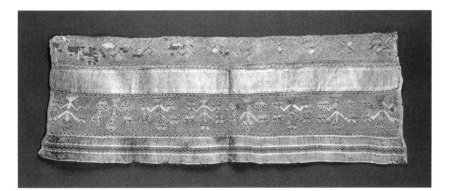

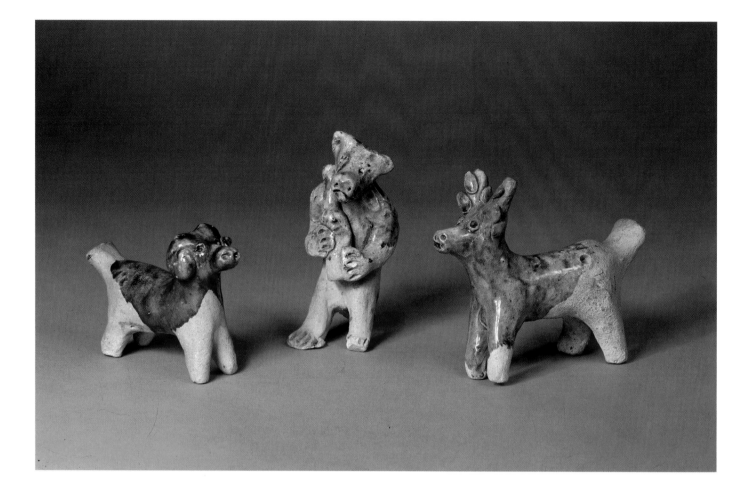

were also used a great deal. In Galich, for example, an old town in Kostroma Province, lace designs were generally accentuated by an outline in green, pink, and yellow threads. One of the lacemakers' favorite practices was to intersperse lace panels with colored silk ribbons. Lace ornaments made there depicted fabulous beasts and birds, traditional peasant embroidery motifs, as did lace from Kaliazin and Torzhok, two towns in Tver Province.

In the eighteenth century, there was also a lace-making industry in Orel Province, particularly in the towns of Yelets, Mtsensk, and villages in their vicinity. Their best quality work did not fall short of European standards. Thin silk lace was the specialty of the town of Balakhna on the Volga, where kerchiefs, scarves, and dress trimmings were woven.

Lace from the town of Mikhailov in Riazan Province, dense and thick, had the form of a narrow strip and was made of red, blue, and white threads. Peasants used to decorate their shirts, chemises, and aprons with it. The Mikhailov lace has retained its originality and is widely used for trimming modern clothes.

Very famous lace, predominantly of white linen thread, is made in Vo-

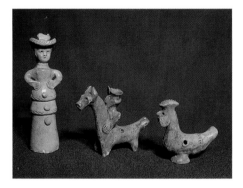

Ram, Bear, and *Deer.* Late 19th or early 20th century
Skopin, Riazan Province
Handworked clay, fired and glazed. Height 5, 8.5, and 7
Ethnography Museum, Leningrad

Lady, Horseman, and *Cock.* Late 19th or early 20th century
Village of Abashevo, Penza Province
Handworked clay, fired and glazed, with stamped design.
Height 11, 8.5, and 4.5
Ethnography Museum, Leningrad

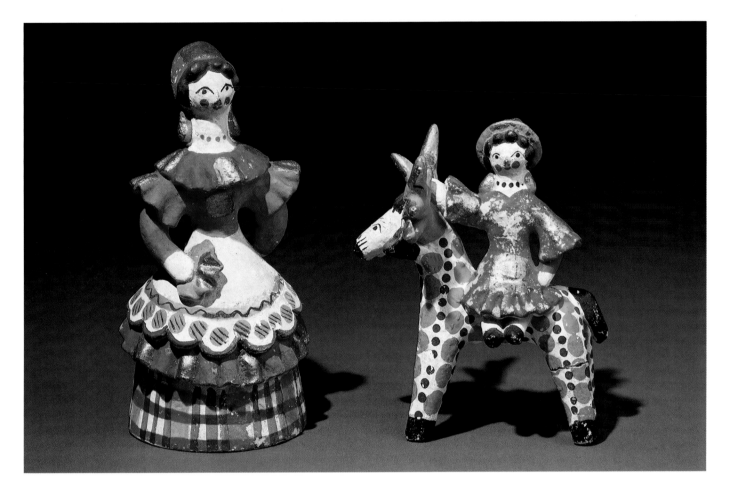

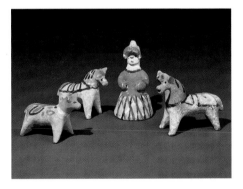

Lady and Horsewoman. 1940
By Ye. Koshkina
Kirov
Handworked clay, fired and painted. Height 20 and 17.5
Ethnography Museum, Leningrad

Dog, Horses,* and *Lady. Late 19th century
Kargopol District, Arkhangelsk Province
Handworked clay, fired and painted. Height 5 (dog), 6 and 8
 (horses), and 10 (lady)
Ethnography Museum, Leningrad

logda. The design is formed by a smooth continuous line of clothwork against an openwork netting.

Contemporary lace-making has been more enriched with new motifs and images than embroidery. Instead of producing lengths of lace, women now engaged in the trade make articles for interior decoration or for wear such as tablecloths, bedspreads, and napkins, or collars, scarves, and dress insets and panels.

Pottery-making, one of the earliest and most widespread trades in Russia, was practiced throughout the country. The form of earthenware vessels and methods of decoration varied from place to place. They were closely linked with local artistic tastes and traditions. Thus, in Yaroslavl Province, smoked and burnished jugs of simple and severe form and noble appearance were made in the nineteenth century, whereas in the same period the town of Skopin, in Riazan Province, had a reputation for its ornate pitchers for *kvass*, which were amazingly intricate in form and profusely decorated.

In addition to pottery, clay toys were often made. Especially celebrated toys were produced by women artisans from what was formerly known as Dymkovo Sloboda, a suburb of Viatka (presently Kirov). The Dymkovo toy

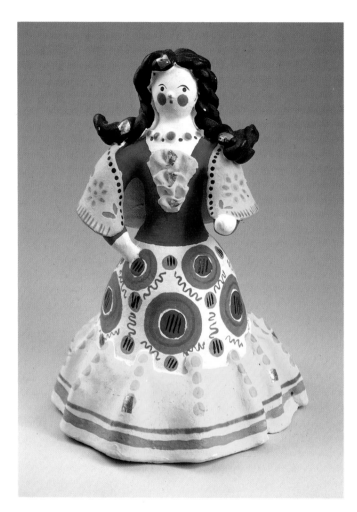

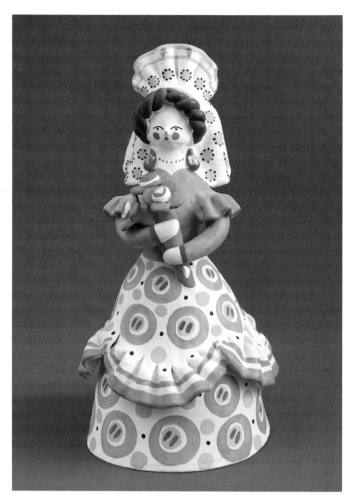

is nearly five hundred years old. An annual fair known as *Svistunya* (Whistling Woman) used to be held in Viatka, where clay whistles and figurines were brought by the thousands from all the neighborhoods. The Viatka fair tradition derives from the heathen Slavonic custom of celebrating the arrival of spring; even the still-popular figurines of imposing ladies were at one time linked with pagan beliefs. The soft plastic modelling of the Dymkovo figurines representing wet nurses, horsemen, gold-horned deer and goats, or splendid turkeys is accentuated by brightly painted decorations on white ground; the foundation's color is achieved by covering the surface with powdered chalk dissolved in milk. Toys made in the 1930s and 40s, the time when the craft was revived, are particularly expressive. Contemporary Dymkovo toys conform to the traditional style, yet each reflects the craftsman's individual manner.

The style of ceramic toys produced in the village of Filimonovo, in the Tula Region, is entirely different. The static elongated figures of people and animals are devoid of all pictorial elements characteristic of the Dymkovo ware. There is, however, a peculiarly latent dynamism in their clear-cut

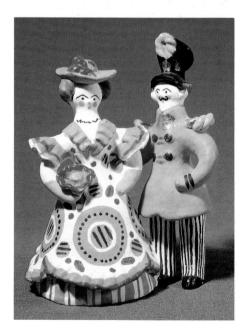

Gypsy Woman. 1977
By Z. Penkina
Kirov
Handworked clay, fired and painted. Height 18
Union of Artists, Moscow

Bride. 1978
By Z. Kazakova
Kirov
Handworked clay, fired and painted. Height 23
Union of Artists, Moscow

Lady and Her Admirer. 1971
By Ye. Koss-Denshina
Kirov
Handworked clay, fired and painted. Height 16 and 17
The Russian Museum, Leningrad

On the Bench. 1979
Kirov
Handworked clay, fired and painted. Height 17
Union of Artists, Moscow

Turkey. 1978
Kirov
Handworked clay, fired and painted. Height 20
Union of Artists, Moscow

Carriage. 1979
Kirov
Handworked clay, fired and painted. Height 16
Union of Artists, Moscow

outlines, sharply correlated volumes, and in the conventionality of their decoration–alternating red and green stripes.

In shape, the Penza toys are similar to the Filimonovo ware, but they are larger and painted in local colors. Toys from Kargopol, in the Arkhangelsk Region, demonstrate a greater freedom of modelling and painting. Interesting toys are made in the Kursk Region, though their modelling and painted decoration in specks of color are somewhat crude and naive.

Folk pottery formed the foundation for the thriving industries of Gzhel, one of the most important folk art centers. Gzhel is the name of a locality in the vicinity of Moscow, where high-quality clays abound and where the

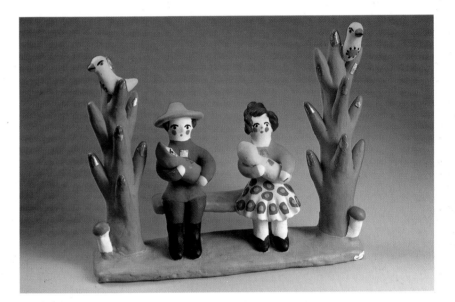

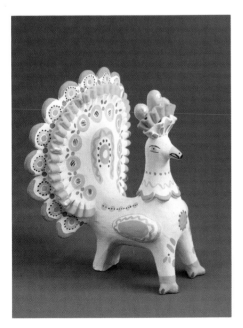

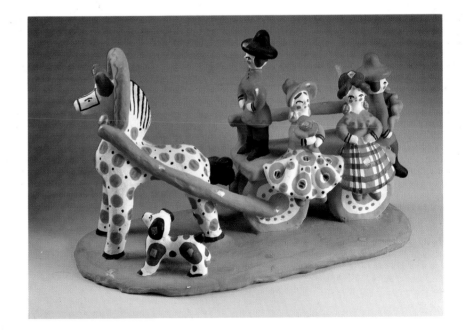

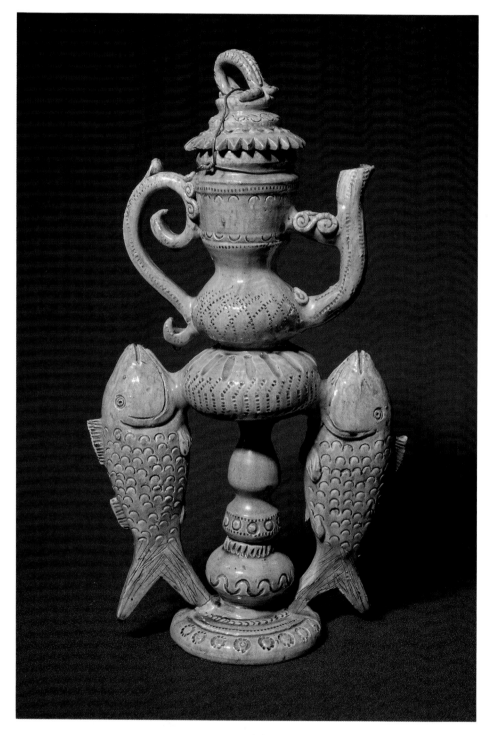

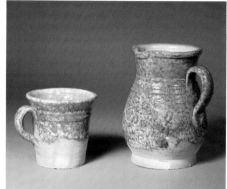

Jug. 1900
Skopin, Riazan Province
Clay, fired and glazed, with stamped design. Height 40
Ethnography Museum, Leningrad

Jug and mug. Late 19th century
Skopin, Riazan Province
Clay, fired and glazed. Height 9.5 and 15
Ethnography Museum, Leningrad

Jug for *kvass*. 1978
Skopin, Riazan Region
Handworked clay, fired and glazed. Height 44
Union of Artists, Moscow

Candelabrum. 1978
By N. Nasonova
Skopin, Riazan Region
Handworked clay, fired and glazed. Height 34
Union of Artists, Moscow

Jug for *kvass*. 1978
Skopin, Riazan Region
Handworked clay, fired and glazed. Height 45
Union of Artists, Moscow

Vessel for *kvass*. 1978
Skopin, Riazan Region
Handworked clay, fired and glazed. Height 45
Union of Artists, Moscow

potter's craft has been practiced from a very early date. Raw clay from
Gzhel was brought to Moscow from the fifteenth to seventeenth centuries
so that craftsmen from the potters' quarter there could throw earthenware,
toys, and tiles. Gzhel majolica from the last quarter of the eighteenth centu-

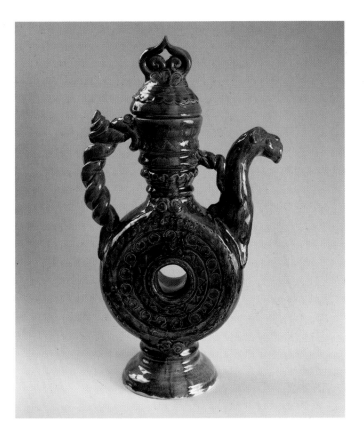

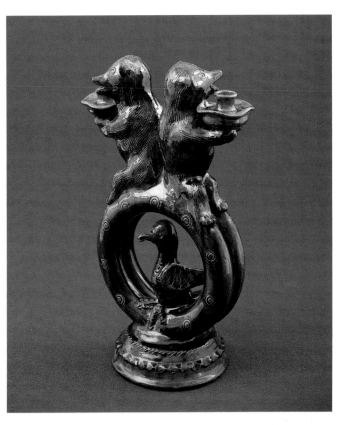

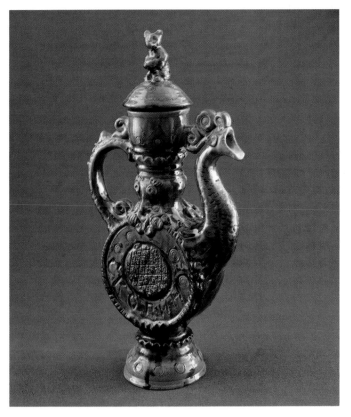

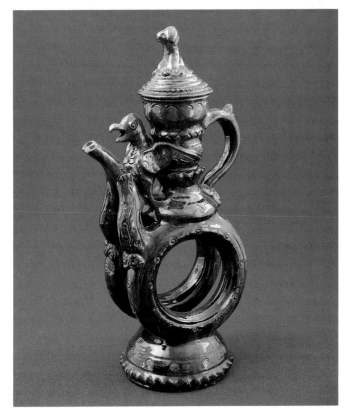

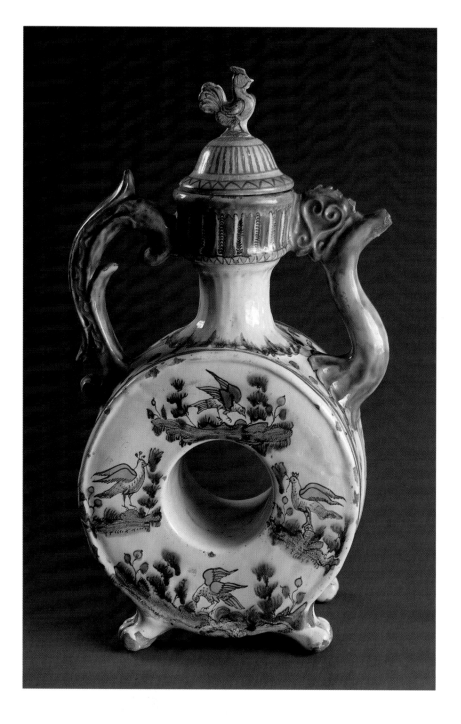

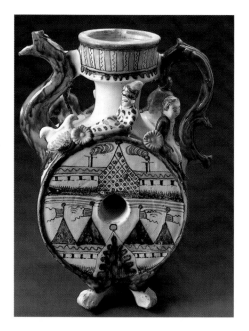

Jug for *kvass*. 18th century
Gzhel, Moscow Province
Clay, fired and painted over wet enamel. Height 39
The Russian Museum, Leningrad

Jug for *kvass*. Last third of the 18th century
Gzhel, Moscow Province
Clay, fired and painted over wet enamel. Height 38
Museum of Folk Art, Moscow

ry is especially remarkable. Jugs, plates, *kvass* pitchers, and the like were covered with white enamel, upon which designs were painted before the foundation had dried. Vessels from Gzhel have gentle rounded shapes with gradually widening necks. *Kvass* pitchers, as a rule, are decorated with applied handworked figurines. The Gzhel ware's light and airy painting is pleasing to the eye, with plenty of unfilled space around the trees, shrubs, and flowers, amidst which large birds or hares are depicted. Sometimes jugs

Dish. Last third of the 18th century
Gzhel, Moscow Province
Clay, fired and painted over wet enamel. Diameter 29.7
Museum of Folk Art, Moscow

Jug for *kvass*. 18th century
Gzhel, Moscow Province
Clay, fired and painted over wet enamel. Height 36
The Russian Museum, Leningrad

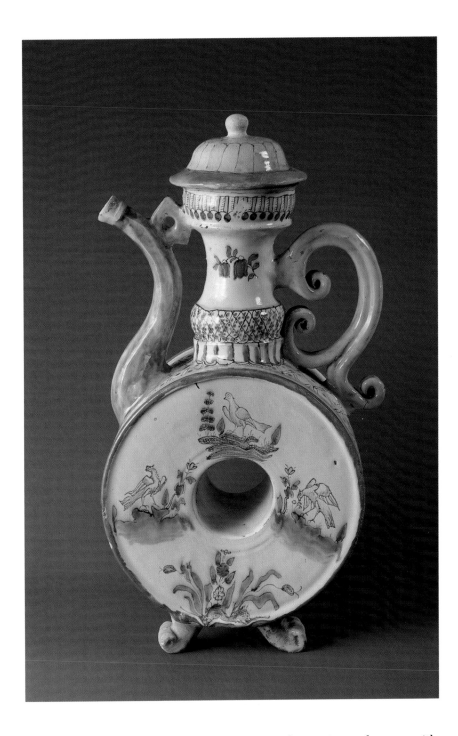

and *kvass* vessels were decorated with magnificent views of towns with towers, turrets, and wisps of chimney smoke.

In the first half of the nineteenth century, the production of faience and what is sometimes known as semi-faience was mastered in Gzhel, where there were also several factories manufacturing porcelain crockery. Their painted decorations demonstrate the people's taste and predilection for un-pretentious motifs.

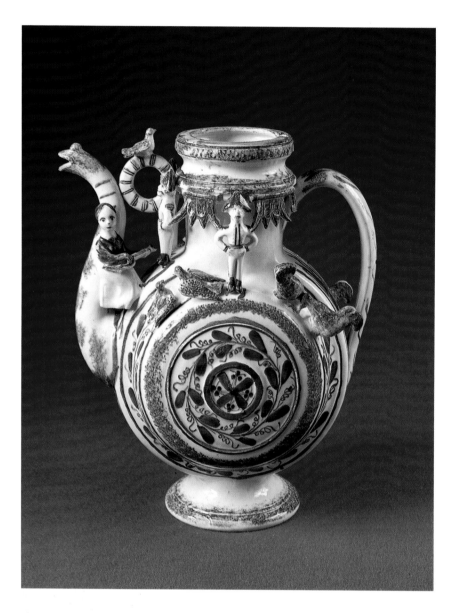

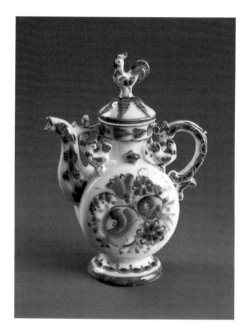

Jug. Mid-19th century
Gzhel, Moscow Province
Semi-faience, painted underglaze. Height 32.5
Museum of Folk Art, Moscow

Teapot: *Cockerels.* 1978
By L. Azarova
Gzhel, Moscow Region
Porcelain, painted underglaze. Height 21
Union of Artists, Moscow

Little Girl Riding a Hen. Early 20th century
Gzhel, Moscow Province
Porcelain, painted overglaze. Height 5.3
Museum of Folk Art, Moscow

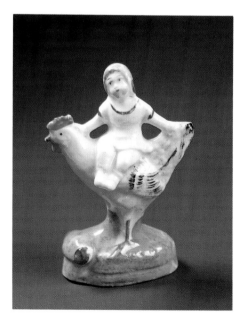

In the late nineteenth century, the Gzhel industries suffered a crisis and it was not until Soviet times that a true revival of the traditional Gzhel art took place. Largely owing to the efforts of Alexander Saltykov, an eminent Soviet art historian, the production of crockery and decorative figurines was resumed in its traditional range of forms and designs in blue and white. This, however, did not mean simply copying the previous century's wares, for the legacy of the past was creatively assimilated into something new.

Painted tiles, the production of which is a long-standing tradition, occupy a place of prominence in Russian ceramic art. The earliest tiles, unglazed red and with designs in relief, were later superseded by glazed green ones, then by polychrome tiles with colored relief, and ultimately by flat

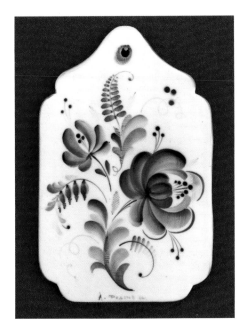

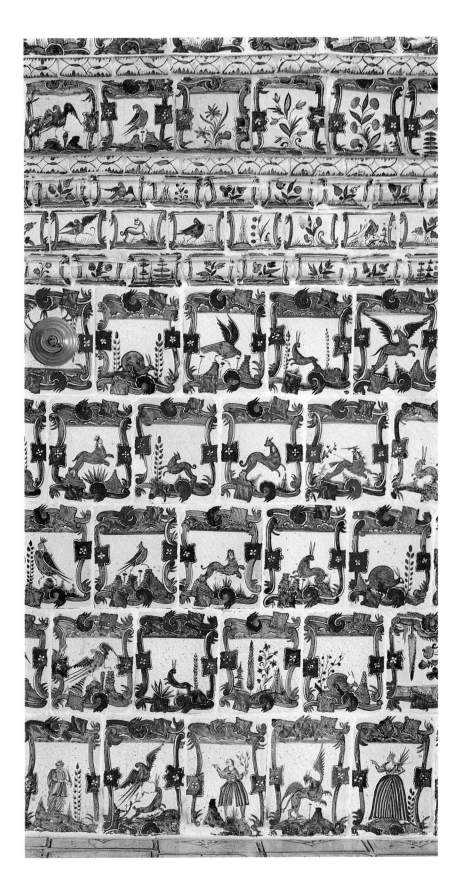

Cheese board. 1978
By A. Fedotov
Gzhel, Moscow Region
Porcelain, painted underglaze. 14 × 23
Union of Artists, Moscow

Part of tiled stove. Late 18th or early 19th century
Clay, fired and painted over wet enamel. 226 × 183 × 109
The Russian Museum, Leningrad

tiles with designs painted in subtle shades of color. In the seventeenth century, green and polychrome tiles with ornaments in relief were used to decorate cathedrals, especially in Yaroslavl, Kostroma, and Moscow. Large home fireplaces and stoves were also faced with tiles, which helped maintain the warmth longer. Such fireplaces were practical as well as beautiful. Seventeenth-century tiles were colorful and highly decorative. Eighteenth-century tiles bore pictorial designs often derived from book illustrations or *lubok* folk pictures. Considerable ingenuity and a sense of humor were displayed by potters from Vologda, Kostroma, Yaroslavl, Kaluga, and Vladimir, who painted these small majolica pieces to cover the entire surface of the fireplace with a decorative, carpet-like composition. Quite often the pictures on the tiles were provided with explanatory or didactic inscriptions.

The art of tile-making is widespread; yet urban tastes are evident not only in the complicated fireplace structure, with its columns, cornices, and niches that required considerable brick-laying skill, but also in the painted decoration based on antique and biblical subjects. In eighteenth- and early nineteenth-century Russian folk art, urban culture did generate certain developments, but folk artisans enriched them significantly. The Gzhel majolicas, the birch-bark containers with incised designs from Veliky Ustiug, the Gorodets distaffs, and, finally, the Russian painted tiles are all important examples of this phenomenon.

The Russian people's creative talent has manifested itself equally well in the art of goldsmiths and jewelers. Fine metalwork in copper and silver was practiced as early as the tenth–twelfth centuries, the epoch of Kievan Rus. Later, metal was used widely in towns and villages to make various household utensils, architectural details, weapons, and personal ornaments. Various methods and techniques, such as casting, chasing, engraving, gilding, nielloing, filigree, granulation, cloisonné, and painted enamels, were

Detail of tile. Second half of the 18th century
St. Petersburg
Clay, fired, painted, and glazed
The Russian Museum, Leningrad

Stove tile. 18th century
Clay, fired, painted over wet enamel, and glazed. 16 × 20.5
Museum of Folk Art, Moscow

Tile. Second half of the 18th century
Clay, fired, painted, and glazed. 22 × 18
The Russian Museum, Leningrad

Stove tiles. 18th century
Clay, fired and painted over wet enamel. 17 × 20 (each)
Museum of Folk Art, Moscow

used by the smiths, who displayed a great deal of imagination and taste in their work regardless of who had commissioned the article. The owner's status, however, was quite plain. Thus, mostly iron objects were found in peasant homes, such as hammered and pierced door hinges and locks, cabbage choppers, and tall candlewood holders. And beginning in the seven-

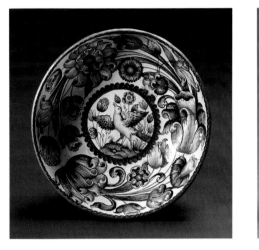

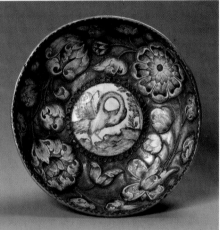

Bowl. Late 17th century
Solvychegodsk, Vologda Province
Silver, with filigree and painted enamel. Diameter 14.9
The Hermitage, Leningrad

Bowl. Late 17th century
Solvychegodsk, Vologda Province
Silver, with filigree and painted enamel. Diameter 15
The Hermitage, Leningrad

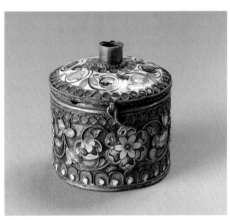

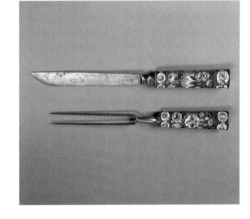

Small box. Last quarter of the 18th century
Solvychegodsk, Vologda Province
Silver, with filigree and enamel. Height 5.1
The Hermitage, Leningrad

Fork and knife. Late 18th century
Solvychegodsk, Vologda Province
Iron and silver, with filigree and painted enamel.
 Length 24 and 25.5
The Hermitage, Leningrad

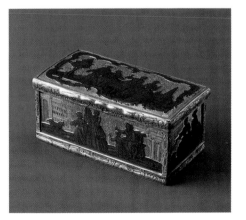

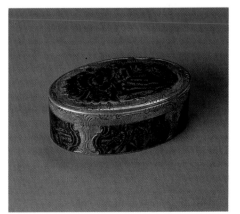

Snuffbox. 1766
Veliky Ustiug, Vologda Province
Silver gilt, chased, engraved, nielloed, and mat-tooled.
 9.6 × 4.4 × 5.2
The Hermitage, Leningrad

Snuffbox. 1777
Veliky Ustiug, Vologda Province
Silver gilt, chased, embossed, engraved, and nielloed.
 Height 3.4
The Hermitage, Leningrad

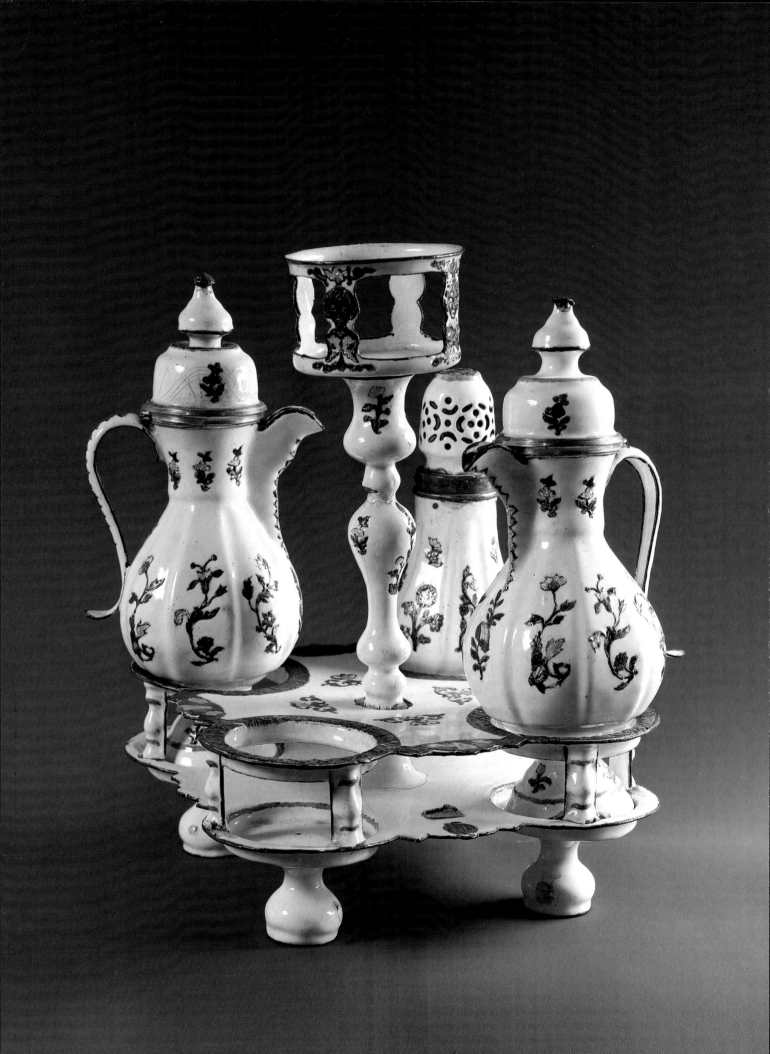

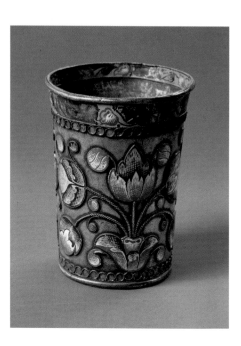

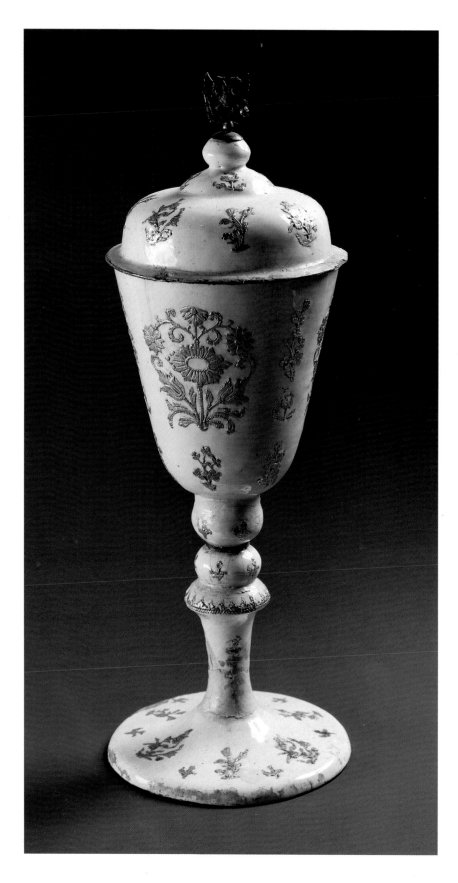

Cruet stand. 1760s–70s
Veliky Ustiug, Vologda Province
Copper, enamelled, with silver mounts. Height 27
The Hermitage, Leningrad

Cup. Last quarter of the 17th century
Solvychegodsk, Vologda Province
Silver, with filigree and painted enamel. Height 8.9
The Hermitage, Leningrad

Cup. 1760s
Veliky Ustiug, Vologda Province
Silver gilt, with enamelling. Height 30
The Hermitage, Leningrad

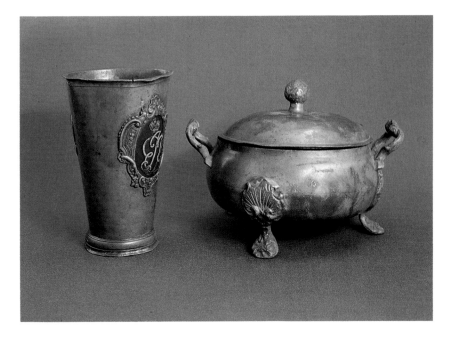

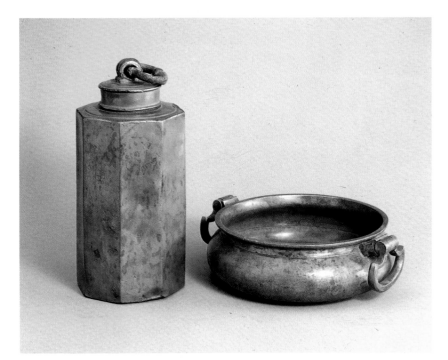

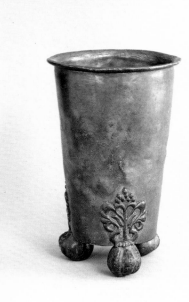

Cup and covered bowl. First half of the 18th century
Moscow
Cast tin, with enamelling. Height 19 and 18.5
The Hermitage, Leningrad

Flask and bowl. First half of the 18th century
Moscow
Cast tin. Height of flask 20.5; diameter of bowl 18
The Hermitage, Leningrad

Ornaments for horse's harness. 17th century
Moscow
Cast tin, Length 9 and 10.2
The Hermitage, Leningrad

Cup. First half of the 18th century
Moscow
Cast tin. Height 14.5
The Hermitage, Leningrad

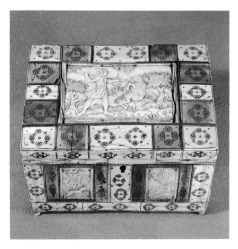

Detail of casket. Late 18th century
Tula
Steel and ormolu, faceted and damascened in gold and silver
The Hermitage, Leningrad

Casket. Second half of the 18th century
Kholmogory, Arkhangelsk Province
Wood, inlaid with carved ivory and engraved metal.
11.5 × 9 × 11
The Russian Museum, Leningrad

teenth century, many chests, caskets, and boxes bound with metal straps decorated with pierced designs were made. The inside of the box was often painted with bright pictures resembling painted panels from northern Russia, icons, and *lubok* folk pictures. In northern Russia, various copper cast articles were in common use, such as combs, inkpots, and large square or round plaques worn by horse doctors as identity badges.

In the seventeenth and eighteenth centuries, tinware was still in general use. Equally widespread was the traditional casting of decorative details: thin openwork plaques were usually placed on mica, which was sometimes painted, and these were used as adornments for lanterns, mirror frames, and other household items.

In the second half of the seventeenth century, two northern towns, Veliky Ustiug and Solvychegodsk, became centers for various metal crafts; their polychrome cloisonné enamelling was especially famous. In the eighteenth century, Veliky Ustiug produced plates, snuffboxes, and trays decorated with white and colored enamel, into which fancy-shaped silver details were soldered. In Solvychegodsk, small metal cups, bowls, jewelry boxes, and perfume cases were made—all painted over enamel in refractory enamels. Their charm lies in the inimitable beauty of their ornamentation consisting of plants and flowers painted with a light and free touch in pale opaque tones of yellow, light blue, orange, and soft green.

Niello silverwork produced in Veliky Ustiug in the second half of the eighteenth century is also highly original. Many of the subjects represented on snuffboxes, jewelry boxes, trays, and flagons were borrowed from book illustrations, prints, and *lubok* folk pictures. These motifs were skillfully translated by silversmiths into their medium by nielloed hatching, engraving the gilt ground, and chasing the central ornament. The highly ornate forms of the Veliky Ustiug silverware evince a Baroque and Rococo influence.

Veliky Ustiug nielloed silverware was greatly sought after both by the landed gentry and wealthy townfolk. The Veliky Ustiug smiths' skill had considerable impact on the niello silverwork of such centers as Moscow, Vologda, Kostromà, and Tobolsk. In the second half of the nineteenth century, the industry was threatened with extinction, and at the beginning of the twentieth century there was only one active silversmith in Veliky Ustiug. After the October Revolution every effort was made to revive the rare craft. Mikhail Chirkov, a specialist in the field, set up a workshop and taught niello to a group of young people; artistic guidance was provided by Evstafy Shilnikovsky. By and by the shop grew into a factory named Northern Niello, the wares of which, particularly jewelry, are very popular today.

At about the same time new life was infused into the art of color enamelling in Rostov. In the eighteenth century, the town was the main center of ecclesiastic enamel miniature production, but the art fell into decline in the late nineteenth century. After the October Revolution a workshop was set up in Rostov in order to explore new applications for the old art. Sergei

Decorative panel: *Rostov*. 1970s
By G. Anisimov
Rostov, Yaroslavl Region
Wood, painted in enamel. 9.5 × 13
Private collection

Decorative panel: *Morning*. 1976
By A. Tikhov
Rostov, Yaroslavl Region
Wood, painted in enamel. 14 × 8
Private collection

Box. 1920s
Rostov, Yaroslavl Region
Copper, painted in enamel. Height 3.6
Museum of Folk Art, Moscow

Casket. 1920s
Rostov, Yaroslavl Region
Copper, painted in enamel. 12.3 × 8.8 × 7.8
Museum of Folk Art, Moscow

Chekhonin, an eminent Russian artist, participated in the work. His compositions with floral ornaments proved invaluable as guidelines for the Rostov craftsmen to evolve a new distinctive style of enamel miniature with the traditional white background. Brooches, pendants, and mirror frames were made with this type of decoration. At present, Rostov jewelry combines enamelled ornamental or pictorial designs in filigree settings.

Jewelry and personal ornaments have always been a prominent part of Russian applied arts. Necklaces, bracelets, earrings, insets for clothes, and pendants of various sorts were produced in Kiev, Vladimir, and Riazan as early as the tenth–twelfth centuries. These decorations were an integral

Casket: *In a Boat*. 1976
By A. Tikhov and V. Soldatova
Rostov, Yaroslavl Region
Silvered copper, painted in enamel, with filigree. 11 × 5 × 3.5
Union of Artists, Moscow

Box: *Hunting*. 1970
By N. Kulandin
Rostov, Yaroslavl Region
Silvered copper, painted in enamel. 7 × 5
Private collection

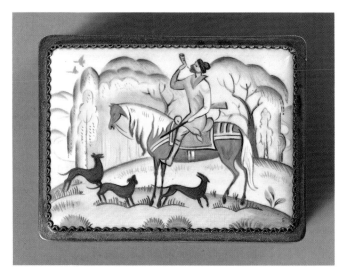

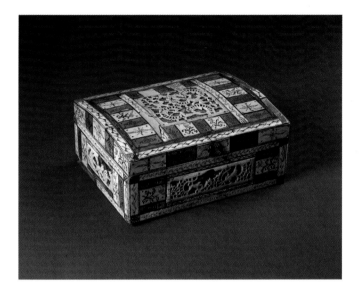

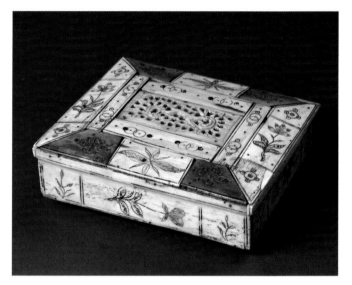

part of national costumes. Because they were elaborately and beautifully made, they were often more valued than the clothes they matched. Sixteenth-century foreign visitors observed that there was rarely a Russian woman not wearing earrings made of silver or another metal. The ubiquitous custom of wearing personal adornments facilitated the growth of centers for their production. One of them was the village of Krasnoye on the Volga (the present Kostroma Region), where inexpensive copper and silver decorations were made.

Any account of Russian metalwork would be incomplete without mentioning Tula, Pavlovo-on-the-Oka, and the Urals, where workshops and factories existed at a very early date. They produced quite a few remarkable articles deserving to be called objects of art rather than craftsmen's wares. One of the most notable articles made in the village of Pavlovo-on-the-Oka was a copper padlock. Designed for purely practical purposes, such objects were ingeniously made in the form of birds or animals.

Tula is the oldest Russian weapons manufacturing center. Pistols and shotguns of Tula workmanship were highly reputed abroad for their technical excellence as well as for their beautiful finish and decoration. Besides firearms, the production of various knickknacks such as candlesticks, snuffboxes, vases, caskets, and even furniture, began in the second half of the eighteenth and first half of the nineteenth centuries. Such traditional techniques as gilding, burnishing, engraving in relief, damascening in gold and silver, and others were employed. But the most remarkable discovery of the Tula smiths was the so-called diamond cut. Their "diamond" consisted of a steel stem and head with a certain number of polished facets, which glittered and sparkled like diamonds. On the hilt of a sword dating from the second half of the eighteenth century (Historical Museum, Moscow), there are over eleven thousand round, oval, and pear-shaped "diamonds" of this sort.

As evidenced by archaeological finds and written records, bone carving was practiced in Russia as early as the tenth century. Crosses, icons, and domestic articles such as combs, spoons, and chess sets were carved from bone in Novgorod in the fourteenth and fifteenth centuries. In the seven-

Casket. Second half of the 18th century
Kholmogory, Arkhangelsk Province
Carved ivory. 15 × 8 × 10.5
Museum of Folk Art, Moscow

Casket. Second half of the 18th century
Kholmogory, Arkhangelsk Province
Carved ivory. 11 × 3 × 9
Museum of Folk Art, Moscow

teenth century, the craft was adopted in northern Russia, mainly in Kholmogory and Arkhangelsk, where walruses were hunted for their tusks. Mammoth ivory found in the tundra was also an excellent material for carving.

Bone panels, white, colored green or burnt sienna, were widely used as decorative facing for wooden boxes and jewelry caskets. The Kholmogory carvers were often invited to Moscow to work for the court. They made ornate cups, caskets, chessmen, and many other objects elaborately decorated with carving and engraving. Kholmogory ivory carving peaked in the eighteenth century. Subjects were often derived from prints, book illustrations, or folk wood carvings. The main decoration carved in low relief was generally bordered by fine openwork ornament. Engraving did not play a very important role at that time, nor did coloring. The decorative effect depended chiefly on openwork carving, which highlighted the ivory's whiteness with its exquisite texture. Diverse objects were produced ranging from toiletries to pieces of furniture. Sculpted groups in the round were carved too: apart from small-scale figurines, large carved compositions arranged on a stand were often devoted to the life of the Nenets people, faithfully reproducing their hunters, reindeer, sledges, dogs, trees, and dwellings.

In the early nineteenth century, the carvings became less delicate, the relief and openwork decorations more monotonous, and the shapes less complicated. The artistic standards were going downhill, and by the turn of the century the craft was well-nigh extinct. Only three carvers were left in Kholmogory by 1917, but these three played an important role for it was they who taught the first Soviet craftsmen when the industry was revived in the 1920s. It began to flourish from the 1950s on, and today Kholmogory is one of the most important folk art centers in the Soviet Union.

Vase. 1980
By N. Butorin
Village of Lomonosovo, Arkhangelsk Region
Engraved sperm-whale tooth. Height 14
Private collection

Box: *Farewell to Winter.* 1976
Village of Lomonosovo, Arkhangelsk Region
Ivory, carved and engraved. 10.8 × 7 × 10
Museum of Folk Art, Moscow

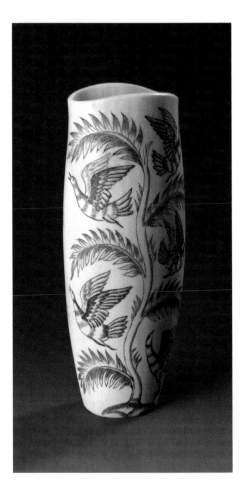

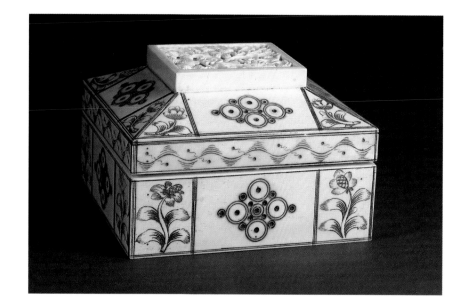

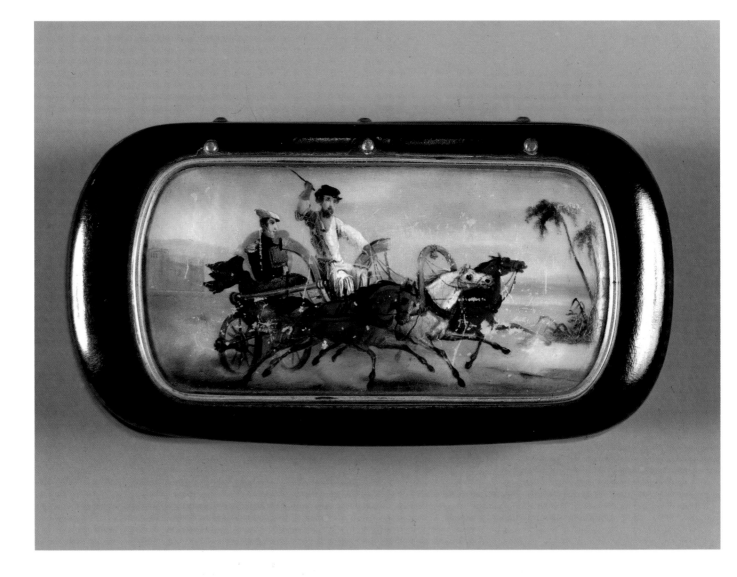

The village of Fedoskino is deservedly regarded as the cradle of Russian lacquer miniatures. In the late eighteenth century, this picturesque spot in the vicinity of Moscow became a lively production center for black-lacquered papier-mâché articles painted with colorful miniatures, such as snuffboxes, jewelry caskets, teapots, cigarette cases, etc. They were already popular in the first quarter of the nineteenth century, but before long Lukutin lacquers (named after the workshop's proprietor) became famous even in Western Europe for their perfect execution, original subjects, and peculiar techniques employed in ornamentation, such as painting on metal-plated inserts, gold leaf, or mother-of-pearl—materials that gleam through the coat of paint, creating an illusion of the setting sun, glittering snow, or glossy silk. The miniature painters often borrowed their subjects from lithographs, book illustrations, and famous Russian or Western European paintings. Essentially Russian motifs, such as *Troika* or *Tea-drinking*, began to pre-

Snuffbox: *Troika.* 1840s
Village of Fedoskino, Moscow Province
Papier-mâché, painted and lacquered. 56 × 10.7
Museum of Folk Art, Moscow

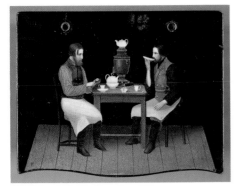

Lid of box: *Tea-drinking.* 1863–76
Village of Fedoskino, Moscow Province
Papier-mâché, painted and lacquered. 9.7 × 7.5
Museum of Folk Art, Moscow

Box: *Tea-drinking.* 1934
By I. Semionov
Village of Fedoskino, Moscow Province
Papier-mâché, painted and lacquered. 14 × 9
Museum of Folk Art, Moscow

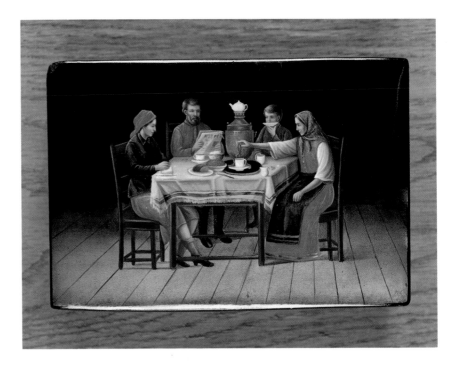

dominate toward the middle of the nineteenth century, and the Fedoskino style, with its vivid color, concise mode of expression, and organic blend with the object's shape, shone at its brightest. Present-day masters, who work fruitfully in different genres, continue to uphold these vital traditions.

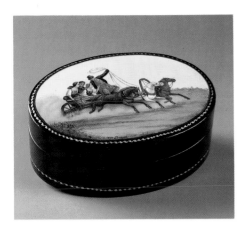

Box: *Troika.* 1954
By G. Tochonov
Village of Fedoskino, Moscow Region
Papier-mâché, painted and lacquered. Height 4
Museum of Folk Art, Moscow

Box: *Wandering Clowns.* 1978
By S. Rogatov
Village of Fedoskino, Moscow Region
Papier-mâché, painted and lacquered. 9 × 7.5
Union of Artists, Moscow

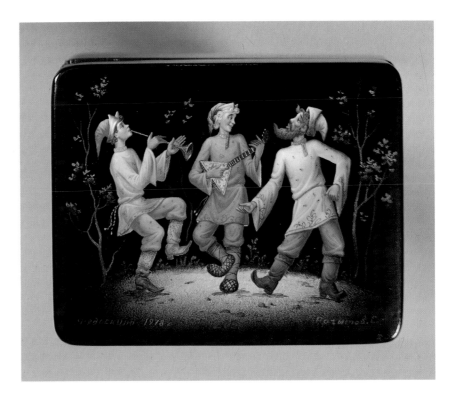

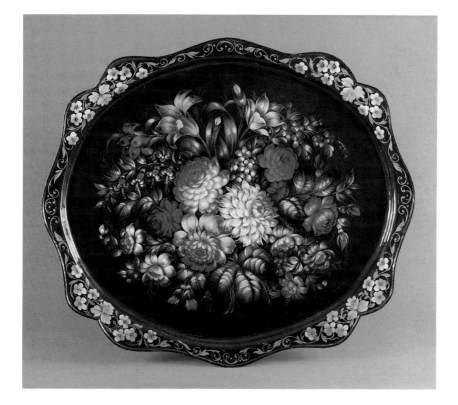

Fedoskino's neighboring village, Zhostovo, also saw the beginning of its folk craft industry in the late eighteenth century. The Vishniakovs' workshop opened first, and before long the making of tin trays bearing painted designs or naively romantic landscapes became the specialty of the village. Toward the middle of the nineteenth century, the Zhostovo craftsmen evolved their own system of painted decoration, which exists to this day. Derived largely from lacquer miniature, it is based on superimposing several coats of paint with subtle glazing, minute finishing strokes, and highlights. A bunch of flowers, placed at the center of a round, oval, or fancy-shaped tray, became their favorite motif.

While maintaining the traditional painting manner, present-day craftsmen from Zhostovo also improvise. Each painter arranges the bouquet, molds the form of flowers and leaves, and ornaments the rim in his own characteristic way. This accounts for the variety and vitality of Zhostovo folk painting today.

The lacquer miniature of Palekh, Mstiora, and Kholuy has grown out of the illustrious traditions of icon painting, for which these towns, situated near Vladimir and Suzdal, were famous as early as the sixteenth century. After the October Revolution, icon painters searched for new avenues and took up lacquer painting. Their papier-mâché technique was borrowed from the Fedoskino craftsmen, but, unlike them, the Palekh painters used tempera instead of oils.

Tray. 1977
By M. Savelyev
Village of Zhostovo, Moscow Region
Metal, painted and lacquered. Diameter 78
Union of Artists, Moscow

Tray. 1975
By V. Letkov
Village of Zhostovo, Moscow Region
Metal, painted and lacquered. Diameter 80
Union of Artists, Moscow

Tray. 1976
By Ye. Lapshin
Village of Zhostovo, Moscow Region
Metal, painted and lacquered. Diameter 85
Union of Artists, Moscow

Box: *Three Musicians.* 1924
By I. Golikov
Palekh, Ivanovo Region
Papier-mâché, painted and lacquered. 9.5 × 6.8
Museum of Folk Art, Moscow

Snuffbox: *Reapers.* 1925
By I. Markichev
Palekh, Ivanovo Region
Papier-mâché, painted and lacquered. 9.8 × 6.4
Museum of Folk Art, Moscow

Casket: *Blacksmiths.* 1925
By I. Markichev
Palekh, Ivanovo Region
Papier-mâché, painted and lacquered. 9.2 × 7.2
Museum of Folk Art, Moscow

Decorative plate: *Hunting.* 1979
By N. Gribov
Palekh, Ivanovo Region
Papier-mâché, painted and lacquered. Diameter 22
Union of Artists, Moscow

In the 1920s, the Palekh painters' first works and especially those by Ivan Golikov, the most gifted of them, were recognized as consummate art. In a poetically romantic fashion their art reflected the peasantry's new life and portrayed popular characters and themes from Russian folklore, Soviet

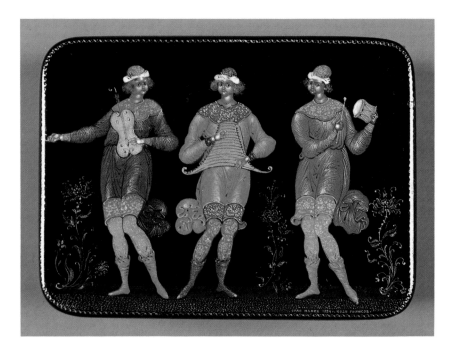

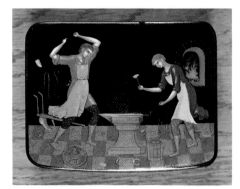

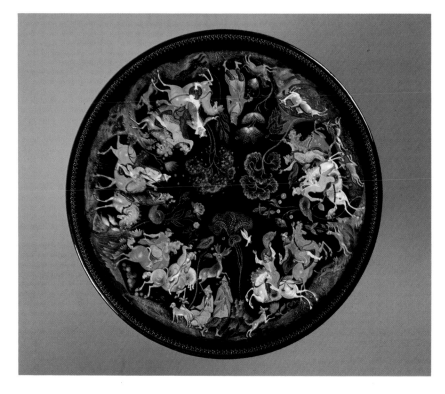

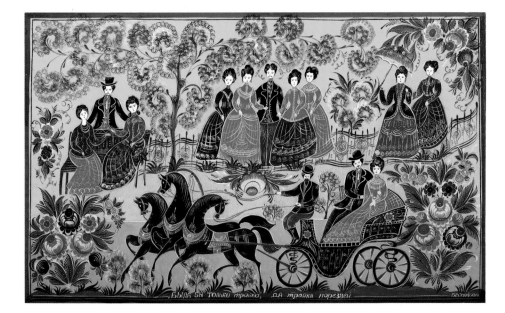

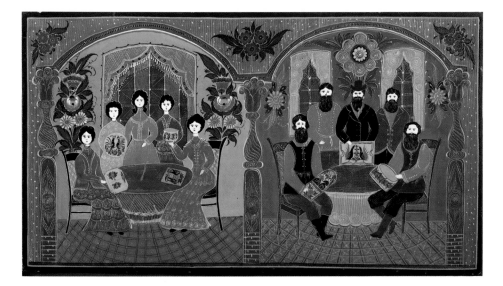

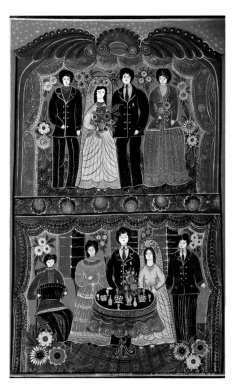

literature and songs. Each miniature painted on a box or case has a dynamic composition and distinctive coloring, in which vermillion fused with exquisite gold patterns is heightened by the black background.

The old generation of Palekh craftsmen established the tradition of teamwork, which has remained unshakable to the present day. The Palekh painters are remarkably versatile: their work ranges from stage scenery, book illustration, and monumental mural painting to the restoration of old murals.

Apart from Fedoskino and Palekh, lacquer painting is also practiced in

Panel: "If I but had a troika..." (a line from a Russian folk
 song). 1978
By L. Bespalova
Gorodets, Gorky Region
Painted wood. 60 × 36
Union of Artists, Moscow

Panel: *Gorodets*. 1977
By L. Bespalova
Gorodets, Gorky Region
Painted wood. 95 × 45
Union of Artists, Moscow

Tray. 1978
Gorodets, Gorky Region
Painted wood. Diameter 37
Union of Artists, Moscow

Panel: *Wedding Celebration*. 1978
By F. Kasatova
Gorodets, Gorky Region
Painted wood. 56 × 35
Union of Artists, Moscow

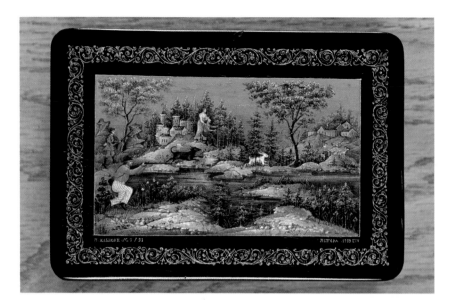

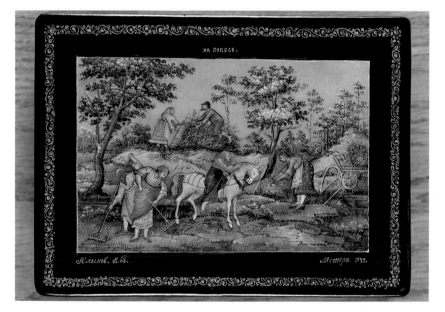

Box: *Shooting Hares*. 1933
By N. Klykov
Mstiora, Vladimir Region
Papier-mâché, painted and lacquered. 12.8 × 8.8
Museum of Folk Art, Moscow

Box: *Felling Trees*. 1933
Mstiora, Vladimir Region
Papier-mâché, painted and lacquered. Diameter 9.5
Museum of Folk Art, Moscow

Casket: *Hay-making*. 1944
By N. Klykov
Mstiora, Vladimir Region
Papier-mâché, painted and lacquered. 14.5 × 10.4
Museum of Folk Art, Moscow

Mstiora and Kholuy, which are the youngest of these centers. Mstiora's
miniature is remarkable for its subtle lyricism in the treatment of landscape
backgrounds. Their young painters draw both from Russian history, leg-
ends, and ballads, and from contemporary life. In recent years Kholuy
painters have been very active, treating folklore and heroic subjects in a ro-
mantic and technically interesting way.

Russian folk art was based on local artistic traditions, collective experi-
ence, and mastery handed down from generation to generation, compo-
nents that determine its contemporary development.

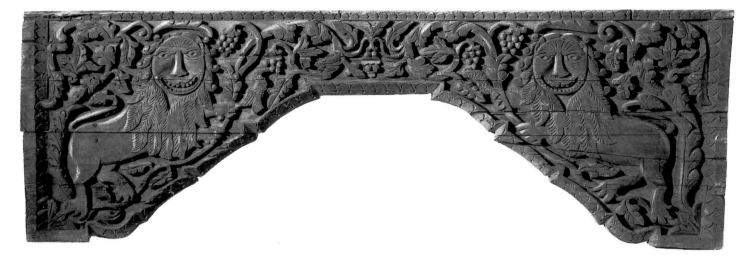

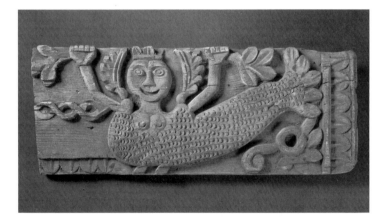

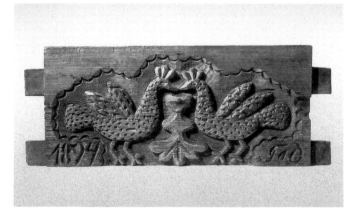

Plank (exterior decoration of a peasant house). Mid-19th
 century
Nizhni-Novgorod Province
Carved wood. 238 × 78
Ethnography Museum, Leningrad

Plank (exterior decoration of a peasant house). Mid-19th
 century
Nizhni-Novgorod Province
Carved wood. 214 × 27
Ethnography Museum, Leningrad

Plank (exterior decoration of a peasant house). Mid-19th
 century
Gorodets District, Nizhni-Novgorod Province
Carved wood. 67 × 27
Museum of Folk Art, Moscow

Fragment of window surround. 1894
Village of Nikitino, Kostroma Province
Carved wood. 66 × 30
Ethnography Museum, Leningrad

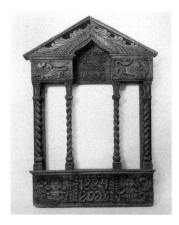

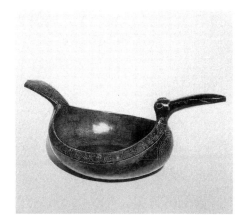

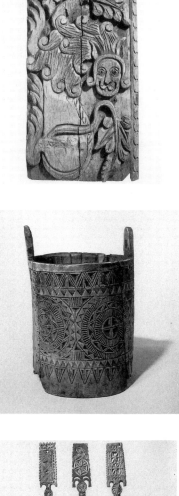

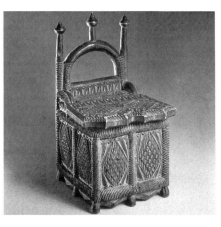

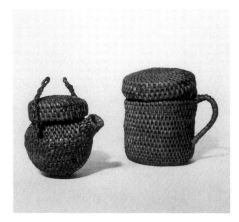

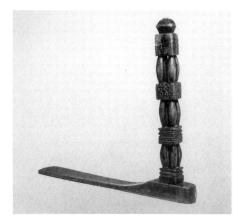

Plank (exterior decoration of a peasant house). Mid-19th
 century
Nizhni-Novgorod Province
Carved wood. 64 × 39
Ethnography Museum, Leningrad

Pail. Second half of the 19th century
Vologda Province
Wood, chiselled and carved. Height 21, diameter 19
Ethnography Museum, Leningrad

Distaffs. 19th century
Yaroslavl Province
Carved wood. Height 74, 71, and 73
Ethnography Museum, Leningrad

Window surround. 1884
Nizhni-Novgorod Province
Carved wood. 160 × 104
Ethnography Museum, Leningrad

Salt-box. 19th century
Kostroma Province
Carved wood. 24 × 14.5 × 13.7
Museum of Folk Art, Moscow

Shveika (an appliance for sewing)
Northern Russia
Wood, lathe-turned and painted. Height 55
Ethnography Museum, Leningrad

Skobkar (scoop for home-brewed beer). 18th century
Northern Russia
Wood, chiselled, carved, and painted. 72 × 37
Ethnography Museum, Leningrad

Wash pitcher and mug. Late 19th century
Village of Osinovka, Kostroma Province
Wickerwork (pine roots). Height and diameter 16 (pitcher);
 height 21, diameter 18 (mug)
Ethnography Museum, Leningrad

Mangle. 19th century
Nizhni-Novgorod Province
Carved wood. 62 × 10
Ethnography Museum, Leningrad

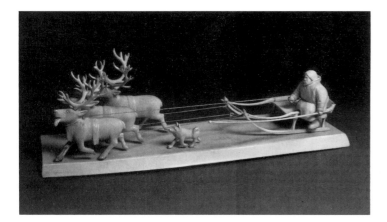

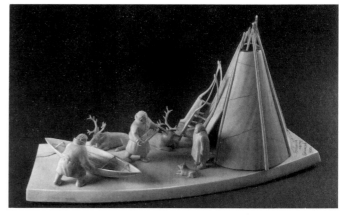

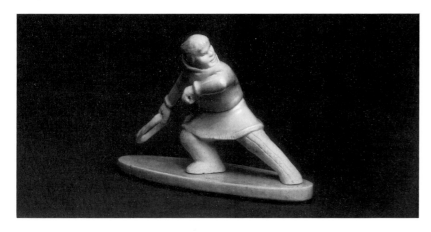

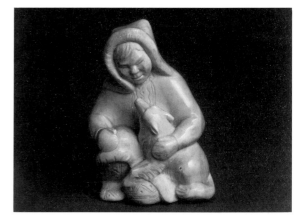

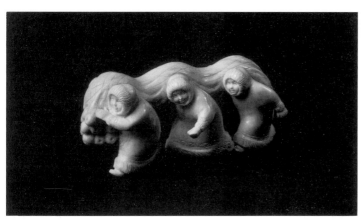

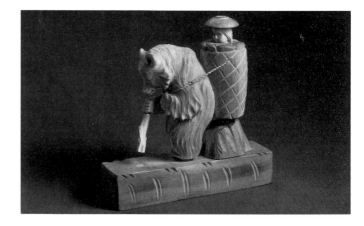

Reindeer Ride. 1936
By V. Denisov
Tobolsk, Tiumen Region
Carved mammoth ivory. Height 7
Museum of Folk Art, Moscow

Reindeer Breeder with a Lasso. 1962
By G. Krivoshein
Tobolsk, Tiumen Region
Carved mammoth ivory. Height 6.5
Museum of Folk Art, Moscow

Fisherwomen Carrying a Net. 1970
By G. Krivoshein
Tobolsk, Tiumen Region
Carved mammoth ivory. Height 5
Museum of Folk Art, Moscow

Return from Fishing. 1936
By V. Denisov
Tobolsk, Tiumen Region
Carved mammoth ivory. Height 18
Museum of Folk Art, Moscow

Friends. 1962
By G. Khazov
Tobolsk, Tiumen Region
Carved mammoth ivory. Height 6
Museum of Folk Art, Moscow

Composition based on a Russian fairy tale. 1963
By N. Levin
Village of Bogorodskoye, Moscow Region
Carved wood. 11.8 × 13.5 × 3.7
Museum of Folk Art, Moscow

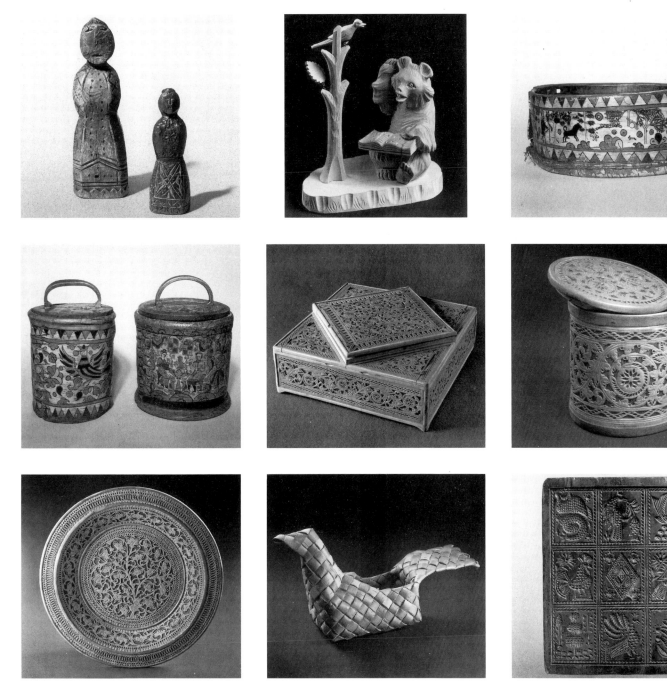

Dolls. 19th century
Arkhangelsk Province
Carved wood. Height 76 and 33
Ethnography Museum, Leningrad

Containers. Second half of the 19th century
The Northern Dvina area, Vologda Province
Wood and painted birch bark. Height 22 and 20,
 diameter 20 and 21
Ethnography Museum, Leningrad

Dish. 1950s
Veliky Ustiug, Vologda Region
Wood and carved birch bark. Diameter 29.5
Museum of Folk Art, Moscow

Spring Song. 1976
By Ye. Andreyev
Village of Bogorodskoye, Moscow Region
Carved wood. Height 16
Private collection

Casket. 1930s
Veliky Ustiug District, Vologda Region
Wood and carved birch bark. 9 × 26.5 × 26.5
Museum of Folk Art, Moscow

Toy duck. 1969
By Ye. Beliayeva
Afanasyevo District, Kirov Region
Woven bast. Length 31.5
Museum of Folk Art, Moscow

Basket. Mid-19th century
The Northern Dvina area, Vologda Province
Wood and painted birch bark. Height 11, diameter 32
Ethnography Museum, Leningrad

Box. 1950s
Veliky Ustiug District, Vologda Region
Wood and carved birch bark. Height 11, diameter 10
Museum of Folk Art, Moscow

Cake mold. 19th century
Central Russia
Carved wood. 33.5 × 28 × 3
Museum of Folk Art, Moscow

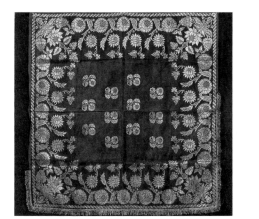 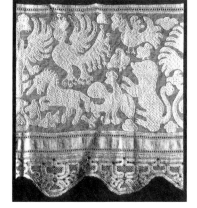 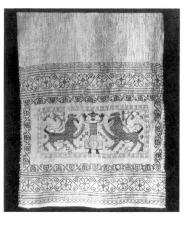

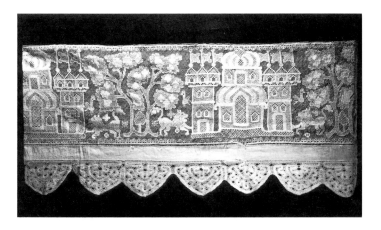 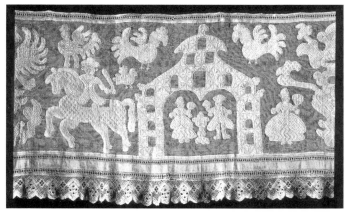

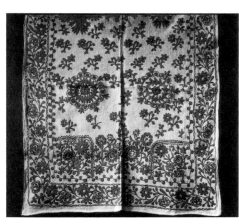 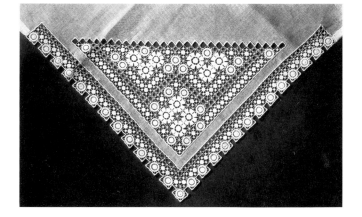

Kerchief. First half of the 19th century
Kolomna District, Moscow Province
Jacquard-woven silk. 101 × 101
Museum of Folk Art, Moscow

Fragment of bed valance. 19th century
Vologda Province
Linen, embroidered in white thread, with lace. 192 × 57
Museum of Folk Art, Moscow

Tablecloth. Second half of the 19th century
Kursk Province
Hemp linen, with tambour embroidery. 226 × 91
Museum of Folk Art, Moscow

Fragment of bed valance. 19th century
Vologda Province
Linen, embroidered in white thread, with lace. 190 × 48.5
Museum of Folk Art, Moscow

Border of towel. 19th century
Olonets Province
Linen, with embroidery and fringes. Width 35
Museum of Folk Art, Moscow

Fragment of bed valance. 19th century
Vologda Province
Linen, embroidered in white thread. 188 × 27.5
Museum of Folk Art, Moscow

Corner of layette sheet. 1980
Krestsy, Novgorod Region
Voile, embroidered in white thread, with drawn-thread work
Private collection

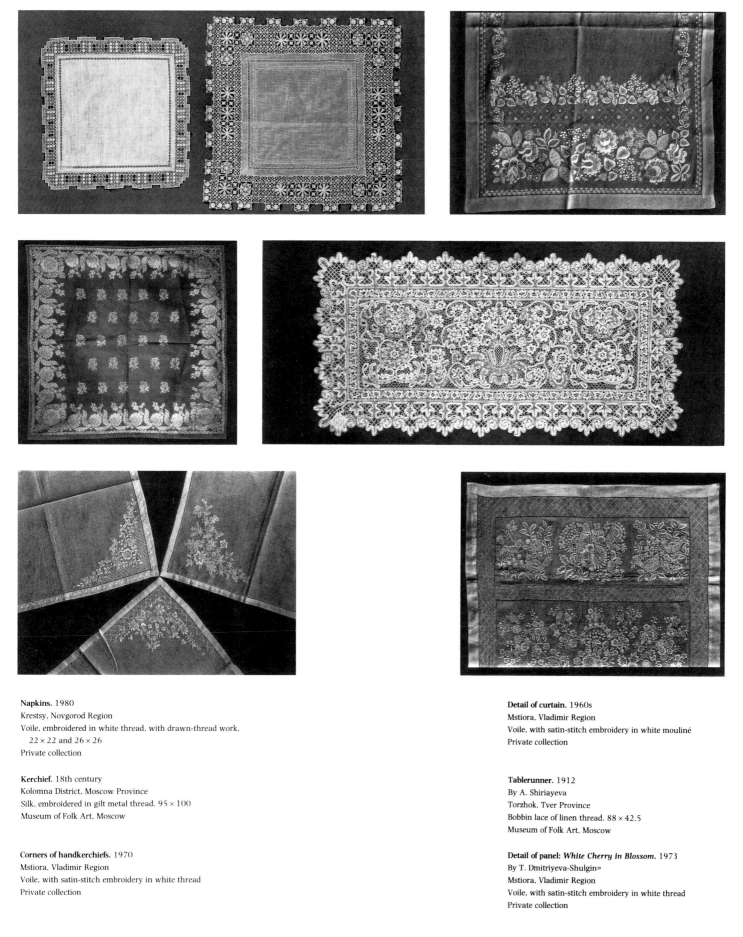

Napkins. 1980
Krestsy, Novgorod Region
Voile, embroidered in white thread, with drawn-thread work.
 22 × 22 and 26 × 26
Private collection

Kerchief. 18th century
Kolomna District, Moscow Province
Silk, embroidered in gilt metal thread. 95 × 100
Museum of Folk Art, Moscow

Corners of handkerchiefs. 1970
Mstiora, Vladimir Region
Voile, with satin-stitch embroidery in white thread
Private collection

Detail of curtain. 1960s
Mstiora, Vladimir Region
Voile, with satin-stitch embroidery in white mouliné
Private collection

Tablerunner. 1912
By A. Shiriayeva
Torzhok, Tver Province
Bobbin lace of linen thread. 88 × 42.5
Museum of Folk Art, Moscow

Detail of panel: *White Cherry in Blossom.* 1973
By T. Dmitriyeva-Shulginᵃ
Mstiora, Vladimir Region
Voile, with satin-stitch embroidery in white thread
Private collection

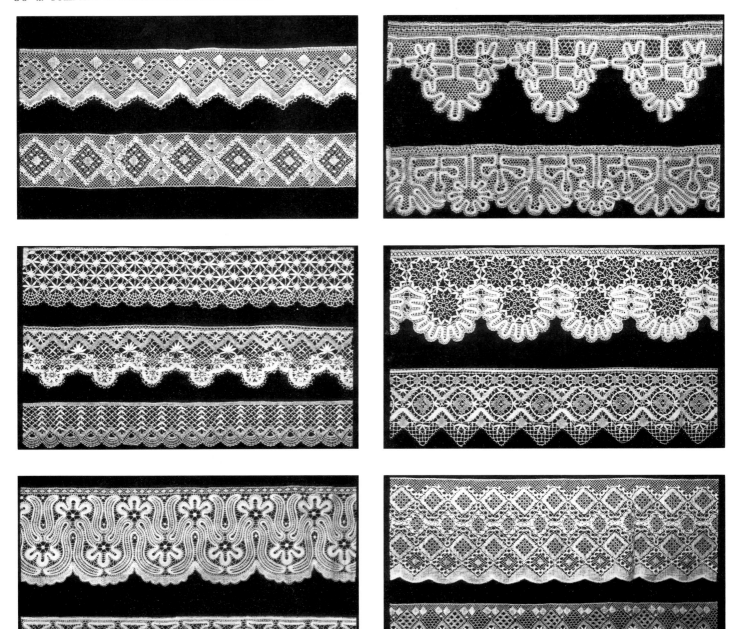

Details of edging and insertion. 1930s
Yelets, Lipetsk Region
Bobbin lace of linen thread. Width 7 and 6.5
Museum of Folk Art, Moscow

Details of edgings. 1938
Vologda
Needlepoint lace of linen thread. Width 7, 7.5, and 5.2
Museum of Folk Art, Moscow

Details of edgings. 1948
By an unknown lacemaker and A. Bogatikova
Bobbin lace of linen thread. Width 6 and 11.5
Museum of Folk Art, Moscow

Details of edgings. 1938
Kaliazin, Kalinin Region
Bobbin lace of linen thread. Width 11.5 and 8
Museum of Folk Art, Moscow

Details of edgings. 1948 and 1938
By N. Kolosova and an unknown lacemaker
Vologda
Bobbin lace of linen thread. Width 12 and 9.3
Museum of Folk Art, Moscow

Details of edgings. 1950s
By M. Dobrina and an unknown lacemaker
Yelets, Lipetsk Region
Bobbin lace of linen thread. Width 14.7 and 7.5
Museum of Folk Art, Moscow

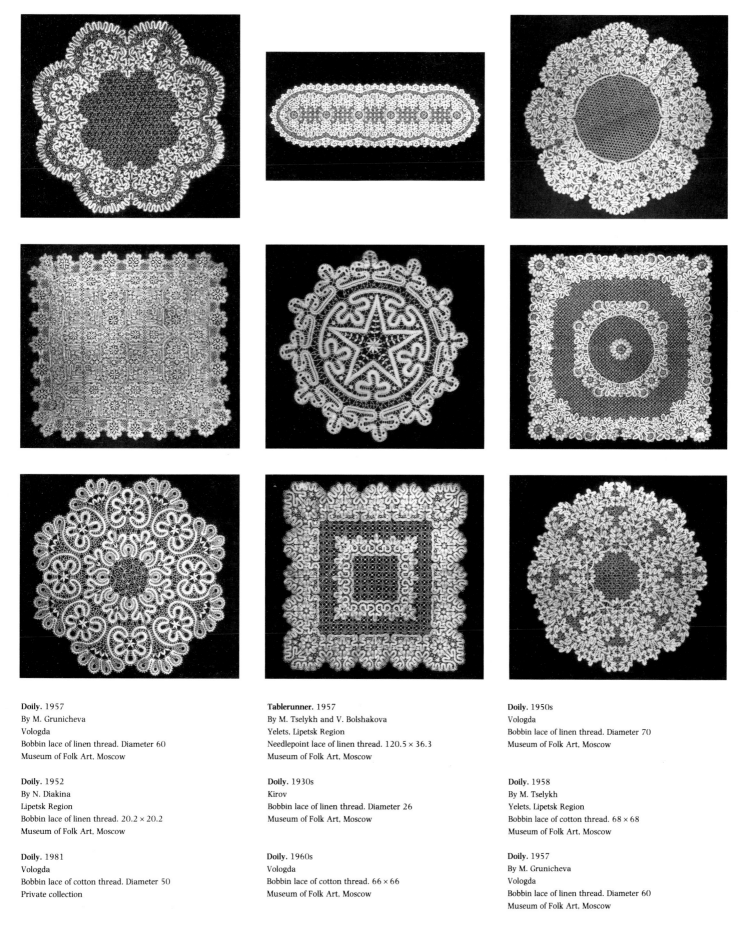

Doily. 1957
By M. Grunicheva
Vologda
Bobbin lace of linen thread. Diameter 60
Museum of Folk Art, Moscow

Doily. 1952
By N. Diakina
Lipetsk Region
Bobbin lace of linen thread. 20.2 × 20.2
Museum of Folk Art, Moscow

Doily. 1981
Vologda
Bobbin lace of cotton thread. Diameter 50
Private collection

Tablerunner. 1957
By M. Tselykh and V. Bolshakova
Yelets, Lipetsk Region
Needlepoint lace of linen thread. 120.5 × 36.3
Museum of Folk Art, Moscow

Doily. 1930s
Kirov
Bobbin lace of linen thread. Diameter 26
Museum of Folk Art, Moscow

Doily. 1960s
Vologda
Bobbin lace of cotton thread. 66 × 66
Museum of Folk Art, Moscow

Doily. 1950s
Vologda
Bobbin lace of linen thread. Diameter 70
Museum of Folk Art, Moscow

Doily. 1958
By M. Tselykh
Yelets, Lipetsk Region
Bobbin lace of cotton thread. 68 × 68
Museum of Folk Art, Moscow

Doily. 1957
By M. Grunicheva
Vologda
Bobbin lace of linen thread. Diameter 60
Museum of Folk Art, Moscow

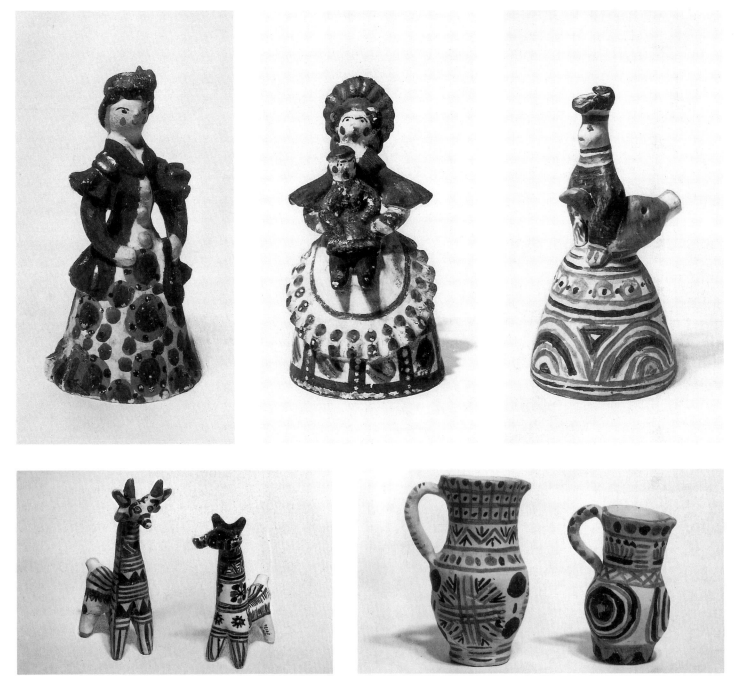

Lady. Late 1920s
Viatka
Handworked clay, fired and painted. Height 15.5
Ethnography Museum, Leningrad

Wet nurse. 1940
By Z. Penkina
Kirov
Handworked clay, fired and painted. Height 18
Ethnography Museum, Leningrad

Woman Carrying a Fowl. 1968
By A. Maslennikova
Village of Filimonovo, Tula Region
Handworked clay, fired and painted. Height 13
Ethnography Museum, Leningrad

Deer and *Hunting Dog with a Duck in Its Mouth.* (1968 and 1969)
Village of Filimonovo, Tula Region
Handworked clay, fired and painted. Height 18 and 14.5
Ethnography Museum, Leningrad

Toy jugs. 1969
Village of Filimonovo, Tula Region
Handworked clay, fired and painted. Height 14 and 12
Ethnography Museum, Leningrad

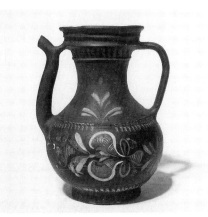

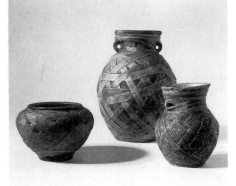

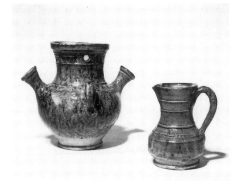

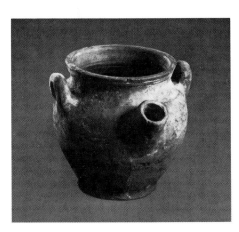

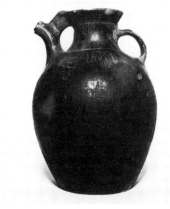

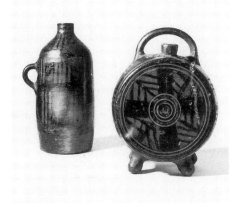

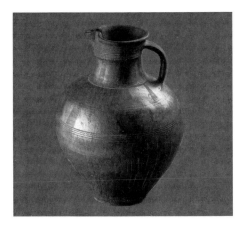

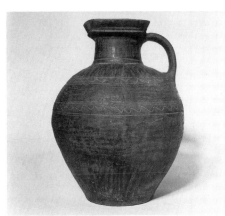

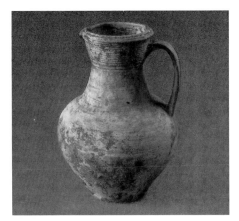

Jug for *kvass*. Mid-19th century
Village of Repino, Nizhni-Novgorod Province
Clay, fired and painted. Height 25
Ethnography Museum, Leningrad

Wash ewer. 1950s
By I. Golikov
Moscow Region
Fired clay. Height 13.5
Museum of Folk Art, Moscow

Jug. Early 20th century
Yaroslavl Province
Clay, fired, smoked, and burnished. Height 36
Museum of Folk Art, Moscow

Pot for porridge and jugs for *kvass*. Late 19th century
Village of Atiurevo, Tambov Province
Clay, fired and covered with woven bast.
 Height 12, 27, and 16
Ethnography Museum, Leningrad

Jug. Late 19th century
Yaroslavl Province
Clay, fired, smoked, and burnished. Height 38
Ethnography Museum, Leningrad

Jug for *kvass*. Late 19th century
Village of Kvakshino, Tver Province
Clay, fired, smoked, and burnished, with incised ornament.
 Height 38
Ethnography Museum, Leningrad

Wash ewer and jug. Late 19th century
Murom, Vladimir Province
Clay, fired and glazed, with stamped design. Height 19 and 13
Ethnography Museum, Leningrad

Two flagons. 19th century
Village of Lazartsevo, Yaroslavl Province
Clay, fired and smoked, with incised decoration.
 Height 29 and 26
Ethnography Museum, Leningrad

Jug. Early 20th century
Tula Province
Clay, fired and painted, with slip decoration. Height 31.5
Museum of Folk Art, Moscow

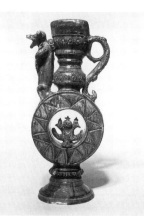

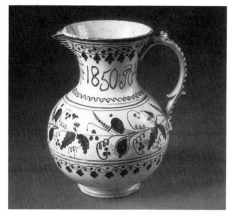

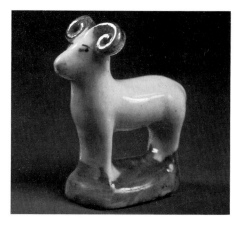

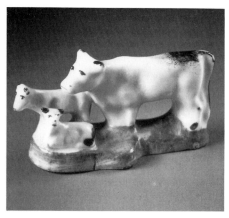

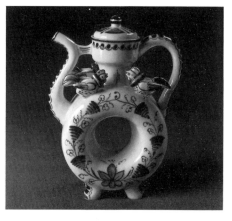

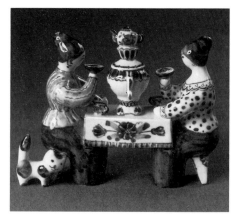

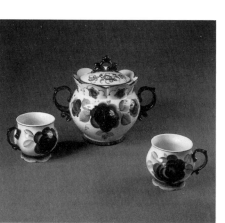

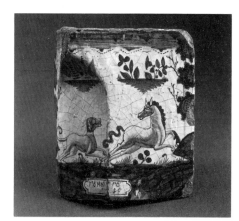

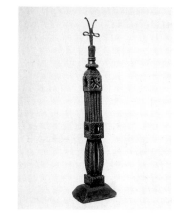

Jug for kvass. 19th century
Skopin, Riazan Province
Handworked clay, fired and glazed. Height 43
Ethnography Museum, Leningrad

Cow and Two Calves. Early 20th century
Gzhel, Moscow Province
Porcelain, painted overglaze. Height 4
Museum of Folk Art, Moscow

Set for compote. 1976
By A. Fedotov
Gzhel, Moscow Region
Porcelain, painted underglaze. Height 18 and 10.5
Museum of Folk Art, Moscow

Jug. 1850
Gzhel, Moscow Province
Semi-faience, painted underglaze. Height 25.3
Museum of Folk Art, Moscow

Jug for kvass: Cockerels. 1967
By L. Azarova and T. Dunashova
Gzhel, Moscow Region
Porcelain, painted underglaze. Height 20.5
Museum of Folk Art, Moscow

Stove tile. 18th century
Clay, fired, painted over wet enamel, and glazed. 17 × 20
Museum of Folk Art, Moscow

Lamb. Early 20th century
Gzhel, Moscow Province
Porcelain, painted underglaze. Height 6.5
Museum of Folk Art, Moscow

Tea party. 1978
By L. Azarova
Gzhel, Moscow Region
Porcelain, painted underglaze. Height 14.5
Museum of Folk Art, Moscow

Candlewood holder. First half of the 19th century
Veliky Ustiug, Vologda Province
Carved wood and metal. Height 91
Ethnography Museum, Leningrad

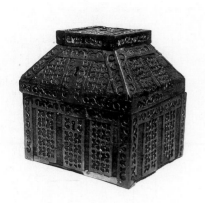

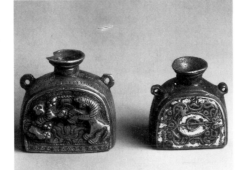

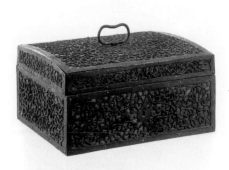

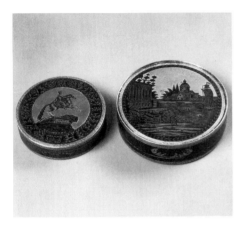

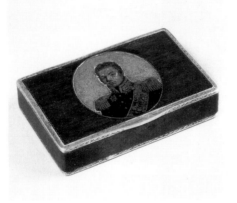

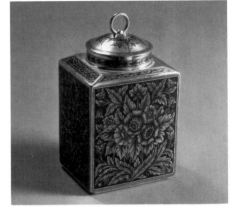

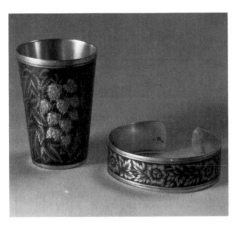

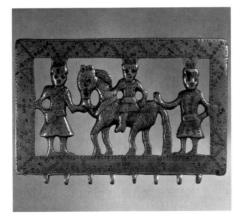

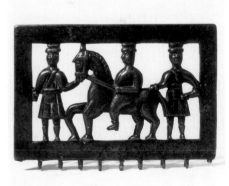

Casket. 18th century
Veliky Ustiug, Vologda Province
Wood, openwork cast metal and mica. Height 30
Ethnography Museum, Leningrad

Snuffboxes. 1803 and 1804
By I. Zhilin
Veliky Ustiug, Vologda Province
Silver gilt, hammered, chased, embossed, engraved, nielloed,
 and mat-tooled. Diameter 8.4 and 10.4
The Hermitage, Leningrad

Drinking glass (by Ye. Shilinkovsky). 1958
Bracelet (by P. Nasonovskaya). 1963
Veliky Ustiug, Vologda Region
Silver gilt, engraved, and nielloed. Height of glass 6;
 diameter of bracelet 4.4
Museum of Folk Art, Moscow

Inkpots. Late 17th or early 18th century
Solvychegodsk, Vologda Province .
Cast copper, with enamelling. Height 5.5 and 4.5
Museum of Folk Art, Moscow

Snuffbox. 1824–27
By L. Zhilin
Veliky Ustiug, Vologda Province
Silver gilt, chased, engraved, nielloed, and mat-tooled.
 1.7 × 8.5 × 5.5
The Hermitage, Leningrad

Plaque from a horse-doctor's bag. 18th century
Northern Russia
Cast copper. 19.7 × 13
Museum of Folk Art, Moscow

Casket. 18th century
Veliky Ustiug, Vologda Province
Wood, with pierced iron mount. 28.5 × 21.5 × 13.5
The Russian Museum, Leningrad

Tea caddy
By V. Yakusheva
Veliky Ustiug, Vologda Region
Silver, with niello decoration. Height 5.7
Museum of Folk Art, Moscow

Plaque from a horse-doctor's bag. 19th century
Arkhangelsk Province
Cast copper. 20 × 12.5
Ethnography Museum, Leningrad

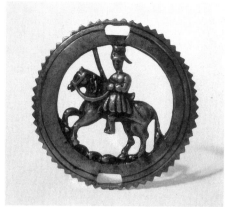

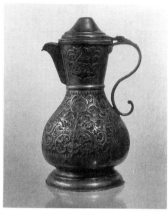

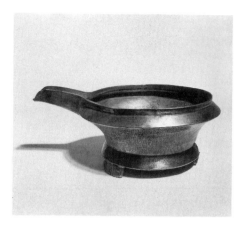

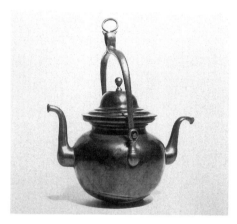

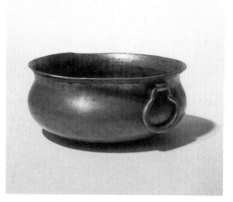

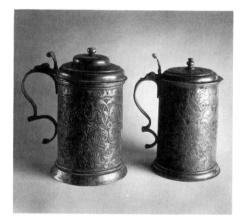

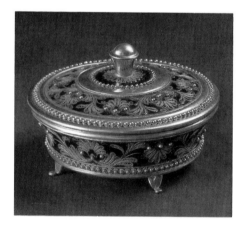

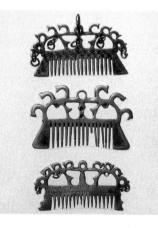

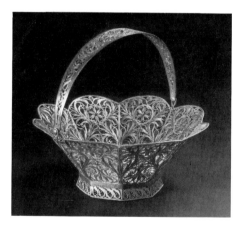

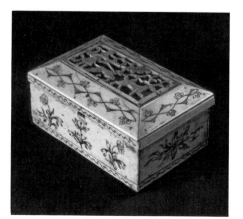

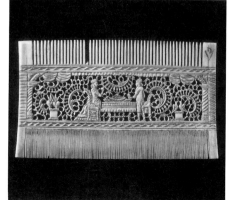

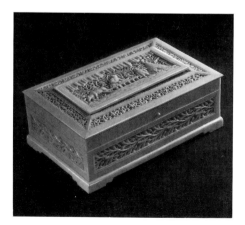

Plaque from a horse-doctor's bag. 19th century
Arkhangelsk Province
Cast copper. Diameter 12
Ethnography Museum, Leningrad

Wash pitcher: *kumgan.* Second half of the 18th century
Urals
Embossed copper. Height 33
The Russian Museum, Leningrad

Dipper. Late 18th or early 19th century
Urals
Copper, hammered and chased. Height 13
Ethnography Museum, Leningrad

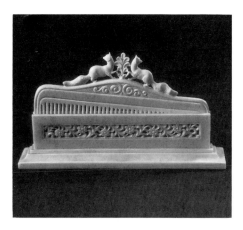

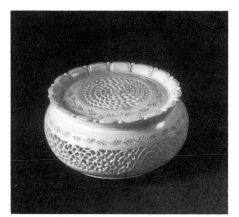

Wash ewer. 19th century
Northern Russia
Hammered copper. Height 37
Ethnography Museum, Leningrad

Cup. 19th century
Northern Russia
Hammered copper. Diameter 18
Ethnography Museum, Leningrad

Tankards. 1751
Urals
Copper, cast and engraved. Height 30.5 and 26
The Hermitage, Leningrad

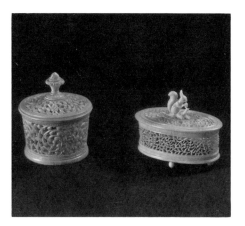

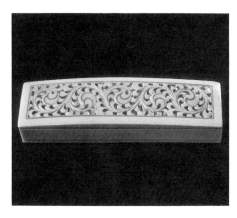

Powder case. 1959
By T. Zadumova
Village of Krasnoye-on-the-Volga, Kostroma Region
Copper, gilt, with enamel, filigree, and granulation.
 Diameter 10.2
Museum of Folk Art, Moscow

Combs. 19th century
Northern Russia
Cast copper. Length 7, 8, and 8
Ethnography Museum, Leningrad

Sweetmeat basket. 1952
Village of Kazakovo, Gorky Region
Silvered brass, with filigree
Museum of Folk Art, Moscow

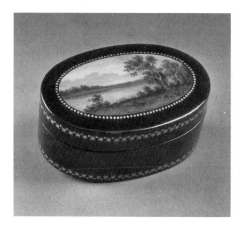

Casket. Second half of the 18th century
Kholmogory, Arkhangelsk Province
Carved ivory. 11 × 5 × 7
Museum of Folk Art, Moscow

Comb. Second half of the 18th century
Kholmogory, Arkhangelsk Province
Carved ivory. 15 × 8.3
Museum of Folk Art, Moscow

Casket: *Off to School.* 1956
By A. Guryev
Village of Lomonosovo, Arkhangelsk Region
Carved mammoth ivory. 15 × 5.2 × 9.2
Museum of Folk Art, Moscow

Comb with stand: *Martens.* 1955
By A. Leontyeva
Village of Lomonosovo, Arkhangelsk Region
Carved mammoth ivory. 13 × 6.5 × 2.5
Museum of Folk Art, Moscow

Box: *Scroll* (by P. Chernikovich). 1954
Box: *Squirrel* (by U. Sharypina). 1959
Village of Lomonosovo, Arkhangelsk Region
Carved mammoth ivory. Height 6 and 5
Museum of Folk Art, Moscow

Two snuffboxes and box for stamps. 19th century
Village of Fedoskino, Moscow Province
Papier-mâché, painted and lacquered. 8.5 × 5.5 and 8.5 × 4
 (snuffboxes); diameter 7 (box for stamps)
The Russian Museum, Leningrad

Box: *Turnip.* 1958
By A. Shtang
Village of Lomonosovo, Arkhangelsk Region
Mammoth ivory, carved and engraved. Height 3, diameter 6
Museum of Folk Art, Moscow

Box. 1966
By A. Guryev
Village of Lomonosovo, Arkhangelsk Region
Wood and carved walrus tusk. 15 × 2.5 × 4
Museum of Folk Art, Moscow

Box: *Landscape.* 1953
By S. Rogatov
Village of Fedoskino, Moscow Region
Papier-mâché, painted and lacquered. Height 3.5
Museum of Folk Art, Moscow

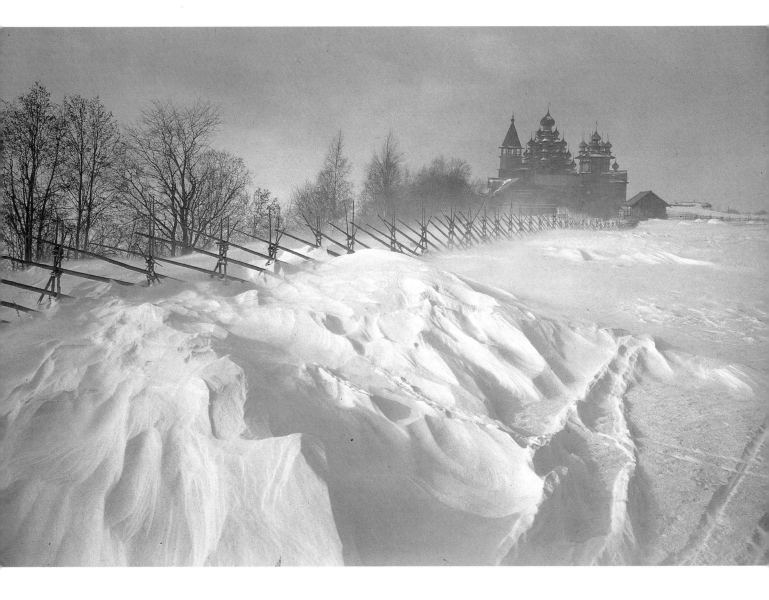

KARELIAN
Folk Art

The majestic northern landscapes of Karelia, a land of lakes, coniferous forests, snowy winters, and quiet "white nights," are reflected in the art of the region's inhabitants. Unique examples of old wooden buildings have survived, including multidomed tent-roofed churches. The development of Karelian art was in close contact with Russian culture, a circumstance that has resulted in similarity between their handicrafts.

In Karelia, houses, outbuildings, tools, furniture, and utensils have always been made of wood, the most common material there. Domestic wooden objects are characterized by simplicity of form and a smooth finish, which stresses the wood's natural texture and color. Bowls, dippers, saltcellars, and large domestic objects are made from undivided, whole volumes. Distaff blades are usually carved with soft shallow notches, which form simple patterns, but sometimes the surface bears no decoration in order to highlight the object's shape. Geometric designs carved on Karelian wooden objects are similar to the lozenges, meanders, and cruciform or jagged figures found on their patterned weavings.

In Karelian embroidery, one of their most popular and venerable crafts, two-sided embroidery was predominant. Pictorial compositions usually representing heathen goddesses, sacred trees, horsemen, and birds were favored in Karelian costume and towel decoration. The general appearance of these embroideries, with their geometric designs and tripartite compositions, is close to the northern Russian needlework.

In the nineteenth century, the so-called Karelian stitch, in which the drawnwork is combined with elements executed in different stitches, became widely known. In this way white bed valances embroidered with subject compositions were worked. Karelian tambour embroideries are notable for the beautiful texture of their alternating dense and sparse designs in red

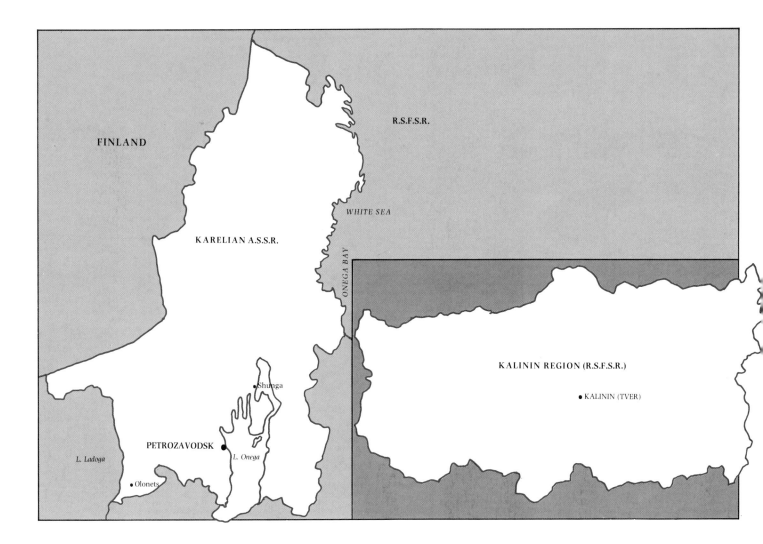

with such motifs as plants, rosettes, and stylized flowers. Karelian embroidery is reminiscent of the painted compositions, often on green or blue backgrounds, occurring on distaffs.

In the late nineteenth and early twentieth century, another type of tambour embroidery—white thread on red calico—became popular. Other colors were seldom included. The compositions consisted of plants or barely recognizable birds and were remarkable for their graphic clarity.

The Karelians living in other parts of the country, e.g., in the Kalinin Region (formerly Tver Province) of the RSFSR, also display features in their art that are characteristic of the old Ugro-Finnish tribes. A special feature of their women's embroidered headdresses is their small yet distinct geometric designs in exquisite color combinations, which sometimes include stylized figures of deer.

By the end of the nineteenth century, several folk art centers had developed in Karelia. One of them was on the northern shore of Lake Onega, where about three hundred needlewomen worked. Their towels, tablecloths, and napkins were decorated with Karelian stitch or raised tambour embroidery. Ever since the 1920s, the articles embroidered by the Onega Needlework Cooperative have been regularly exhibited both at home and abroad. They have in a great measure retained their national character.

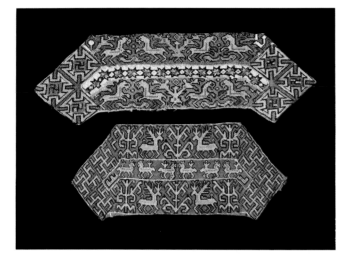

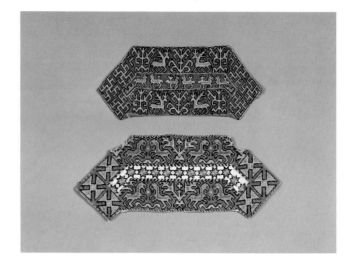

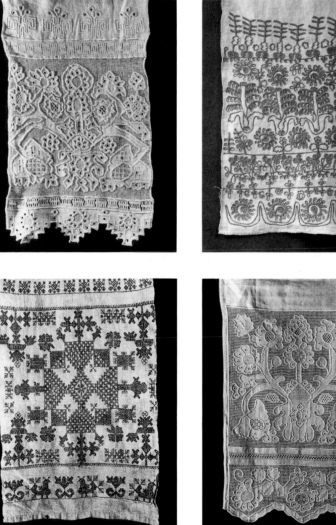

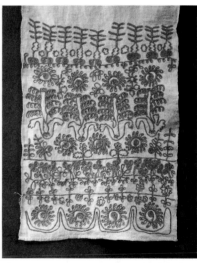

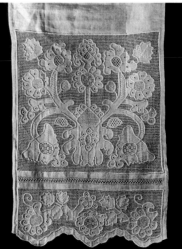

Fragments of headdress. 19th century
Tver Province
Embroidered linen. 30 × 11.5 and 32 × 11
Museum of Folk Art, Moscow

Fragments of headdress. 19th century
Tver Province
Embroidered linen. 30 × 11 and 24 × 11
Museum of Folk Art, Moscow

Fragment of towel border. 1900s
Karelia
Embroidered linen. 34 × 62
Museum of Folk Art, Moscow

Fragment of towel. Early 20th century
Karelia
Embroidered linen. 37 × 278
Museum of Folk Art, Moscow

Border of towel. Early 20th century
Petrozavodsk District, Olonets Province
Embroidered linen. Width 48
Museum of Folk Art, Moscow

Border of towel. 1937
Village of Shunga, Karelian ASSR
Embroidered linen. Width 32
Museum of Folk Art, Moscow

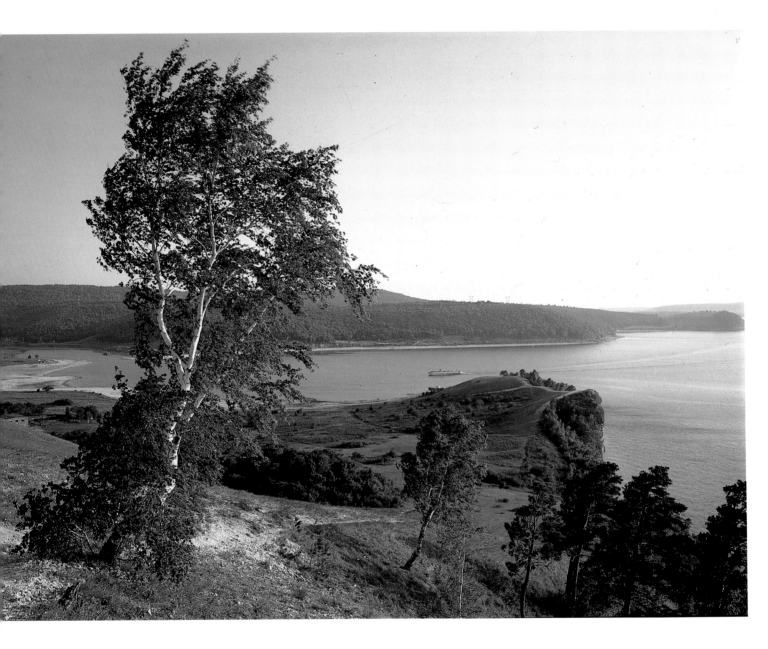

Folk Art in the
VOLGA and KAMA
Areas

The vast territories along the Volga and Kama Rivers, with their numerous tributaries, were inhabited by nomadic and settled tribes at a very early date. The present Komi, Udmurt, and Mari Autonomous Republics are richly forested, and the main occupations of their inhabitants in the past have been hunting and fishing. Locally obtained materials, such as wood, hemp and flax fibers, and clay, were made into household utensils. In the forest-steppe and steppe zones between the Kama and the Urals, as well as around the lower Volga, agriculture and livestock breeding predominated. The inhabitants of this region were consequently engaged in rug-making.

One of the most original and highly developed crafts of the Volga and Kama area was embroidery, practiced by the Komis, Udmurts, Chuvashes, Maris, and Mordvinians. It was lavishly used to decorate clothes and ritual objects. The main techniques were counted, oblique running, satin, and, less frequently, cross stitchery. Intense deep colors were favored. From the late nineteenth century onward the compositions became polychromatic, and yellow, green, pink, and violet tones were introduced. Homeworked embroidery was henceforth combined with factory-made gold braid, galloon, tinsel, brocade, and other fabrics.

Women's dress-like chemises were adorned with particular richness: the front, sleeves, and lap were embroidered. The Udmurt women wore bibs covered with geometric designs, eight-point stars, lozenges, crosses, and indented lines. The Chuvash women decorated the front of their chemises with rhomboid or star-shaped embroidered rosettes, symbols that undoubt-

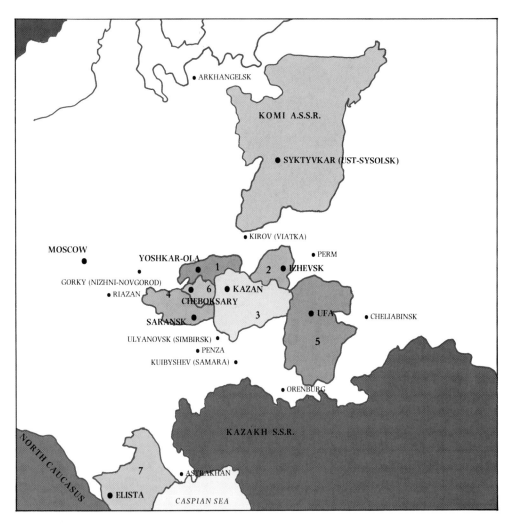

ARKHANGELSK

KOMI A.S.S.R.

● SYKTYVKAR (UST-SYSOLSK)

● KIROV (VIATKA)

MOSCOW
●

YOSHKAR-OLA
●

GORKY (NIZHNI-NOVGOROD)
● RIAZAN

PERM ●

1

2 ● IZHEVSK

6 ● KAZAN

4
CHEBOKSARY

3

● UFA

CHELIABINSK ●

SARANSK ●

ULYANOVSK (SIMBIRSK) ●

● PENZA

KUIBYSHEV (SAMARA) ●

● ORENBURG

KAZAKH S.S.R.

NORTH CAUCASUS

7

● ASTRAKHAN

● ELISTA

CASPIAN SEA

1 MARI A.S.S.R.

2 UDMURT A.S.S.R.

3 TATAR A.S.S.R.

4 MORDVINIAN A.S.S.R.

5 BASHKIR A.S.S.R.

6 CHUVASH A.S.S.R.

7 KALMYK A.S.S.R.

edly had some magic significance. Headbands, headdresses, and pendants suspended from a belt or the hips were important women's costume accessories. Worn with a simple tunic-like dress, they formed an ensemble embodying the notions of ideal feminine beauty. Each embroidered object or detail of clothing follows a certain decorative system and stitchery pattern.

Particularly notable in this respect is the Mordvinian woman's costume consisting of a wide linen chemise with a belt adorned with gorgeous pendants. The neckband, yoke, sleeves, and lap are embroidered in terracotta red and blue worsted. The ornamentation is based on recurring simple geometric motifs that match the tailored details of the dress. The costume is complemented by an embroidered headdress in the shape of a rectangular towel and by bulky pendants.

One of the distinctive features of Mordvinian, Chuvash, and Udmurt embroideries is the use of outline stitchery to accentuate the shape of each element in the design. Another is the density of embroidery, which resembles woven carpet designs. The general impression of severity is due to the ornamental symmetry and rhythmically alternating motifs. In Udmurt needlework the design is generally arranged diagonally, but this does not impair the sensation of harmony and grandeur produced by the balanced patterns and the measured rhythm of their large-scale geometric forms.

The Tatars embroidered first and foremost their ritual towels, curtains, and tablecloths. Their embroidered plant designs were included in colorful

Decorative apron. 19th century
Kazan Province (Mordvinians)
Linen, embroidered in wool and decorated with tinsel,
 galloons, beads, and shells. 26 × 50
Ethnography Museum, Leningrad

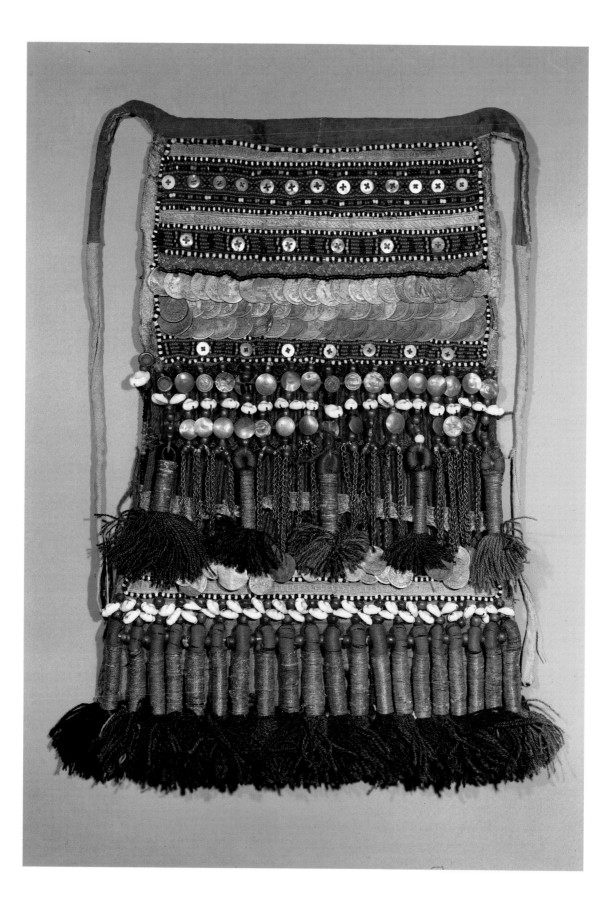

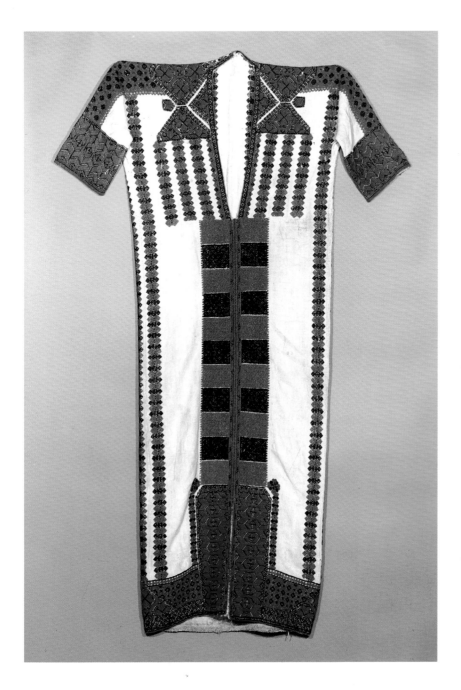

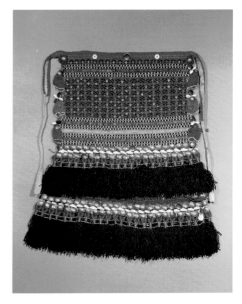

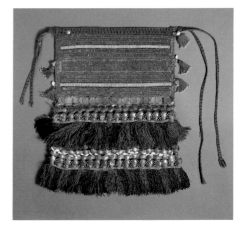

Peasant woman's chemise for festive occasions. 19th century
Simbirsk Province (Erzia Mordvinians)
Linen, embroidered in wool. Length 142
Ethnography Museum, Leningrad

Decorative apron. Late 19th or early 20th century
Village of Stariye Sosny, Samara Province (Mordvinians)
Linen, embroidered in wool and adorned with tinsel, galloons,
 sequins, beads, and shells. 35 × 48
Ethnography Museum, Leningrad

Decorative apron. 19th century
Penza Province (Mordvinians)
Cotton, decorated with beads, sequins, spangles, plaques,
 coins, and fringes. 33 × 47
Museum of Folk Art, Moscow

symmetric compositions with realistically depicted flower bouquets. Similar embroidery on colored velvet or silk decorated Tatar headdresses, purses, and knickknacks. In the late nineteenth century, machine-made tambour embroidery became widespread.

Bashkir embroidery is known for its pronounced decorative quality, which goes back to tambour embroidery of the ancient Turkic nomads; but in the eighteenth and nineteenth centuries, it became closer to Tatar nee-

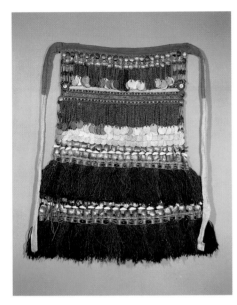

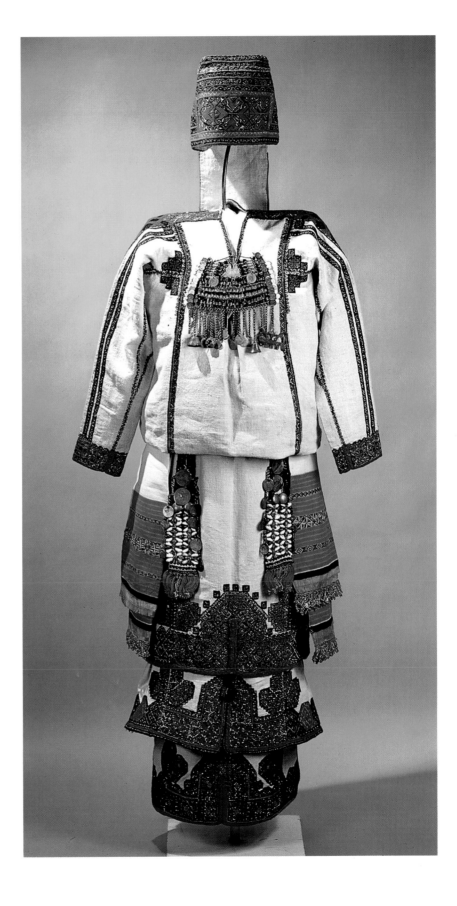

Decorative apron. Late 19th or early 20th century
Village of Stariye Sosny, Samara Province (Mordvinians)
Linen, embroidered in wool and adorned with sequins, beads,
 and shells. 33 × 51
Ethnography Museum, Leningrad

Peasant woman's costume for festive occasions.
 Late 19th century
Nizhni-Novgorod Province (Moksha Mordvinians)
Homespun linen, embroidered in wool and decorated with
 shells, beads, bugles, and sequins
Ethnography Museum, Leningrad

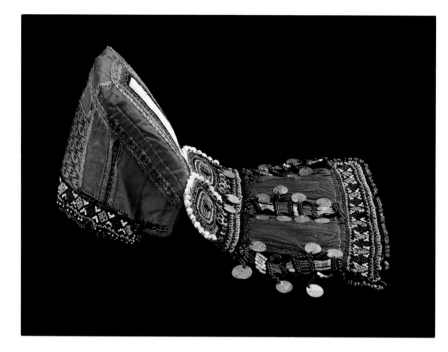

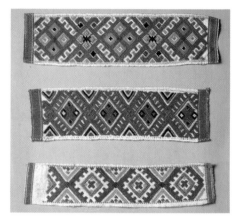

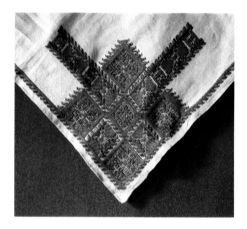

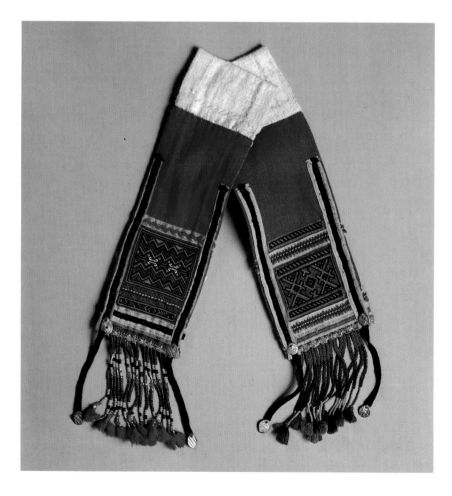

Peasant woman's headdress. 19th century
Penza Province (Mordvinians)
Cotton, with embroidery, decorated with beads, braid,
 spangles, shells, and coins. Length 50.5
Museum of Folk Art, Moscow

Ornamental detail of married woman's dress.
 Mid-19th century
Simbirsk Province (Chuvashes)
Red calico, with embroidery and beaded tassels. 8.4 × 31.5
Museum of Folk Art, Moscow

Samplers of embroidery. 19th century
Simbirsk Province (Chuvashes)
Embroidered linen. 31 × 6.5, 30 × 8.8, 33 × 9.6
Museum of Folk Art, Moscow

Corner of bridal shawl. Late 19th century
Simbirsk Province (Chuvashes)
Embroidered linen
Museum of Folk Art, Moscow

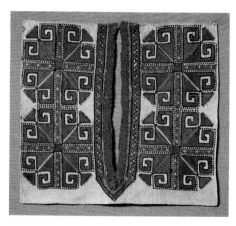

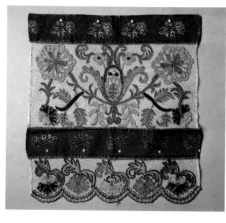

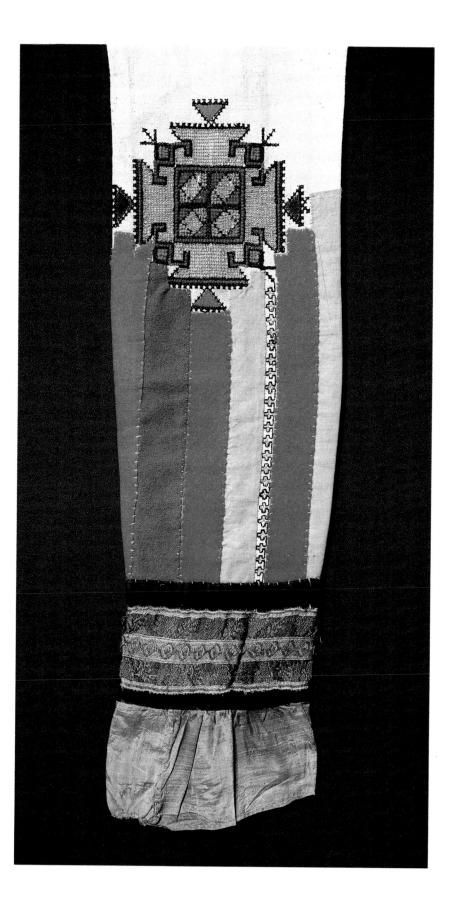

Part of woman's dress. 19th century
Kazan Province (Chuvashes)
Linen, embroidered in silk
Ethnography Museum, Leningrad

Border of towel. Mid-19th century
Kazan Province (Tatars)
Jacquard-woven silk, with embroidery. Width 44
Museum of Folk Art, Moscow

Sleeve of woman's dress. Late 19th century
Sarapul District, Viatka Province
Linen, embroidered in silk, with cloth inserts. 17 × 58
Ethnography Museum, Leningrad

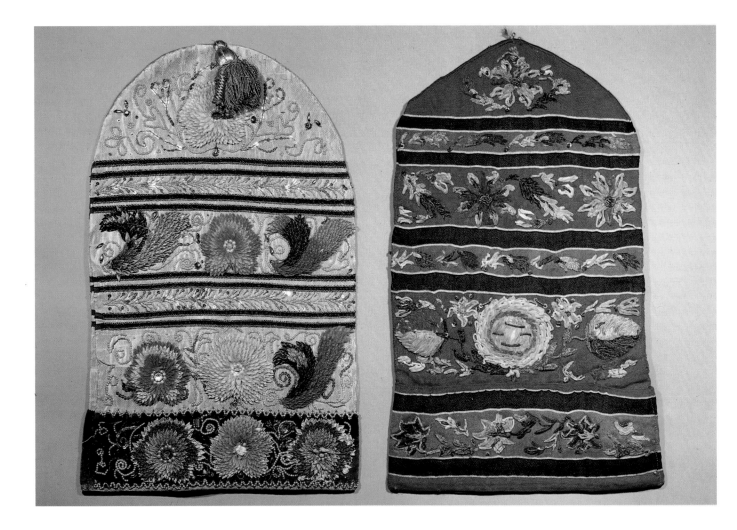

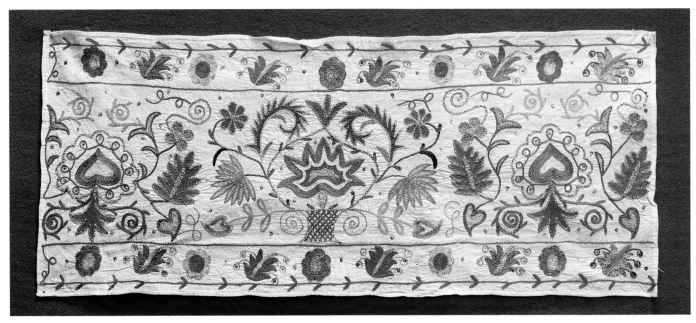

Women's headdresses. Late 19th or early 20th century
Kazan Province (Tatars)
Velvet, embroidered in silk, with beadwork and tinsel.
 Height 41 (each)
Ethnography Museum, Leningrad

Towel. Mid-19th century
Kazan Province (Tatars)
Calico, embroidered in silk and metal thread and decorated
 with spangles. 52 × 21
Museum of Folk Art, Moscow

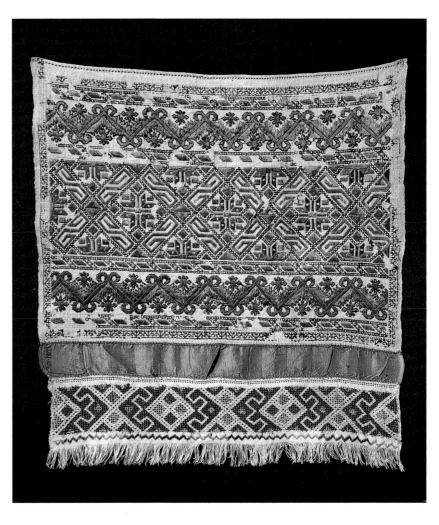

Detail of wedding towel. Early 20th century
Kazan Province (Tatars)
Cotton, embroidered in silk and decorated with lace
Museum of Folk Art, Moscow

Fragment of headband border. 19th century
Village of Isiangildina, Orenburg Province
Linen, embroidered in silk. 29 × 36
Ethnography Museum, Leningrad

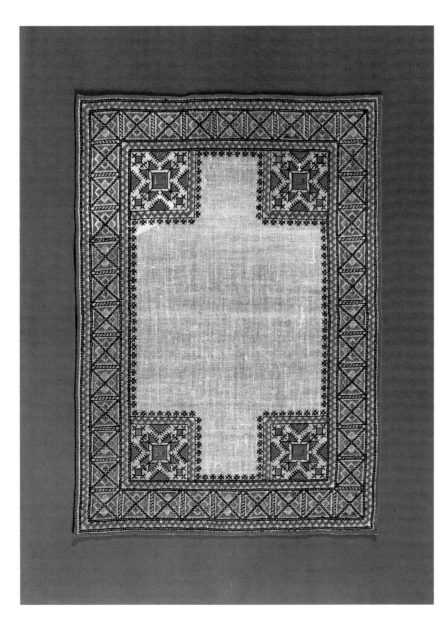

dlework. The clear-cut outlines, embroidered in chain stitch on a cotton or brightly colored woollen foundation, give the design an essentially graphic aspect. Violations of symmetry in its color distribution are characteristic.

Hand-loom weaving is also practiced throughout the Volga and Kama region. Komi-Permiak woven belts for men and women can be considered true works of art. They were associated with various beliefs and myths, and they were used as protective mascots and as an indispensable element in marriage ceremonies. Their ornamental motifs, based mainly on combinations of red, white, and black, are extremely varied.

Groom's kerchief. 1958
By Ye. Yefremova
Chuvash ASSR (Chuvashes)
Embroidered linen. 50 × 35
Museum of Folk Art, Moscow

Tablecloth. 1977
By Ye. Yefremova
Cheboksary District, Chuvash ASSR (Chuvashes)
Linen, embroidered in mouliné. 250 × 112
Union of Artists, Moscow

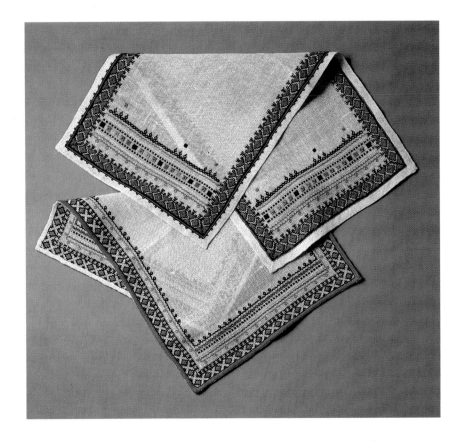

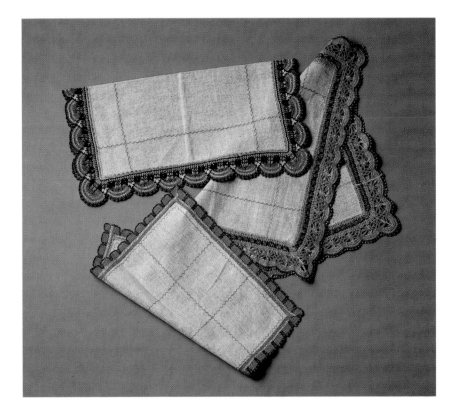

Runners. 1970s
By Ye. Yefremova
Cheboksary District, Chuvash ASSR (Chuvashes)
Linen, embroidered in mouliné. 36 × 70 (each)
Private collection

Napkins. 1975
Mikhailov, Riazan Region (Russians)
Linen, embroidered in mouliné and decorated with lace.
 36 × 36, 36 × 36, and 35 × 35
Private collection

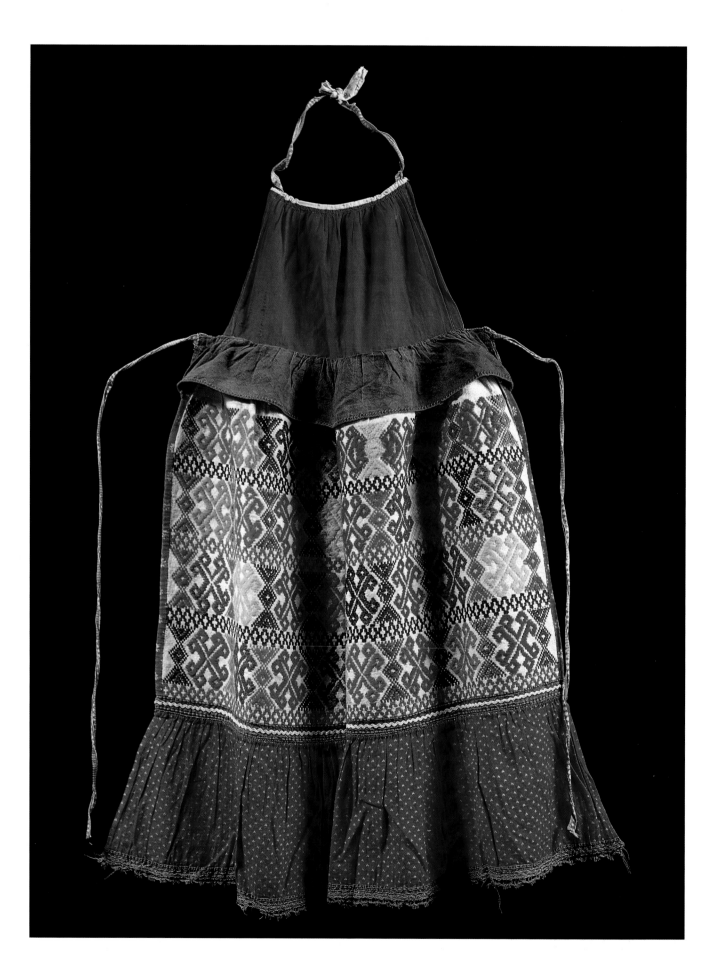

Apron. 1960s
By I. Ilyina
Udmurt ASSR (Udmurts)
Homespun patterned linen. Length 85
Museum of Folk Art, Moscow

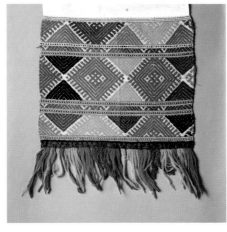

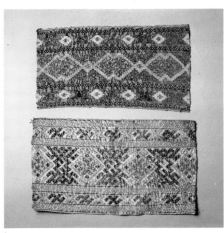

Border of woman's headband. Early 20th century
Samara Province (Udmurts)
Homespun patterned cotton. Width 32
Museum of Folk Art, Moscow

Borders of towels. Fragments. 19th century
Kasimov, Riazan Province (Tatars)
Homespun patterned linen, embroidered in silk.
 37 × 19 and 38 × 21
Museum of Folk Art, Moscow

Parts of belts for men and women. Late 19th or early 20th
 century
Perm Province (Komis)
Homespun woollen and linen threads woven into a pattern
Ethnography Museum, Leningrad

Weaving standards were remarkably high in Tataria and especially in Bashkiria, where woven objects were essential in the old nomadic life; today they still play an important role in home decoration. The Bashkirs are skilled weavers, especially of *palases*—flat-surfaced rugs with age-old geometric and plant motifs and intense bright colors, particularly red, green, orange, and violet.

As forests are abundant, wood carving has been practiced by all the inhabitants of the Volga and Kama region. Among the wooden objects made by the Komis, carved and sometimes painted dippers, saltcellars, and architectural details, decorated with solar symbols, horses, and birds, are

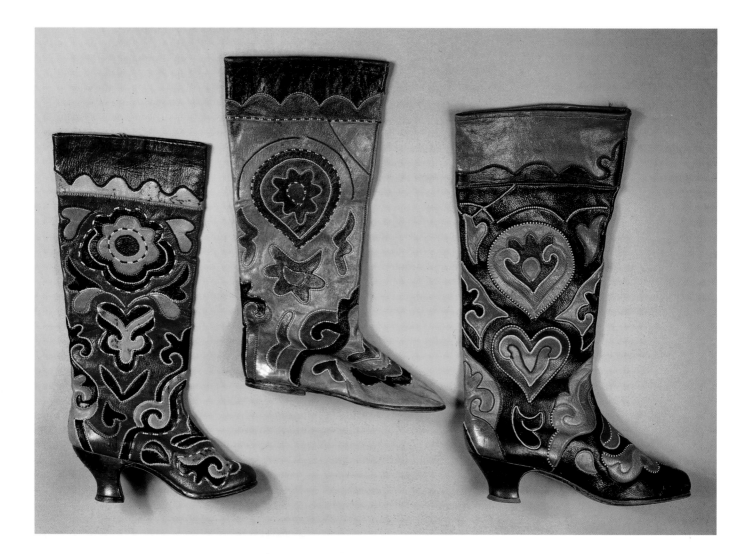

especially notable for their pleasing appearance. Their typical wooden vessels are carved in the form of ducks, a tradition that dates back to Neolithic times (third and second millennia B.C.). The Chuvashes and Maris make numerous ritual dippers carved from wood for home-brewed beer. Highly original chests for bridal trousseaus are the Mordvinians' specialty. They make them from large blocks of wood, which they chisel and adorn with skillfully arranged incisions. The Bashkirs show considerable skill in making vessels for *kumiss* (fermented mare's milk), which they decorate with chains carved out of whole pieces of wood or *kap* (growths on the trunks or roots of birch trees).

Other noteworthy crafts in the Volga and Kama region include knitted stockings and mittens by the Komis, and articles of leather and felt with appliqué by the Tatars.

Jewelry has also played a considerable role in Tataria. Kazan was an important center for this trade because it catered not only to the Volga region but also to Kazakhstan and Central Asia as well. Tatar jewelers excelled in many techniques and frequently used precious metals, mostly silver, which they set with precious and semiprecious stones. Tatar personal

Women's boots for festive occasions. Early 20th century
Kazan Province (Tatars)
Multicolored leather mosaics. Height 42, 37, and 45
Ethnography Museum, Leningrad

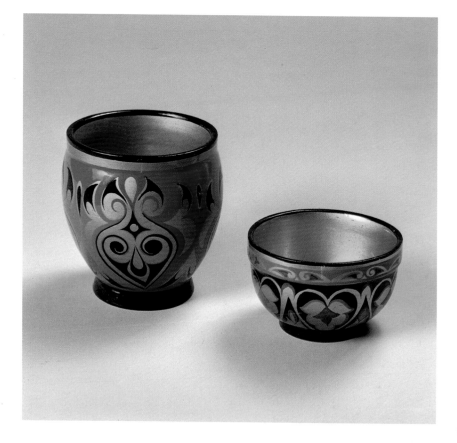

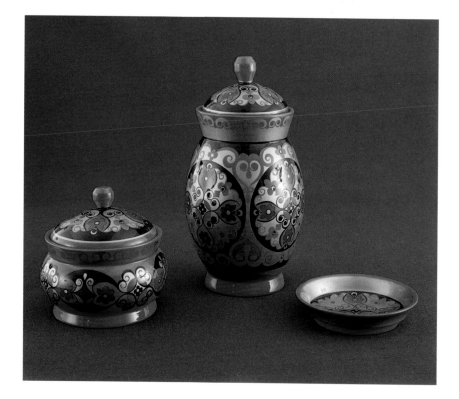

Vase and cup. 1977
Ufa, Bashkir ASSR (Bashkirs)
Painted wood. Height 12 and 8: diameter 8 and 10
Museum of Folk Art, Moscow

Breakfast set. 1978
Bashkir ASSR (Bashkirs)
Wood, lathe-turned and painted. Height 1.5, 23, and 13
Union of Artists, Moscow

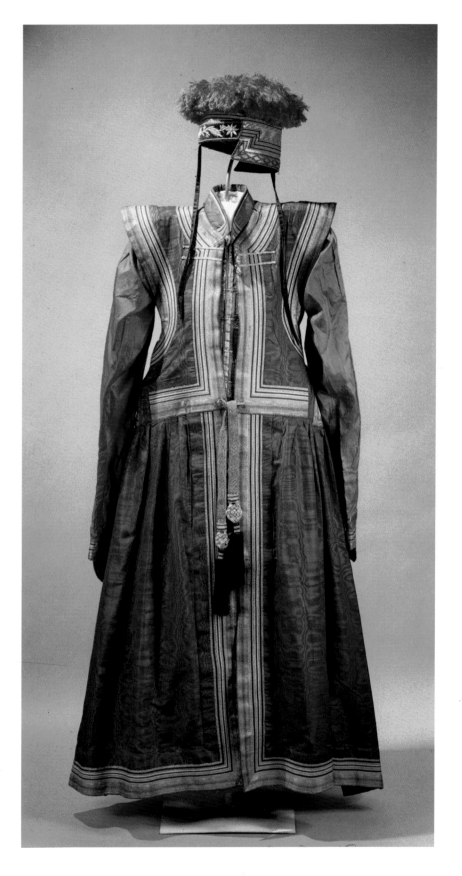

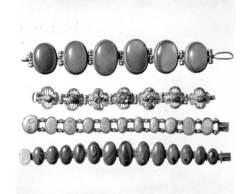

Dress and headdress of wealthy Kalmyk woman. Early 20th
 century
Astrakhan Province (Kalmyks)
Moiré, silk rep, velvet, brocade, embroidered in gold braid and
 gold thread. Length of dress 131; height of headdress 11
Ethnography Museum, Leningrad

Bracelets. Late 19th century
Ufa Province (Tatars)
Silver, with malachite (top), turquoise (second and third from
 top), and cornelian (bottom); filigree work (third from top).
 Length 19, 18.5, 17, and 20.5
Ethnography Museum, Leningrad

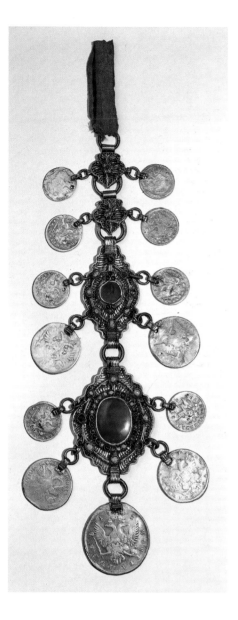

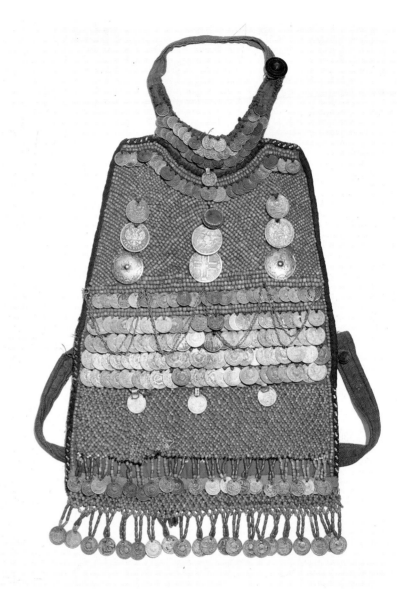

Pendant. Late 19th or early 20th century
Tatar ASSR (Tatars)
Silver, with cornelian, turquoise, and fine filigree. Length 30
Ethnography Museum, Leningrad

Breast decoration. 1940
Bashkir ASSR (Bashkirs)
Sateen, decorated with corals and silver and metal discs.
 Length 41
Ethnography Museum, Leningrad

ornaments for the head, neck, and chest, made in a wide range of shapes and designs, are remarkable for their rich colors and craftsmanship.

The folk arts of the Kalmyk Autonomous Republic, which lies in the lower reaches of the Volga, are very original. Needlework and felt-making are practiced by the women, and the men make metal, wooden, and leather objects. Beautiful embroidery in gold relief decorates Kalmyk girls' velvet hats and men's shirt fronts. Kalmyk wooden tobacco pipes with niello silver mountings are also impressive, not to mention their interesting felt rugs embroidered with monochrome patterns.

Many of these traditional crafts have nowadays grown into thriving industries in the Volga and Kama region.

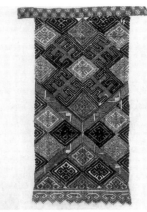
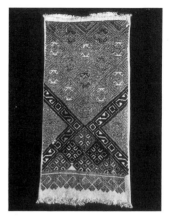

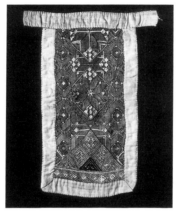
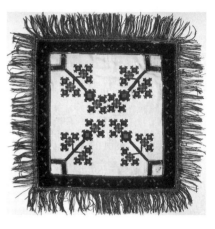

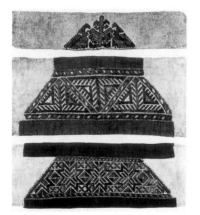
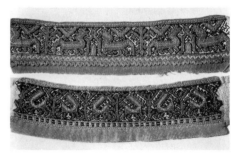

Hems of peasant women's dresses. Late 19th or early 20th
 century
Penza Province (Moksha Mordvinians)
Linen, embroidered in wool. Width 57, 56, and 59
Ethnography Museum, Leningrad

Front panel of peasant woman's dress. Late 19th century
Glazov District, Viatka Province (Udmurts)
Linen, embroidered in silk. 18 × 30
Ethnography Museum, Leningrad

Samplers of embroidery for woman's dress. 19th century
Kazan Province (Chuvashes)
Linen, embroidered in silk and wool
Ethnography Museum, Leningrad

Front panel of peasant woman's dress. 19th century
Glazov District, Viatka Province (Udmurts)
Linen, embroidered in silk. 17 × 33
Ethnography Museum, Leningrad

Woman's bib. Early 20th century
Village of Gorodishche, Penza Province (Udmurts)
Linen, with embroidery and red calico borders. 22 × 40
Ethnography Museum, Leningrad

Headbands. Late 19th or early 20th century
Orenburg Province (Bashkirs)
Linen, embroidered in silk and wool. Width 7, 15, and 12
Ethnography Museum, Leningrad

Front panel of peasant woman's dress. 19th century
Glazov District, Viatka Province (Udmurts)
Linen, embroidered in silk. 18 × 36
Ethnography Museum, Leningrad

Headdress cover. Late 19th century
Village of Urustamok, Samara Province (Udmurts)
Linen, embroidered in silk. 73 × 73
Ethnography Museum, Leningrad

Headbands. Mid-19th century
Kazan Province (Maris)
Linen, embroidered in wool. Width 7 (each)
Ethnography Museum, Leningrad

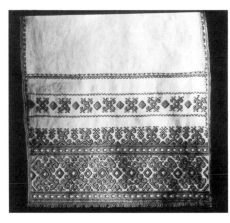

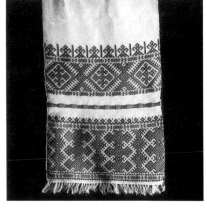

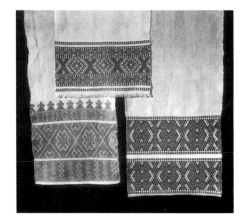

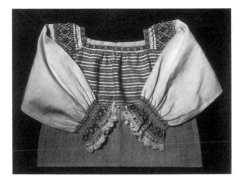

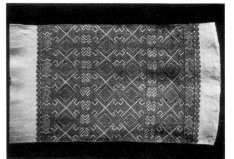

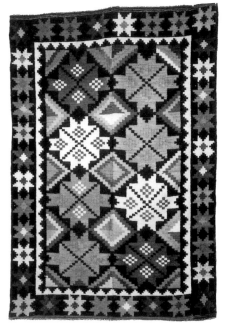

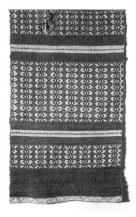

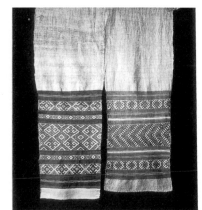

Part of towel. 1959
By L. Orlova and R. Kozyreva
Yoshkar-Ola, Mari ASSR (Maris)
Linen, embroidered in wool and mouliné and decorated with
 braid. Width 35
Museum of Folk Art, Moscow

Part of peasant woman's blouse for festive occasions. Early
 20th century
Village of Noshul, Vologda Province (Zyrian Komis)
Homespun patterned linen
Ethnography Museum, Leningrad

Fragment of headband border. 1908
Village of Novoye Kudashevo, Ufa Province (Bashkirs)
Homespun patterned linen. 36 × 67
Ethnography Museum, Leningrad

Border of towel. 1977
Syktyvkar, Komi ASSR (Komis)
Homespun patterned linen. Width 32
Museum of Folk Art, Moscow

Part of turban. 1890s
Samara Province (Udmurts)
Homespun patterned linen. Width 33
Museum of Folk Art, Moscow

Decorative towels. 1950s
Bashkir ASSR (Bashkirs)
Homespun patterned linen. Width 38 and 32
Ethnography Museum, Leningrad

Borders of towels. Late 19th or early 20th century
Vologda Province (Zyrian Komis)
Homespun patterned linen. Width 76, 35.5, and 34
Ethnography Museum, Leningrad

Rug. 1950s
Miyakinsky District, Bashkir ASSR (Bashkirs)
Homespun woollen and cotton threads, woven into a pattern.
 150 × 215
Ethnography Museum, Leningrad

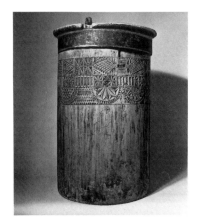

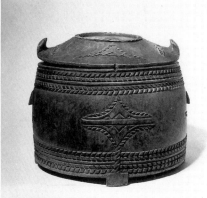

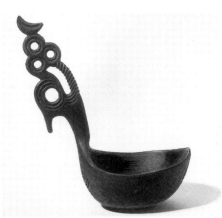

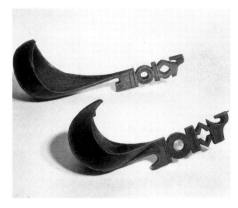

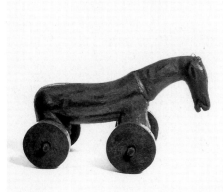

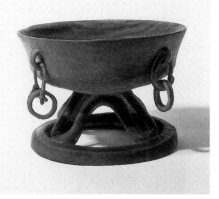

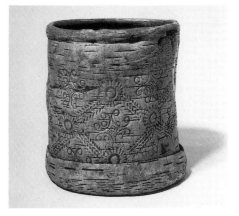

Marriage box. 19th century
Samara Province (Mordvinians)
Carved wood. Height 76, diameter 47
Ethnography Museum, Leningrad

Dippers for beer. Late 19th century
Kosmodemyansk District, Kazan Province (Chuvashes)
Carved wood. Length 24 and 33
Ethnography Museum, Leningrad

Pull-toy. Early 20th century
Ust-Sysolsk District, Vologda Province (Izhem Komis)
Carved wood. Height 12
Ethnography Museum, Leningrad

Container for *kumiss*. Late 19th century
Village of Bainazarovo, Orenburg Province (Bashkirs)
Carved wood. Height 20, diameter 34
Ethnography Museum, Leningrad

Saltcellar. Late 19th or early 20th century
Ust-Sysolsk District, Vologda Province (Zyrian Komis)
Carved wood. Length 18
Ethnography Museum, Leningrad

Bowl for honey or *kumiss*. Late 19th or early 20th century
Ufa Province (Bashkirs)
Carved wood. Height 9, diameter 14
Ethnography Museum, Leningrad

Scoop for *kumiss*. Late 19th or early 20th century
Village of Bainazarovo, Orenburg Province (Bashkirs)
Carved wood. Length 22
Ethnography Museum, Leningrad

Laundry beetles. 19th century
Village of Ust-Tsylma, Arkhangelsk Province (Izhem Komis)
Wood, carved and painted. Length 68, 52, and 52.5
Ethnography Museum, Leningrad

Vessel for milk or honey. 20th century
Agryz District, Tatar ASSR (Udmurts)
Birch bark, with stamped designs. Height 24, diameter 22
Ethnography Museum, Leningrad

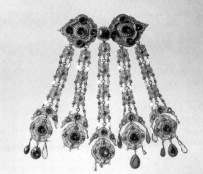

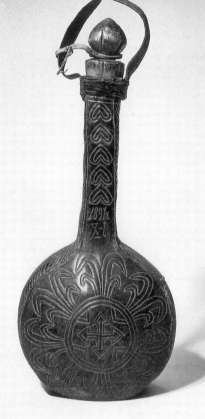

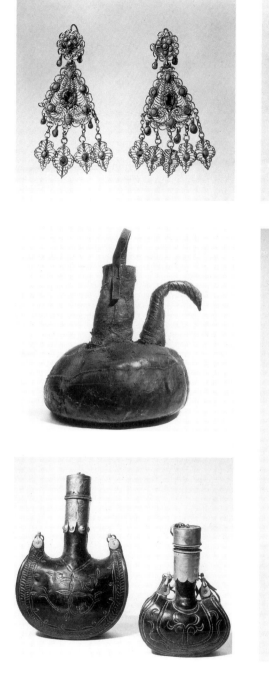

Earrings. 19th century
Kazan (Tatars)
Silver, with turquoise and fine filigree. Length 11.5
Ethnography Museum, Leningrad

Spouted vessel for liquid. Early 20th century
Astrakhan Province (Kalmyks)
Leather. Height 27
Ethnography Museum, Leningrad

Flasks for milk vodka. Early 20th century
Astrakhan Province (Kalmyks)
Stamped leather and engraved metal. Height 28 and 22
Ethnography Museum, Leningrad

Breast ornament. Late 19th century
Kazan Province (Tatars)
Silver, with malachite, turquoise, glass, and fine filigree.
 Length 25.5
Ethnography Museum, Leningrad

Vessel for milk vodka (an alcoholic beverage used in Kalmykia
 and made by the fermentation of milk). 1897
Salsk District, Don Province (Kalmyks)
Stamped leather and wood. Height 55
Ethnography Museum, Leningrad

Breast decoration. 1920s
Cheliabinsk District, Orenburg Province (Bashkirs)
Cloth, decorated with silver and metal discs, corals, turquoise,
 and amethysts. Length 41.5
Ethnography Museum, Leningrad

Breast decoration. Early 20th century
Cheliabinsk District, Orenburg Province (Bashkirs)
Cloth, with red calico, silver discs, mother-of-pearl, corals, and
 cornelians. Length 37
Ethnography Museum, Leningrad

Folk Art in
SIBERIA

Inhabitants of the Khakass Autonomous Region, the Tuva Autonomous Republic, the Buriat Autonomous Republic, and the Gorno-Altai Autonomous Region form the bulk of the population in southern Siberia. This extensive territory was a cradle of ancient cultures, as evidenced by numerous archaeological finds. Many types of archaic earthenware, rock paintings, stone stelae with pictures in relief or drawn in contour lines, and bronze and bone objects in the Siberian Scythian style demonstrate the ancient inhabitants' links with the tribes of western Siberia, the Altai, Eastern Europe, and Central Asia.

In later periods, southern Siberian art was undoubtedly affected by Turkic and Mongolian cultures. However, it maintained connections with the artistic heritage of northern Siberia and even assimilated some cultural traditions from Russian settlers in the region. All this resulted in the emergence of complex arts with heterogeneous imagery, which incorporated many highly original local features.

The Krasnoiarsk territory includes the Khakass Autonomous Region, which lies in the middle reaches of the Yenisei River. Numerous archaeological finds, including figures of men and animals in bone, stone, and wood, ornaments, horse trappings, and various metal vessels attest to the fact that the arts of the Khakass people date back to the remote past. Ancient traditions continue to exist and develop in the modern folk art. Wood and stone carving, embroidery, and especially traditional costume-making occupy a place of prominence.

1 KHAKASS AUTONOMOUS REGION
2 GORNO-ALTAI AUTONOMOUS REGION

The art of the Tuva Autonomous Republic, which lies to the south of Khakassia, is rooted in the Neolithic and Bronze Ages, and in the Scythian and Hun cultures. In those times animal representations, carved from bone or wood, or stamped on gold plates in the characteristic Siberian Scythian style, were quite common there. Casting, gilding, engraving, and other metalwork techniques were further developed in the early Turkic period (sixth-eighth centuries). Articles from this time are profusely decorated with plant and geometric designs. The traditional chased and engraved ornaments are still seen today on silver buckles, wedding ornaments, and steels.

In the past, two wooden chests placed opposite the entrance were indispensable objects found in every *yurta* dwelling. Their polychrome designs, painted in oil on bright backgrounds, are highly decorative. Along with a bed of the same style, they were the main adornments in the nomadic herdsman's dimly lit *yurta*. Curiously enough, the Tuvans willingly move their traditional chests even into well-appointed modern apartments.

In Tuva, it was also customary to punch intricate geometric designs with wooden dies on leather flasks, harnesses, cushions, and saddlebags.

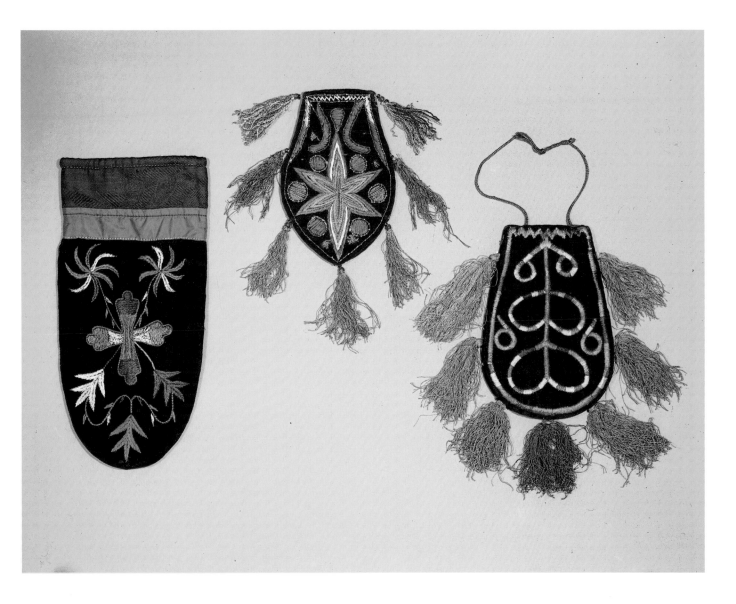

Tobacco pouches and mitten. Early 20th century
Yenisei Province (Khakasses)
Velvet, embroidered in silk. Length 26, 15.5, and 14.5
Ethnography Museum, Leningrad

Tuvan figurines, which usually represent animals, are unique. They were predated by formalized and generalized stone or wood carvings, which early nomads commonly used for ritual purposes. However, from the nineteenth century on animal representations have become more realistic. Presently, mythological characters occasionally occur alongside the traditional images of domestic and wild animals.

In the past, the Buriats, another Siberian ethnic group, widely practiced the crafts of embroidery, wood carving, metal-casting, and goldsmithing. All their domestic wooden objects, no matter how made or for what purpose, were carved, painted with designs, or inlaid with metal. Various metalwork techniques were employed in the making of copper and silver ornaments and tableware. Leather articles were decorated with stamped designs, appliqué, or embroidery.

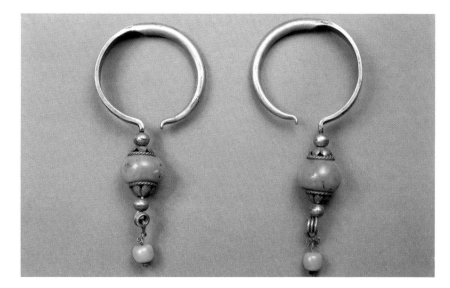

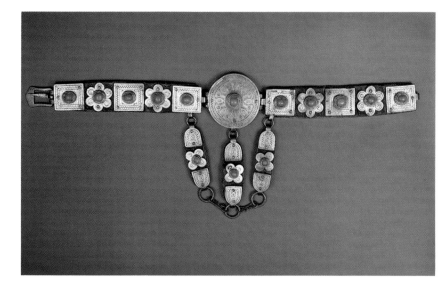

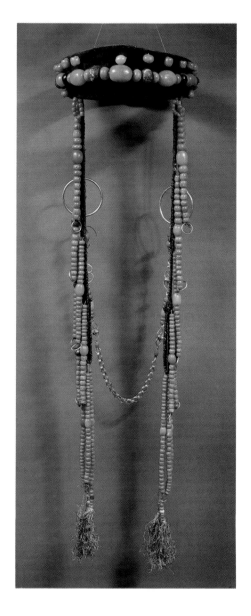

The traditional skills and techniques are still quite evident in silver decorations, tobacco pipes, steels, and arms made in present-day Buriatia. The decoration of these articles is based on a well-balanced combination of geometric and plant designs.

Buriat national costumes are generally trimmed with their traditional tambour patterns, the ancient motifs of which suit even modern urban clothes well. Their leather goods, such as gloves, boots, and purses, look especially attractive.

A process of enrichment can be observed in present-day Siberian art and culture. The inhabitants are reviving some of their forgotten crafts and producing novel objects, which are in keeping with their new life-styles without completely breaking with tradition.

Earrings. Early 20th century
Aginsk Aimak, Transbaikalia (Buriats)
Silver and amber. Length 9
Ethnography Museum, Leningrad

Woman's belt. Early 20th century
Aginsk Aimak, Transbaikalia (Buriats)
Silver, engraved and set with corals, and leather. Length 126
Ethnography Museum, Leningrad

Young girl's headdress decoration. Mid-19th century
Aginsk Aimak, Transbaikalia (Buriats)
Velvet, with silver, corals, lapis lazuli, amber, and silk tassels.
 Length 55
Ethnography Museum, Leningrad

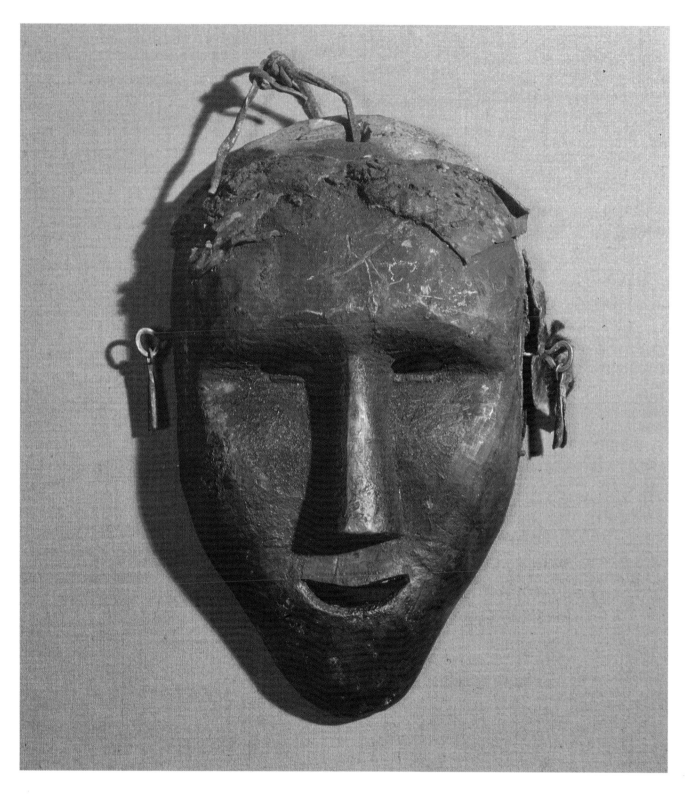

Mask. Early 20th century
Transbaikalia (Buriats)
Wood and leather, with iron pendants and ribbons. Height 34
Ethnography Museum, Leningrad

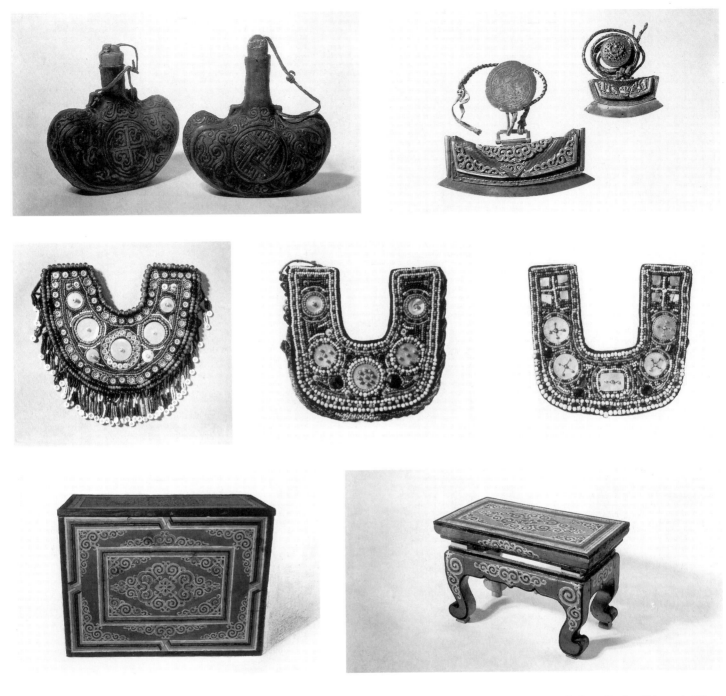

Flasks for *kumiss*. Late 19th or early 20th century and 1945
Upper reaches of the Yenisei; Tuva Autonomous Region
(Tuvans)
Stamped leather and wood. Height 27 and 31
Ethnography Museum, Leningrad

Bridal breast decoration. Late 19th or early 20th century
Minusinsk District, Yenisei Province (Khakasses)
Cloth, with mother-of-pearl buttons and corals. Width 13
Ethnography Museum, Leningrad

Box for woman's clothes. 1960
Village of Teeli, Bai-Taiga District, Tuva Autonomous Region
(Tuvans)
Painted wood. 61.5 × 31.5 × 46
Ethnography Museum, Leningrad

Bridal breast decoration. Early 20th century
Achinsk District, Yenisei Province (Khakasses)
Cloth, with mother-of-pearl, corals, and beadwork. Width 24
Ethnography Museum, Leningrad

Steels for striking fire from a flint. Late 19th or early 20th
century
Upper reaches of the Yenisei (Tuvans)
Steel, silver-plated metal, chased and engraved, and leather.
Height 15.5 and 10.5
Ethnography Museum, Leningrad

Bridal breast decoration. Early 20th century
Achinsk District, Yenisei Province (Khakasses)
Cloth, with mother-of-pearl, corals, and beadwork. Width 23
Ethnography Museum, Leningrad

Miniature table. 1960
Village of Teeli, Bai-Taiga District, Tuva Autonomous Region
(Tuvans)
Painted wood. Height 27.5
Ethnography Museum, Leningrad

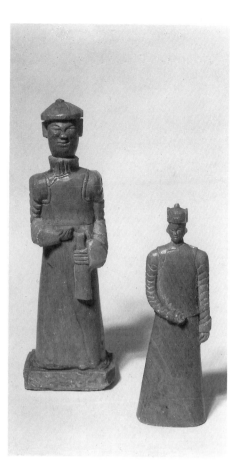

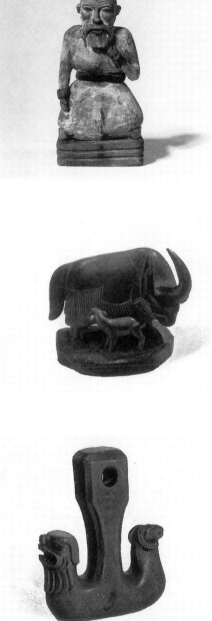

Ritual statuette. Late 19th or early 20th century
Upper reaches of the Yenisei (Tuvans)
Wood, carved and painted. Height 18.5
Ethnography Museum, Leningrad

Buffalo. 1977
By T. Khertek
Kyzyl, Tuva ASSR (Tuvans)
Carved stone. Height 15
Union of Artists, Moscow

Hook for cradle. 1956–57
By T. Khertek
Village of Kyzyl-Tag, Tuva Autonomóus Region (Tuvans)
Carved stone. Height 10
Ethnography Museum, Leningrad

Toys. Late 19th or early 20th century
Upper reaches of the Yenisei (Tuvans)
Carved stone. Height 16 and 36
Ethnography Museum, Leningrad

Sarlyk (Tibetan cow). 1978
By Ye. Tiuliush
Kyzyl, Tuva ASSR (Tuvans)
Carved stone. Height 9
Union of Artists, Moscow

Ox and Horse. Late 19th or early 20th century
Upper reaches of the Yenisei (Tuvans)
Carved stone. Height 4 and 8.7
Ethnography Museum, Leningrad

Sarlyk (Tibetan cow). 1978
By P. Arakchaa
Kyzyl, Tuva ASSR (Tuvans)
Carved stone. Height 10
Union of Artists, Moscow

Fantastic Animal. 1977
By V. Shoshin
Kyzyl, Tuva ASSR (Tuvans)
Carved stone. Height 8
Union of Artists, Moscow

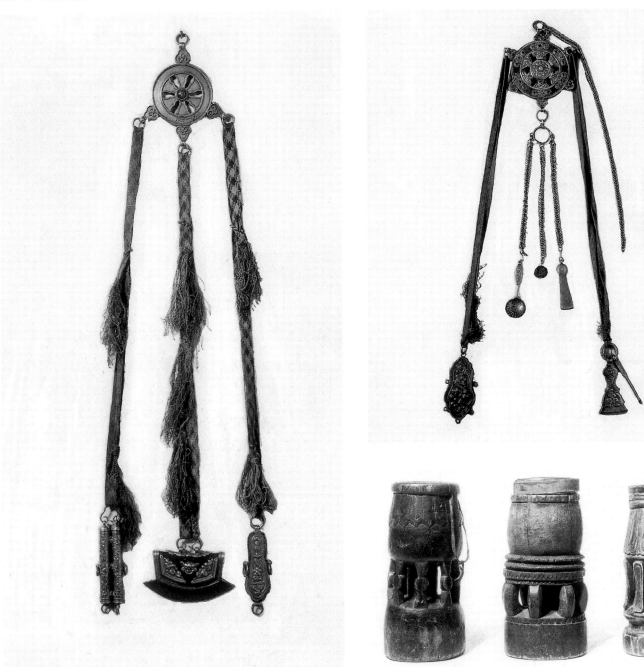

Woman's belt decoration with needle case and steel. Late 19th
or early 20th century
Transbaikalia (Buriats)
Chased silver and leather with silk braid; steel. Length 85
Ethnography Museum, Leningrad

Woman's belt decoration. Late 19th or early 20th century
Transbaikalia (Buriats)
Chased silver and metal with silk braid. Length 28
Ethnography Museum, Leningrad

Mortars for salt or tea. First quarter of the 20th century
Transbaikalia (Buriats)
Carved wood. Height 22, 24, and 23
Ethnography Museum, Leningrad

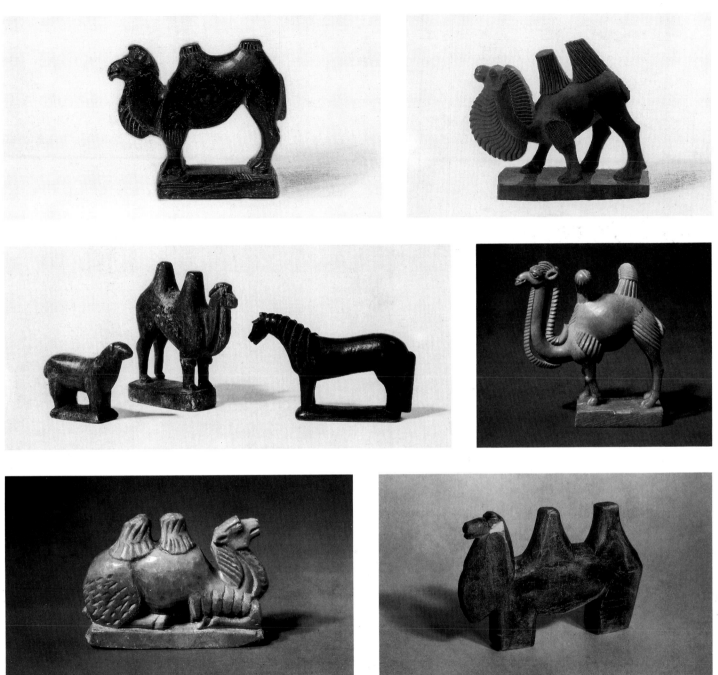

Camel. Late 19th or early 20th century
Upper reaches of the Yenisei (Tuvans)
Carved stone. Height 7.3
Ethnography Museum, Leningrad

Ram, Camel, **and Horse.** Late 19th or early 20th century
Transbaikalia (Buriats)
Wood, carved and painted. Height 4, 9.5, and 5
Ethnography Museum, Leningrad

Camel. Late 19th or early 20th century
Upper reaches of the Yenisei (Tuvans)
Carved stone. Height 6
Ethnography Museum, Leningrad

Camel. 1978
By Ye. Tiuliush
Kyzyl, Tuva ASSR (Tuvans)
Carved stone. Height 11
Union of Artists, Moscow

Camel. 1970
By Kh. Khuna
Tuva ASSR (Tuvans)
Carved stone. Height 11.5
Ethnography Museum, Leningrad·

Camel. First quarter of the 20th century
Aginsk Aimak, Transbaikalia (Buriats)
Carved wood. Height 12.5
Ethnography Museum, Leningrad

Folk Art in the
FAR NORTH
and
FAR EAST

The boundless expanses of Russia's Far North and Far East are populated by peoples that settled in these lands of permafrost, arctic nights, and brief summers as early as the dawn of the Christian era. Their culture and art have distinctive characteristics peculiar to each ethnic group, as well as common regional features. Because of their geographic location with its severe climate, they lived in isolation from one another as well as from urban culture, which retarded their social development and long preserved their rigorous conservative life-style.

The most populous northern communities are the Yakuts, who used to be nomadic livestock herdsmen. Until the end of the nineteenth century, the horse was an important figure in their tribal life, customs, rituals, and folklore. The horse took part in their national spring festival. One of the festival's ritual objects was a large wooden loving cup for *kumiss*. The making of such cups was a specialized skill handed down from one generation to the other. The vessels were boiled in fat to make them watertight, as a result of which they acquired a smooth surface and dark color. The body of the cup was carved with bands of delicate ornament and decorated with thin copper or silver rims and pendants. In the perfection of their proportions and elegance of ornaments the Yakut cups bear comparison with vessels of antiquity. Equally beautiful shapes and ornamentation are characteristic of Yakut bowls and *kumiss* ladles.

The skill with which the Yakuts stress volume by means of decoration is also quite evident in their birch-bark articles, usually made by women.

A simplicity of shape is characteristic of their storage boxes for clothes, their funnels and pails for *kumiss*, their birch-bark vessels, milk pails, and needle cases. The components of these articles are tied together with dark horsehair plaited into ingenious patterns that contrast with the light-colored birch bark and resemble embroidered ornaments; borders of withe skillfully attached to the bark enhance the design's beauty. The effect is further heightened by the use of beads, stamped designs, and tassels made of colored woollen cloth or reindeer suede. *Yurta* roofs were also made of birch bark, which was decorated with bands of wavy or carved patterns with mica and metal insets.

Metal is a common material in Yakut folk arts, and it was lavishly employed in harness decorations. The high pommel has silver or brass mounts with chased or engraved ornamentation, and the saddle-cloth made of red or blue wool is adorned with sewn-on flat metal plaques, surrounded by colored beads.

Yakut personal ornaments, especially those which were worn by women over fur coats or camisoles, are very original. Their massive necklaces were fitted with long pendants hanging over the chest and back; they are composed of engraved or openwork plates and colored beads and usual-

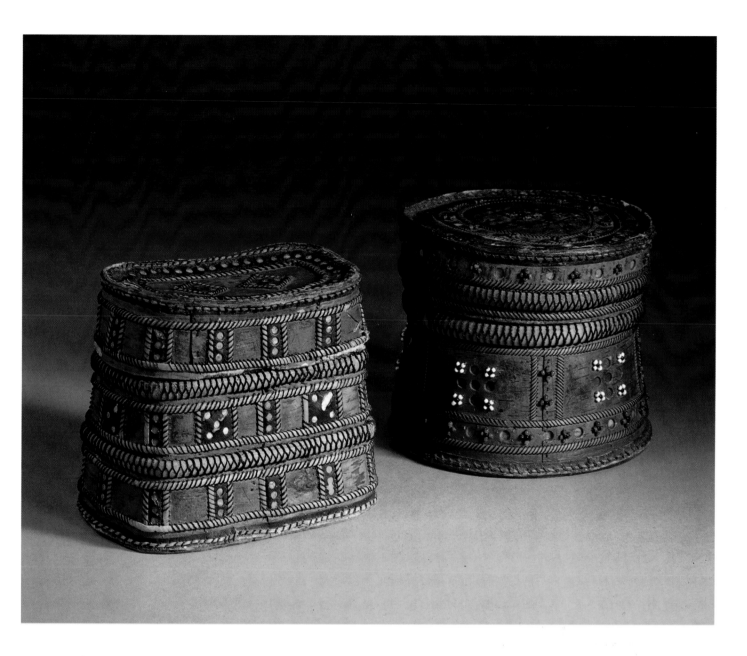

Boxes for needlework. Early 20th century
Yakutsk Region (Yakuts)
Birch bark, mica, horsehair, wood, and beads.
 Height 11 and 17
Ethnography Museum, Leningrad

ly terminate in a decorative figure. A necklace of this type could weigh as much as fifteen kilograms. Yakut ornaments are somewhat similar to jewelry from other Turkic nations, which is manifest in their headbands with pendants, earring shapes, belts of engraved plates, and paired bangles up to eight centimeters wide.

In the eighteenth and nineteenth centuries, ivory carving was a flourishing art in Yakutia, where prehistoric mammoth tusks were found and worked into such objects as elaborately carved caskets with inscriptions and pictorial designs. In the late nineteenth and early twentieth century, mostly small figurines and inexpensive utilitarian articles were produced. A

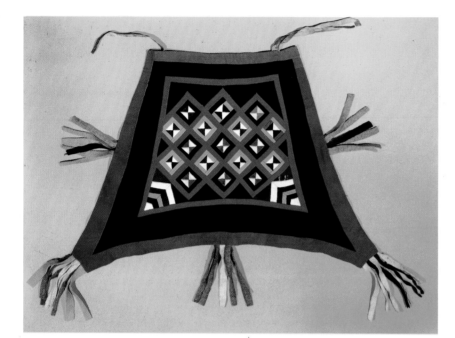

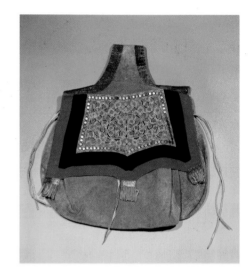

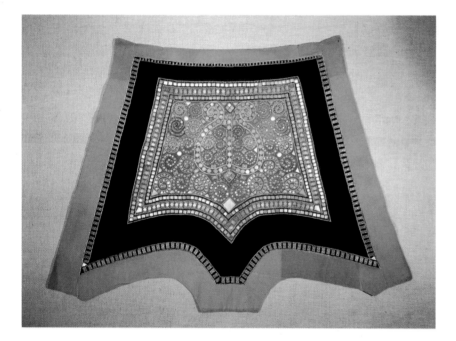

Saddle-cloth. Early 20th century
Viliuysk-District, Yakutsk Region (Yakuts)
Mosaics of cloth, suede, and duck. Width 52
Ethnography Museum, Leningrad

Saddle-cloth. Early 20th century
Yakutsk Region (Yakuts)
Cloth, with beads, metal discs, and plaques. Width 76
Arctic and Antarctic Museum, Leningrad

Woman's saddlebag. Early 20th century
Yakutsk Region (Yakuts)
Elk hide, decorated with velvet, embroidered woollen-cloth
 bands and metal discs. Height 57
Ethnography Museum, Leningrad

carvers' cooperative was organized in Yakutia in the 1920s. Present-day carvings depict the life and scenery of Yakutia and episodes from its national epics.

In the Far North, making clothes and trimmings has traditionally been an important and favored occupation. Various animal skins, such as col-

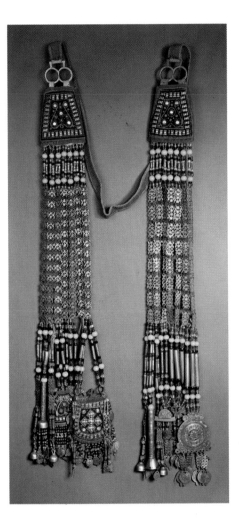

Bridal pendant decoration. Mid-19th century
Yakutsk Region (Yakuts)
Copper and silver, cast, pierced, and engraved, velvet and
 cloth, with beadwork and sewn-on metal discs. Length 112
Ethnography Museum, Leningrad

Belt decorations for bridal fur coat. Mid-19th century
Yakutsk Region (Yakuts)
Copper and silver, cast and engraved, leather, and amber
 beads. Length 52
Ethnography Museum, Leningrad

ored reindeer suede and hides, silver-gray or golden pelts from reindeer legs,
as well as silver fox, ermine, fox, sable, squirrel, otter, and seal furs, and
even some bird skins, go into the making of warm and attractive clothes
that are light and comfortable to wear. The inhabitants of this region dress
the fur skillfully and use it thriftily, which results in designs that are highly
functional and attractive at the same time. High winter boots made of rein-
deer or horse hide clearly demonstrate their ability to combine efficiency
with beauty. Each northern ethnic group has its own system for ornament-

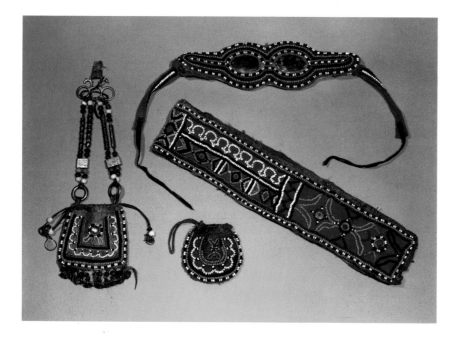

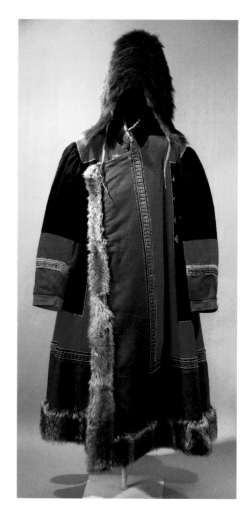

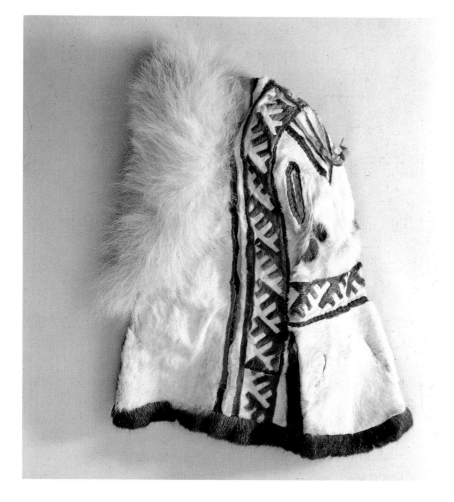

Handbag, snow spectacles, belt, and tobacco pouch.
Early 20th century
Yenisei Province (Dolgans)
Suede and cloth with beadwork, metal. Length 9 (handbag)
and 19 (snow spectacles); 28 × 7.5 (belt); 7 × 8 (tobacco
pouch)
Ethnography Museum, Leningrad

Woman's hat. 1930
Arkhangelsk Region (Nentsy)
Reindeer pelt, with colored cloth appliqué and fur trimming
Museum of Anthropology and Ethnography, Leningrad

Fur coat and hat. Early 20th century
Yakutsk Region (Yakuts)
Cloth with metal ornaments and fur. Length of coat 112;
height of hat 35
Ethnography Museum, Leningrad

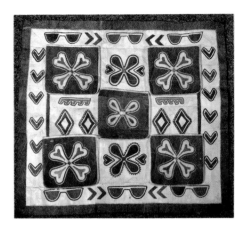

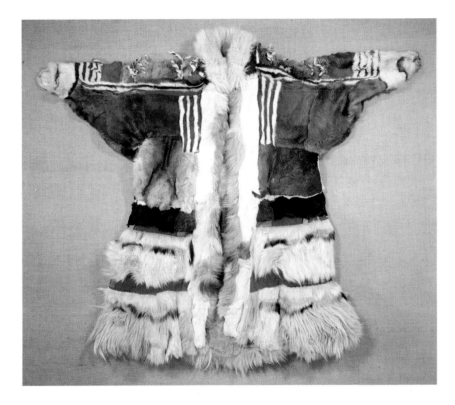

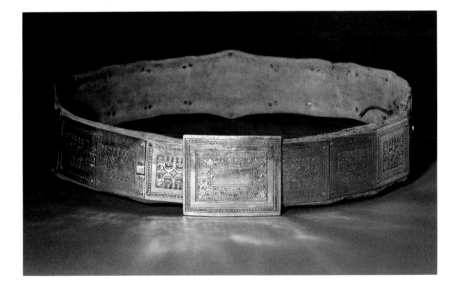

Rug. 1930s
Chukchi National Area (Eskimos)
Reindeer pelt, with appliqué and embroidery in sinew thread
 and colored silk
Museum of Anthropology and Ethnography, Leningrad

Woman's outer garment for festive occasions. Early 20th
 century
Arkhangelsk Province (Nentsy)
Cloth and brocade, with fur mosaics. Length 145
Ethnography Museum, Leningrad

Woman's belt. Late 20th century
Yakutsk Region (Yakuts)
Leather and engraved metal. Length 114
Ethnography Museum, Leningrad

ing them. The Nentsy, for example, stripe them by alternating bands of dark
fur and insets of colored cloth with strips of light-colored pelts from reindeer
legs. The Koriaks, on the other hand, trim the same kind of boots with small
mosaic patterns of fur. The Khantes decorate their high summer boots,
which are made of colored reindeer suede, with rows of geometric designs.

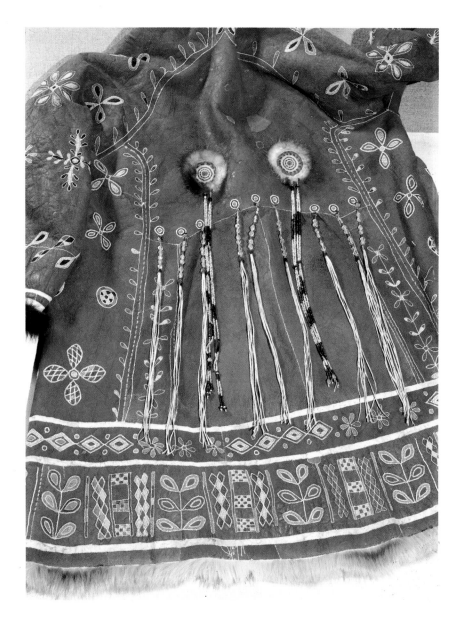

All their clothes, hats, and mittens are trimmed with fur, forming a harmonious ensemble, which is often supplemented by bags made of plain reindeer suede, fur, or colored cloth adorned with beadwork.

Notwithstanding the similarity of methods employed, each ethnic group in this region selects its own materials and emphasizes their decorative qualities in its own distinctive way. Each community's national costume can be unmistakably identified by its cut and trimmings. What they do have in common, though, is the mastery of their fur dressing, done entirely by hand, and their intricately patterned inlay work. While making their national costumes, women in the Far North have demonstrated tremendous

Part of man's outer garment. 1966
Karaghih District, Koriak Autonomous Area (Koriaks)
Reindeer fur, embroidered in cotton thread
Ethnography Museum, Leningrad

Rug. 1950s
Primorye Territory (Chukchis)
Processed reindeer pelt, fur, bird skins, embroidered in
 reindeer hair. 52 × 52.5
Arctic and Antarctic Museum, Leningrad

Rug. 1950s
Primorye Territory (Chukchis)
Processed seal skin and cloth, embroidered in reindeer hair,
 cotton thread, and colored silk
Museum of Anthropology and Ethnography, Leningrad

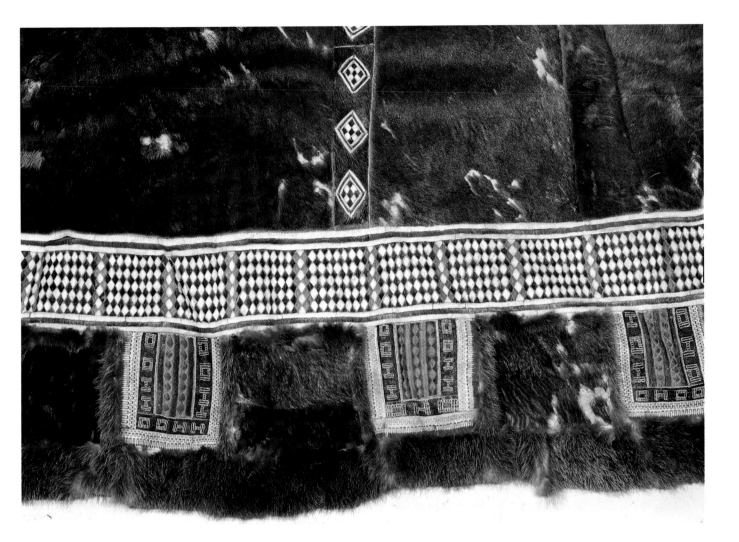

Detail of man's outer garment. 1899–1900
Primorsky Region (Koriaks)
Reindeer pelt, with fur mosaics and needlework in sinew
 thread and colored silk
Museum of Anthropology and Ethnography, Leningrad

ingenuity in selecting pelts and combining them with soft plain reindeer suede, bright beads, or designs in fur mosaic.

A fine array of arts and crafts can be found in the Far East of the USSR. Restrained clear ornamentation characterizes the various birch-bark or wooden objects made by hand as well as the embroidered cloth trimmings. Oval wooden boxes with lids, which are generally decorated with low-relief carving, are also common here. Oval shapes are equally typical of the birch-bark boxes, which are fairly low and decorated with stamped designs accentuated by a thin dark outline. The Ulchi used to carve their birch-bark boxes, or containers in such a way that light-colored patterns were disposed on a dark-tinted background and vice versa. Squat boxes with large lids, which were used as plates, were characteristic pieces of tableware. Every detail demonstrates the artisan's subtle understanding of the material, shape, and proportions of the object. Fine modelling is equally distinctive in their wickerwork and basketry for domestic use.

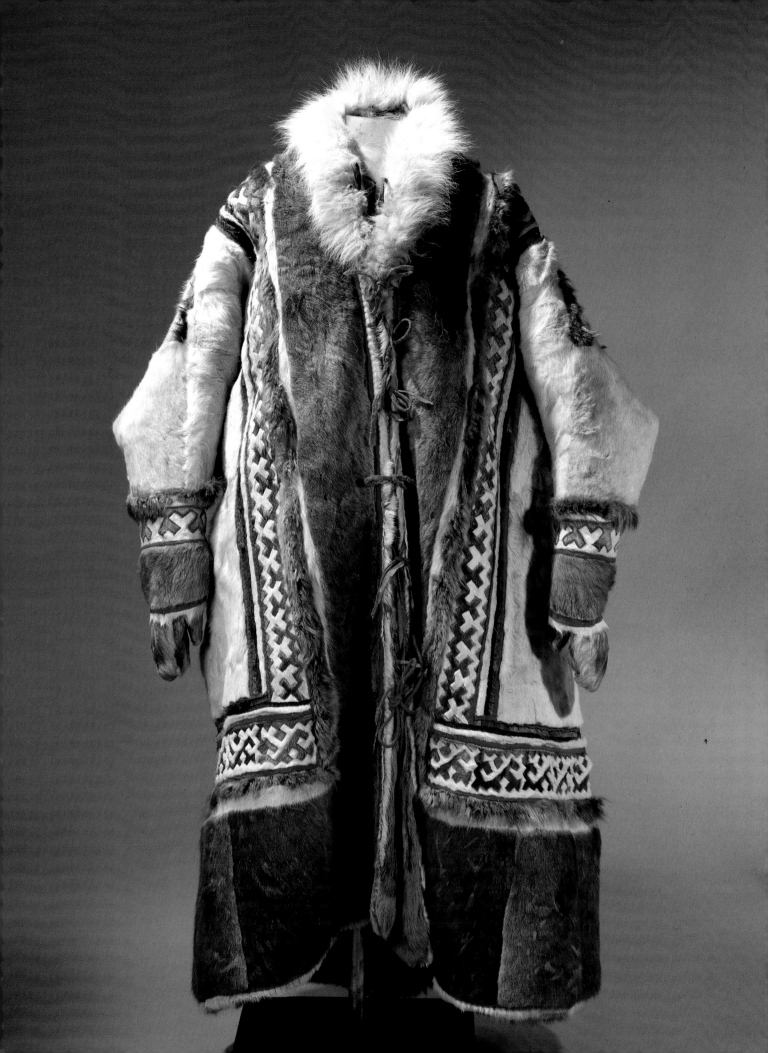

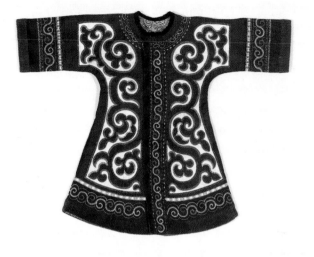

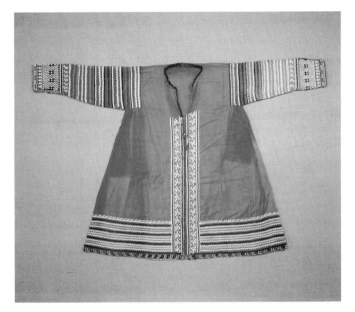

Far Eastern national costumes, headdresses, and footwear are all decorated with embroidery. It usually borders the sleeves and skirts of robes but sometimes fills the entire garment's surface with designs of plant motifs and appliqué; in this case plain or ornamented bands accentuate the lines of the cut. The local embroidery is generally worked in thin silk thread with subtle tonal gradations on a colored background.

Those nations of the Soviet Far East that hunted sea animals developed high standards of bone and ivory carving. Artifacts from the first centuries A.D. provide ample evidence that this region's inhabitants, the Eskimos and, somewhat later, the Chukchis and the Koriaks, used sea-animal bones and tusks to make harpoons, arrowheads, hooks, and other hunting and trapping equipment. A fairly large number of exquisitely carved amulets in the shape of birds, walruses, seals, foxes, and whales have been unearthed. The attraction of these small figurines lies in their naive realism and the artist's ability to capture the essence of the creature depicted—a feature that survives in their art to the present day. Throughout the eighteenth and nineteenth centuries, animals were central to this art. Gradually, however, narrative subjects became more important and appeared on oars, boats, benches, bucket handles, tobacco pipes, and other articles. Walrus tusks with engraved scenes were introduced in the early twentieth century and quickly gained world renown.

In 1931, a workshop for bone carving was set up in Uelen, a settlement on the Bering Sea coast. It was headed by Vukvutagin, an outstanding carver, who was succeeded by another eminent craftsman, Tukkai, who left a considerable number of remarkable carvings.

Although working in much the same vein as before, present-day Chukchi carvers have tackled a wider range of subjects and produced new types

Woman's outer garment. Early 20th century
Beriozov District, Tobolsk Province (Khantes)
Reindeer and polar fox fur, mosaics. Length 130
Ethnography Museum, Leningrad

Child's dress. 1973
Ulchi District, Khabarovsk Territory (Ulchi)
Sateen, with appliqué and embroidery. Length 60
Union of Artists, Moscow

Woman's summer dress. 1930s
Tobolsk (Khantes)
Sateen, with cotton appliqué and beadwork
Arctic and Antarctic Museum, Leningrad

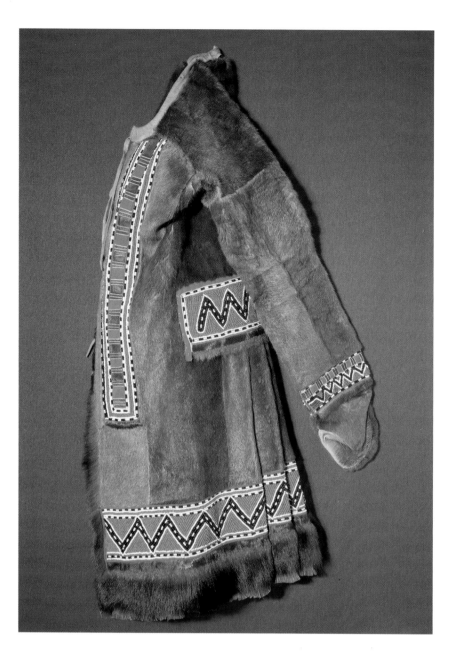

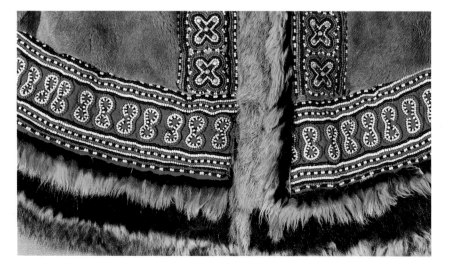

Woman's outer garment for festive occasions. Early 20th
 century
Yakutsk Region (Evenks)
Reindeer fur, with beadwork. Length 98
Ethnography Museum, Leningrad

Detail of woman's outer garment. Early 20th century
Yenisei Province (Evenks)
Reindeer pelt, decorated with colored cloth, beadwork, and fur
 fringes.
Ethnography Museum, Leningrad

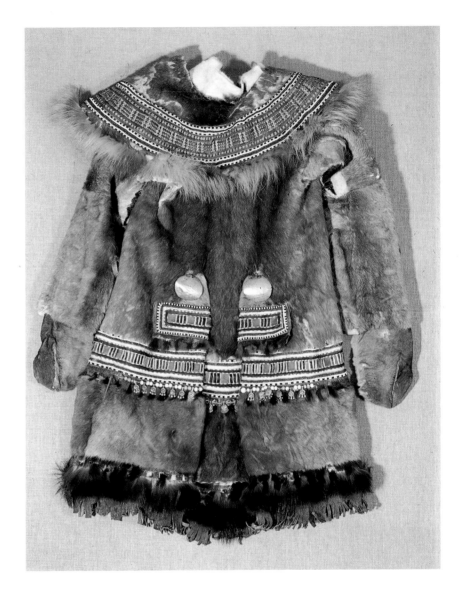

Woman's outer garment. 1899–1902
Yenisei Province (Evenks)
Fur, with strips of reindeer pelt and metal discs. Length 105
Museum of Anthropology and Ethnography, Leningrad

of compositions (deer and dogs in harness, hunting scenes, etc.), infusing them with greater dynamism. Nature, with which these craftsmen who are also hunters are intimately familiar, remains the primary theme and inspiration for their poetic art.

In the past few decades, the art of bone engraving has developed with particular intensity in this region. Both men and women have produced many works of fine draftsmanship, vivid color, and interesting subject matter. They portray hunting scenes, show new aspects of life in remote settlements, or illustrate local legends, fairy tales, and epics.

Rockwell Kent, the American artist to whom a woman carver named Yelena Yanku had given her composition as a birthday present, wrote her a letter of thanks saying that tusk carving was one of her land's wonders and that her art revealed the soul of her people.

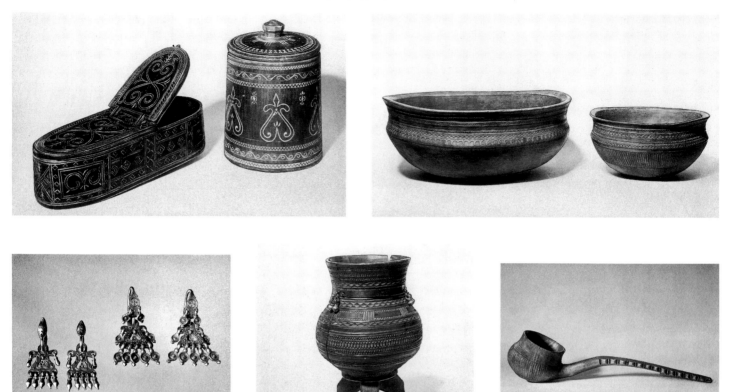

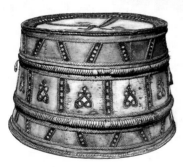

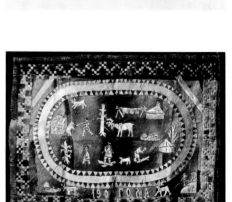

Boxes for needlework. Mid-19th century
Viliuysk, Yakutsk Region (Yakuts)
Wood, carved and painted. Height 7.5 and 20
Ethnography Museum, Leningrad

Bowls for meat. Late 19th or early 20th century
Yakutsk Region (Yakuts)
Carved wood. Height 25 and 17, diameter 55 and 33
Ethnography Museum, Leningrad

Earrings. Late 19th or early 20th century
Yakutsk Region (Yakuts)
Silver, cast and engraved. Length 3.3 and 3.7
Ethnography Museum, Leningrad

Bowl for *kumiss*. Late 19th or early 20th century
Yakutsk Region (Yakuts)
Carved wood and metal. Height 19.5
Ethnography Museum, Leningrad

Dipper for *kumiss*. Late 19th or early 20th century
Yakutsk Region (Yakuts)
Carved wood. Length 58
Ethnography Museum, Leningrad

Box for fur and silver articles. Late 19th or early 20th century
Yakutsk Region (Yakuts)
Birch bark, horsehair, mica, and leather. Height 37
Ethnography Museum, Leningrad

Bowls for *kumiss*. Late 19th century
Yakutsk Region (Yakuts)
Carved wood. Height 40, 55, and 36
Ethnography Museum, Leningrad

Box for needlework. Late 19th or early 20th century
Yakutsk Region (Yakuts)
Carved wood and cast metal. Height 15, diameter 19.5
Ethnography Museum, Leningrad

Decoration of hem. Early 20th century
Primorsky Region (Koriaks)
Reindeer pelt, with fur mosaics
Ethnography Museum, Leningrad

Casket. Mid-19th century
Yakutsk Region (Yakuts)
Carved ivory. 21.5 × 12.5 × 21.5
The Hermitage, Leningrad

Rug. Early 20th century
Primorsky Region (Koriaks)
Reindeer pelt, with fur mosaics. 117 × 88
Ethnography Museum, Leningrad

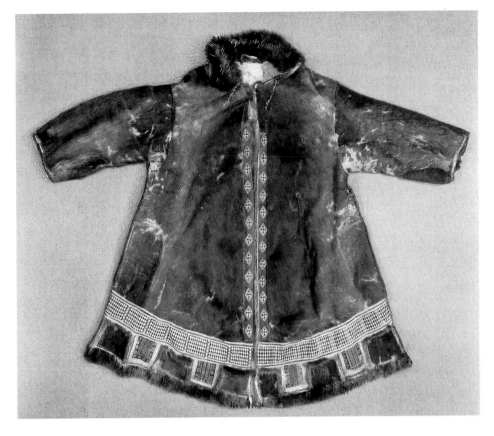

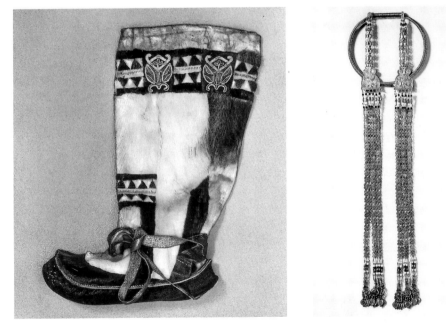

Man's outer garment. 1899–1900
Kamchatka Region (Koriaks)
Reindeer pelt, with fur mosaics. Length 132
Museum of Anthropology and Ethnography, Leningrad

Man's boot. 1930s
Kamchatka Region (Koriaks)
Reindeer leg pelts, with fur mosaics and embroidery.
 Height 79
Museum of Anthropology and Ethnography, Leningrad

Torque. Late 19th or early 20th century
Yakutsk Region (Yakuts)
Metal, cast and engraved, and leather with beadwork.
 Length 80
Ethnography Museum, Leningrad

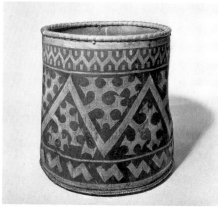
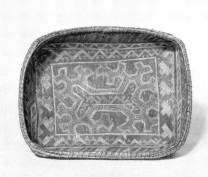
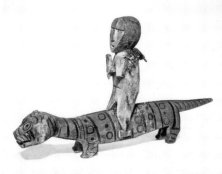

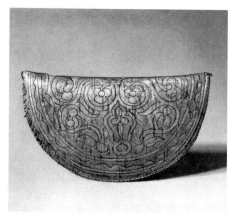
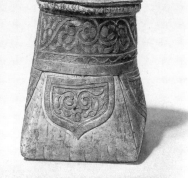
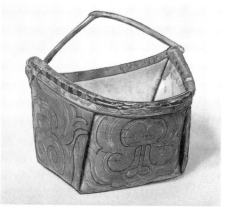

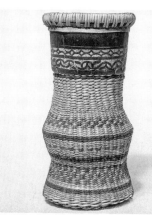
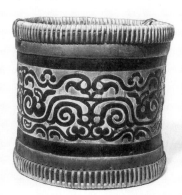

Box. Early 20th century
Tobolsk Province (Khantes)
Birch bark, with scratched designs. Height 33, diameter 33
Ethnography Museum, Leningrad

Saltcellar. Late 19th or early 20th century
Primorsky Region (Ude)
Birch bark, with stamped designs. Height 11
Ethnography Museum, Leningrad

Box for dishes. Early 20th century
Khabarovsk Territory (Nanaitsi)
Willow wickerwork, with stamped birch-bark band.
 Height 22, diameter 26
Ethnography Museum, Leningrad

Plate. Early 20th century
Beriozov District, Tobolsk Province (Mansis)
Birch bark, with incised designs. 26 × 18 × 8
Ethnography Museum, Leningrad

Box with lid. Late 19th or early 20th century
Primorsky Region (Ude)
Birch bark, with carved appliqué. Height 16
Ethnography Museum, Leningrad

Box for spoons. Early 20th century
Khabarovsk Region (Nanaitsi)
Willow wickerwork. Height 24
Ethnography Museum, Leningrad

Deity of hunting (ritual figure). Late 19th or early 20th
 century
Primorsky Region (Ude)
Wood, carved and painted. Height 42
Ethnography Museum, Leningrad

Basket. First half of the 20th century
Khabarovsk Region (Ude)
Birch bark, with stamped designs. Height 21
Ethnography Museum, Leningrad

Box for odds and ends. First half of the 20th century
Khabarovsk Territory (Nanaitsi)
Birch bark, with appliqué. Height 25, diameter 26
Ethnography Museum, Leningrad

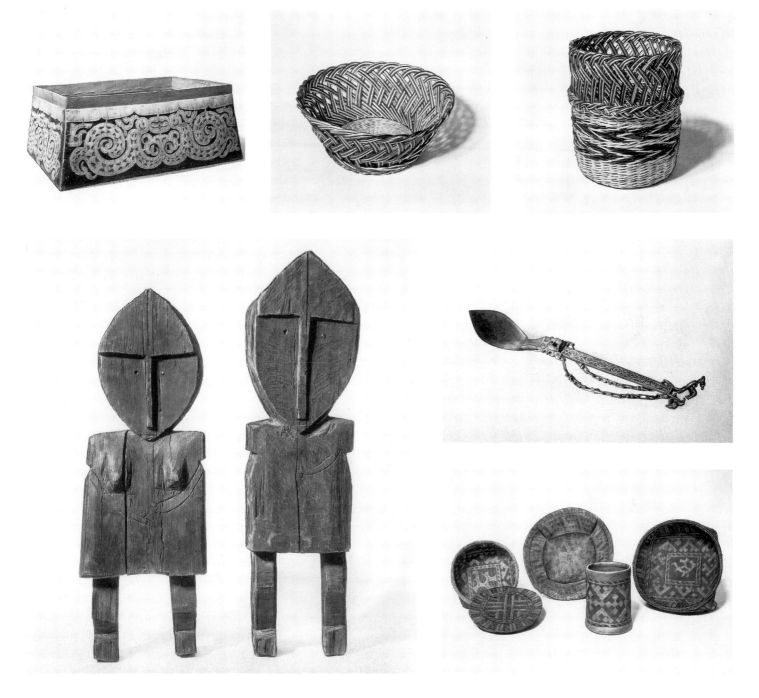

Box for clothes. 1950s
Nanaitsi District, Khabarovsk Territory (Nanaitsi)
Birch bark, carved and painted, with appliqué. 47 × 14 × 33
Ethnography Museum, Leningrad

Guardian spirit figures. Late 19th or early 20th century
Primorsky Region (Nanaitsi)
Carved wood. Height 73 and 79
Ethnography Museum, Leningrad

Biscuit dish. 1975
By G. Tayer
Amur District, Khabarovsk Territory (Nanaitsi)
Willow wickerwork. Height 10
Ethnography Museum, Leningrad

Basket. 1975
By G. Tayer
Amur District, Khabarovsk Territory (Nanaitsi)
Willow wickerwork. Height 19, diameter 15
Ethnography Museum, Leningrad

Spoon for wedding feast. Late 19th or early 20th century
Primorsky Region (Nanaitsi)
Carved wood. Length 68
Ethnography Museum, Leningrad

Containers. First half of the 19th century
Tobolsk Province (Khantes)
Birch bark, with incised designs. Diameter 12, 23, 16, and 9
Ethnography Museum, Leningrad

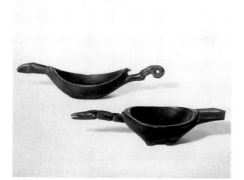

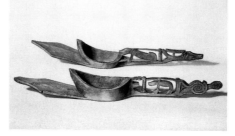

Case for arrowheads. Late 19th or early 20th century
Sakhalin Island (Nivkhi)
Carved wood and leather. Length 42
Ethnography Museum, Leningrad

Snuffboxes. Late 19th or early 20th century
Ussuriisk Area, Primorsky Region (Orochi)
Birch bark, carved, stamped, and painted. 15.5 × 10,
18 × 13.5
Ethnography Museum, Leningrad

Boxes for spoons. Early 20th century
Primorsky Region (Orochi)
Birch bark, carved and painted, with leather appliqué. Height
20, 25, and 18
Ethnography Museum, Leningrad

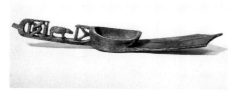

Box for spoons. 20th century
Khabarovsk Territory (Orochi)
Birch bark, with appliqué and fangs. Height 24.5, diameter 10
Ethnography Museum, Leningrad

Box for woman's belongings. First half of the 20th century
Khabarovsk Territory (Orochi)
Birch bark, with stamped designs and appliqué. Height 21,
diameter 30
Ethnography Museum, Leningrad

Fan. First half of the 20th century
Primorye Territory (Orochi)
Birch bark, with stamped designs. 38 × 21
Ethnography Museum, Leningrad

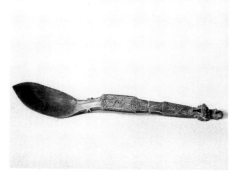

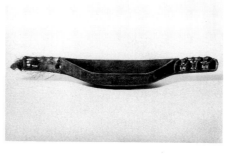

Tiger with Snakes on Its Back. Early 20th century
Primorye Territory (Orochi)
Wood, carved and painted. Length 46
Ethnography Museum, Leningrad

Platters for bear meat. Early 20th century
Primorsky Region (Ulchi)
Carved wood. Length 56 and 49
Ethnography Museum, Leningrad

Box for tools. Early 20th century
Primorsky Region (Ulchi)
Wood, carved and painted. 44.5 × 33.3 × 7.8
Ethnography Museum, Leningrad

Platters for festive occasions. Late 19th or early 20th century
Amur Region (Nivkhi)
Carved wood. Length 30 and 35
Ethnography Museum, Leningrad

Platter for bear meat. Late 19th or early 20th century
Amur Region (Nivkhi)
Carved wood. Length 90.5
Ethnography Museum, Leningrad

Spoon for taking fish out of the pot. First half of the 20th
century
Amur Estuary, Khabarovsk Territory (Nivkhi)
Carved wood. Length 50.5
Ethnography Museum, Leningrad

Platters for bear meat. Late 19th or early 20th century
Amur Region (Nivkhi)
Carved wood. Length 96 and 89
Ethnography Museum, Leningrad

Platter for bear meat. Early 20th century
Sakhalin Region (Nivkhi)
Carved wood. Length 72
Ethnography Museum, Leningrad

Toys. Early 20th century
Amur Estuary, Primorsky Region (Nivkhi)
Carved wood. Length 14.5, 18, and 36
Ethnography Museum, Leningrad

Box for spoons and chopsticks. Early 20th century
Primorsky Region (Ulchi)
Birch bark, carved and painted, with willow wickerwork.
Height 16, diameter 11.5
Ethnography Museum, Leningrad

Small pail. 1960s
Village of Ukhta, Ulchi District, Khabarovsk Territory (Ulchi)
Birch bark, with willow wickerwork and appliqué. Height 14
Ethnography Museum, Leningrad

Dish for fish. 1976
By O. Rosugbu
Village of Bulava, Ulchi District, Khabarovsk Territory (Ulchi)
Willow wickerwork. Diameter 37
Ethnography Museum, Leningrad

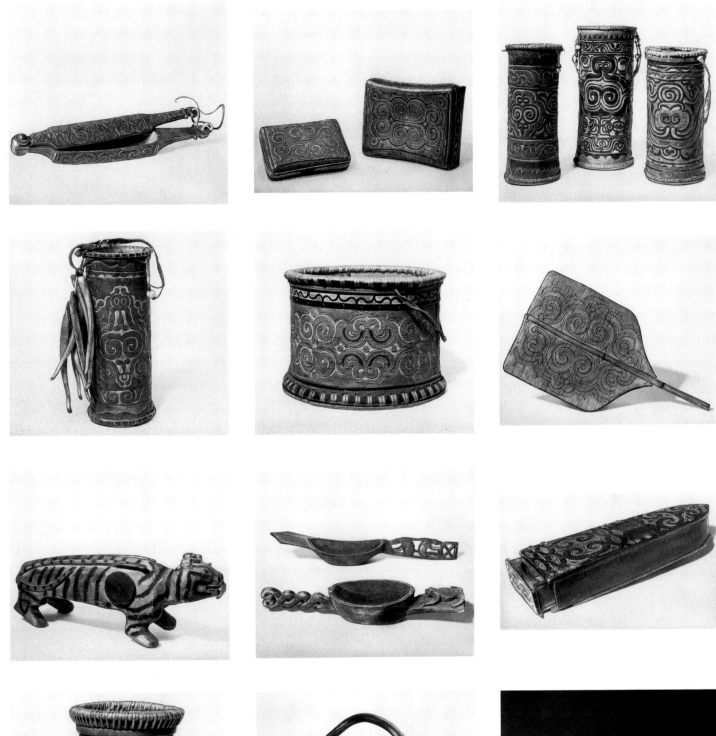

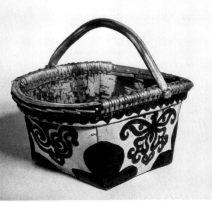

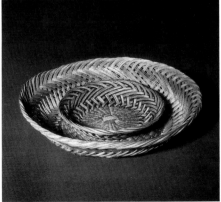

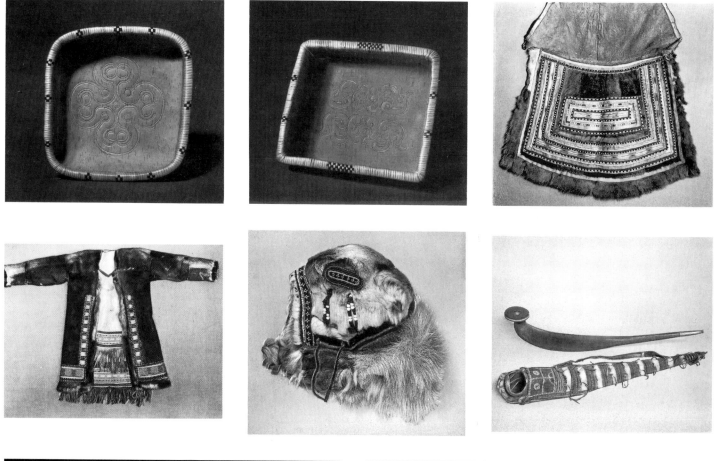

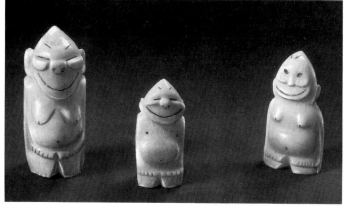

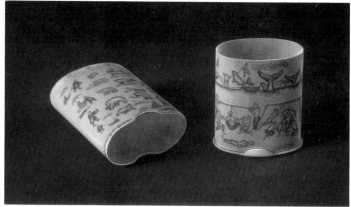

Container. 1978
By O. Rosugbu
Village of Bulava, Ulchi District, Khabarovsk Territory (Ulchi)
Stamped birch bark, with willow wickerwork. 19 × 19 × 5
Ethnography Museum, Leningrad

Woman's outer garment. 1899–1902
Yenisei Province (Evenks)
Fur mosaics, with reindeer pelt appliqué. Length 100
Museum of Anthropology and Ethnography, Leningrad

Amulets. 1930s
Village of Uelen, Chukchi National Area (Chukchis)
Carved walrus tusk. Height 7.5, 5.5, and 6.5
Museum of Folk Art, Moscow

Container. 1978
By O. Rosugbu
Village of Bulava, Ulchi District, Khabarovsk Territory (Ulchi)
Stamped birch bark, with willow wickerwork. 24 × 21 × 5.5
Ethnography Museum, Leningrad

Hat. Early 20th century
Yenisei Province (Evenks)
Fur, with beadwork, metal spangles, and pendant made of
 reindeer hooves. Height 30
Ethnography Museum, Leningrad

Detail of man's bib. 1898
Yenisei Province (Evenks)
Reindeer pelt, embroidered in reindeer hair and beads,
 trimmed with colored cloth and fur
Museum of Anthropology and Ethnography, Leningrad

Tobacco pipe and case. 1904
Anadyr Area, Primorsky Region (Chukchis)
Wood, horn, and leather embroidered in reindeer hair.
 Length 87.5
Ethnography Museum, Leningrad

Cigarette case. 1940s
Village of Uelen, Chukchi National Area (Chukchis)
Engraved ivory. Height 9
Museum of Folk Art, Moscow

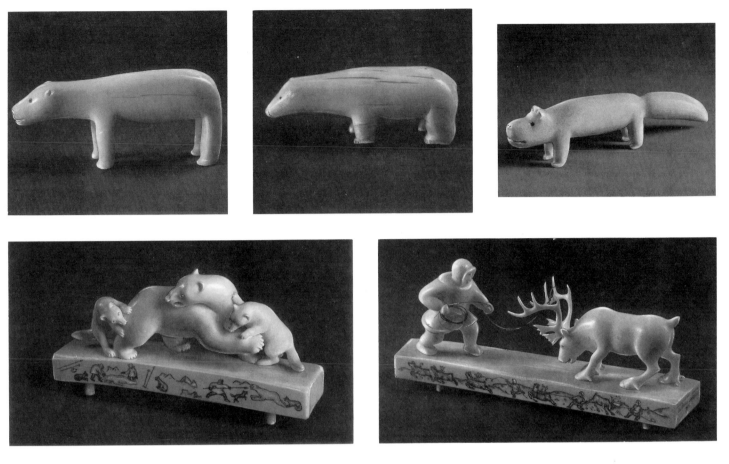

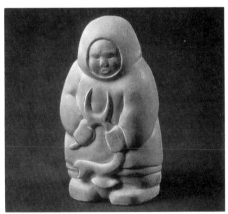

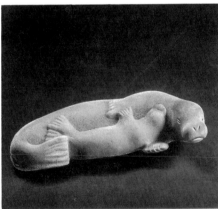

Polar Bear. 1930
Village of Uelen, Chukchi National Area (Chukchis)
Carved walrus tusk. Height 6
Museum of Folk Art, Moscow

Wolves Attacking a Bear. 1956
By Ya. Tukkai
Village of Uelen, Chukchi National Area (Chukchis)
Walrus tusk, carved and engraved. Height 8
Museum of Folk Art, Moscow

Reindeer Breeder. 1976
By V. Tegotin
Village of Uelen, Chukchi National Area (Chukchis)
Carved whalebone. Height 17
Museum of Folk Art, Moscow

Polar Bear. 1930s
Village of Uelen, Chukchi National Area (Chukchis)
Carved walrus tusk. Height 3.2
Museum of Folk Art, Moscow

Walrus. 1976
By V. Tegotin
Village of Uelen, Chukchi National Area (Chukchis)
Carved whalebone. Height 10.5
Museum of Folk Art, Moscow

Polar Fox. 1930s
Village of Uelen, Chukchi National Area (Chukchis)
Carved walrus tusk. Height 2.5
Museum of Folk Art, Moscow

Herdsman and Reindeer. 1957
By I. Seigutegin and V. Emkul
Village of Uelen, Chukchi National Area (Chukchis)
Walrus tusk, carved and engraved. Height 8.5
Museum of Folk Art, Moscow

Seal. 1976
By A. Tymnetagin
Village of Uelen, Chukchi National Area (Chukchis)
Carved whalebone. Height 4.5
Museum of Folk Art, Moscow

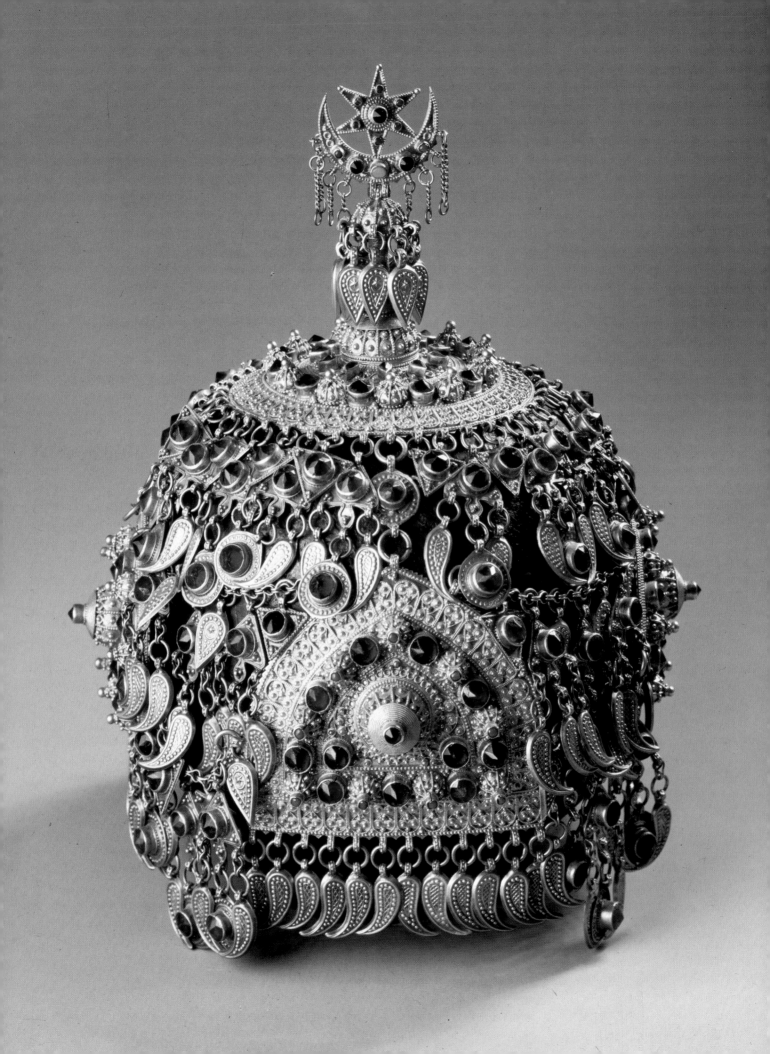

Woman's head ornament. 19th century
Village of Ili-Su, Baku Province
Silver gilt, decorated with filigree and semiprecious stones.
 Height 21
Museum of Azerbaidzhani Carpets and Handicrafts, Baku

FOLK ART
IN THE
CAUCASUS

What is loosely described as the Caucasus is a large geographical region in the southern European part of the Soviet Union between the Black Sea and the Caspian Sea. The Great Caucasus Ridge with its high snowclad peaks, which extends more than nine hundred miles from east to west, divides the area into the North Caucasus and Transcaucasia. The latter comprises the following three Republics: the Armenian SSR, the Georgian SSR, and the Azerbaidzhan SSR. The North Caucasus is part of the Russian Soviet Federated Socialist Republic and includes the following Autonomous Republics: the Daghestan ASSR, the Chechen-Ingush ASSR, the Kabardino-Balkarian ASSR, and the North Ossetian ASSR.

The Caucasus' advantageous geographical position on a route between countries of the West and the Near East, as well as its rich and varied natural resources, created favorable conditions for the emergence of ancient human civilizations in this area. As far back as the third millennium B.C., the Caucasus had regular contacts with Asia Minor, Syria, Mesopotamia, Persia, China, and India. It was in Transcaucasia that Urartu came into being, the most ancient of the then existing states within what is now the Soviet Union. Urartu reached the zenith of its development in the eighth century B.C.

The numerous ethnic groups and peoples inhabiting the Caucasus have created a rich culture, in which folk decorative arts play a leading role. Such traditional handicrafts as carpet-making, cotton-, wool-, and silk-weaving, patterned knitting, embroidery, metalwork and goldsmithing, pottery, and wood and stone carving have age-old records in the Caucasus and are still practiced on a large scale today.

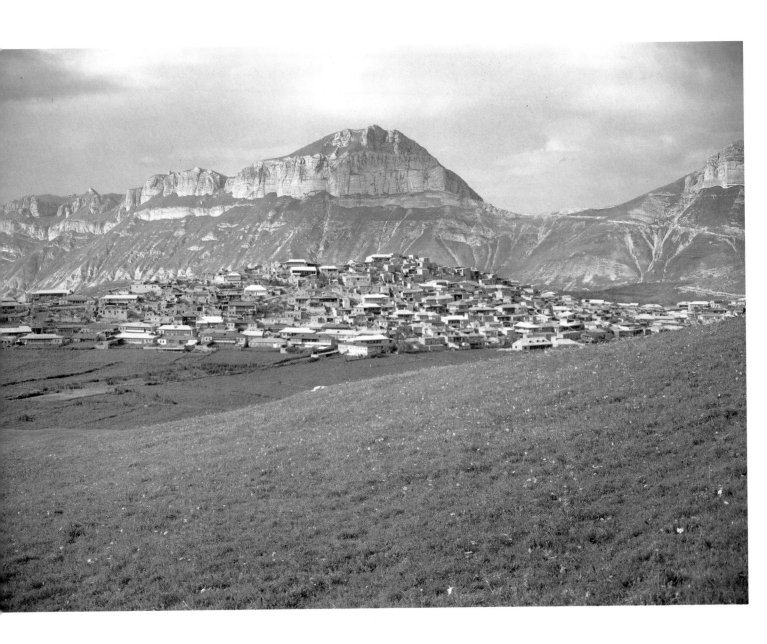

Folk Art in the
NORTH CAUCASUS

Each national community in the North Caucasus has its own highly original folk arts. Notwithstanding this diversity proceeding from the widely differing sources and roots of these arts, they show a considerable degree of stylistic and artistic similarity. This unusual connection between disparate ethnic groups, which settled in the region in different epochs, is understandable when taking into account that they are linked by a similar geographical environment as well as by their extensive cultural and economic ties from time immemorial. The most widely practiced crafts in the North Caucasus were gold-thread embroidery, carpet- and felt-making, pottery, jewelry, and stone and wood carving.

In the mountains, peasants adorned the walls of their houses and watchtowers, as well as their stone memorials, with decoration in relief. The main subjects, common to other arts in the Middle Ages as well, were real and imaginary animals. Other popular motifs were hunting and battle scenes. Crafts from this period, which have survived to this day, include gravestone carving in low relief and the production of stone utensils sparingly decorated with geometric or plant designs.

Carved gravestones are commonly found in mountain settlements in the Chechen-Ingush Autonomous Republic, Kabardino-Balkarian Autonomous Republic, and North Ossetian Autonomous Republic. The generalized figure of a Caucasian highlander is plainly recognizable in the shape of these gravestones. Certain decorative symbols, and perhaps even carved scenes from the deceased's life, gave some indication of his former occupa-

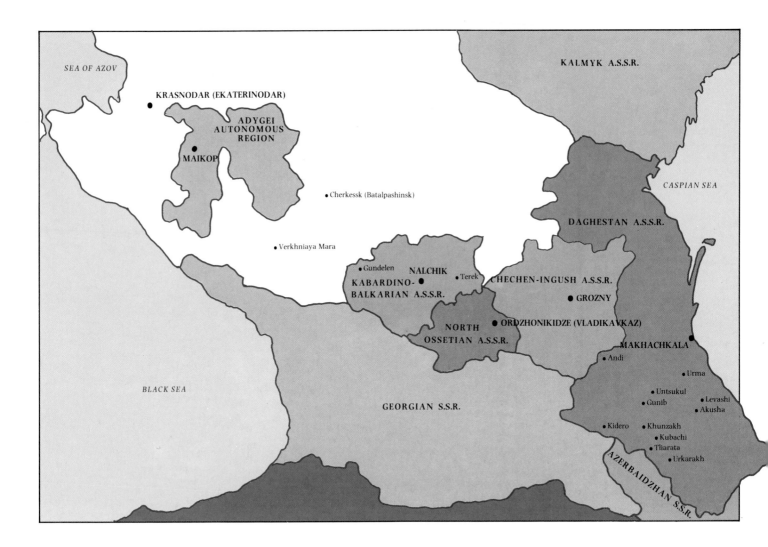

tion. Thus, a hammer and anvil in the ornamental border would show that under this gravestone a blacksmith was buried, while a pair of oxen with a man's figure behind it would suggest a tiller's grave; attributes of carpet-making would be depicted on a weaver's gravestone. Gravestones from the late nineteenth and twentieth centuries were often painted.

High standards of workmanship are evident in the wooden utensils for domestic use. Hard woods were generally used, especially to make thin-walled cups and bowls, sometimes accompanied by spoons or forks tied to them with wooden chains. The vessels' walls were often carved with *tamga*, the family crests. *Tamgas* are typical elements of ornamentation found all over the North Caucasus and their execution is calligraphically refined. Such signs are also carved on front doors in remembrance of visits, and metal *tamgas* appear on branding irons for cattle. The same motif is to be found on gravestones, in gold-thread embroidery, stamped designs on leather, appliqué, and even on patterned mats. The motif's highly genera-lized and stylized treatment is echoed by the manner in which plant designs are presented on felt rugs, which were widely used by all the people of the North Caucasus

A remarkable gift for creating beautiful objects from available materials is demonstrated by the Adygeis, Circassians, and Kabardinians, who use

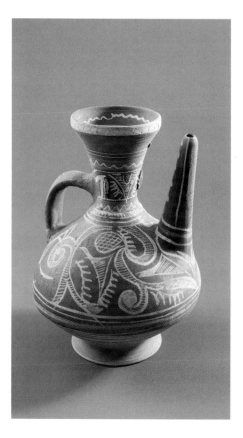

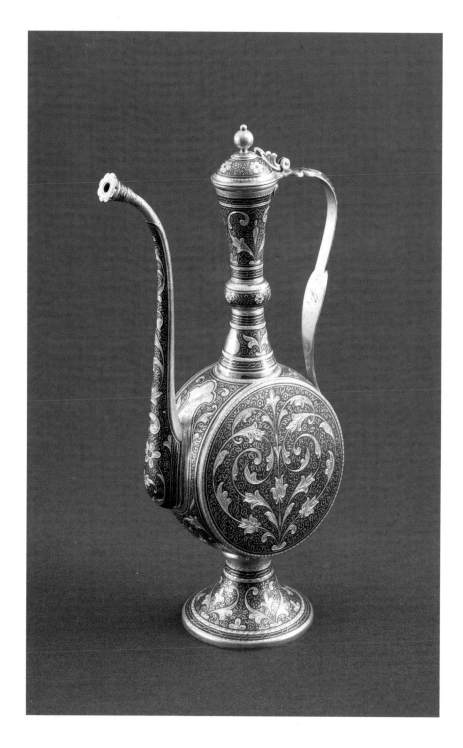

Jug. 1979
Village of Balkhar, Akusha District, Daghestan ASSR
Clay, fired, with slip decoration. Height 22
Union of Artists, Moscow

Jug. 1979
Village of Kubachi, Daghestan ASSR
Silver, engraved and nielloed. Height 35
Museum of Folk Art, Moscow

reed and straw for making patterned mats (*ardzhens*). These mats show an infinite variety of elementary geometric motifs and are still used in home decoration and in some traditional rituals.

Embroidery in gold thread is one of the most popular women's handicrafts in the North Caucasus. It chiefly decorates traditional women's costumes, riding outfits, and some articles of interior decoration. The large-scale generalized designs of Kabardinian gold embroidery can be traced back to heathen times. The formalized plant designs found in North Ossetia are on the whole more life-like. In the eighteenth and nineteenth centuries,

the gold embroidery produced in this region was already known far beyond
the confines of the Caucasus.

For most ethnic groups in the North Caucasus handicrafts were leisure-
time activities; only in some settlements lying high in the mountains, where
farming or livestock breeding were practically impossible, did they develop
into folk craft industries. This was the case with Daghestan, the eastern part
of the region, where the *aul* (village) of Kubachi, with its illustrious colony
of folk artists, has retained its importance to the present day. There is prob-
ably no other place in the world where so many crafts are practiced and
with such perfection. A Kubachi artisan's house is like a museum in which
you can see fine examples of Eastern and Western china, glass, and metal.
But the local inhabitants take particular pride in the work of their own mas-

Cushion cover insert. Late 19th or early 20th century
Village of Kubachi, Kaitag-Tabasaran Area, Daghestan Region
Linen, with satin-stitch embroidery in silk. 87 × 65
Ethnography Museum, Leningrad

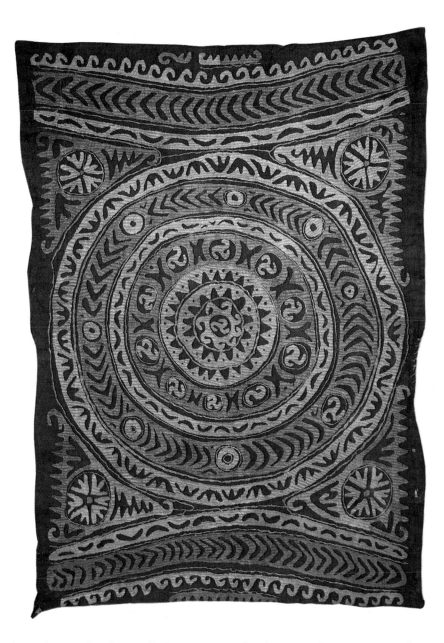

Cushion cover insert. 19th century
Daghestan Region
Linen, embroidered in silk. 50 × 20
Ethnography Museum, Leningrad

Cushion cover insert. Late 19th or early 20th century
Village of Kaitag, Kaitag-Tabasaran Area, Daghestan Region
Linen, with satin-stitch embroidery in silk. 93 × 64
Ethnography Museum, Leningrad

ters. They make thin-walled copper vessels of unique shapes: jugs, pails, dishes, and cups, chased with large geometric figures. Another popular domestic item in mountain villages was a large bronze cauldron. Only in Kubachi did they continue to produce these cauldrons until the beginning of the twentieth century. Their earliest cauldrons were decorated with embossed representations of wild animals and hunting and battle scenes reminiscent of those found in medieval stone reliefs. Later, they were superseded by plant motifs. In the nineteenth century, the cauldron walls became plain, but the traditional noble shapes were retained.

Kubachi goldsmiths and armorers were well known in the East as far back as the Middle Ages, and in the eighteenth and nineteenth centuries their work appeared on Russian, West European, and American markets.

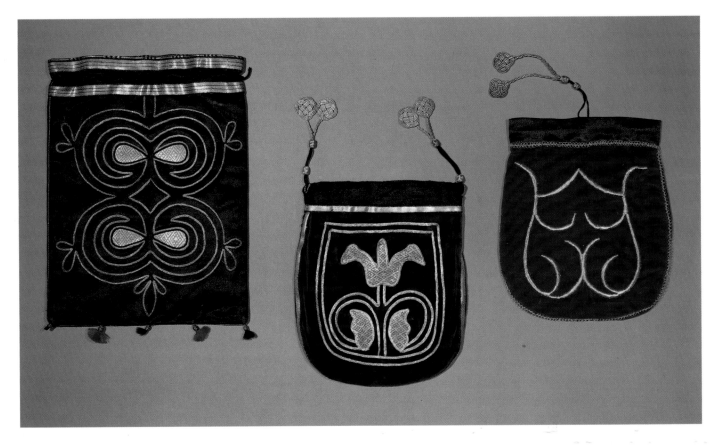

Kubachi buckles, clasps, pendants, bracelets, earrings, and other traditional adornments for women are usually decorated with an intricate combination of branch patterns nielloed on matted silver. The same motif adorns dishes and jugs made by smiths from this village. Niello, despite its deservedly high reputation as one of the specialties of Kubachi, is not the only technique employed by the local craftsmen; as willingly they use filigree combined with granulation, especially to make stunning wedding ornaments, which are set with precious or semiprecious stones and enamels.

Engraving and damascening with gold and silver were widely used to adorn the locally made side- and firearms; another special craft was the making of silver chains. The fine workmanship in all these techniques resulted from dedicated loyalty to tradition and skills passed from generation to generation.

The local people show an especially fond attachment to their pottery. There are three leading centers for folk ceramics in Daghestan: the settlements of Ispik and Sulevkent, known for their varicolored glazed earthenware, and Balkhar, where the potters have specialized in throwing slip-painted jugs of somewhat archaic shapes. The slip painting included basic geometric elements such as circles, zigzags, strokes, and dots, which organically blended with the vessel's shape. Handthrowing also plays an important role, both in shaping the pottery and in molding its decorations—a practice dating back to the time when the potter's wheel was still unknown in the mountains of Daghestan. Nowadays sculpted figurines are also produced there. Handworked clay animals and compositions depicting scenes

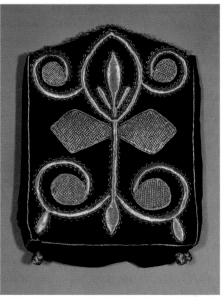

Tobacco pouches. Early 20th century
Village of Kart-Dzhurt, Batalpashinsk District, Kuban Region
Silk (left) and velvet (middle and right), embroidered in gold thread. 22 × 17, 17 × 15, and 17 × 15
Ethnography Museum, Leningrad

Sewing kit. Early 20th century
Village of Takhtamukai, Yekaterinodar District, Kuban Region
Velvet, embroidered in gold thread. 18 × 16
Ethnography Museum, Leningrad

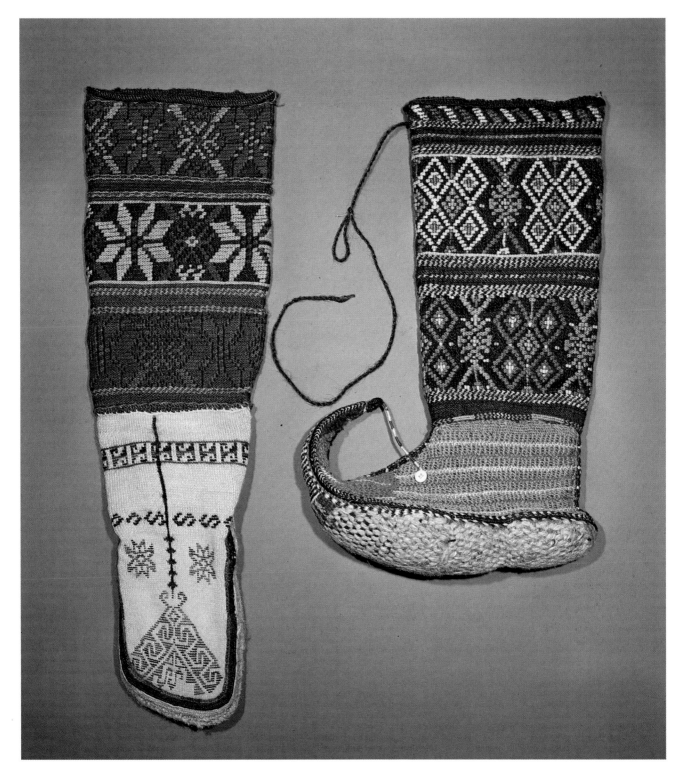

Two women's boots. Early 20th century
Village of Bokhnoda, Gunib Area, Daghestan Region; village of
 Goroda, Avar Area, Daghestan Region
Knitted wool. 28 × 40, 28 × 42
Ethnography Museum, Leningrad

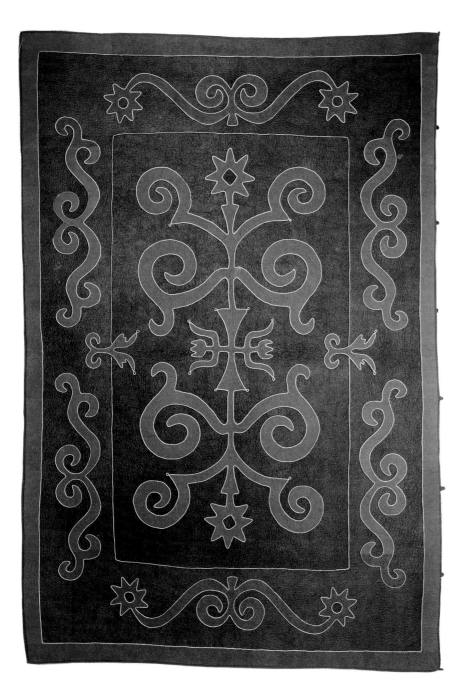

Felt. 1964
By M. Dadanayeva
Village of Dyshny-Vedeno, Chechen-Ingush ASSR
Mosaics of woollen felt. 164 × 242
Ethnography Museum, Leningrad

Felt curtain for shelf. 1950s
By G. Baidayeva
Village of Baidayevka, Kabardino-Balkarian ASSR
Wool with appliqué. 487 × 129
Ethnography Museum, Leningrad

Socks. 1950s
Daghestan ASSR
Knitted wool. Length 30 and 20
Ethnography Museum, Leningrad

from life in the mountains created by the craftswoman Zubaidat Umalayeva and her pupils are well known in Daghestan; the realism of the subjects is combined with highly skilled modelling.

Ceramics from Balkhar had always been made by women, but in Sulevkent, where unglazed pottery painted in slip was produced until the nineteenth century, the trade had been exclusively male. From then on, glazed jugs and dishes with molded or incised decoration were made. Potters from Sulevkent often left their village to work elsewhere; therefore their charac-

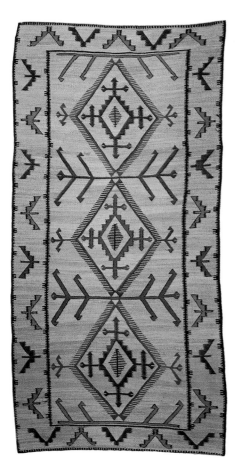

Mat. 1957
Village of Urma, Levashi District, Daghestan ASSR
Wool interwoven with stems of grass. 228 × 140
Ethnography Museum, Leningrad

Felt. 1930s
Village of Gundelen, Kabardino-Balkarian ASSR
Mosaics of woollen felt. 250 × 160
Ethnography Museum, Leningrad

teristic *chechen* wide-necked vessels were used by many national communities in the North Caucasus.

In the past, special popularity was enjoyed by ware from the village of Kala in southern Daghestan, where the industry had originated. The painted ornamentation on Kala pottery consisted mainly of stylized rosettes and trailing sprouts. Cosmogonic motifs were also sometimes included, which indicates that the potter's trade developed there at a very early date. In the fourteenth century, Kala was destroyed by its enemies and some of the inhabitants fled to the neighboring village of Ispik. The most typical Ispik ware is a large shallow dish with a broad sloping rim. Under its cherry-red glaze there is generally a design in relief, consisting of geometric elements and figures of birds and galloping horses. The older the article, the more life-like its representations.

By the nineteenth century, the designs had become more stylized, generalized, and dry, and the execution showed signs of deterioration. In the twentieth century, unglazed, unattractive utilitarian ware has replaced what used to be fine objects of folk art.

Untsukul is an important woodworking center where such objects as walking sticks, tobacco pipes, personal ornaments for women, decorative panels, and dishes are made of beautiful dark cherry-red cornel with silver and brass insets. The ornamentation consists chiefly of geometric motifs in varying arrangements. Modern Untsukul decoration may also include stylized images of birds, snow leopards, and Caucasian goats.

Carpet-making is one of Daghestan's most developed folk arts. In Daghestan's northern plains different types of flat-woven carpets and straw

mats interwoven with colored wool are made. Patterned felt rugs are also common, but the most valuable articles are knotted pile carpets, which are woven in the mountains of southern Daghestan. Such kinds of carpets as the *tabasaran*, *derbent*, *akhty*, *mikrakh*, and some others are remarkable for their very high density, which enables the weavers to decorate them with elaborately detailed designs of great complexity.

A characteristic feature of the Daghestan carpet is a medallion in bold graphic outline, placed in the center. The background is usually filled with geometric ornaments or geometrically treated plant motifs. The saturated color scheme is based on the juxtaposition of reds, blues, yellows, greens,

Tabasaran carpet. 1979
Daghestan ASSR
Pile-woven wool (synthetic dyes). 225 × 170
Union of Artists, Moscow

Carpet. 1979
Daghestan ASSR
Pile-woven wool (synthetic dyes). 200 × 130
Union of Artists, Moscow

Carpet. 1979
Daghestan ASSR
Pile-woven wool (synthetic dyes). 250 × 130
Union of Artists, Moscow

and pale blues. The *sumakh*, a special type of flat-woven carpet, is similar to pile carpets, but it is smooth-faced and has a soft layer of loose weft threads on the back, also forming a pattern. *Sumakhs* are remarkably strong and for this reason are ideal for use in the daily life of mountain dwellers. Carpet-weaving has remained to this day one of Daghestan's leading folk arts.

The arts and crafts of the North Caucasus are deeply entrenched in the people's life and national culture. It is on this basis that their age-old artistic traditions are maintained and enriched.

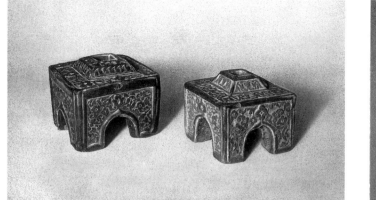

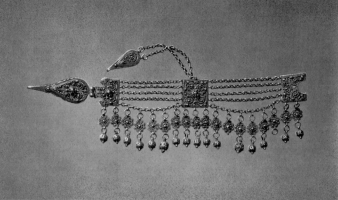

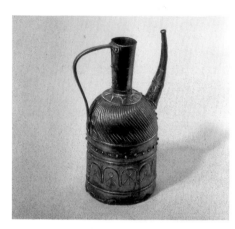

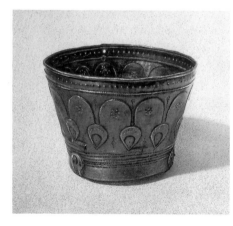

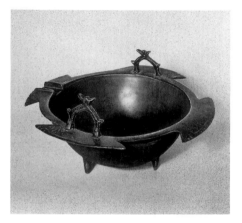

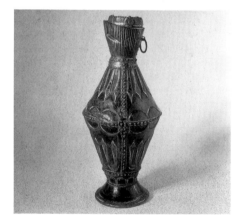

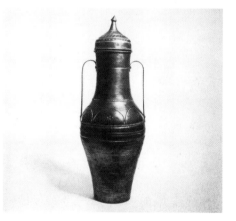

Stands for distaffs. Late 19th or early 20th century
Village of Kubachi, Kaitag-Tabasaran Area, Daghestan Region
Carved stone. 9 × 14 × 14 and 11.4 × 15.5 × 15.5
Ethnography Museum, Leningrad

Jug. Late 19th or early 20th century
Village of Kubachi, Kaitag-Tabasaran Area, Daghestan Region
Copper, chased, stamped, and engraved. Height 31.5,
 diameter 5.5
Ethnography Museum, Leningrad

Jug. Late 19th or early 20th century
Village of Kubachi, Kaitag-Tabasaran Area, Daghestan Region
Copper, chased and stamped. Height 62, diameter 14
Ethnography Museum, Leningrad

Dish. Late 19th century
Andiysky Area, Daghestan Region
Copper, with chased and stamped designs. Diameter 66
Ethnography Museum, Leningrad

Vessel for wedding gifts. Late 19th or early 20th century
Village of Kubachi, Kaitag-Tabasaran Area, Daghestan Region
Chased copper. Height 20, diameter 29
Ethnography Museum, Leningrad

Ornament for woman's headdress. 1852
Village of Bokhnoda, Gunib Area, Daghestan Region
Silver, with filigree, stamped design, and granulation.
 Length 36.2
Ethnography Museum, Leningrad

Cauldron. 11th or 12th century
By Abubekr, son of Akhmer Mervezi
Village of Kubachi, Daghestan
Cast copper. Height 19, diameter 54
Ethnography Museum, Leningrad

Jug for wedding ceremonies. Late 19th or early 20th century
Daghestan Region
Copper, chased and stamped. Height 76, diameter 15.5
Ethnography Museum, Leningrad

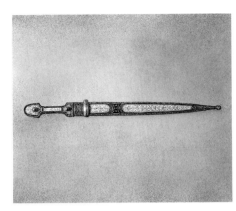

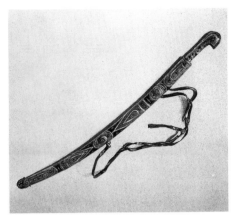

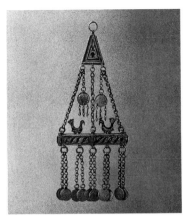

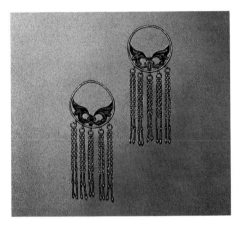

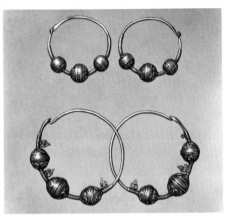

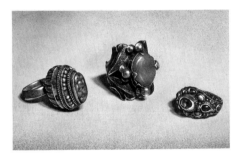

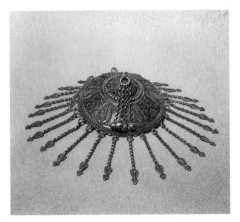

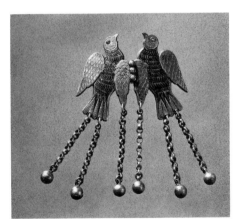

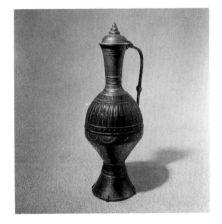

Dagger with scabbard. Late 19th or early 20th century
Village of Kazikumukh, Daghestan Region
Steel, damascened in gold, with enamel and ivory. 48 × 4
Ethnography Museum, Leningrad

Temple pendants. Late 19th century
Village of Balkhar, Kazikumukh Area, Daghestan Region
Silver, engraved and nielloed, with corals. Length 12,
 diameter 5 (each)
Ethnography Museum, Leningrad

Woman's head decoration. Late 19th or early 20th century
Daghestan Region
Silver, with niello, granulation, and filigree. Diameter 10.5
Ethnography Museum, Leningrad

Saber with sheath. Late 19th or early 20th century
Village of Kubachi, Kaitag-Tabasaran Area, Daghestan Region
Steel (blade); silver, decorated with niello, engraving, filigree,
 and enamel (leather sword belt). Length 110
Ethnography Museum, Leningrad

Temple pendants. Late 19th or early 20th century
Village of Kubachi, Kaitag-Tabasaran Area, Daghestan
 Region; village of Karata, Andiysky Area, Daghestan Region
Silver, with filigree and niello. Diameter 6 and 8
Ethnography Museum, Leningrad

Clasp. Late 19th or early 20th century
Daghestan Region
Silver, engraved and nielloed. Length (with pendants) 10
Ethnography Museum, Leningrad

Ornament for woman's dress. Late 19th century
Village of Kubachi, Kaitag-Tabasaran Area, Daghestan Region
Silver, engraved and nielloed, with granulation and corals.
 20.5 × 8.5
Ethnography Museum, Leningrad

Finger rings. Late 19th or early 20th century
Village of Kubachi, Kaitag-Tabasaran Area, Daghestan Region
Silver, decorated with granulation, niello, and filigree, and set
 with pearls and glass (left), glass (middle), paste and
 turquoise (right). Diameter 2, 2.5, and 2.2
Ethnography Museum, Leningrad

Jug. Early 20th century
Chechen-Ingushia
Chased copper. Height 78, diameter 20
Ethnography Museum, Leningrad

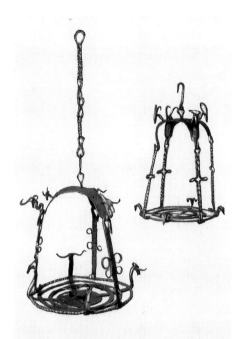

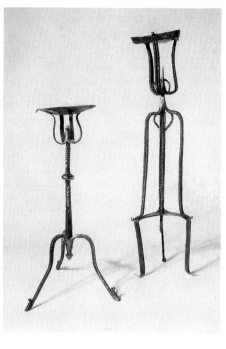

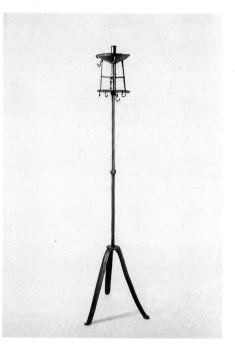

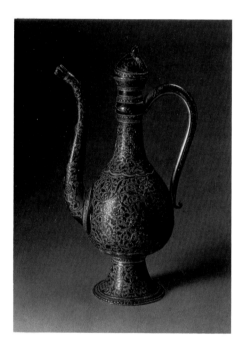

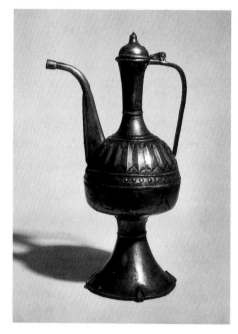

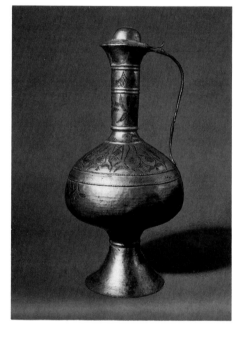

Hanging fixture with holders for candlewood. 1920s and early
 20th century
North Ossetia, Vladikavkaz Area, Terek Region
Hammered iron. Height 46 and 44; diameter 43 and 32
Ethnography Museum, Leningrad

Ewer. 1930s
Village of Kubachi, Daghestan ASSR
Silver, engraved and nielloed
Museum of Folk Art, Moscow

Standing holders for candlewood. Early 20th century
Village of Tliarata, Gunib Area, Daghestan Region; village of
 Karata, Andiysky Area, Daghestan Region
Hammered iron. Height 47 and 65
Ethnography Museum, Leningrad

Wash pitcher. 1930s
Chechen-Ingush ASSR
Copper, tin-plated, chased, and stamped. Height 40,
 diameter 14.8
Ethnography Museum, Leningrad

Candlestand. Early 20th century
Nalchik Area, Terek Region
Hammered iron. Height 117
Ethnography Museum, Leningrad

Jug. 1939
Village of Gotsatl, Khunzakh District, Daghestan ASSR
Copper, tin-plated, chased, and engraved. Height 58,
 diameter 19
Ethnography Museum, Leningrad

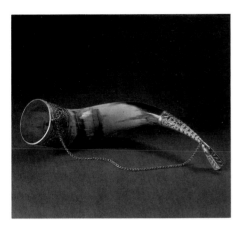

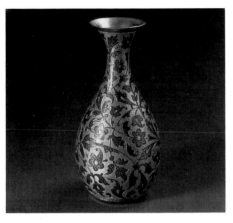

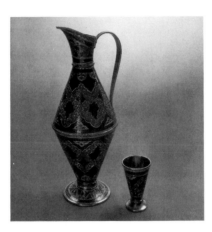

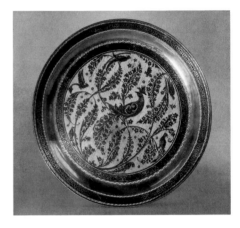

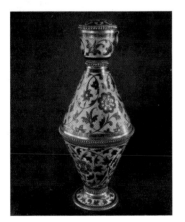

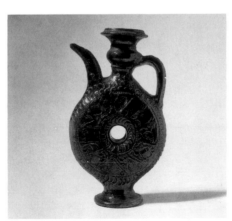

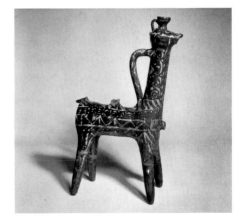

Drinking horn. 1950s–60s
Daghestan ASSR
Mount of silver, engraved and nielloed. Length 20
Museum of Folk Art, Moscow

Vase. 1960s
By R. Alikhanov
Village of Kubachi, Daghestan ASSR
Silver, engraved and nielloed. Height 12
Museum of Folk Art, Moscow

Covered vessel. 1978
By G. Magomedov
Village of Kubachi, Daghestan ASSR
Silver, engraved and nielloed. Height 18
Union of Artists, Moscow

Jewel casket. 1960
By M. Dzhamalnurikov
Village of Gotsatl, Khunzakh District, Daghestan ASSR
Silver, engraved and nielloed. 16 × 7 × 3
Museum of Folk Art, Moscow

Jug and beaker. 1976
By R. Alikhanov
Village of Kubachi, Daghestan ASSR
Silver, gilt, engraved, and nielloed. Height 23 (jug) and 7.5
 (beaker)
Union of Artists, Moscow

Pitcher. Late 19th or early 20th century
Village of Sulevkent, Kaitag-Tabasaran Area, Daghestan
 Region
Clay, fired, stamped, and glazed. Height 28, diameter 8.5
Ethnography Museum, Leningrad

Vase. 1960s
By R. Alikhanov
Village of Kubachi, Daghestan ASSR
Silver, engraved and nielloed. Height 20
Museum of Folk Art, Moscow

Decorative plate. 1977
By G. Magomedov
Village of Kubachi, Daghestan ASSR
Silver, engraved and nielloed. Diameter 19
Union of Artists, Moscow

Candle holder. Late 19th or early 20th century
Village of Balkhar, Kazikumukh Area, Daghestan Region
Clay, fired, with slip decoration and glaze. Height 37
Ethnography Museum, Leningrad

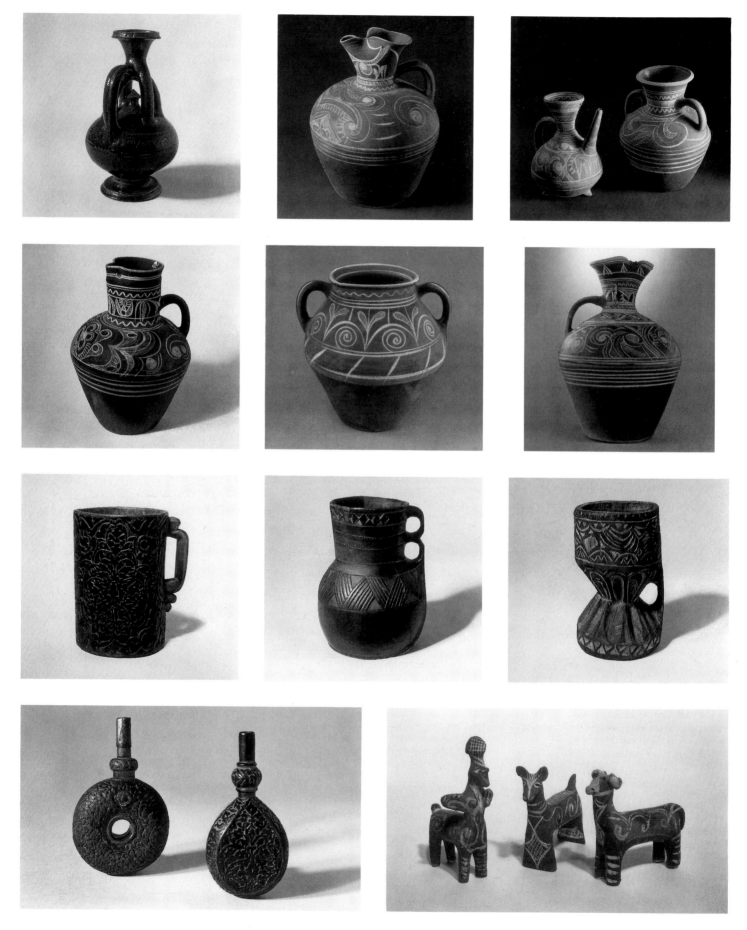

Jug. Early 20th century
Village of Urkarakh, Daghestan Region
Clay, fired, stamped, and glazed. Height 27, diameter 8
Ethnography Museum, Leningrad

Jug. 1950s
Village of Balkhar, Akusha District, Daghestan ASSR
Clay, fired, with slip decoration. Height 24, diameter 15
Museum of Folk Art, Moscow

Jug and butter churn. 1950s
Village of Balkhar, Akusha District, Daghestan ASSR
Clay, fired, with slip decoration. Height 25 and 30;
 diameter 15 and 20
Museum of Folk Art, Moscow

Jug. 1960
By P. Kadiyeva
Village of Balkhar, Akusha District, Daghestan ASSR
Clay, fired, with slip decoration. Height 29, diameter 11.5
Ethnography Museum, Leningrad

Pot. 1976
Village of Balkhar, Akusha District, Daghestan ASSR
Clay, fired, with slip decoration. Height 26
Union of Artists, Moscow

Jug. 1978
Village of Balkhar, Akusha District, Daghestan ASSR
Clay, fired, with slip decoration. Height 35
Union of Artists, Moscow

Measure for meal. Late 19th or early 20th century
Village of Kubachi, Kaitag-Tabasaran Area, Daghestan Region
Carved wood. Height 24, diameter 19
Ethnography Museum, Leningrad

Jug. Late 19th or early 20th century
Village of Karata, Andiysky Area, Daghestan Region
Carved wood. Height 23.5, diameter 15
Ethnography Museum, Leningrad

Mortar. Late 19th or early 20th century
Village of Karata, Andiysky Area, Daghestan Region
Carved wood. Height 19, diameter 12
Ethnography Museum, Leningrad

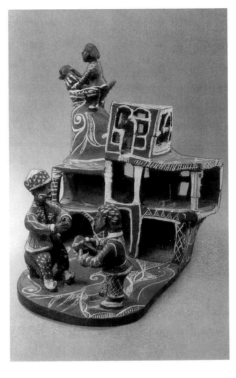

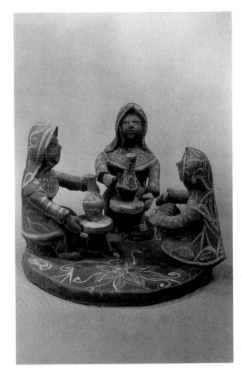

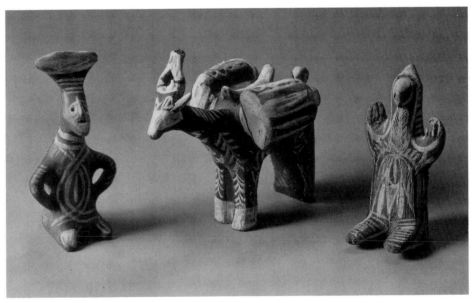

Powder flasks. Late 19th century
Village of Kubachi, Kaitag-Tabasaran Area, Daghestan Region
Carved wood. Height 16 and 17
Ethnography Museum, Leningrad

Toys. 1965 and 1970s
By S. Kurbanova and Z. Umalayeva
Village of Balkhar, Akusha District, Daghestan ASSR
Handworked clay, fired, with slip decoration
Ethnography Museum, Leningrad

Sculptural group: *Life in Balkhar.* 1977
By Z. Umalayeva
Village of Balkhar, Akusha District, Daghestan ASSR
Handworked clay, fired, with slip decoration
Union of Artists, Moscow

Toys. 1950s
By Z. Umalayeva
Village of Balkhar, Akusha District, Daghestan ASSR
Handworked clay, fired, with slip decoration. Height 9, 9,
 and 8
Museum of Folk Art, Moscow

Sculptural group: *Balkhar Women at Work.* 1979
By Z. Umalayeva
Village of Balkhar, Akusha District, Daghestan ASSR
Handworked clay, with slip decoration
Union of Artists, Moscow

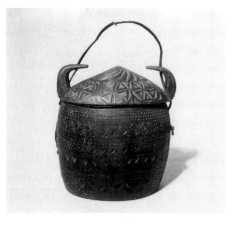

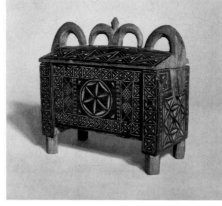

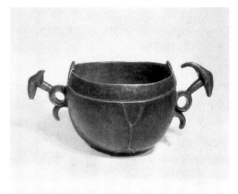

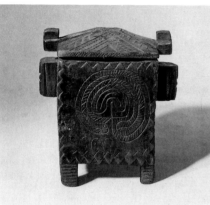

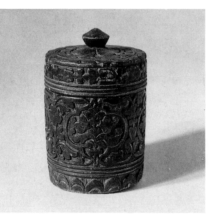

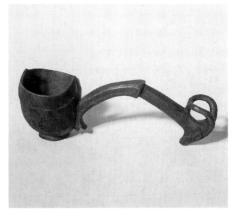

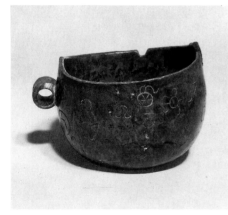

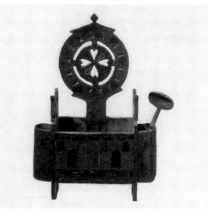

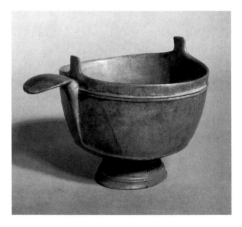

Container for meal. Late 19th or early 20th century
Village of Kidero, Andiysky Area, Daghestan Region
Carved wood. Height 26, diameter 21.5
Ethnography Museum, Leningrad

Salt-box. Early 20th century
Village of Kala, Daghestan Region
Carved wood. 26 × 17 × 17
Ethnography Museum, Leningrad

Cup with family crests. Early 20th century
Nalchik Area, Terek Region
Carved wood. Height 14, diameter 20
Ethnography Museum, Leningrad

Salt-box. Late 19th or early 20th century
Village of Karata, Andiysky Area, Daghestan Region
Carved wood. 20.5 × 12 × 14
Ethnography Museum, Leningrad

Box. Early 20th century
Village of Kubachi, Kaitag-Tabasaran Area, Daghestan Region
Carved wood. Height 8.5, diameter 7
Ethnography Museum, Leningrad

Case for cutlery. 1920s–30s
Village of Balkhar, Akusha District, Daghestan ASSR
Carved wood. 33 × 40 × 11
Ethnography Museum, Leningrad

Finger bowl. Early 20th century
Ossetia
Carved wood. Height 17, diameter 21
Ethnography Museum, Leningrad

Dipper. Early 20th century
Nalchik Area, Terek Region
Carved wood. Length 26
Ethnography Museum, Leningrad

Cup. 1930s
Kabardino-Balkarian ASSR
Carved wood. Height 14, diameter 17
Ethnography Museum, Leningrad

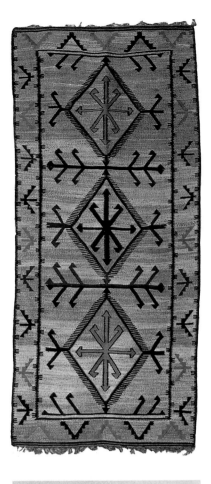

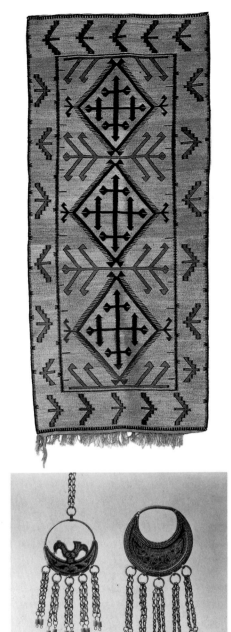

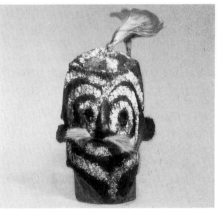

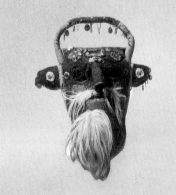

Insert. 19th century
Daghestan Region
Linen, embroidered in silk. 104 × 51
Ethnography Museum, Leningrad

Mask for wedding pantomime. 1920s
Village of Kubachi, Kaitag-Tabasaran Area, Daghestan Region
Painted felt and horsehair. 36 × 30
Ethnography Museum, Leningrad

Mat. 1978
Daghestan ASSR
Plaited stems of grass and wool. 220 × 100
Union of Artists, Moscow

Mask. 1950s
Village of Verkhniaya Mara, Karachaev-Cherkess Autonomous
 Region
Felt and wool, with pieces of cloth and coins. 55 × 33
Ethnography Museum, Leningrad

Mat. 1978
Daghestan ASSR
Plaited stems of grass and wool. 230 × 100
Union of Artists, Moscow

Temple pendants. Late 19th or early 20th century
Village of Karata, Kaitag-Tabasaran Area, Daghestan Region
Silver, with fine filigree. Length 12 and 15
Ethnography Museum, Leningrad

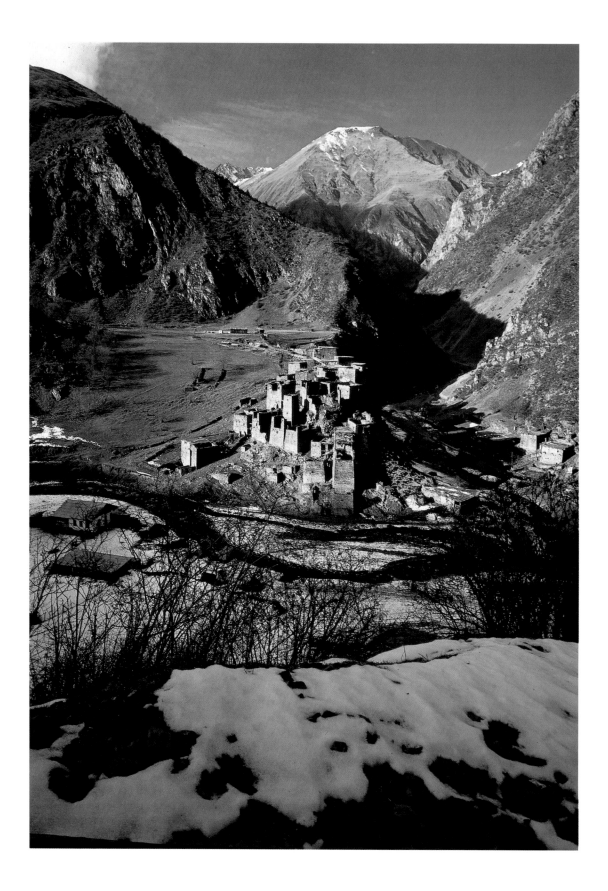

Folk Art in
GEORGIA

Georgia is a land where agriculture, viticulture, livestock breeding, and highly developed handicrafts have coexisted from a very early date. Georgian arts flourished in the Middle Ages, but the formation of a Georgian national culture and art must have gone back to far earlier times, for the medieval stage of their development was very high. We know this from the beautiful stone cathedrals and churches with carved decorations and frescoes, the excellent local chased work in high relief, the fine cloisonné enamelling comparable to that of Byzantine workmanship, and the splendid jewelry and weaving.

For all their common stylistic bases, Georgian folk arts demonstrate a considerable regional variety. Thus, traditional crafts in the mountainous regions of Svanetia and Khevsuretia differ from those practiced on the plains of Kakhetia or in the coastal areas of Abkhazia.

In Georgia, as in many other republics, pottery is an exceptionally old art. In some parts of Georgia it was known as far back as the Neolithic Age, spreading later throughout the country.

Excavations at Trialeti have yielded pottery with slip-painted and molded decorations from the middle of the second millennium B.C. Elegant proportions characterize Georgian terracotta vessels made in the early centuries A.D. In medieval times, ceramic wares became more diversified and glazed or painted decorations more popular.

Georgian pottery conforms to certain age-old conventions based on utilitarian considerations: the huge vessels are made expressly for the stor-

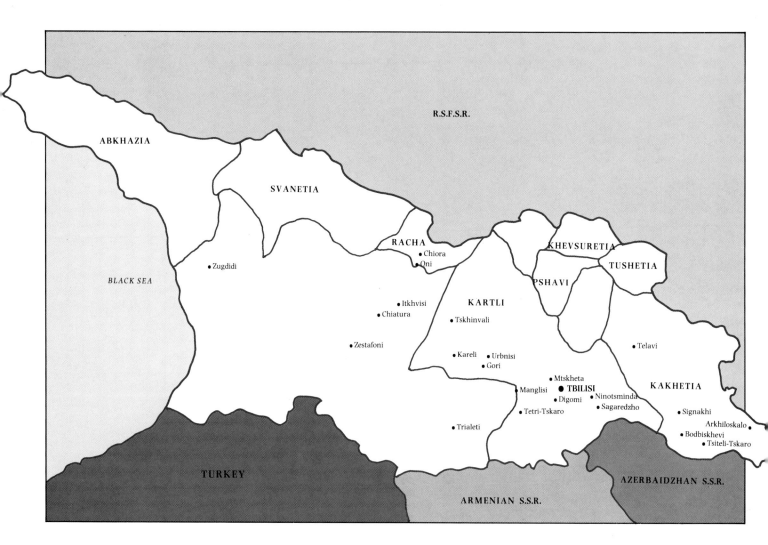

age of wine, slim-necked jugs are used for water or wine, pottery jars for keeping cheese, and pitchers for milk and young wine. In each center earthenware had its local peculiarities. Thus, potters from Telavi specialized in throwing capacious jugs, with short narrow necks, of light-colored clay, which they decorated with stripes or splashes of dark red slip, whereas in the village of Shrosha (western Georgia), clays with considerable mica content were widely used as lusters. In addition, figured handworked vessels were made here, including the traditional *marani* type with colored slip or painted decorations.

Toward the end of the nineteenth century the production of earthenware by folk potters declined, but an energetic revival is occurring at present. In the late 1950s, ceramic artists in Tbilisi began actively to draw from the traditions of ancient and more recent folk pottery, thus setting the trend for most of the present-day work in the national folk style.

The Caucasus is known for its ancient traditions of metal smelting; archaeological excavations have yielded evidence from the remote past of highly advanced copper-, bronze-, silver-, and goldsmithing. The subjects chased on some vessels from Trialeti (second millennium B.C.) reflect the religious beliefs of ancient Georgian tribes.

Jug for wine. Late 19th century
Village of Shrosha, Tiflis Province
Red clay, fired. Height 35.5
The Dzhanashia Museum of Georgia, Tbilisi

Jugs and bowl. Late 19th century
Village of Shrosha, Tiflis Province
Clay, fired and glazed. Height 12.5, 11.5, 5.5, and 12.5
The Dzhanashia Museum of Georgia, Tbilisi

***Marani*: vessel for wine.** 19th century
Kakhetia
Clay, fired and glazed. Height 30
The Dzhanashia Museum of Georgia, Tbilisi

Jug. 19th century
Village of Ninotsminda, Tiflis Province
Clay, fired and glazed, with slip decoration. Height 45.5
The Dzhanashia Museum of Georgia, Tbilisi

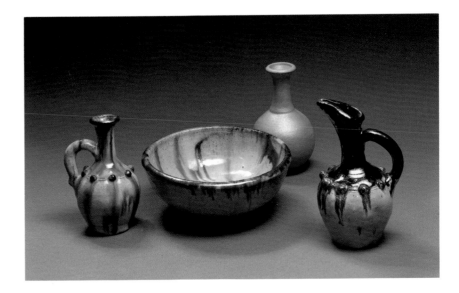

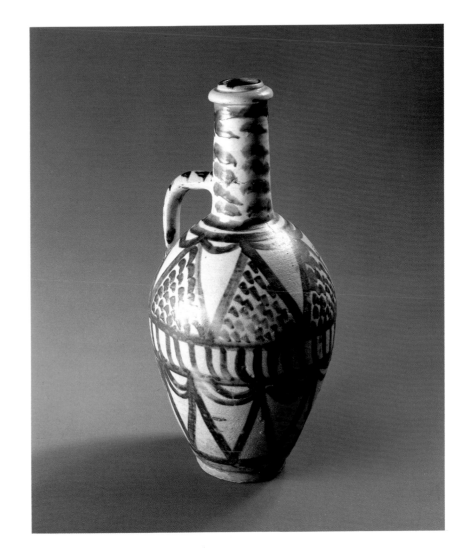

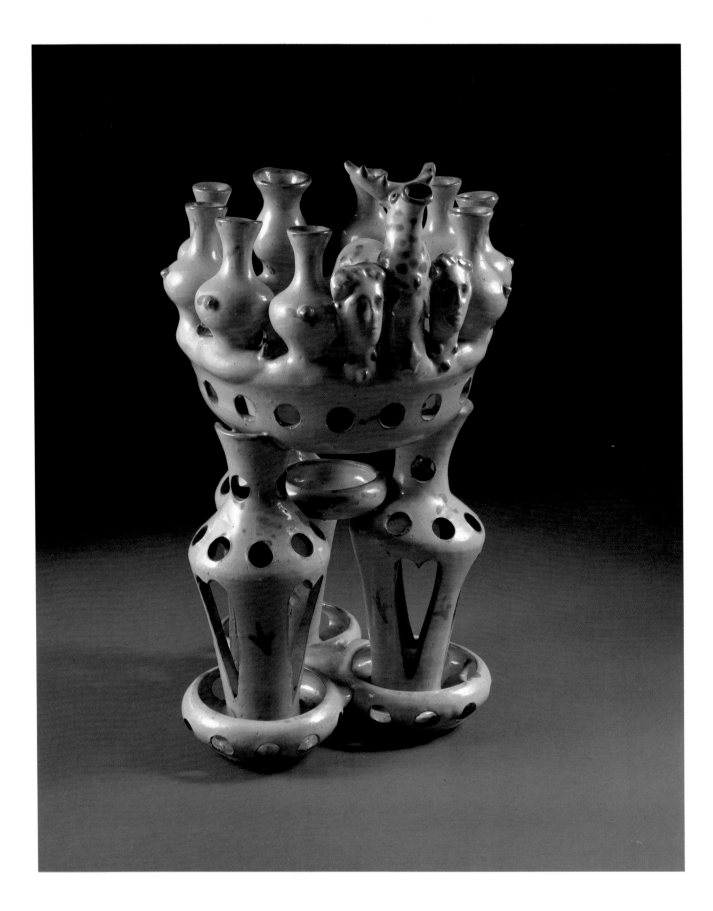

Marani: **vessel for wine.** 1949
By I. Kbilashvili
Gori
Clay, fired and glazed. Height 35.5
Museum of Folk and Applied Arts, Tbilisi

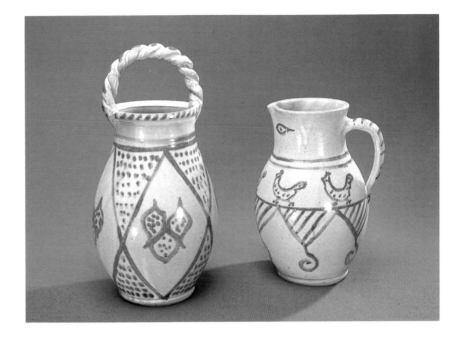

Jars for oil and milk. 1978
By I. Tatulashvili
Gori
Clay, fired and painted underglaze. Height 28 and 20
Union of Artists, Moscow

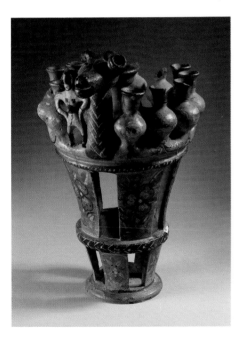

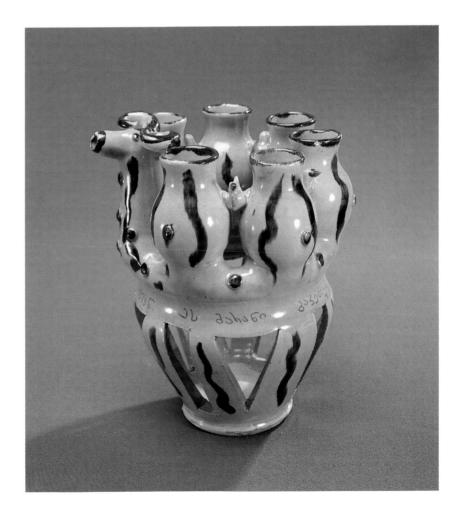

Marani: **vessel for wine.** 1920s–30s
Tbilisi
Clay, fired and painted. Height 35
Museum of Folk and Applied Arts, Tbilisi

Marani: **vessel for wine.** 1970
By Sh. Takniashvili
Gori
Clay, fired and painted underglaze. Height 25
Union of Artists, Moscow

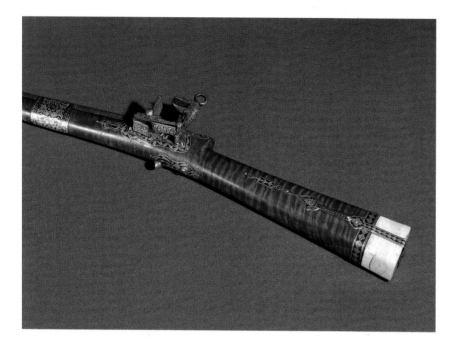

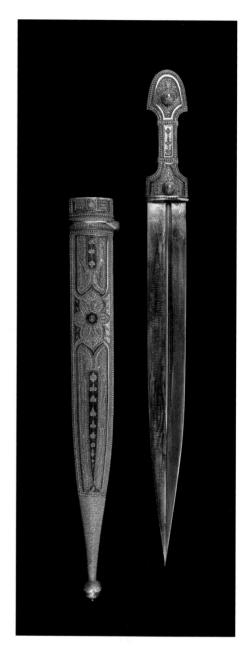

The ancient land of Kolkhida has provided some artifacts from the Iron Age, among which the cast figures of animals and human beings decorating ritual objects and personal ornaments are particularly noteworthy.

The venerable traditions of metalwork and jewelry-making were further developed in feudal times, primarily in ecclesiastic objects. In the decoration of arms and armors, a distinctive style emerged, in which chasing, niello, engraving, damascening, and sometimes gilding were standard techniques. In side- and small-arms, the decorative effect is due to their ornamental austerity and to the sharp contrast between the silver details and the black sheath.

Traces of ancient traditions can also be seen in Georgian wood carving, weaving, and national costumes. Particularly interesting in this respect are the rustic furniture and domestic utensils made in rural mountainous districts. There they have long benches, up to four meters in length, with comfortable backs, low stools, and sometimes an armchair decorated with carving, which distinguishes it as the most important piece of furniture in the room. The carved designs are mainly geometric and consist of rosettes and spirals, which had a symbolic significance in heathen times. The wood's natural color and texture, enhanced by the free yet austere carving, are crucial to the overall appearance of the furniture and utensils, the shapes of which seem to derive from the stern stone exteriors of the mountain dwellings.

Pileless and felt carpet-making, as well as wool-weaving, knitting, and embroidery, were widely practiced in Georgia, and particularly well developed in Khevsuretia. The Khevsurs made their men's and women's clothes

Rifle. 1800–1830
Steel, with gold inlay (lock and barrel); silver gilt, chiselled and nielloed (decoration)
The Hermitage, Leningrad

Dagger and scabbard. 1915
By Z. Pantsulia
Zugdidi
Steel (blade); silver, with filigree, niello, and engraving.
 Length 61
Museum of Folk and Applied Arts, Tbilisi

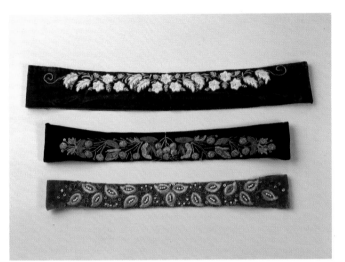

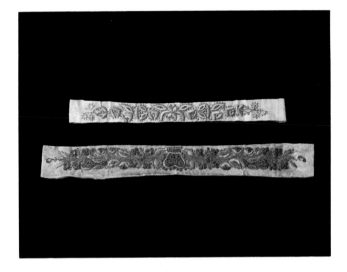

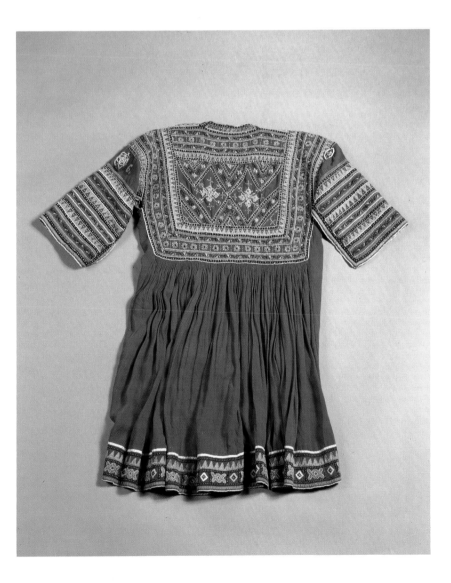

Headbands. Late 19th century
Tbilisi
Velvet, with satin-stitch embroidery in silk, and with couched
 silverwork and beads (bottom). 5 × 47.5, 5.5 × 46.5, and
 4.5 × 45
Museum of Folk and Applied Arts, Tbilisi

Headbands. Late 19th century
Tbilisi
Velvet, with satin-stitch embroidery in silk, and with couched
 silverwork and beads. 4 × 52 and 6 × 46.5
Museum of Folk and Applied Arts, Tbilisi

Woman's blouse. 19th century
Khevsuretia
Sateen, with embroidery in cross stitch and appliqué
 decoration. 81 × 44
Museum of Folk and Applied Arts, Tbilisi

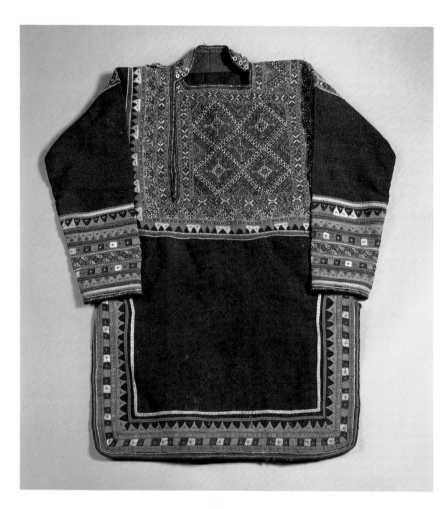

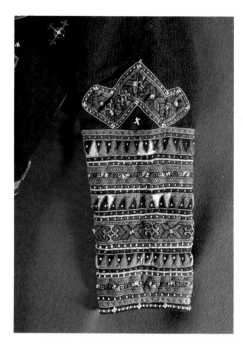

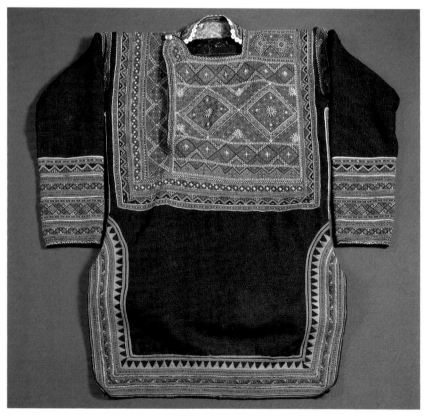

Man's shirt. 19th century
Khevsuretia
Wool, with cross-stitch embroidery and appliqué decoration.
93 × 53
Museum of Folk and Applied Arts, Tbilisi

Man's shirt. Early 20th century
Khevsuretia
Wool, with embroidery and appliqué decoration. 90 × 58
The Dzhanashia Museum of Georgia, Tbilisi

Sleeve of a man's shirt. 20th century
Khevsuretia
Wool, with embroidery and appliqué decoration. 86 × 58
The Dzhanashia Museum of Georgia, Tbilisi

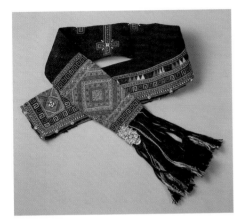

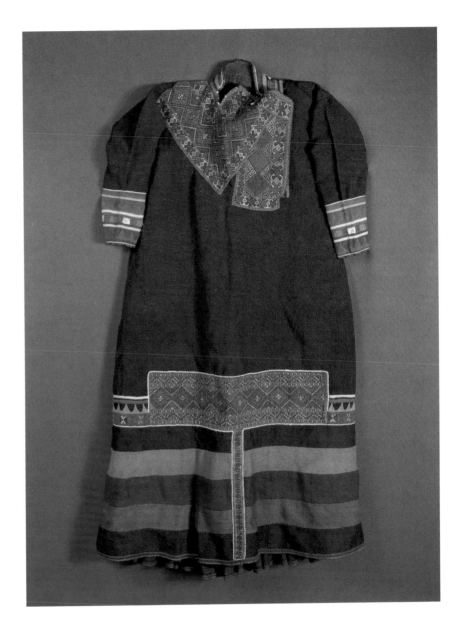

Woman's headband. Early 20th century
By B. Ochiauri
Khevsuretia
Wool, with cross-stitch embroidery, beadwork, and appliqué.
 130 × 22
Museum of Folk and Applied Arts, Tbilisi

Woman's dress. 20th century
Khevsuretia
Wool, with embroidery and appliqué decoration. 140 × 58
The Dzhanashia Museum of Georgia, Tbilisi

with dense woollen cloth. Their costume, consisting of a long loose under-dress and a shorter shirt gathered at the waist, was generously decorated with embroidery. The front of the underdress, embroidered with small densely stitched designs, showed above the shirt's low neckline. The cuffs, hem, and button-down front of this overgarment were trimmed with similar needlework designs, as were the headdress with a patterned scarf and the high knit boots, which all together formed a beautiful ensemble. The clear-cut composition of embroidered designs is based on strips, squares, and crosses. Despite this decoration's austerity, it allows for infinite variations, which were brilliantly realized by the Khevsur women, for whom making clothes

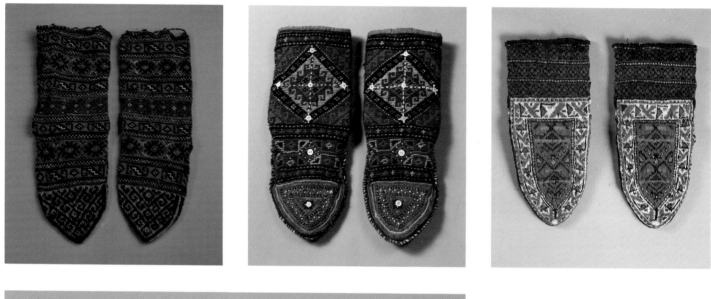

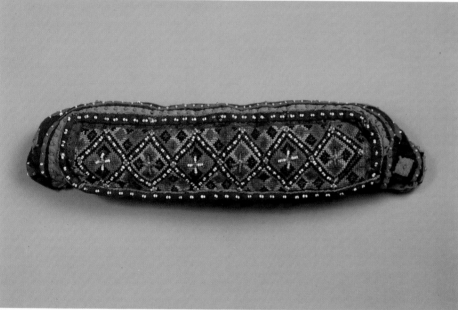

Man's socks. 20th century
Tsiteli-Tskaro
Knitted wool. Length 22
The Dzhanashia Museum of Georgia, Tbilisi

Man's socks. Late 19th or early 20th century
Khevsuretia
Knitted wool, with beadwork. Length 25
The Dzhanashia Museum of Georgia, Tbilisi

Man's socks. Early 20th century
Khevsuretia
Knitted wool. Length 20
The Dzhanashia Museum of Georgia, Tbilisi

Woman's headdress. 1969
By M. Tsiklauri
Khevsuretia
Cloth, with cross-stitch embroidery and beads. 28 × 7
Museum of Folk and Applied Arts, Tbilisi

was a handicraft familiar from childhood. They paid particular attention to men's costumes, the embroidery of which was a matter of prestige for the needlewomen. Originally they embroidered men's shirt fronts separately, but in the course of time they began to embroider the pattern in woollen thread right onto the garment and to include white beads and buttons.

Khevsur knit footwear—thick-soled high boots which are still produced there—contains some of the same elements of ornamental austerity and beautiful color as found in their costumes. Similar boots were worn in other parts of Georgia, differing in shape and design according to region. Quite

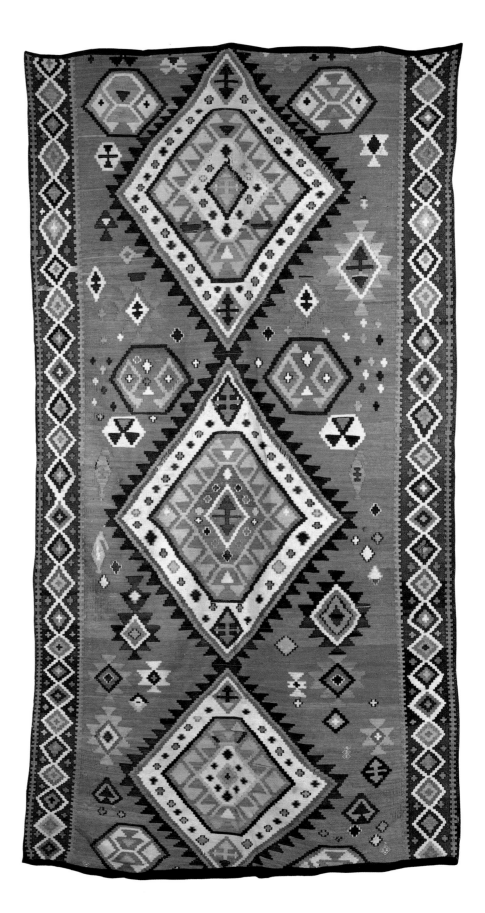

Palas. First half of the 19th century
Tushetia
Flat-woven wool. 200 × 140
Museum of Folk and Applied Arts, Tbilisi

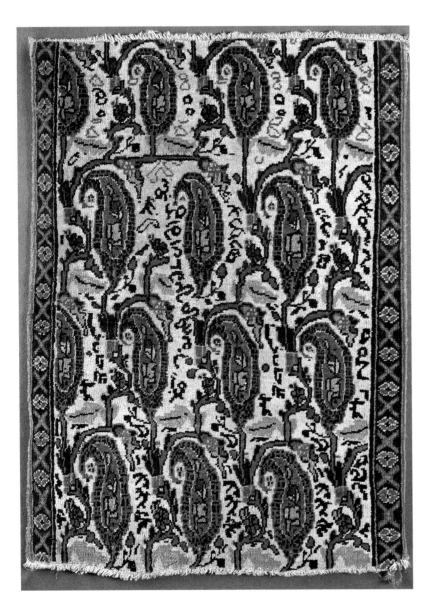

often their decoration echoed the patterns of the *palases* produced in those days in the same localities. Tushetia was one of the regions known for their production. The earlier *palases* made there are characterized by somewhat severe geometric ornamentation, while more recent ones have brighter colors and more diversified decorative motifs, including plants and representations of deer. These later innovations reflected urban tastes and were treated with special freshness and originality by women weavers from the village of Alvani.

In recent years quite remarkable felt rugs have also been produced in Tushetia. They are particularly notable for their attractive designs and bold color combinations.

The great attention paid to folk art in Georgia has stimulated and en-

Carpet. 1912
Kartli
Pile-woven cotton and wool. 57 × 79
The Dzhanashia Museum of Georgia, Tbilisi

Saddlebag. Early 20th century
Kakhetia
Hand-woven wool. 54 × 130
The Dzhanashia Museum of Georgia, Tbilisi

Palas. 20th century
Kartli
Flat-woven wool. 166 × 220
The Dzhanashia Museum of Georgia, Tbilisi

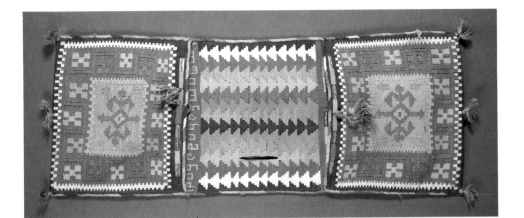

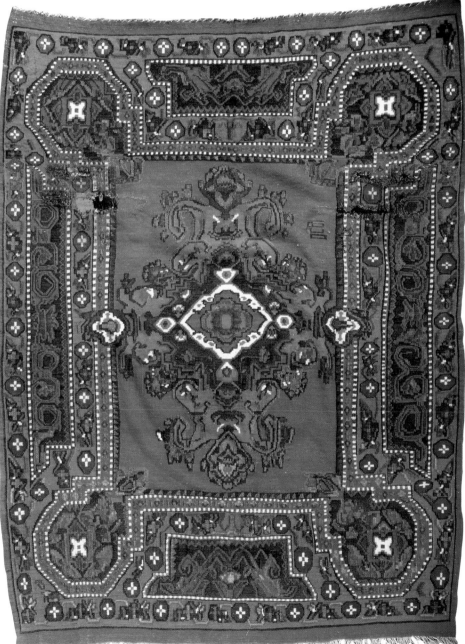

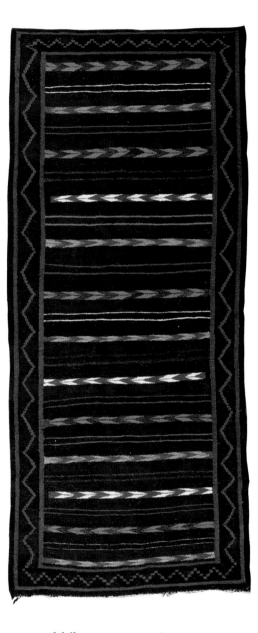

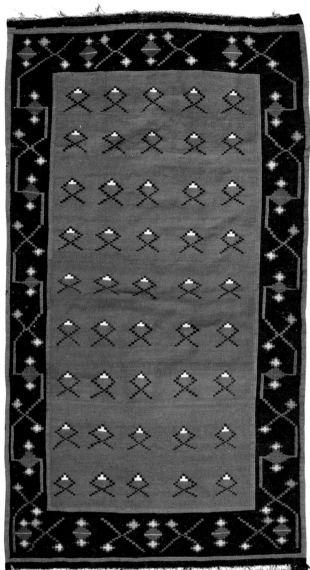

couraged folk artisans as well as professionals, who also endeavor to revitalize the traditional imagery and characteristic national ornamentation. Both ceramic art and chasing have been revived, and the latter is one of the leading handicrafts in Georgia today. Contemporary goldsmiths and jewelers display an acute awareness of the nation's artistic traditions in their work. Much of the ornamentation employed in the production of pile-woven carpets, which is a new industry, also derives from the traditional motifs found in folk embroidery, knitting, and weaving. The art of hand-printing textiles is being revived too.

Georgian folk art, remarkable for its plastic congruity and functionalism, is a vivid reflection of Georgia's life-style, artistic tastes, and scenic beauty.

Palas. 20th century
Village of Kvemo-Alvani, Kakhetia
Flat-woven wool. 100 × 230
The Dzhanashia Museum of Georgia, Tbilisi

Palas. 20th century
Village of Kvemo-Alvani, Kakhetia
Flat-woven wool. 125 × 220
The Dzhanashia Museum of Georgia, Tbilisi

 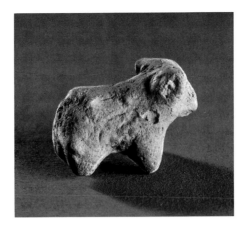 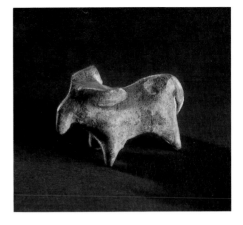

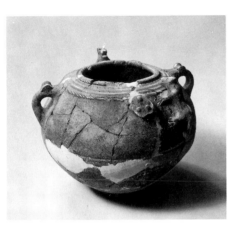 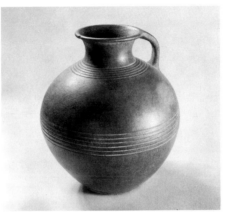 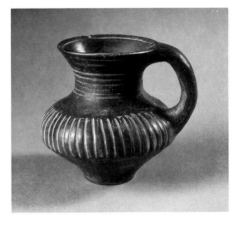

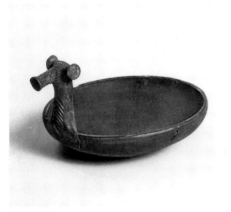 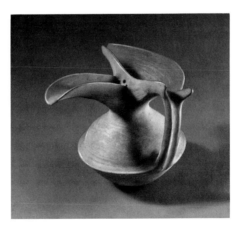 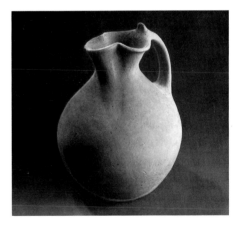

Votive figure of a ram. First half of the third millennium B.C.
Found in the village of Urbnisi, Kareli District
Handworked clay, fired. 4.5 × 2.9
The Dzhanashia Museum of Georgia, Tbilisi

Pot with figures of lions. Middle of the second millennium B.C.
Found in the village of Gadrekili, Sagaredzho District
Fired clay, with applied handworked decoration. Height 19
The Dzhanashia Museum of Georgia, Tbilisi

Bowl with stylized animal head as handle. First half of the first millennium B.C.
Found in the village of Kvasatali, Tskhinvali District
Clay, fired, carbon-smoked, and burnished. Diameter 13.5
The Dzhanashia Museum of Georgia, Tbilisi

Votive figure of a ram. First half of the third millennium B.C.
Found in the village of Urbnisi, Kareli District
Handworked clay, fired. 3.5 × 2.6
The Dzhanashia Museum of Georgia, Tbilisi

Jug. Second half of the second millennium B.C.
Found in the Samtavr burial ground, Mtskheta
Clay, fired, carbon-smoked, and burnished. Height 30.5
The Dzhanashia Museum of Georgia, Tbilisi

Jug. First millennium B.C.
Found in the village of Arkhiloskalo, Tsiteli-Tskaro District
Fired clay. Height 12.5
The Dzhanashia Museum of Georgia, Tbilisi

Votive figure of a ram. First half of the third millennium B.C.
Found in the village of Urbnisi, Kareli District
Handworked clay, fired. 3.1 × 1.8
The Dzhanashia Museum of Georgia, Tbilisi

Jug. Beginning of the first millennium B.C.
Found in the Samtavr burial ground, Mtskheta
Clay, fired, carbon-smoked, and burnished, with reed
 decoration heightened with white paste. Height 15
The Dzhanashia Museum of Georgia, Tbilisi

Jug with trefoil lip. First century A.D.
Found in the village of Urbnisi, Gori District
Fired clay. Height 20.5
The Dzhanashia Museum of Georgia, Tbilisi

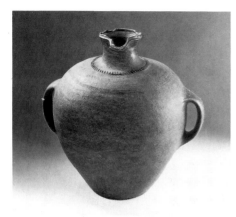

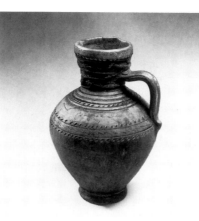

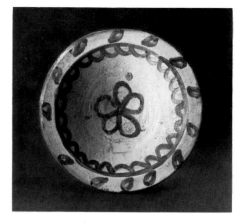

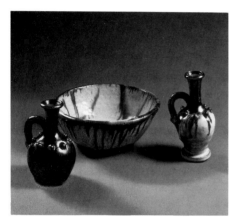

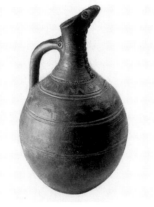

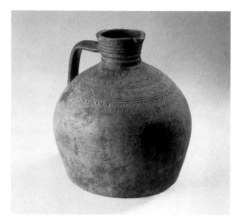

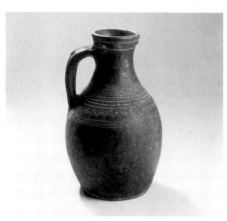

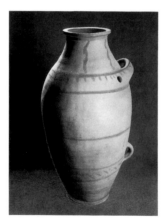

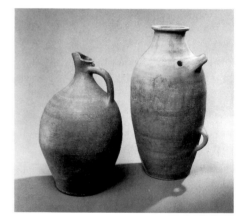

Jug. 19th century
Tiflis Province
Fired clay. Height 37
The Dzhanashia Museum of Georgia, Tbilisi

Jugs and bowl. Late 19th century
Village of Shrosha, Tiflis Province
Clay, fired and glazed. Height 10.5, 6, and 14
The Dzhanashia Museum of Georgia, Tbilisi

Jug for wine. Early 20th century
Village of Tskhavati, Tiflis Province
Fired clay. Height 25
The Dzhanashia Museum of Georgia, Tbilisi

Jug for wine. 19th century
Kakhetia
Fired clay. Height 25
The Dzhanashia Museum of Georgia, Tbilisi

Jug. Late 19th century
Village of Digomi, Tiflis Province
Fired clay. Height 40
The Dzhanashia Museum of Georgia, Tbilisi

Butter churn. 20th century
Village of Tskhavati, Tiflis Province
Red clay, fired, with slip decoration. Height 62
The Dzhanashia Museum of Georgia, Tbilisi

Bowl. 19th century
Village of Ninotsminda, Tiflis Province
Clay, fired and glazed, with slip decoration. Height 8.5
The Dzhanashia Museum of Georgia, Tbilisi

Jug for wine. Early 20th century
Village of Bodbiskhevi, Tiflis Province
Fired clay. Height 23
The Dzhanashia Museum of Georgia, Tbilisi

Jug and butter churn. 1978
By Z. Mgebrishvili
Village of Bodbiskhevi, Signakhi District
Clay, fired, with slip decoration. Height 32 and 42
Union of Artists, Moscow

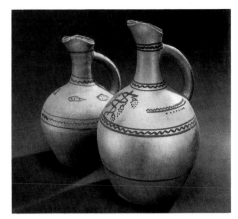

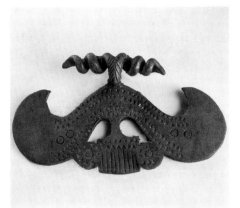

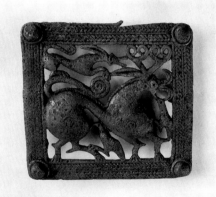

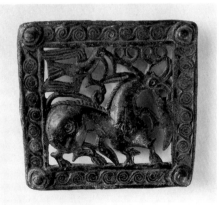

Two jugs. 1978
By V. Shvelidze
Village of Shrosha, Zestafoni District
Clay, fired, with slip decoration. Height 30 and 20
Union of Artists, Moscow

Pectoral in the shape of a fantastic bird with a ram's head.
First half of the second millennium B.C.
Found in the village of Brili, Oni District
Bronze, cast, embossed, and engraved. 13.2 × 7.3
The Dzhanashia Museum of Georgia, Tbilisi

Belt buckle with an ibex. 2nd century A.D.
Found in the village of Dzhavistavi, Gori District
Bronze, cast and engraved. 8 × 6.5
The Dzhanashia Museum of Georgia, Tbilisi

Pectoral with stylized rams' heads. First half of the second
millennium B.C.
Found in the village of Brili, Oni District
Bronze, cast and embossed. 6.6 × 5.7
The Dzhanashia Museum of Georgia, Tbilisi

Belt buckle with fantastic animals. 1st century A.D.
Found in the village of Itkhvisi, Chiatura District
Cast bronze. 10.5 × 10
The Dzhanashia Museum of Georgia, Tbilisi

Belt buckle with fantastic animals. 2nd century A.D.
Found in the village of Dzhavistavi, Gori District
Cast bronze. 15.5 × 15
The Dzhanashia Museum of Georgia, Tbilisi

Pectoral in the shape of a ram's head. First half of the second
millennium B.C.
Found in the village of Brili, Oni District
Bronze, cast and engraved. 6.4 × 2.9
The Dzhanashia Museum of Georgia, Tbilisi

Belt buckle with fantastic animals. 1st or 2nd century A.D.
Found in the village of Gori, Ambrolauri District
Cast bronze. 14.5 × 14.5
The Dzhanashia Museum of Georgia, Tbilisi

Belt buckle with fantastic animals. 2nd century A.D.
Found in the village of Manglisi, Tetri-Tskaro District
Cast bronze. 10 × 9
The Dzhanashia Museum of Georgia, Tbilisi

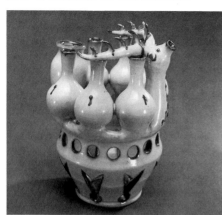

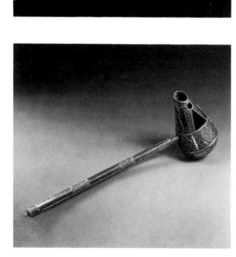

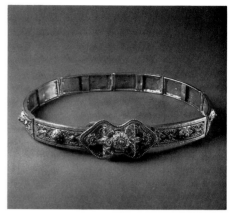

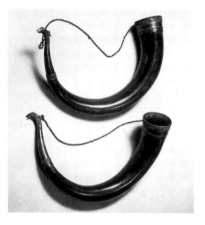

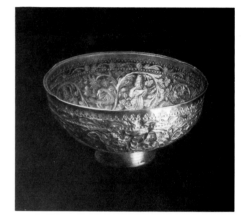

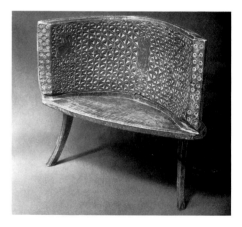

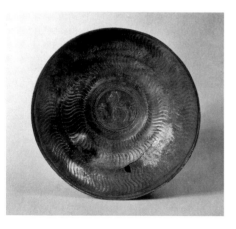

Marani: **vessel for wine.** 1980
By I. Tatulashvili
Gori
Handworked clay, fired and painted underglaze. Height 28
Union of Artists, Moscow

Drinking horns. 1940
By G. Handamashvili and A. Dzhikia
Tbilisi
Mount of silver, engraved and nielloed, with filigree and
 enamel. Length 41.5 (each)
Museum of Folk and Applied Arts, Tbilisi

Bowl with a sacred horse in front of an altar. 3rd century A.D.
Found in the Armaziskhevi necropolis, Mtskheta
Silver, embossed and engraved. Diameter 21.4
The Dzhanashia Museum of Georgia, Tbilisi

Pendant in the shape of a bear. First half of the second
 millennium B.C.
Found at Azanta, Abkhazia
Bronze, cast and engraved. 2.6 × 1.4
The Dzhanashia Museum of Georgia, Tbilisi

Bowl. Mid-19th century
By M. Mashulashvili
Tbilisi
Silver, embossed and nielloed. Height 8, diameter 18.5
Museum of Folk and Applied Arts, Tbilisi

Dipper. 1950
By F. Dzhikia and A. Dzhikia
Tbilisi
Silver, with filigree and niello. Length 39
Museum of Folk and Applied Arts, Tbilisi

Woman's belt. 1920s–30s
By A. Dzhikia
Tbilisi
Silver, with fine filigree. Length 86
Museum of Folk and Applied Arts, Tbilisi

Bowl. Mid-19th century
By M. Mashulashvili
Tbilisi
Silver, chased and embossed. Height 9.5, diameter 20
Museum of Folk and Applied Arts, Tbilisi

Armchair. Early 19th century
Eastern Georgia
Carved wood. Height 77
Museum of Folk and Applied Arts, Tbilisi

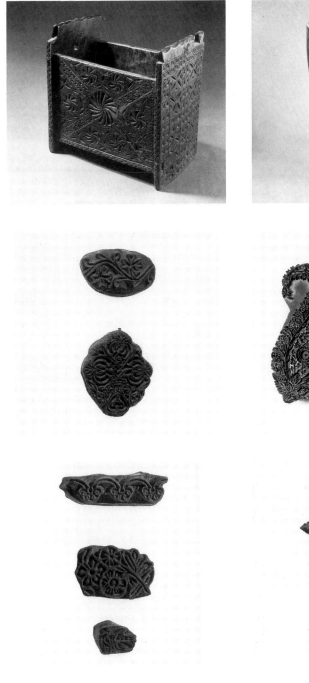

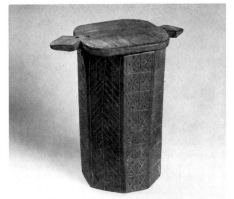

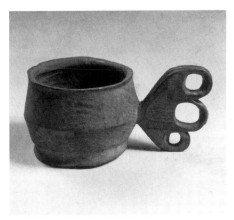

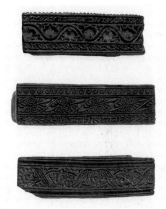

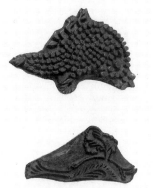

Chest. Early 19th century
Khevsuretia
Carved wood. 28 × 30 × 16
The Dzhanashia Museum of Georgia, Tbilisi

**Blocks for printing textile fabric with decorative designs in
color.** Early 20th century
Kartli
Carved wood. Length 8.5 and 8
The Dzhanashia Museum of Georgia, Tbilisi

**Blocks for printing textile fabric with decorative designs in
color.** Early 20th century
Kartli
Carved wood. Length 2.5, 7, and 9
The Dzhanashia Museum of Georgia, Tbilisi

Vessel for beer. Early 20th century
Khevsuretia
Carved wood. Height 35
The Dzhanashia Museum of Georgia, Tbilisi

**Blocks for printing textile fabric with decorative designs in
color.** Early 20th century
Kartli
Carved wood. Length 18 and 23
The Dzhanashia Museum of Georgia, Tbilisi

**Blocks for printing textile fabric with decorative designs in
color.** Early 20th century
Kartli
Carved wood. Length 10 and 9
The Dzhanashia Museum of Georgia, Tbilisi

Salt-box. Early 20th century
Pshavi
Carved wood. Height 22, diameter 12
The Dzhanashia Museum of Georgia, Tbilisi

**Blocks for printing textile fabric with decorative designs in
color.** Early 20th century
Kartli
Carved wood. Length 16, 17, and 17
The Dzhanashia Museum of Georgia, Tbilisi

Cup. Early 20th century
Tushetia
Carved wood. Height 5
The Dzhanashia Museum of Georgia, Tbilisi

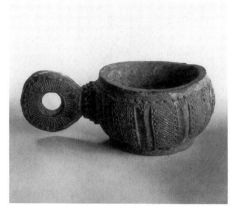

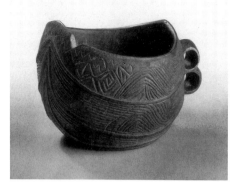

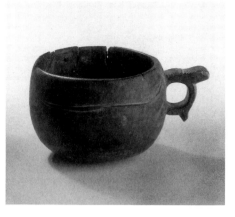

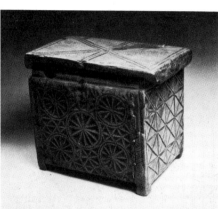

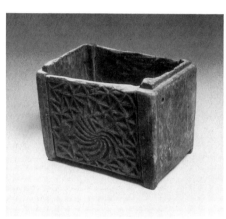

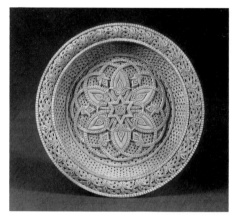

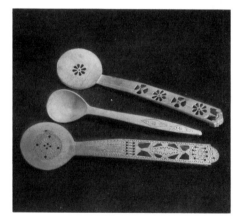

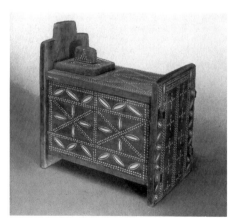

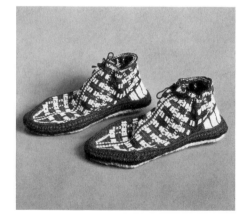

Cup. Early 20th century
Racha
Carved wood. Height 6.5
The Dzhanashia Museum of Georgia, Tbilisi

Casket. Early 20th century
Svanetia
Carved wood. 20 × 25 × 17
The Dzhanashia Museum of Georgia, Tbilisi

Spoons. 1978
By O. Laziashvili
Village of Alambudzhari
Carved wood. Length 43, 35, and 40
Union of Artists, Moscow

Cup. Early 20th century
Village of Chiora, Racha
Carved wood. Height 9
The Dzhanashia Museum of Georgia, Tbilisi

Casket. Early 20th century
Svanetia
Carved wood. 17.5 × 23 × 16
The Dzhanashia Museum of Georgia, Tbilisi

Casket. 1978
By A. Ochiauri
Shuankho, Dusheti District
Wood, carved and painted. Height 40
Union of Artists, Moscow

Cup. Early 20th century
Svanetia
Carved wood. Height 7
The Dzhanashia Museum of Georgia, Tbilisi

Dish. 20th century
Carved wood. Diameter 40
The Dzhanashia Museum of Georgia, Tbilisi

Man's indoor shoes. 20th century
Village of Kvemo-Alvani, Kakhetia
Knitted wool. 27 × 12
The Dzhanashia Museum of Georgia, Tbilisi

Tablecloth. Second half of the 19th century
Eastern Georgia
Printed cotton. 64 × 240
The Dzhanashia Museum of Georgia, Tbilisi

Tablecloth. Second half of the 19th century
Eastern Georgia
Printed cotton. 67 × 226
The Dzhanashia Museum of Georgia, Tbilisi

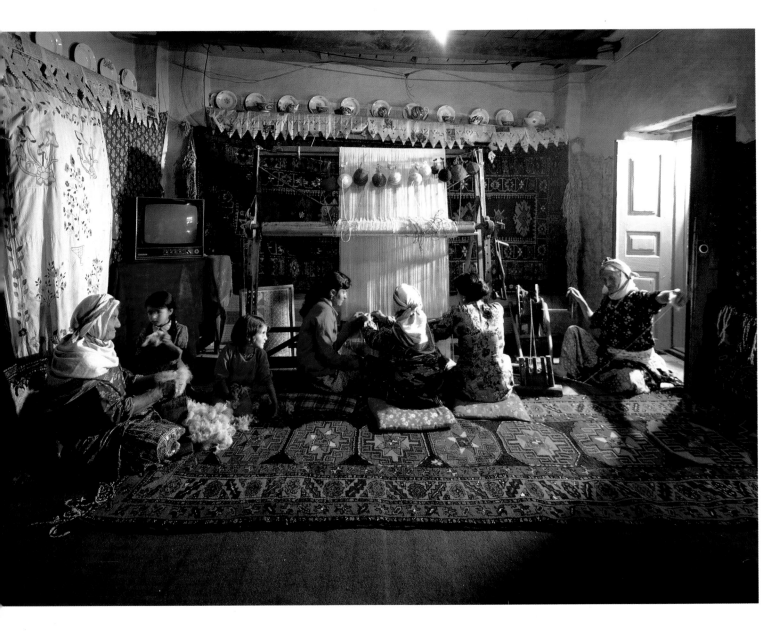

Folk Art in
AZERBAIDZHAN

Azerbaidzhan lies to the southeast of the Great Caucasus Ridge. This ancient land has undergone many changes and upheavals, particularly during its early history. Its artistic formation proceeded under the influence of widely different cultures. When the country was part of the Achaemenid Empire, the Azerbaidzhanians absorbed the best of ancient Persian culture; conquered by Alexander the Great, they came into contact with Classical traditions; and under the Arab Caliphate they drew from the refined culture of Islam. Assimilated in local traditions, all this gave rise to a rich and original culture and folk art.

The making of bronze vessels is one of Azerbaidzhan's most ancient crafts, which was already thriving in the twelfth–fourteenth centuries. The zoomorphic shapes of some vessels show a curious synthesis of ancient symbolism and motifs taken from nature. Despite Islamic restrictions on the portrayal of living creatures, Azerbaidzhani folk art always maintained contact with life. The walls of metal vessels were often engraved with exquisitely ligatured inscriptions in Persian and Arabic. These were didactic quotations from the Koran, maxims and aphorisms, or the artisan's good wishes to the future owner. Sometimes the artisan's name was skillfully included in the design, appearing within one of the ornamental elements.

Bronze-casting in Azerbaidzhan dates from the early Middle Ages, which is corroborated by the fact that in composition and subject motifs its ornamentation is close to the decorative elements of miniature paintings from that time. The making of chased copperware achieved importance in the eighteenth and nineteenth centuries, especially in Shemakha, Giandzha, and Lagich. Various jugs,˙ pails, bowls, candlesticks, and braziers were chased with sumptuous plant designs ingeniously combined with engraved epigraphs so characteristic of Oriental art. The masterly chased and engraved designs seem to flow with ease and smoothness over the vessel's walls, forming a composition of extraordinary harmony and perfect balance. Occasionally these intricately contrived compositions include medallions with hunting and battle scenes or presenting love motifs from Oriental poetry. Today, the leading center for copperware production is the village of Lagich in northern Azerbaidzhan.

In the thirteenth century, Marco Polo, the famous Venetian merchant and explorer, visited Azerbaidzhan and gave one of the earliest descriptions known of the local jewelers' and goldsmiths' workshops, noting their high work standards. The local smiths employed the whole range of techniques known at that time: engraving, filigree, inlay, niello, and enamelling. These

Stag. First millennium B.C.
Found in the Nakhichevan ASSR
Bronze, cast and engraved. Height 12
University of Azerbaidzhan, Baku

Pot. 17th or 18th century
Shemakha
Copper, with cloisonné enamel. Diameter 30
Inscription in Arabic
The Mustafayev Art Museum, Baku

Grease lamp. 18th or 19th century
Baku
Engraved copper. Height 20
Museum of Azerbaidzhani Carpets and Handicrafts, Baku

Pot. 17th or 18th century
Baku
Copper, with cloisonné enamel. Height 18, diameter 12
Museum of the History of Azerbaidzhan, Baku

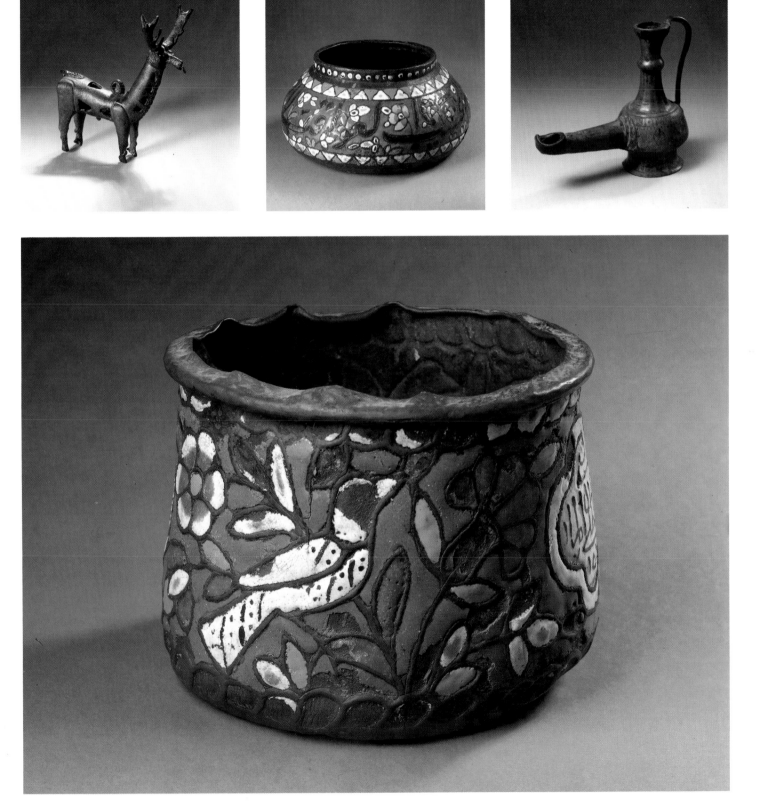

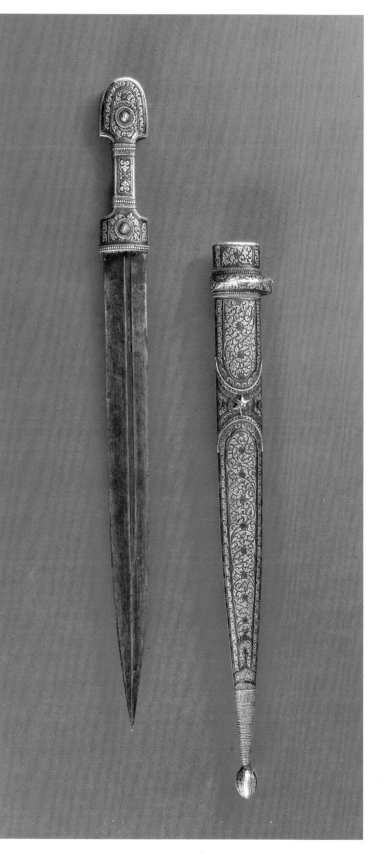

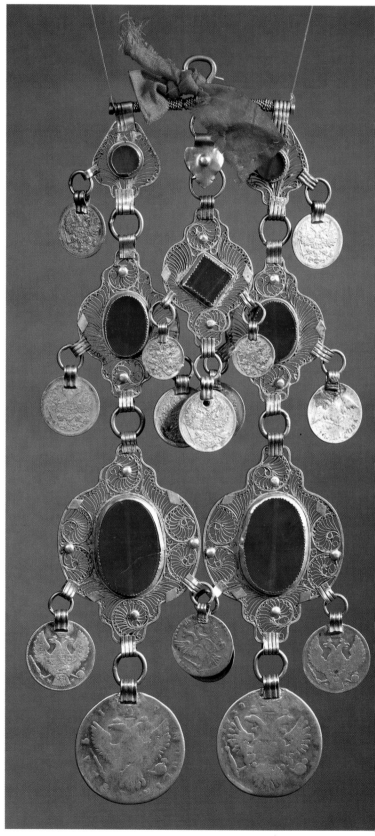

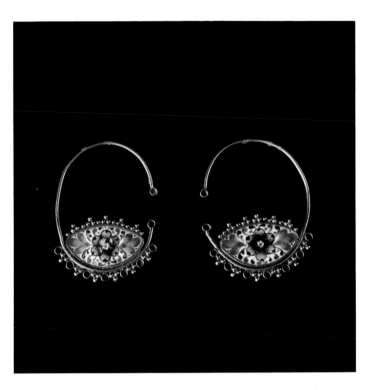

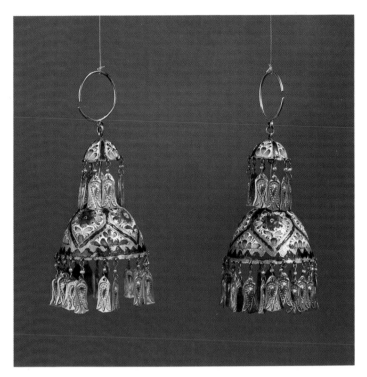

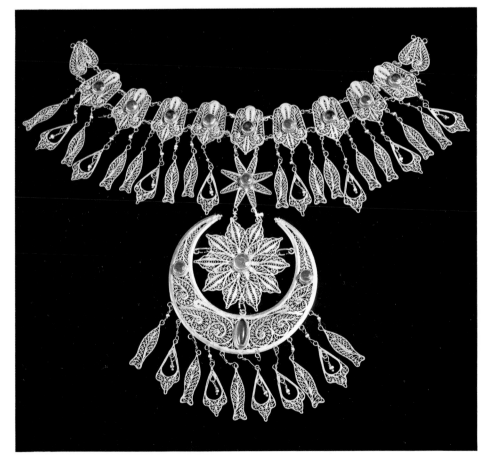

Dagger and scabbard. 19th century
Zakataly
Steel (blade); silver, chased and engraved (scabbard and hilt).
 Length 50 (with scabbard)
Museum of Azerbaidzhani Carpets and Handicrafts, Baku

Woman's breast ornament. Early 20th century
Baku
Silver, set with cornelians, with fine filigree and coin
 pendants. Length 14
Ethnography Museum, Leningrad

Earrings. 19th century
Baku
Gold, with enamel decoration
Museum of the History of Azerbaidzhan, Baku

Earrings. Late 19th century
Baku
Gold, painted in enamel, with pearls and stamped gold
 pendants. Length 10
Ethnography Museum, Leningrad

Woman's breast ornament. 19th century
Baku
Gold, worked in fine filigree and set with ruby and turquoise
Museum of the History of Azerbaidzhan, Baku

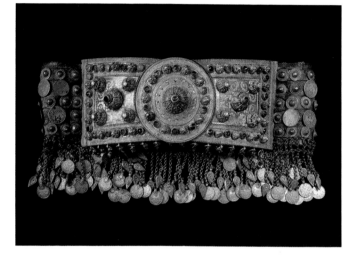

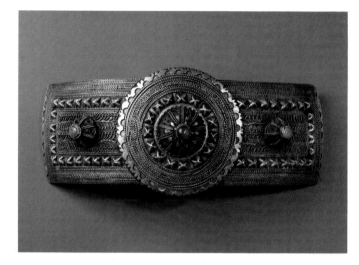

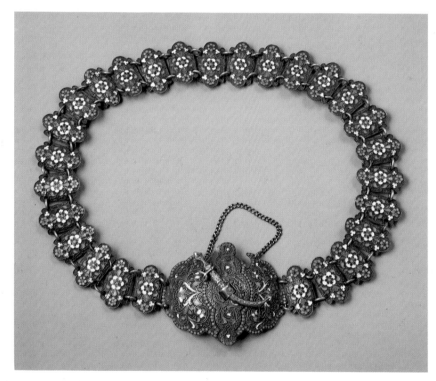

traditions proved enduring, for up to the twentieth century the craftsmen of Baku, Shusha, Sheki, and other towns and villages continued to make men's and women's belts with silver plaques decorated with filigree and enamels. In the markets of the East they competed favorably with the best work of Armenian, Georgian, and Daghestanian smiths.

Azerbaidzhan's ceramic art is no less ancient. Earthenware cauldrons excavated at Orenkala and Giandzha evidence links between the medieval potters of Azerbaidzhan and Central Asia. Plain unglazed ware was predom-

Woman's belt. 19th century
Nukha
Silver, chased, engraved, and decorated with semiprecious
stones and coins. 50 × 10
Private collection, Baku

Belt buckle. 19th century
Nukha
Silver, decorated with fine filigree and semiprecious stones.
25 × 8
Private collection, Baku

Woman's belt. 19th century
Baku
Silver, with cloisonné enamel. Length 76
Private collection, Baku

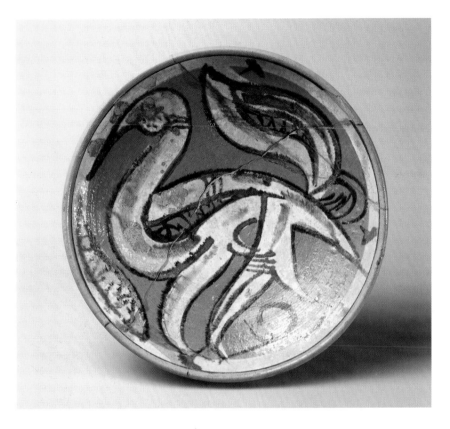

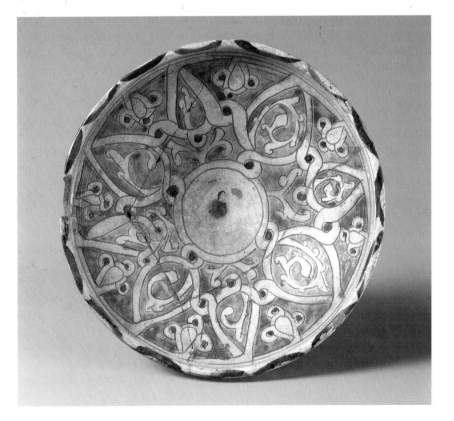

Dish. 12th or 13th century
Found at the site of Orenkala
Clay, fired and painted underglaze. Diameter 27
Museum of the History of Azerbaidzhan, Baku

Dish. 12th or 13th century
Found at the site of Orenkala
Clay, fired and painted underglaze. Diameter 23
Museum of the History of Azerbaidzhan, Baku

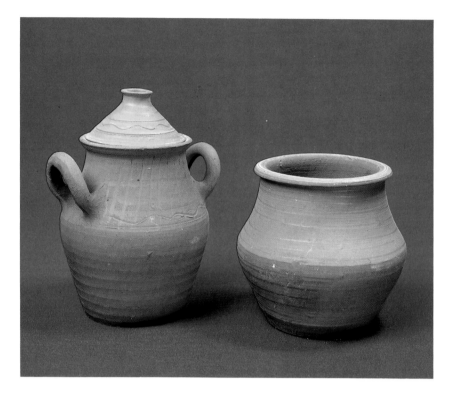

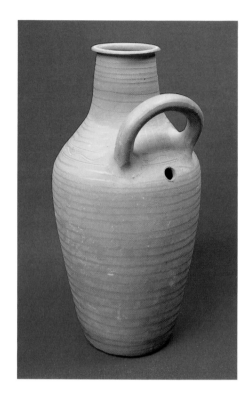

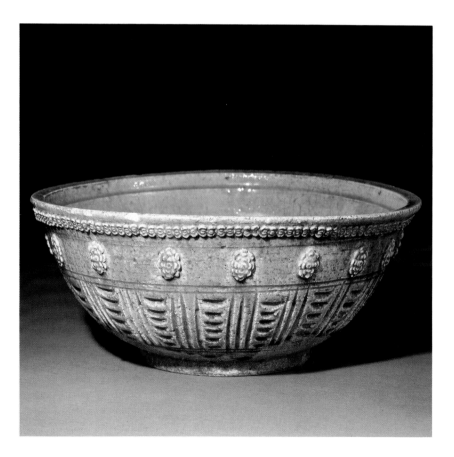

Vessels. 1979
By Sh. Mammedov
Fired clay. Height 22 and 17
Union of Artists, Moscow

Butter churn. 1978
By M. Ismailov
Fired clay. Height 60
Union of Artists, Moscow

Bowl for sherbet. Late 19th century
Ordubad, Nakhichevan District
Clay, fired, glazed, with stamped design, and applied
 handworked decoration. Height 14, diameter 35.5
Ethnography Museum, Leningrad

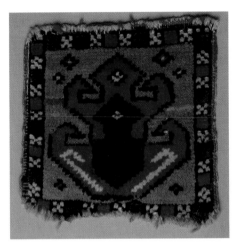

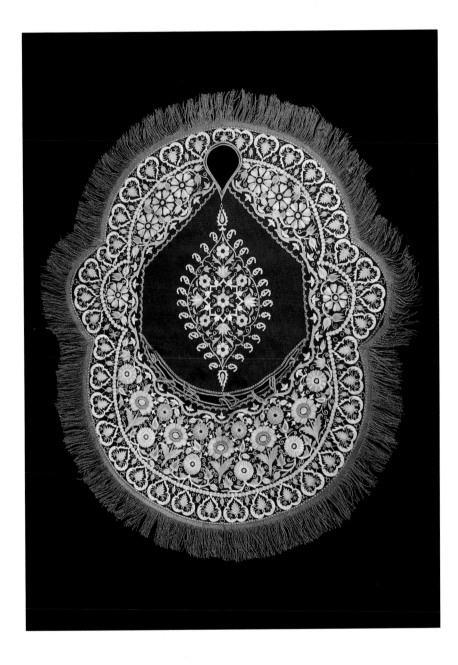

Rug. 18th century
Kuba
Pile-woven wool (natural dyes). 16 × 16
Private collection, Baku

Saddle-cloth. 18th century
Baku
Cloth, with tambour embroidery in silk. 90 × 60
Museum of the History of Azerbaidzhan, Baku

inant then, and only these two centers produced sumptuous bowls, dishes, vases, jugs, and lamps painted in enamels of the purest colors. Ingeniously contrived compositions were slip-painted on their walls; their motifs were similar to designs chased on Azerbaidzhani bronze and copper vessels and comprised exquisite pictures of animals and birds, hunting scenes, or scenes of *galanterie* bordered by plant ornamentation. The range of subjects was traditional for the medieval East, but what is striking is the variety with which these stylistically close themes are treated. Such refined art could only be the result of many generations' quests and endeavors.

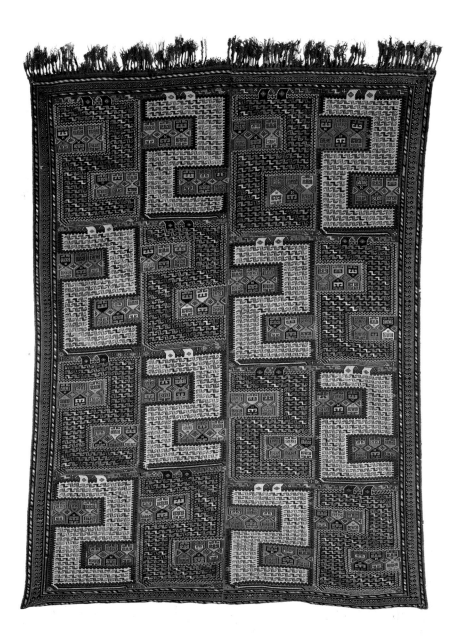

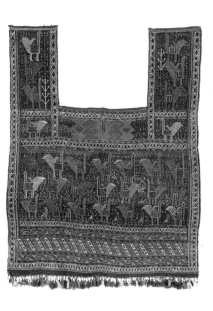

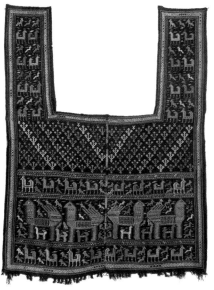

The reputation of many of Azerbaidzhan's architectural treasures owes a great deal to another branch of ceramic art—the making of glazed tiles. Tiles seen on tombs dating from the fourteenth century are still amazingly fresh and bright in color and consummate in ornamental design. This period's traditions were continued in the sixteenth to nineteenth centuries, as exemplified by the tile panel from the seventeenth-century tomb of Sheik Sefi in Ardebıl. The exquisite polychrome plumage of fantastic birds included in the panel's composition recalls fourteenth-century tilework. Likewise, the azure tiles decorating the cupola of the Imam-zadeh mausoleum built in Giandzha in the eighteenth or nineteenth century show affinity with the tile facing of a medieval mausoleum in Barda.

Varni **rug.** 19th century
Karabakh
Flat-woven wool`(natural dyes). 300 × 200
The Mustafayev Art Museum, Baku

Horse-cloth. 19th century
Kazakh
Flat-woven wool (natural dyes). 160 × 120
Museum of Azerbaidzhani Carpets and Handicrafts, Baku

Horse-cloth. 19th century
Baku
Flat-woven wool (natural dyes). 166 × 127
Museum of Azerbaidzhani Carpets and Handicrafts, Baku

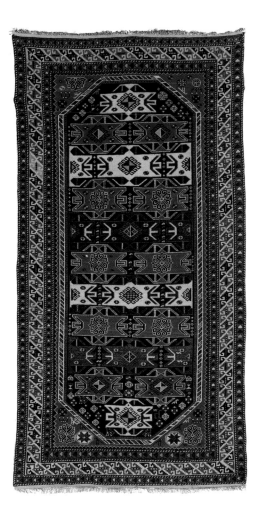

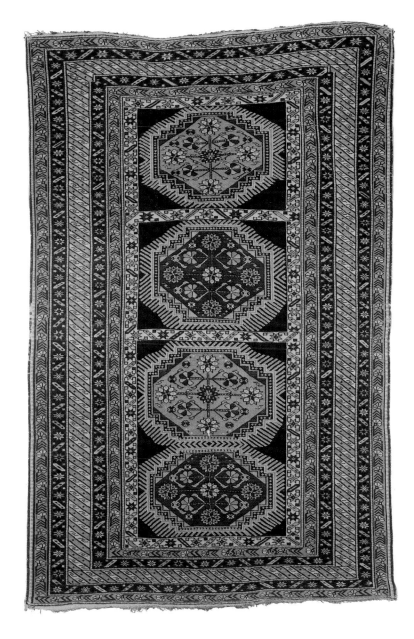

Carpet. 19th century
Kuba
Pile-woven wool (natural dyes). 215 × 120
Private collection. Baku

Surakhany carpet. 18th century
Baku
Pile-woven wool (natural dyes). 180 × 118
The Mustafayev Art Museum. Baku

A special place in Azerbaidzhani folk art belongs to carved tombstones, which are often shaped like a horse or sheep. On the sides of these monuments, and on rectangular stelae one can often see sculpted scenes of hunting, ploughing, or feasting; various domestic jobs and ceremonies are also portrayed. Their rendering is naively ingenuous but not devoid of poetic feeling. This figurative art stands in contrast to the traditional predilection for exquisite ornamentation, although these naively realistic scenes are primarily placed within intricately interlaced ornamental borders.

Similar unusual combinations are to be found in Azerbaidzhani pile carpets, the weaving of which is one of the republic's most remarkable folk art industries. One exemplary nineteenth-century carpet is devoted to the

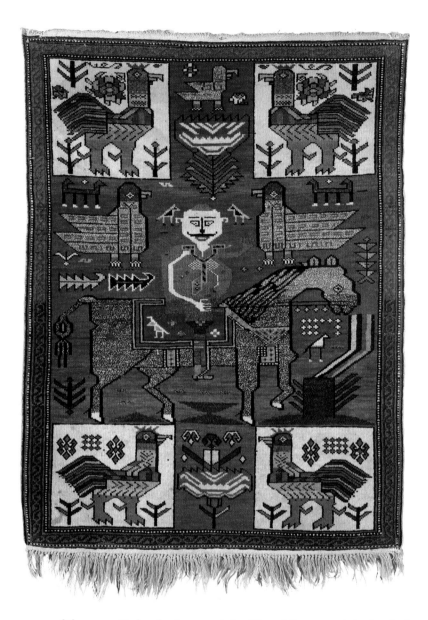

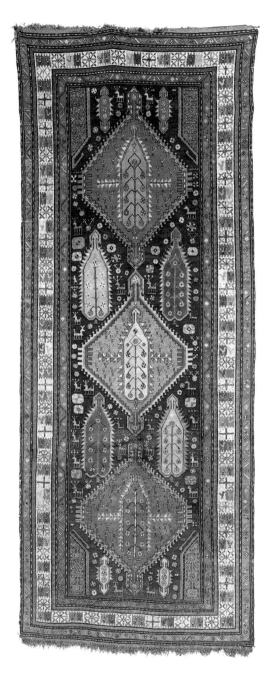

seasons of the year. Its border is executed with a delicacy matched only by its counterpart in miniature painting. Its central part is a rather elaborate narrative of the people's daily life, the ingenuousness of which brings to mind pictures by self-taught primitivist painters.

Among the earliest surviving Azerbaidzhani carpets are examples dating from the thirteenth to fifteenth centuries made in Shirvan, Giandzha, and Karabakh. Their main ornamental motifs are geometric or stylized zoomorphic and plant designs. The oldest known carpet with a narrative subject belongs to the fifteenth century. It was woven by a woman from Karabakh to illustrate the fairy tale *Melik-Mammed*, and it is presently the property of the Stockholm City Museum in Sweden. Knotted pile carpet-making is one of Azerbaidzhan's most widely spread folk crafts; it is practiced, there and all over the Caucasus, only by women, who learn it from childhood.

Carpet with the representation of a falconer. 19th century
Shemakha
Pile-woven wool (natural dyes). 94 × 74
Museum of Azerbaidzahni Carpets and Handicrafts, Baku

Shakhly **carpet.** 19th century
Kazakh
Pile-woven wool (natural dyes). 314 × 128
Museum of Azerbaidzhani Carpets and Handicrafts, Baku

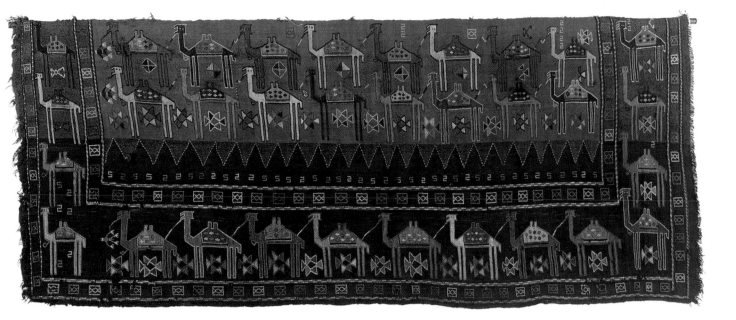

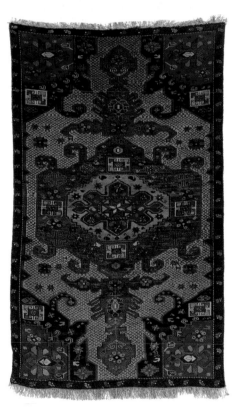

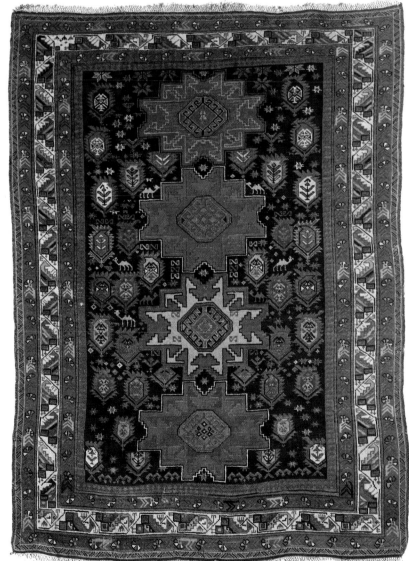

***Shadda* carpet.** 19th century
Village of Lemberan, Karabakh
Flat-woven wool (natural dyes). 245 × 95
The Mustafayev Art Museum, Baku

***Gymyl* carpet.** 19th century
Shirvan
Pile-woven wool (natural dyes). 196 × 130
Museum of Azerbaidzhani Carpets and Handicrafts, Baku

Carpet. 19th century
Shirvan
Pile-woven wool (natural dyes). 150 × 110
Museum of Azerbaidzhani Carpets and Handicrafts, Baku

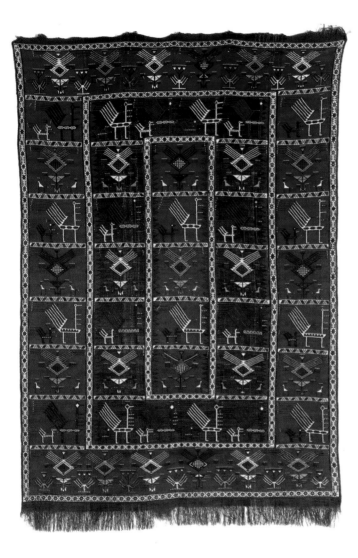

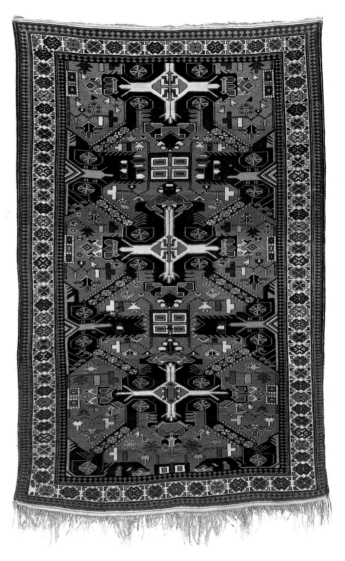

There are about a hundred and fifty varieties of Azerbaidzhani carpets differentiated according to center of manufacture. They fall into three broad categories: the Kuba-Shirvan, the Giandza-Kazakh, and the Karabakh types—with great local variation of artistic and technical features.

Carpets made in Azerbaidzhan were already famous in the late Middle Ages, as evidenced by some paintings by Andrea Mantegna, Carlo Crivelli, Hans Memling, Hans Holbein, Jan van Eyck, and other Western European artists. Many remarkable carpets appearing in their canvases have been attributed to the Azerbaidzhan school.

In the sixteenth and seventeenth centuries, Azerbaidzhan exported its carpets on a large scale. This period can be regarded as the heyday of carpet-making in Azerbaidzhan. The carpet's high knot density enabled the weaver to produce compositions with small, delicate designs of great complexity. In the eighteenth and nineteenth centuries, the weave became coarser and consequently the ornament simpler. Nevertheless, the craft has survived to the present day; in addition to pile carpets, Azerbaidzhani weav-

Zili carpet. Late 19th century
Baku
Flat-woven wool (natural dyes). 200 × 148
Museum of Azerbaidzhani Carpets and Handicrafts, Baku

Carpet. Early 20th century
Shirvan
Pile-woven wool (natural dyes). 200 × 120
Museum of Azerbaidzhani Carpets and Handicrafts, Baku

Sumakh carpet. Late 19th century
Shemakha
Flat-woven wool (natural dyes). 291 × 216
Museum of Azerbaidzhani Carpets and Handicrafts, Baku

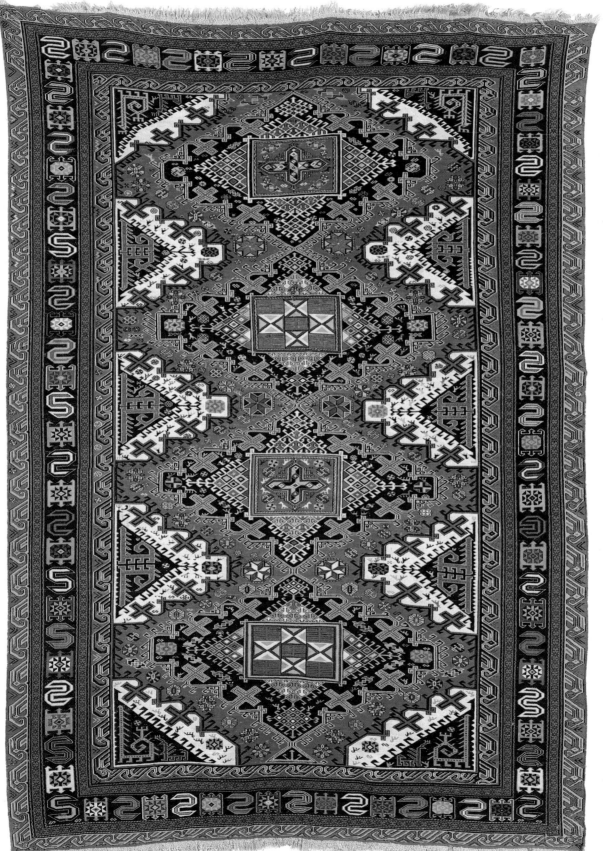

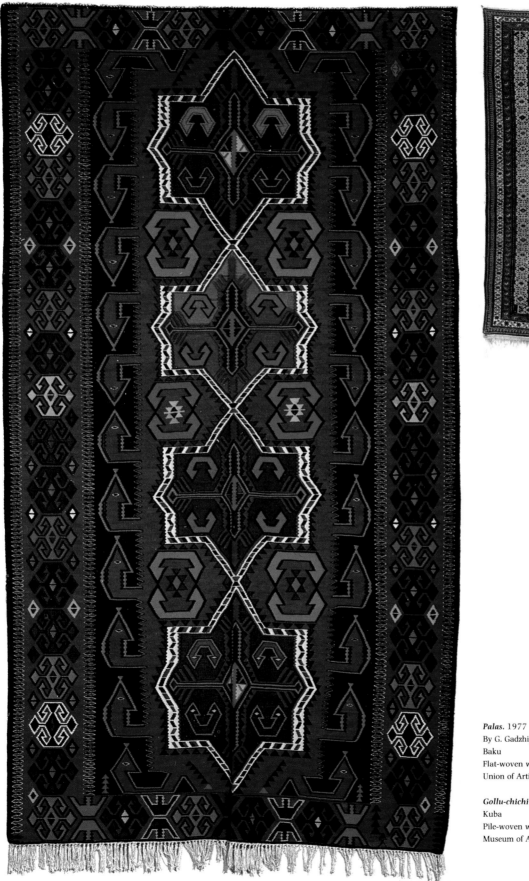

Palas. 1977
By G. Gadzhiyeva
Baku
Flat-woven wool (synthetic dyes). 250 × 150
Union of Artists, Moscow

Gollu-chichi carpet. Early 20th century
Kuba
Pile-woven wool (natural dyes). 207 × 143
Museum of Azerbaidzhani Carpets and Handicrafts, Baku

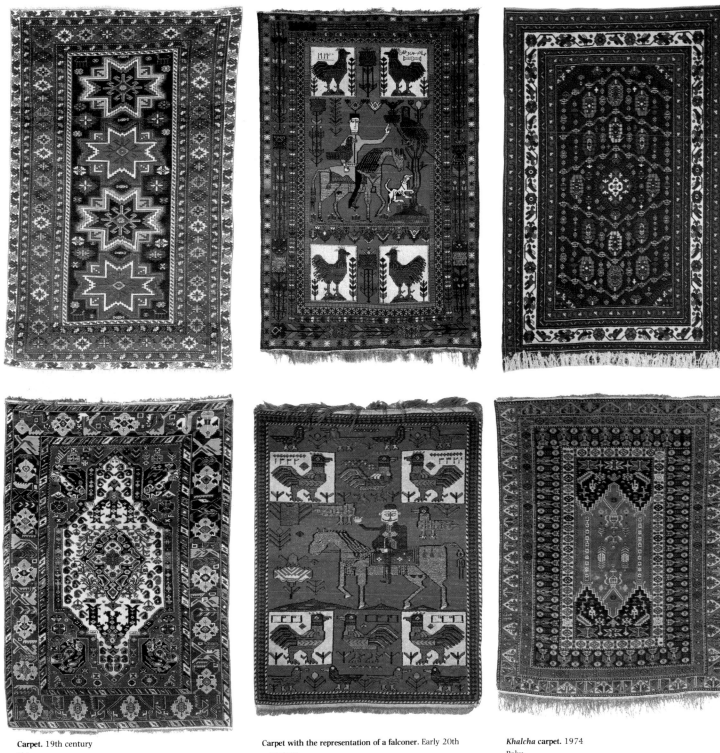

Carpet. 19th century
Shirvan
Pile-woven wool (natural dyes). 145 × 100
Museum of Azerbaidzhani Carpets and Handicrafts, Baku

Pirgasanly **carpet.** Early 20th century
Shirvan
Pile-woven wool (natural dyes). 180 × 135
Museum of Azerbaidzhani Carpets and Handicrafts, Baku

Carpet with the representation of a falconer. Early 20th
 century
Shirvan
Pile-woven wool (natural dyes). 195 × 132
Museum of Azerbaidzhani Carpets and Handicrafts, Baku

Carpet with the representation of a falconer. 1914–15
Pile-woven wool (synthetic dyes). 105 × 82
Ethnography Museum, Leningrad

Khalcha **carpet.** 1974
Baku
Pile-woven wool and cotton (synthetic dyes). 156 × 101
Ethnography Museum, Leningrad

Carpet. 19th century
Shirvan
Pile-woven wool (natural dyes). 165 × 130
Museum of Azerbaidzhani Carpets and Handicrafts, Baku

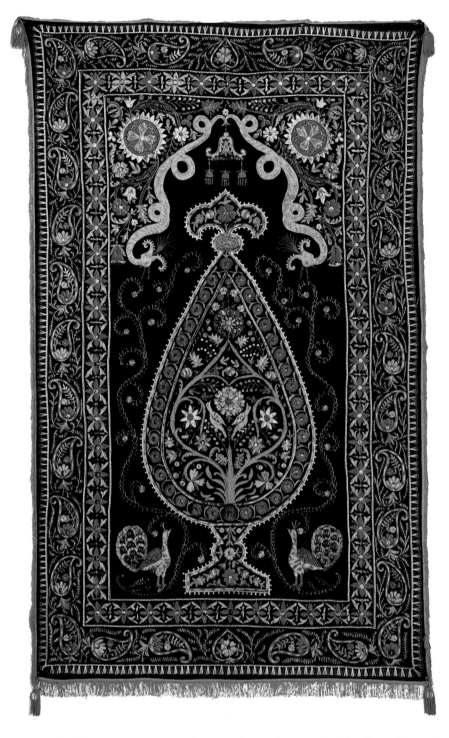

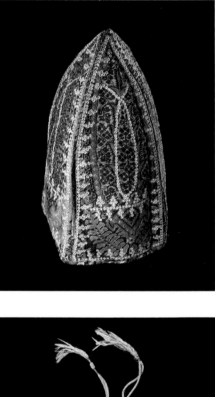

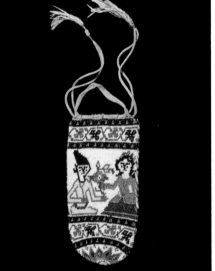

ers make flat-woven carpets, often supplementing wool with silk, gold, and silver threads. In 1967, the Carpet Museum was opened in Baku.

Textile-weaving was another craft known in Azerbaidzhan at quite an early date. When the poet Nizami's body was exhumed in Old Giandzha, fragments of silk cloth with traces of plant ornamentation were unearthed. Similar specimens were also excavated in Baku in deposits from the twelfth to fifteenth centuries. In the fifteenth and sixteenth centuries, textile-weaving was already practiced extensively throughout Azerbaidzhan. Their celebrated silks, exported to Russia, Persia, Turkey, India, Italy, and England, were woven in the workshops of Shemakha, Ardebil, Baku, Nakhichevan,

Hanging. 19th century
Nukha
Cloth, with tambour embroidery in silk. 270 × 160
Museum of Azerbaidzhani Carpets and Handicrafts, Baku

Man's headdress. 19th century
Shusha
Cloth, with satin-stitch and tambour embroidery
The Mustafayev Art Museum, Baku

Tobacco pouch. 19th century
Shusha
Silk, with beadwork. 14 × 7
Museum of the History of Azerbaidzhan, Baku

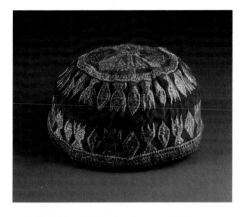

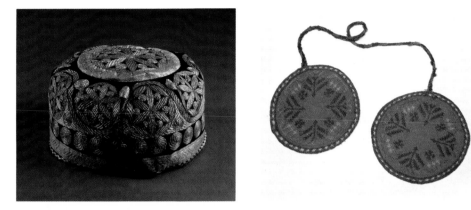

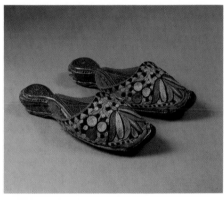

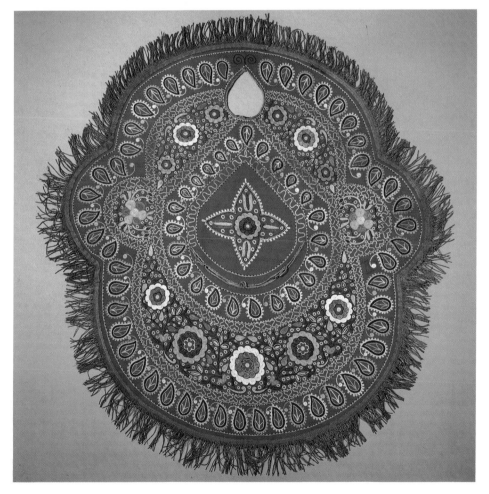

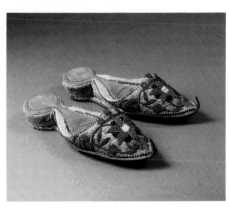

Headdress. 19th century
Baku
Velvet, embroidered in gold thread
The Mustafayev Art Museum, Baku

Woman's slippers. 19th century
Nukha
Leather, with tambour embroidery and engraved silver
 insoles. Length 20
The Mustafayev Art Museum, Baku

Woman's slippers. 19th century
Shusha
Silk, with beadwork. Length 20
The Mustafayev Art Museum, Baku

Headdress. 19th century
Shusha
Velvet, embroidered in gold thread
The Mustafayev Art Museum, Baku

Saddle cover. Late 19th century
Nukha
Cloth, with tambour embroidery in silk. 73 × 73
Ethnography Museum, Leningrad

Potholders. Early 20th century
Village of Ismailly
Knitted wool. Diameter 16.5 (each)
Ethnography Museum, Leningrad

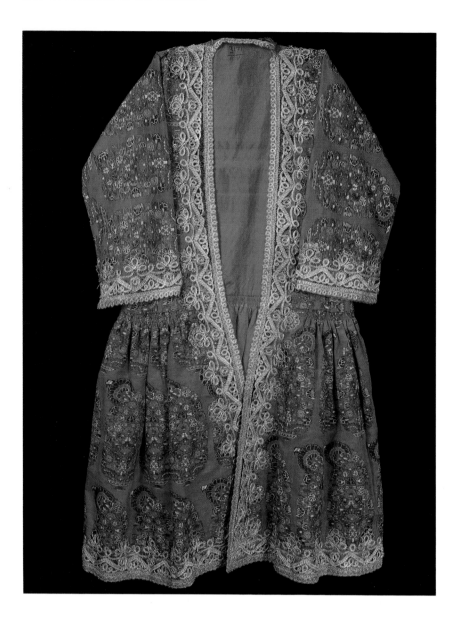

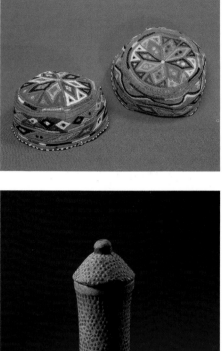

and other towns. Besides geometric and plant designs, the silks had orna-
ments with subjects derived from miniature painting, poetry, or from
carved, engraved, and chased decorations.

In the eighteenth and nineteenth centuries, embroidery became almost
as important as weaving, and great respect was enjoyed by the needlework
of Nukha (now known as Sheki), where it was worked in colored lisle
threads on woollen cloth or velvet. The work was remarkable for its highly
intricate plant designs incorporating birds and animals. The same region
was also famous for printed silk kerchiefs.

One of the glories of Azerbaidzhani folk art is embroidery in gold thread
on fabrics or leather. Although sharing many characteristics with needle-
work from other areas in the Caucasus, Azerbaidzhani gold embroidery nev-
ertheless displays a distinctive local flavor.

Among the surviving local crafts a prominent place belongs to wood

Woman's dress. 19th century
Shemakha
Velvet, with lace of gold thread
The Mustafayev Art Museum, Baku

Skullcaps. 1978
By D. Mamedova
Hand-woven wool, with embroidery. Diameter 22 (each)
Union of Artists, Moscow

Jug. 12th–14th centuries
Found at Barda
Glazed glass. Height 36
Museum of the History of Azerbaidzhan, Baku

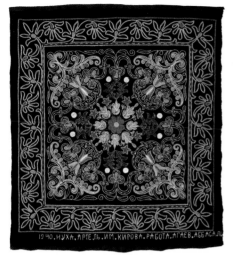

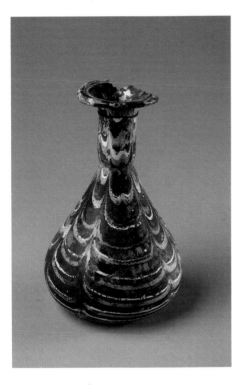

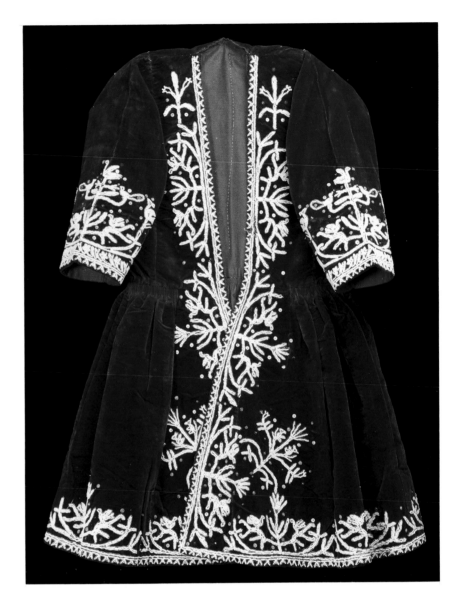

Cushion cover insert. 1940
By A. Agayev
Nukha
Velvet, with tambour embroidery in silk. 49 × 56
Ethnography Museum, Leningrad

Scent bottle. 1st–3rd centuries
Found at Mingechaur
Glass. Height 11.5
Museum of the History of Azerbaidzhan, Baku

Woman's dress. 19th century
Village of Shakhtakhty, Nakhichevan District
Velvet, embroidered in gold thread
The Mustafayev Art Museum, Baku

carving. It is used in the decoration of houses, especially for openwork on shutters and lintels, and in the making of furniture, musical instruments, and wooden utensils. The local carving style is essentially similar to what is found in other countries of the Orient. As a rule, the composition is based on geometric or plant designs, though zoomorphic motifs occasionally occur in wooden blocks used for printing designs on fabrics. Truly lacy openwork is used in the decoration of ingeniously contrived lattices designed for skylights in Azerbaidzhani houses. Other techniques widely employed in Azerbaidzhani woodwork are marquetry, intarsia, inlay, and, less frequently, painted decoration.

The age-old traditions of folk art are still very much alive not only in the work of present-day Azerbaidzhani craftsmen but also in the republic's professional art. Azerbaidzhani folk art is a brilliant chapter in the history of art and culture of the entire Union of Soviet Socialist Republics.

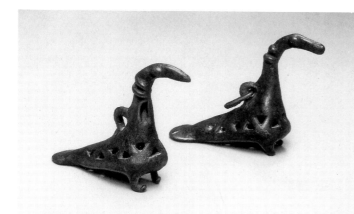

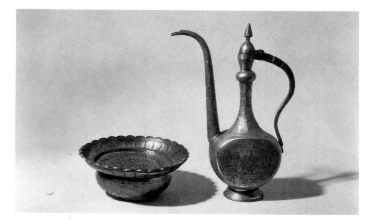

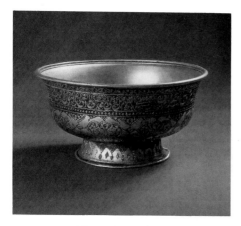

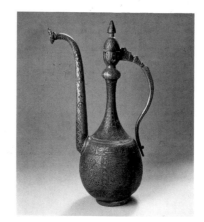

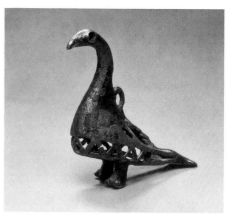

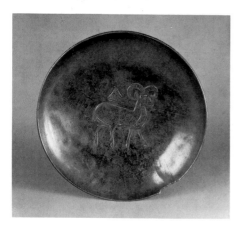

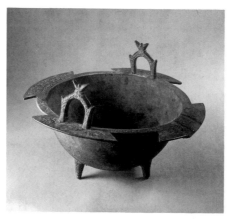

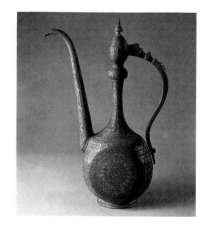

Ritual pendants. First millennium B.C.
Found at Kirovabad
Bronze, cast, chased, and engraved. Length 5
Private collection, Baku

Bowl. 19th century
Village of Lagich, Shemakha District, Baku Province
Copper, chased and engraved. Height 14, diameter 24
Inscription in Arabic
Museum of Azerbaidzhani Carpets and Handicrafts, Baku

Dish with a moufflon ram. 6th or 7th century
Found in Lenkoran District
Silver, chased and engraved. Diameter 21.6
Museum of the History of Azerbaidzhan, Baku

Cauldron. 12th or 13th century
By Master Ahmad
Shirvan
Bronze, cast and engraved. Height 30, diameter 131
Inscribed in Arabic on the body: *Ahmad ibn-Muhammad*
Private collection, Baku

Jug. 19th century
Shemakha
Copper, chased and engraved. Height 35, diameter 21
Inscription in Arabic
Museum of Azerbaidzhani Carpets and Handicrafts, Baku

Jug and finger bowl. Late 19th century
Nakhichevan
Copper, tin-plated and engraved. Height 10 and 41; diameter
10 (finger bowl)
Ethnography Museum, Leningrad

Ritual pendant. First millennium B.C.
Found at Kirovabad
Bronze, cast and chased, with pierced decoration and
engraving. Length 6
Private collection, Baku

Jug. 18th or 19th century
Giandzha
Copper, chased and engraved. Height 40
The Mustafayev Art Museum, Baku

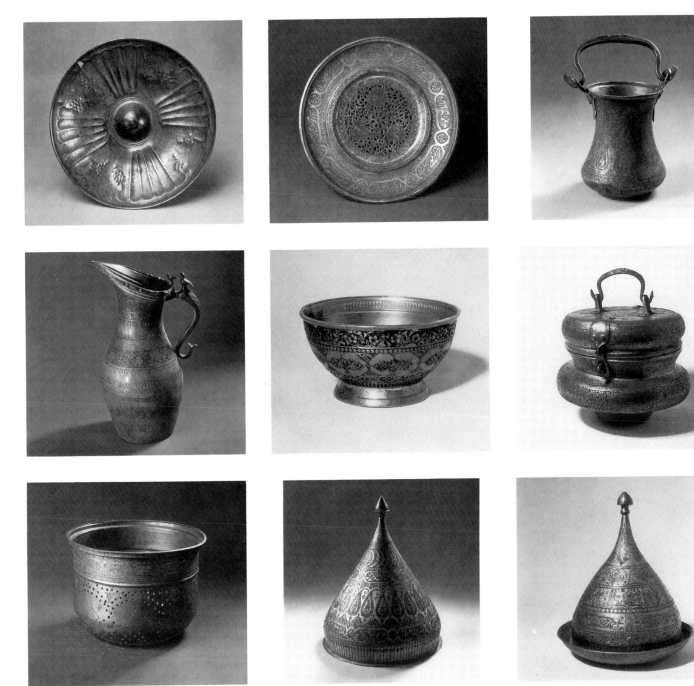

Dish with a cluster of grapes. 6th or 7th century
Found at Mingechaur
Silver, chased, embossed, and engraved. Diameter 19.5
Museum of the History of Azerbaidzhan, Baku

Jug. 19th century
Shemakha
Copper, chased and engraved. Height 41
Museum of Azerbaidzhani Carpets and Handicrafts, Baku

Pot. 19th century
Shemakha
Copper, chased and engraved. Height 17, diameter 25
Museum of Azerbaidzhani Carpets and Handicrafts, Baku

Plate. 19th century
Shemakha
Copper, decorated with openwork and engraving. Height 6,
 diameter 28
Inscription in Arabic
Museum of Azerbaidzhani Carpets and Handicrafts, Baku

Bowl. Late 19th century
Nukha
Copper, tin-plated and engraved. Height 8, diameter 13
Ethnography Museum, Leningrad

Cover for pilaf plate. 19th century
Shemakha
Engraved copper. Height 34
Museum of Azerbaidzhani Carpets and Handicrafts, Baku

Pot. 19th century
Village of Lagich, Shemakha District, Baku Province
Copper, chased and engraved. Height 34
Museum of Azerbaidzhani Carpets and Handicrafts, Baku

Container. 1895
Village of Lagich, Shemakha District, Baku Province
Copper, tin-plated and engraved. Height 31, diameter 32
Ethnography Museum, Leningrad

Pilaf plate with cover. Early 20th century
Village of Lagich, Shemakha District, Baku Province
Copper, tin-plated and engraved. Height 29, diameter 23.5
Ethnography Museum, Leningrad

Pot. Second millennium B.C.
Found in Khanlar District
Clay, fired, with incised decoration. Height 30, diameter 32
The Mustafayev Art Museum, Baku

Vessel. 7th–5th centuries B.C.
Found at Mingechaur
Fired clay. Height 30, diameter 18
Museum of the History of Azerbaidzhan, Baku

Bowl. Second millennium B.C.
Found in Khanlar District
Clay fired, carbon-smoked, burnished, with incised
 decoration. Height 11, diameter 20
Museum of Azerbaidzhani Carpets and Handicrafts, Baku

Vessel in the form of a bird. 7th–5th centuries B.C.
Found in the village of Molla Macherramly, Fizuli District
Fired clay. Height 21
Museum of the History of Azerbaidzhan, Baku

Butter churn. 1970s
By Sh. Mammedov
Sheki
Fired clay. Height 72
Ethnography Museum, Leningrad

Vessel. 7th–5th centuries B.C.
Found in the village of Abdurakhmanly, Fizuli District
Clay, fired, carbon-smoked, burnished, and engraved.
 Height 19, diameter 20
The Mustafayev Art Museum, Baku

Pot with cover. 1960s
Sheki
Fired clay, with incised ornament. Height 17
Ethnography Museum, Leningrad

Spoon. 19th century
Wood, carved and painted. Length 21
The Mustafayev Art Museum, Baku

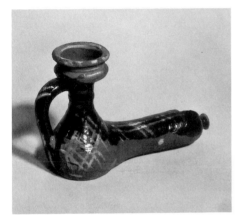

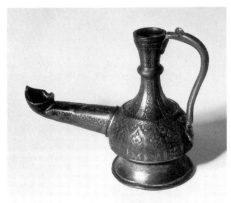

Bowls. Early 20th century
Kuba
Clay, fired, with underglaze slip decoration. Height 7.5 and 6,
 diameter 16 and 17
Ethnography Museum, Leningrad

Candle holder. Early 20th century
Kuba District, Baku Province
Clay, fired, with underglaze slip decoration. 13.5 × 19
Ethnography Museum, Leningrad

Oil lamp. Early 20th century
Village of Lagich, Shemakha District, Baku Province
Copper, tin-plated and engraved. Height 19
Ethnography Museum, Leningrad

Blocks for stamping designs on bread. 1969
Sheki
Handworked clay, fired, and stamped with geometric designs.
 Height 5, diameter 19 (each)
Ethnography Museum, Leningrad

Saddlebag. 1976
By Ye. Abdullayeva
Kakhi District
Flat-woven wool (synthetic dyes). 160 × 57
Union of Artists, Moscow

Folk Art in
ARMENIA

Armenia is a land of rocks and mountains. From time immemorial agriculture was concentrated in its valleys and livestock rearing in its mountains. The Armenian Plateau is not only picturesque but has a wealth of mineral resources, including building materials such as tufa and basalt, copper and iron ore, and excellent pottery clays. The hot climate is good for cotton growing, and the rich mountain pastures encourage sheep-breeding for wool. The availability of all these materials facilitated the growth of various handicrafts such as pottery, stone carving, smithing, goldsmithing, weaving, carpet-making, embroidery, and lace-weaving.

Situated on the crossroads between East and West, Armenia was repeatedly ravaged by invaders. The troops of Rome, Byzantium, the Arab Caliphate, the Seljuk Turks, and the Tatar Mongols devastated the country, arresting its cultural development for long periods, sometimes for centuries. Despite the vicissitudes of history, Armenians always remained faithful to their national artistic and cultural traditions. Folk art figured prominently in the preservation of traditions. Its permanence and continuity of skill, passed from generation to generation, proved to be a unifying force and a breeding ground for all Armenian decorative arts. It is largely for this reason that a certain stylistic affinity is demonstrated by such diverse Armenian arts as architecture, stone carving, book illuminating, carpet-making, lace-weaving, and embroidery.

Stone carving is probably the most characteristic Armenian art. Its earliest surviving examples are carved images of fish once held to be protectors of springs; they date back to the second millennium B.C. In the state of Urartu (eighth and seventh centuries B.C.), and under the first Armenian dynasties (sixth to first centuries B.C.), the arts of masonry and stone carving flourished. In the architecture of the Hellenistic period and in numerous temples dating from the ninth to the thirteenth century, carved decoration was also prevalent.

It was the custom in Armenia to erect vertical stone slabs, known as *khachkars*, decorated with a carved cross symbolizing a Tree of Life, which sometimes grew out of a grain or a sun. These monuments, which were also employed as gravestones, often commemorated important events, such as military victories, inaugurations of construction projects, or were simply used as landmarks or border posts. *Khachkars* with their age-old history are among the brightest manifestations of the creative talent of Armenian carvers over many generations.

Pottery is another ancient and common Armenian craft, which has been known there, according to archaeological finds, from the Neolithic Age. Seven different kinds of local clay were highly regarded and even exported to ancient lands of the East and to Greece. Light-colored clays were

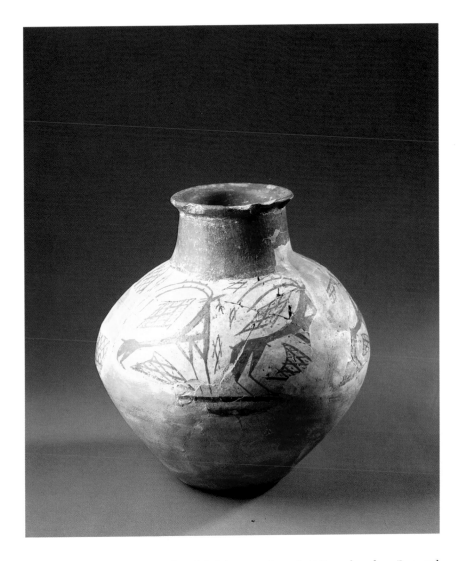

Jug. Beginning of the first millennium B.C.
Found in the village of Oshakan, Ashtarak District
Fired clay, with slip decoration. Height 26.5
Museum of the History of Armenia, Yerevan

used in manufacturing glazed bricks to adorn building facades. But red clays were particularly valued for their plasticity and appealing dark color. In the Middle Ages jugs made from this clay were traded in Syria, Egypt, and Persia. Excavations in the ancient Armenian capitals, Dvin and Ani, have demonstrated that ceramic art was highly developed in the eleventh to thirteenth centuries, when squat shapes were popular. Large *karas* vessels were especially beautiful, though smaller household vessels showed a wide variety of shapes and a fine burnished finish. The potters of that time achieved a remarkable compositional unity by carefully balancing the molded decorations or painted designs with the volume and subordinating them to the object's overall shape. Their red-clay vessels are among the masterpieces of medieval Armenian art. In the eighteenth and nineteenth centuries, these ancient traditions were still very much alive in the work of folk ceramic artists, and even now there are folk potters in Armenia who produce traditional pottery, such as vessels for wine and water, bread-baking stoves, and milk jugs among others.

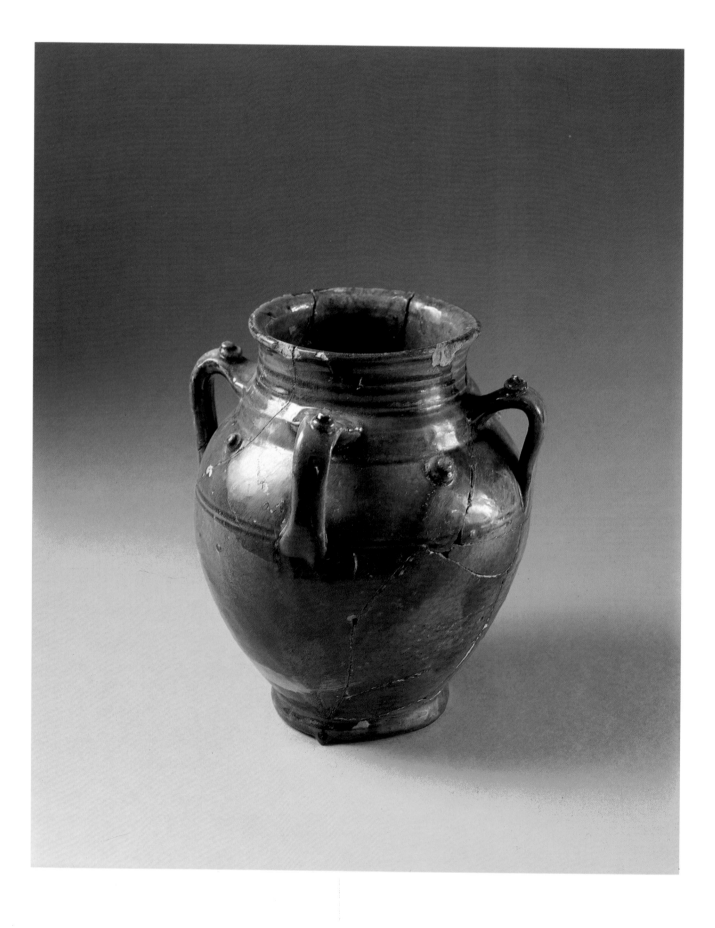

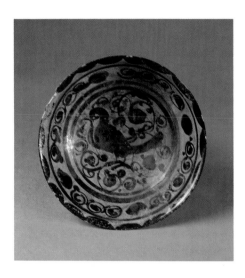

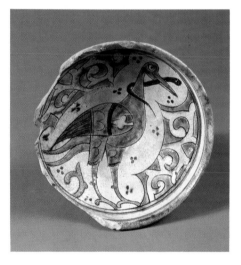

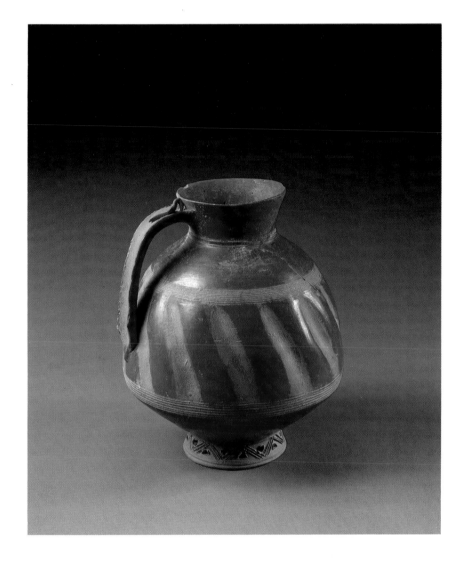

Jar. 9th–13th centuries
Found at the site of Dvin, Artashat District
Clay, fired and glazed. Height 19.5
Museum of the History of Armenia, Yerevan

Bowl. 9th or 10th century
Found at the site of Dvin, Artashat District
Painted faience. Height 6, diameter 17
Museum of the History of Armenia, Yerevan

Bowl. 11th or 12th century
Found at the site of Dvin, Artashat District
Clay, fired, with underglaze slip decoration.
 Height 10, diameter 21
Museum of the History of Armenia, Yerevan

Jug. 11th or 12th century
Found at the site of Dvin, Artashat District
Red clay, fired and burnished. Height 18
Museum of the History of Armenia, Yerevan

In a number of mountain villages certain archaic throwing methods, which used to be practiced by the local women, have survived to the present day. Their saltcellars, large numbers of which were produced until the turn of the twentieth century, are quite original and still fairly common in the villages. They are similar to jugs, with a solid base and sealed top, fashioned in the form of a very formalized female figure. Salt comes from an opening in the middle part. Some of these pots were decorated with applied handworked details reflecting certain ethnographic features of Armenian women's costumes.

Throughout Armenia, particularly where sheep-rearing thrived in its mountainous regions, woollen articles were used in every home: for warmth, the floors and walls were covered with felted, pile, or flat-woven carpets, and patterned woollen socks and stockings were knit. Armenian carpets are known to have been exported and sold in Baghdad as early as the eighth century. A museum in Vienna possesses a thirteenth-century Ar-

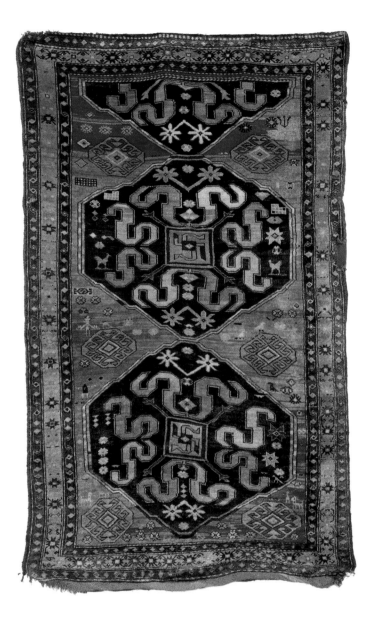

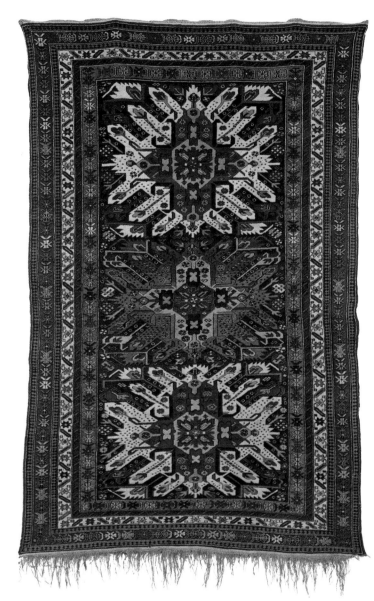

menian carpet with an inscription in Armenian. The Victoria and Albert Museum in London has an example of late seventeenth-century work, inscribed in Armenian as follows, "Gohar, sinful and weak-spirited, has woven this carpet with her still immature hands and may he who reads her name pray for her blessing." According to Marco Polo, the Armenians made carpets that were the finest in the world for workmanship and beauty.

During the eighteenth and nineteenth centuries various carpet-like articles were made, such as horse-cloths, saddlebags, and suspended cradles. They were remarkable for dense knotting, beautiful colors, and varied designs. The high quality of Armenian carpets was due, in part, to the ancient methods of dyeing the yarn with pigments of animal or vegetable origin. A keen understanding of the beauty of each color and of the coloring in general is equally characteristic of those who produced simple flat-woven rugs

Vishapagorg carpet. 19th century
Village of Gadrud, Nagorny Karabakh
Pile-woven wool (natural dyes). 240 × 150
Museum of the History of Armenia, Yerevan

Vishapagorg carpet. 19th century
Village of Khydzoresk, Erivan Province
Pile-woven wool (natural dyes). 224 × 154
Museum of the History of Armenia, Yerevan

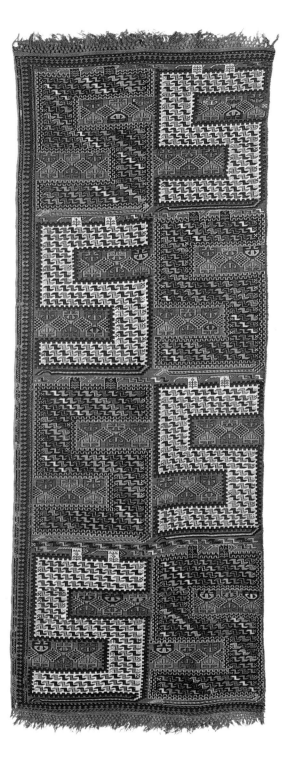

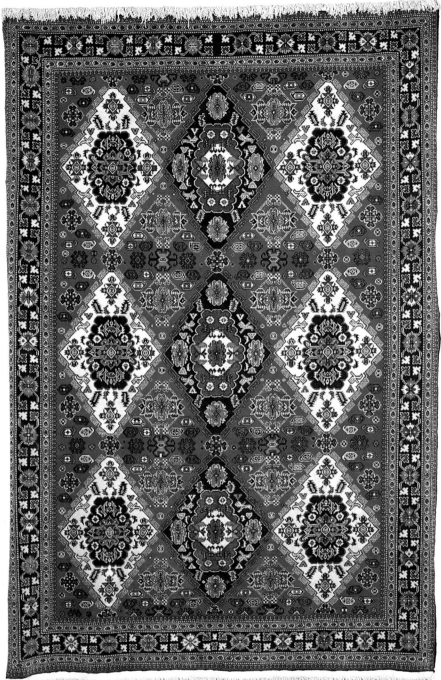

Carpet. 18th century
Western Armenia
Flat-woven wool. 270 × 105
Museum of the History of Armenia, Yerevan

Carpet. 1960s
Pile-woven wool and cotton (synthetic dyes). 300 × 200
Union of Artists, Moscow

and who wove valuable pile carpets with fine elaborate designs. Different regions in Armenia had their own distinctive carpet styles but they all shared a rhythmic clarity of plant designs and an austere combination of deep blue with reds ranging from brownish red to pale rose.

From the beginning of Soviet times Armenian women weavers have

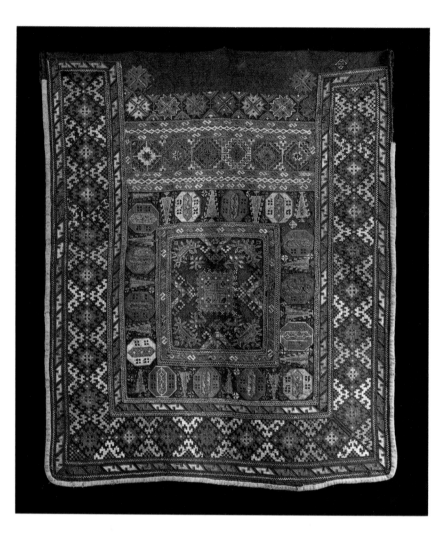

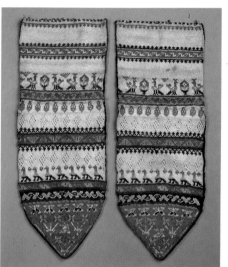

Apron. 18th century
Western Armenia
Wool, with cross-stitch embroidery. 93 × 71
Museum of the History of Armenia, Yerevan

Socks. 19th century
Western Armenia
Knitted wool. Length 33
Museum of the History of Armenia, Yerevan

Socks. 19th century
Western Armenia
Knitted silk. Length 28
Museum of the History of Armenia, Yerevan

Border of towel. 19th century
Western Armenia
Cotton, with satin-stitch embroidery in gold thread.
Width 30.5
Museum of the History of Armenia, Yerevan

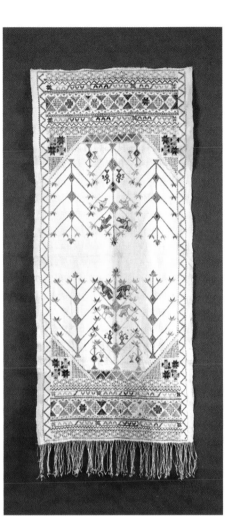

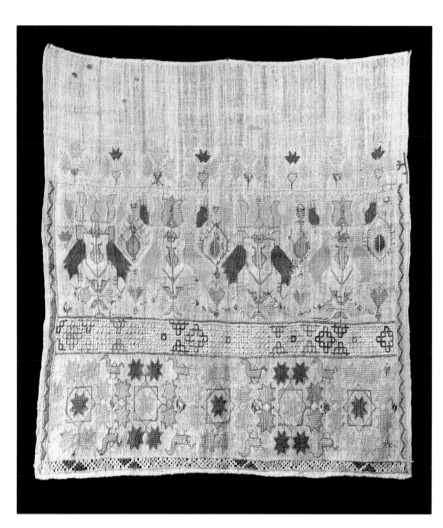

Towel. 19th century
Western Armenia
Cotton, with satin-stitch embroidery in silk. 38 × 90
Museum of the History of Armenia, Yerevan

Towel. 18th century
Western Armenia
Cotton, with cross-stitch embroidery in silk. 39 × 43
Museum of the History of Armenia, Yerevan

formed cooperatives, which produce articles woven of quality yarn and with patterns designed according to the classic examples by contemporary artists. Their carpets are highly regarded in foreign markets.

In some parts of Armenia there was a particularly strong propensity to trim clothes with embroidery. Surviving examples of needlework from the thirteenth to the nineteenth century are remarkable for technical excellence and restrained dull colors. Attractively arranged ornaments and beautiful colors are seen on aprons embroidered in wool, on shawls with a needle-work design on one corner, on gold-embroidered headdresses, and on dress fronts and sleeves. Embroidery in gold and colored silk thread was charac-teristic of urban clothes. Embroidered designs, generally of formalized trees or, occasionally, birds, were widely used to decorate small towels.

All types of lace-weaving were practiced in Armenia as well, but nee-dlepoint lace, which was made with a sewing needle and thin thread, was the most widespread, both in towns and in the countryside. By alternating loops of different configurations with tight knots, Armenian needlewomen

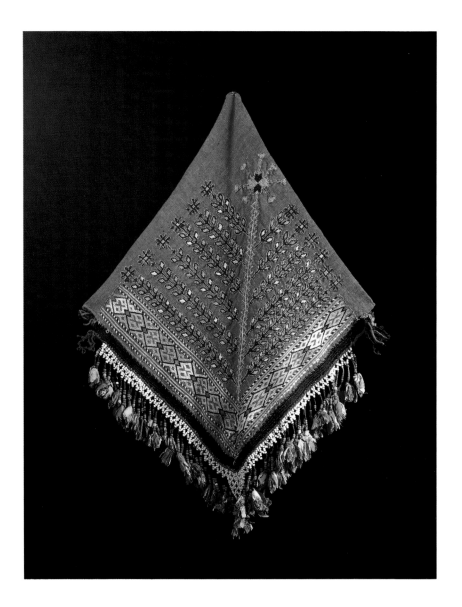

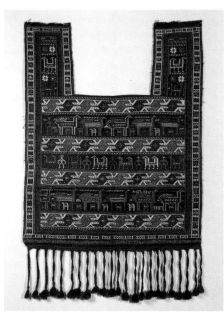

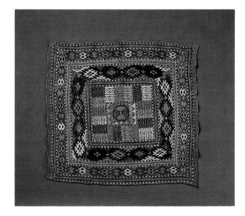

produced varied and exquisite gossamer-like patterns. Both old lace and contemporary examples are notable for their clear-cut yet delicate patterns, interspersed with slightly more substantial rosettes, roundels, lozenges, clusters of grapes, and, occasionally, representations of birds.

At the end of the nineteenth century, several thousand women were engaged in lace-weaving. Wherever Armenians settled, they produced needlepoint lace, which was highly sought after in Europe and America in the early twentieth century.

Metalwork has an even older history in Armenia. Among the wealth of relics from the Bronze Age a prominent place belongs to multifigured compositions for ritual purposes, which include representations of human beings, birds, and horses, single or in teams.

In the Middle Ages chasing flourished in Armenia. It was widely em-

Woman's kerchief. 19th century
Western Armenia
Cotton, with satin-stitch and cross-stitch embroidery in silk
and gold thread. 113 × 78
Museum of the History of Armenia, Yerevan

Horse-cloth. 1887
Village of Lori, Erivan Province
Pile-woven wool (natural dyes). 138 × 110
Museum of the History of Armenia, Yerevan

Detail of woman's kerchief. 19th century
Western Armenia
Cotton, with satin-stitch embroidery in silk
Museum of the History of Armenia, Yerevan

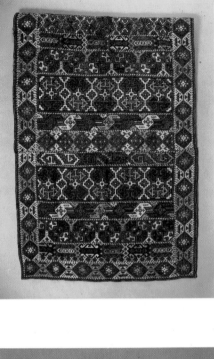

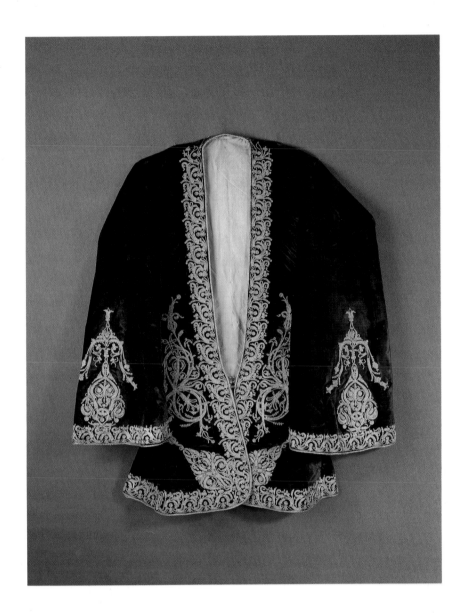

Apron. 19th century
Western Armenia
Wool, with cross-stitch embroidery. 57 × 98
Museum of the History of Armenia, Yerevan

Leggings. Late 19th or early 20th century
Wool, with embroidery. 25 × 15
Museum of the History of Armenia, Yerevan

Jacket. 1860
Western Armenia
Velvet, with embroidery in gold thread. Length 64
Museum of the History of Armenia, Yerevan

ployed to decorate ecclesiastic objects, particularly silver covers for manuscript books, and women's costume accessories such as belts or figured buckles, buttons, and the elaborate Armenian headdress, which was worn with a kerchief and a frontlet, forming an original ensemble.

Armenian jewelry demonstrates a predilection for exquisite designs executed with painstaking meticulousness. As well as personal adornments, various other silver articles, such as small boxes, plates, and glass holders, were made in the nineteenth century. The standards of filigree work, in which plant motifs predominated, were particularly high. The delicate filigree lacework was woven of very thin silver wire and enhanced by narrow bands of shiny plain silver. Contemporary silversmiths are also well versed in this traditional craft.

Copper tableware, prevalent in peasant households, was also an impor-

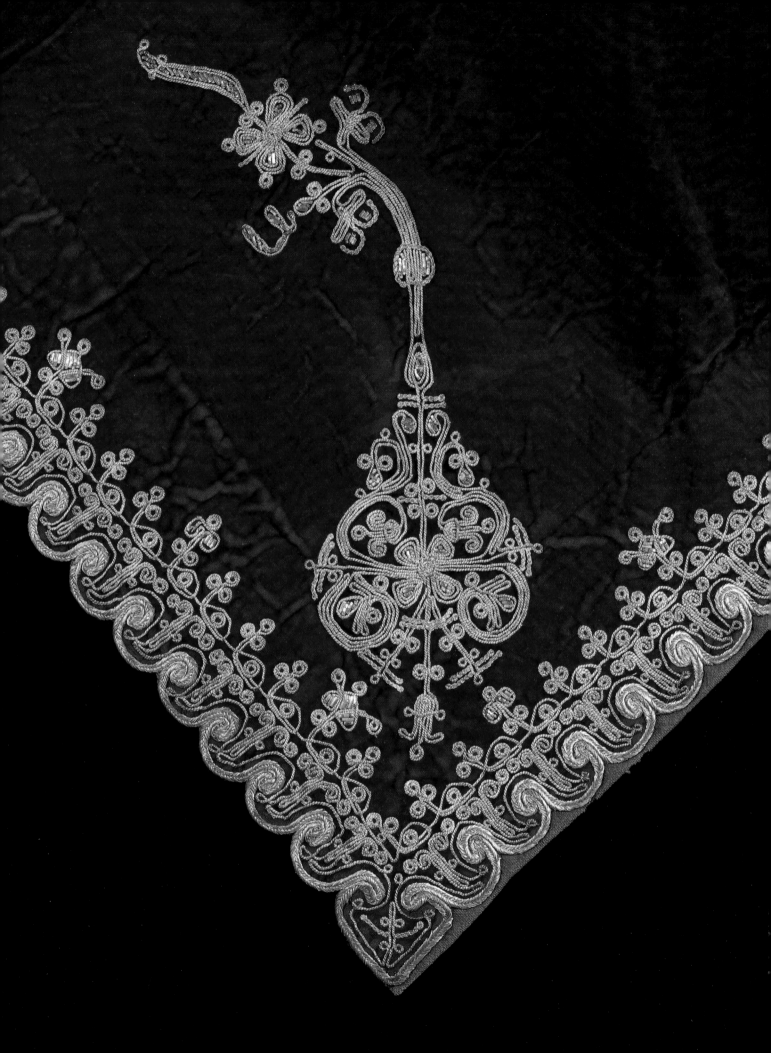

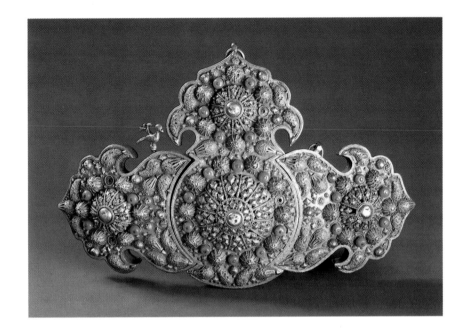

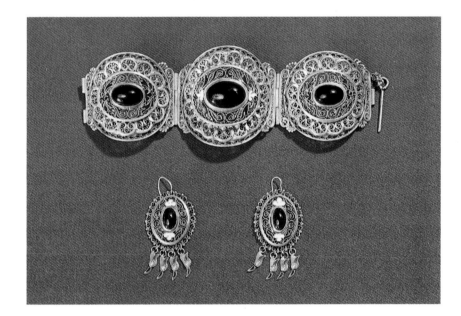

Detail of woman's apron. 1900
Western Armenia
Velvet, with embroidery in gold thread
Museum of the History of Armenia, Yerevan

Belt buckle. 19th century
Western Armenia
Silver, set with corals, with granulation and applied filigree.
 Length 25, width 15
Museum of the History of Armenia, Yerevan

Bracelet and earrings (*Jubilee*** set).** 1977
By R. Sarvazian and E. Isakian
Yerevan
Silver, with filigree and topazes. Length 17 (bracelet),
 4 (earrings)
Union of Artists, Moscow

tant product of Armenian metalwork, especially in the nineteenth century, when several small production centers existed. Tea kettles, bowls, plates, jugs, and the like were usually unadorned, but the simple graceful forms seem to bring out their materials' best qualities.

The Armenian peasantry also made wooden objects and utensils such as trays, dishes, spoons, and ladles, which they sometimes decorated with incised geometric designs. The traditions of wood carving are being actively revived by contemporary Armenian craftsmen.

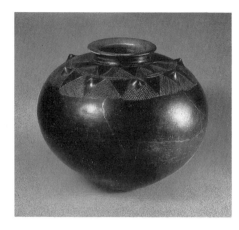

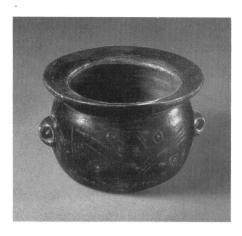

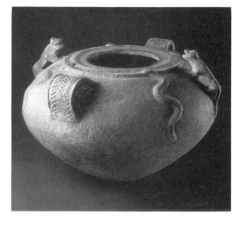

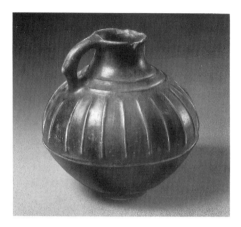

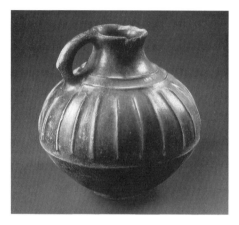

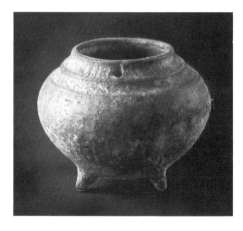

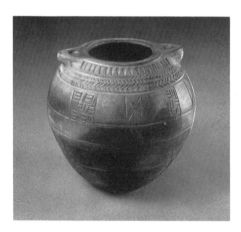

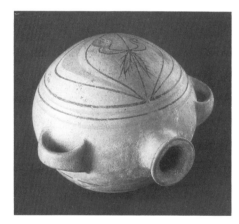

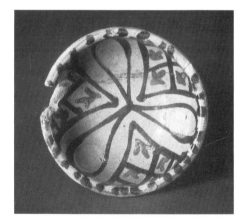

Pot. Third millennium B.C.
Found at the site of Shengavit, Yerevan
Clay, fired, carbon-smoked, and burnished. Height 44
Museum of the History of Armenia, Yerevan

Jug. Beginning of the first millennium B.C.
Found in the village of Akunk, Abovian District
Clay, fired, carbon-smoked, and burnished. Height 20
Museum of the History of Armenia, Yerevan

Pot. 8th century B.C.
Found at the site of Astkhiblur near the village of Yenokavan,
 Idzhevan District
Fired clay. Height 10
Museum of the History of Armenia, Yerevan

Pot. Third millennium B.C.
Found at the site of Mokhrablur, Echmiadzin District
Clay, fired, carbon-smoked, and burnished. Height 14.5
Museum of the History of Armenia, Yerevan

Jug. Beginning of the first millennium B.C.
Found in the village of Akunk, Abovian District
Clay, fired, carbon-smoked, and burnished. Height 19.5
Museum of the History of Armenia, Yerevan

Flask. 3rd or 2nd century B.C.
Found at Oshakan, Ashtarak District
Clay, fired and painted. Height 28
Museum of the History of Armenia, Yerevan

Pot with decoration in the shape of animals. End of the second
 millennium B.C.
Found at Sanain
Fired clay, with applied handworked decoration. Diameter 40
Museum of the History of Armenia, Yerevan

Three-footed pot. 8th or 7th century B.C.
Found at the site of Astkhiblur near the village of Yenokavan,
 Idzhevan District
Fired clay. Height 23.5
Museum of the History of Armenia, Yerevan

Bowl. 9th century
Found at the site of Dvin, Artashat District
Clay, fired, with underglaze slip decoration. Height 4,
 diameter 9.5
Museum of the History of Armenia, Yerevan

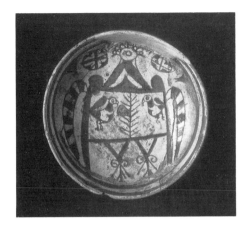

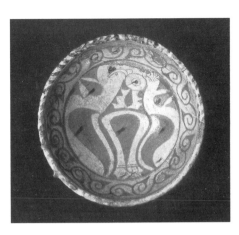

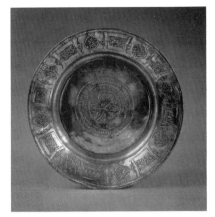

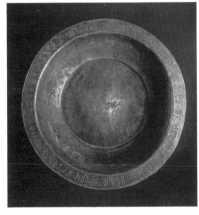

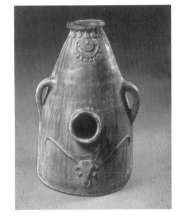

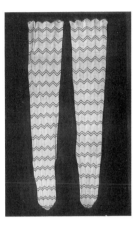

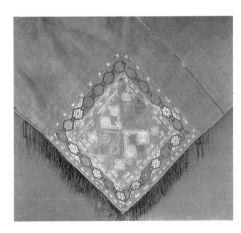

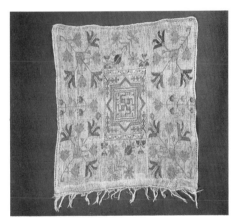

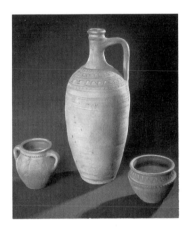

Bowl. 11th or 12th century
Found at the site of Dvin, Artashat District
Clay, fired, with underglaze slip decoration.
 Height 5.5, diameter 13.5
Museum of the History of Armenia, Yerevan

Dish. 1731
Western Armenia
Copper, chased and engraved. Diameter 21
Museum of the History of Armenia, Yerevan

Woman's kerchief. 19th century
Western Armenia
Cotton, with satin-stitch embroidery in silk. 95 × 70
Museum of the History of Armenia, Yerevan

Bowl. 11th or 12th century
Found at the site of Dvin, Artashat District
Clay, fired, with underglaze slip decoration.
 Height 6.5, diameter 18
Museum of the History of Armenia, Yerevan

Container for salt. 19th century
Village of Eranos, Erivan Province
Fired clay, with applied handworked decoration.
 Height 72, diameter 16
Museum of the History of Armenia, Yerevan

Border of towel. 19th century
Western Armenia
Cotton, with satin-stitch embroidery in silk. Width 39 × 42
Museum of the History of Armenia, Yerevan

Dish. 1702
Engraved copper. Diameter 33.5
Museum of the History of Armenia, Yerevan

Stockings. 19th century
Knitted cotton. Length 69
Museum of the History of Armenia, Yerevan

Jug and small pots. 1950s
Yerevan
Fired clay. Height 9, 40, and 8
Union of Artists, Moscow

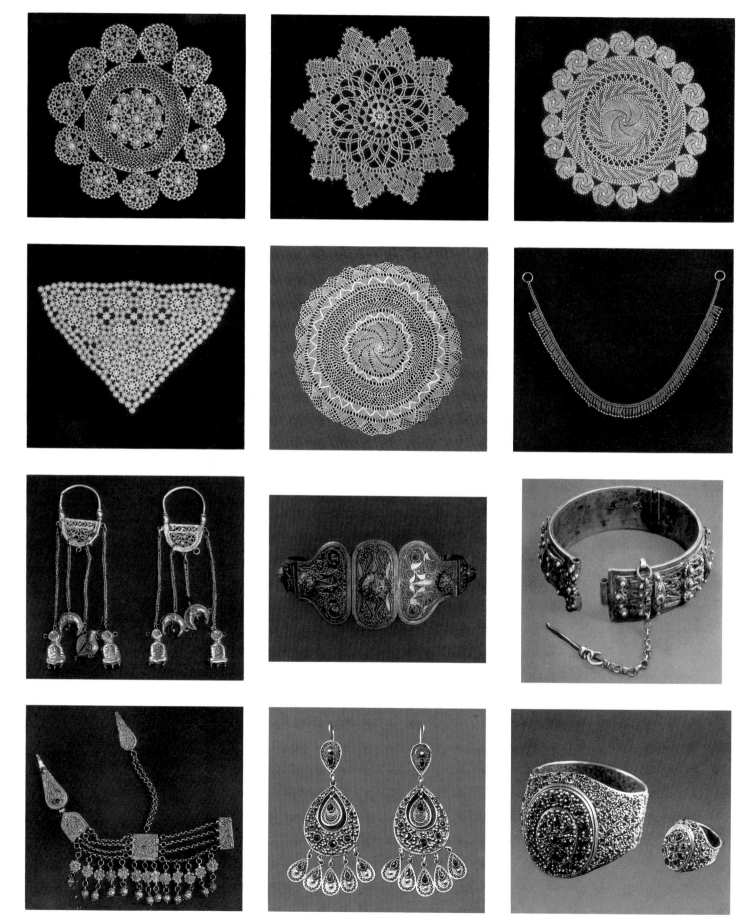

Doily. Early 20th century
By S. Dzhrbashian
Western Armenia
Bobbin lace of cotton thread. Diameter 15
Museum of Armenian Folk Art, Yerevan

Doily. Early 20th century
By S. Dzhrbashian
Western Armenia
Bobbin lace of cotton thread. Diameter 13
Museum of Armenian Folk Art, Yerevan

Doily. Early 20th century
Yerevan
Bobbin lace of cotton thread. Diameter 19
Museum of the History of Armenia, Yerevan

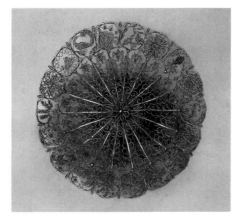
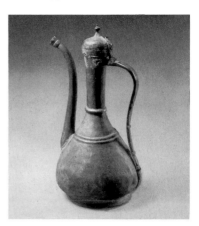

Kerchief. 1920
Yerevan
Bobbin lace of cotton thread. Shorter sides 25 (each), longer
 side 35
Museum of the History of Armenia, Yerevan

Doily. 1950s
By A. Sandalchan
Yerevan
Bobbin lace of cotton thread. Diameter 15
Union of Artists, Moscow

Necklace. 10th or 11th century
Found at the site of Dvin, Artashat District
Gold, with fine filigree. Length 34
Museum of the History of Armenia, Yerevan

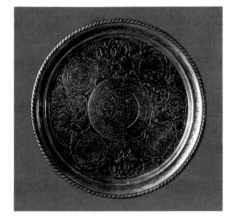
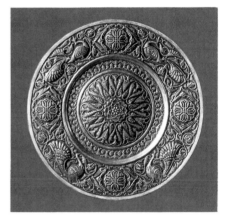

Earrings. 10th or 11th century
Found at the site of Dvin, Artashat District
Gold, cast and chased, with filigree. Length 14
Museum of the History of Armenia, Yerevan

Belt buckle. 19th century
Western Armenia
Silver, with filigree and granulation. Length 22, width 9
Museum of the History of Armenia, Yerevan

Bracelet. 19th century
Western Armenia
Silver, with filigree. Diameter 6
Museum of the History of Armenia, Yerevan

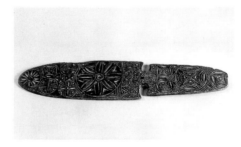
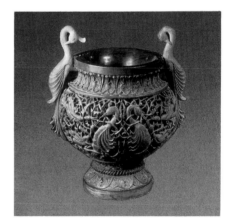

Ornament for woman's headdress. 19th century
Goris
Silver, with filigree and granulation. Length 34
Museum of the History of Armenia, Yerevan

Earrings. 1979
By M. Mandalian
Yerevan
Silver, with filigree and granulation. Length 6.5
Museum of Armenian Folk Art, Yerevan

Bracelet and ring. 1979
By M. Mandalian
Yerevan
Silver, with filigree and granulation. Diameter 5.5 and 2
Museum of Armenian Folk Art, Yerevan

Dish. 20th century
By V. Anagortsian
Silver, with filigree. Diameter 30
Museum of Armenian Folk Art, Yerevan

Decorative dish. 1958
By K. Norashkharian
Yerevan
Engraved copper. Diameter 25
Museum of Armenian Folk Art, Yerevan

Last for stockings. 19th century
Village of Otsun, Erivan Province
Carved wood. 62 × 15
Museum of the History of Armenia, Yerevan

Jug. 1801
Echmiadzin
Chased copper. Height 27
Museum of the History of Armenia, Yerevan

Decorative dish. 1957
By H. Hakopian
Yerevan
Silver, chased and carved. Diameter 30
Museum of Armenian Folk Art, Yerevan

Vase: *Cilicia.* 1964
By A. Azatian.
Yerevan
Carved wood. 26 × 30
Museum of Armenian Folk Art, Yerevan

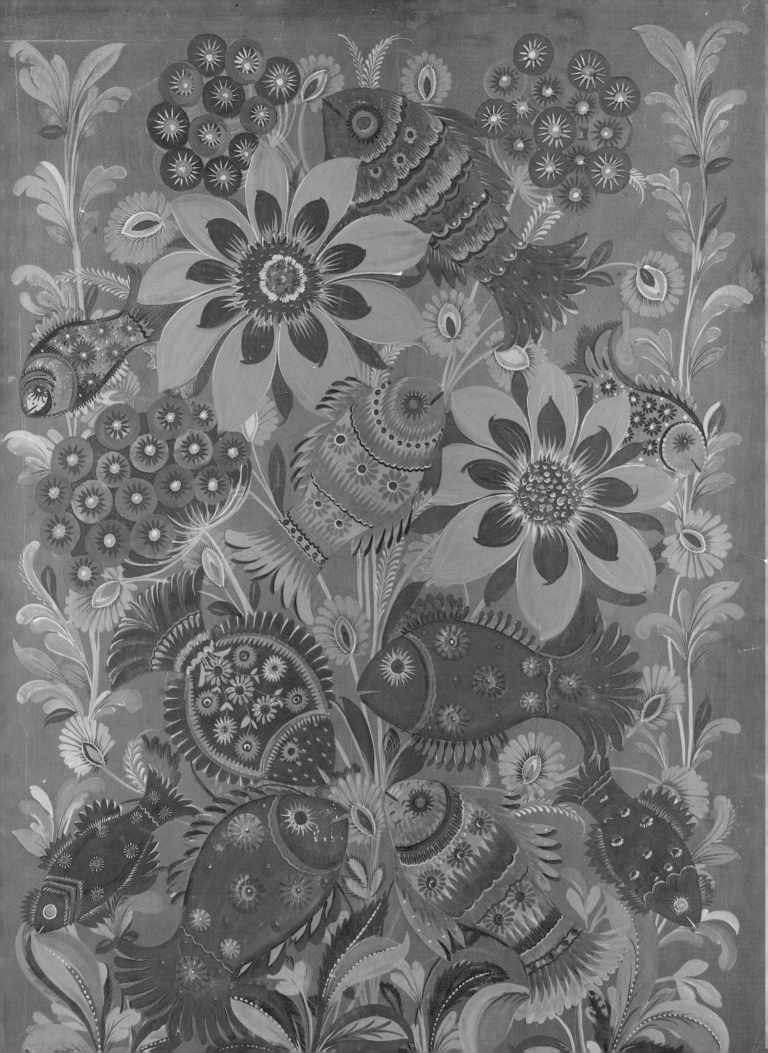

UKRAINIAN, BYELORUSSIAN, AND MOLDAVIAN FOLK ART

Three Soviet republics, the Ukraine, Byelorussia, and Moldavia, are located along the western border of the USSR, and each is endowed with a rich cultural legacy. Until relatively recently the majority of their population were peasants, and peasant art was practiced on a wide scale. Traditional forms of national art and folk craft centers in these republics have remained popular to this day. Thousands of craftsmen are engaged in handloom-weaving, wood carving, ceramic art, and many other arts and crafts.

Such traits as devotion to custom and tradition, and love for their national costumes and historical rural dwellings, are equally manifested in each of the three republics. The vitality of folk Ukrainian, Byelorussian, and Moldavian culture is evidenced not only by the vigorous revival of their traditional folk arts but also by the emergence of new artistic trends. Although generating from modern tastes, these trends do not repudiate their folklore roots but merely enhance them. Even professional artists are appreciably affected by folk art. Among the three republics strong cultural relations are maintained, which in no way impairs the originality of each republic's culture and art.

Folk Art in the
UKRAINE

Ukrainian folk art traditions are rooted in the art and culture of ancient Kievan Rus. In 1908, a potter's workshop was excavated by Vikenty Khvoiko in Kiev. This remarkable find includes the kiln for firing ceramic tiles, as well as stoves for fusing differently colored enamels and tile fragments, the glaze of which was still in perfect condition. Apart from tiles, the Kievan potters produced other glazed and enamelled earthenware. In the centuries that followed, Ukrainian pottery became prominent in other towns, such as Oposhnia and Mirgorod near Poltava; Glukhov and Baturin near Chernigov; Bubnovka, Gaisin, and Tulchin in Podolia; Kosov, Kolomyia, and Pistyn near Stanislav; and Vasilkovo, Dybintsy, and Mezhgorye in the vicinity of Kiev.

Ukrainian pottery is remarkable for its clear-cut shapes and attractive decoration. Wheel-thrown pots are often embellished with simple stamped designs of bands or wavy lines. Earthenware dating from the fourteenth and fifteenth centuries still shows Byzantine influence, but later each area's wares began to take on a distinctive local character. The Kievan potters, for example, emphasized the plastic expressiveness of their work, while ornamental rosettes borrowed from wood carving and die-stamped on wet clay before firing were favored by the Kharkov potters. Vessels from Oposhnia were remarkable for their high quality and attractive painted designs decorating the entire surface. White and green color schemes, unique ornaments, and a special painting technique are all characteristic of pottery made by the Huzuls in the western Ukraine.

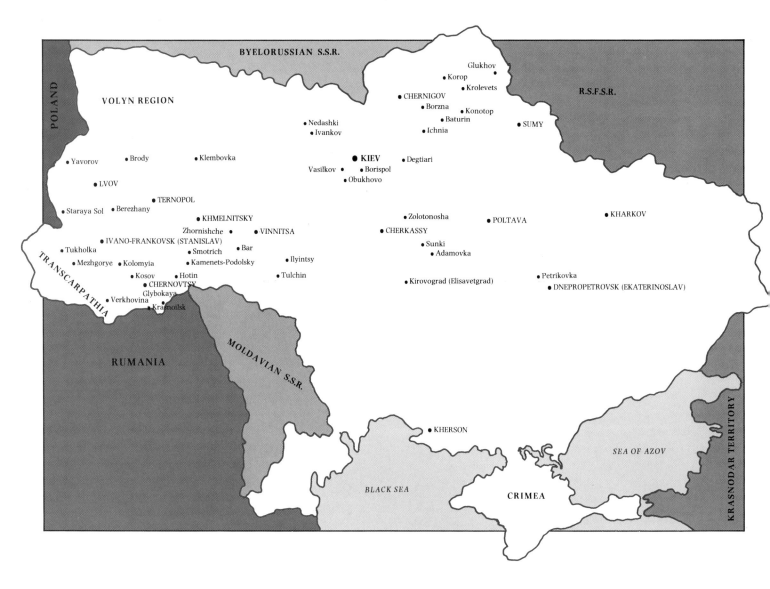

In the late eighteenth and early nineteenth century, mass-produced crockery became increasingly widespread in towns, supplanting wheel-thrown pottery. Despite this, folk pottery retained its traditional austere utilitarian shapes and geometric and plant motifs, and extensive use of jugs, pots, flasks, and other types of earthenware in peasant homes continued. They were generally arranged on a special shelf in the house, adding color to the interior and blending with the brightly embroidered towels, variegated rugs, handloomed bedspreads, and tablecloths, to produce a rich colorful atmosphere. Bowls made in the village of Oposhnia, where excellent colored clays are available, were painted with cockerels in white outline on a red background and then glazed. The birds had rounded tail feathers and were surrounded by twigs painted in a free, sweeping manner. Some artists aimed at the utmost simplicity of composition, while others elaborated it by enlarging the cockerel and introducing lush foliage, which replaced the twigs, and thin stripes in two or three colors, which ran along the bowls' edges. Pottery with underglaze decorations is still made in Oposhnia, but in the present-day range of ware, vessels in the form of fantastic lions and rams are important. Ingenious and dynamic despite their rather large size, these figures show affinity with traditional earthenware toys.

Well-to-do peasant's house interior. 19th century
Huzul Transcarpathia
Museum of Ethnography and Handicrafts, Lvov

Stove tile. 1830s
Village of Ichnia, Borzna District, Chernigov Province
Clay, molded and fired, with underglaze slip decoration.
19 × 16 × 5
Ethnography Museum, Leningrad

Village headman's house. 1910
Built by V. Voloshin
Village of Tukholka, Eastern Galicia
Museum of Peasant Architecture and Domestic Life, Lvov

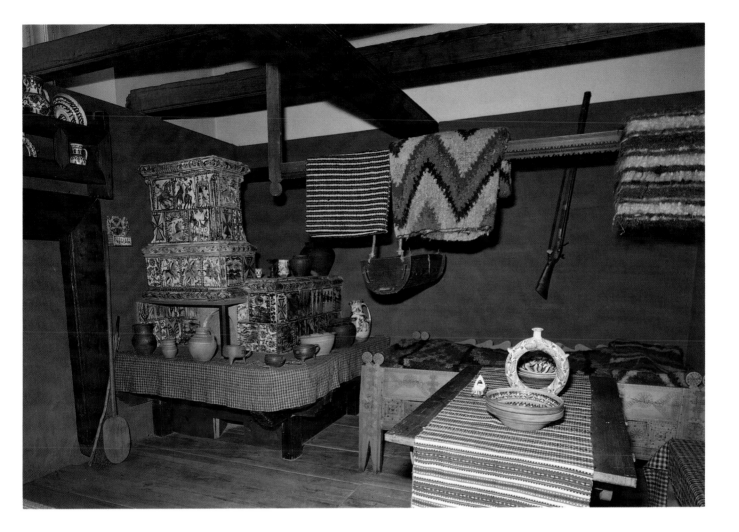

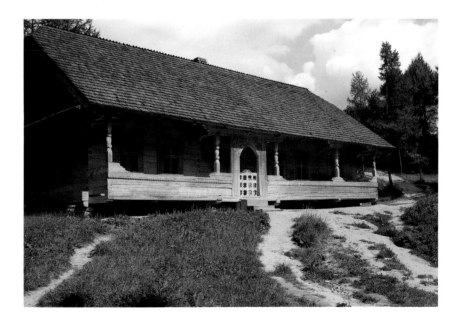

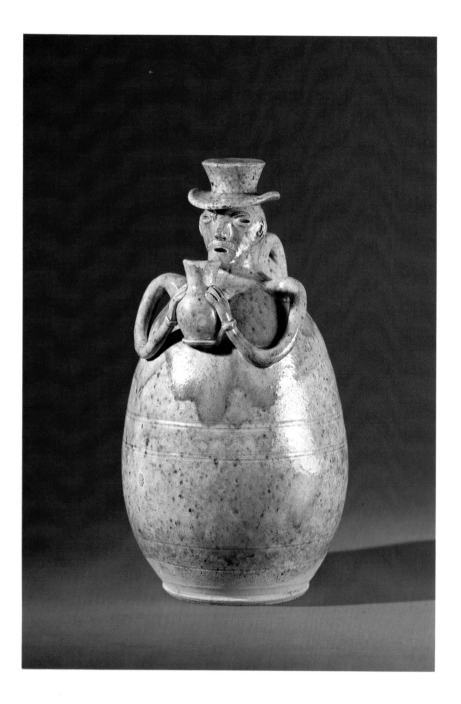

Vessel: *Old Man with a Jar*. 19th century
Kharkov Province
Clay, fired, glazed, and with applied handworked decoration.
 Height 23, diameter 12
Museum of Ukrainian Folk Decorative Arts, Kiev

Stove tile. 1830s
Village of Ichnia, Borzna District, Chernigov Province
Clay, molded and fired, with underglaze slip decoration.
 20 × 15 × 5
Ethnography Museum, Leningrad

Stove tile. Late 18th or early 19th century
Village of Sunki, Cherkassy Province
Clay, molded and fired, with underglaze slip decoration.
 22.5 × 28
Museum of Ukrainian Folk Decorative Arts, Kiev

Dybintsy village pottery was even more decorative. Besides cockerels, their designs included peahens and other birds painted attractively in several colors. The Dybintsy potters also made beautiful two-handled jars with graceful necks resembling Greek amphoras. Another popular ware was a pumpkin-like vessel painted in white, red, brown, and green with fish, birds, and plants.

While the Oposhnia and Dybintsy wares were decorated in a bright painterly manner with broad, sweeping brushstrokes, the urban potters of

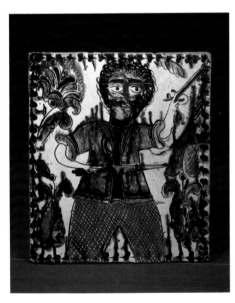

Stove tile. 1830s
Village of Ichnia, Borzna District, Chernigov Province
Clay, molded and fired, with underglaze slip decoration.
 20 × 14.5 × 5
Ethnography Museum, Leningrad

Stove tile depicting a brigand. Second half of the 19th century
Kosov, Eastern Galicia
Clay, molded and fired, with underglaze slip decoration.
 23.5 × 20
Private collection, Lvov

Korchaga **jar.** 19th or early 20th century
Eastern Galicia
Fired clay, with applied details and underglaze slip decoration.
 Height 28
Museum of Ukrainian Folk Decorative Arts, Kiev

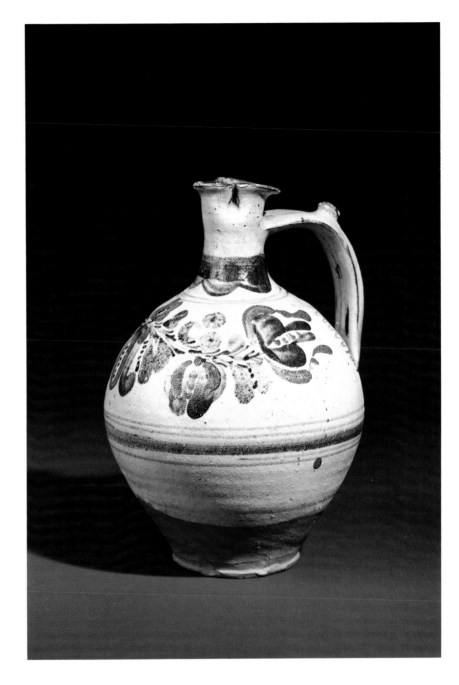

Kosov employed an entirely different approach. They would outline the design through the wet slip, fire the vessel in a kiln, and, later, color the incised design. Matvei Kovalsky and Petro Gavrishchev were the first known potters from this area. They worked in the early nineteenth century, and fortunately some of their bowls and tiles have survived. Abandoning the traditional system of ornamentation based on simple geometric patterns, they began depicting genre scenes and historic events with amazing ingenuity and freedom. It was in Gavrishchev's work that the comical image of

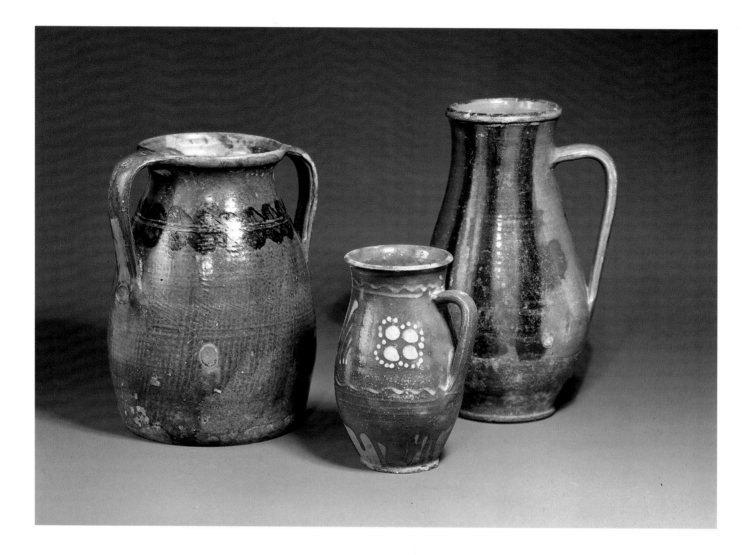

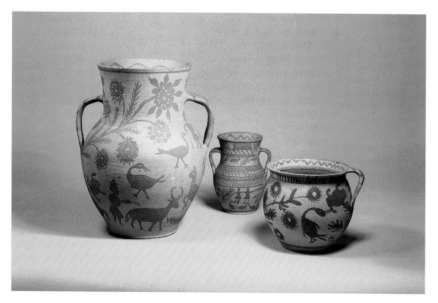

Jugs. Early 20th century
Eastern Galicia
Fired clay, with applied details and underglaze slip decoration.
 Height 27, 18.5, and 30
Museum of Ukrainian Folk Decorative Arts, Kiev

Jugs and pot. Early 20th century
By Ya. Batsutsa
Village of Adamovka, Letichev District, Podolsk Province
Clay, fired and painted. Height 31, 14, and 15
Museum of Ethnography and Handicrafts, Lvov

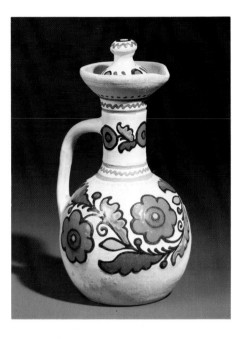

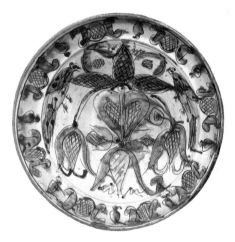

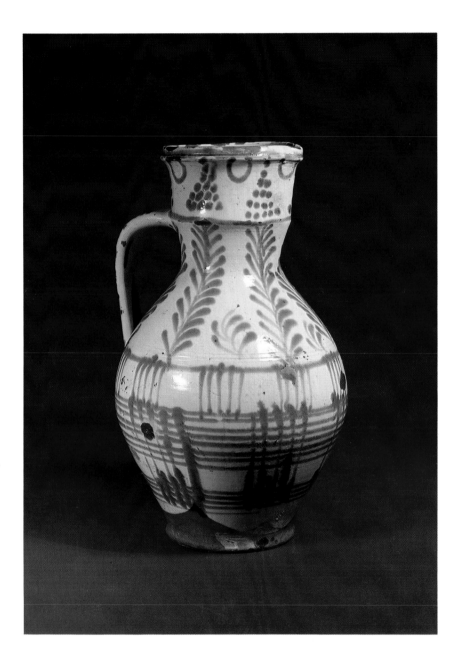

Decanter. Early 20th century
By F. Chirvenko
Village of Oposhnia, Poltava Province
Fired clay, with applied details and underglaze slip decoration.
 Height 22
Museum of Ukrainian Folk Decorative Arts, Kiev

Bowl: *Flowerpot with Birds.* Second half of the 19th century
Kosov, Eastern Galicia
Fired clay, with slip and incised underglaze decoration.
 Diameter 30
Museum of Ethnography and Handicrafts, Lvov

Jug. Early 20th century
Berezhany, Eastern Galicia
Fired clay, with applied details and underglaze slip decoration.
 Height 33.4
Museum of Ethnography and Handicrafts, Lvov

the Austrian soldier appeared for the first time in Huzul ceramics. The conqueror was shown smoking a pipe, riding in a carriage, or drinking a huge glass of vodka, but never in combat. Occasionally he was depicted engaged in more important endeavors such as riding horseback—his haughty, idle look dispelling any notion that he was in the midst of bullets and shells, but more likely on a parade or hunting ground, or perhaps just flaunting himself in front of the ladies. The heyday of Huzul ceramics was in the second half of the nineteenth century when such craftsmen as Piotr Baraniuk and Oleksa Bakhmatiuk from Kosov, and Dmitro Zantiuk from Pistyn, were its chief representatives. Baraniuk and Bakhmatiuk continued the narrative

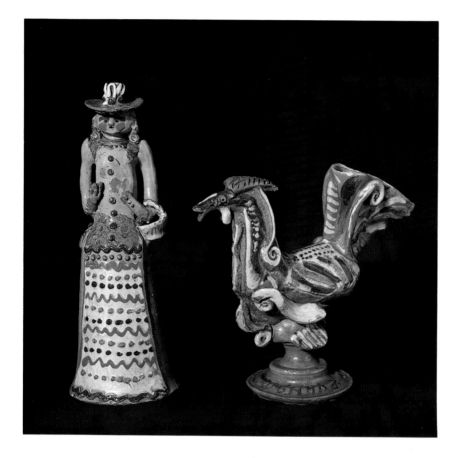

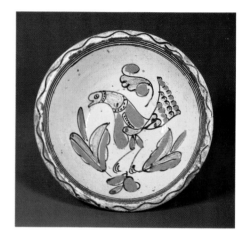

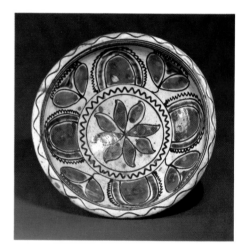

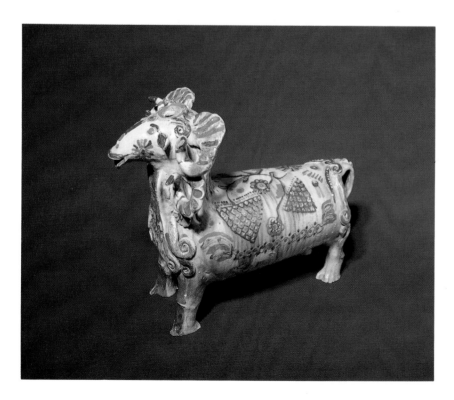

Vessel: *Rooster.* 1903. **Whistle:** *Young Lady.* 1902
By Ye. Nachovnik
Village of Misskiye Mliny, Zenkov District, Poltava Province
Handworked clay, fired, with underglaze slip decoration.
 Height 29 and 36.5
Ethnography Museum, Leningrad

Vessel: *Ram.* 1903
By Ye. Nachovnik
Village of Misskiye Mliny, Zenkov District, Poltava Province
Handworked clay, fired, with underglaze slip decoration.
 41 × 47
Ethnography Museum, Leningrad

Bowl. Early 20th century
Bar, Podolsk Province
Fired clay, with underglaze slip decoration. Diameter 27.5
Museum of Ethnography and Handicrafts, Lvov

Bowl. 1920s
Shargorod, Vinnitsa Region
Clay, fired, with underglaze slip decoration. Diameter 28
Private collection, Kiev

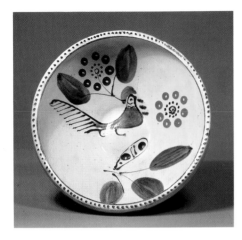

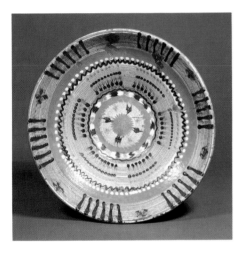

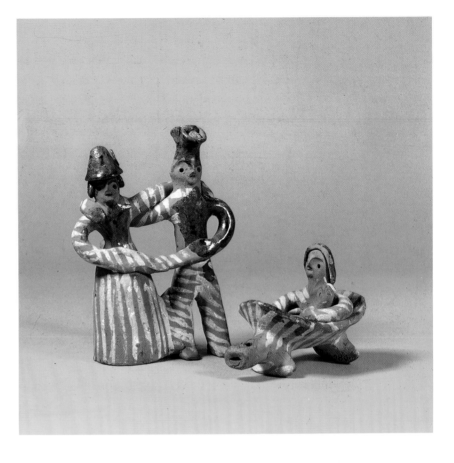

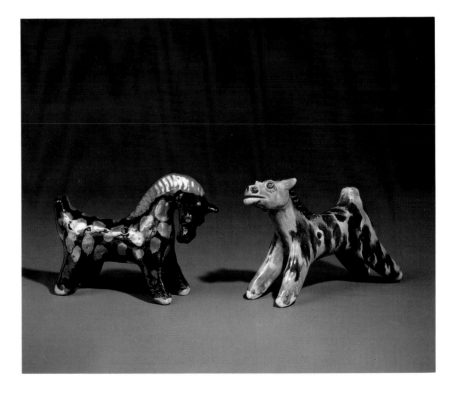

Bowl. 1930s
By G. Borodziansky
Smotrich, Khmelnitsky Region
Clay, fired, with underglaze slip decoration. Diameter 34
Private collection, Kiev

Bowl. 1930s
By I. Chumak
Village of Lesovoye, Vinnitsa Region
Clay, fired, with underglaze slip decoration. Diameter 32
Private collection, Kiev

Whistles. Early 20th century
Village of Staraya Sol, Eastern Galicia
Handworked clay, fired, with underglaze slip decoration.
 Height 14.8 and 8.5
Museum of Ethnography and Handicrafts, Lvov

Horses. 1950s
By Ye. Zhelezniak
Kiev
Handworked clay, with colored glaze. Height 9 and 8
Museum of Ukrainian Folk Decorative Arts, Kiev

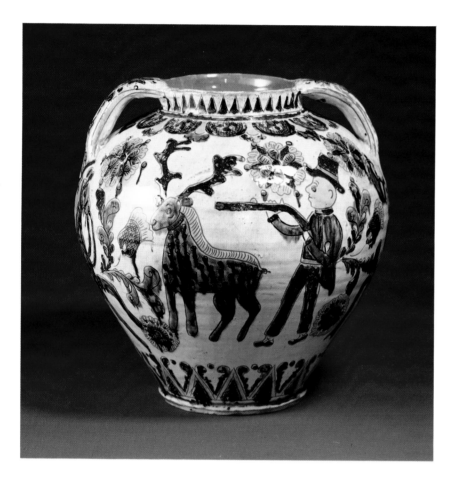

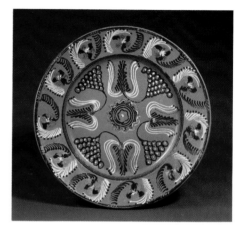

Vase: *Sportsman*. 1959
By N. Verbivskaya
Kosov, Stanislav Region
Fired clay, with underglaze slip and engraved decoration.
 Height 28
Museum of Huzul Folk Art, Kolomyia

Dish. 1930s
By A. Gerasimenko and Ya. Gerasimenko
Villlage of Bubnovka, Vinnitsa Region
Clay, fired, with underglaze slip decoration. Diameter 37
Museum of Ukrainian Folk Decorative Arts, Kiev

Jug. 1960s
By K. Voloshchuk
Kosov, Ivano-Frankovsk Region (Stanislav Region before
 1962)
Fired clay, with underglaze slip decoration. Height 27.5
Museum of Ukrainian Folk Decorative Arts, Kiev

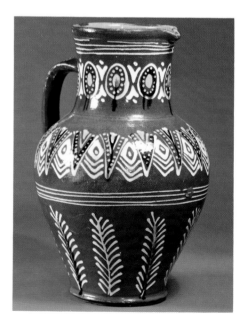

line. Their tilework bore genre scenes and scenes of *galanterie*, which some-
times formed a series. When there was not enough space for the composi-
tion on one tile, the hunt or battle scene would be spread onto a second or
third tile. Tiles of this kind were arranged in rows as stove and fireplace fac-
ing. Most of their tilework compositions have an organic link with Huzul
folklore. Like the anonymous authors of peasant ballads and tales rich in
hyperbole, folk craftsmen often resorted to exaggeration to stress their atti-
tudes on the subject portrayed and to achieve a vividness peculiar to folk
art. In addition to subject compositions that appeared as late as the nine-
teenth century, Huzul pottery retained elements of the geometric style and
traditional motif of the Tree of Life—a gorgeous flower stretching toward
the rim of the bowl flanked on both sides by figures of oxen, deer, and birds.
An inclination for representing animals has proved enduring in these parts.
They occupy a place of prominence in the work of the famous folk artist
Pavlina Tsvilyk from Kosov and in modern painted decorations on bowls,
jugs, and tankards made by other artists in the same area.

 In other Ukrainian centers of folk ceramics, such as the villages of Va-
silkovo, Bubnivtsy, and Adamovka, the traditional decorative techniques

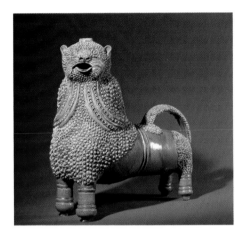

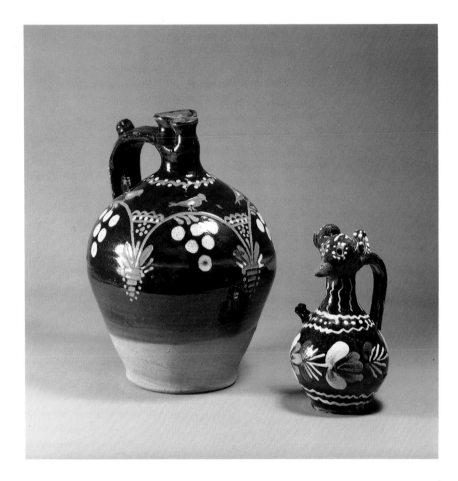

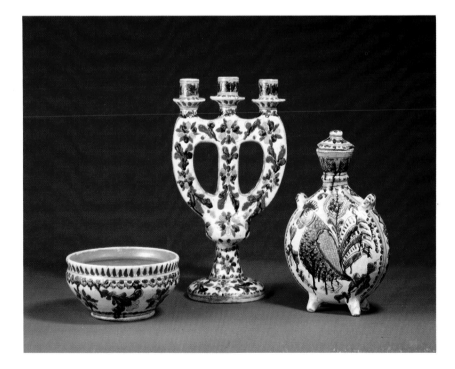

Vessel in the form of a lion. 1960s
By I. Bilyk
Oposhnia, Poltava Region
Handworked clay, fired and glazed. Height 90
Museum of Ukrainian Folk Decorative Arts, Kiev

Ewer and bottle with a stopper in the form of a ram's head.
1957
By M. Galas
Village of Vilkhivka, Transcarpathian Region
Clay, fired, with applied details, and with underglaze slip and
incised decoration. Height 25.5 and 16.5
Museum of Ukrainian Folk Decorative Arts, Kiev

Bowl, candelabrum, and jug. 1959–60
By P. Tsvilyk
Kosov, Stanislav Region
Clay, fired, with applied details (candelabrum and jug) and
with underglaze slip and incised decoration. Height 16,
33.5, and 26
Museum of Ukrainian Folk Decorative Arts, Kiev

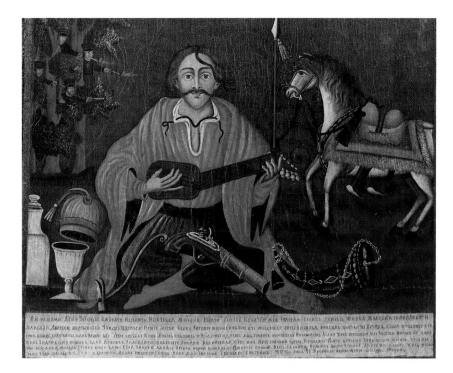

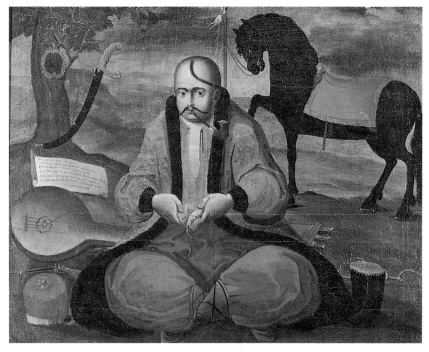

and motifs have been carefully preserved. Ukrainian potters have demonstrated in the past few decades that this province of folk art remains as important and vivacious as ever.

In an etching entitled *Presentations in Chigirin* by Taras Shevchenko, a famous nineteenth-century Ukrainian poet and artist, one can see the interior of a peasant house, on the wall of which hangs a picture of a Cossack seated under a tree strumming a pandora. This detail in the print can hardly be accidental, for the artist was intimately familiar with the life of the

Cossack Mamai (Ukrainian folk picture). 1834
Oil on canvas. 74 × 51
Museum of Ukrainian Fine Arts, Kiev

Cossack Mamai (Ukrainian folk picture). Late 18th or early
 19th century
Oil on canvas. 91 × 86
History Museum, Chernigov

Ukrainian peasantry. As a matter of fact, in the seventeenth and eighteenth centuries this folk painting motif was so common that the depiction of a Cossack with his musical instrument could be seen in every peasant house painted on cardboard, plywood, or simply on a whitewashed wall. It became known by its folklore name as Cossack Mamai. The image originated in the sixteenth century and later became stereotyped as a stocky man seated with his legs tucked under him, next to his ever-present black horse, a devoted companion in battle and long marches. His kit and arms hang from tree branches, his spear and free army flag are stuck into the ground, and a decanter of vodka and a glass are at his feet. These pictures were elaborately painted with rustic ingenuity: the Cossack's shirt collar and sleeves are decorated with the characteristic national embroidery, his saber glitters,

Cossack Mamai (Ukrainian folk picture)
Oil on canvas. 50.5 × 69.5
Museum of Ukrainian Fine Arts, Kiev

Cossack Mamai (Ukrainian folk picture). First half of the 19th
 century
Oil on canvas. 90 × 73
Museum of Local Lore. Odessa

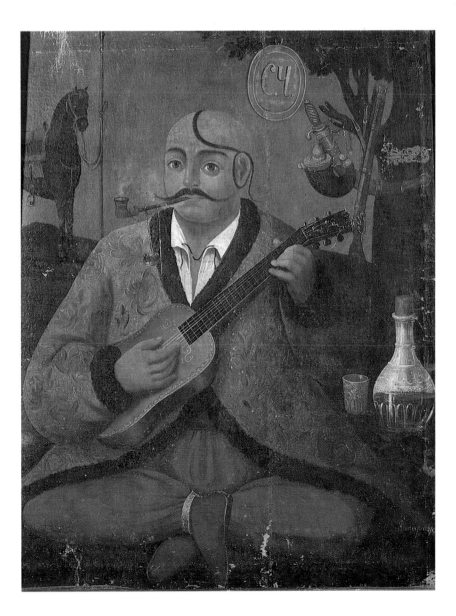

the horse's mane is neatly brushed. The Cossack typifies the freedom-loving *haydamak* rebels.

Ukrainian folk pictures originated to some extent from the old tradition of decorative painting by peasants. Their picturesque and fertile land alone could have stimulated the local predilection for decorating houses, furniture, dishes, and most wooden utensils. Even in pagan times ornamented window and door frames were fairly common there. Until the eighteenth century plant motifs predominated in the local painted decorations, but later folk artists increasingly leaned toward battle scenes, genre subjects, and folklore characters, which had parallels in decorations on contemporary tiles, ceramic and glass vessels, and wooden and earthenware toys.

When the stormy period of Peter the Great's military campaigns came to a close in the early eighteenth century, plant designs reappeared as predominant elements in folk painting. Peasants again began to paint walls and pediments of their houses with ornamental friezes, and around their doors and windows they depicted garlands of flowers. Inside the house, stoves, beams, and corners were similarly decorated. The entire pier was sometimes painted with carpet-like patterns. In contrast to central Ukrainian subject decorations, austere ornaments of graphically linear designs, similar to Rumanian and Slovene patterns, were common in the peripheral Transcarpathian region and northern Bukovina. Until the twentieth century paints were made by the artist himself, who mixed powdered clay with egg and milk, adding dyes extracted from flowers, grass, bark, and tree roots. As aniline dyes emerged, the colors became brighter, although some of their purity was lost.

Like Russian painted decorations, Ukrainian designs were generally rapidly executed without preliminary sketches or drawings. The folk artisan's skill was so great that the entire interior of a house took only a day or two to paint. Especially famous are the painted designs in the villages of Petrikovka in the Dnepropetrovsk area, Bolotnia in the Kiev area, and Yavorov in the Lvov area. There even today not only the houses but also most of the utensils are painted.

Individual artists play an important role in Ukrainian folk art. Hanna Sobachko-Shostak, for example, produced her first works before the 1917 October Revolution. They are distinguished for their expressive quality and fresh color; some of them were used as sketches for carpets, tapestries, and embroideries, which were made in the workshop of Ye. Pribylskaya, another woman artist whose work had been shown at exhibitions in Kiev, St. Petersburg, and Berlin. The name of Sobachko-Shostak had begun to appear in the Western European press, but wide recognition came to her only in Soviet times. During the May Day festivities of 1919 her new works, *The Horsemen*, *The Red May*, and *The Ukrainian Wreath*, which were painted on colored backgrounds, were displayed at the first exhibition of Soviet Ukrainian folk art. On the same occasion the streets and squares of Kiev were decorated with huge panels painted after her sketches.

St. George Slaying the Dragon. First half of the 20th century
Eastern Galicia
Oil on glass. 44 × 32.5
Museum of Ethnography and Handicrafts, Lvov

World of Wonders. 1973
By M. Primachenko
Village of Bolotnia, Ivankov District, Kiev Region
Gouache and watercolor on paper. 89 × 64
Museum of Peasant Architecture and Domestic Life, Kiev

Compared with the bright and broad manner in which Hanna Sobach-ko-Shostak worked, paintings by Katerina Belokur, a peasant woman from the Poltava area, appear more intimate and refined. This impression is due both to her lyrical manner and her accomplished technique, which distinguished her from the common run of folk painters. Without any assistance she had progressed from painting pretty flowers to creating large skillfully balanced compositions involving hundreds of minutely elaborated details. At first Belokur did not prime her canvases and the bright colors soon lost their luster. With great persistence she would reconstruct every detail, trying to master the unyielding medium. Despairing of her attempts to preserve the picture, she realized that the canvas should be prepared beforehand. Although by that time different methods of priming had been known for centuries, she eventually evolved her own technique. The peasant girl began to cover her canvas with several coats of oil mixed in definite proportions until she had what was both a priming and a color ground for her painting.

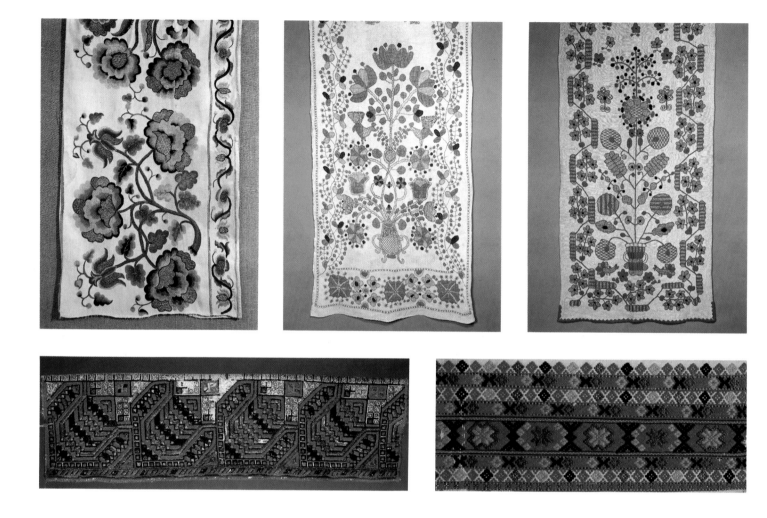

Belokur's working methods were also peculiar: she outlined neither the whole nor any constituent part of her composition on the canvas, nor did she use any preliminary sketches or studies. One can only marvel at the artist's unerring sense of harmony and color, which enabled her to preserve the cohesion of a painting she had worked on for several years. At an international exhibition in Paris in 1948 some of the canvases by this Ukrainian peasant woman were awarded a gold medal.

Maria Primachenko, from the village of Bolotnia in the Kiev area, is undoubtedly the most famous living folk painter in the Ukraine. The sources of her optimistic art permeated with poetic fantasy are not difficult to find, for the same mood and characteristics are seen in old painted decorations on Ukrainian peasant trunks, in colorful Ukrainian embroidery, and in folklore. Her paintings are inhabited by many of the same creatures that form the imagery of local painting. They include the traditional peahens, herons, or rams, as well as unfamiliar fantastic monsters traceable to heathen mythology and later transformed by naive peasant mentality. However, Primachenko's monsters, shown sauntering peacefully in thickets of gorgeous

Detail of surplice. 18th century
Village of Sukhorovka, Poltava Region
Homespun linen, with satin-stitch embroidery in silk and
 metal thread
Museum of Ukrainian Folk Decorative Arts, Kiev

Detail of towel. 19th century
Kiev Province
Homespun linen, embroidered in cotton thread
Museum of Ukrainian Folk Decorative Arts, Kiev

Detail of towel. Early 20th century
Village of Reshetniaki, Poltava Region
Homespun linen, embroidered in cotton thread
Museum of Ukrainian Folk Decorative Arts, Kiev

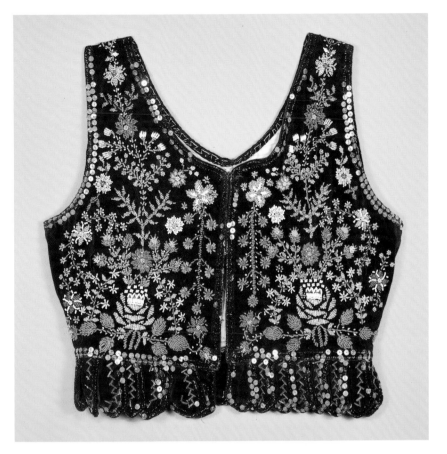

Detail of woman's headdress. 19th century
Gorodenka District, Eastern Galicia
Homespun linen, with embroidery in cotton, silk, and metal
 thread
Museum of Ethnography and Handicrafts, Lvov

Detail of woman's headdress. Early 20th century
Village of Richka, Kosov District, Eastern Galicia
Homespun linen, with embroidery in silk thread
Museum of Huzul Folk Art, Kolomyia

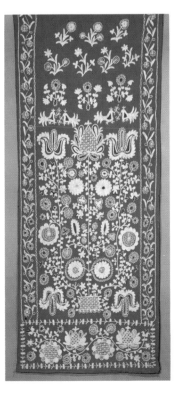

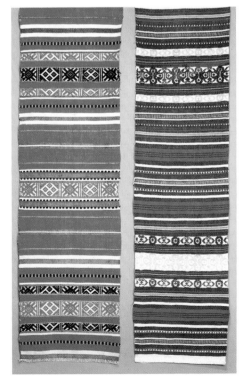

Woman's sleeveless blouse. 19th century
Kosov District, Eastern Galicia
Cloth, embroidered in silk and woollen thread, with beadwork
 and spangles
Museum of Huzul Folk Art, Kolomyia

Detail of towel. Early 20th century
Village of Mezhirich, Sumy District, Kharkov Province
Homespun linen, with tambour embroidery in cotton thread
Museum of Ukrainian Folk Decorative Arts, Kiev

Details of towels. Late 19th or early 20th century
Kiev Province
Homespun patterned linen
Museum of Ukrainian Folk Decorative Arts, Kiev

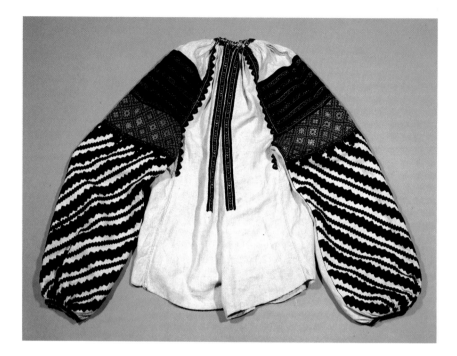

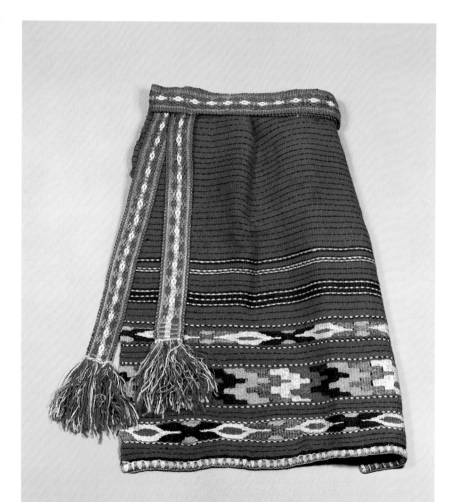

Woman's blouse. Late 19th or early 20th century
Eastern Galicia
Crewelwork. 68 × 60
Museum of Ukrainian Art, Lvov

Apron and waistbelt. Early 20th century
Kiev Province and Poltava Province
Homewoven wool, with embroidery. 76 × 51; length of belt
 355
Museum of Ukrainian Folk Decorative Arts, Kiev

Detail of sleeve of woman's blouse. Early 20th century
Eastern Galicia
Homespun linen, with half-cross-stitch embroidery in cotton
 and woollen thread
Museum of Ukrainian Folk Decorative Arts, Kiev

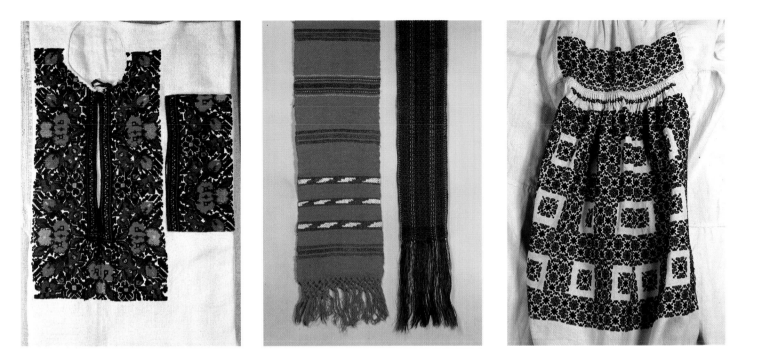

Details of man's shirt. Early 20th century
Village of Borshchev, Eastern Galicia
Homespun linen, with half-cross-stitch embroidery in cotton
and woollen thread
Museum of Ukrainian Folk Decorative Arts, Kiev

Details of apron and waistbelt. Early 20th century
Kiev Province and Poltava Province
Homewoven wool
Private collection, Kiev

Detail of sleeve of woman's blouse. Early 20th century
Kiev Province
Homespun linen, with cross-stitch embroidery in cotton
thread
Museum of Ukrainian Folk Decorative Arts, Kiev

flowers, are not very frightening; her lion, with knitted brows, is even re-
clining on a bed like a cat. Moreover, her favorite characters are not exotic
beasts or monsters but kindly hares, foxes, and birds, which are often clad
in bright national costume and engaged in merrymaking. These images, as
well as her wonderful flowers reaching out for the sun, demonstrate that
Primachenko's work is in the mainstream of Ukrainian folk art.

Ukrainian textiles, like the painted decorations, are characterized by
vivid colors and highly varied designs.

Embroidery has been practiced on a large scale in the Ukraine from the
earliest times, as evidenced by fabric fragments excavated by archaeologists,
by some frescoes and miniatures dating back to Kievan Rus, and by written
records. Embroidered geometric designs on the collars, cuffs, and fronts of
women's shirt-like dresses are clearly seen on numerous stone figures sur-
viving from the tenth and eleventh centuries. The style of clothing and em-
broidery has remained essentially the same since. In the eighteenth and
nineteenth centuries, Ukrainian needlewomen used over a hundred varie-
ties of stitches in embroidering the towels, shirts, tablecloths, and bed-
spreads for which the Ukraine is famous. The designs include geometric or-
naments that used to have a symbolic significance, plant motifs interspersed
with bird and animal images, or a female figure with outstretched arms,
deriving from ancient popular beliefs. One object would sometimes be
trimmed with embroidery executed in a combination of different techniques
to make it particularly decorative. In some localities the customary colored
embroidery was supplanted by whitework in satin stitch. Embroidery is so

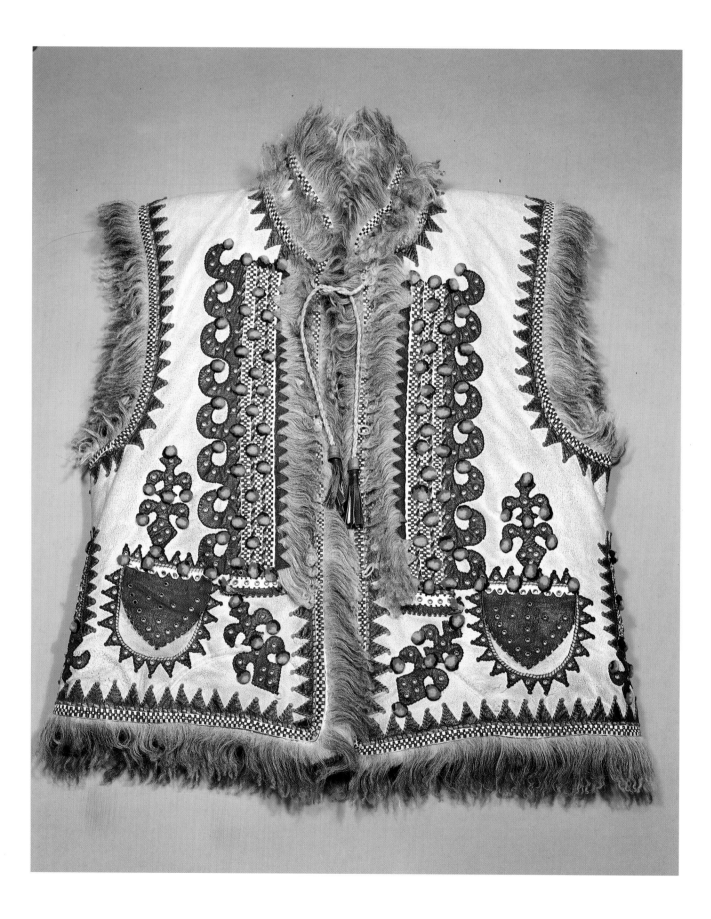

Sleeveless jacket. 1900
Kosov District, Eastern Galicia
Sheepskin, with leather appliqué. Length 59
Museum of Huzul Folk Art, Kolomyia

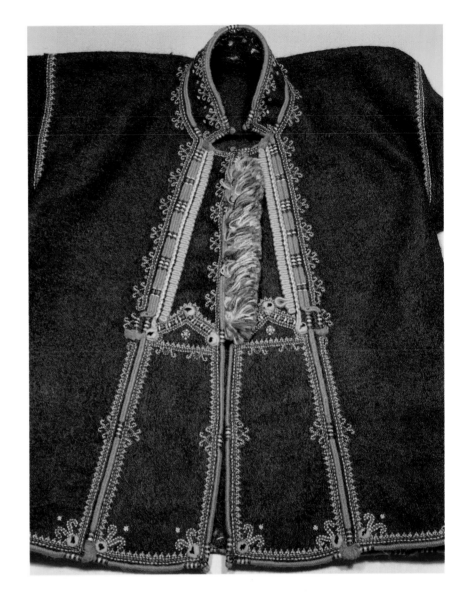

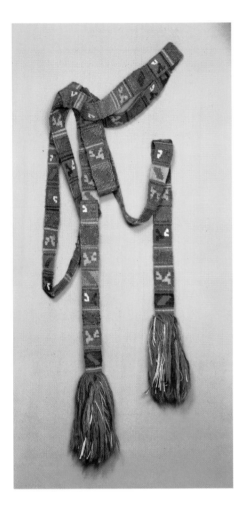

Belt. Early 20th century
Village of Shishaki, Poltava Province
Homewoven wool. Length 300
Museum of Ukrainian Folk Decorative Arts, Kiev

Man's jacket. 1935
Nadvornaya District, Stanislav Region
Cloth, embroidered in woollen thread. Length 70
Museum of Huzul Folk Art, Kolomyia

popular in the Ukraine that it is hard to give preference to any particular group of practitioners, yet the needlewomen from the old villages of Degtiari, Klembivka, and Kosmach in the Chernigov and Vinnitsa areas are of especially high repute.

Patterned weaving also continues to develop in modern times. Various geometric designs on tablecloths, towels, bedspreads, skirts, and other textile articles are twilled to form a raised pattern on the cloth's surface, which resembles low-relief designs carved on wood. Despite the appearance of textile factories in the Ukraine as far back as the late eighteenth century, handloom weaving has survived in peasant homes to the present day.

The Ukraine is famous also for its flat-homewoven rugs, *kilims*, first mentioned in the sixteenth century. A century later they were made on a fairly large scale in Brody, Sokhachiovo, and Lvov. Judging by written de-

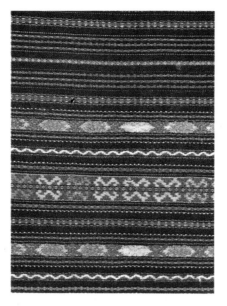
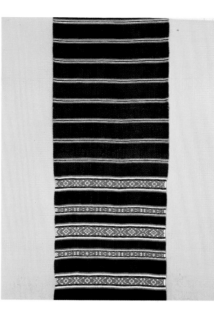
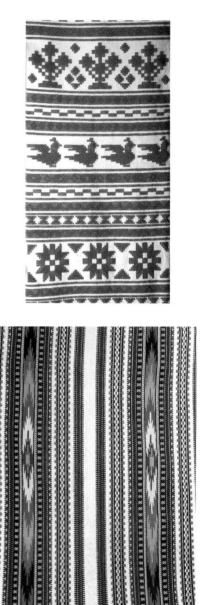
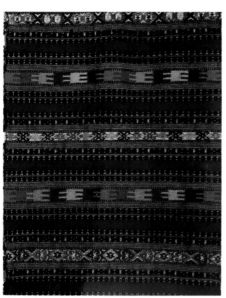

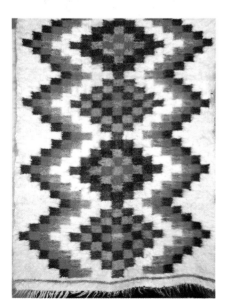
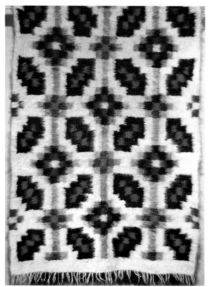
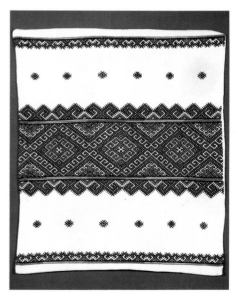

Detail of apron. 1930s
Village of Kudrintsy, Ternopol Region
Shuttle-woven wool, with interwoven silk and metal threads
Private collection, Kiev

Detail of towel. 1961
By A. Veres
Village of Obukhovichi, Kiev Region
Homewoven cotton and rayon
Museum of Ukrainian Folk Decorative Arts, Kiev

Detail of towel. 1960s
Krolevets, Sumy Region
Homewoven cotton and rayon
Museum of Ukrainian Folk Decorative Arts, Kiev

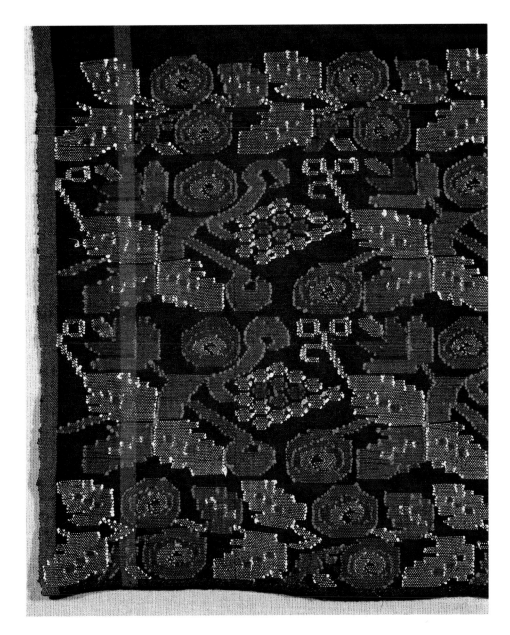

Detail of carpet. 1962
By A. Martyshchuk
Village of Sheshory, Ivano-Frankovsk Region
Homewoven patterned wool
Museum of Huzul Folk Art, Kolomyia

Woman's blouse. 1960
By P. Berezovskaya and M. Oleinik
Village of Klembovka, Vinnitsa Region
Crepe de chine, embroidered in mouliné
Museum of Ukrainian Folk Decorative Arts, Kiev

Pillowcase. 1967
By O. Gorbovaya
Kosov, Ivano-Frankovsk Region
Homespun patterned linen, embroidered in mouliné. 41 × 4
Museum of Ukrainian Folk Decorative Arts, Kiev

Rug. 1969
By V. Shkriblik
Yavorov, Ivano-Frankovsk Region
Homewoven wool. 250 × 148
Museum of Huzul Folk Art, Kolomyia

Detail of rug. 1971
By V. Chernomudiak
Kosov, Ivano-Frankovsk Region
Homewoven wool
Museum of Huzul Folk Art, Kolomyia

Pillowcase. 1974
By N. Gerasimiuk
Village of Babin, Kosov District, Ivano-Frankovsk Region
Homespun linen, embroidered in cotton thread. 46 × 40
Museum of Huzul Folk Art, Kolomyia

Detail of woman's dress. 1960s
Chernovtsy Region
Homewoven wool and cotton
Museum of Ukrainian Folk Decorative Arts, Kiev

Detail of napkin. 1970
By A. Gerasimovich
Kosov, Ivano-Frankovsk Region
Homespun linen, embroidered in mouliné
Museum of Ukrainian Folk Decorative Arts, Kiev

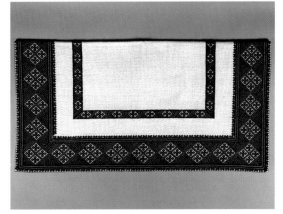

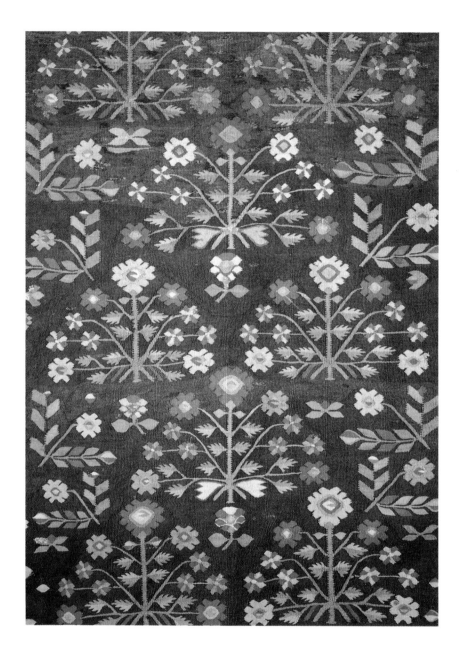

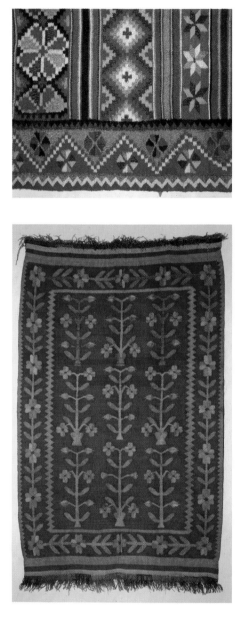

scriptions of them, the earliest designs consisted of floral patterns in the Baroque style. As carpet-weaving methods developed, both flat- and pile-woven rugs were made in the Ukraine. They became an essential part of a peasant household and were used as wall hangings or coverings for shelves and benches. Their plant ornamentation varied greatly depending on their function. Rugs commissioned by wealthy customers usually retained some High Baroque or Neoclassic features. Their color scheme was soft, with golden, white, pale blue, or sandy tones predominating. Rugs for the peasantry, on the other hand, had bold woven designs in reds, greens, or yellows on deep green, yellow, or blue backgrounds, a trend that became dom-

Carpet. Mid-19th century
Kiev Province
Flat-woven wool on hemp ground. 220 × 155
Museum of Ethnography and Handicrafts, Lvov

Detail of rug. 1892
Village of Nedashki, Volyn Province
Flat-woven wool
Museum of Ethnography and Handicrafts, Lvov

Rug. Early 20th century
Village of Bazarintsy, Eastern Galicia
Flat-woven wool. 218 × 136
Museum of Ethnography and Handicrafts, Lvov

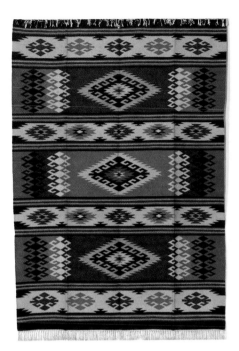

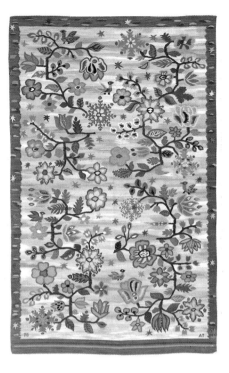

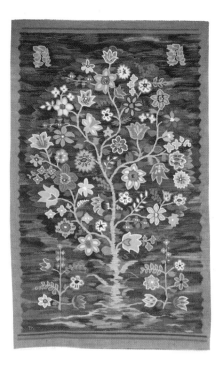

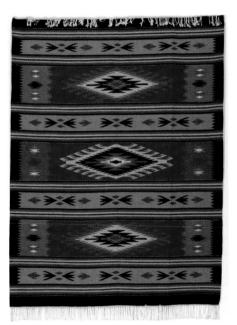

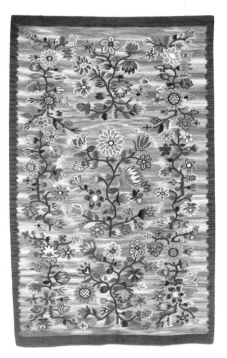

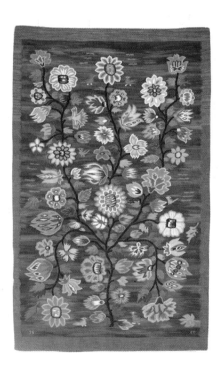

Rug. 1978
Ternopol Region
Flat-woven wool. 140 × 210
Union of Artists, Moscow

Rug. 1978
Ternopol Region
Flat-woven wool. 140 × 120
Union of Artists, Moscow

Tapestry. 1978
By L. Tovstukha
Village of Reshetilovka, Poltava Region
Homewoven wool. 200 × 140
Union of Artists, Moscow

Tapestry. 1978
By L. Tovstukha
Village of Reshetilovka, Poltava Region
Homewoven wool. 200 × 400
Union of Artists, Moscow

Tapestry. 1978
By L. Tovstukha
Village of Reshetilovka, Poltava Region
Homewoven wool. 200 × 140
Union of Artists, Moscow

Tapestry. 1978
By L. Tovstukha
Village of Reshetilovka, Poltava Region
Homewoven wool. 200 × 140
Union of Artists, Moscow

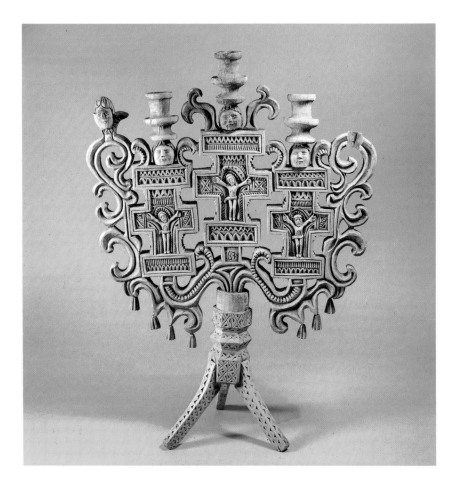

inant in the nineteenth century. Rugs made in the Ukraine today carry subject designs, emblems, symbols, and, occasionally, portraits, as well as traditional geometric and plant ornaments.

The ornamental concepts of embroidery and weaving are reflected in yet another form of Ukrainian folk art—egg painting. Like the ornamentation used in other folk arts, it shows considerable variation, with plant motifs prevailing in the east of the Ukraine, and geometric designs, interspersed with zoomorphic elements, in the west. Eggs were painted practically all over the Ukraine, resulting in an exceptional diversity of both color and execution. The most intricate designs were painted by the Huzuls, particularly in the village of Kosmach, which is famous for its rich artistic traditions. The most remarkable quality is the amazing profusion of detail painted on the egg's spherical surface, which is not well suited for painting. While the Kosmach embroideries, the village specialty, were treasured heirlooms passing from generation to generation, painted eggs lasted only a few weeks or even a few days. Yet their ornamentation was no less elaborate and ornate than Kosmach needlework. In order to understand the fond attention given them by peasant women, who set aside all other chores and their usual needlework to spend hours decorating those eggs, one must appreciate the special symbolic role they played in the spring rites. These rites are generally believed to be linked with the Christian holiday of Easter. As a matter of fact, painted eggs, like many other folk art traditions, have far

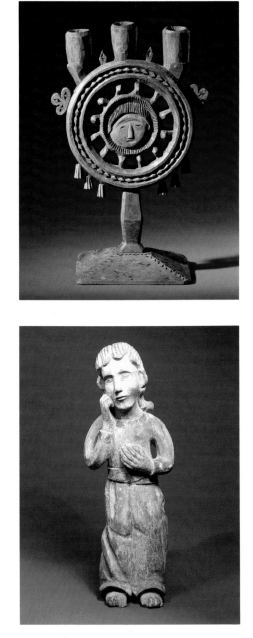

Candelabrum. 1874
Kosov, Eastern Galicia
Carved wood. Height 56
Museum of Ethnography and Handicrafts, Lvov

Candelabrum. 19th century
Village of Sheshory, Eastern Galicia
Carved wood. Height 29.5
Museum of Ukrainian Folk Decorative Arts, Kiev

Christ Mourning. 19th century
Western Ukraine
Carved wood
Private collection, Lvov

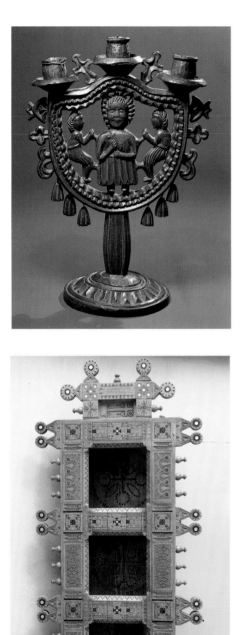

Candelabrum. 19th century
Eastern Galicia
Carved wood. Height 35
Private collection, Lvov

Detail of shelf for pottery. 1920s
By V. Shkribliak
Kosov, Eastern Galicia
Wood, carved and pokerworked, inlaid with beads and
 mother-of-pearl
Museum of Ukrainian Art, Lvov

older roots that can be traced back to Slavonic pagan beliefs, which upheld the myth that the universe originated from the egg. Inspired by loyalty to their customs and traditions, the artisans of today paint these eggs with the same veneration as before. When a young man gives a girl a beautifully decorated and carefully selected egg, it shows that he is favorably disposed to her; for children these eggs are playthings, while for elderly people they are a token of friendship and good will.

Although painted egg designs and colors largely echo traditional embroidery motifs, they are easier to experiment with than expensive needlework; therefore many needlewomen test their new designs on eggs. Actually, the process of dyeing the egg in the western Ukraine is fairly complicated. The ornament is not applied with a brush, so it is imprecise to call them painted eggs. The egg is first hard-boiled or hollowed. Molten wax is applied with a special pipe to those areas of the surface that are to remain blank, and the egg is immersed in a solution of yellow dye. Then the yellow parts of the ornament are waxed and the egg is immersed in red dye. Finally, after covering the red parts of the design with wax, the egg is placed in black dye. When dry, the egg is heated and the wax removed from the surface with a soft cloth. At this point the egg is ready for some finishing touches. A few green or blue dots are added with a brush, after which a dash of fat is applied to the surface to enliven the colors.

Especially attractive eggs are adorned with subject designs surrounded by ornamental borders. The central picture depicts a spring flower in a vase, a deer, a fish, a Huzul cottage amidst greenery, or even a scene from the life of the Carpathian Huzuls. In Kosmach alone, about sixty women practice egg dyeing. They are encouraged by an old legend, which purports that the evil spirit dwelling on the high summits of the Carpathian Mountains will not prevail over the jolly, hard-working Huzuls so long as the colors of these miniature paintings remain unfaded and the weave of their intricate pattern unbroken.

The ornament of the Huzul eggs has a great deal in common with designs carved on wooden objects of Ukrainian workmanship. A popular belief shared by all Slavs prescribed that a protective fetish should be carved, or made otherwise, and nailed over the entrance to the house and barn in order to protect the inhabitants and their livestock from harm and disease and drive away the evil spirits. After the adoption of Christianity, the cross (which, incidentally, had also figured as a symbol of the sun in some pagan beliefs) became the main protective image. It was found all over the house: on the walls, beams, cupboards, tables, and even on wooden tableware. As a rule, it was decorated with solar symbols such as circles, rosettes, or polygons. Eventually wood carving was practiced on such a large scale in the Ukraine that there remained very few objects in peasant homes that were not skillfully adorned with carved designs. The ornament always matched the shape of the object. For a long time the only tool used for carving was a knife, which in no way hindered the quality. Knives were used for making

outlines; chisels for cutting patterns consisted of three-edged dents, which were characteristic of the regions of Poltava, Kiev, and Podolia. As in Russia, this latter type of carving appeared on distaffs, battledores, furniture in peasant homes, and so forth. Geometric motifs, including solar signs, also recall Russian wood carving. A certain austerity of ornamentation did not preclude the use of numerous expressive details by Ukrainian craftsmen. On the whole, though, their carving designs are softer and more vivid than those of their Russian counterparts.

Wooden boards for stamping designs on *prianik* cakes, textile-printing blocks, and tile-stamping dies, the latter used in the east of the Ukraine in the eighteenth and nineteenth centuries, formed a separate, more limited group of wooden objects. Here geometric designs were already superseded by plant motifs, with figures of stylized fantastic beasts blending with the soft outlines of floral sprays and wisps of grass. Some of the intricately carved designs show Baroque influence.

In the nineteenth century, one could still see in the east of the Ukraine some wooden dippers and other objects shaped like birds, resembling similar articles from northern Russia. The latter are fashioned in a more generalized manner and hence appear more symbolic and monumental than the Ukrainian birds, which are treated in a more life-like manner.

Plate. 19th century
Poltava Province
Wood, chiselled and painted in oil. 24.5 × 23 (oval)
Museum of Ukrainian Folk Decorative Arts, Kiev

Plate and spoon. 1963
By Yu. Miklashchuk
Village of Brustury, Ivano-Frankovsk Region
Carved wood. Diameter of plate 22.8, length of spoon 23.9
Museum of Ukrainian Folk Decorative Arts, Kiev

Plate. 1978
By D. Shkribliak
Kosov, Ivano-Frankovsk Region
Carved wood. Diameter 38
Union of Artists, Moscow

Platter. 1903
Village of Demki, Zolotonosha Uyezd, Poltava Province
Wood, chiselled, carved, and painted in oil. 40 × 42 × 3
Ethnography Museum, Leningrad

Tankards. 1959 and 1963
By I. Grimaliuk
Village of Richka, Ivano-Frankovsk Region
Wood, carved and pokerworked. Height 13.8 and 34
Museum of Huzul Folk Art, Kolomyia

Box. 1979
By D. Shkribliak
Kosov, Ivano-Frankovsk Region
Carved wood. 22 × 34 × 16
Union of Artists, Moscow

Chest. 1906
By N. Bublik
Village of Ogrin, Ekaterinoslav Province
Wood, painted in oil, with hammered metal mounts
Museum of Ukrainian Folk Decorative Arts, Kiev

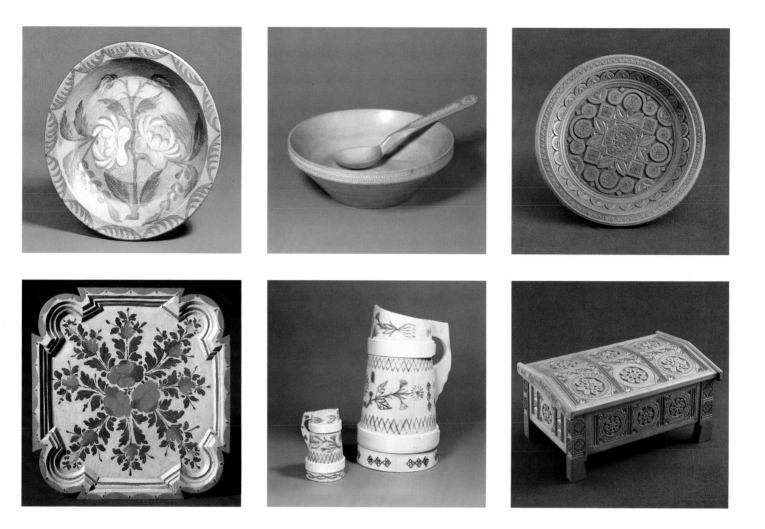

Toward the turn of the twentieth century carved wooden articles were increasingly supplanted by factory-made utensils. Only in some areas of the western Ukraine did carving hold its own, but even here it gradually gave way to pokerwork, which was sufficiently decorative and less time-consuming. The main center for pokerwork is the village of Richka in the Carpathian Mountains. Utensils made in this way with gracefully arranged ornaments based on simple geometric motifs are still in demand in the area. Ivan Grimaliuk is regarded as the leading artist. Another notable artist from Richka, Mikhailo Medvedchuk, whose reputation was not confined to the Carpathians, was famous for making fine musical instruments, including fiddles, reed pipes, and cymbals. He used to make them out of trees struck by lightning because, according to popular belief, the wood of such trees retains the sonority of thunder and the purity of lightning.

Next to Richka lies the village of Yavorov, famous for its high standards of wood carving, which adorns souvenirs and other decorative objects. In the nineteenth century, small boxes, flasks, and dishes from Richka, profusely and variously decorated, became articles of merchandise selling well in Austria, Hungary, Poland, and other Western European countries.

A Huzul carver, Yuri Shkribliak, well known for his skill, used to supplement virtuoso carving with beautiful inlay work of various woods,

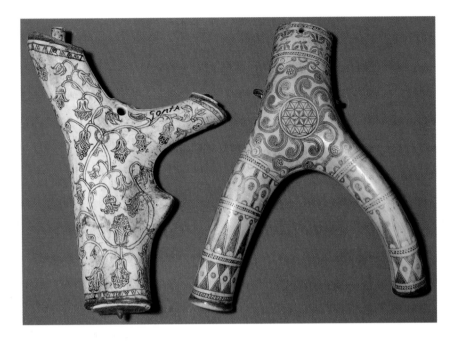

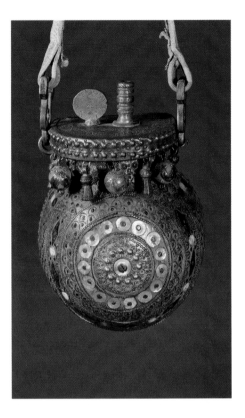

mother-of-pearl, horn, and metal. Insets of pearwood, olive, sycamore, hornbeam, imported mahogany, and ebony greatly enriched his wares' colored range. The introduction of colored beads, a later development, brought about new trends in the decoration of wooden articles.

In the 1920s–30s the making of wooden utensils was at a low ebb. Forty years later, however, the industry was revived in its former center, where the local artistic traditions have been revitalized and useful domestic objects are still produced to this day.

Metalwork and bone and horn carving, especially in the production of arms, powder flasks, and decorative details for saddles and other things used by the Cossacks in daily life, also figured prominently in the Ukrainian folk art of the past. Brass tobacco pipes, resembling small-size hookahs in shape, were indispensable for every male Huzul. The reason they were made of metal rather than the traditional wood is quite simple: just watch an elderly Huzul warm his hands, cold from a moist wind, on his elongated pipe. Another advantage of metal was its longevity, for such a pipe would often pass from generation to generation.

Engravings on brass pistol handles, belt buckles, nutcrackers, pipes, and insets on powder flasks were similar to those found on wooden articles, but were appropriately scaled down and adapted to metal. It is hardly surprising, therefore, that they were made by those craftsmen who specialized in wood carving such as Yuri Shkribliak, Mirko Megedeniuk, and the brothers Dmitro and Mikola Dudchakov, who are recognized as the most accomplished Ukrainian carvers of the first half of the twentieth century. The use of geometric ornaments to decorate metal objects can be traced back to old Slavic customs. In heathen myths, objects themselves often had a cer-

Powder flasks. 1641 and 18th century
Volyn Province
Engraved stag horn. Height 24.5 and 27
Museum of Ukrainian Art, Lvov

Powder flask. 1892
Kosov, Eastern Galicia
Wood, with carved brass mounts, inlaid with mother-of-pearl,
 beads, and Venetian glass. Height 17
Museum of Ethnography and Handicrafts, Lvov

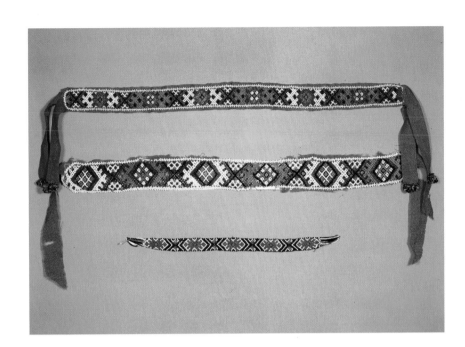

Mask for New Year pantomime. 1973
Village of Voloka, Glybokaya District, Chernovtsy Region
Goat's hair, cotton, wool, straw, feathers, and bugles.
 Length 40
Ethnography Museum, Leningrad

Neck ornaments. Early 20th century
Eastern Galicia
Bead braid. Length 30, 31, and 18
Museum of Huzul Folk Art, Kolomyia

tain symbolic significance. Thus hatchets used by men and women alike were the weapons with which the pagan god Perun was believed to fight his enemies in order to clear the way for his heavenly chariot. Consequently, in local lore a small brass hatchet decorated with a clear linear ornament was supposed to frighten off the evil spirits allegedly surrounding the peasants in the mountains, forests, and fields. With a staff in his hand and armed with a hatchet, many a nobleman of old would take to the road and fight his oppressors or foreign invaders. Folk paintings from the Carpathian Ukraine have delightfully preserved such scenes.

Originally, Ukrainian wood sculpture was of a predominantly religious character. Until late in the nineteenth century, motifs derived exclusively from folklore occurred only in sculpted beehives, mostly around Chernigov. Later, compositions in the round with subjects from peasant life became popular, especially in the western Ukraine, where they were marked by ethnographic authenticity and detailed characterizations. This work was especially attractive for the naiveté, warmth, and freshness with which the artist depicted every characteristic detail of everyday life. In the twentieth century, there has been continuous interest in Ukrainian folk sculpture based on genre, folklore, and heroic subjects.

A very original kind of folk sculpture is found in Kosov District, where small figurines are modelled out of cottage cheese made from sheep's milk. At first this was commonly done by herdsmen during their outings to mountain pastures, but in the course of time women took over. Figurines of this sort representing horses, deer, or chickens, cursorily colored with a few red or green lines, are popular both locally and with visitors.

One of the Ukraine's most remarkable traditional folk crafts is free

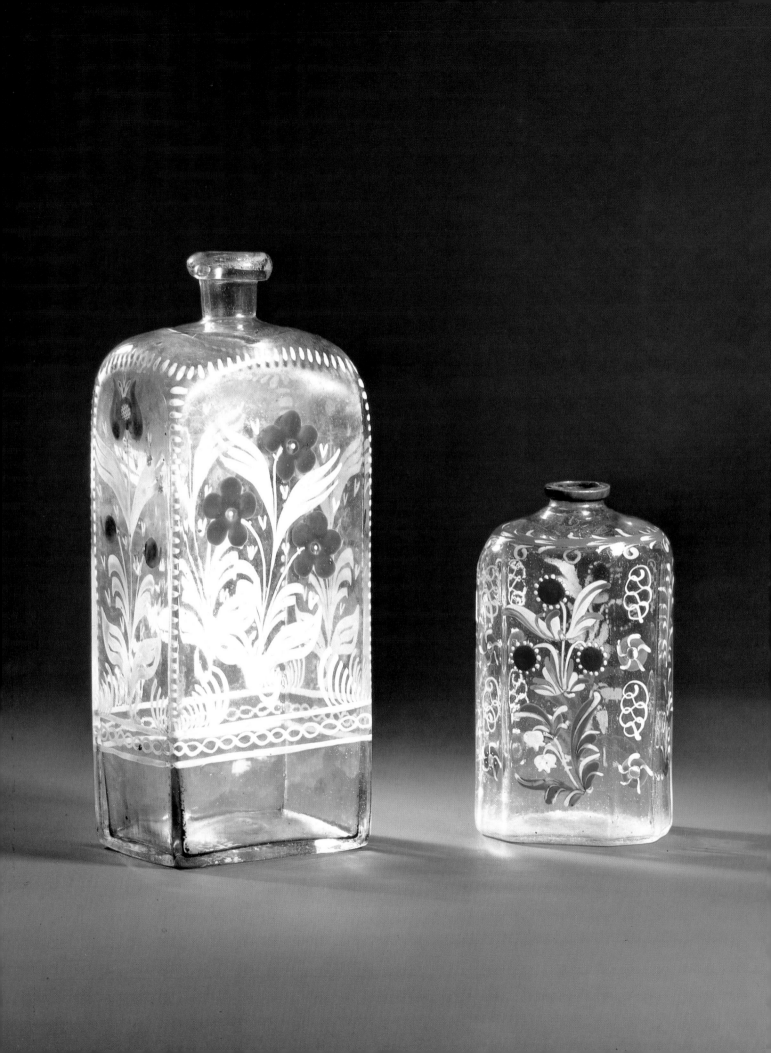

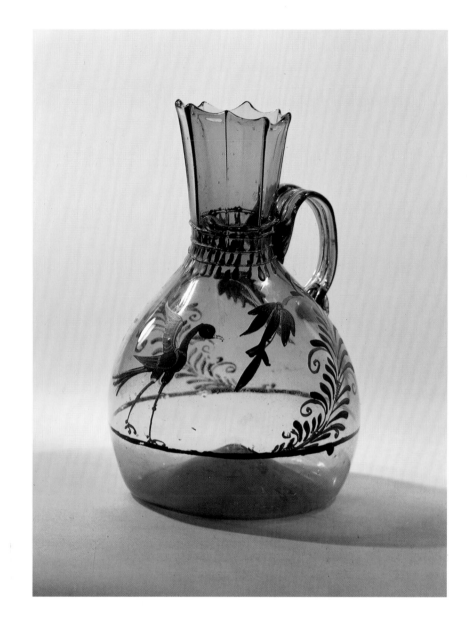

Bottles. 18th or early 19th century
Free-blown glass, painted in enamel colors. Height 18 and 15
Museum of Ukrainian Folk Decorative Arts, Kiev

Vessel: *Egyptian Ram.* 18th century
Western Ukraine
Free-blown glass, with applied details. Height 12.5
Museum of Ethnography and Handicrafts, Lvov

Jug. First half of the 18th century
Free-blown glass, painted in enamel colors. Height 21
Museum of Ukrainian Folk Decorative Arts, Kiev

glassblowing (*huta* glass). Some of the earliest *huta* vessels were decorated with applied multicolored bands. The golden age of Ukrainian *huta* glass occurred in the seventeenth and eighteenth centuries when, in the region of Chernigov alone, there were about ten dozen glassblowing workshops. Their wares were sold in Russia, Poland, Lithuania, Rumania, Turkey, and even Germany, a country where glass-making was already a well-established industry. This great demand for Ukrainian *huta* glass influenced its style toward more expensive tastes. Goblets and decanters were engraved with designs ranging from bouquets of flowers tied with ribbons and stylized shields with heraldic crests to elegantly lettered benedictory inscriptions and toasts, and the date of manufacture, which was ingeniously interwoven into compositions. Sometimes goblets and decanters were engraved with

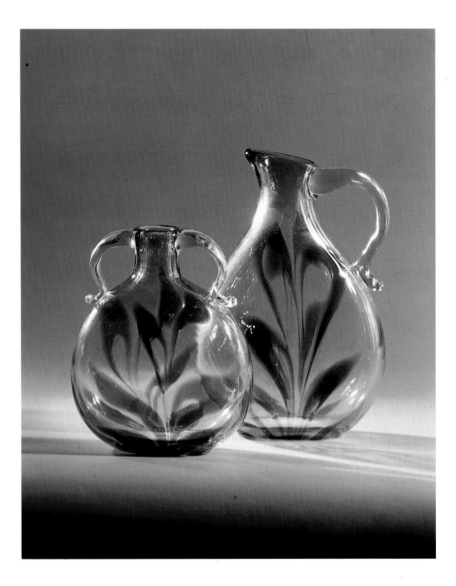

pictures: a horseman with sword raised proudly, a Cossack brigadier with banner and mace, etc. But more common were the traditional Ukrainian images of peacocks, herons, and spiders, as well as such animals as the fallow deer, bear, and fox, which were popular with the common people. Both painted and engraved glassware were expensive and hence hardly accessible to the peasantry. For this reason, typical peasant vessels were not forgotten. Blown mostly in the form of bears and figured bottles, they were established as the most original peasant glassware styles. It was only natural, therefore, that these were among the first articles produced by more recent blowers when the industry, which had been extinct since the end of the nineteenth century, was being revived.

Encouraged by Ukrainian folk art's diversity, broad popularity, and remarkable beauty, thousands of artisans continue to maintain and develop its old-time traditions.

Decanter and ewer. 1967
By P. Dumich
Lvov
Free-blown colored glass, with applied molded details. Height 16 and 21
Museum of Ukrainian Folk Decorative Arts, Kiev

Baskets. 1940s
By P. Shaban
Village of Khodovichi, Lvov Region
Free-blown colored glass, with applied details. Height 16.5 and 16
Museum of Ukrainian Folk Decorative Arts, Kiev

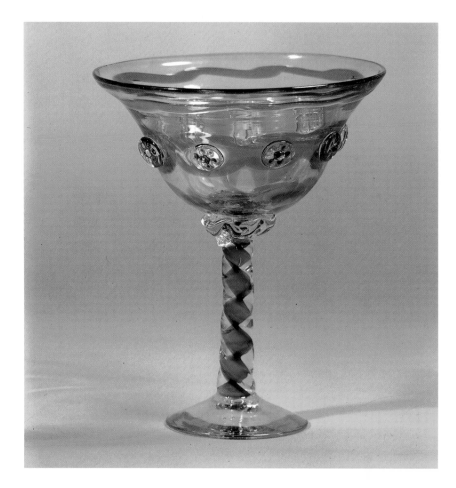

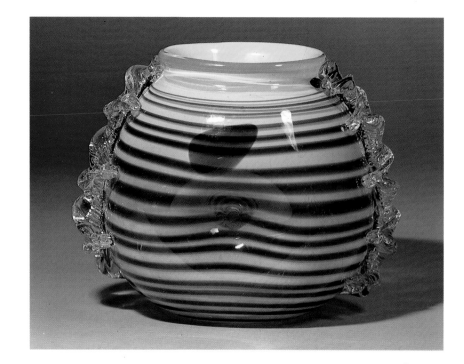

Vase (from the *Dreaming of Venice* series). 1981
By M. Pavlovsky
Lvov
Mold-blown glass, with applied details. Height 22.7
Private collection, Lvov

Vase. 1979
By A. Ghera
Lvov
Mold-blown glass, with applied details. Height 15
Museum of the Art Glass Factory, Lvov

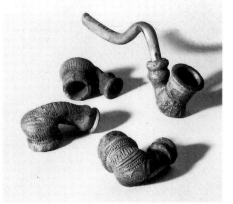

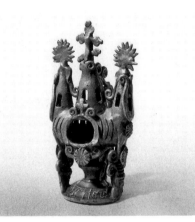
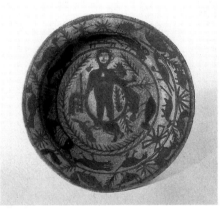
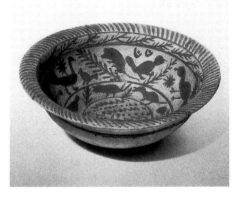

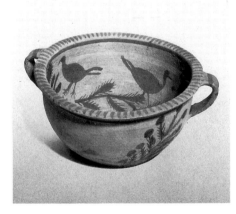
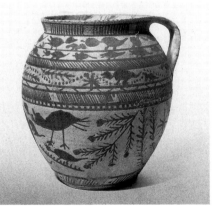
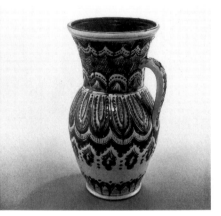

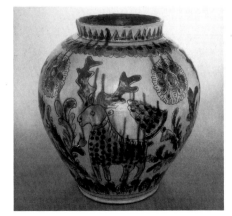
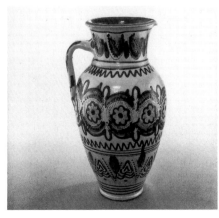
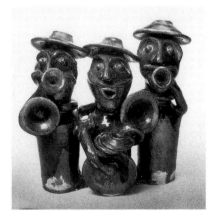

Stove tile. Early 19th century
Village of Ichnia, Borzna District, Chernigov Province
Clay, molded and fired, with underglaze slip decoration.
 20 × 15 × 5
Ethnography Museum, Leningrad

Stove tile. Early 19th century
Konotop, Chernigov Province
Clay, molded and fired, with underglaze slip decoration.
 20.5 × 15.5 × 5
Ethnography Museum, Leningrad

Tobacco pipes. Late 19th or early 20th century
Village of Velikaya Budishcha, Zenkov District, Poltava
 Province
Clay, molded and fired, with stamped designs. Length 2.5, 3,
 4, and 4.5
Ethnography Museum, Leningrad

Incense burner. 1903
By Ye. Nachovnik
Village of Misskiye Mliny, Zenkov District, Poltava Province
Handworked clay, fired and glazed. 31 × 17
Ethnography Museum, Leningrad

Bowl. 1913
By Ya. Batsutsa
Village of Adamovka, Letichev District, Podolsk Province
Fired clay, with underglaze slip decoration. Diameter 19
Ethnography Museum, Leningrad

Bowl. 1913
By Ya. Batsutsa
Village of Adamovka, Letichev District, Podolsk Province
Clay, fired and painted. Diameter 22
Ethnography Museum, Leningrad

Pot. 1913
By Ya. Batsutsa
Village of Adamovka, Letichev District, Podolsk Province
Clay, fired and painted. Height 11
Ethnography Museum, Leningrad

Jar. 1913
By Ya. Batsutsa
Village of Adamovka, Letichev District, Podolsk Province
Clay, fired and painted. Height 20
Ethnography Museum, Leningrad

Jug. 1978
By V. Skoritsky
Kosov, Ivano-Frankovsk Region
Fired clay, with underglaze slip decoration. Height 27
Union of Artists, Moscow

Vase. 1979
By A. Aronets
Kosov, Ivano-Frankovsk Region
Fired clay, with underglaze slip decoration. Height 21
Union of Artists, Moscow

Jug. 1979
By G. Belianskaya
Kosov, Ivano-Frankovsk Region
Fired clay, with underglaze slip decoration. Height 32
Union of Artists, Moscow

Musicians. 1978
By A. Ganzha
Village of Zhornishche, Ilyintsy District, Vinnitsa Region
Handworked clay, fired and glazed. Height 32
Union of Artists, Moscow

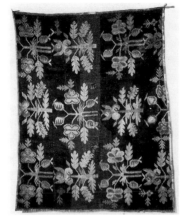

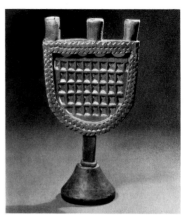

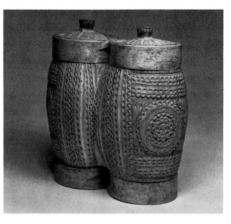

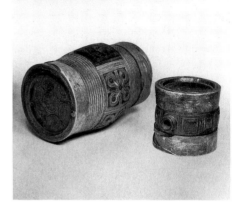

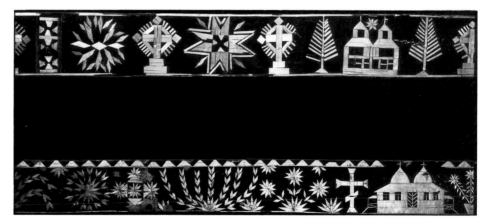

Rug. 19th century
Elisavetgrad District, Kherson Province
Flat-woven wool. 163 × 130
Ethnography Museum, Leningrad

Double vessel. 19th century
Eastern Galicia
Carved wood. Height 21
Museum of Huzul Folk Art, Kolomyia

Details of shelves. 19th century
Village of Polkachov, Volyn Province; village of Rozvazhev,
 Kiev Province
Tinted wood, with straw appliqué
Museum of Ukrainian Folk Decorative Arts, Kiev

Candelabrum. 19th century
Eastern Galicia
Carved wood. Height 35
Private collection, Lvov

Barrel and box for cheese. Second half of the 19th century
Yavorov, Eastern Galicia
Carved wood. Height 28 and 17
Museum of Huzul Folk Art, Kolomyia

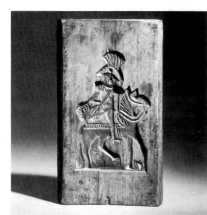

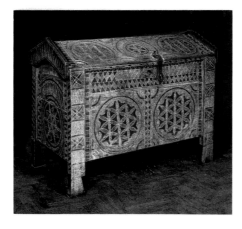

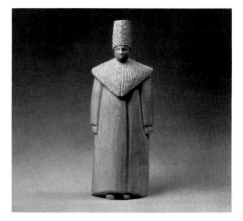

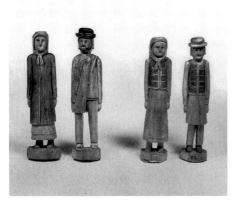

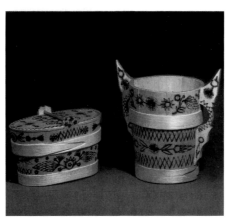

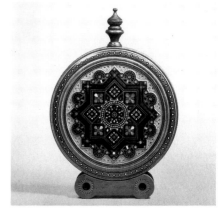

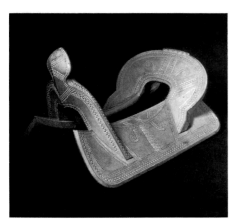

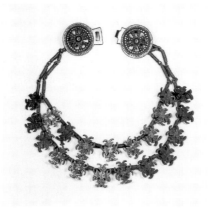

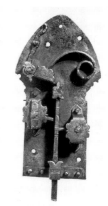

Cake mold. 19th century
Borispol, Kiev Province
Carved wood. 22.5 × 12.5
Museum of Ukrainian Folk Decorative Arts, Kiev

Figures of peasants. 1924
By I. Metinets
Village of Vysotsko, Eastern Galicia
Wood, carved and tinted. Height 17, 17, 14, and 14
Museum of Ukrainian Art, Lvov

Saddle. 1945
Kosov, Stanislav Region
Carved wood. 46 × 33
Museum of Huzul Folk Art, Kolomyia

Chest. 19th century
Kosov District, Eastern Galicia
Wood, carved and tinted. Height 56
Museum of Huzul Folk Art, Kolomyia

Salt containers
By I. Grimaliuk
Village of Richka, Ivano-Frankovsk Region
Wood, carved and pokerworked. Height 17.5 and 27.5
Museum of Ukrainian Folk Decorative Arts, Kiev

Necklace. Late 18th or early 19th century
Eastern Galicia
Brass, cast and chased. Length 70
Museum of Huzul Folk Art, Kolomyia

Man Wearing a Sheepskin Coat. Late 19th or early 20th
century
Carved wood. Height 18.5
Museum of Ukrainian Folk Decorative Arts, Kiev

Flask. 1960
By M. Yusipchuk
Kosov, Stanislav Region
Wood, carved and tinted, inlaid with mother-of-pearl, beads,
and brass. Height 26
Museum of Ukrainian Folk Decorative Arts, Kiev

Detail of lock for chest. Early 19th century
Village of Oposhnia (?), Zenkov District, Poltava Province
Hammered iron
Ethnography Museum, Leningrad

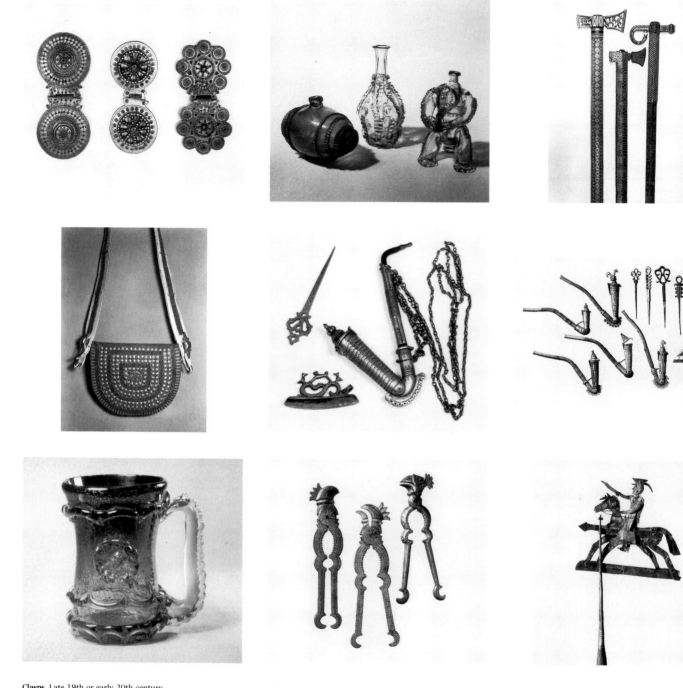

Clasps. Late 19th or early 20th century
Eastern Galicia
Brass. Length 7.5, 7, and 7.5
Museum of Ukrainian Art, Lvov

Hunter's bag. Early 20th century
By V. Yakibiuk
Village of Richka, Eastern Galicia
Leather, with chased brass and neusilber. 22 × 27
Museum of Ukrainian Art, Lvov

Mug. 1970s
By Ya. Matsiyevsky
Lvov
Free-blown glass, with applied details. Height 18
Private collection, Lvov

Miniature barrel, decanter, and vessel in the form of a bear.
 19th century
Colored *huta* glass. Height 15, 27, and 23
Ethnography Museum, Leningrad

Pipe cleaner, steel, and tobacco pipe. Late 19th or early 20th
 century
Village of Richka, Kosov District, Eastern Galicia
Brass, neusilber (pipe), and steel, cast and chased.
 Length 10.2, 7, and 13.5
Museum of Huzul Folk Art, Kolomyia

Nutcrackers. 1904
Kosov, Eastern Galicia
Copper, cast, hammered, and engraved. Length 17, 17, and
 15.2
Ethnography Museum, Leningrad

Details of hatchets and walking stick. Early 20th century
Eastern Galicia
Brass and neusilber, cast, engraved, and inlaid with beads
Museum of Ukrainian Art, Lvov

Tobacco pipes and pipe cleaners. Early 20th century
Eastern Galicia. Steels. 1978
By P. Kharinchuk
Village of Kransnoilsk, Verkhovina District, Ivano-Frankovsk
 Region
Copper, cast, hammered, and engraved. Length 17, 18, 18,
 18.5, and 19 (pipes); 12, 13.5, 14.5, 13.5, 11, and 11
 (pipe cleaners); 12 and 11 (steels)
Ethnography Museum, Leningrad

Weather vane. Early 20th century
Korop, Krolevets District, Chernigov Province
Cut iron. 34 × 30
Ethnography Museum, Leningrad

Folk Art in
BYELORUSSIA

Byelorussian builders, potters, wood carvers, glassblowers, and goldsmiths continued and enriched old Russian cultural traditions while simultaneously establishing highly original arts of their own. However, even in the eleventh and twelfth centuries the artistic legacy of Kievan Rus was still very strong in the western principalities, as evidenced by archaeological finds from Turov, Minsk, Volkovysk, Grodno, and Polotsk. The Museum of the Byelorussian SSR in Minsk contains about forty thousand items of Byelorussian workmanship executed with great technical skill and dating from the early Middle Ages. The geometric and zoomorphic ornamental motifs current in those days still possessed the essential features of Eastern Slavic art. The main crafts then were metalwork, and bone and stone carving, which were superseded in the course of time by pottery, wood carving, embroidery, weaving, and smithing.

Peasant household utensils were functional and modestly ornamental in design. Made of easily accessible materials such as wood, straw, flax, and birch bark, these simple and inexpensive objects are nevertheless attractive by virtue of their well-proportioned and clear-cut shapes, concise but expressive ornamentation, and stylistic unity.

Very few examples of the household utensils used by the peasantry in the seventeenth century still exist in Byelorussia. In contrast, the work of Byelorussian carvers, mirror-makers, stove-setters, and gold- and silversmiths is well represented in a number of famous churches and palaces built

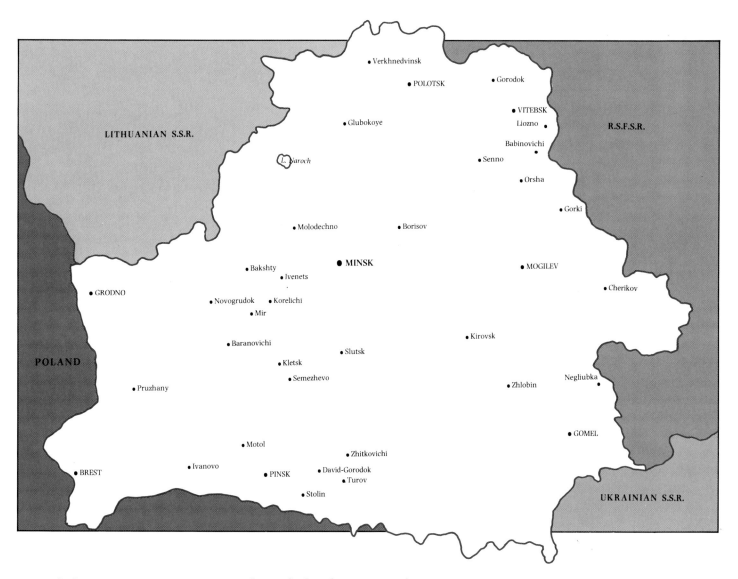

with their participation in Moscow and Yaroslavl in the seventeenth century. Beautiful varicolored tiles with low-relief floral motifs, grapes, oak leaves, and palmettes, which decorate those buildings, are held in particular regard.

Byelorussia abounds in clays of different colors and compositions, which enabled the potter's trade to spread quickly. Byelorussian earthenware for domestic use gives the impression of extreme modesty, because the jugs, cups, and bowls are smoked and burnished or glazed in one color, and generally bear no applied details, though they have occasionally slip-painted underglaze with ingenious designs. Throughout the centuries their appearance has remained practically unchanged, which reflects the stability of the Byelorussian peasantry's aesthetic taste. Some traditional types of earthenware are still in common use in the region of Polesye, for example. Their large spherical vessels are very expressive: squat bulky bodies with tapering necks and slim elongated handles.

The Byelorussian potters of the past did not confine themselves to producing only utilitarian wares. In many areas around Mogilev, for example, clay toys were made. Certain stylistic features of these ceramic figurines from Orsha and Senno Districts show an affinity with Russia's famous Dym-

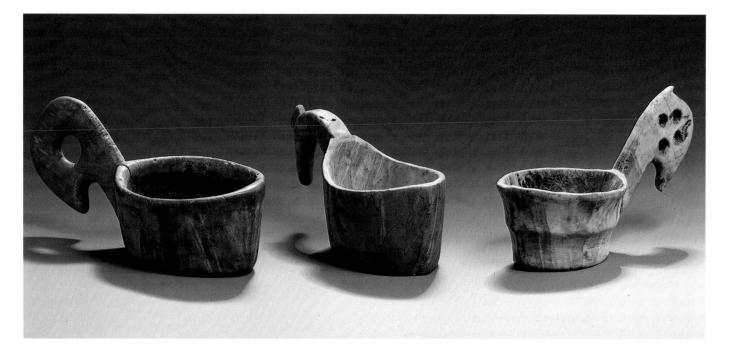

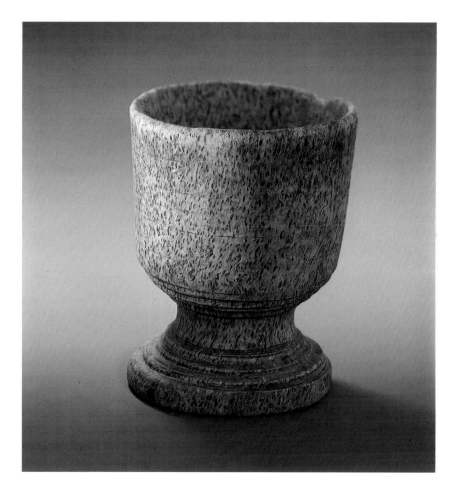

Dippers. Late 19th or early 20th century
Eastern Byelorussia
Wood, chiselled and carved. Height 7, 6, and 7
Museum of the Byelorussian SSR, Minsk

Mortar. Late 19th century
Village of Matkovtsy, Borisov District, Minsk Province
Lathe-turned wood. Height 16, diameter 13
Private collection, Minsk

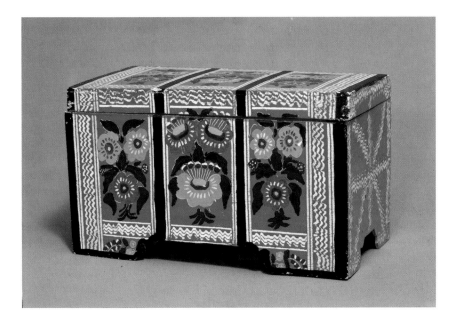

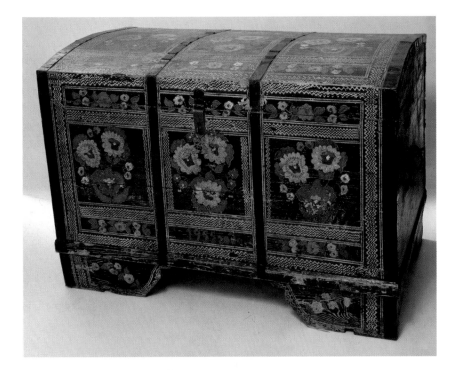

kovo toys. In addition to pottery, copper and brass utensils were also com-
mon until the turn of the twentieth century. As a rule, they had plain
shapes and bore no decoration other than a chased finish, which caused an
intricate play of light on the vessel's scaly surface.

The same simplicity of form, coupled with a monumental quality, is
characteristic of Byelorussian wooden vessels. They are often shaped like

Small chest. 1960s
By P. Dovger
Village of Ogovo, Ivanovo District, Brest Region
Painted wood. 33.5 × 16 × 19.5
Museum of the Byelorussian SSR, Minsk

Chest. 1955
Village of Ogovo, Ivanovo District, Brest Region
Painted wood. 108 × 74 × 61
Museum of the Byelorussian SSR, Minsk

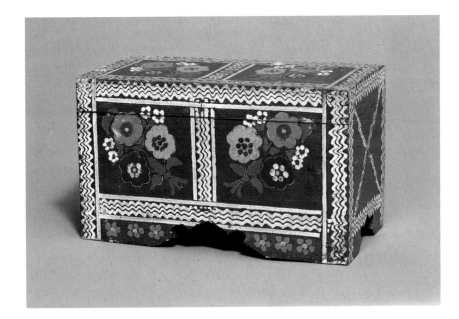

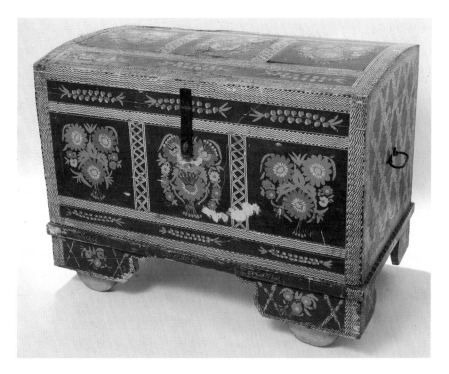

Small chest. 1960s
By P. Dovger
Village of Ogovo, Ivanovo District, Brest Region
Painted wood. 40 × 21 × 23
Museum of the Byelorussian SSR, Minsk

Chest. 1959
By L. Dovger
Village of Ogovo, Ivanovo District, Brest Region
Painted wood. 110 × 63 × 81
Museum of the Byelorussian SSR, Minsk

waterbirds, a motif also prevalent in Russian and Ukrainian folk art; the handles of pitchers often terminate in stylized horses' heads.

Outline carving was widely used to decorate distaffs. Their chief ornamental motifs were solar signs and occasionally stylized plants. Relief or openwork carving often adorned houses, the architectural details of which showed some elements of the Baroque and Empire styles. This is hardly sur-

prising, for Byelorussian carvers created a number of magnificent iconostases, remarkable for their decoration, in the Trinity Church of Vitebsk and in cathedrals in Mogilev and the Novodevichy Convent in Moscow.

Fine taste and an original national flavor are also apparent in the straw-plait details of these iconostases. The unique straw-weaving technique employed has literally no parallel outside Byelorussia. In the past straw-plaiting was primarily confined to such domestic articles as boxes and bread baskets, but this medium is now popular in fashioning decorative figurines and other compositions in which the artisan makes clever use of the material's plastic qualities to tackle quite complex tasks. A wealth of unusually expressive textures can be produced by various straw-plaiting techniques.

Straw is also used as inlay for wooden articles in Byelorussia. In Zhlobin, for example, straw insets arranged in geometric designs, which are frequently in polychrome, adorn the dark surfaces of locally made decorative panels, dishes, and boxes. Ordinary basketry is not neglected either, although the present-day range has changed: while in the old days straw and wicker were generally woven into large, six-foot-tall containers for grain storage, now they are made into small bread, fruit, or sewing baskets, as well as vases and handbags.

An illustrious page in the history of Byelorussian art was the work of the Slutsk textile factory, which was opened in the eighteenth century and was particularly famous for its belts. Slutsk belts occupy a special place in

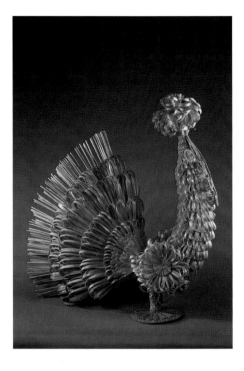

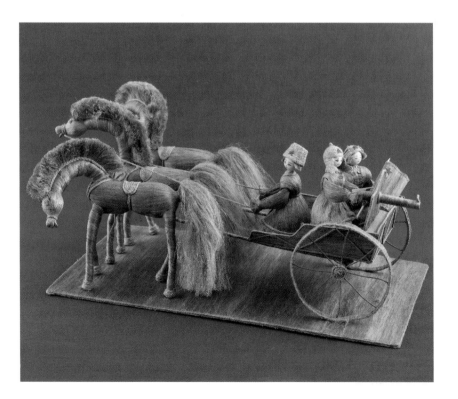

Cart with Machine Gun and Red Army Men. 1978
By Z. Levchenia
Molodechno, Minsk Region
Painted wood, plaited flax, and cotton threads. Height 14
Union of Artists, Moscow

Bird. 1978
By T. Agafonenko
Minsk
Plaited straw. Height 50
Union of Artists, Moscow

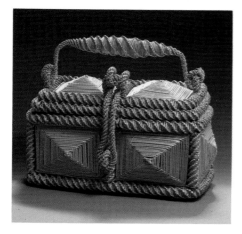

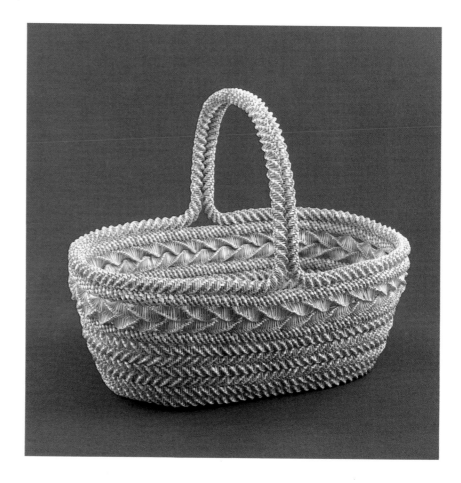

Dish for fruit. 1979
By G. Solomianko
Baranovichi, Brest Region
Plaited straw. 57 × 36
Union of Artists, Moscow

Casket. 1930s
By A. Shanteleyev
Village of Perespa, Senno District, Vitebsk Region
Plaited straw. 25 × 17 × 19
Museum of the Byelorussian SSR, Minsk

Basket. 1979
By G. Solomianko
Baranovichi, Brest Region
Plaited straw. 58 × 70 × 40
Union of Artists, Moscow

Byelorussian art. Though their designs are quite similar to traditional folk patterns, they display a more refined interpretation of plant motifs and a more subdued color scheme.

Belt-making was time-consuming and costly, so few besides the Polish and Russian gentry could afford them. Slutsk belts were sometimes modelled after Oriental fabric designs, especially at the beginning, but before long, due to local talented craftsmen, these articles became highly original. The reputation of the Slutsk belts was so great in the eighteenth and nineteenth centuries that the industry spread to some other towns in Byelorussia, as well as to the Ukraine and Poland. This art had a considerable impact on other Byelorussian folk arts and crafts, particularly on embroidery. A certain stylistic affinity with the Slutsk belts is also evident in Byelorussian rugs, which were made by serf weavers on some estates in the first quarter of the nineteenth century.

Painting on wood was widely practiced in the past by Byelorussian peasants. Their furniture, shutters, chests, distaffs, and other domestic wooden articles were as a rule decorated with painted designs, the character and style of which conformed to the general trend toward conciseness and monumentality current at that time in Byelorussia. The contemporary

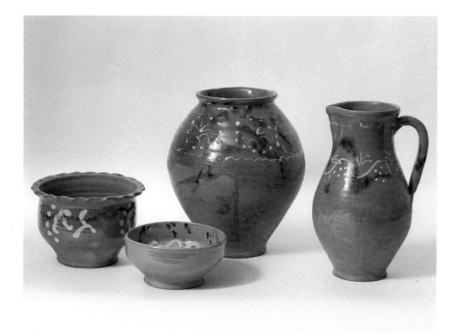

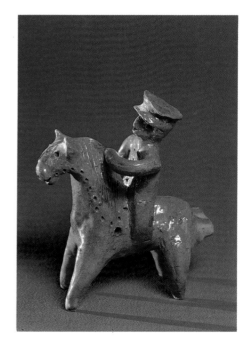

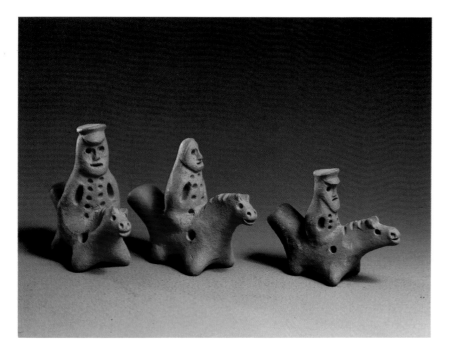

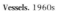

Vessels. 1960s
By N. Orekhov and M. Shchadinsky
Village of Babinovichi, Liozno District, Vitebsk Region
Fired clay, with underglaze slip decoration. Height 13, 7, 27,
 and 28
Private collection, Minsk

Horsemen. 1977
By S. Glebka
Village of Khorositsa, Novogrudok District, Grodno Region
Handworked clay, fired. Height 6, 6, and 6.5
Private collection, Minsk

Horseman. 1978
By Z. Zhilinsky
Pruzhany District, Brest Region
Handworked clay, fired and glazed. Height 12
Private collection, Minsk

style of painted decoration, though, is significantly different. Some forty
years ago the village of David-Gorodok became a center for painting of small
pieces of plywood with flowers and vegetables to be used as price tags for
seeds sold at the marketplace. These representations of plants are life-like,
detailed, and vivid.

Chemise and apron. 1930s
Brest Region
Linen, embroidered in cotton thread. 110 × 170 and 60 × 90
Museum of the Byelorussian SSR, Minsk

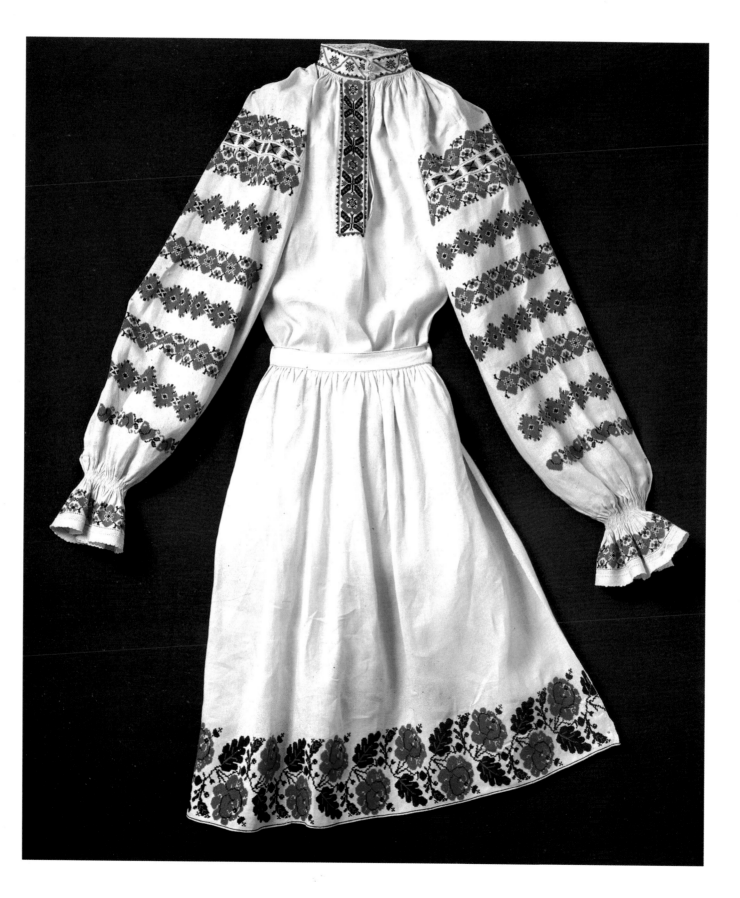

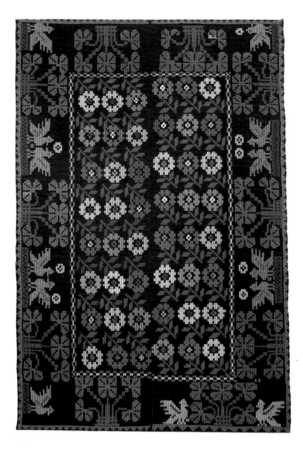 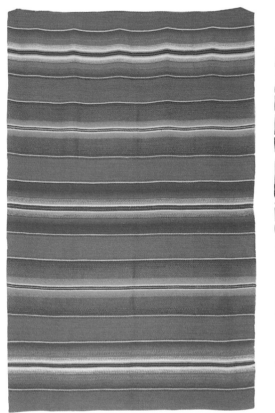 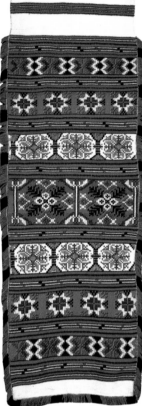

The same naive realistic quality is characteristic of other contemporary Byelorussian crafts, such as cloth mats (notably from the Lake Naroch area), painted glassware, and wood sculpture. Their compositions demonstrate the folk artists' predilection for the narrative interpretation of their themes, a trend observable in Byelorussian weaving and embroidery as well.

While some crafts have been influenced by novel trends and ideas, in many others the old traditions have been faithfully and tenaciously preserved. For example, in the village of Negliubka in the Gomel Region the embroidery, lace, weaving, and carving are all based on traditional motifs. Some pottery made in the village of Ivenets in the Minsk Region is essentially traditional as well, although its forms are more varied today and its decoration more saturated with color.

Contemporary Byelorussian folk art has become increasingly popular, and with good reason: smoked and burnished pottery from Pruzhany, glazed ceramics from Gorodok, towels from Motol, patterned textiles from the Pinsk area, bedspreads from the Grodno Region, and tablecloths from Verkhnedvinsk, all look decorative whether in a town apartment or a village house.

Rug. 1962
By A. Zhuravlevich
Village of Diakovichi, Zhitkovichi District, Gomel Region
Homewoven linen, cotton, and wool. 202 × 135
Museum of the Byelorussian SSR, Minsk

Bedspread. 1978
By M. Rusinovich
Grodno Region
Homewoven wool and cotton. 200 × 130
Union of Artists, Moscow

Towel. 1979
By T. Derenok
Village of Negliubka, Gomel Region
Homewoven linen and cotton. 390 × 45
Union of Artists, Moscow

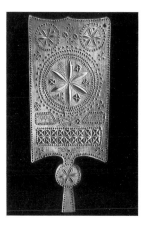
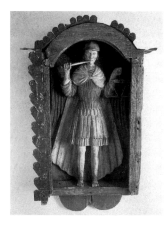
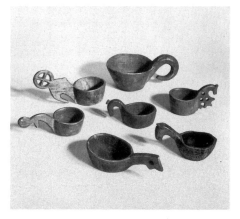
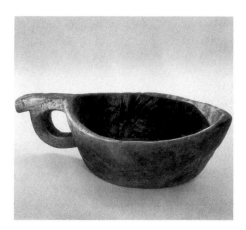
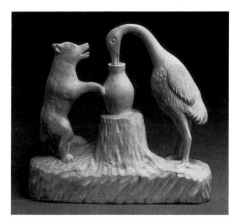
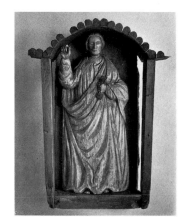

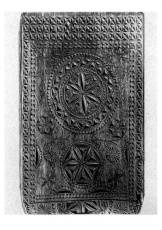

Roadside saint. 18th century
Minsk Province
Wood, carved and painted. 72 × 27 × 9
Private collection, Minsk

St. George. Late 19th century
Village of Zabolot, Grodno Province
Wood, carved and painted, with tinplate cover. 71 × 60 × 21
Museum of the Byelorussian SSR, Minsk

Distaff. 1924
Village of Khodosy, Kamenets District, Brest Region
Carved wood. 56 × 20 × 3
Private collection, Minsk

The Apostle Peter. Late 19th century
Village of Zabolot, Grodno Province
Carved wood, with tinplate cover. 42 × 30 × 8
Museum of the Byelorussian SSR, Minsk

Dippers. Late 19th century
Slutsk and Borisov Districts, Minsk Province; Mogilev District,
 Mogilev Province
Wood, chiselled and carved. Height range from 3 to 6
Ethnography Museum, Leningrad

Dipper. 1930s
Village of Ozdamichi, Stolin District, Brest Region
Chiselled wood. Height 9
Private collection, Minsk

The Archangel Michael. Late 19th century
Village of Zabolot, Grodno Province
Carved wood, with tinplate cover. 41 × 34 × 8
Museum of the Byelorussian SSR, Minsk

Detail of distaff. Early 20th century
Village of Podomsha, Brest District, Grodno Province
Carved wood
Private collection, Minsk

Fox and Crane. 1971
By V. Olshevsky
Minsk
Carved wood. Height 21
Museum of the Byelorussian SSR, Minsk

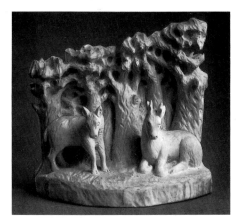

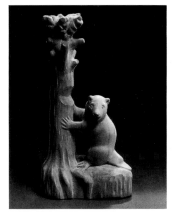

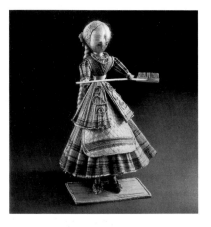

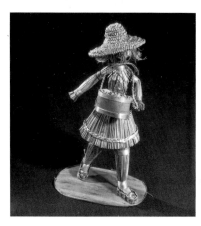

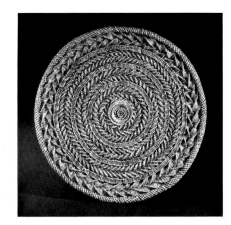

Fawns. 1976
By V. Olshevsky
Minsk
Carved wood. Height 20
Museum of the Byelorussian SSR, Minsk

Young Girl with a Rake. Late 1970s
By Ye. Artemenko
Mogilev
Plaited straw, mouliné, and acrylic. Height 30
Museum of Folk Art attached to the Chemical Industry
 Institute, Moscow

Sower. 1979
By Ye. Artemenko
Mogilev
Plaited straw. Height 32
Union of Artists, Moscow

Basket. Early 20th century
Village of Lobanovka, Cherikov District, Mogilev Province
Wickerwork. 25 × 30 × 41
Ethnography Museum, Leningrad

Birds. 1978
By Ye. Los and T. Agafonenko
Minsk
Basket for sweets. 1977
By Ye. Artemenko
Mogilev
Plaited rushes and straw. Height 33, 41, and 26.5
Ethnography Museum, Leningrad

Vase. 1930s
Village of Sebiaki, Vitebsk District, Vitebsk Region
Willow-rods plaited with straw. 26 × 20
Ethnography Museum, Leningrad

Beaver. 1978
By V. Olshevsky
Minsk
Carved wood. Height 23
Museum of the Byelorussian SSR, Minsk

Bird. 1978
By Ye. Los
Minsk
Straw. Height 25
Union of Artists, Moscow

Tray. 1979
By G. Solomianko
Baranovichi, Brest Region
Plaited straw. Diameter 40
Union of Artists, Moscow

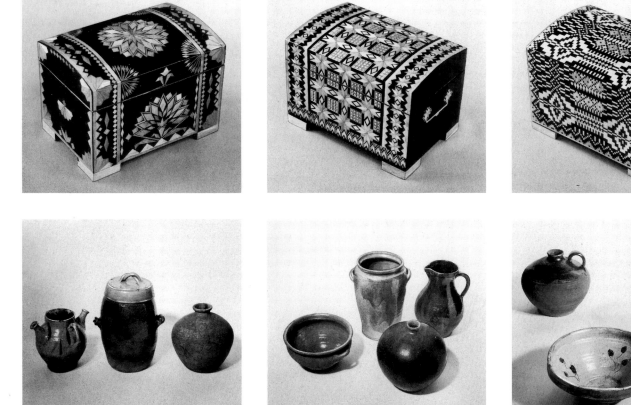

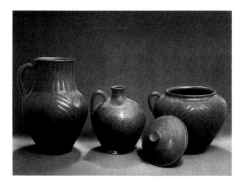

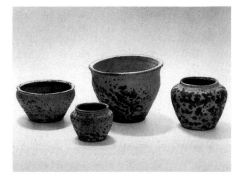

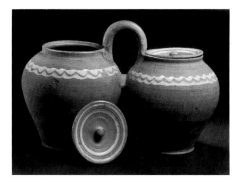

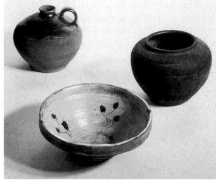

Casket. 1979
By V. Degtiarenko and M. Degtiarenko
Zhlobin, Gomel Region
Wood, inlaid with straw. 13.5 × 20 × 12
Union of Artists, Moscow

Wash-handjar and two jugs. Early 20th century
Vitebsk Province
Clay, fired and glazed. Height 22, 32, and 24
Ethnography Museum, Leningrad

Vessels. 1979
By A. Tokarevsky
Pruzhany, Brest Region
Clay, fired, carbon-smoked, and burnished. Height 31, 22,
 and 27
Museum of the Byelorussian SSR, Minsk

Casket. 1979
By V. Degtiarenko and M. Degtiarenko
Zhlobin, Gomel Region
Wood, inlaid with straw. 20 × 22 × 13
Union of Artists, Moscow

Bowl, jar, pot for hot water, and jug. Early 20th century
Vitebsk and Mogilev Provinces
Fired clay. Height 13.5, 24, 31, and 29
Ethnography Museum, Leningrad

Pots. 1980
By F. Vashchilo
Village of Ganevichi, Kletsk District, Minsk Region
Fired clay, with slip decoration. Height 17, 13, 25, and 18;
 diameter 10, 10, 18, and 14
Private collection, Minsk

Casket. 1979
By V. Degtiarenko and M. Degtiarenko
Zhlobin, Gomel Region
Wood, inlaid with straw. 28 × 32 × 22.5
Union of Artists, Moscow

Vessel for oil, bowl, and pot. Early 20th century
Vitebsk and Minsk Provinces
Fired clay, with underglaze slip decoration. Height 19, 10,
 and 17
Ethnography Museum, Leningrad

Double vessel. 1981
By I. Bychko
Village of Mir, Korelichi District, Grodno Region
Fired clay, with slip decoration. 35 × 23 × 17
Private collection, Minsk

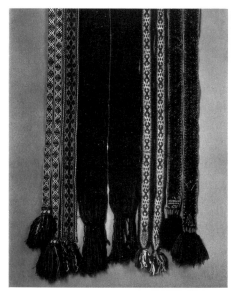

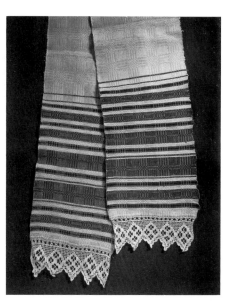

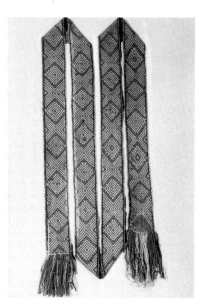

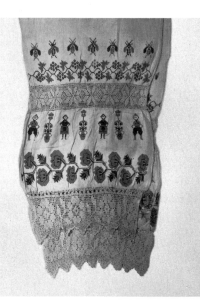

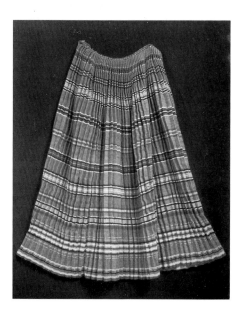

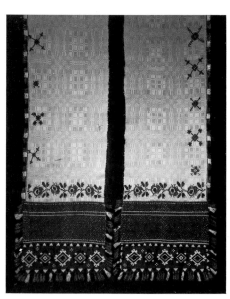

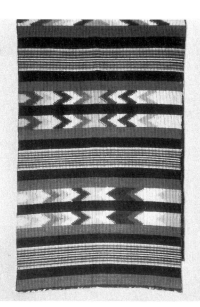

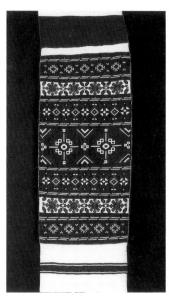

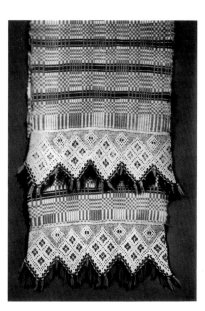

Details of belts. 1910s–50s
Minsk, Brest, and Mogilev Provinces (now Regions)
Homespun linen, cotton, and wool
Museum of the Byelorussian SSR, Minsk

Towel. Early 20th century
By M. Khomutova
Village of Bystraya, Gorets District, Mogilev Province
Homespun linen, with bobbin lace of cotton thread. 262 × 27
Museum of the Byelorussian SSR, Minsk

Belt. 1910s
Village of Semezhevo, Slutsk District, Minsk Province
Homespun linen and wool. 262 × 6
Museum of the Byelorussian SSR, Minsk

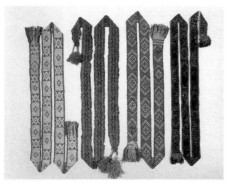

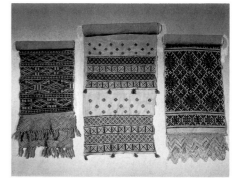

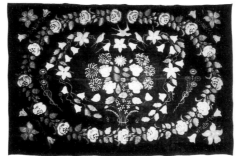

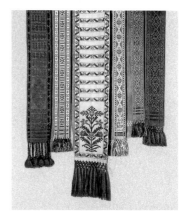

Towel. 1910s
Village of Ostrov, Pinsk District, Minsk Province
Homespun linen, with bobbin lace and embroidery in cotton
 thread. 289 × 42
Museum of the Byelorussian SSR, Minsk

Skirt. Early 20th century
By M. Kuleshova
Village of Gladkiye, Orsha District, Mogilev Province
Homewoven linen and wool. 92 × 108
Museum of the Byelorussian SSR, Minsk

Towel. 1932
By P. Podvalskaya
Village of Stolpishchi, Kirov District, Mogilev Region
Homespun linen, with bobbin lace and embroidery in
 mouliné. 370 × 38
Museum of the Byelorussian SSR, Minsk

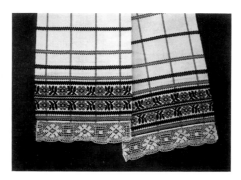

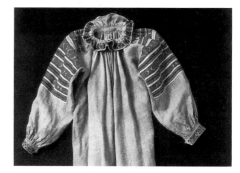

Runner. 1972
By N. Sonchik
Village of Ugryn, Zelva District, Grodno Region
Flat-homewoven wool, cotton, and rayon. 315 × 72
Museum of the Byelorussian SSR, Minsk

Belts. 1910s–60s
Minsk, Mogilev and Gomel Provinces (now Regions)
Homespun linen and wool. 250 × 4.5, 232 × 6, 262 × 5.5, and
 254 × 5.5
Museum of the Byelorussian SSR, Minsk

Towels. 1910, 1910, 1880
Village of Strigan, Brest District, Grodno Province; Minsk
 Province; village of Kosovichi, Gomel District, Mogilev
 Province
Homespun linen, with bobbin lace of cotton thread (left and
 right). 146 × 29, 200 × 37, and 228 × 30
Museum of the Byelorussian SSR, Minsk

Towel. 1979
By T. Derenok
Village of Negliubka, Gomel Region
Homewoven linen and cotton. 390 × 45
Union of Artists, Moscow

Wall hanging. 1930s
By V. Babich
Village of Mikulino, Glubokoye District, Vitebsk Region
Painted canvas. 132 × 200
Private collection, Minsk

Details of souvenir belts. 1978–79
By N. Pavlova and V. Yustinko
Minsk Region
Homespun linen, with cotton fringes
Union of Artists, Moscow

Towel. 1916
By Ye. Butrik
Village of Bakshty, Grodno Province
Homespun linen with bobbin lace of cotton thread. 360 × 40
Museum of the Byelorussian SSR, Minsk

Towel. 1972
By O. Lukashevich
Village of Motol, Ivanovo District, Brest Region
Cotton, embroidered in mouliné, with lace borders. 246 × 30.5
Museum of the Byelorussian SSR, Minsk

Woman's blouse. Early 20th century
Village of Kozlovichi, Mozyr District, Minsk Province
Homespun linen with embroidery in cotton thread. 110 × 150
Museum of the Byelorussian SSR, Minsk

Folk Art in
MOLDAVIA

If you come to Moldavia and visit one of its villages, let us say on the Dniester River, your first and probably most memorable encounter with Moldavian folk art will take place in the street. Moldavian house fronts have a festive and hospitable appearance. The paintings on the stucco walls, the carved pediments, cornices, and porches, the woodwork of gates, cellars, and wells, the pierced designs decorating the tin roofs and chimneys, and the lacework of window surrounds, speak volumes for this land's folk art traditions. A vast variety of elements is included in their decorations, such as sun symbols sometimes combined in the same composition with life-like representations of animals and birds, or geometric ornaments turning into complicated anthropomorphic forms, or winding plant designs stretching in a row along the fence and eaves of the house. Not only wood, but stone and stucco as well are obedient and rewarding materials in the skilled hands of Moldavian decorators. Wooden posts and planks, which were formerly used to build the galleries of Moldavian houses, have been supplanted by stone pillars, with square, round, or octagonal bases. Their spiral shafts are decorated with colored carved ornaments, the reds and greens of which echo the color of tiled roofs and luxuriant verdure. This kind of column with a tall plinth, a spiral shaft, and an ornate capital belongs to no conventional order and is characteristic only of Moldavian rural houses.

Central to the house is its *casa mare*, or drawing room, where guests are entertained and where various solemn occasions in the life of the fami-

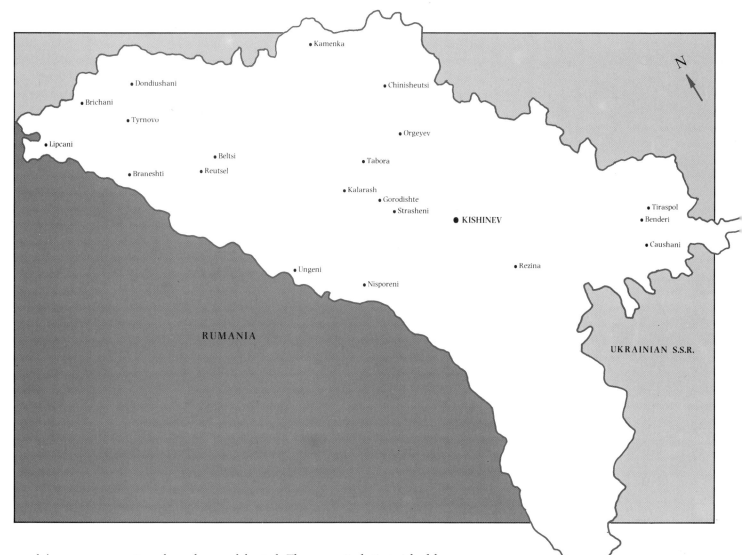

ly's many generations have been celebrated. The room is distinguished by a particularly smart decor echoing the festive appearance of the facade. The floral representations seen on its walls, embroidered towels, and carpets are enhanced by bunches of dried grass tucked between the beam and the ceiling, as well as by bouquets of artificial flowers made from paper, wood shavings, and fabric. Everything here seems to show a joyful respect for nature, a sentiment that is the key to understanding Moldavian folk art.

Some of the wall paintings in Moldavian houses depict fantastic trees with huge leaves, while others are devoted to familiar village landscapes or to scenes with ivied castles from the world of fairy tales. Even in the past, a streak of naive realism was present in the work of Moldavian folk painters. Coupled with a strong leaning toward improvisation, which was characteristic of all Moldavian arts and crafts in the nineteenth and early twentieth centuries, this naiveté resulted in a rich national flavor and artistic originality. Even the fact that small peasant houses should have a special room reserved for festive occasions is a very typical manifestation of the Moldavian peasant's outlook on life.

The most surprising thing about the interior of Moldavian houses is the large number of rugs (mostly flat-woven *kilims*) used as wall hangings or coverings for the floor, benches, and beds; even saddlebags are made of them. In Moldavian rugs dating from the eighteenth and nineteenth centuries, the center is filled with stylized flowers, and the color scheme consists

Rug. Late 18th century
Kishinev District, Bessarabia Province
Homewoven wool. 370 × 107
Museum of Local Lore, Kishinev

Rug. Early 19th century
Benderi District, Bessarabia Province
Homewoven wool. 365 × 135
Museum of Local Lore, Kishinev

Rug. Late 18th century
Orgeyev District, Bessarabia Province
Homewoven wool. 310 × 112
Museum of Local Lore, Kishinev

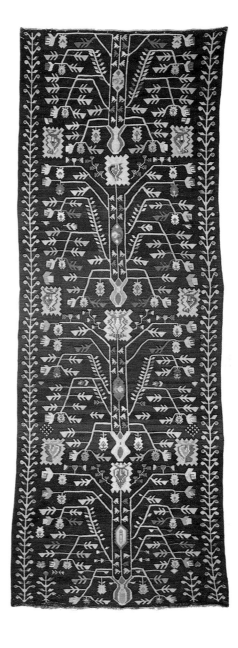
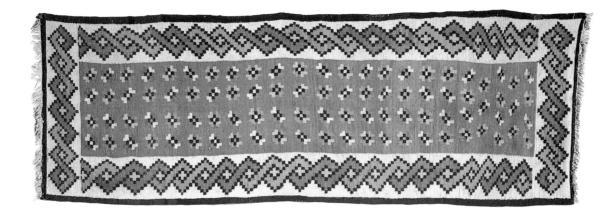

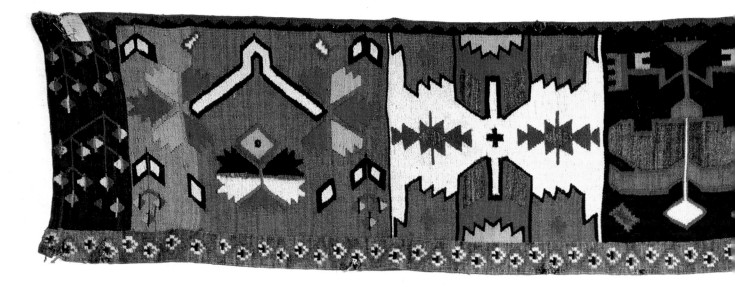

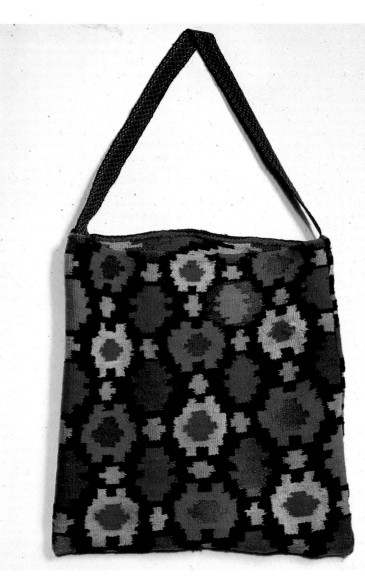

Runner. Early 19th century
Village of Tabora, Orgeyev District, Bessarabia Province
Homewoven wool. 325 × 48
Museum of Local Lore, Kishinev

Bag. Early 20th century
Hotin District, Bessarabia Province
Homewoven wool. 40 × 36
Museum of Local Lore, Kishinev

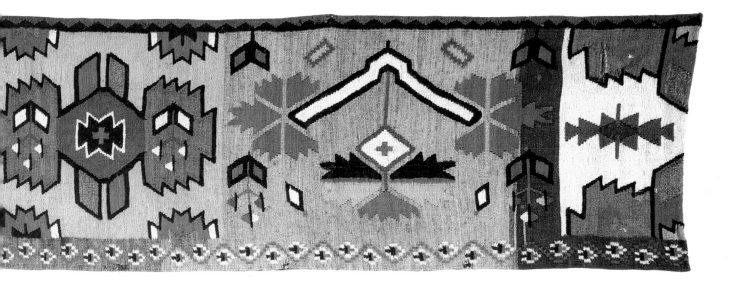

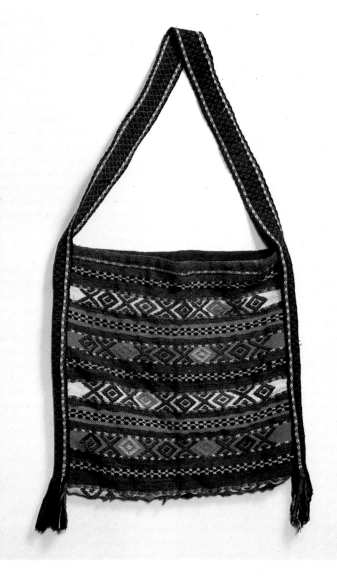

Bag. Early 20th century
Village of Criva, Hotin District, Bessarabia Province
Homewoven wool. 33 × 34
Museum of Local Lore, Kishinev

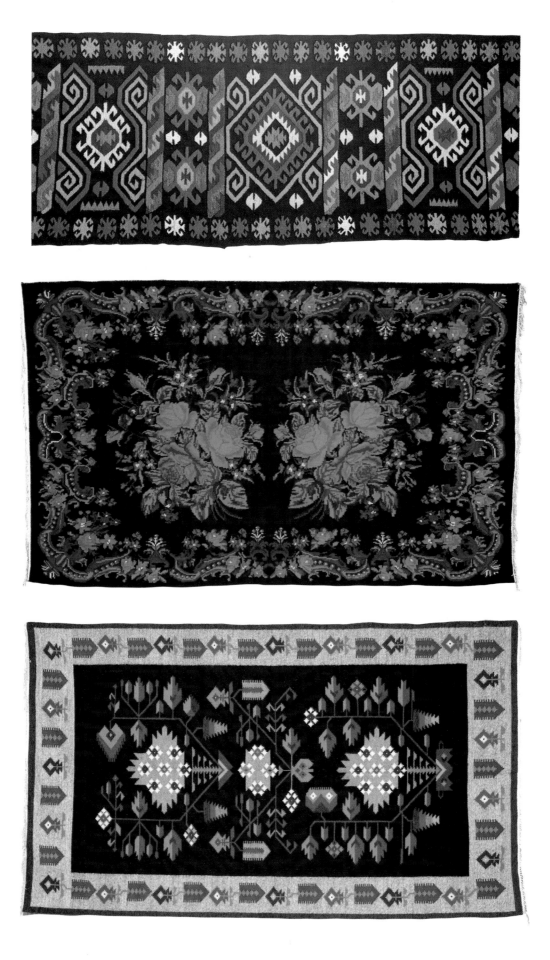

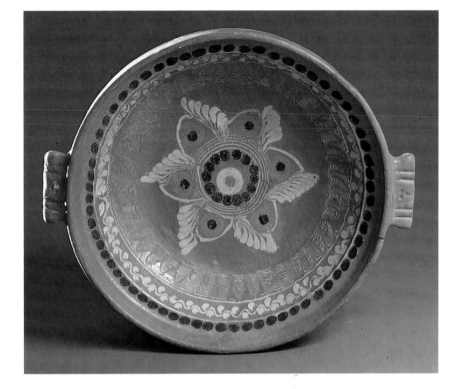

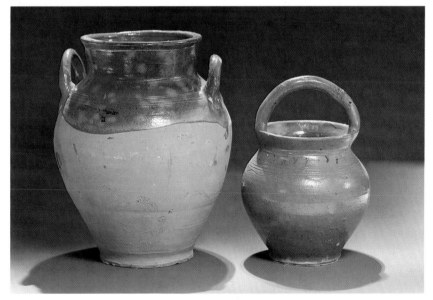

of blue, green, red, and orange tones. The border, contrasting in color with
the rest of the rug, is adorned with winding floral designs. Sometimes in-
stead of large flowers in the center one can see pots with branching bushes,
which form a delicate ornamental pattern. The pots are also covered
throughout with brightly colored flowers and grasses.

The same plant motifs and realistic approach were seen in the decora-
tion of Moldavian jugs, bowls, wine coolers, fireplace tiles, and other earth-

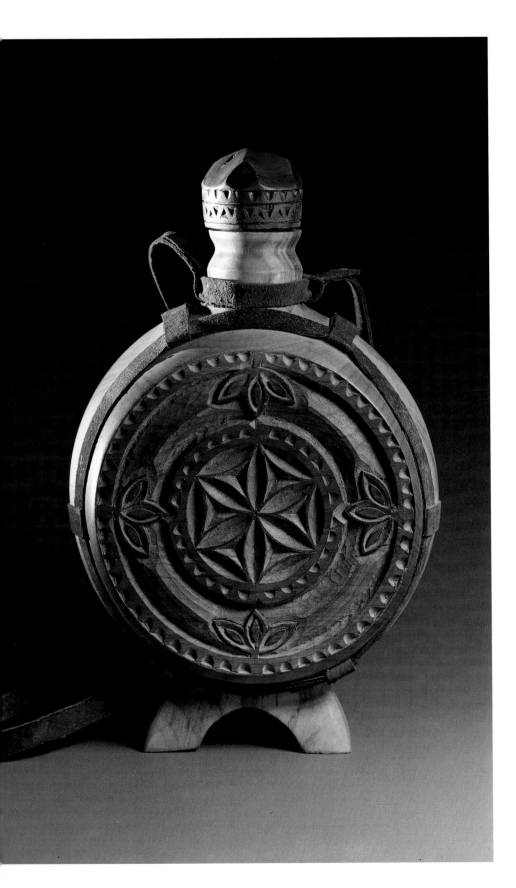

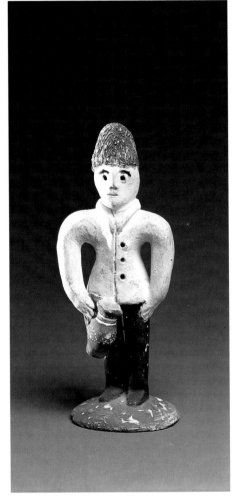

Decorative vessel. 1978
By A. Zakharov
Kishinev
Carved wood. Height 38
Museum of Local Lore, Kishinev

Figure of a man. 1967
By K. Zingaliuk
Village of Chinisheutsi, Rezina District
Handworked clay, fired, with underglaze slip decoration.
 Height 12
Museum of Local Lore, Kishinev

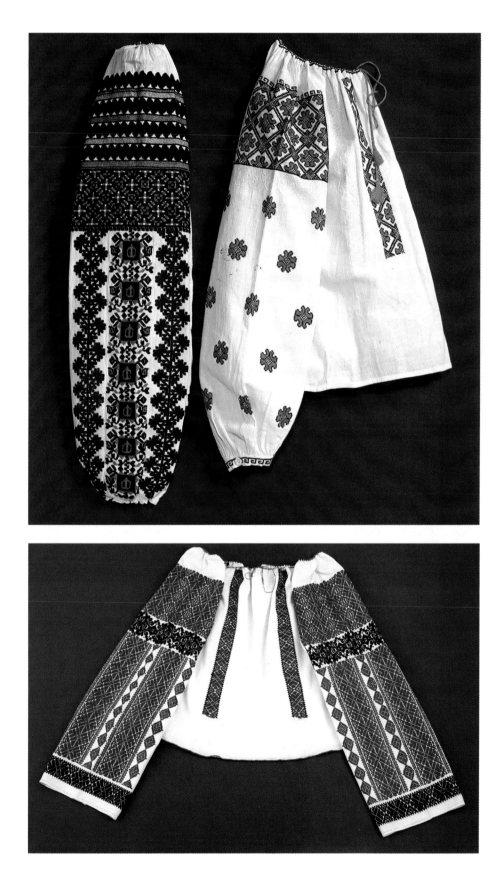

Blouses. 1870 and 1975
By M. Gavrilash (village of Noviye Bogeni, Beltsi District,
 Bessarabia Region) and Ye. Yakishina (Kishinev)
Homewoven linen, with cross-stitch and satin-stitch
 embroidery in mouliné and wool. 74 × 23 and 58 × 50
Museum of Local Lore, Kishinev

Blouse. 1977
By G. Posteuca
Village of Bukovka
Cotton, with embroidery. 68 × 64
Union of Artists, Moscow

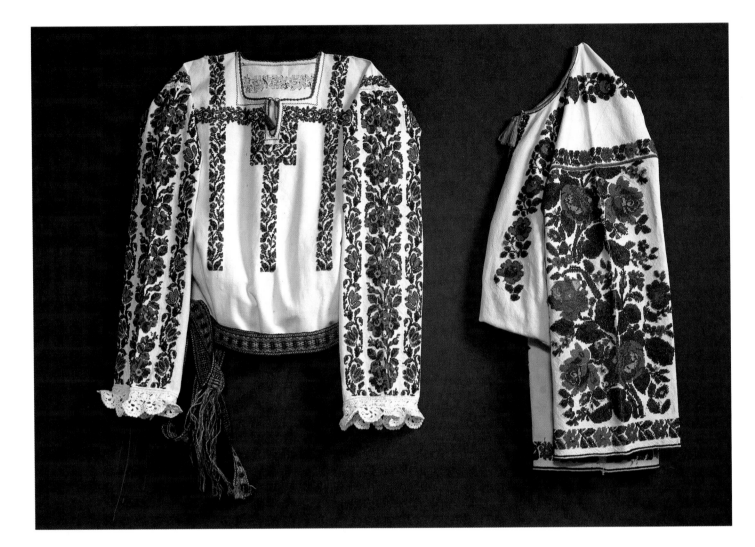

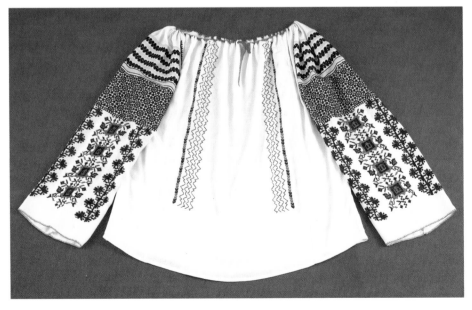

Blouses. 1930
Village of Reutsel, Beltsi District; village of Bulaneshti, Orgeyev
 District
Linen, with embroidery in cotton thread and beadwork.
 42 × 130 (each)
Museum of Local Lore, Kishinev

Blouse. 1977
By Ye. Feofilova
Kishinev
Crepe de chine, with embroidery. 42 × 130
Union of Artists, Moscow

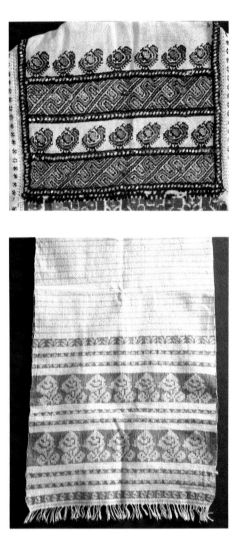

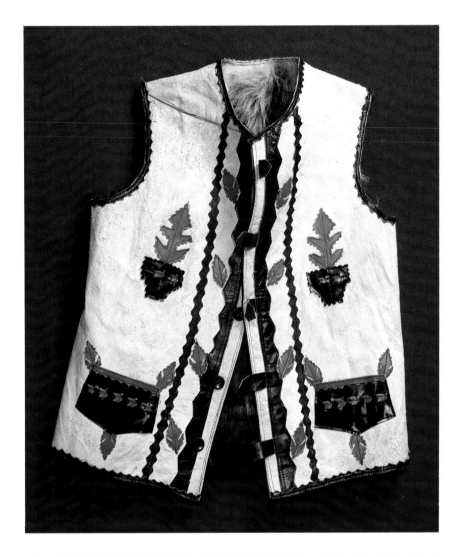

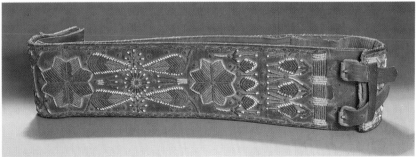

Detail of blouse. Late 19th century
Central Moldavia
Homewoven linen, with cross-stitch, satin-stitch, and tambour
 embroidery in mouliné and metal thread, with beading
Museum of Local Lore, Kishinev

Towel. Late 19th century
Homewoven patterned linen and cotton. 156 × 43
Museum of Local Lore, Kishinev

Sleeveless jacket. 1977
Village of Mileshti, Nisporeni District
Sheepskin, with leather appliqué. 78 × 67
Museum of Local Lore, Kishinev

Man's belt. Late 19th or early 20th century
Village of Pelenia, Bessarabia Province
Leather, with beadwork. 95 × 8
Museum of Local Lore, Kishinev

enware. Some of their pottery bore representations of human beings and animals. Large-scale varicolored painted decorations in green, blue, brown, and yellow tones on white or brown backgrounds were more common than applied details or incised designs. As well as glazed earthenware, smoked and burnished pots and jugs were made in Moldavia, with shiny geometric designs barely visible on their smoky-grey surfaces.

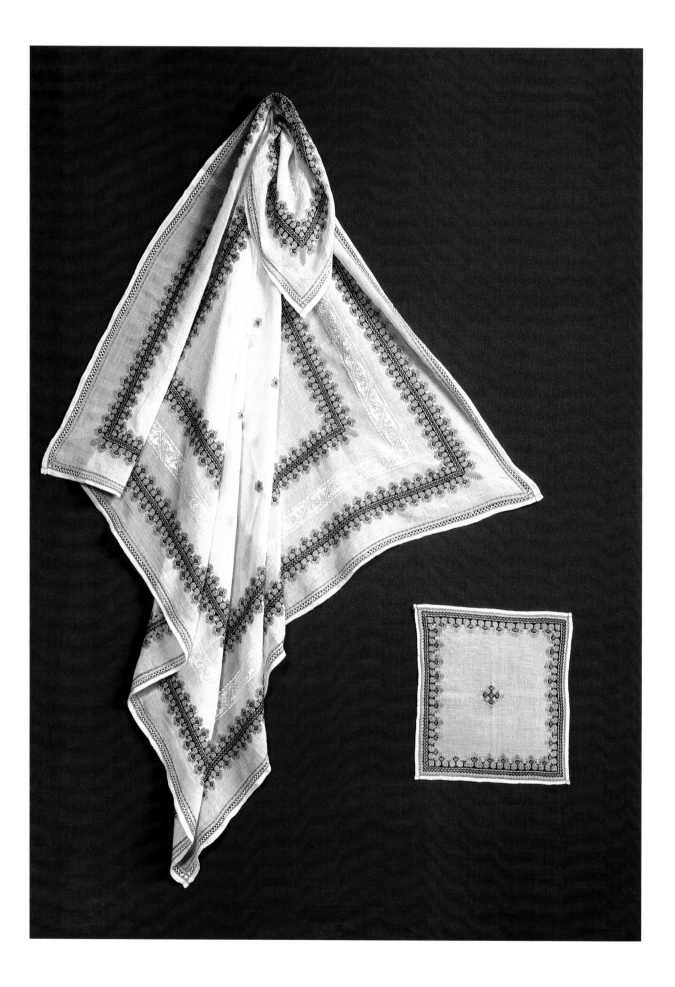

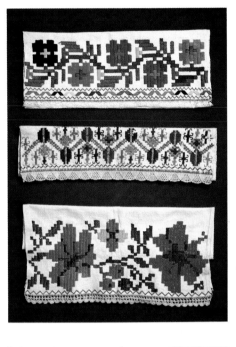

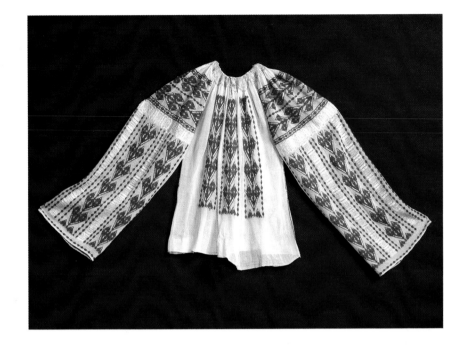

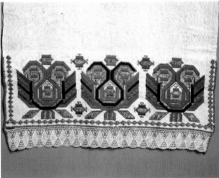

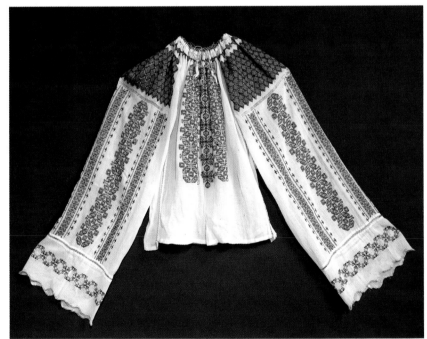

Tablecloth and napkin. 1905
Raw silk, with cross-stitch embroidery in silk thread.
 116 × 114 and 25 × 27
Museum of Local Lore, Kishinev

Ritual towels. 1907
By unknown craftsmen (top and bottom) and by L. Pustica
Village of Podoima, Bessarabia Province
Homespun linen, with satin-stitch embroidery in cotton
 thread. 15 × 39, 10 × 42, and 20 × 41
Museum of Local Lore, Kishinev

Ritual towel. 1950s
By F. Tsurcan
Village of Podoimitsa, Kamenka District
Homespun linen, with satin-stitch embroidery in
 cotton thread. 30 × 47
Museum of Local Lore, Kishinev

Blouse. Early 20th century
Beltsi District, Bessarabia Province
Raw silk, with satin-stitch embroidery in silk thread. 65 × 64
Museum of Local Lore, Kishinev

Blouse. Early 20th century
Village of Lipcani, Hotin District, Bessarabia Province
Raw silk, with satin-stitch embroidery in silk thread. 68 × 64
Museum of Local Lore, Kishinev

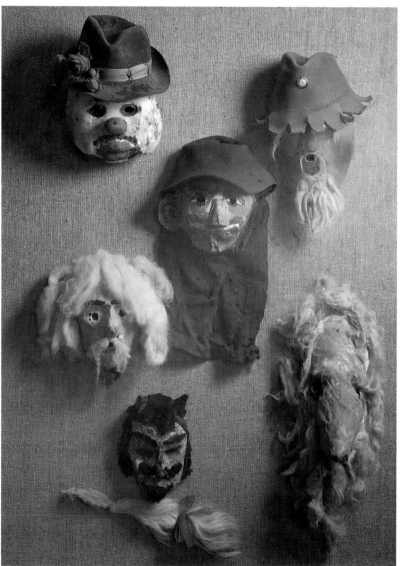

Love for color was equally evident in Moldavian wooden objects. Simple ornaments were often incised on spoon handles and then colored with cinders. The same technique was used in the decoration of wooden mugs, plates, and dishes.

The cheerful appearance of their typical houses is matched by the Moldavians' colorful, highly decorative national costumes, which include women's blouses and men's sleeveless jackets decorated with embroidery, colored braid, and beads, shepherds' belts with colored appliqué, and other items. They give their wearers a vivacity akin to that found in their fiery folk music and dance.

A great many folk carvers, needlewomen, and weavers are active in Moldavia today, and even professional artists show loyalty to the traditions of folk art with its unfading local color.

Costume parts for the New Year *Malanka* celebration. 1979
Village of Clocushna, Brichani District
Cardboard, foil, colored paper, and tinsel
Museum of Local Lore, Kishinev

Masks for the New Year *Malanka* celebration
Village of Clocushna, Brichani District
Goat's hair, cotton, wool, paper, cardboard, and cloth
Museum of Local Lore, Kishinev

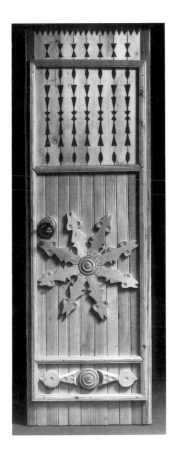

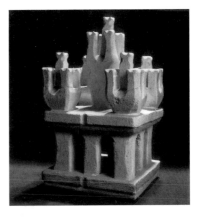

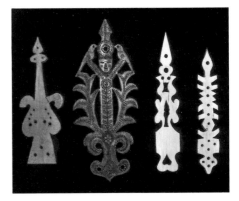

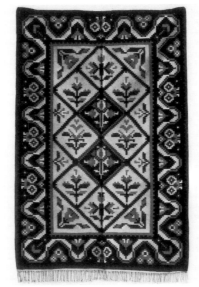

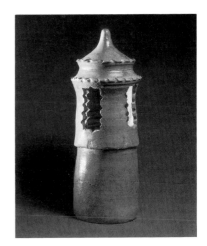

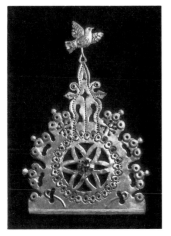

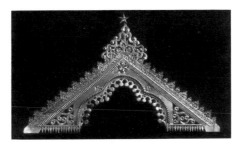

Gate. 1980
By I. Mikhai
Village of Gorodishte, Kalarash District
Carved wood, with fretwork. 113 × 70
Museum of Local Lore, Kishinev

Gable ornament for peasant house. 1978
By D. Boldul
Village of Tabani, Brichani District
Cut tinplate. 50 × 30
Museum of Local Lore, Kishinev

Chimney top. 1970
By A. Lisnik
Village of Braneshti, Orgeyev District
Carved stone. 65 × 42 × 42
Museum of Local Lore, Kishinev

Palas. 1979
By S. Bilyk
Wool interwoven with cotton threads. 140 × 90
Union of Artists, Moscow

Porch pediment for peasant house. 1978
Village of Tabani, Brichani District
Cut tinplate. 107 × 107 × 132
Museum of Local Lore, Kishinev

Chimney top. 1970
By A. Lisnik
Village of Braneshti, Orgeyev District
Carved stone. 70 × 42 × 42
Museum of Local Lore, Kishinev

Gable ornaments for peasant houses. 1970
Second ornament on the right by L. Glushchenko
Strasheni District
Carved wood, with pokerwork. Height 52, 67, 58, and 52
Museum of Local Lore, Kishinev

Chimney top. 1970s
By V. Gonchar
Village of Gozhineshti, Kalarash District
Clay, fired and glazed. Height 70
Museum of Local Lore, Kishinev

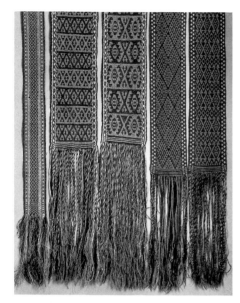

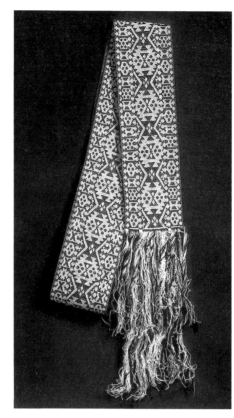

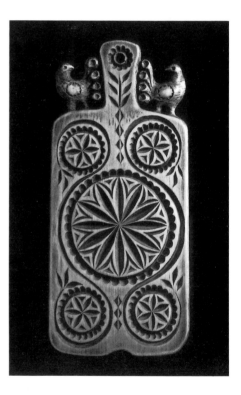

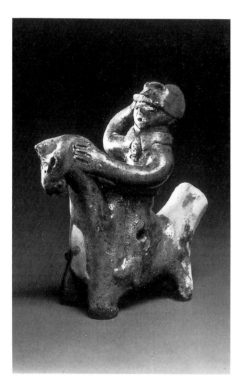

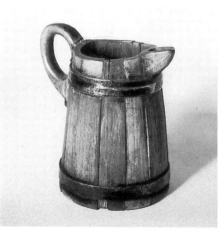

Men's belts. Late 19th or early 20th century
Ungeni, Northern Moldavia
Homewoven wool. Width 7, 13, 13, 11.5, and 11.5
Museum of Local Lore, Kishinev

Man's belt. 1930s–40s
By I. Kimchensky
Brichani District
Homewoven wool. 285 × 13
Museum of Local Lore, Kishinev

Pot. 1979
By A. Mazur
Village of Chinisheutsi, Rezina District
Clay, fired, carbon-smoked, and burnished. Height 32
Union of Artists, Moscow

Whistle. 1968
By Ye. Ternovskaya
Village of Chinisheutsi, Rezina District
Handworked clay, fired and glazed. Height 10
Museum of Local Lore, Kishinev

Mug. 1950s
Village of Varzoreshti, Nisporeni District
Wood. Height 17.5
Ethnography Museum, Leningrad

Kitchen board
By L. Glushchenko
Tiraspol
Carved wood. 32 × 24
Museum of Local Lore, Kishinev

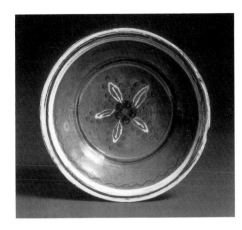

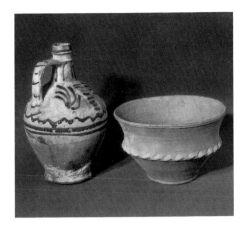

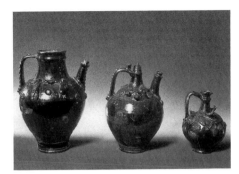

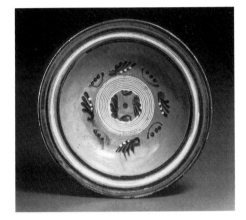

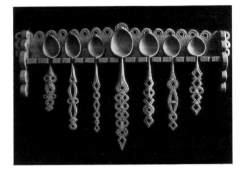

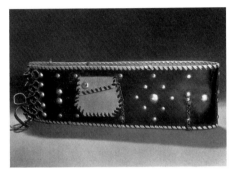

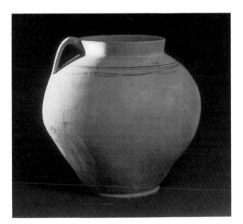

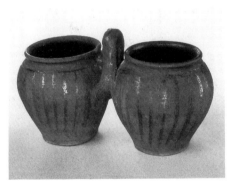

Bowl. Late 19th century
Chinisheutsi, Benderi District, Bessarabia Province
Fired clay, with underglaze slip decoration. Diameter 23
Museum of Local Lore, Kishinev

Plate. 1960s
Village of Chinisheutsi, Rezina District
Fired clay, with slip decoration. Diameter 23
Museum of Local Lore, Kishinev

Pot. 1979
By A. Mazur
Village of Chinisheutsi, Rezina District
Clay, fired, carbon-smoked, and burnished. Height 26
Union of Artists, Moscow

Jug and bowl. 1920
Village of Caushani, Benderi District, Bessarabia Province
Fired clay. Height 30 and 14.5
Museum of Local Lore, Kishinev

Spoons on rack. 1978
Tiraspol
Carved wood
Museum of Local Lore, Kishinev

Pot. 1971
By V. Gonchar
Village of Gozhineshti, Kalarash District
Fired clay, with slip decoration. Height 24
Museum of Local Lore, Kishinev

Spouted vessels. 1949
Village of Tyrnovo, Dondiushani District
Clay, fired and glazed. Height 37, 33, and 23
Museum of Local Lore, Kishinev

Man's belt. 1970
Kishinev
Leather, with metal ornament. 84 × 12
Museum of Local Lore, Kishinev

Double pot. 1979
By A. Mazur
Village of Chinisheutsi, Rezina District
Clay, fired, carbon-smoked, and burnished, with applied
 decoration. 32 × 40
Union of Artists, Moscow

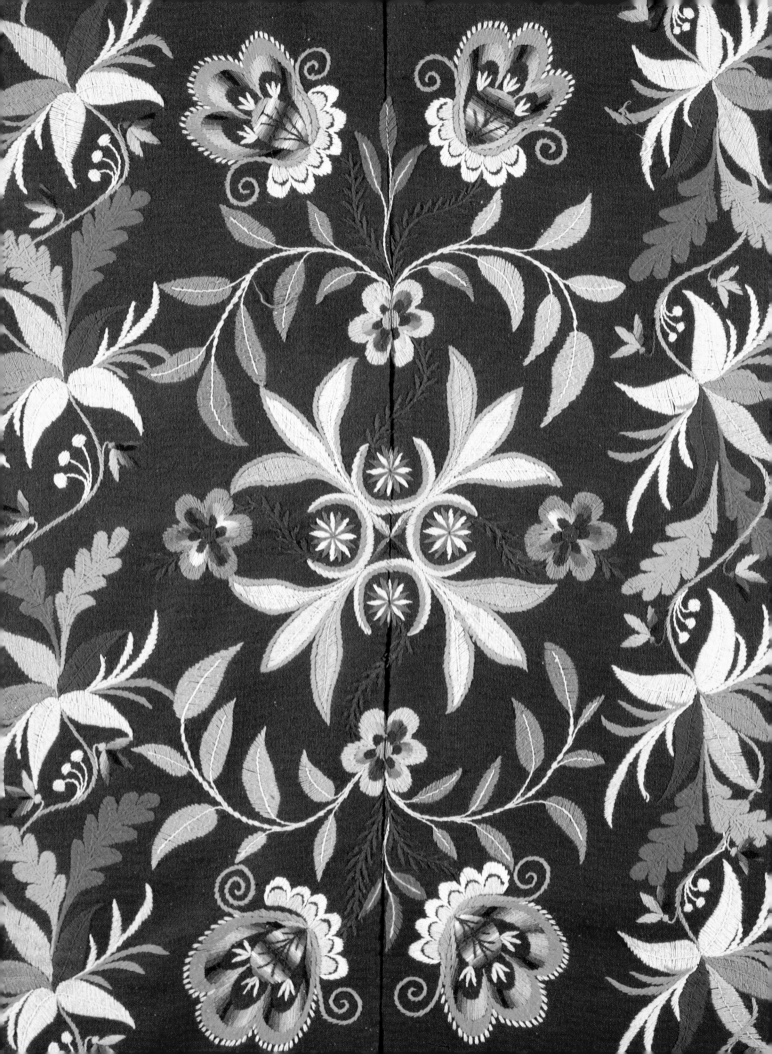

FOLK ART
IN THE
BALTIC AREA

The republics of Lithuania, Latvia, and Estonia, which lie on the Baltic Sea coast, account for only one percent of the Soviet Union's total area, but they play a significant role in the country's economy and culture. They have highly developed industries, modern agriculture, and interesting arts and crafts.

The Lithuanians and Latvians belonging to the Baltic ethnic group, and the Estonians of Finno-Ugric descent, settled in this region in the third–second millennia B.C. Over the centuries they have developed a distinctive culture, of which traditional folk arts are a considerable part. Wood, clay, flax, wool, copper, silver, and amber, the wonderful gift of the Baltic Sea, were the favorite materials used by their urban and peasant craftsmen. These raw materials were, and are still today, made into remarkable works of art, which are intrinsic parts of their culture and life. Even their choir music festivals, in which thousands of singers participate, attest to the Baltic peoples' devotion to their cultural heritage.

Loyalty to tradition is also evident in their folk arts. They are practiced by both individuals and organized teams of craftsmen, who blend the traditional with the novel in their work by incorporating professional artistic innovations. Baltic art is popular abroad as well as at home due to the many professional and folk art exhibitions that have been held regularly in every part of the Soviet Union and in many foreign countries. These exhibitions have helped to demonstrate the flourishing Baltic region's cultural life to the world.

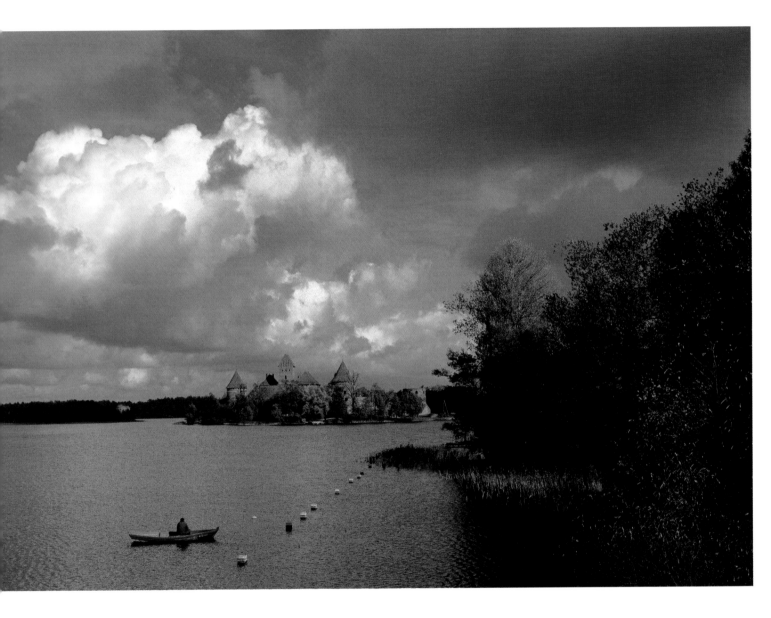

Folk Art in
LITHUANIA

Lithuanian wood sculpture is justly regarded as having no parallel in Europe by virtue of its wide popularity, originality, and expressive imagery. Most of the extant statuary from the past can be traced back to Roman Catholic iconography. Yet some pagan idols excavated by archaeologists prove that the craft was widespread even before Christianity was adopted in Lithuania in the fourteenth century. This is indirectly evident in the Lithuanian artists' rather free interpretation of canonical images. Thus, in their hands, the Spanish saint Isidore acquired the appearance of a typical Lithuanian peasant. St. Isidore was thought to help the village people in their hard work; therefore images of him were usually placed by the fields at the far edge of the village. At the village entrance there used to be a figure of St. Florian, patron saint of firemen, who was to pray to Providence for mercy and deliverance from the scourge of fire, which so often and so disastrously afflicted man in the past.

As the original image underwent transformation, so did its symbolic significance. Thus, St. George, hardly recognizable as a commoner on horseback slaying a dragon with his spear, was now regarded as the protector of the oppressed. Such frivolous treatment of canonical subjects vexed the senior clergy, who, as a result, banned statues of this kind and insisted on their removal from roadsides and homesteads. Yet they continue to spring up like trees on Lithuanian soil as expressions of the people's aspirations.

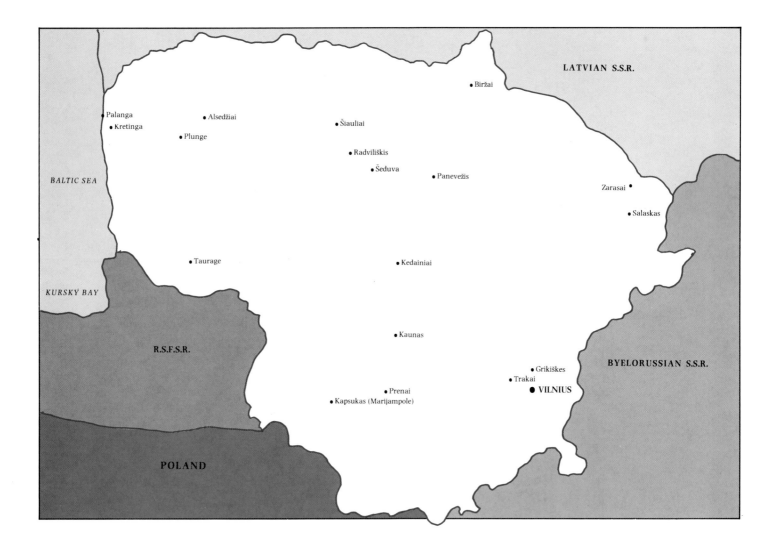

Wood was also used in other Lithuanian crafts. Various objects, such as peasant clogs, carved vessels, painted chests, distaffs, and other utensils indispensable in the peasant household for centuries, were traditionally made of wood in Lithuania.

A popular type of Lithuanian metalwork, the so-called "little suns," decorations for the roofs of houses, originated from the custom of erecting roadside statues. The "little suns" were decorated with exquisitely hammered flowers and leaves. The art of folk metalwork declined as manufacturing industries developed, and it was not until recently that it was revived, largely owing to the enthusiasm of present-day smiths.

Lithuanian scenery does not display a rich variety of colors. This is reflected in the color scheme of the local homespun or embroidered articles and glazed pottery. The typical geometric ornamentation used in Lithuanian woven or plaited belts is generally formed by two, or sometimes three to four alternating colors. Although the color range appears modest, Lithuanian handloom textiles show a surprising variety of design. Their stylistic austerity testifies to the fact that the Lithuanians based their craft on the artistic language of the remote past. The symbolism of certain ornamental elements is no longer clear, but on the whole the decoration retains its national flavor and vigor. It is for this reason that Lithuanian textiles can be easily distinguished from others.

The Crucifixion. Mid-19th century
Žemaitija
Colored woodcut. 72.7 × 59.7
The Čiurlionis Museum of Fine Arts, Kaunas

St. George. Late 19th or early 20th century
Village of Jakštaičiai, Kretinga District
Wood, carved and tinted. Height 39
The Čiurlionis Museum of Fine Arts, Kaunas

The Holy Family. 19th century (?)
Oil on panel. 43 × 32
The Čiurlionis Museum of Fine Arts, Kaunas

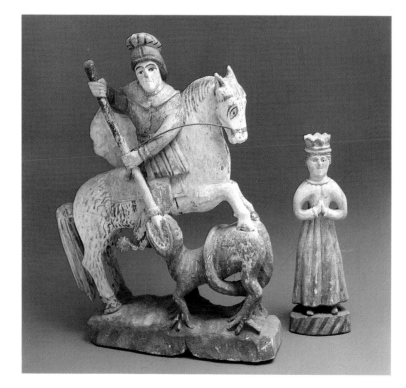

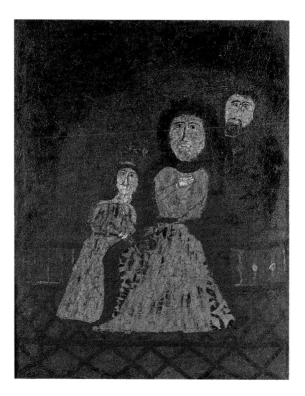

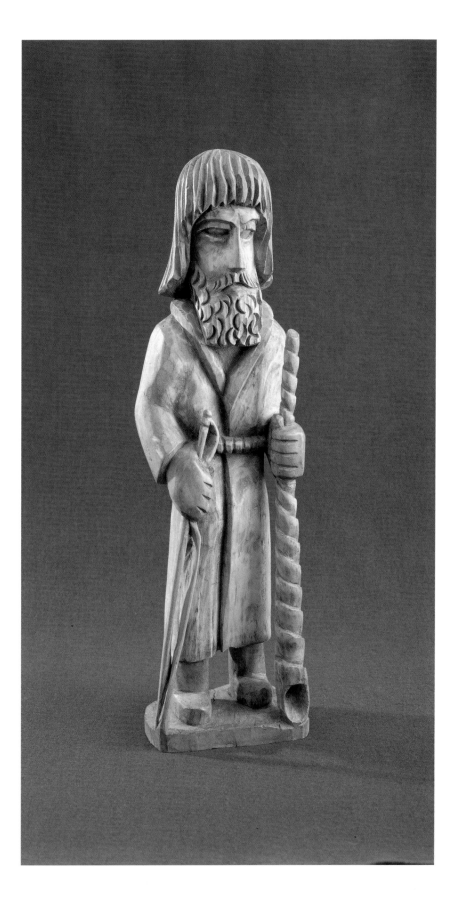

Shepherd. 1978
By V. Ulevičius
Vilnius
Carved wood. Height 85
Union of Artists, Moscow

Cloth for bedspread. 19th century
Village of Grušlaukis, Kretinga District
Homespun wool and linen. 178 × 132
The Čiurlionis Museum of Fine Arts, Kaunas

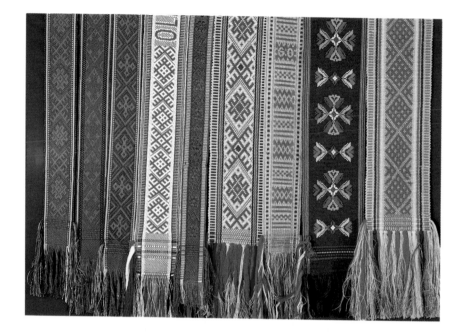

Besides wood carving and weaving, pottery has also played an important role in the domestic life of the people. It included what can be described as the most necessary pieces, such as jugs, tankards, and bowls, which accounts to some extent for the lack of variety in their earthenware. They are somewhat heavy, with thick walls, and their sparse ornament is slip-

Cloth for apron. Late 19th century
Skriaufniai, Marijampole District
Homewoven cotton, linen, wool, and worsted. 80.7 × 112.3
The Ciurlionis Museum of Fine Arts, Kaunas

Details of belts. 1979
Homewoven patterned wool
Union of Artists, Moscow

Joined pots. 1978
By S. Šidlauskas
Šiauliai District
Fired clay, with underglaze slip decoration. 26 × 42
Union of Artists, Moscow

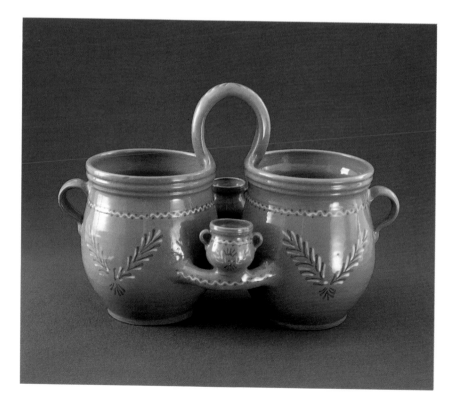

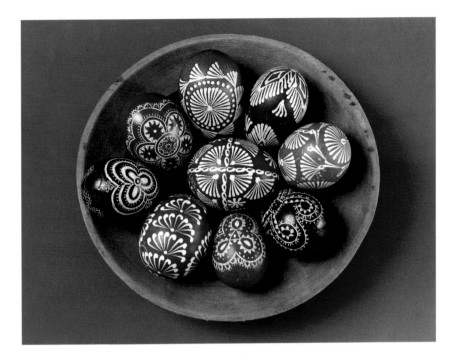

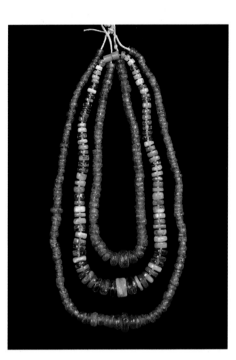

painted with very simple geometric and plant motifs in white, yellow, brown, or green. This limited range of techniques, though, does not mean that Lithuanian potters were ignorant of other types of earthenware. In the northeast, for example, fine ceramics from the Latgal area were in common use. In their palaces and manor houses, the rich Lithuanians had large collections of Western European faience and porcelain, which were certainly familiar to peasant potters, as evidenced by popular eighteenth- and nineteenth-century folk prints and paintings. Nevertheless, Lithuanian ceramic art remained protected from external influences by the people's original life style and loyalty to tradition.

Among the articles produced by folk artists, painted Easter eggs were particularly renowned. Like the textiles and pottery, they are characterized by restrained colors.

The Lithuanian coast is well known for rich deposits of amber, which is widely used in jewelry. As far back as the Neolithic Age, ritual figurines were made of this material. For many centuries, however, amber was almost neglected by folk artists and it was not until the twentieth century that it became central to Lithuanian folk art. In Palanga, a popular seaside resort, a special museum was set up to display the best work done by professional and folk artists.

Lithuanian folk art with its age-long traditions is as alive today as ever. Thousands of wood carvers, weavers, needlewomen, smiths, potters, and goldsmiths are engaged in their respective folk art industries. Annual arts and crafts festivals, including contests in which the most skilled craftsmen participate, are a familiar feature of Lithuanian life.

Easter eggs. 1962–63
Kaunas and Prenai Districts
The Čiurlionis Museum of Fine Arts, Kaunas

Beads. 19th century
Prenai and Trakai Districts
Amber
The Čiurlionis Museum of Fine Arts, Kaunas

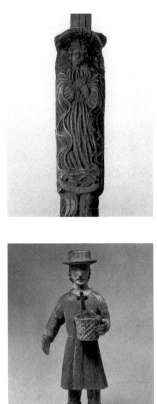

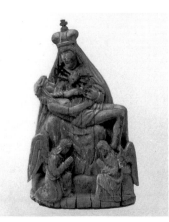

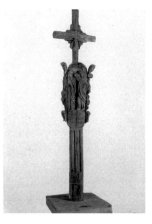

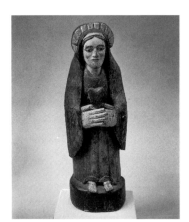

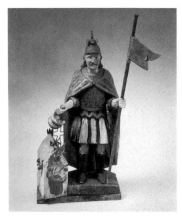

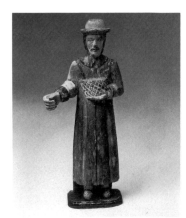

Mary Magdalene. Detail of a cross. Late 19th century
By V. Svirskis
Village of Juodžiai, Grikiškis Volost, Kedainiai District
Carved wood
The Čiurlionis Museum of Fine Arts, Kaunas

St. Isidore. 19th century
Wood, carved and tinted. Height 28.9
The Čiurlionis Museum of Fine Arts, Kaunas

Sorrow. Late 19th century
Plunge District
Wood, carved and tinted. Height 44.5
The Ciurlionis Museum of Fine Arts, Kaunas

Pietà. ca. 1880
By Šiaulinskas
Village of Bebrujai, Šeduva Volost, Panevežis District
Wood, carved and tinted. Height 45.5
The Čiurlionis Museum of Fine Arts, Kaunas

St. Florian. Early 20th century
Village of Krapštikai, Alsedžiai Volost, Plunge District
Wood, carved and tinted. Height 40.8
The Čiurlionis Museum of Fine Arts, Kaunas

St. Isidore. Late 19th or early 20th century
Taurage District
Wood, carved and tinted. Height 35.3
The Čiurlionis Museum of Fine Arts, Kaunas

Cross with *Christ and the Virgin*.
(with Two details).1893
By V. Svirskis
Village of Juodžiai, Grikiškis Volost, Kedainiai District
Wood, carved and tinted. Height 420
The Čiurlionis Museum of Fine Arts, Kaunas

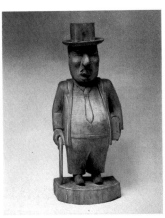

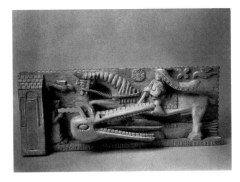

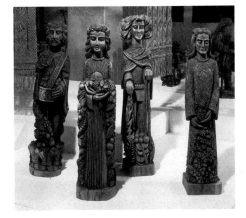

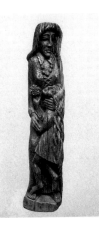

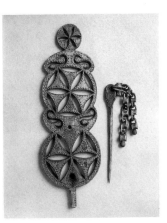

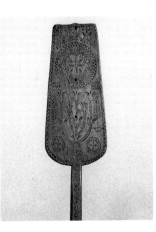

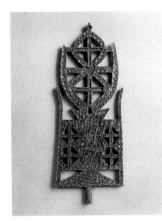

Man with a Briefcase. About 1964
By S. Riauba
Village of Godeliai. Plunge District
Carved wood. Height 45.5
The Čiurlionis Museum of Fine Arts, Kaunas

Neris and Vilnele. 1978
By I. Užkurnis
Vilnius
Wood, carved and varnished. Height 185
The Čiurlionis Museum of Fine Arts, Kaunas

Detail of distaff. 1861
Carved wood
The Čiurlionis Museum of Fine Arts, Kaunas

St. George. 1975
By L. Šepka
Vilnius
Carved wood. 89 × 35
The Čiurlionis Museum of Fine Arts, Kaunas

Iron ornaments. 1978
By J. Bakauskas
Radviliškis
Hammered iron. 38 × 38 (each)
Union of Artists, Moscow

Fragment of distaff. 1898
Carved wood
The Čiurlionis Museum of Fine Arts, Kaunas

Seasons of the Year. 1977
By V. Ulevičius
Plunge
Carved wood. Height 107, 104, 99, and 103
Union of Artists, Moscow

Fragments of distaff. 1892
By Kaveckas
Plunge
Carved wood
The Čiurlionis Museum of Fine Arts, Kaunas

Detail of distaff. 1848
Carved wood
The Čiurlionis Museum of Fine Arts, Kaunas

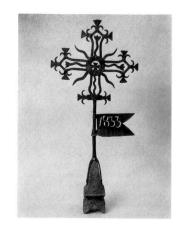

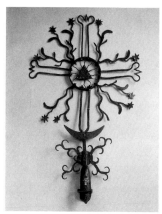

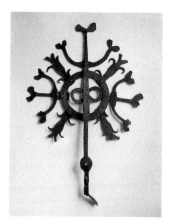

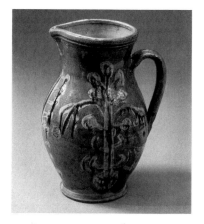

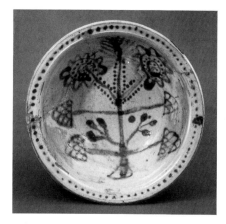

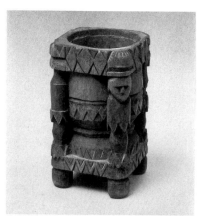

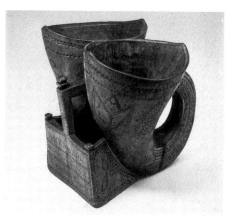

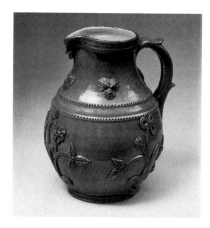

Weather vane. 1833
Village of Užduburiai, Plunge District
Hammered iron. Height 86.3
The Čiurlionis Museum of Fine Arts, Kaunas

Jug. Late 19th or early 20th century
Clay, fired and glazed. Height 24.6
The Čiurlionis Museum of Fine Arts, Kaunas

Double pot for carrying lunch to the field. 19th century
Clay, fired and glazed. Height 16.5
The Čiurlionis Museum of Fine Arts, Kaunas

Upper part of memorial. 19th century
Village of Batakiai, Taurage District
Hammered iron. 93 × 59
The Čiurlionis Museum of Fine Arts, Kaunas

Bowl. Late 19th or early 20th century
Clay, fired and glazed. Diameter 22
The Čiurlionis Museum of Fine Arts, Kaunas

Wedding double cup. 1770
Carved wood. Height 22
The Čiurlionis Museum of Fine Arts, Kaunas

Gable ornament. 19th century
Village of Purvaigiai, Plunge District
Hammered iron. Height 66
The Čiurlionis Museum of Fine Arts, Kaunas

Salt-box. Late 19th century
Village of Gubavele, Salakas Volost, Zarasai District
Carved wood. 17.5 × 10.5 × 10
The Čiurlionis Museum of Fine Arts, Kaunas

Jug. 1913
By N. Teseckis
Biržai
Clay, fired and glazed, with applied details. Height 25.3
The Čiurlionis Museum of Fine Arts, Kaunas

Folk Art in
LATVIA

Unlike Lithuanian crafts, which are based chiefly in the countryside, Latvian crafts, both urban and rural, have been closely interrelated since the early Middle Ages. This led to the production of objects that were very diverse yet stylistically similar, which, in turn, resulted in the evolvement of generally accepted artistic and technological techniques.

Popular Latvian crafts were pottery, embroidery, weaving, leathercraft, knitting, metalwork, and woodwork. Lathe-turned objects were generally decorated with ornamental bands of different widths, sometimes touched with color. Musical instruments, furniture for peasant homes, and some tableware were made by similar methods. Geometric and plant motifs decorated distaffs, saltcellars, and the lids of large round boxes. The carved designs decorating domestic objects in Latvia are based on large clear-cut forms and strong rhythms. In addition to wooden utensils, Latvian peasants wove containers from tree roots and made birch-bark articles of every size and description, which were decorated with carved or stamped designs. Vessels woven of roots were large and solid-looking; their surface, formed by closely intermatching roots, is rough to the touch. Despite the limitations imposed by this weaving technique, their patterns are extraordinarily varied. Latvian birch-bark boxes, recalling northern Russian containers, look light and airy in comparison, an impression which is enhanced by their pleasant geometric ornamentation of simple elements. Articles made of hollowed pieces of wood were also common, especially large thick-walled bowls, the shapes of which bring to mind smoked and burnished earthenware.

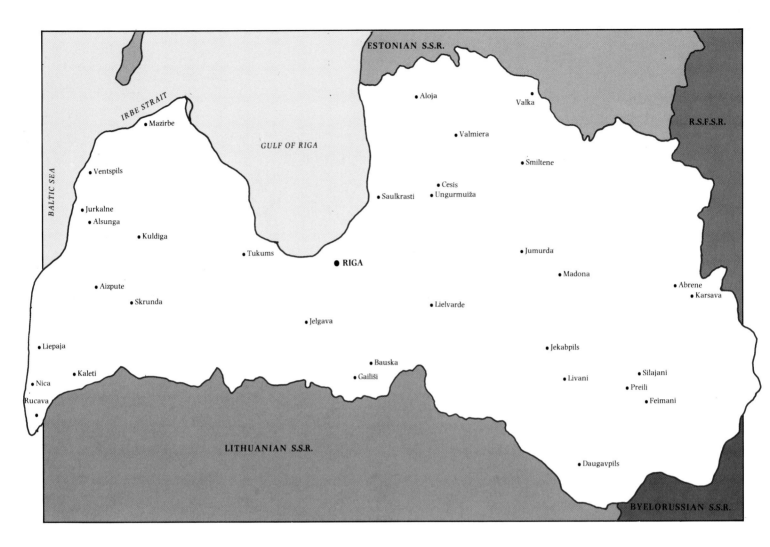

As furniture in peasant homes was rarely decorated with carving, numerous possibilities opened up for folk painters to cover rustic chests of drawers and trunks (which could be used as makeshift beds) with colorful formalized plant designs. In the middle, there was generally a pot of flowers or a shrub in full blossom, with birds, solemn and motionless, arranged symmetrically on its branches. The painting was usually in two or three colors on a contrasting background.

Like the painters, folk metalworkers benefitted from the lack of carving on furniture. Forged details, which were a common and important aspect of furniture decoration, attest to the very high smithing standards among the Latvian peasantry.

Interesting examples of Latvian peasant ironware can be found among their candelabra, which were suspended from the ceiling as the interior's centerpiece. In the nineteenth century, they superseded the previously popular candlestick of simple yet attractive design.

Peasant smiths also made personal decorations, which were an integral element of national costumes. Buckles with chased or engraved ornaments were popular accessories for women's dresses. Metalwork and jewelry-making traditions have been carefully preserved in Latvia, therefore the contemporary ornaments have not lost their national flavor.

Basket. 1984
Riga
Wickerwork. Height 32, diameter 28.5
Private collection, Riga

Marriage chest. 1846
Karsava Volost, Madona District
Painted wood, with metal mount. 62 × 120 × 66
History Museum of the Latvian SSR, Riga

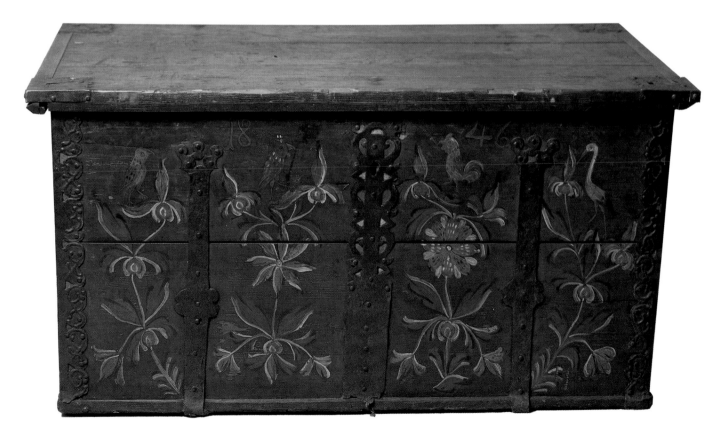

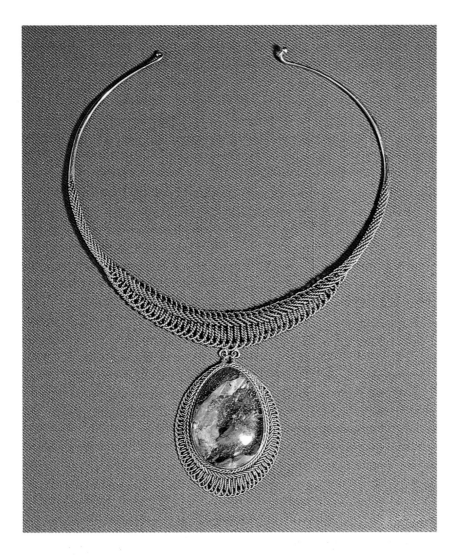

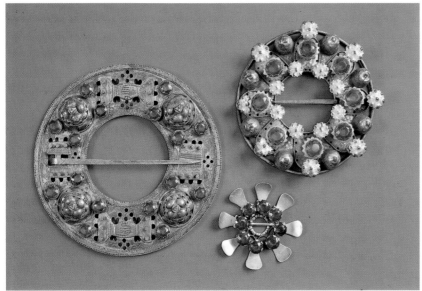

Necklace. 1978
By R. Ozola
Riga
German silver with filigree and amber
Union of Artists, Moscow

Brooches. 18th century
Kuldiga; Jelgava
Silver, chased and engraved, with glass insets. Diameter 20.8,
 9.5, and 15.4
History Museum of the Latvian SSR, Riga

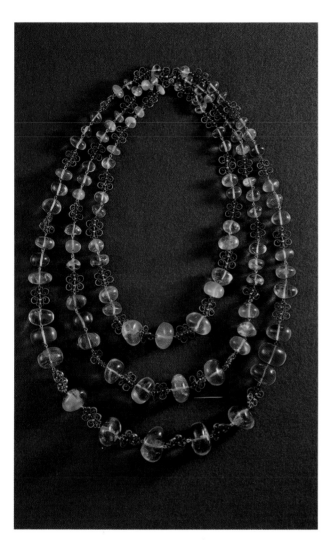

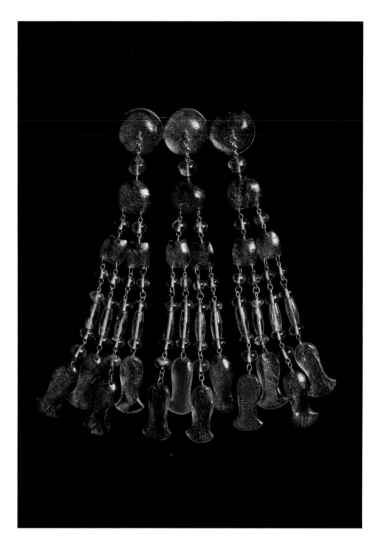

Necklace. 1979
By R. Ozola
Riga
Silver and amber
Union of Artists, Moscow

Woman's ornament. 1980
By G. Kripena
Liepaja
Metal and amber. 20 × 17
History Museum of the Latvian SSR, Riga

Pottery has been popular in Latvia from time immemorial. Heavy earthenware of archaic form and large size was made in the western and southern provinces, whereas in the north and east of the country variegated glazed wares of many different shapes and rich decorations were produced. Latvian pottery was known in Europe as far back as the second half of the nineteenth century, especially the work of Jekabs Dranda, an outstanding ceramic artist from Smiltene in northern Latvia. Flat decorative dishes from his wheel, often quite large, are remarkable for their splendid multicolored glazes and exquisite painted decorations consisting mostly of plant motifs.

The ceramic industry in southeastern Latvia is one of the oldest in the republic. Even today a fair number of potters working there come from famous families in which the trade has existed for generations. They make crockery, candelabra, toys, and whistles with handworked, painted, or in-

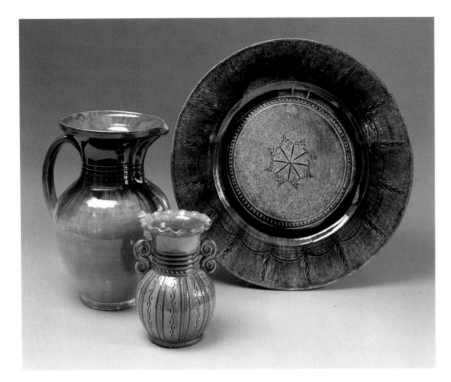

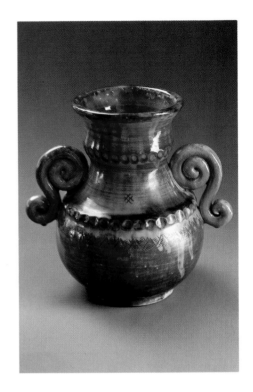

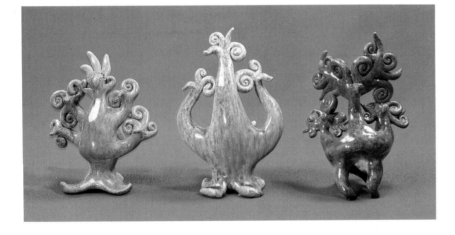

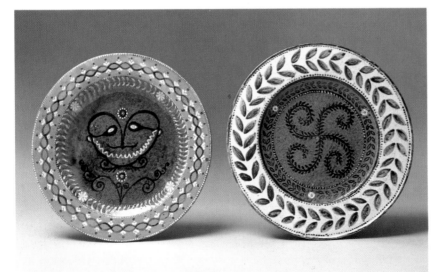

Pitcher and decorative plate. 1976 and 1973
By P. Černiavski
Vase. 1950s
By P. Vilcan
Gailiši, Preili District
Clay, fired, engraved, and glazed. Height 26.5 and 15.8
 (pitcher and vase); diameter 38 (dish)
History Museum of the Latvian SSR, Riga

Whistles. 1978
By P. Ķise
Rezekne
Handworked clay, fired and glazed. Height 10.5, 12, and 11
Union of Artists, Moscow

Plates. Early 20th century
By J. Dranda
Smiltene Volost, Valka District
Clay, fired and painted underglaze. Diameters 31, 32
History Museum of the Latvian SSR, Riga

Vase. 1978
Clay, fired and glazed, with applied details and incised design.
 Height 16
Union of Artists, Moscow

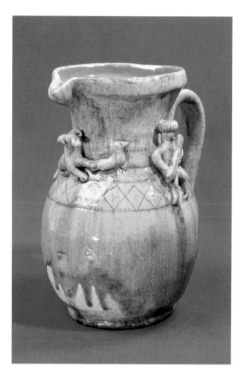 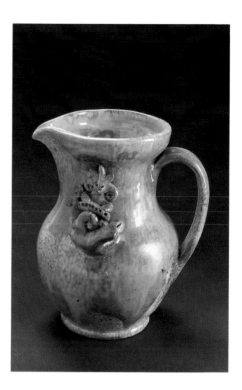

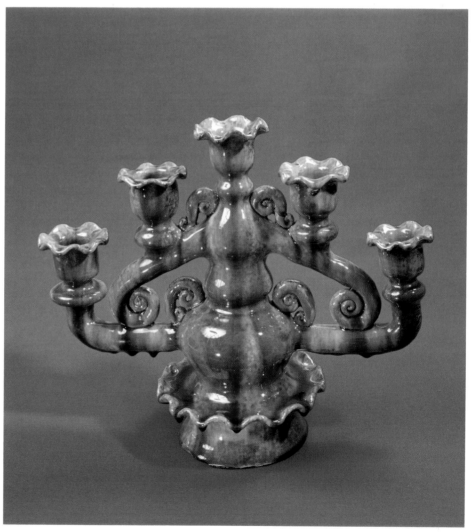

Pitcher. 1968
By A. Paulans
Feimaņi, Rezekne District
Clay, fired and glazed, with applied details. Height 30
Union of Artists, Moscow

Milk jug. 1978
By A. Kapostiņš
Rezekne
Clay, fired, with applied details and incised design, painted
　underglaze. Height 17
Union of Artists, Moscow

Ewer. 1978
Clay, fired and glazed, with applied details. Height 15
Union of Artists, Moscow

Candelabrum. 1978
By V. Vogula
Rezekne
Handworked clay, fired and glazed. 30 × 35
Union of Artists, Moscow

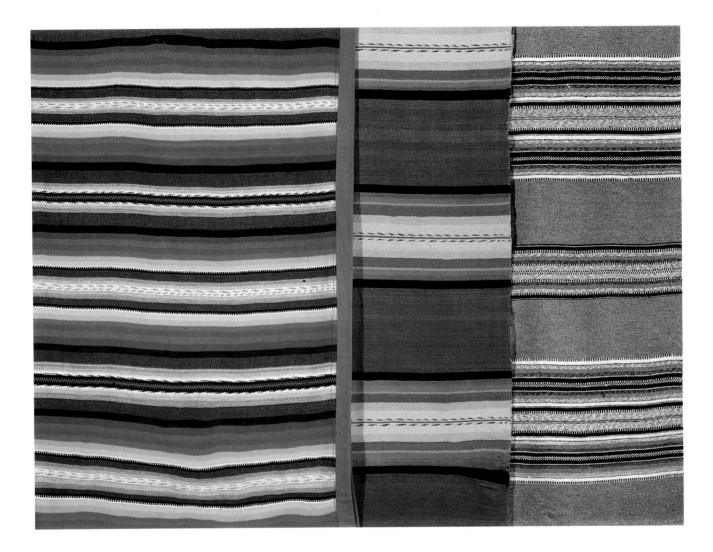

cised decorations. Their favorite glazes are green and brown; underglaze designs are painted in yellow, black, red, or brown slips. Clay toys are made in the traditional forms of horsemen, animals, fantastic beasts, birds, etc. Pottery walls and intricately interwined parts of candlesticks are often decorated with zoomorphic motifs.

Crafts practiced by Latvian women are remarkably diverse. Homespun bedspreads, which are particularly revered in Latvia, vary considerably according to the place of their production: in Angzem, they are striped with sharply contrasting bright colors; Videm bedspread patterns comprise complex ornamental bands deriving from traditional Latvian belts; in Kurzeme spreads, the design is arranged symmetrically in the manner of a mirror reflection.

Cloaks were an indispensable element of women's costumes all over Latvia. They were made in different ways: woven in patterns, knit, or embroidered on factory-made cloth. Quite often these cloaks were worn with matching mittens of the same style. Latvian folk weaving is characterized

Details of blankets. Early 20th century, 1887, and 1915
By an unknown craftsman (left), M. Zalite (center), and K. Vandere (right)
Aloja Volost, Valmiera District; Jaunpiebalga Volost, Cesis District; Cirkale Volost, Valka District
Homewoven wool and linen. Width 164, 182, and 145
History Museum of the Latvian SSR, Riga

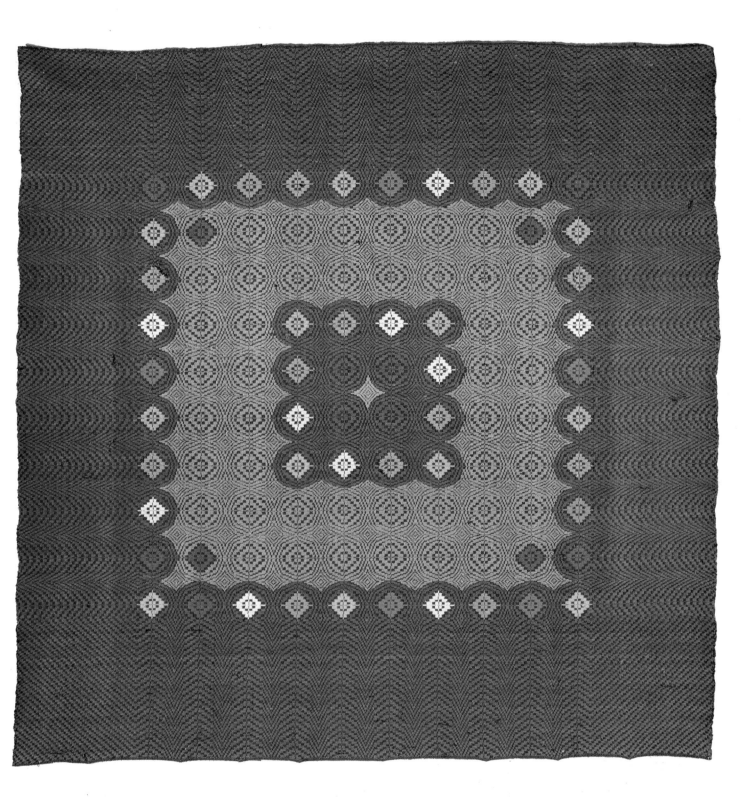

Blanket. Early 20th century
By E. Briede
Kuldiga
Homewoven wool and cotton. 156 × 152
History Museum of the Latvian SSR, Riga

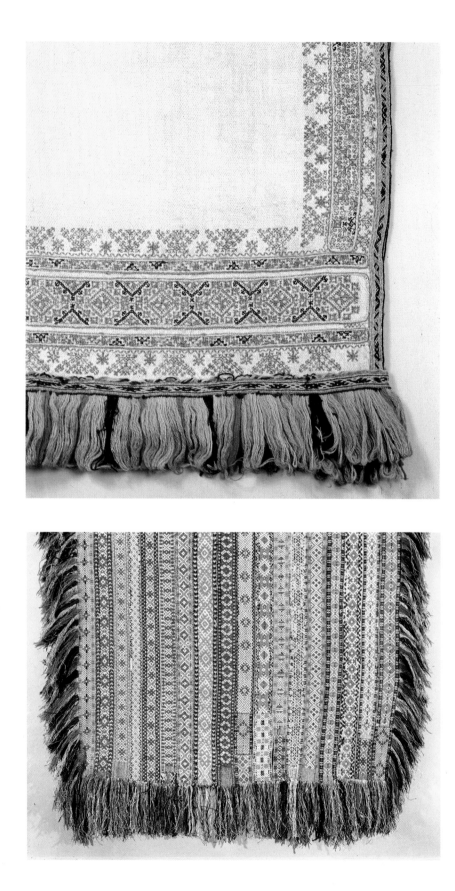

Detail of shawl. First half of the 19th century
Ungurmuiža Volost, Jekabpils District
Homewoven wool with embroidery
History Museum of the Latvian SSR, Riga

Bedspread composed of belts. Late 19th or early 20th century
Zemgale, Southern Latvia
Homewoven wool and linen. Width 95
History Museum of the Latvian SSR, Riga

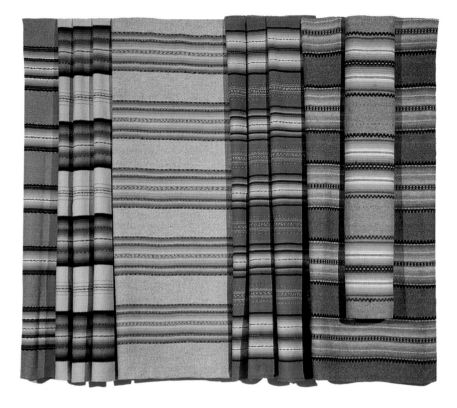

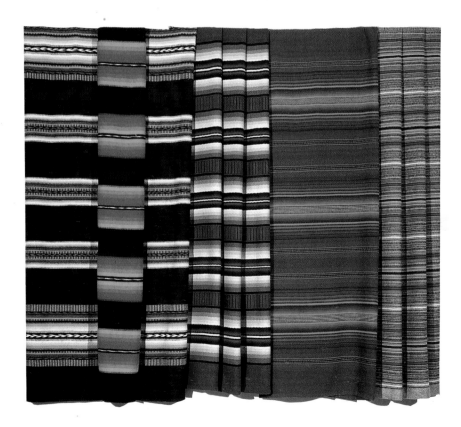

Details of bedspreads. 1977
By A. Jansone (left) and M. Paegle (right)
Tukums; Valmiera
Homewoven wool and cotton
Union of Artists, Moscow

Details of bedspreads. 1977–78
By A. Jansone, P. Jakobsone, and P. Plase
Tukums
Homewoven wool and cotton
Union of Artists, Moscow

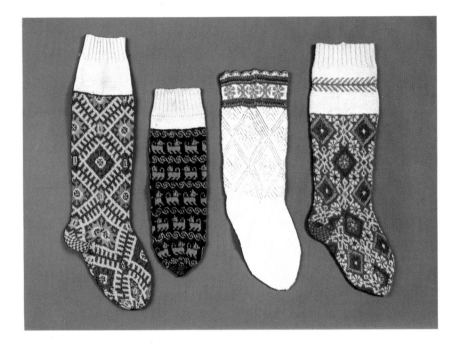

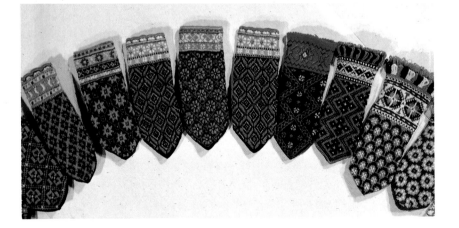

Stockings. Late 19th or early 20th century
Alsunga Volost, Aizpute District
Knitted wool. Length 60.5, 42, 50, and 58
History Museum of the Latvian SSR, Riga

Mittens. 1930 (left) and early 20th century
By S. Baldiševica (left) and unknown masters
Kraslava Volost, Daugavpils District; Rezekne District; Livani
 Volost, Daugavpils District
Knitted wool. 31.5 × 11, 29 × 11.5, 34 × 11, and 30 × 10.3
History Museum of the Latvian SSR, Riga

Mittens. 1970s
By Z. Krumberga, A. Purvine, and L. Malčece
Riga
Knitted wool
Union of Artists, Moscow

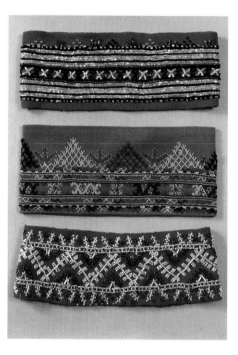

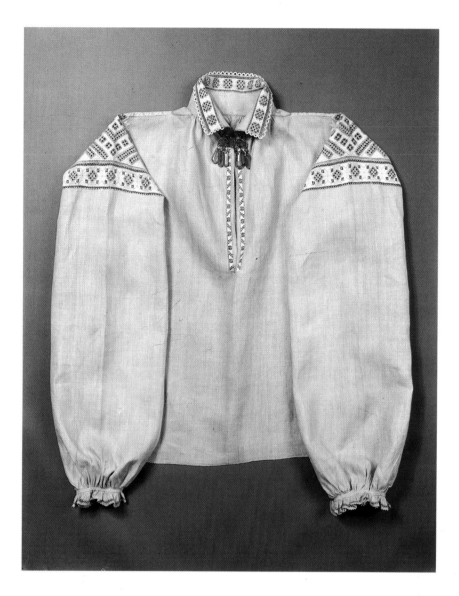

Young girls' headdresses. 19th century
Jumurda Volost, Cesis District; Lielvarde Volost, Riga District;
 Bauska District
Embroidered wool, with beadwork. 25.5 × 9.5, 25.5 × 11,
 and 27.5 × 9
History Museum of the Latvian SSR, Riga

Woman's blouse. Late 19th century
Rucava Volost, Liepaja District
Linen, with embroidery in cotton thread. 62 × 69
History Museum of the Latvian SSR, Riga

by color schemes rich in warm tones and by extremely varied geometric and plant designs. In addition to their multicolored woven and embroidered articles, refined two-color compositions were produced in some parts of Latvia, such as embroidery in black thread, the solemn austerity of which evokes parallels with Moldavian needlework. Quite often the design was based solely on the juxtaposition of different textures of the same color, as exemplified by satin-stitch embroideries in white thread, monochrome patterned weavings of white or gray wool, and straw mats. Latvian knit stockings, socks, gloves, and mittens possess a striking variety of designs and exquisite color schemes. The intricately patterned knitwork of Kurzeme is especially notable.

In the Latvian SSR there are presently over two hundred amateur studios for handicrafts, where thousands of people of all ages and occupations learn the traditional skills of creating objects of daily use.

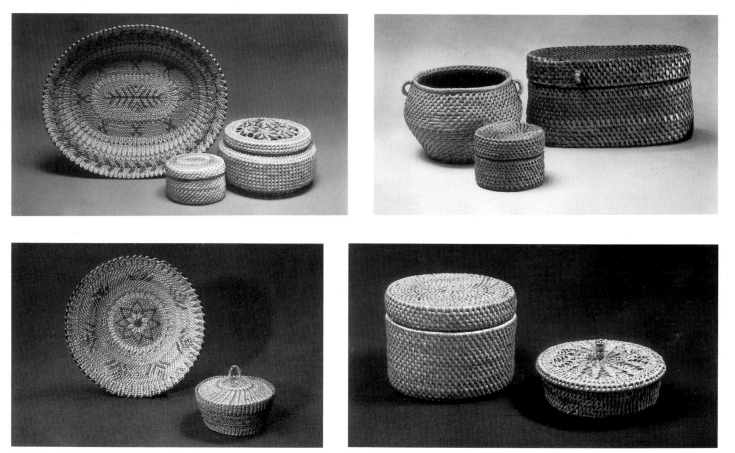

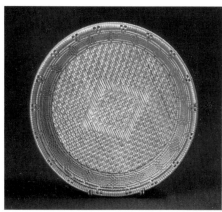

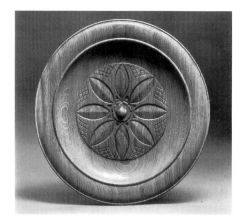

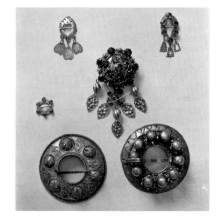

Decorative dish. 1967
By E. Priedite
Village of Saulkrasti, Riga Region
Containers. 1970 and 1972
By J. Lusiņš and Ž. Donis
Cesis; Jelgava
Plaited roots. 6.3 × 27 × 22 (dish); height 5, diameter 8.5;
 height 9, diameter 13
History Museum of the Latvian SSR, Riga

Biscuit dish and box. 1970s
Wickerwork
Union of Artists, Moscow

Biscuit dish
By J. Austriņš
Willow rods interwoven with straw
Union of Artists, Moscow

Decorative plate. 1973
By E. Placeņš
Liepaja
Lathe-turned wood, carved and inlaid with amber.
 Diameter 42.3
History Museum of the Latvian SSR, Riga

Bowl and marriage boxes. 19th century
Renda Volost, Kuldiga District (bowl); Ventspils District;
 Alsunga Volost, Aizpute District (boxes)
Plaited roots. Height 13, diameter 16.5 (bowl); height 8,
 diameter 10.5; 15.5 × 29 × 15
History Museum of the Latvian SSR, Riga

Boxes. 1977
By Briedis
Wickerwork
Union of Artists, Moscow

Brooches. 17th–first half of 20th century
Kuldiga (top); Riga (center); Liepaja (bottom)
Silver, chased and engraved, with glass insets. Length 4.7, 16,
 and 7.5; diameter 3.6, 12.1, and 12.3
History Museum of the Latvian SSR, Riga

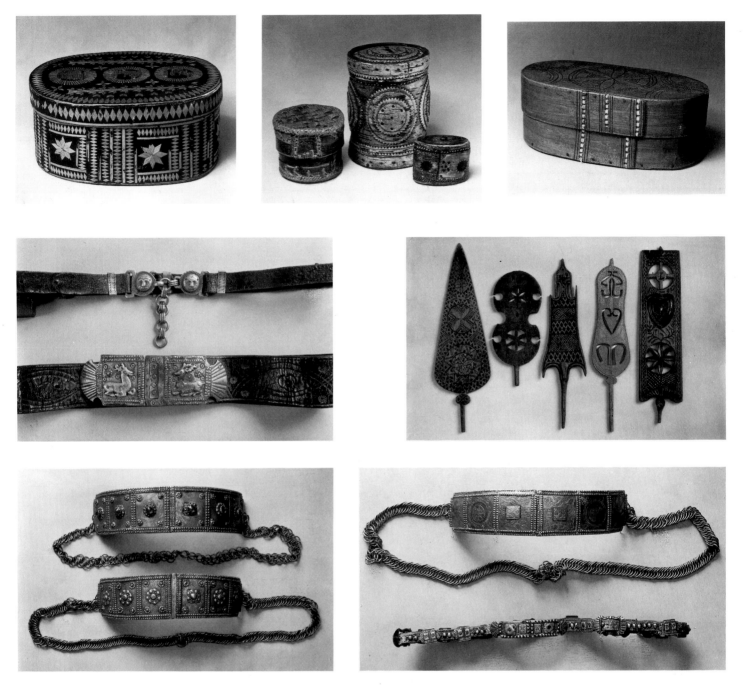

Marriage box. First half of the 18th century
Lielvarde Volost, Riga District
Wood, inlaid with straw. 10 × 23.5 × 18
History Museum of the Latvian SSR, Riga

Buckles for men's belts. Late 19th or early 20th century
Alsunga Volost, Aizpute District; Sarkanmuiž Volost, Ventspils
 District
Brass, stamped, chased, and engraved. 11.5 × 3.7; 19.5 × 6
History Museum of the Latvian SSR, Riga

Belts. 19th century
Piltene, Ventspils District; Užava Volost, Ventspils District
Brass, chased and set with glass. 18 × 8; length of chain 84;
 18 × 8.5, length of chain 100
History Museum of the Latvian SSR, Riga

Two marriage boxes and snuffbox. 19th century
Vilaka Volost, Abrene District; Kurzeme, Western Latvia
Carved lime bark, decorated with plaited bast and birch-bark
 appliqué, leather. Height 10, diameter 12; height 19.5,
 diameter 14.5; 7 × 9.5 × 5
History Museum of the Latvian SSR, Riga

Marriage box. 19th century
Sarkanmuiž Volost, Ventspils District
Carved wood, inlaid with goose feathers. 14 × 39 × 21
History Museum of the Latvian SSR, Riga

Fragments of distaffs. 1879; 1896; 1852; 1850–1900; 1891
Jurkalne Volost, Aizpute District; Kaleti Volost, Liepaja District;
 village of Mazirbe, Ventspils District; Skrunda Volost,
 Kuldiga District; Jurkalne Volost, Aizpute District
Carved wood. Height 48.6, 29.7, 43.5, 45, and 45.5
History Museum of the Latvian SSR, Riga

Belts. 1832 and 19th century
Renda Volost, Kuldiga District; Kurzeme, Western Latvia
Brass, chased and engraved. 17 × 6.5; length of chain 106;
 97 × 1.7
History Museum of the Latvian SSR, Riga

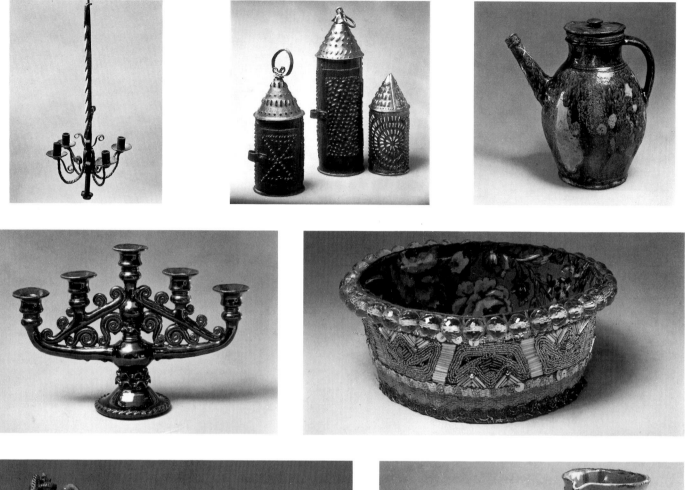

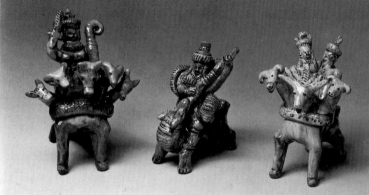

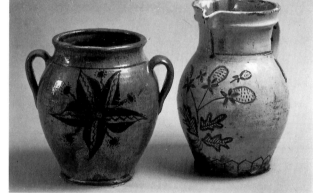

Candelabrum. 19th century
Jurkalne Volost, Aizpute
Hammered iron. Height 70
History Museum of the Latvian SSR, Riga

Candelabrum. 1959
By S. Kalve
Riga
Handworked clay, fired and glazed. 31.5 × 46.5 × 15
History Museum of the Latvian SSR, Riga

Whistles. 1972 (two) and 1968
By A. Paulans
Feimaņi, Rezekne District
Handworked clay, fired, engraved, and glazed. Length 15, 13,
 and 14.5
History Museum of the Latvian SSR, Riga

Lamps. Second half of the 19th century
Dinike Volost, Liepaja District; Rundale Volost, Bauska
 District; Kurzeme, Western Latvia
Hammered iron. Height 27, 40, and 24, diameter
 14.5, 12.3, and 10.5
History Museum of the Latvian SSR, Riga

Spouted vessel. Late 19th century
Zemgale, Southern Latvia
Clay, fired and glazed. Height 34.5
History Museum of the Latvian SSR, Riga

Maiden's headdress. 19th century
Nica Volost, Liepaja District
Cardboard frame covered with textile, embroidered, and
 decorated with beadwork and brocade ribbons. Height 9,
 diameter 23.5
History Museum of the Latvian SSR, Riga

Pot and ewer. 1890 and early 20th century
Rucava Volost, Liepaja District
Clay, fired, engraved, and glazed. Height 28 and 34
History Museum of the Latvian SSR, Riga

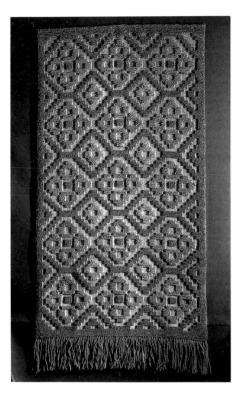

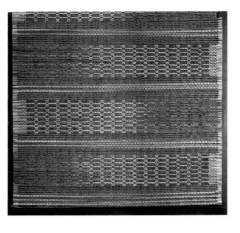

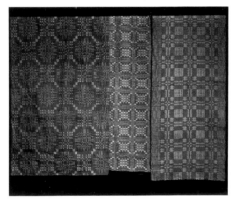

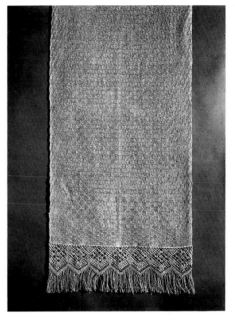

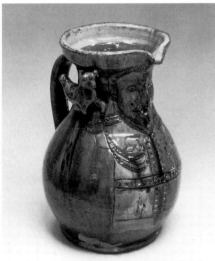

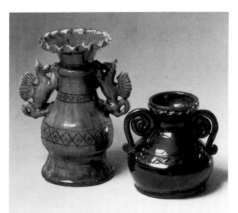

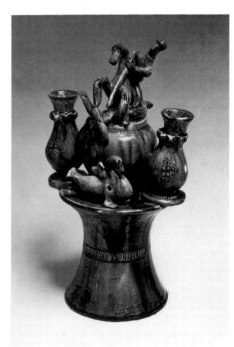

Wall hanging. 1980
By N. Akmene
Jelgava
Homewoven wool and cotton. 150 × 84
History Museum of the Latvian SSR, Riga

Pitcher. 1937
By A. Paulans
Silajanj Volost, Rezekne District
Clay, fired, engraved, and glazed, with applied details.
 Height 28.5
History Museum of the Latvian SSR, Riga

Wall hanging. 1964
By I. Lace
Riga
Cotton, interwoven with rushes. 210 × 106
History Museum of the Latvian SSR, Riga

Details of towels. Late 19th or early 20th century
Rucava and Nica Volosts, Liepaja District
Homewoven linen and cotton. Width 43, 58, and 56
History Museum of the Latvian SSR, Riga

Vases. 1972 and 1930s
By A. Paulans
Feimani, Rezekne District
Clay, fired, engraved, and glazed, with applied details.
 Height 19 and 10
History Museum of the Latvian SSR, Riga

Detail of decorative towel. 1973
By V. Banga
Saldus
Homespun linen, with lace. Width 58
History Museum of the Latvian SSR, Riga

Money box. 1930s
By A. Paulans
Silajaņi Volost, Rezekne District
Clay, fired, engraved, and glazed, with applied figures.
 29.5 × 17.5 × 12
History Museum of the Latvian SSR, Riga.

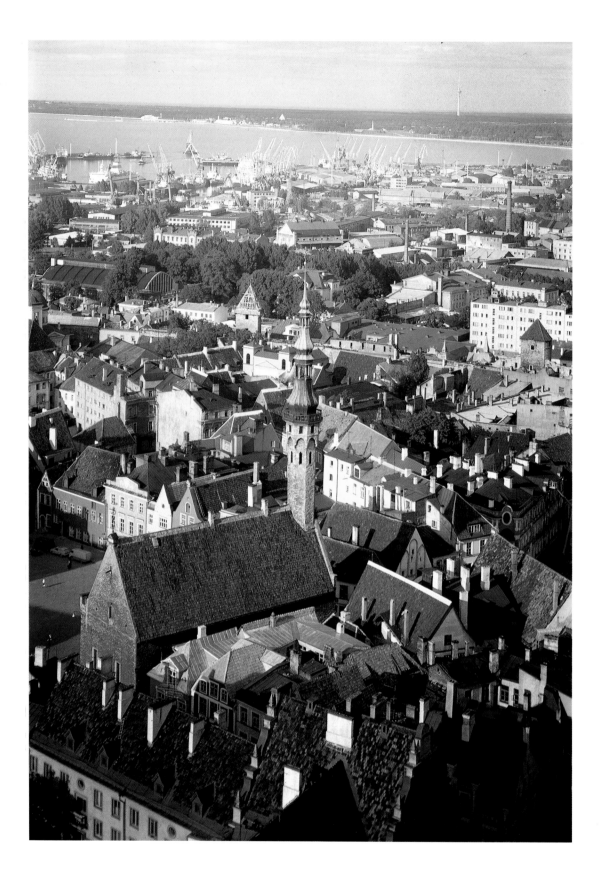

Folk Art in
ESTONIA

Well into the middle of the nineteenth century most peasant houses in Estonia were not equipped with chimney flues, and fireplace smoke quickly covered everything with thick layers of soot. Consequently interiors could not be richly decorated. Only the shapes and details of certain wood carvings on household utensils evince fine taste and high standards of workmanship. The forested northeast of the republic adjoining Lake Peipus was an important center for wooden furniture and utensil production. A hundred years ago about a thousand craftsmen, who catered to all Estonia except its islands, worked in Avinurme and its neighboring areas. Simple yet expressive techniques, such as carving and pokerwork, were used to make the contours of large geometric designs distinguishable even in the dark smoky interiors.

A taste for ornamentation is especially characteristic of the Estonian islanders from Muhu, Kihnu, and Saaremaa, as demonstrated primarily by their ubiquitous embroidery and, to a lesser extent, by the decoration of their wooden wares. The backs of chairs in peasant homes on Muhu Island are adorned with representations of plants, besides commonly used cosmogonic motifs. An expressive highlight, such as a rosette comprising several petals, an oval, a cross, or a heart, is generally in the center of the composition. The seats of these chairs are woven of rope, straw, or seaweed to form highly varied patterns reminiscent of twill weaves. Also worthy of note are the local beer tankards made up like barrels, which are often inlaid with dark or light wooden mosaic designs. Carved patterns are widely used for

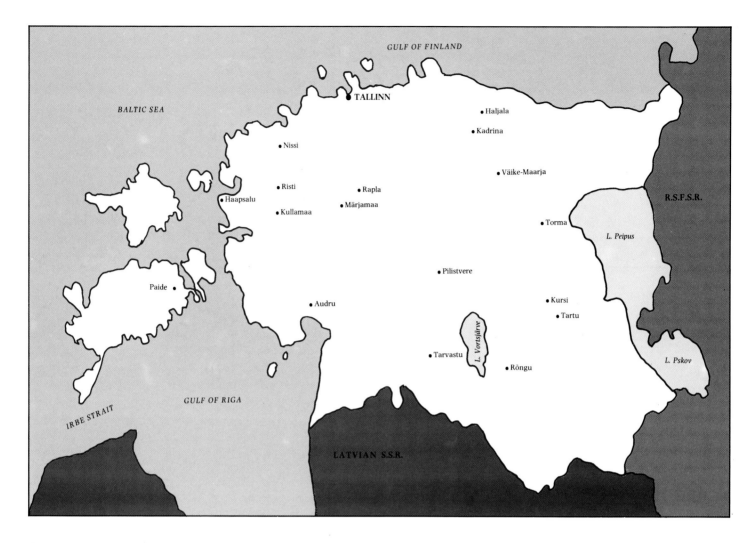

adorning such mugs, their lids frequently bearing stylized designs carved in low relief.

In addition to wooden articles the Estonians used copper tableware of fine proportions and well-defined forms. Silver-, copper-, and brasswork were also practiced on a wide scale. In eastern Estonia the chief decoration for women's costumes in the past was a large fibula, up to twenty centimeters in diameter, which was worn on the breast. Its conical surface was usually covered with flowing designs of stylized plants. As well as fibulae, long necklaces with silver pendants in the shape of leaves or hearts, suspended from figured chains, were worn. Flat brooches with colored glass insets were also popular. The techniques of engraving, chasing, and stamping were all used in Estonian jewelry.

As different parts of Estonia were relatively isolated from each other in the past, over a hundred and fifty distinctive local costume styles developed. Their decorative richness and diversity are especially noticeable in women's headdresses, in which various materials and techniques, such as embroidery in silk or wool, spangles, beads, and even small metal bells, were used. Estonian embroidery employs a wide range of designs including archaic motifs, geometric patterns, and complicated plant compositions. The needlewomen from Muhu Island are famous for their varicolored embroidery with realistic large-scale floral representations. In the area of Haapsalu, an original technique of weaving multicolored, intricately patterned shawls and

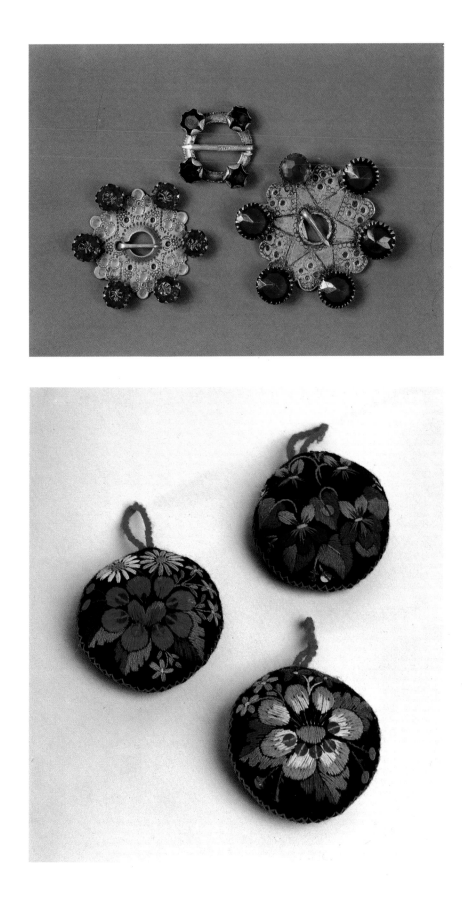

Brooch-like buckles. Mid-19th century
Audru; Paide and Jämaja, Saaremaa Island, West Estonia
Neusilber, hammered and chased, with glass insets. Diameter
 7, 3, and 5
Museum of Ethnography of the Estonian SSR, Tartu

Pincushions. 1978
By L. Kirst
Muhu Island, West Estonia
Wool, with satin-stitch embroidery. Diameter 9 (each)
Union of Artists, Moscow

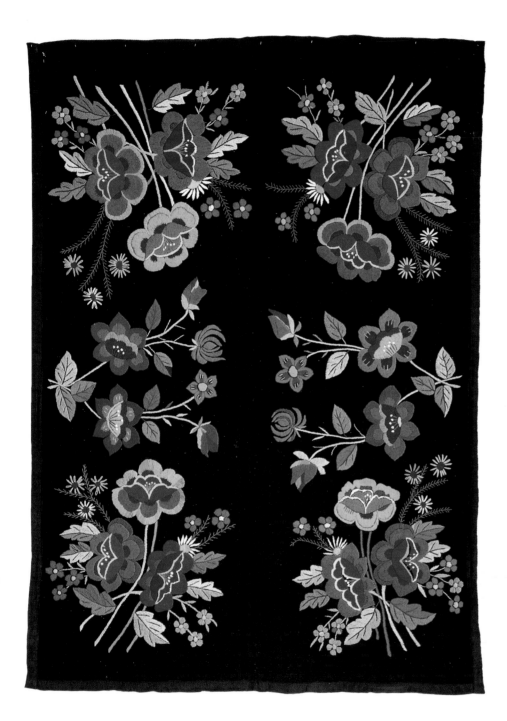

similarly decorated wraps is used. Zoomorphic motifs, plant designs, and human figures are found on traditional Estonian rugs, which became popular in the nineteenth century. Terry carpets were used as blankets during sledge rides, but now their bright coloring and high artistic quality make them ideal for interior decoration.

Bedspread. 1977
By L. Sutendu
Wool, with satin-stitch embroidery in cotton thread.
190 × 120
Union of Artists, Moscow

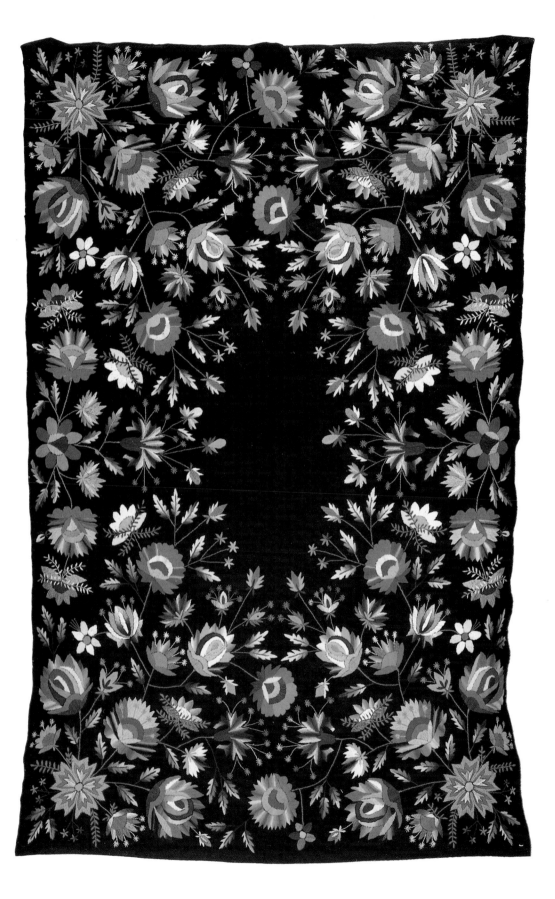

Bedspread. 1977
By D. Naader
Wool, with satin-stitch embroidery. 210 × 130
Union of Artists, Moscow

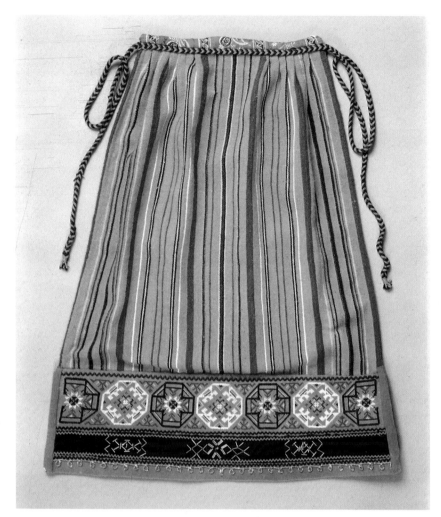

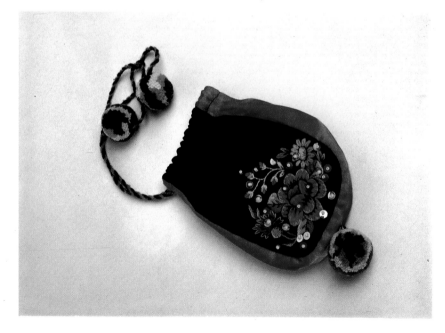

Apron. 1889
Muhu Island, West Estonia
Cotton, with embroidery in wool thread, beadwork, and
rep-weave belt. 71.5 × 60
Museum of Ethnography of the Estonian SSR, Tartu

Tobacco pouch. 1979
By Z. Aaher
Muhu Island, West Estonia
Wool, with satin-stitch embroidery. 14 × 8
Union of Artists, Moscow

Wall carpet. 1969
Mari Adamson
Wool, cotton, Manila hemp
The Estonian Art Museum, Tallinn

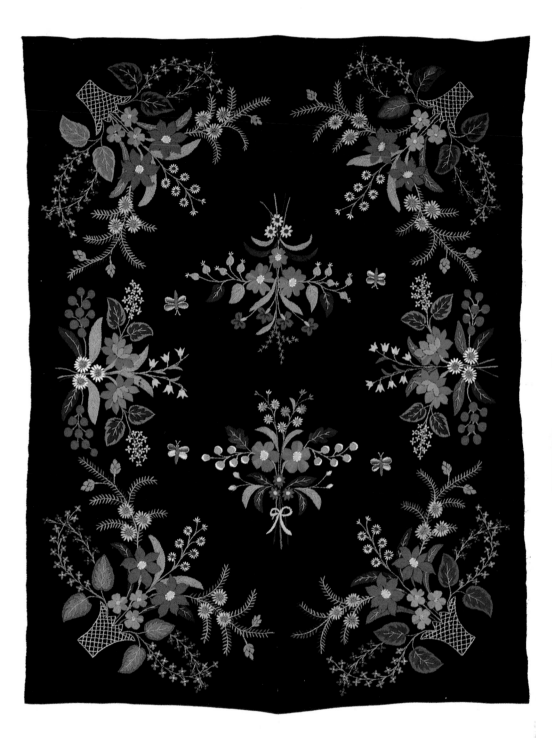

Rug. 1979
Wool, with embroidery
Union of Artists, Moscow

Contemporary Estonian leather articles, with their stamped or applied decoration, are deservedly popular. Women's costumes from Hiiumaa Island used to include traditional belts decorated with metal insets, embroidery, and sewn-on chains. Important accessories for men's costumes were tobacco pouches, which were decorated with simple stamped designs, with appliqué, or inlaid with fabric and leather of a different color.

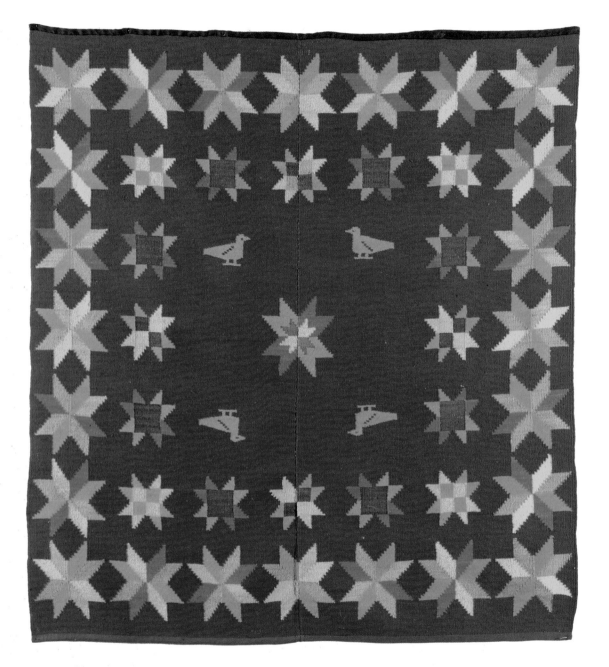

In the nineteenth century, shoes with low heels produced on the islands were decorated with stamped, slightly colored designs and rich inlay work. Rich decoration is also evident on local horse trappings and sheaths for Finnish knives. Leather articles made at present, such as dustcovers, bookmarks, eyeglass cases, purses, and little boxes, are not so richly adorned but are still based on traditional motifs.

A folk artists' cooperative, known as Uku, has been active in the past few decades circulating many useful objects, the design and ornamentation of which hark back to the age-old utilitarian traditions of folk art. These revivals are deservedly appreciated both within and outside the republic.

Sledge rug. Early 20th century
Märjamaa, West Estonia
Homewoven wool and cotton. 117.5 × 126.5
Museum of Ethnography of the Estonian SSR, Tartu

Bedspread. 1977
Muhu Island, West Estonia
Cloth, embroidered in woollen thread. 110 × 160
Union of Artists, Moscow

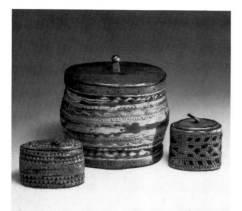

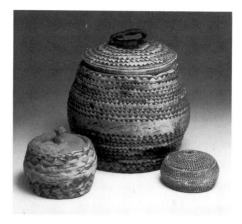

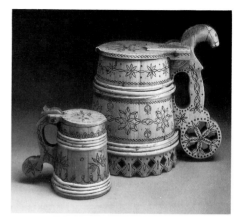

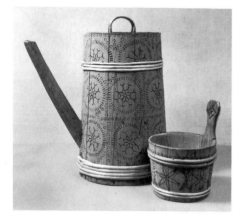

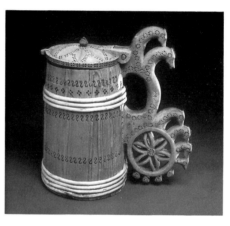

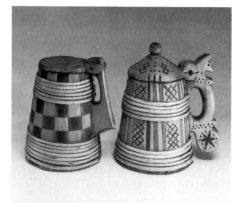

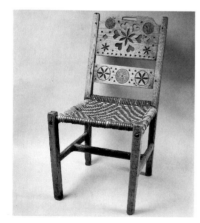

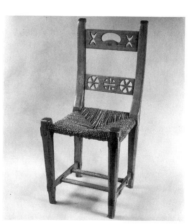

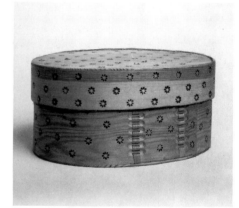

Boxes. Mid-19th century
Pilistvere, South Estonia; Rõngu, South Estonia
Wood and birch bark. Height 5, 11.6, and 5
Museum of Ethnography of the Estonian SSR, Tartu

Beer container and dipper. First half of the 19th century
and 1919
Kõpu, South Estonia; Rapla, West Estonia
Wood, with pokerwork. Height 48 and 16.5
Museum of Ethnography of the Estonian SSR, Tartu

Chair. 1889
Muhu Island, West Estonia
Carved wood, with wickerwork. 83 × 41 × 41
Museum of Ethnography of the Estonian SSR, Tartu

Boxes. Mid-19th century
Haljala and Kadrina, North Estonia
Wood and birch bark. Height 3 and 12.5
Museum of Ethnography of the Estonian SSR, Tartu

Beer tankard. 1870
Kullamaa, West Estonia
Carved wood, with pokerwork. Height 32
Museum of Ethnography of the Estonian SSR, Tartu

Chair. 1901
West Estonia
Carved wood, with wickerwork
Museum of Ethnography of the Estonian SSR, Tartu

Beer tankards. 1915
Nissi, North Estonia
Carved wood, with pokerwork
Museum of Ethnography of the Estonian SSR, Tartu

Beer tankards. 1840 and 1878
Risti, North Estonia; Kihnu Island, West Estonia
Carved wood, with intarsia and pokerwork (right). Height 18
and 21
Museum of Ethnography of the Estonian SSR, Tartu

Box. 1978
By H. Ormisson
Wood and bast, with pokerwork. Height 25
Union of Artists, Moscow

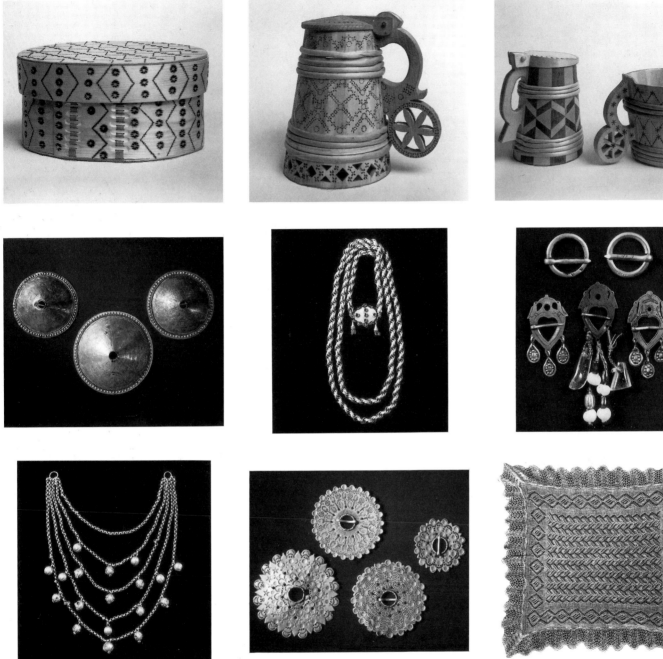

Box. 1978
By H. Ormisson
Wood and bast, with pokerwork. Height 28
Union of Artists, Moscow

Brooches. Mid-19th century
Tarvastu and Kursi, South Estonia
Neusilber, chased and engraved. Diameter 17.3, 21.2, and 18
Museum of Ethnography of the Estonian SSR, Tartu

Chain necklace. Second half of the 19th century
Southeast Estonia (Setu)
Plaited neusilber. Length of upper string 34, diameter of
bead 1.5
Museum of Ethnography of the Estonian SSR, Tartu

Beer tankard. 1977
By T. Jaaremaa
Carved wood, with pokerwork. Height 40
Union of Artists, Moscow

Chain. Second half of the 19th century
Southeast Estonia (Setu)
Plaited neusilber, with glass insets. Length 200
Museum of Ethnography of the Estonian SSR, Tartu

Brooches. Early 19th century
Väike-Maarja; Torma; Saaremaa Island, West Estonia
Neusilber, chased and engraved
Museum of Ethnography of the Estonian SSR, Tartu

Beer tankard and mug. 1978
By H. Ormisson
Carved wood, with pokerwork. Height 35 and 26,
 diameter 23 and 22
Union of Artists, Moscow

Brooches. Second half of the 19th century
Tarvastu, South Estonia (top); Saaremaa Island, West Estonia
Neusilber, hammered, stamped, and engraved. Diameter 2.6
 and 3; length 3.5, 5.5, and 3.5
Museum of Ethnography of the Estonian SSR, Tartu

Shawl. 1963
By A. Martson
Haapsalu
Knitted wool. 113 × 102
Museum of Ethnography of Estonian SSR, Tartu

FOLK ART
IN
CENTRAL ASIA
AND
KAZAKHSTAN

The people inhabiting Central Asia and Kazakhstan have developed their culture and arts under very special, almost unique, climatic and environmental conditions. The scenery of this enormous territory, the area of which exceeds Western Europe's, is dominated by boundless steppes merging into semideserts and deserts with dry quicksands. This arid land is dotted with small flourishing oases, chiefly along the banks of the two great Central Asian rivers, the Amu Darya and Syr Darya. Here one can see thriving towns and villages, surrounded by lush gardens and vineyards, emerge like mirages of fabulous beauty.

The region between the Amu Darya and the Syr Darya, and the fertile valleys at the foot of the lofty Pamir mountain ranges, supported some of the earliest known human civilizations. The archaeological map of the area is studded with the illustrious names of world-famous cultural treasures, some of which date back to the Paleolithic period. The earliest of them is the Neanderthal cave burial at Teshik-tash, dating back to dozens of millennia before Christian time. Primitive societies were superseded by powerful slave-owning

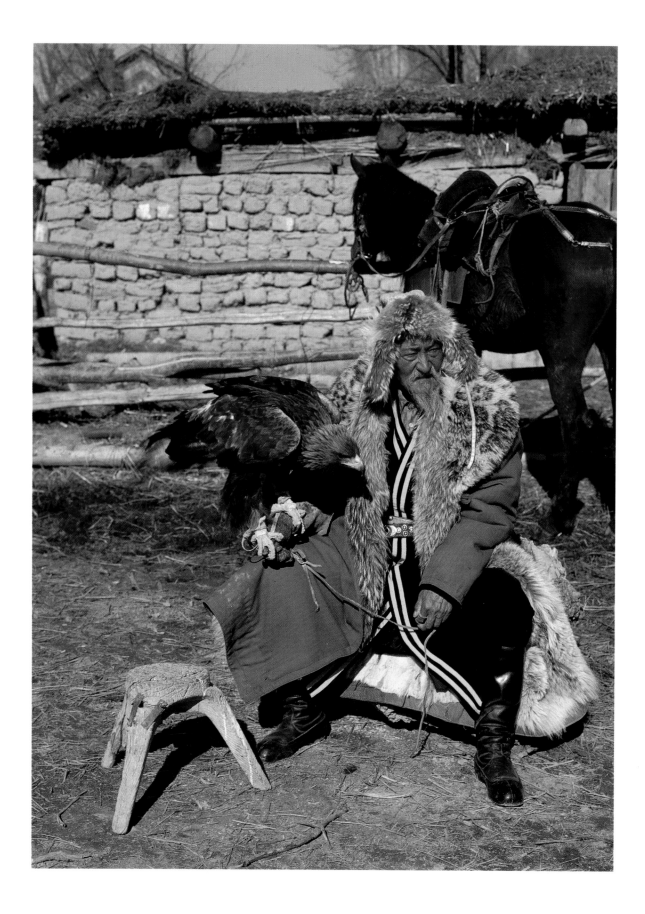

empires, a succession of which emerged and collapsed before gigantic feudal states and small emirates arose in their stead. Reminders of those days are still to be found, such as the ruins of palaces with antique statuary in Merv and Toprak-kala, old Khwarazm's citadels buried in sand, the magnificent buildings with resplendent blue domes from the age of Tamerlane and his successors, and stone figures commemorating fallen warriors or chieftains.

For centuries the development of art in Central Asia and Kazakhstan was determined by the coexistence and interpenetration of two different cultures—one with a settled agricultural population and the other with nomadic or seminomadic livestock-breeding tribes. The two life-styles generated different arts and crafts. In Uzbek and Tadzhik towns some articles were made by craftsmen grouped in workshops, while others were made at home and traded locally. In the countryside, especially in the nomadic *auls* of Turkmenia, Kirghizia, and Kazakhstan, many handcrafted objects were produced solely for domestic use.

An important unifying factor in this region was that it belonged for a long time to the Moslem world. The Arabs, who invaded Central Asia in the eighth century, introduced Islam, which banned the depiction of human beings or animals in works of art. As a result, the ornamental trend was the dominant one in their art for centuries, and their skill in elaborating plant and geometrical designs was brought to perfection. Formalization and generalization, inherent characteristics of the decorative arts, became practically canons in Central Asia. This, however, did not prevent each community from evolving its own distinctive idiom for expressing its world view and ideals of beauty.

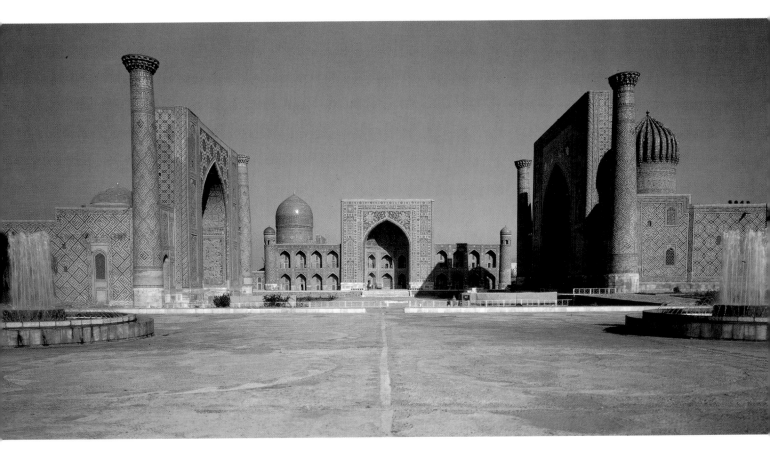

UZBEK
Folk Art

Uzbek decorative arts have always been concerned above all with interior adornment. The Uzbek house with its blind pisé walls is laid out remarkably well, with a maximum of comfort and elegance; its interior decoration is strikingly rich and colorful. The walls of the rooms and of the verandas, known as *aiwans*, are hung with carved or painted alabaster panels, the ceilings are intricately painted, and the wooden columns, doors, and window shutters are embellished with carving. The ornamentation and coloring of household utensils generally match the architectural decor. Such articles as glazed earthenware dishes and bowls, chased and engraved metal jugs and ewers, and woven and embroidered items combine to give the dwelling a pleasant atmosphere created by the owner's aspirations for a happy and prosperous life amidst luxuriant scenery.

Mosques and palaces were traditionally decorated in much the same fashion as dwelling houses. They were constructed with the participation of folk craftsmen, who employed a full range of locally distinctive methods and techniques to decorate the buildings.

The traditions of Uzbek carving and painting on alabaster and wood can be traced back to antiquity and the early Middle Ages. At that time veritable treasures of art were created in Central Asia, such as the shahs' palaces in Khwarazm with their bas-reliefs and painted decor, or the ancient buildings of Varakhsh and Afrasiab. Their pictorial compositions reflecting pre-Islamic myths and beliefs are fused into a beautiful whole of rich ornamentation with plant and geometric motifs. Already at that time they con-

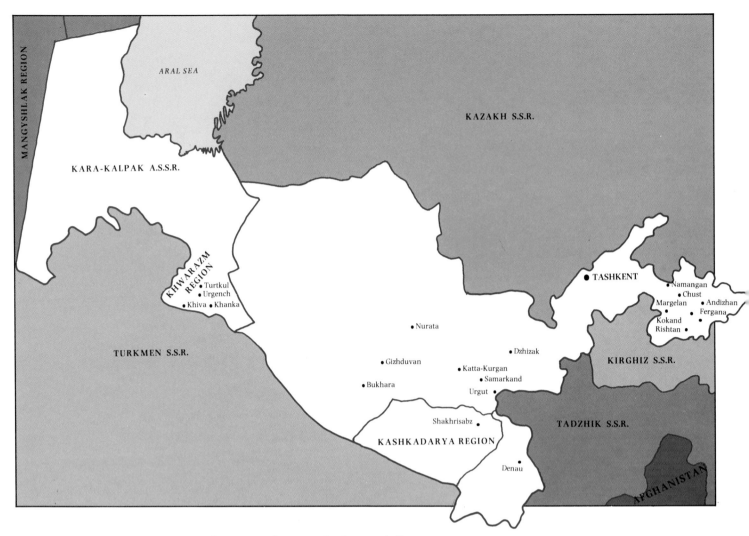

tained some of the conventionality, generalization, rhythm, and dynamism that were to become the underlying principles of Uzbek folk decorative arts.

Over the centuries, various alabaster- and wood-carving techniques evolved, ranging from the simplest work of incising the surface with rectangular, triangular, or rounded grooves to intricate carving in relief, with its rich play of light and shade on the object's surface. Among the highly formalized motifs of flowers and plants a special role is played by the one known as *islimi*, a vine-like design that combines with a geometric design (*girikh*) to form delicate and ingeniously contrived symmetrical compositions. Carved work employed alongside painting results in an organic blend of form, color, and design. The isolation of feudal towns and settlements, which prevailed until the early twentieth century, prevented artistic and technical achievements from spreading beyond the community where they originated so that local art centers and schools were formed and prospered. Thus, in the nineteenth century, Bukhara and Samarkand were major centers for alabaster carving and painting. In the tenth to fifteenth centuries, wood carving was particularly well developed in the towns of Khwarazm. Age-old carving traditions are creatively incorporated in our own time into the architectural decor of buildings, as in the interior of the Navoi Opera and Ballet Theater in Tashkent (1947), the decoration of which was supervised by Shirin Muradov, a famous painter and carver from Bukhara, or in the Tashkent branch of the Lenin Museum, with its carved doors and

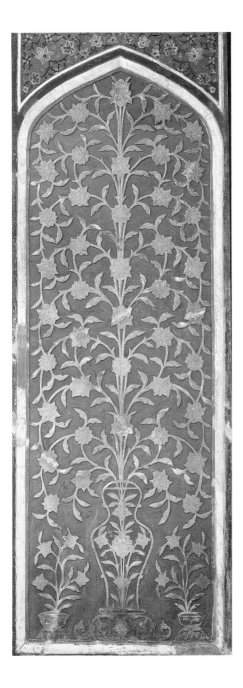

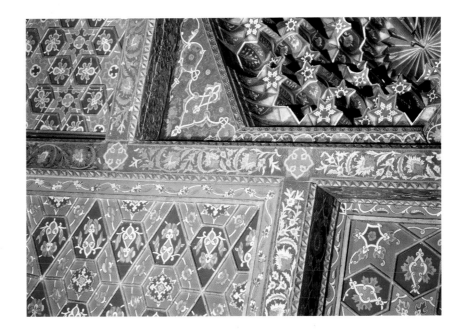

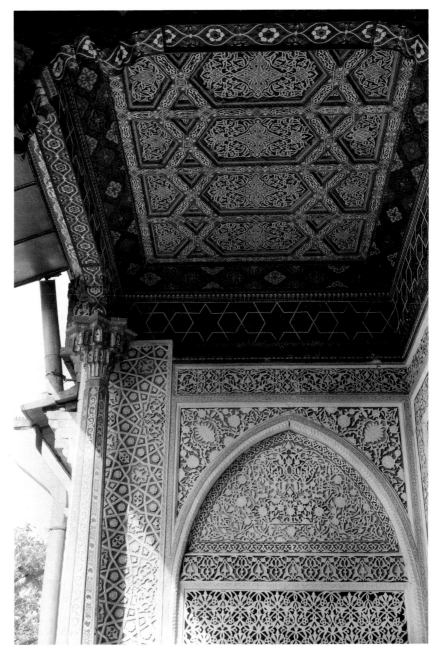

Panel from a house interior. 19th century
Bukhara
Painted alabaster
Art Museum of the Uzbek SSR, Tashkent

Ceiling of a dwelling house. Detail. 1898–1902
Tashkent
Painted wood
Museum of Applied Art of the Uzbek SSR, Tashkent

Front terrace of a dwelling house. Detail. 1898–1902
Tashkent
Painted wood
Museum of Applied Art of the Uzbek SSR, Tashkent

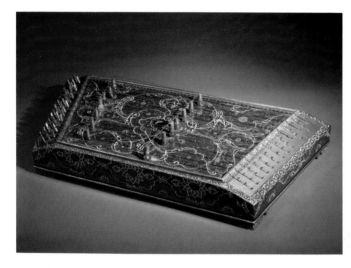

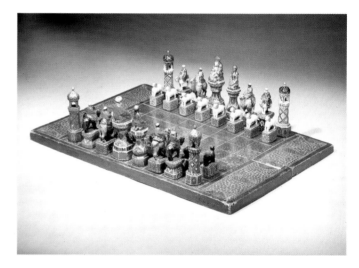

alabaster panels by K. Khaidarov and M. Usmanov. Modern craftsmen also produce carved articles for domestic use, such as small low tables, boxes, pencil boxes, mirror frames, etc. The Tashkent and Kokand craftsmen favor low-relief work with geometrical patterns; they have revived, among other things, the old technique of making lattice screens decorated with marquetry.

Glazed ceramics have been important in architectural decoration in

Musical instrument. 1940
By T. Tokhtakhodzhayev
Tashkent
Painted wood.
Art Museum of the Uzbek SSR, Tashkent

Chess set. Early 20th century
Tashkent
Wood, carved and painted. 14 × 22.5 × 12.5 (chess board)
Art Museum of the Uzbek SSR, Tashkent

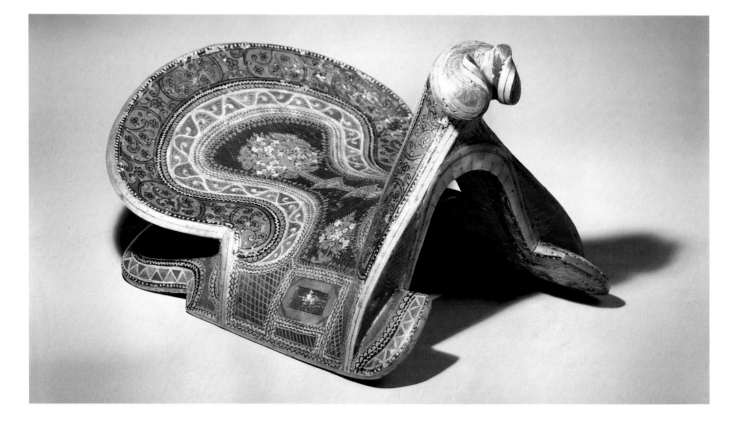

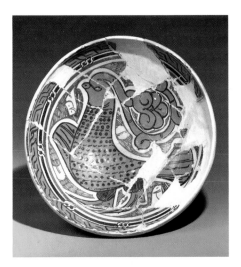

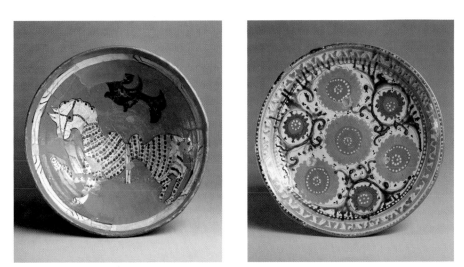

Dish. 10th century
Afrasiab
Clay, fired and painted underglaze
Museum of the History of Uzbek Culture and Art, Samarkand

Dish. 10th or 11th century
Clay, fired and painted underglaze. Diameter 24
Museum of Oriental Art, Moscow

Dish. Late 19th century
Samarkand
Clay, fired and painted underglaze. Diameter 35
Museum of Oriental Art, Moscow

Saddle. 1930s
Tashkent
Wood, carved, painted, inlaid with bone, and lacquered
Art Museum of the Uzbek SSR, Tashkent

Central Asia since the twelfth century, becoming particularly widespread since the fourteenth century, when it was customary to face the walls and domes of large buildings with glazed tiles. In the nineteenth century, Khiva was a major tile-manufacturing center: most intricate mosaic compositions were colored majolica tiles.

The making of glazed pottery began in Central Asia in the eighth century. Among the main productions turned out in the tenth and eleventh centuries were finely shaped cups and dishes with geometric and plant designs, representations of birds and animals, and various inscriptions. The ware of this period is characterized by austere combinations of white, olive, brown, and black. Pottery from the fifteenth and sixteenth centuries is distinguished for its painted grass and floral designs, realistically rendered in cobalt on a white ground.

By the twentieth century glazed ceramics manufacturing had become one of the most important handicraft industries in Uzbekistan. Such towns as Tashkent and Rishtan are now the largest centers of the ceramic industry. The Tashkent potters often combine painted and engraved decorations. Their most characteristic compositions consist of circles and semicircles drawn with the help of compasses and supplemented by rhythmically arranged plant motifs. Mukhitdin Rakhimov, an artist of considerable local repute, is attempting to revive the forms and motifs of ancient and medieval pottery. He is attracted by the exquisitely shaped vessels of the Kushab epoch (first century B.C. to first century A.D.), as well as by the perfectly formed and beautifully painted cups and dishes from the tenth and eleventh centuries.

Rishtan pottery compositions usually display such motifs as blossoming shrubs or branches of pomegranate trees, painted in light blue tones. In the 1970s, I. Kamilov produced a number of conical and spherical bowls with turquoise-blue floral ornamentation in the style of earthenware dating from

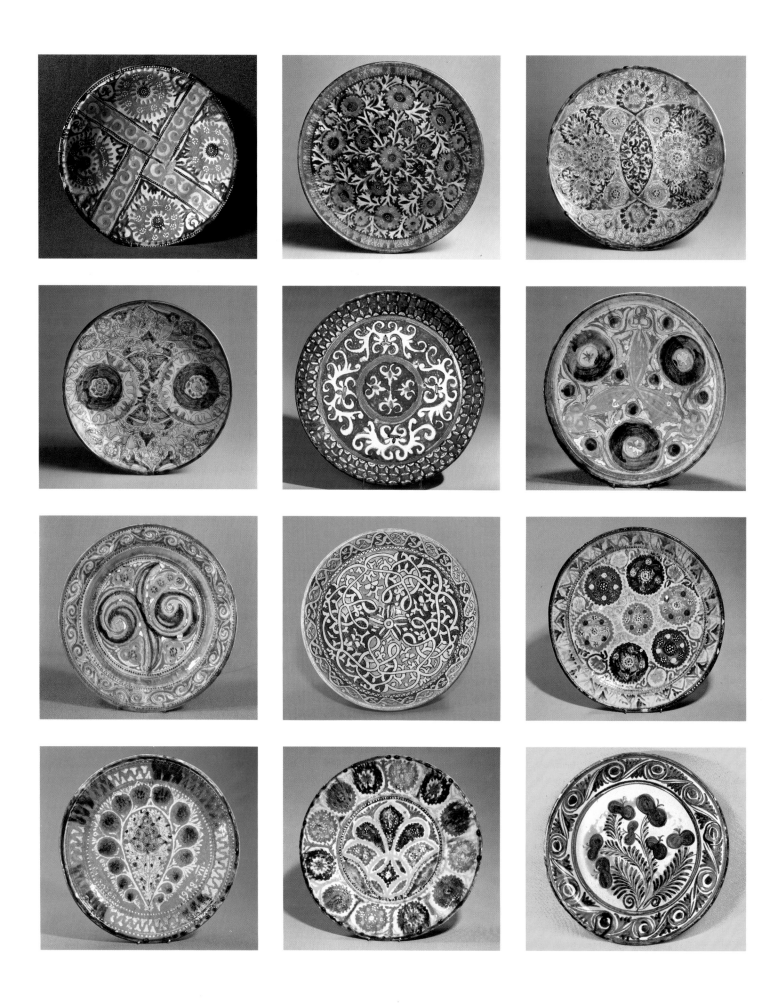

Dish. Late 19th century
Shakhrisabz, Kashkadarya Region
Clay, fired, engraved, and painted underglaze. Diameter 34
Ethnography Museum, Leningrad

Dish. Late 19th or early 20th century
Shakhrisabz, Kashkadarya Region
Clay, fired and painted underglaze. Diameter 32.5
Museum of Oriental Art, Moscow

Dish. Early 20th century
Tashkent
Clay, fired and painted underglaze. Diameter 37
Museum of Oriental Art, Moscow

Dish. 1937
Tashkent
Clay, fired and painted underglaze. Diameter 34
Museum of Oriental Art, Moscow

Dish. 1940
By U. Shermatov
Rishtan, Fergana Region
Clay, fired and glazed. Diameter 42
Museum of Applied Art of the Uzbek SSR, Tashkent

Dish. 1975
By A. Muzaffarov
Shakhrisabz, Kashkadarya Region
Clay, fired and painted underglaze. Diameter 32
Union of Artists, Moscow

Dish. 1975
By A. Muzaffarov
Shakhrisabz, Kashkadarya Region
Clay, fired and painted underglaze. Diameter 34
Union of Artists, Moscow

Dish. 1977
By R. Matchanov
Khanka, Khwarazm Region
Clay, fired and painted underglaze. Diameter 31
Union of Artists, Moscow

Dish. 1978
By I. Narzullayev
Gidzhuvan, Bukhara Region
Clay, fired and painted underglaze. Diameter 31
Union of Artists, Moscow

Dish. 1978
By I. Narzullayev
Gizhduvan, Bukhara
Clay, fired and painted underglaze. Diameter 30
Union of Artists, Moscow

Dish. 1978
By I. Narzullayev
Gidzhuvan, Bukhara Region
Clay, fired and painted underglaze. Diameter 30
Union of Artists, Moscow

Dish. 1978
By Sh. Yusupov
Rishtan, Fergana Region
Clay, fired and painted underglaze. Diameter 31
Union of Artists, Moscow

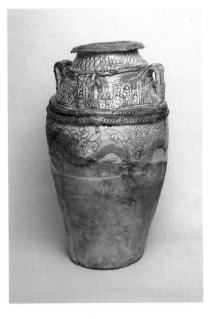

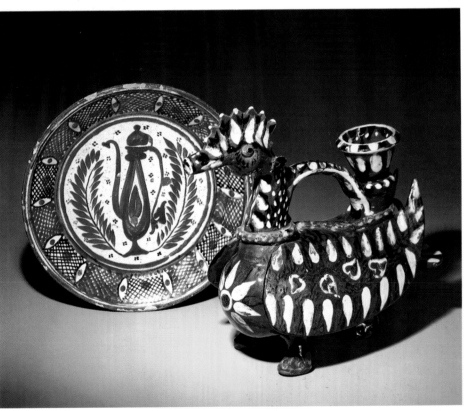

Vase. 1972
By I. Baltayev
Village of Khanka, Khwarazm Region
Clay, fired, engraved, and painted underglaze. Height 63
Union of Artists, Moscow

Jugs (from the Kushan series). 1974
By M. Rakhimov
Tashkent
Clay, fired and burnished, with applied details (right). Height
43 and 8
Union of Artists, Moscow

Bird-shaped vessel and dish. 1962
By I. Kamilov
Rishtan, Fergana Region
Clay, fired, with applied details (vessel), painted in underglaze
Art Museum of the Uzbek SSR, Tashkent

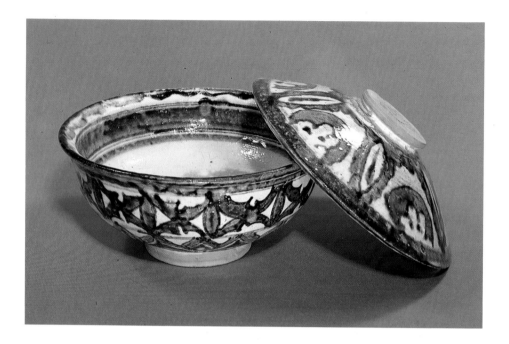

the fifteenth to the seventeenth century. The ware produced in Cizhduvan, a very old ceramics center, is remarkable for its intense red-brown color; a similar color is seen on pottery made in Shakhrisabz.

The Khwarazm region is famous for its pottery establishments in Khiva, Khanka, Novy Urgench, and some other towns. One of the articles popular there is a dish with a huge rounded rim, known as *badiya*. Its dynamic design is thinly outlined in manganese on a white slip ground and

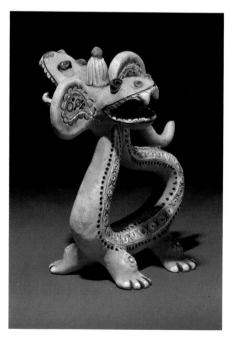

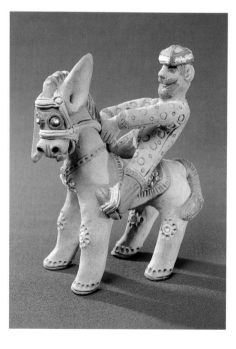

Bowl. 1977
By K. Turapov
Tashkent
Clay, fired and painted underglaze. Diameter 18.5
Union of Artists, Moscow

Two-headed dragon. 1975
By A. Mukhtarov
Samarkand
Handworked clay, fired and painted. 18 × 14
Art Museum of the Uzbek SSR, Tashkent

Uzbek Riding a Donkey. 1978
By A. Mukhtarov
Samarkand
Handworked clay, engraved and painted. Height 28
Union of Artists, Moscow

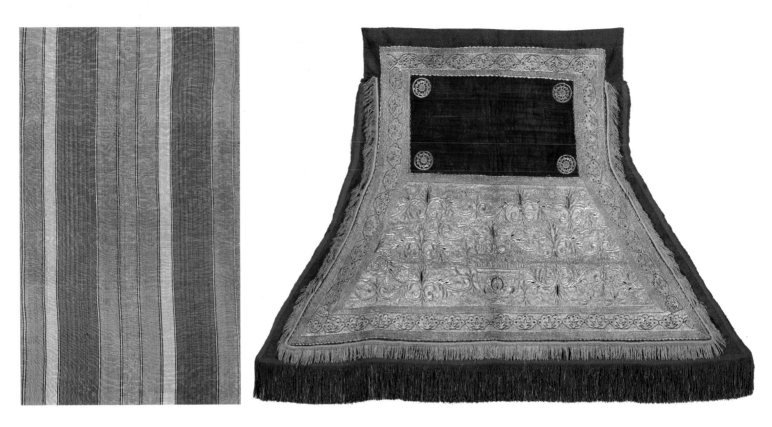

Detail of cloth for man's robe. 19th century
Tashkent
Rep-weave silk and cotton (natural dyes). Width 34.5
Ethnography Museum, Leningrad

Horse-cloth. 19th century
Bukhara
Velvet, embroidered in silk and gold thread (natural dyes).
 90 × 120
Museum of Oriental Art, Moscow

then filled in with dark cobalt-blue or bright turquoise-green. The ornamental composition is built around the center and is generally dominated by interlaced ribbons or large clear-cut rosettes. Another specialty of Khwarazm is a large imposing vessel called *khum*, which bears applied and incised ornaments under the turquoise-green glaze.

Uzbek terracotta toys are closely related to the local folk art's most archaic forms. Small figures of animals, dragons, and other monsters from fairy tales are still being made by potters from Samarkand and the village of Uba near Bukhara. They combine realism with fantasy, vivid modelling with bold colors, and artistic sophistication with the naive fresh perspective of the popular philosophy of life.

Weaving, textile-printing, and embroidery have been developed in Uzbekistan from a very early date. In addition to factory-made textiles, there is presently handloom production of cotton, silk-blend, and silk fabrics. They are decorated with striped or check patterns; another distinctive multicolored design is known as *abr bandi* (*abr* meaning "cloud").

The leading centers where *abr-bandi* silks are woven are Bukhara and Samarkand, as well as the towns of Namangan and Margelan in the Fergana Valley. The color scheme of these silks is dominated by contrasting pure colors in subtle harmonious combinations, from black-and-white and red-and-white to bright varicolored mélange.

Another old Uzbek craft is textile-printing. As machine-weaving developed, the role of this industry dwindled, yet even now it exists on a small-

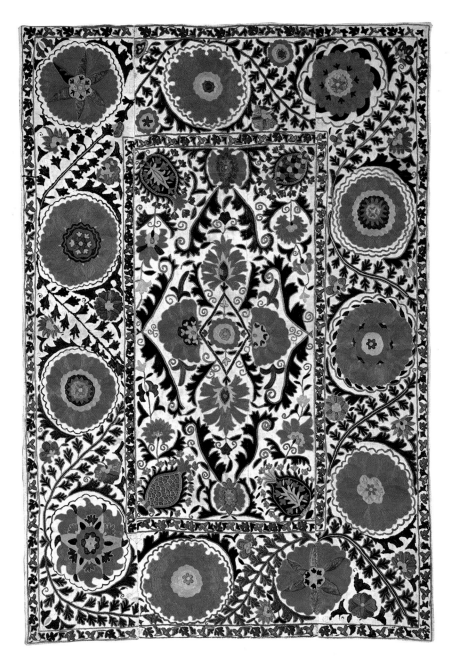

Wall hanging. 19th century
Nurata
Cotton, embroidered in silk (natural dyes). 224 × 163
Museum of Oriental Art, Moscow

Detail of wall hanging. 19th century
Bukhara
Cotton, with printed design and embroidery in wool (natural
dyes)
Art Museum of the Uzbek SSR, Tashkent

Bedspread. 19th century
Bukhara
Cotton, embroidered in silk (natural dyes). 157 × 107
Museum of Oriental Art, Moscow

scale, and skillfully printed tablecloths or bedspreads made today look as at-
tractive as ever, thanks to their ornamental compositions and their warm
soft colors.

A high reputation is enjoyed by large embroidered panels called *suzani*,
which are hung on the walls of Uzbek houses on festive occasions. Until the
second half of the nineteenth century *suzani* embroidery was worked in silk
over a white homespun cloth known as *mateh*, which was later replaced by
coarse machine-made calico or locally made silk. In order to achieve the de-
sired decorative effect, large areas of the design were couched in different
varieties of satin stitch and then worked in chain stitch. The composition

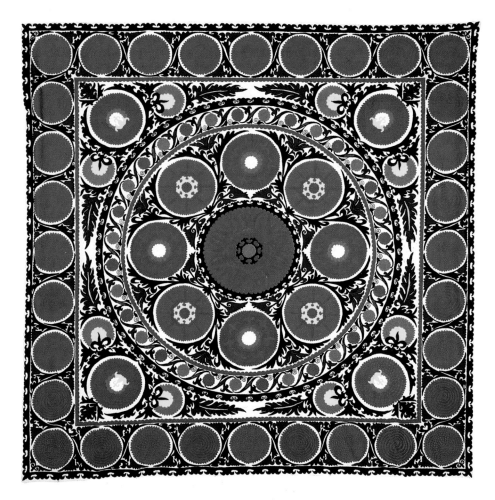

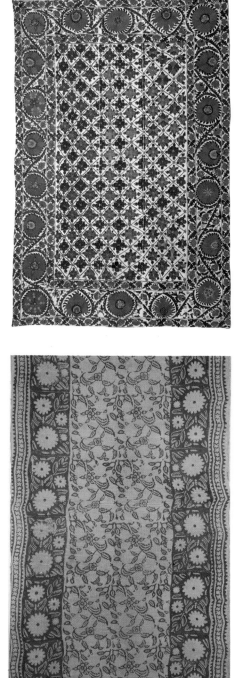

Wall hanging. 1978
By N. Nam and M. Kuchkarova
Tashkent
Cotton, embroidered in silk (synthetic dyes). 220 × 200
Union of Artists, Moscow

Cloth for woman's dress. 1977
By T. Mirzoakhmedov
Margelan
Silk (synthetic dyes). 80 × 80
Union of Artists, Moscow

Wall bag. 19th century
Wool, with embroidery (natural dyes). 74.5 × 70
Ethnography Museum, Leningrad

Wall hanging. 19th century
Bukhara
Cotton, embroidered in silk (natural dyes). 228 × 155
Museum of Oriental Art, Moscow

Detail of runner. 1930
By Abdugafurov
Tashkent
Cotton, with printed design (natural dyes)
Museum of Applied Art of the Uzbek SSR, Tashkent

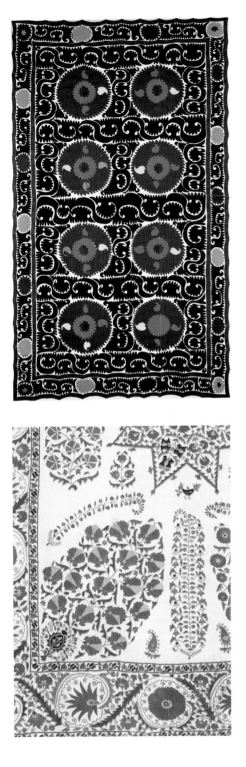

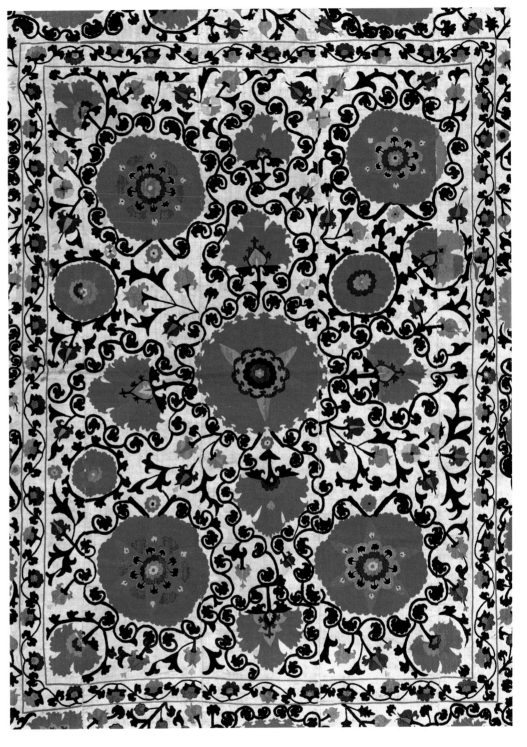

Wall hanging. 1976
By M. Rakhimova
Urgut
Cotton, embroidered in silk (synthetic dyes). 220 × 132
Union of Artists, Moscow

Detail of wall hanging. 19th century
Nurata
Cotton, embroidered in silk (natural dyes)
Museum of Oriental Art, Moscow

Wall hanging. 19th century
Shakhrisabz, Kashkadarya Region
Cotton, embroidered in silk (natural dyes). 262 × 218
Museum of Oriental Art, Moscow

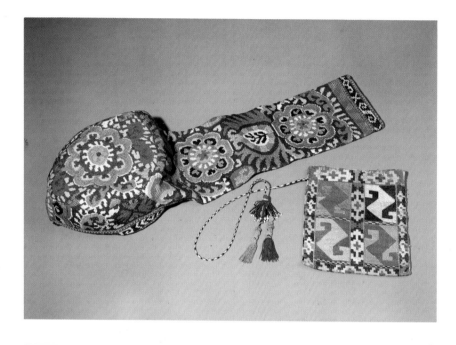

Bag for tea. Early 20th century
Woman's headdress. 1925
By K. Musadzhanov
Cotton, embroidered in silk (natural and synthetic dyes).
 12.5 × 14.5 (tea bag)
Art Museum of the Uzbek SSR, Tashkent

Woman's frontlet. 1880s
Bukhara
Velvet, embroidered in gold and silver thread
Private collection

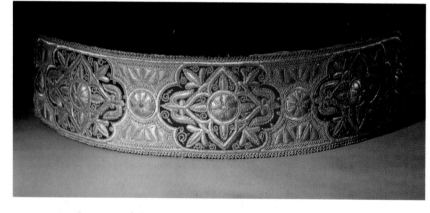

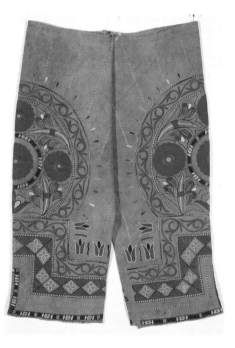

of the main field usually consists of a centerpiece and corners; or, alternatively, the design can be more or less uniform. Occasionally archaic motifs, such as discs or birds, appear on these panels, but more often the design comprises plants. Whether conventionally depicted as branches, flowers, or shrubs, they are all symbolic of wishes for happiness, prosperity, or fertility.

The *tiubeteika* skullcap with its embroidered decoration, which is an integral part of the Uzbek national dress, is a reflection of the rich traditions and originality of Uzbek art. Skullcaps vary a great deal in shape, color, texture, and ornamentation, which generally consists of embroidered flower arrangements, small shrubs, or medallions. The needlework displays fond attention, taste, sense of proportion, and absence of a monotonous repetition of small details. Skullcaps made in Chust, embroidered with white pepperpods or almonds on a black ground, are popular throughout Central Asia, as are multicolored caps from Shakhrisabz, which are worked all over with half-cross stitch.

Man's hunting trousers. 19th century
Suede, embroidered in silk (natural and synthetic dyes).
 Length 96
Ethnography Museum, Leningrad

Skullcaps. 1950s–70s
Shakhrisabz, Andizhan, Bukhara, and Tashkent
Cotton and velvet, embroidered in silk, rayon, gold, and silver
 thread, and with beadwork (synthetic dyes). Diameter 18
 (approximately)
Museum of Applied Art, Tashkent

Belt, skullcaps, and ornamental border for dress. 1978
By M. Khasanova and Z. Safarova
Cotton, embroidered in silk (synthetic dyes). Length of belt 50;
 diameter of caps 30; length of border 35
Union of Artists, Moscow

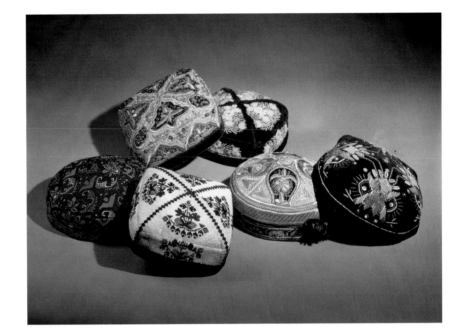

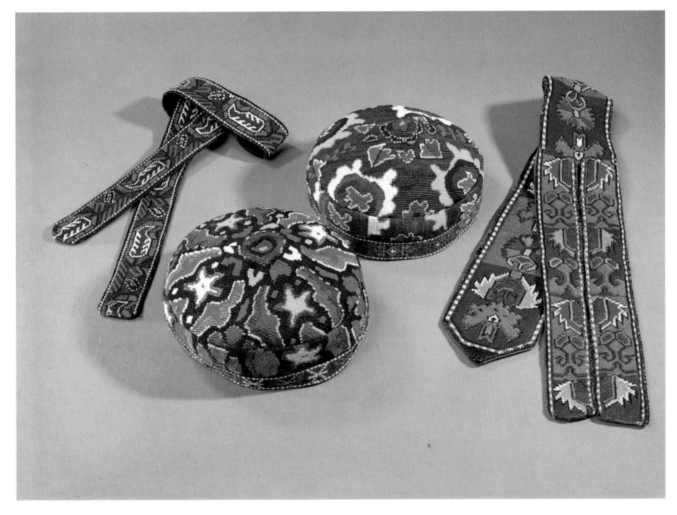

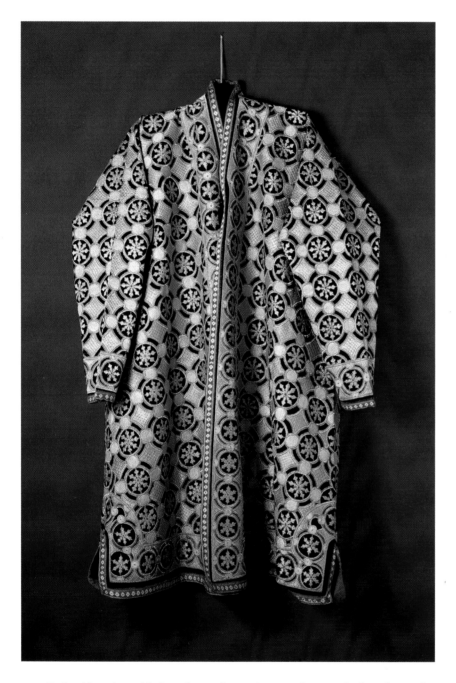

Embroidery in gold thread was formerly an urban trade, based mostly at court workshops and practiced by men. Gold or silver thread covered either the entire design or outlined its contours and was often used in combination with semiprecious stones and metal plaques, on colored silk or velvet. Embroidery was widespread in the ornamentation of clothes, footwear, horse-cloths, saddle-cloths, etc. Nowadays embroidery in gold thread is practiced mostly by women who decorate *suzani* panels, caps, and other articles with it. An outstanding example of contemporary Uzbek needlework is the magnificent curtain for the Navoi Opera and Ballet Theater in Tash-

Robe. Late 19th or early 20th century
Bukhara
Velvet, embroidered in gold thread
Museum of Folk Art, Moscow

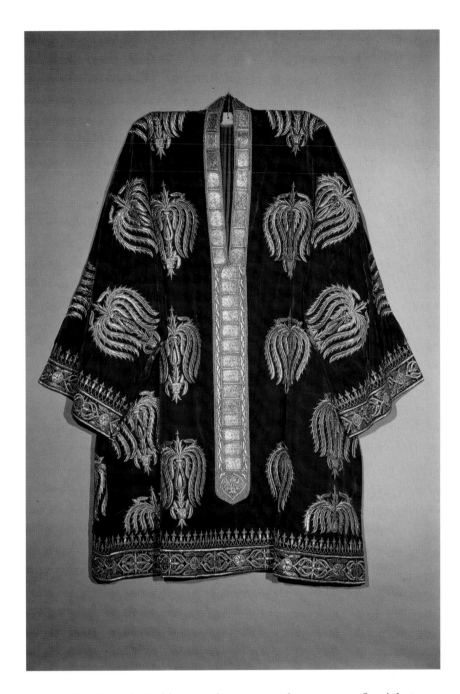

Woman's dress. 1905–10
Bukhara
Velvet, embroidered in gold thread. Length 124
Art Museum of the Uzbek SSR, Tashkent

kent, embroidered by Bukhara craftswomen with sumptuous floral designs.

The earliest examples of embossed and chased metalwork in Uzbekistan date from the early first millennium B.C. Recent excavations at Dalverzin-tepe, in the south of Uzbekistan, yielded a profusion of gold rings, bracelets, necklaces, and other items of exceptional artistic quality and value.

In the first half of the nineteenth century, Uzbek coppersmiths were still producing metal articles chased in relief. In the late nineteenth century, this was replaced by the less labor-consuming techniques of low-relief chasing and engraving. The designs became more diversified, recalling those

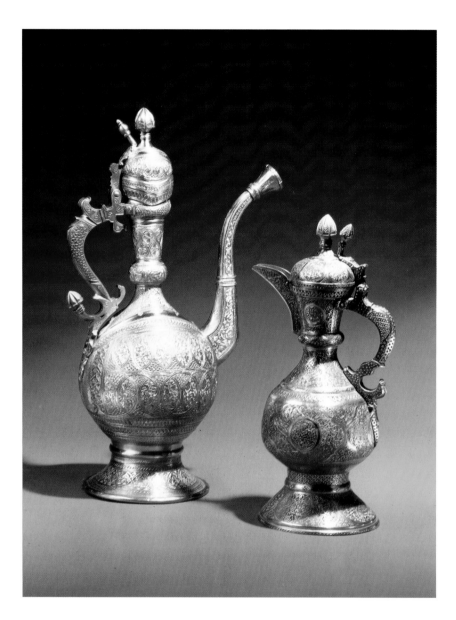

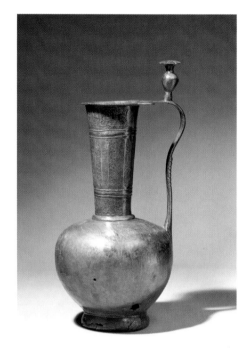

found in wood and alabaster carvings. Today, the leading centers for copper-chasing are Bukhara, Kokand, and Khiva, the architectural splendors of which sometimes figure in the decorative designs on copper trays, often in combination with plant-like motifs.

Uzbek goldsmiths possessed a perfect mastery of such techniques as casting, repoussé, engraving, and filigree. For insets they used pearls, turquoise, coral, cornelian, colored glass, and for some items real gems, such as rubies, emeralds. and sapphires. Women's personal adornments, horse trappings, and arms were particularly sumptuous.

Women's ornaments worn on the forehead, neck, breasts, head, and plaits of hair were made, as matching sets, of amazingly exquisite shapes and rich color combinations. The numerous pendants, easily set into mo-

Teapot and water jug. 19th century
Kokand
Brass and bronze, cast, hammered, and chased. Height 32 and 42
Museum of the History of Uzbekistan, Tashkent

Jug. 12th century
Bronze, cast, chased, and engraved. Height 31
Museum of the History of Uzbekistan, Tashkent

Jug. 19th century
Bukhara
Copper, hammered, cast, and chased. Height 28
Museum of Oriental Art, Moscow

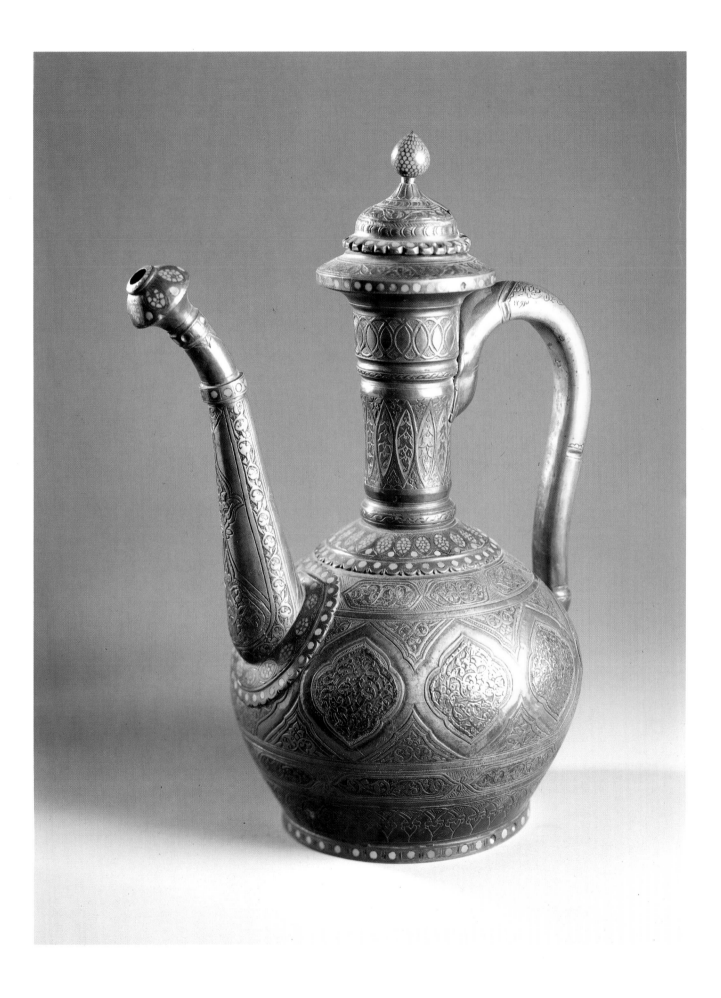

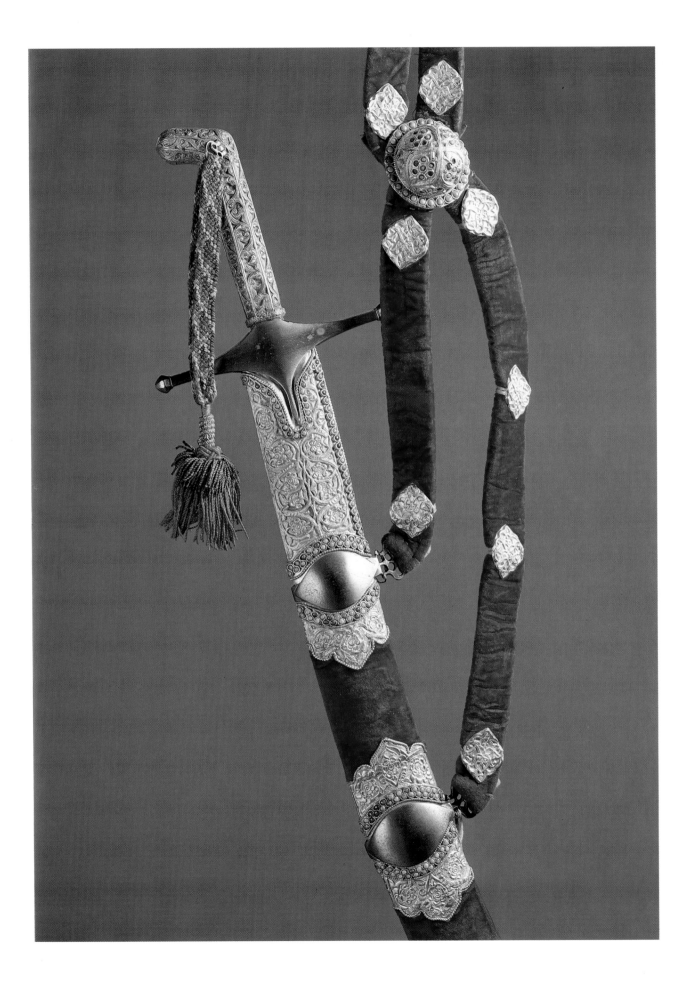

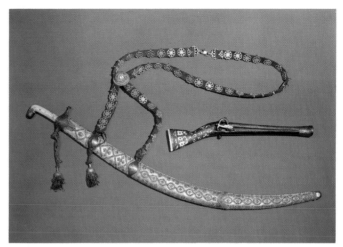

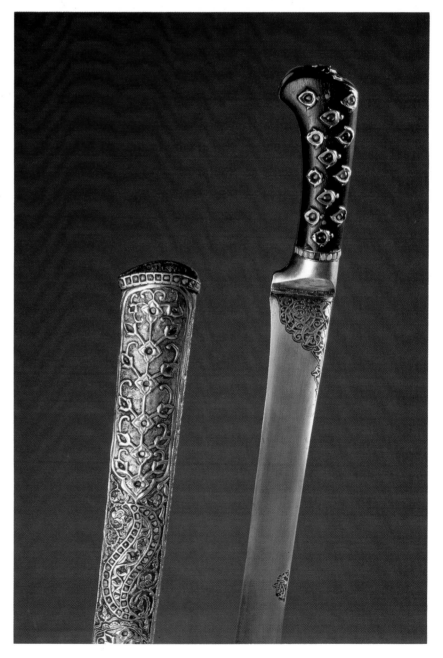

Detail of saber in a scabbard. Second half of the 19th century
Silver gilt, chased and set with turquoise (hilt and scabbard
 ornamentation); plaited silk (sword knot)
The Hermitage, Leningrad

Man's belt. 19th century
Bukhara
Velvet, with silver, gilt, stamped, and set with turquoise and
 cornelian
Art Museum of the Uzbek SSR, Tashkent

Pistol. 19th century
Steel, wooden butt, inlaid with gold and ivory. Length 48.
Saber and scabbard. 17th century
Ivory (hilt); damask steel (blade); silver gilt, set with turquoise
 (scabbard). Length 91
Museum of the History of Uzbekistan, Tashkent

Details of knife and sheath. 19th century
Bukhara
Black horn, set with turquoise and colored glass (hilt); damask
 steel, with silver-gilt ornamentation (blade); silver, gilt,
 chased, and set with colored glass and turquoise (sheath)
Museum of the History of Uzbekistan, Tashkent

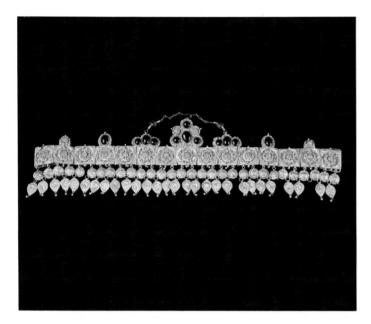

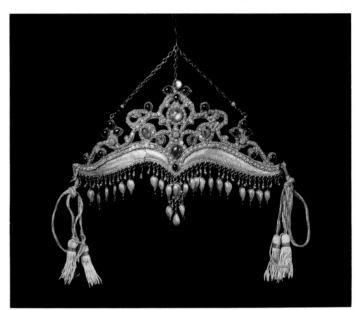

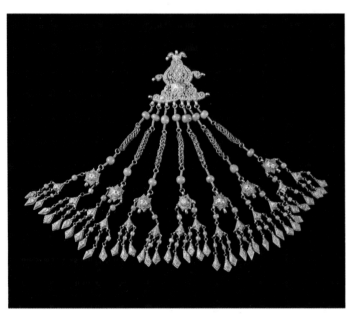

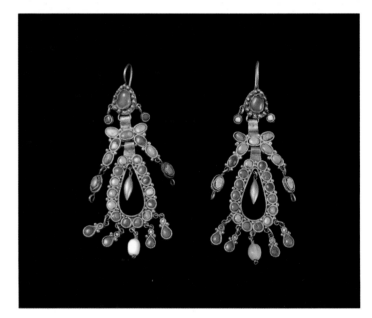

Woman's head ornament. 19th century
Bukhara
Silver, gilt, stamped and chased, decorated with filigree, and
 set with turquoise and colored glass. Length 30
Museum of Oriental Art, Moscow

Pendant decoration. Late 19th century
Bukhara
Silver, gilt, chased, decorated with filigree, and set with
 turquoise and corals
Museum of Oriental Art, Moscow

Diadem. 19th century
Bukhara
Silver, gilt, stamped and engraved, decorated with
 granulation, and set with turquoise and colored glass.
 Length 23.5
Museum of Oriental Art, Moscow

Earrings. 19th century
Bukhara
Silver, chased, with filigree, set with turquoise and colored
 glass. Length 8
Museum of Oriental Art, Moscow

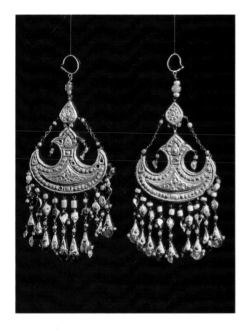

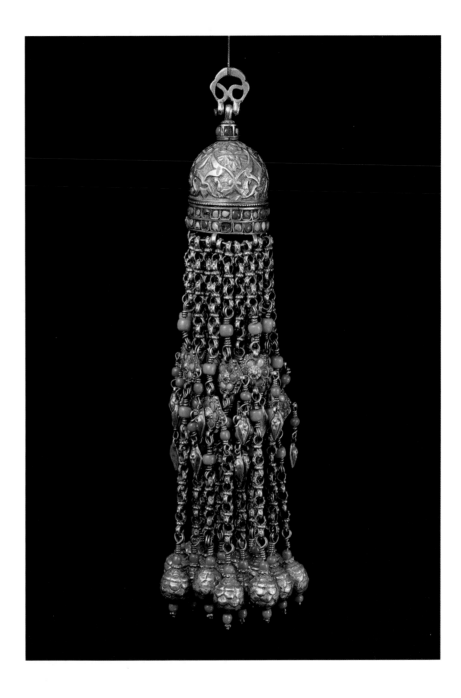

Earrings. Early 20th century
Bukhara
Silver, gilt and stamped, set with glass
Art Museum of the Uzbek SSR, Tashkent

Breast pendant. 19th century
Silver gilt, chased and engraved, with filigree, set with corals
 and turquoise. Length 27
Museum of Oriental Art, Moscow

tion, enhanced the effect of splendor. Men's belts, knives, sabers, horses' saddles, and harness were also elaborately decorated. Rings and earrings for everyday wear were more modest, as were strings of coral beads, with triangular or cylindrical pendants containing protective amulets.

The above account of Uzbek folk art is far from complete, for not all varieties have been mentioned. For example, carved marble dishes are made in Samarkand, and leatherware is produced throughout the republic. In many homes women make pile or pileless carpets. Those with high pile and

simple geometric designs in dark reds are especially famous. In some locali-
ties babies' cribs are adorned with painted decorations; in others, cord is still
braided for clothes trimming. Very interesting snuffboxes are made out of
small pumpkins grown specially for the purpose: their surfaces are engraved
with artless pictures of human beings, birds, animals, plants, and domestic

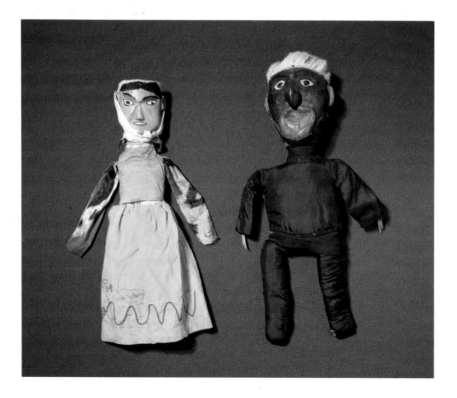

Folk musical instruments. 1974; 1930s; 1975
By Sh. Irmukhamedov
Tashkent
Metal, skin; fired clay; wood, inlaid with mother-of-pearl,
tendons
Museum of Applied Art of the Uzbek SSR, Tashkent

Snuffboxes. 1920s–30s
Gourd, engraved and tinted
Art Museum of the Uzbek SSR, Tashkent

Puppets for folk puppet show. 1900s
Tashkent
Cloth, wood, and glass. Height 58 and 60
Ethnography Museum, Leningrad

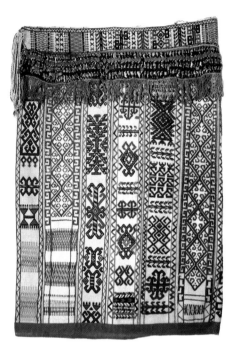

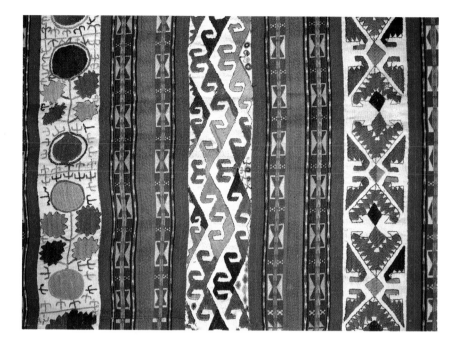

Wall hanging. First third of the 20th century
Turtkul (Kara-Kalpaks)
Pile- and flat-woven wool and cotton (synthetic dyes).
 212 × 149
Ethnography Museum, Leningrad

Detail of *palas*. Late 19th century
Kara-Kalpaks
Flat-woven wool, with embroidery (natural and synthetic
 dyes). 250 × 143
Ethnography Museum, Leningrad

utensils. Yet another fascinating specialty of Uzbek folk art is making puppets for the popular puppet shows.

Uzbekistan includes the Kara-Kalpak Autonomous Soviet Socialist Republic. Its art developed under entirely different geographic and social conditions from those in the rest of the Uzbek SSR. It was mainly concerned with the adornment of the nomadic herdsmen's *yurta* dwellings and clothing. Their patterned weaving, embroidery, and wood carving, arts well developed, are stylistically quite similar to the kindred arts of the Kirghiz and the Kazakh, whereas their carpet-making and goldsmithing have an affinity with Turkmenian work.

The Kara-Kalpak have particularly excelled in the arts of patterned weaving and embroidery, which are widely used to decorate women's dresses, horse trappings, and household objects. Their embroidery on red or black coarse worsted is generally worked in chain stitch, while on cotton small half-cross stitches are used.

The cut and color of their women's dress traditionally depend on the wearer's age. Beautiful blue dresses trimmed with embroidery in red silk thread are made for the young, and equally delightful white dresses, decorated with graceful geometric designs, are worn by elderly women. Embroidered oversleeves are indispensable decorative elements of clothes for every age. The dress, which is generally of simple cut and modest color, is complemented by large-size personal adornments with numerous pendants and jingling little bells.

In contrast to the Uzbek preference for bright pure colors and highly elaborate ornaments, the Kara-Kalpak national costume is marked by a plain composition and austere color scheme.

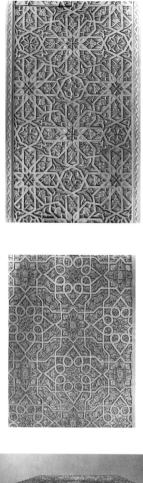

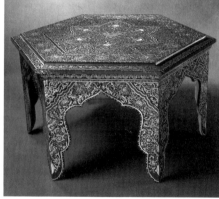

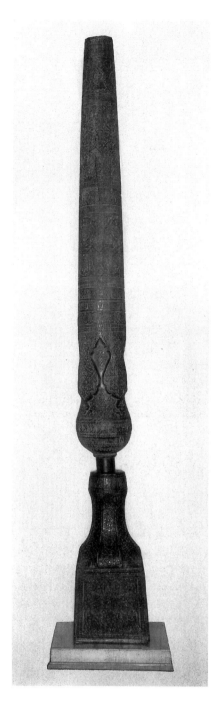

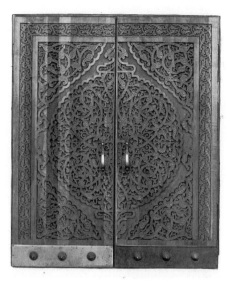

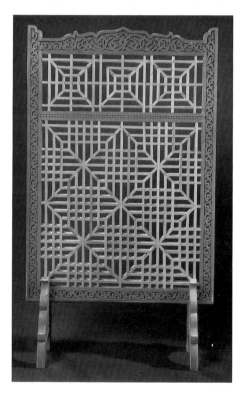

Detail of panel. 1970
By M. Usmanov
Carved alabaster
Branch of the Central Lenin Museum, Tashkent

Detail of panel. 1970
By M. Usmanov
Carved alabaster
Branch of the Central Lenin Museum, Tashkent

Miniature table. 1960
By D. Khakimov
Tashkent
Wood, carved, painted, and lacquered. 21 × 58
Union of Artists, Moscow

Column. 1937
By A. Palvanov
Khiva
Carved wood
Art Museum of the Uzbek SSR, Tashkent

Door. 1970
By K. Khaidarov
Kokand
Carved wood
Branch of the Central Lenin Museum, Tashkent

Screen. 1978
By A. Faizullayev
Tashkent
Carved wood. Height 95
Union of Artists, Moscow

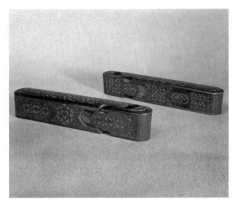

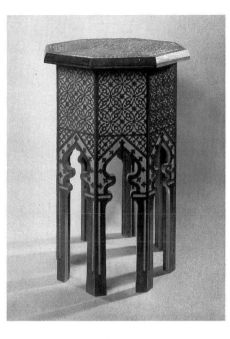

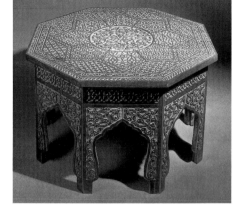

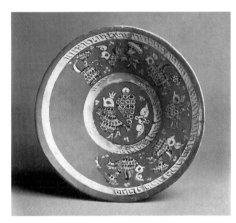

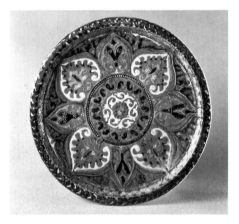

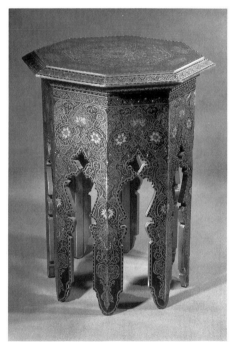

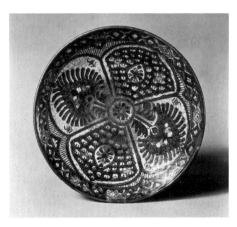

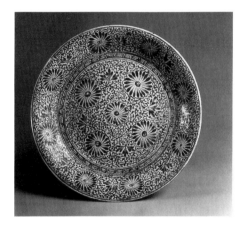

Pencil cases. 1975
By K. Khaidarov
Kokand
Painted wood. Width 2 and 3
Union of Artists, Moscow

Dish. 10th or 11th century
Clay, fired and painted underglaze. Diameter 23
Museum of Oriental Art, Moscow

Dish. 19th century
Khiva
Clay, fired and painted underglaze. Diameter 33
Museum of Oriental Art, Moscow

Small table. 1978
By Kh. Kasymov
Tashkent
Wood, carved and painted. 78 × 56
Union of Artists, Moscow

Small table. 1954
By T. Tokhtakhodzhayev
Tashkent
Wood, carved, painted, and lacquered
Art Museum of the Uzbek SSR, Tashkent

Small table. 1976
By K. Khaidarov
Kokand
Carved wood. 46 × 86
Museum of Applied Art of the Uzbek SSR, Tashkent

Dish. Late 19th or early 20th century
Katta-Kurgan
Clay, fired and painted underglaze. Diameter 37
Museum of Oriental Art, Moscow

Dish. Late 19th or early 20th century
Rishtan, Fergana Region
Clay, fired and painted underglaze. Diameter 35
Museum of Oriental Art, Moscow

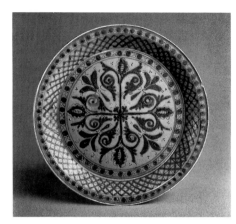

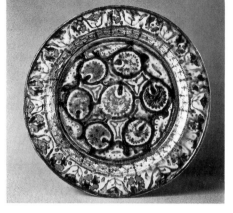

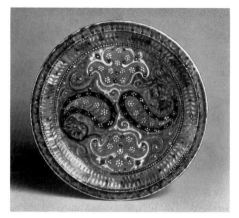

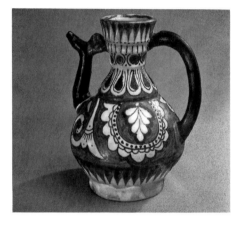

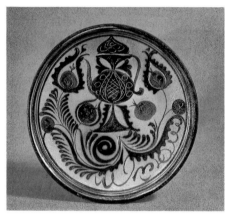

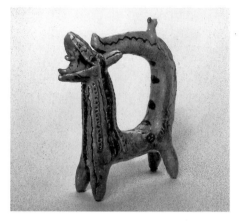

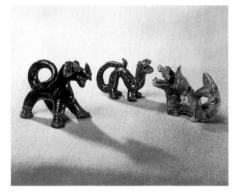

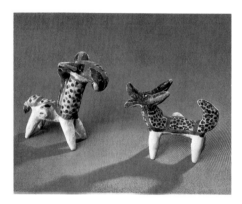

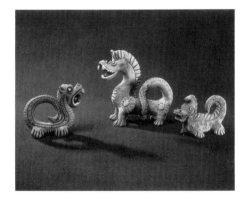

Dish. Early 20th century
Rishtan, Fergana Region
Clay, fired and painted underglaze. Diameter 36
Museum of Oriental Art, Moscow

Jug. 1970s
By I. Kamilov
Handworked clay, fired, painted, and glazed. Height 23
Union of Artists, Moscow

Toys. 1970s
By H. Dzhurakulov
Samarkand
Handworked clay, fired, engraved, and glazed. Height 9, 6,
and 6
Union of Artists, Moscow

Dish. Early 20th century
Bukhara
Clay, fired and painted underglaze. Diameter 32.5
Museum of Oriental Art, Moscow

Dish. 1978
By Sh. Yusupov
Rishtan, Fergana Region
Clay, fired and painted underglaze. Diameter 32
Union of Artists, Moscow

Whistles. 1976
By H. Rakhimova
Uba, Bukhara Region
Handworked clay, fired, engraved, and painted. Length 13
Union of Artists, Moscow

Dish. 1919
Katta-Kurgan
Clay, fired and painted underglaze. Diameter 33
Museum of Oriental Art, Moscow

Toy. 1970s
By H. Dzhurakulov
Samarkand
Handworked clay, engraved and glazed. Height 8
Union of Artists, Moscow

Toys. 1978
By I. Vakhidov
Samarkand
Handworked clay, fired and engraved. Height 7, 10, and 5
Union of Artists, Moscow

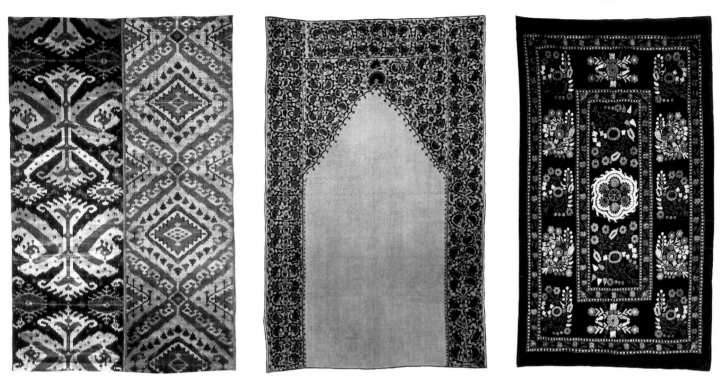

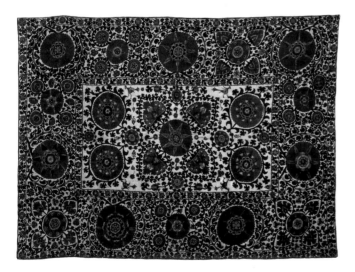

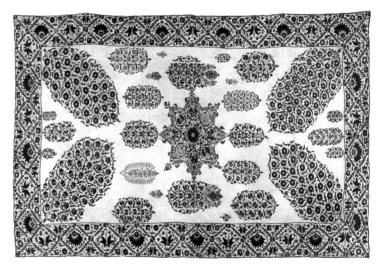

Velvet. Last quarter of the 19th century
Bukhara
Silk and cotton, with *abr-bandi* ornamentation (natural dyes).
 Width 41.5 and 42.5
Ethnography Museum, Leningrad

Wall hanging. 19th century
Shakhrisabz, Kashkadarya Region
Cotton, embroidered in silk (natural dyes). 275 × 200
Museum of Oriental Art, Moscow

Wedding sheet. 19th century
Bukhara
Cotton, embroidered in silk (natural dyes). 263 × 165
Museum of Oriental Art, Moscow

Wall hanging. 1976
By S. Takhirova
Tashkent
Velvet, embroidered in silk (synthetic dyes). 230 × 133
Ethnography Museum, Leningrad

Wall hanging. 19th century
Nurata
Cotton, embroidered in silk (natural dyes). 260 × 130
Museum of Oriental Art, Moscow

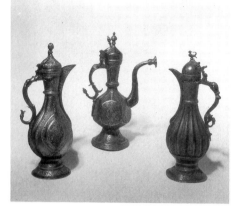

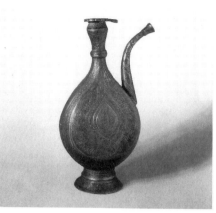

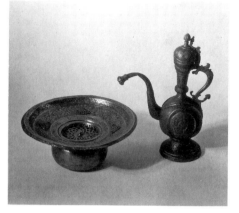

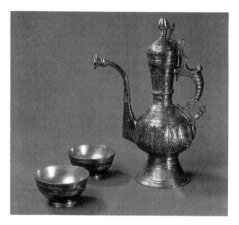

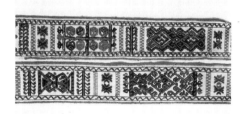

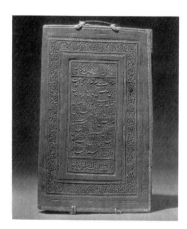

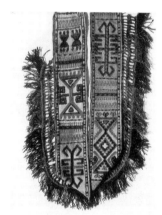

Jugs. 19th century; 1868–69; late 19th century
Vessel in the center by Ab-Rasul and M. Sharif in Bukhara;
 two other vessels by unknown craftsmen in Kokand
Copper, bronze, cast, hammered, and chased. Height 35, 33,
 and 33
Ethnography Museum, Leningrad

Cups and jug. 1960s–70s
By M. Madaliyev
Copper, cast, hammered, and chased. Height 5, 3, and 25
Union of Artists, Moscow

Folder. 19th century
Tashkent
Stamped leather
Art Museum of the Uzbek SSR, Tashkent

Jug. 1900–1901
By Ali-Nazar-Kadikhu-Kokandi
Kokand
Copper, cast, hammered, and chased. Height 40
Ethnography Museum, Leningrad

Band for fixing a *yurta* tent. First quarter of the 20th century
Kara-Kalpaks
Pile- and flat-woven wool and cotton (synthetic dyes).
 366 × 19
Ethnography Museum, Leningrad

Wall decoration. First quarter of the 20th century
Kara-Kalpaks
Pile- and flat-woven wool (synthetic dyes). 204 × 16
Ethnography Museum, Leningrad

Washbasin and jug. Late 19th century and early 20th
 century
Bukhara and Kokand
Copper, hammered, chased, and carved, with smalt decoration
 (basin). 16 × 38 (basin); height 43 (jug)
Ethnography Museum, Leningrad

Puppets for folk puppet show. 1900s
Tashkent
Wood, cloth, fur, leather, and glass. Height 49 and 48
Ethnography Museum, Leningrad

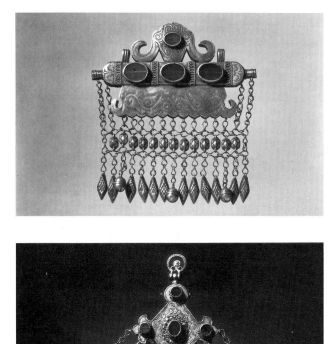

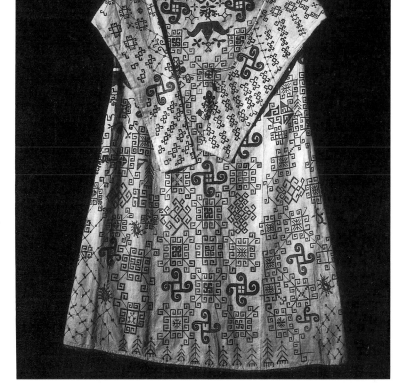

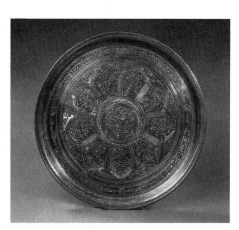

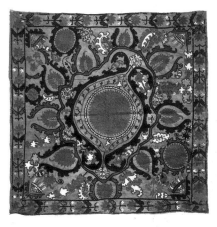

Woman's breast ornament. Early 20th century
Kara-Kalpaks
Silver, gilt, stamped, engraved, and set with cornelian and
 turquoise. 20 × 9
Ethnography Museum, Leningrad

Woman's breast ornament. Early 20th century
Kara-Kalpaks
Silver, stamped and engraved, decorated with filigree, and set
 with cornelian. 16 × 17
Ethnography Museum, Leningrad

Bag for tea. First third of the 20th century
Kecheimiok District (Kara-Kalpaks)
Cotton and coarse woollen fabric, embroidered in silk (natural
 dyes). 18 × 14
Ethnography Museum, Leningrad

Dish. 1971–72
By M. Madaliyev
Copper, hammered and chased
Union of Artists, Moscow

Mantle worn over woman's headdress. Late 19th or early
 20th century
Kara-Kalpaks
Cotton, embroidered in silk (natural dyes). Length 140
Ethnography Museum, Leningrad

Cover for brazier table. Late 19th century
Dzhizak
Cotton, embroidered in silk (natural dyes). 105 × 106
Ethnography Museum, Leningrad

TADZHIK
Folk Art

Tadzhikistan is a land of old and rich culture. Archaeological excavations of the site of the palace that once belonged to the rulers of Usrushana in Bunzhikat (present Shahristan) and of a town site in the ancient Sogdian principality (Pyandzhikent) have shown that the Tadzhiks' ancestors were already highly civilized as early as the fifth to the eighth century.

That period's art was amazingly varied and original. On the territory of Pyandzhikent, with its palaces and town streets, statues, paintings, fine jewelry, and wood carvings have been unearthed. The abundance of coins suggests highly developed commerce, while numerous amber, coral, and pearl objects corroborate written evidence of the extensive foreign trade maintained by the country.

Two distinct trends are observable in Tadzhik folk arts from the tenth to nineteenth centuries. The first of them is represented by handicraft industries based on highly developed skills and conventions; the second, less sophisticated, but more original and archaic, was connected with the making of domestic utensils within the household. The first trend was particularly strong in northern Tadzhik art, where urban handicraft industries were important, while the second was characteristic of the arts of the republic's mountainous regions. Owing to their geographic position and historical background, certain settlements there kept their life-style intact for centuries. Perched in the impenetrable Karategin, Darvaz, and West Pamir Mountains, there are small settlements where until recently subsistence

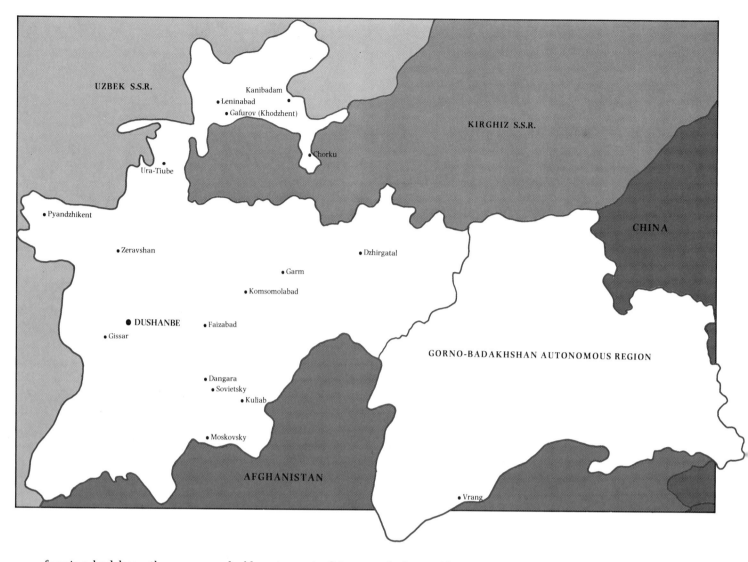

farming had been the norm, and old customs, traditions, and rites, with their symbolism and archaic mythological beliefs, had survived.

The figurative and ornamental forms of northern Tadzhik folk art show considerable affinity with Uzbek art, since the two nations' material and spiritual cultures are almost inseparable. Tadzhik craftsmen participated alongside their Uzbek counterparts in creating many famous cultural treasures in Bukhara and Samarkand.

At the same time, Tadzhikistan had its own urban handicraft centers. In the nineteenth and early twentieth centuries, Ura-Tiube and Khodzhent were famous for their carving and painting on wood; Ura-Tiube, Khodzhent, Kanibadam, and Chorku were known for their glazed pottery; and Khodzhent and Gissar for their silks.

Like the Uzbeks, the Tadzhiks decorated the walls and ceilings of their dwellings with painted polychrome ornaments, beside which they favored carved wooden and alabaster adornments. All these decorations produced a harmonious effect, which, together with the symbolism characteristic of them, contributed to the atmosphere of peace and benevolence, the like of which is found in Oriental poetry with its ideal world resembling a magnificent garden in blossom. Architectural details, such as painted wooden plafonds and friezes of complicated shapes, carved columns with multitiered capitals, or carved alabaster panels were matched by the beautiful objects

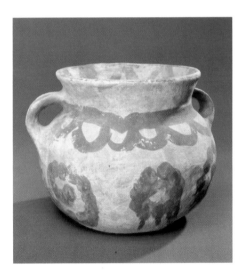

Jug. 1974
By Z. Rakhimova
Village of Gambulak
Handworked clay, fired, with slip decoration. Height 21
Union of Artists, Moscow

Pot for milk and butter. 1978
By D. Shoyeva
Village of Gambulak
Handworked clay, fired, with slip decoration. Height 15
Union of Artists, Moscow

found in the room: large pieces of embroidery, painted pottery, multicolored felt rugs, and *palases* covering the floor.

Interior decoration follows a rigid age-old pattern, whether it be a village dwelling, a town apartment, or a mosque. When a plafond is painted, the artist takes into consideration not only the structural characteristics of the building but also the size of each constituent design in the painted decoration, which may have one or several axes of symmetry. As a result, despite the complexity and variety of the patterns, all these plafonds, painted beams, and friezes appear natural either separately or taken as a whole.

Painted compositions were based on two main types of traditional ornaments: the first geometric (*girikh*), the second plant-like (*islimi*), in the form of a trailing stem with leaves, buds, and flowers. Occasionally, images of lions and horses from ancient mythology occur on Tadzhik murals.

The choice of color scheme was always of crucial importance where the design and scale of the painted ornament were considered. Pigments, prepared with egg yolk, were applied pure, unmixed. Cold tones, such as blue or green, were generally selected for the background, which set off the brightness of the designs' reds, oranges, and yellows. The artists' predilection for intense colors was but natural: with the air outside hot and dusty, the verandas were shaded and the rooms kept in semidarkness, so the colors seemed to diffuse, soften, and lose their brightness, forcing the artist to employ the most intense of them.

Tadzhik wood carving demonstrates loyalty to their national folk art traditions. The ancient carving on extant capitals from columns seen in some villages in the valleys of Fergana and the Upper Zeravshan, as well as many other surviving architectural details, finely carved in high relief of almost sculpted quality, display the same highly developed decorative features as those seen in painted decoration. Carvers from Ura-Tiube were particularly famous for their complex and dynamic plant designs executed in rather low relief with thoroughly modelled outlines and a punched background emphasizing the wood's rich texture.

Pottery is an important area of Tadzhik folk art. Glazed cups and dishes from Khodzhent, with their designs of plants in blue and turquoise over white slip, are extraordinarily varied. Present-day glazed ware from Chorku is notable for its subtle gradations of light blue hues, while earthenware from Kanibadam is marked by its monumental quality and broad, large-scale painted designs. Pottery made in the mountainous regions is made entirely by hand.

Handworked earthenware is a rare phenomenon in folk art, and Tadzhik ware is without parallel in the Soviet Union. The simple and imposing forms and the decorative modesty and dignity of these handthrown ceramics are truly fascinating. Gazing upon them, one feels as if time has stood still, preserving for us these manifestations of our ancestors' spiritual values and ingenuous perceptions of reality.

In the villages of the Dashti-Dzhum, Karategin, Darvaz, and Kuliab

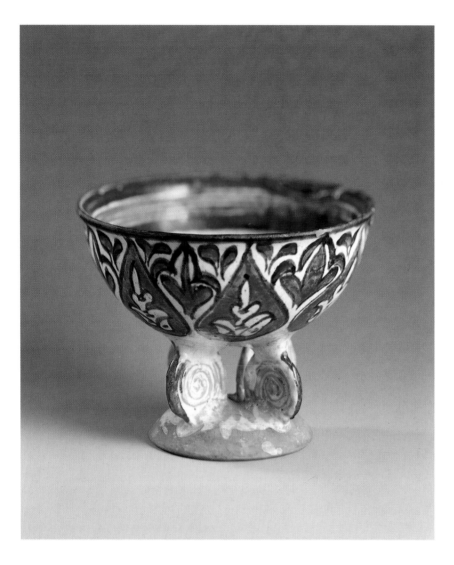

areas women have always modelled pottery. The shaping and firing of their wares were generally accompanied by rites intended to invest the pottery with magical powers to protect its user from disease or misfortune. Clay beads and amulets were applied to the vessels, which were slip-painted in red or brown with symbolic signs in the form of circles and zigzags. The wares of Darvaz are burnished, with applied handworked details; the Dash-ti-Dzhum pottery is painted with spiral patterns; and in Faizabad simple plant motifs are favored.

Greenish-brown slip decoration is characteristic of glazed pottery made in Karatag and Denau, where glazed terracotta toys are also produced. Originally they were small whistles modelled in the shape of fantastic lions or horses, but now these animal figurines can be up to forty centimeters high. They are favorite creations of the famous ceramic artist Gafur Khalilov, who lives in Ura-Tiube. Particularly well known are his dragons, painted with colored dots and strokes on a white background.

Vase. Late 19th or early 20th century
Khodzhent
Clay, with applied details, fired, and painted underglaze.
 Height 15.5
Museum of Oriental Art, Moscow

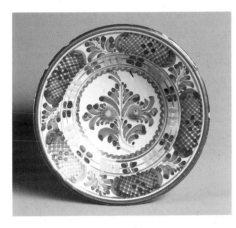

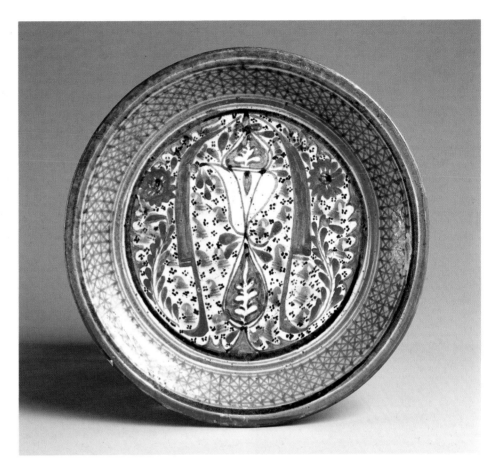

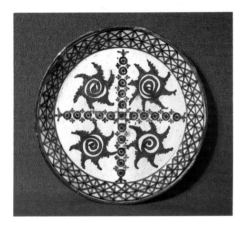

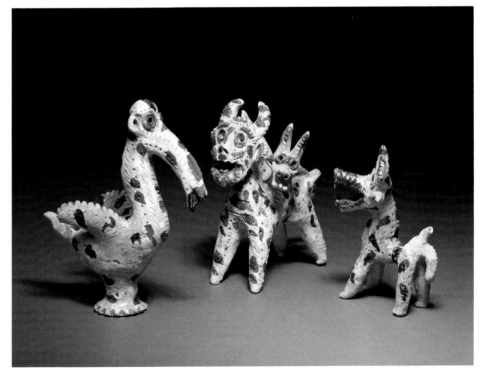

Dish. 19th century
Khodzhent
Clay, with applied details, fired, and painted underglaze.
 Diameter 26.5
Museum of Oriental Art, Moscow

Dish. 1960s
Village of Chorku, Leninabad Region
Clay, fired and painted underglaze. Diameter 29.5
Ethnography Museum, Leningrad

Dish. Early 20th century
Khodzhent
Clay, fired and painted underglaze. Diameter 31
Museum of Oriental Art, Moscow

Whistles. 1972
By G. Khalilov
Ura-Tiube
Handworked clay, fired, engraved, and painted underglaze.
 Height 25.7, 23.5, and 19
Ethnography Museum, Leningrad

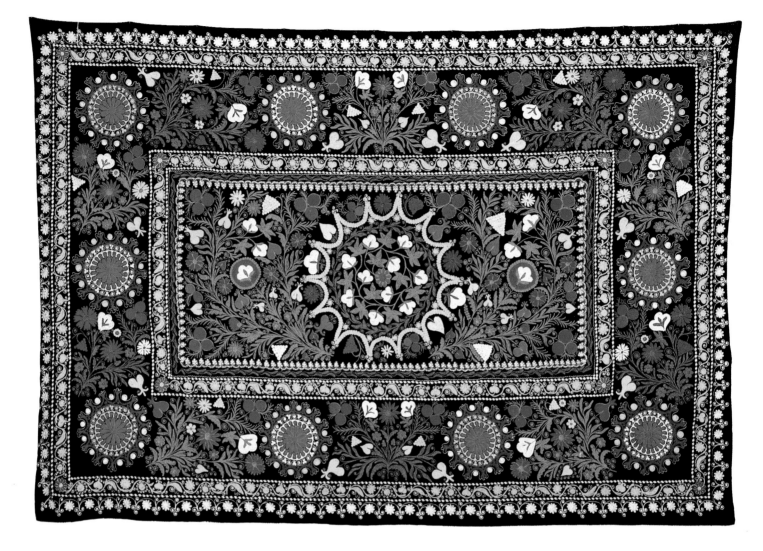

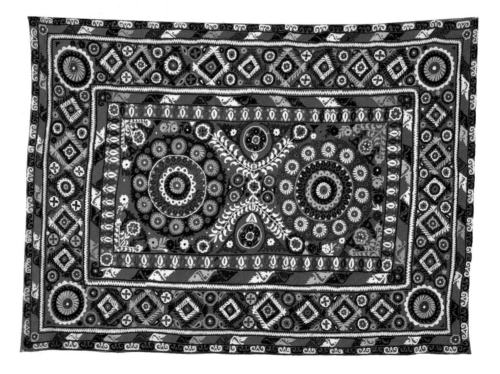

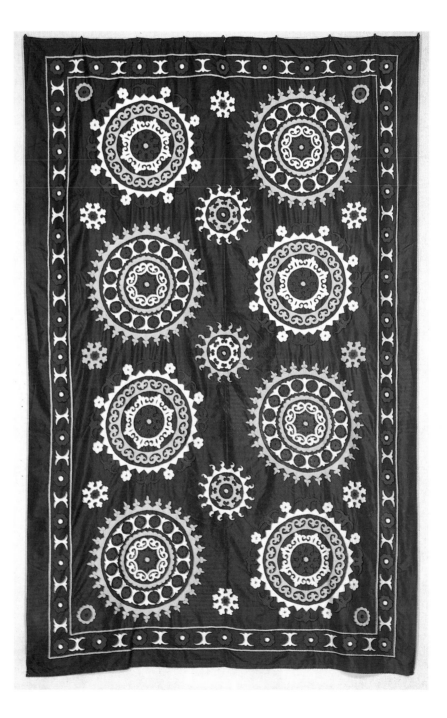

Wall hanging
By N. Kasymova
Leninabad
Velvet, embroidered in mouliné (synthetic dyes). 230 × 320
Union of Artists, Moscow

Wall hanging. 1974
By D. Naichmonova
Khuf District
Cotton, embroidered in mouliné (synthetic dyes). 175 × 260
Union of Artists, Moscow

Wall hanging. 1978
By Z. Bakhreddinova
Leninabad
Silk, with embroidery (synthetic dyes). 180 × 300
Union of Artists, Moscow

Embroidery has also been a popular art in Tadzhikistan. Large decorative panels, stylistically similar to Uzbek *suzani* work, with large formalized floral designs and roundels, are embroidered in Ura-Tiube and Leninabad. In the mountainous regions women's blouses, men's loincloths, cradle accessories, and headdresses are profusely adorned with embroidery. Very attractive festive dresses are made and embroidered in Kuliab, Karategin, and Kalaikhumb. The richest embroidery appears on the sleeves, with the bodice

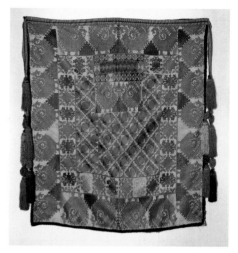

and the lap following in importance. The designs are worked on white, yellow, or red foundations, in brightly colored cotton or silk thread of predominantly violet or crimson tones. The needlewomen show considerable skill in subordinating the ornamentation to the cut and style of the article. In this respect Tadzhik skullcaps are worthy of note. Their embroidered rosettes, flower arrangements, stars, zigzags, roses, and tulips form concentric compositions consisting of three or four parts depending on the cap's shape; both the designs and colors of these compositions are arranged in full conformity to the rules of symmetry and rhythm. Each region has its own varied stock of shapes, color schemes, and ornaments. The favorite style in the Pamirs is a flat-bottomed skullcap with a broad capband and embroidered geometric ornamentation.

Bridal veils formerly used in the Pamirs are of exceptional artistic value. Their ornamentation consisted predominantly of images and motifs reflecting early, pre-Islamic beliefs and included Trees of Life, roosters, and peacocks. They were usually worked in satin stitch with crimson silk on a white foundation material. Pairs of roosters flanking a Tree of Life appeared in the center and along the borders. Their crimson color was not arbitrary: it symbolized fire, which was thought to scare evil spirits away from the bride.

Wedding veil. First half of the 19th century
Karategin
Cotton, embroidered in silk (natural dyes). 80 × 72
Ethnography Museum, Leningrad

Skullcaps. 1971, 1970, and 1960
By S. Gadoyeva, S. Saidkozimova, and an unknown craftsman
Kuliab; Komsomolabad; West Pamirs
Cotton, embroidered in silk (synthetic dyes)
History Institute of the Tadzhik SSR Academy of Sciences,
 Dushanbe

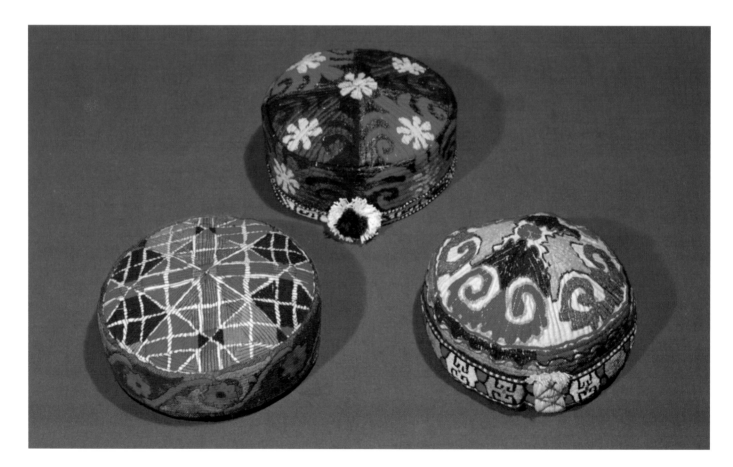

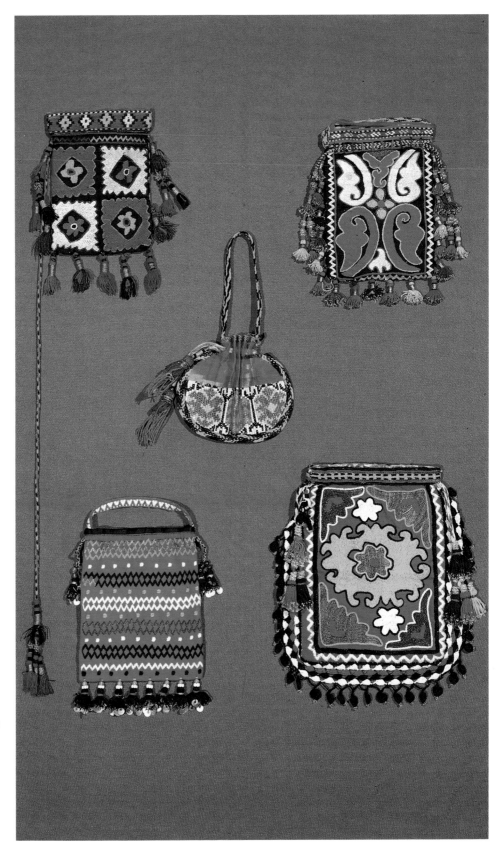

Fabric for woman's dress. 1977
Silk, with *abr-bandi* ornamentation (synthetic dyes). Width 73
Ethnography Museum, Leningrad

Bags for tea and purse. 1950s and early 20th century
By O. Khidirova (upper left bag)
Villages of Dzhirgatal and Bedaki-Poen near Garm; Bukhara
Cotton, embroidered in silk, with beadwork (natural and
 synthetic dyes). 12 × 17 (upper left bag)
History Institute of the Tadzhik SSR Academy of Sciences,
 Dushanbe

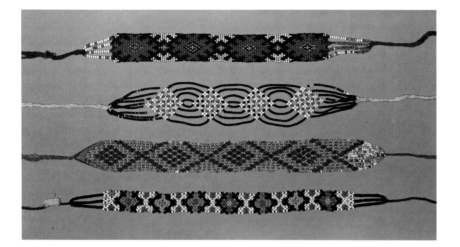

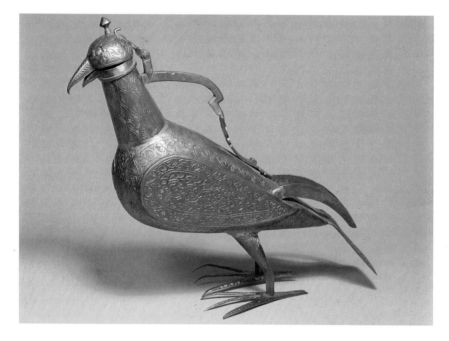

Jewelry was an important accessory for Tadzhik women's costumes. Women in such centers as Bukhara, Kuliab, and Gissar made some ornaments themselves, especially earrings, rings, bracelets, brooches, necklaces, neckbands with beadwork, and amulets sewn onto garments.

On the whole, Tadzhik ornamentation, which includes plant, zoomorphic, and other motifs, is rich and varied. In character and composition it has much in common with Uzbek arts, although it is also closely related to the arts of the nomadic world.

Tadzhik arts and crafts display considerable affinity with the cognate handicrafts of Afghanistan, Iran, and other Eastern countries, with whom they share a number of common features. Nevertheless, just as Tadzhikistan developed its national identity, its folk art acquired distinctive traits and originality.

Neck ornaments. 1960s–70s
By N. Alimamedova (bottom)
Village of Vrang, Ishkashim District, Gorno-Badakhshan
 Autonomous Region; village of Samsolik, Garm District
Plaited strings of beads. 30.5 × 2; 29 × 2.7; 23.5 × 3.8;
 27 × 2.5
Ethnography Museum, Leningrad

Decorative vessel. Early 20th century
Bukhara
Copper, cast, hammered, chased, and engraved. Height 39.8
Ethnography Museum, Leningrad

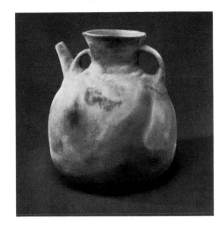 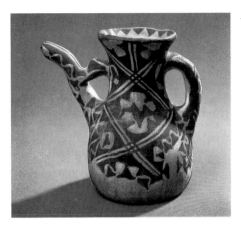 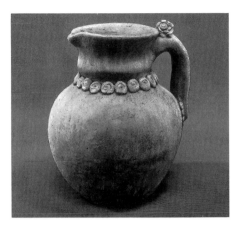

 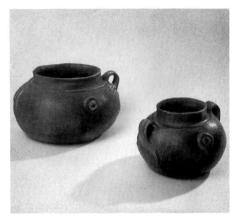 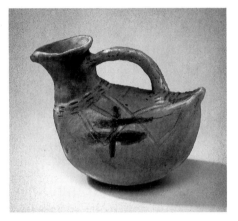

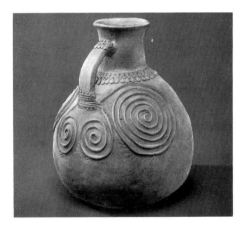 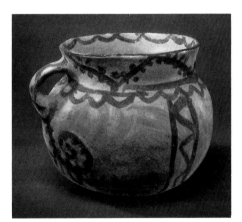 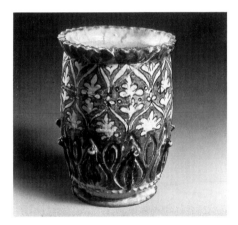

Jug. 1977
By O. Rakhimova
Sovietsky District
Handworked clay, fired. Height 41
Union of Artists, Moscow

Milk pot. 1975
By S. Fazlunova
Village of Egid, Kalaikhumb District, Gorno-Badakhshan
　Autonomous Region
Clay, with applied details, fired, and burnished. Height 14
Union of Artists, Moscow

Jug. 1979
By S. Karimova
Village of Gidzhovak, Dangara District, Kuliab Region
Clay, with applied details, fired, and carved. Height 40
Union of Artists, Moscow

Jug. 1978–79
By Sh. Safarova
Village of Tashtidzhum, Moskovsky District, Kuliab Region
Handworked clay, fired, with slip decoration
Union of Artists, Moscow

Milk pots. 1975
By S. Fazlunova
Village of Egid, Kalaikhumb District, Gorno-Badakhshan
　Autonomous Region
Clay, with applied details, fired, and burnished. Height 12
Union of Artists, Moscow

Churn. 1978
By K. Ibodova
Village of Gambulak
Handworked clay, fired, with slip decoration. Height 14
Union of Artists, Moscow

Jug
By M. Mirzoyev
Fired clay, with applied details. Height 17
Union of Artists, Moscow

Drinking vessel. 1974
By Z. Rakhimova
Village of Gambulak
Handworked clay, fired and engraved, with slip decoration.
　Height 10
Union of Artists, Moscow

Vase. Late 19th century
Khodzhent
Clay, with applied details, fired, and painted underglaze.
　Height 22
Museum of Oriental Art, Moscow

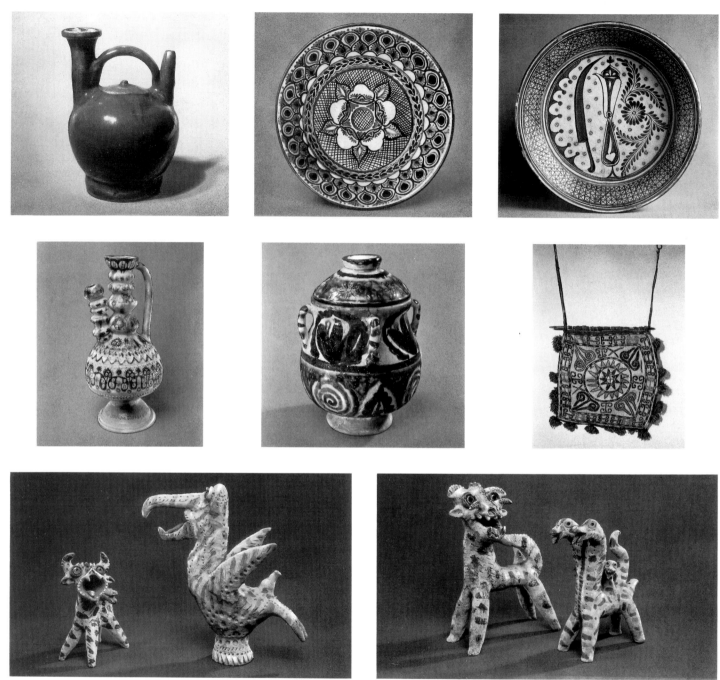

Jug. Late 19th century
Bukhara
Clay, with applied decoration, fired, and painted underglaze.
 Height 24
Ethnography Museum, Leningrad

Jug. 20th century
By the Sakhibov brothers
Village of Chorku, Leninabad Region
Clay, with applied details, fired, and painted underglaze.
 Height 62
Union of Artists, Moscow

Dragon-shaped whistles. 1978
By G. Khalilov
Ura-Tiube
Handworked clay, fired and painted. Height 10 and 17
Union of Artists, Moscow

Bowl. 1978
By M. Mirzoyev
Dushanbe
Clay, fired and painted underglaze. 11 × 38
Union of Artists, Moscow

Jar for jam. 1978
By B. Mavlianov
Kanibadam
Clay, with applied details, fired, and painted underglaze.
 Height 26
Union of Artists, Moscow

Dish. Early 20th century
Khodzhent
Clay, fired and painted underglaze. Height 33
Museum of Oriental Art, Moscow

Bridal bag for personal ornaments and trinkets. 1962
By Kh. Niezmamadova
Village of Vrang, Ishkashim District, Gorno-Badakhshan
 Autonomous Region
Felt, embroidered in wool (synthetic dyes). 53 × 51
Ethnography Museum, Leningrad

Dragon-shaped whistles. 1978
By G. Khalilov
Ura-Tiube
Handworked clay, fired, carved, and painted. Height 14
 and 12
Union of Artists, Moscow

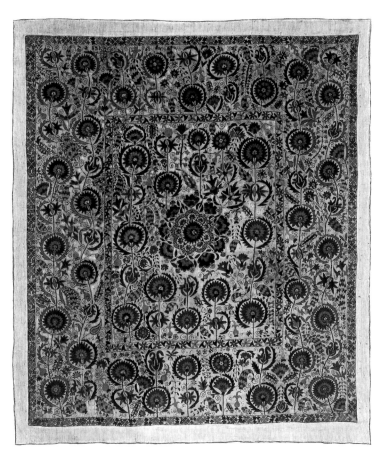

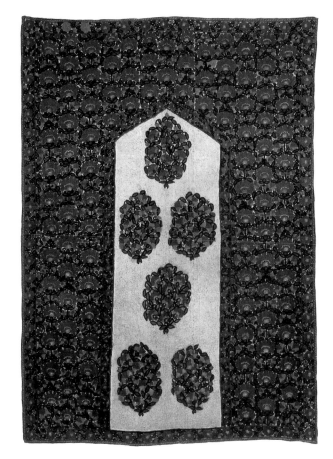

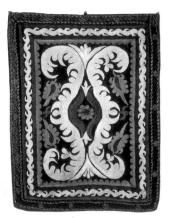

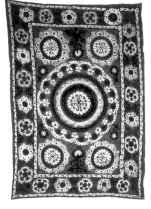

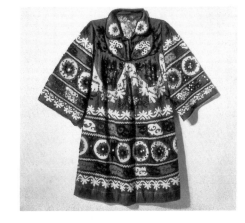

Wall hanging. 19th century
Ura-Tiube
Cotton, embroidered in silk (natural dyes). 180 × 161
Museum of Oriental Art, Moscow

Wall hanging for bridal bedroom. 1920s
Ura-Tiube
Cotton, embroidered in silk (natural dyes). 114 × 89
Ethnography Museum, Leningrad

Wall hanging. 1975
Kuliab
Cotton, embroidered in silk (synthetic dyes). 212 × 150
Ethnography Museum, Leningrad

Prayer rug. 19th century
Ura-Tiube
Cotton, embroidered in silk (natural dyes). 120 × 72
Museum of Oriental Art, Moscow

Bridal dress. 1977
Karategin
Cotton, embroidered in cotton thread (synthetic dyes). 98 × 40
Ethnography Museum, Leningrad

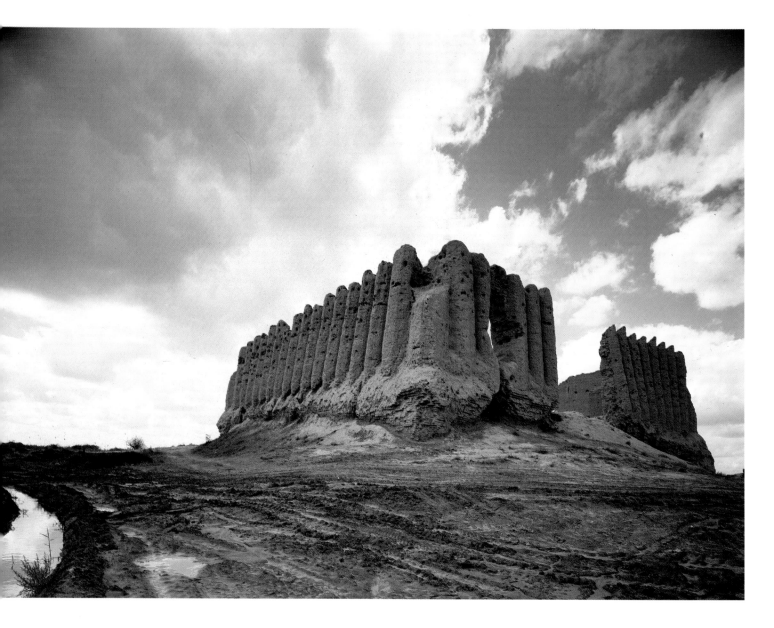

TURKMEN
Folk Art

Turkmen folk art is best known for its pile-woven carpets, which, apart from being essential in the household, were from a very early date an important export commodity. Their extraordinary variety and beauty stem from their method of execution—hand-weaving. Weavers, mostly women, are introduced to the craft in early childhood and gradually master all the processes of this difficult time-consuming art.

There once existed flourishing towns and villages in the agricultural oases of Turkmenia, which were wiped out by bloody, devastating wars. By the eighteenth century Merv, Nis, and Tedzhen had declined. Pottery was no longer made. The only surviving industries were silk-weaving, carpet-making, and goldsmithing, which catered to the local nomadic and semi-nomadic population. Felts were produced for covering *yurta* tents, floors (carpets were also used), and for making sacks and bags in which clothes and utensils were kept.

The Turkmen women weavers are skilled in making all types of carpets—piled, flat-woven, and woven in a mixed technique. Their mastery is demonstrated by the density of pile and the correspondence of the density to its height, which enhances the design's clarity and vividness.

The composition of a Turkmen carpet depends upon its shape and purpose. In carpets used as floorspreads or as material for different types of sacks, the central field is surrounded by a border consisting of several rows of ornamentation, with a broad panel known as an *elem* along the edge on

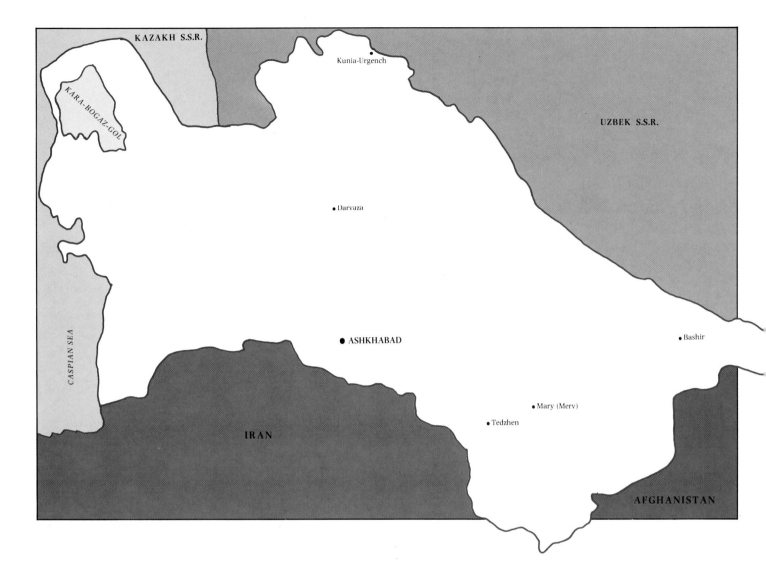

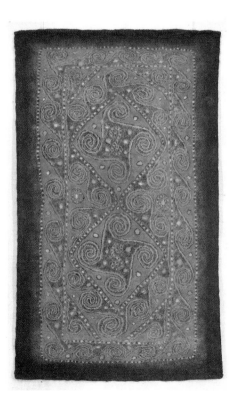

one or both sides. The ornamental patterns are arranged in horizontal or vertical rows. In *ensi* carpets hung at the *yurta*'s entrance and in *namazlyk* prayer rugs the design is vertical. The central field of an *ensi* hanging is divided into several parts, each repeating the same design, which generally consists of formalized zoomorphic or plant-like motifs. The compositions on *namazlyk* rugs often include architectural motifs. *Iolam* strips used for binding the *yurta* components have a characteristic frieze-like design.

The woven design greatly depends on color for its expressiveness and appeal. The diagonal color distribution in Turkmen carpets, which does not follow the design's vertical or horizontal lines, gives the otherwise austere flat ornament an illusory depth, liveliness, and painterly vividness. The ornament seems to melt away and merge with the groundwork.

The ornamentation of most carpets of Turkmen workmanship includes a medallion (*göl*), which may be in the shape of a lozenge, an octagon, a square, a quadrangle with cut corners, or an even more complex figure. Heraldic zoomorphic figures may appear at the center of the medallion, which are often additionally adorned with indentations or scrolls. Each tribe used to have one or several *göls* used as crests. The crests are of some help today in classifying Turkmen pile-woven carpets. In accordance with the tribes from which they originated, five broad categories of Turkmen carpets are distinguished: *salor*, *saryk*, *tekke*, *yomud*, and *ersari*.

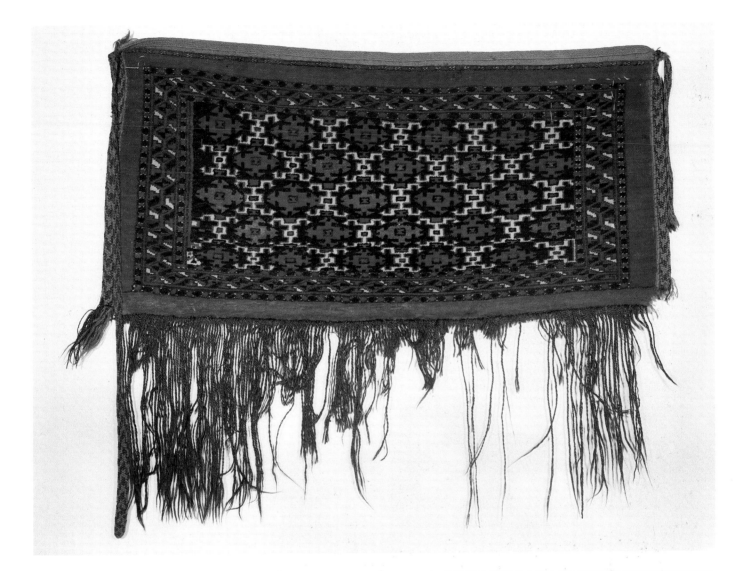

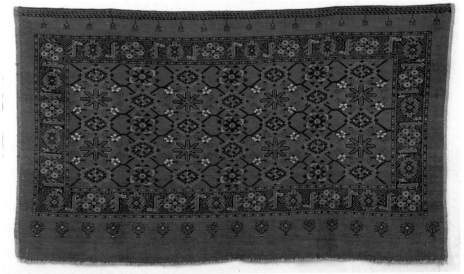

Carpet. 1974
By S. Batyrova
Woollen felt (synthetic dyes)
Union of Artists, Moscow

Wall bag. Early 20th century
Saryk Turkmen
Pile-woven wool, silk, and cotton (natural dyes). 80 × 37
Ethnography Museum, Leningrad

Bag for storing clothes and utensils. Mid-19th century
Saryk Turkmen
Pile-woven wool and cotton (natural dyes)
Museum of Oriental Art, Moscow

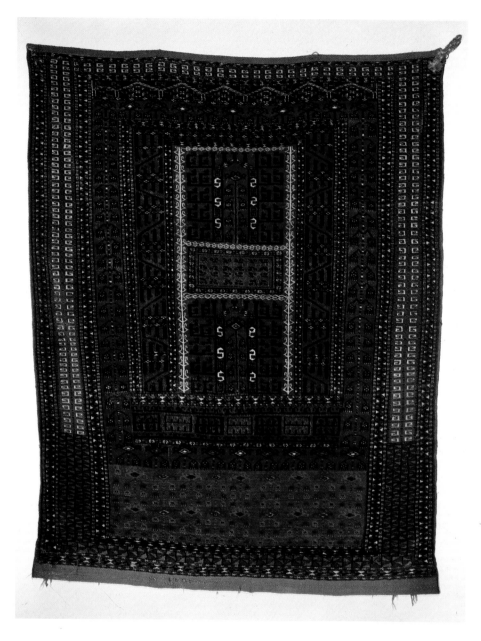

Overdoor hanging. Early 19th century
Saryk Turkmen
Pile-woven wool and cotton (natural dyes). 129 × 144
Ethnography Museum, Leningrad

Band for fixing a *yurta* tent. Last third of the 19th century
Yomud Turkmen
Pile- and flat-woven wool and cotton (natural and synthetic
 dyes). 212 × 44
Ethnography Museum, Leningrad

Cloth covering for a camel. Late 18th or early 19th century
Tekke Turkmen
Pile-woven wool (natural dyes). 140 × 83
Fine Arts Museum of the Turkmen SSR. Ashkhabad

Cloth covering for a camel. Mid-19th century
Tekke Turkmen
Wool, with embroidery (natural dyes). 91 × 148
Ethnography Museum, Leningrad

Wall bag. Late 19th century
Akhal-Tekke Turkmen
Pile-woven wool (natural dyes). 38.5 × 110
Fine Arts Museum of the Turkmen SSR. Ashkhabad

The most prized of Turkmen carpets were produced by the Salor and Saryk tribes. The Salors are regarded as the pioneers of Turkmen carpet-making, but they ceased producing them in the mid-nineteenth century. Fortunately, their *göls*, with very slight modifications, were continued in the Saryks' work, especially in smaller pieces. *Salors* are notable for their clear-cut details (woven in 1.5 knot) and refined dark red or brown color scheme. Their *göls* are in the shape of stepped elongated octagons. *Saryks* are woven in double knot on a dark foundation; this is especially characteristic of *ensi* hangings. Smaller articles often have rich fringed decoration in black wool, with pink silk admixtures for a glossy effect.

Overdoor hanging. 19th century
Tekke Turkmen
Pile-woven wool (natural dyes). 104 × 76
Fine Arts Museum of the Turkmen SSR. Ashkhabad

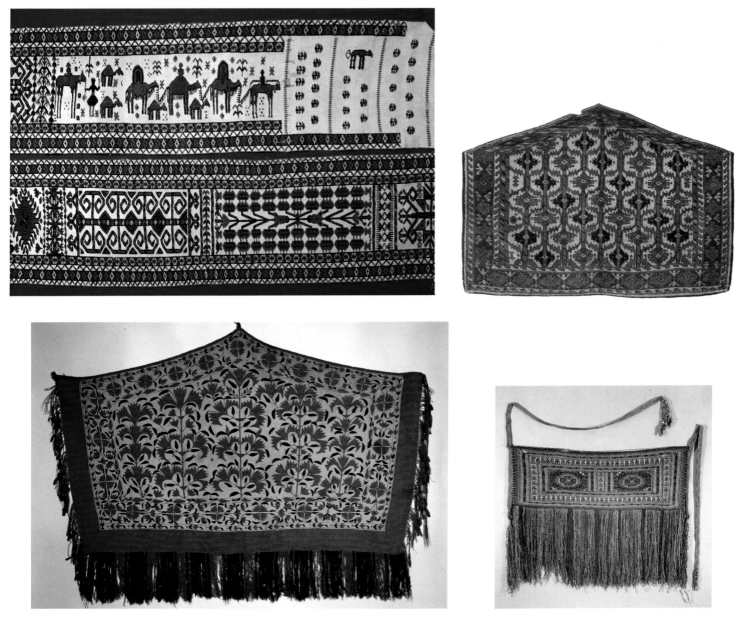

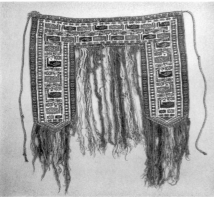

Tekke carpets are hardly less popular. Their color scheme is relatively light and rich in shades, and their ornamentation extraordinarily varied. Of considerable interest are the Tekkes' bags (*akchuvals*), executed in combination weave so as to produce horizontal stripes of white pile alternating with smooth-faced bands in cold crimson tones.

Yomud carpets display a great variety of functional types and ornamentation. In the nineteenth century, pentagonal and heptagonal carpets, with which the Yomuds caparisoned camels for wedding ceremonies, and small flat- and pile-woven rugs for covering the camel's neck and chest were still in wide use.

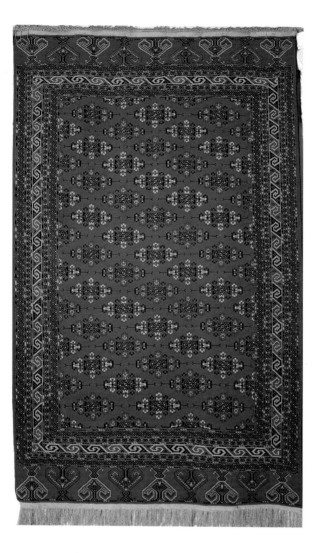

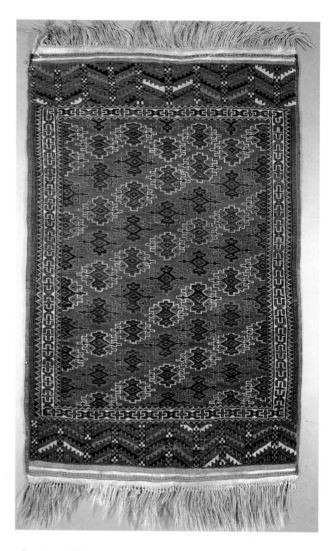

Yomud carpets are double-knotted, with a relatively low density. Their color scheme is based on brown, red, and golden tones, with inclusions of whites, blues, and greens. The medallion is generally in the shape of a lozenge with indented contours. The border decoration originally represented a trailing vine, but lost its previous life-like quality in later work, turning into an elongated toothed pattern.

The Choudors' and Ersaris' carpets form a special stylistic group. The former have high pile and large lozenge *göls*, in which browns, light yellows, blues, and whites predominate. In the Ersaris' carpets the large *göls* are placed near each other. Among the Ersaris there were many ethnic groups of different origin, a circumstance reflected in their carpet varieties. One type of their carpets is named after Beshir, a large trading center. Among the Beshir carpets there are medallion and nonmedallion carpets with comprehensive designs. Their geometrical ornaments are white, orange, light blue, and yellow.

While maintaining their artistic traditions, the Turkmen carpet-weavers enrich their designs with novel motifs and subjects. The creative work of some women weavers employed by the Turkmenkover carpet-making workshop is of great interest. They have considerable experience in weaving subject panels and portraits.

Rug. Late 19th century
Ersari Turkmen
Pile-woven wool (natural dyes). 180 × 76
Ethnography Museum, Leningrad

Rug. Early 20th century
Yomud Turkmen
Pile-woven wool (natural and synthetic dyes). 198 × 87
Fine Arts Museum of the Turkmen SSR, Ashkhabad

Cloth for a camel's young. Late 19th century
Tekke Turkmen
Pile-woven wool (natural and synthetic dyes). 40 × 80
Fine Arts Museum of the Turkmen SSR, Ashkhabad

Covering for a camel. 19th century
Ersari Arabachi Turkmen
Pile-woven wool, silk, and cotton (natural dyes). 123 × 88
Ethnography Museum, Leningrad

Carpet: *Campaign Against Illiteracy.* 1972
By V. Sabitova
Pile-woven wool (synthetic dyes)
Union of Artists, Moscow

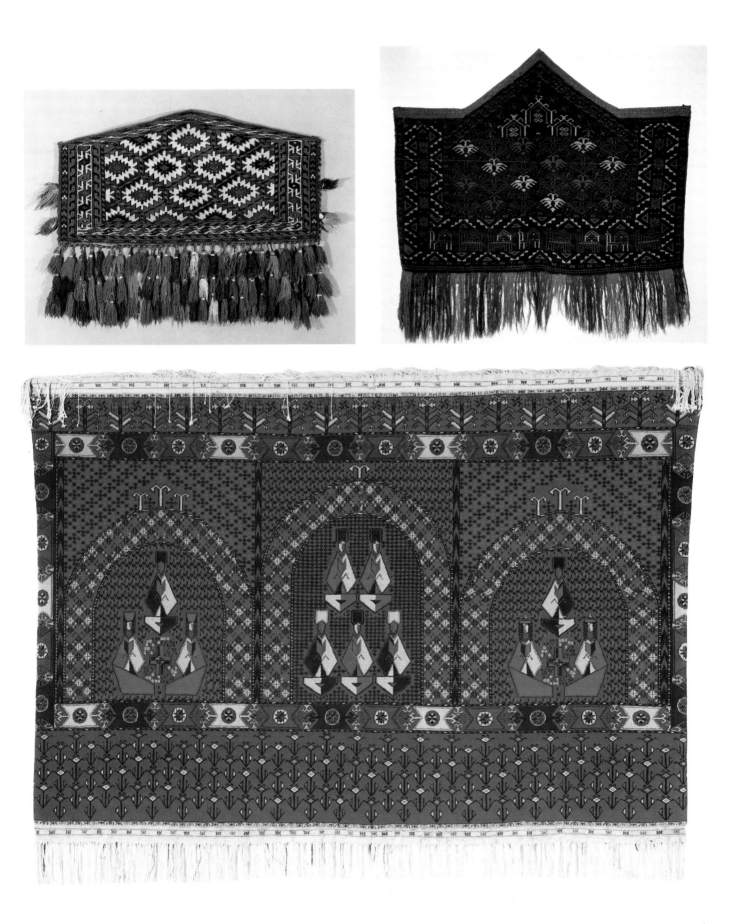

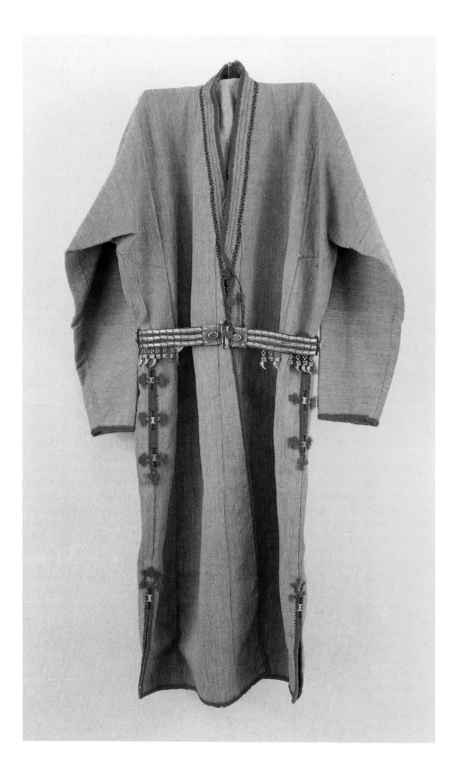

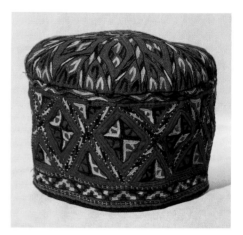

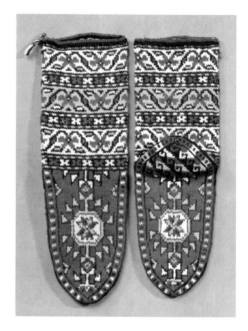

Man's robe and belt. Late 19th century and late 19th or early
 20th century
Saryk Turkmen (robe) and Tekke Turkmen (belt)
Knitted wool, with embroidery (natural dyes); silver, set with
 cornelian
Museum of Local Lore, Ashkhabad

Cap. Late 19th or early 20th century
Tekke Turkmen
Silk, with embroidery (synthetic dyes)
Museum of Oriental Art, Moscow

Socks. 1976
By G. Atayeva
Ashkhabad
Knitted wool (synthetic dyes). Length 37
Union of Artists, Moscow

Among the various domestic crafts practiced by Turkmen women,
knitting and embroidery are particularly significant. The latter is widely
used to decorate men's and children's skullcaps and miscellaneous house-
hold articles, but especially to trim women's dresses and festive robes usual-

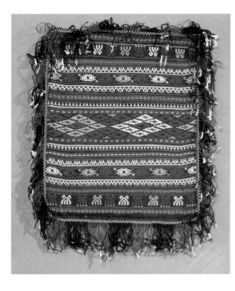

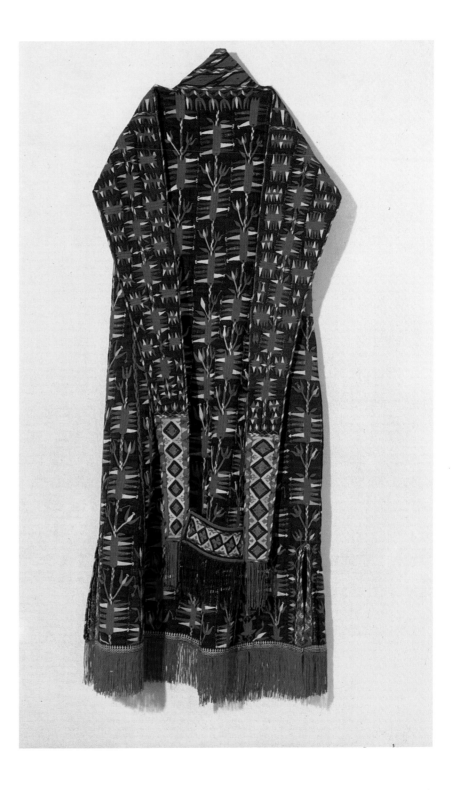

Table cover. 1978
By Ya. Saparova
Sateen, embroidered in silk and mouliné (synthetic dyes).
 35 × 24
Union of Artists, Moscow

Woman's robe for covering the head. Late 19th or early 20th
 century
Tekke Turkmen
Silk, with embroidery (natural dyes)
Fine Arts Museum of the Turkmen SSR, Ashkhabad

ly made of thick, heavy silk with dangling dummy sleeves. The embroidery
is feather- or chain-stitched with colored silk or cotton thread on a yellow,
red, white, or green foundation. Embroidered designs consist of triangles,
lozenges, or formalized plants.

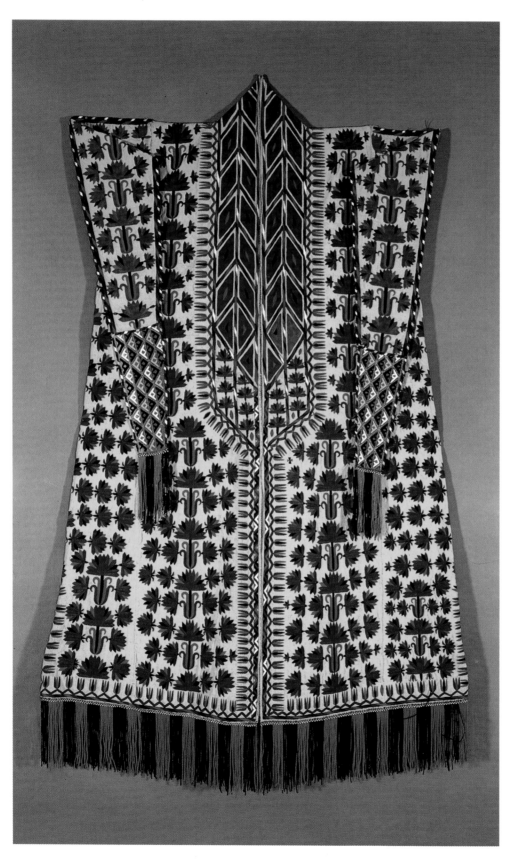

Woman's festive robe for covering the head. 1930s
Tekke Turkmen
Silk, embroidered in cotton (synthetic dyes). Length 121
Fine Arts Museum of the Turkmen SSR, Ashkhabad

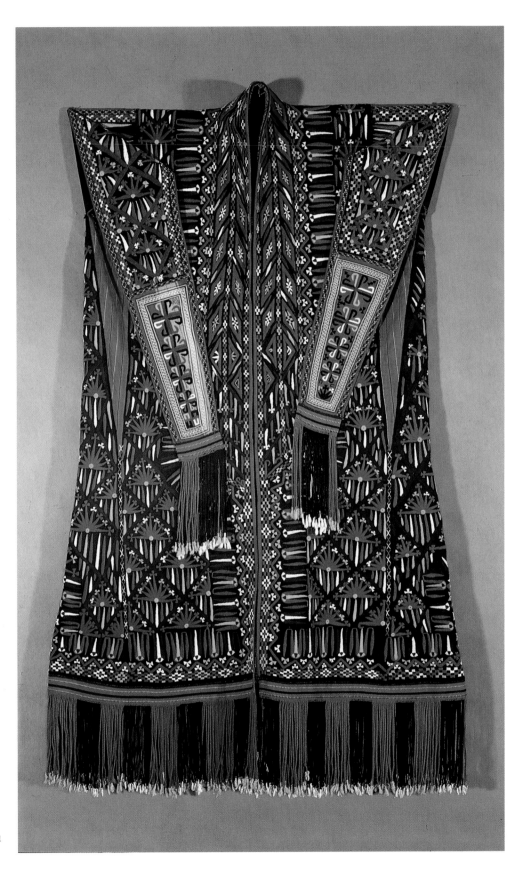

Woman's wedding robe for covering the head. 1930
Akhal-Tekke Turkmen
Silk, embroidered in cotton (synthetic dyes). Length 111
Fine Arts Museum of the Turkmen SSR, Ashkhabad

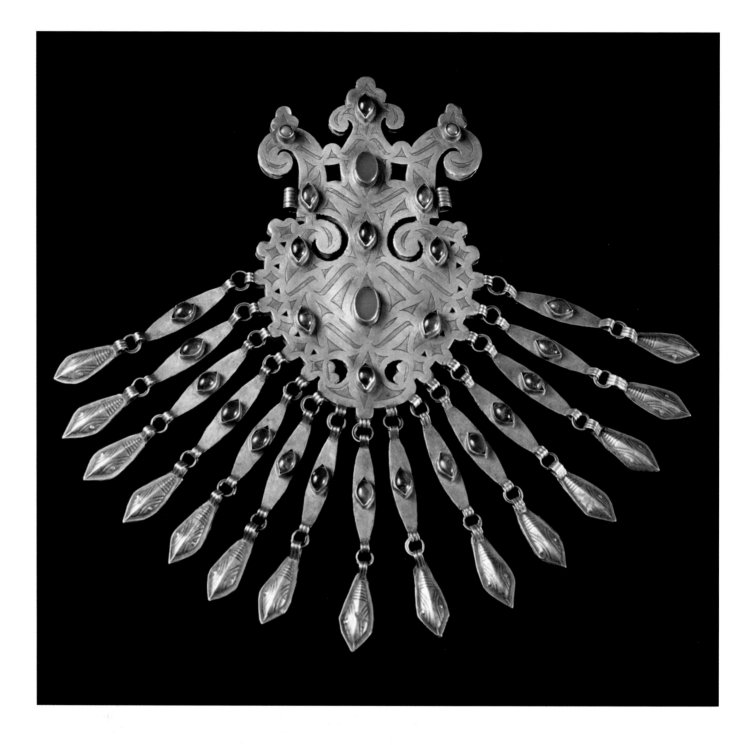

Turkmen jewelry and ornaments, produced mainly in towns, are very massive and give much the same impression of solemn monumentality as their carpets. Made of sheet silver or silver-plated copper, and set with cornelian, colored glass, turquoise, or coral, they are heavy, simple, and concise in design. The austerity of their forms is emphasized by the techniques employed, such as stamping, casting, engraving, and parcel-gilt work. Or-

Clasp for woman's robe. 19th century
Silver, gilt, stamped, chased, engraved, and set with
cornelians. Length 12
Museum of Oriental Art, Moscow

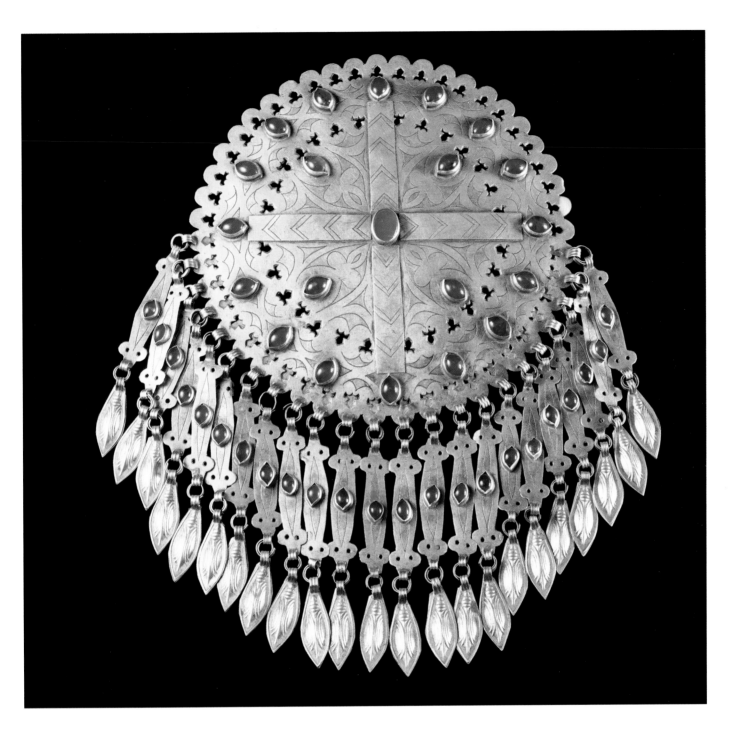

Clasp for woman's robe. Early 20th century
Tekke Turkmen
Silver, gilt, engraved, stamped, chased, and set with
 cornelians and glass. 11 × 9
Museum of Oriental Art, Moscow

naments worn on the head and on the breast are fitted with pendants in
the form of bells, triangles, or lozenges, which produce a rustling and jin-
gling effect when the woman walks. Young girls' forehead ornaments are
of exquisite delicacy.

Like their carpet-making, Turkmen goldsmithing is founded on tradi-
tions that are genuinely national and original. The traditions are remark-

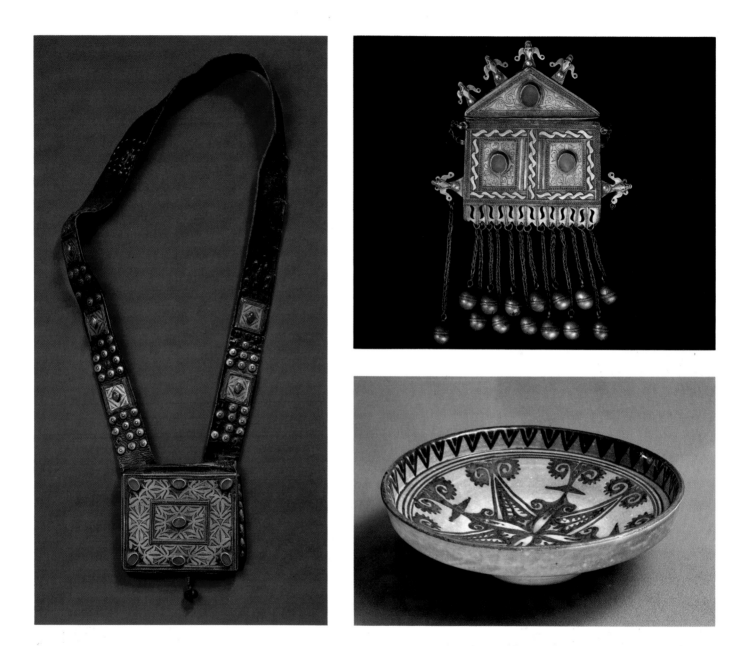

ably stable and still determine the development of every art and craft in present-day Turkmenia.

In recent years, pottery production has been revived in Kunia-Urgench and some other towns, where earthenware dishes, tall bowls, and large jugs for water are thrown. All these articles are painted with multipetalled rosettes under turquoise glaze.

There is a certain stateliness, monumentality, and proud serenity about Turkmen art, which matches the character of the people living under severe desert and semidesert conditions. Their art is characterized by simplicity and clarity of design, coupled with a festive spirit.

Bag for the Koran. 19th century
Leather, with silver ornaments, gilt, stamped, chased,
 engraved, and set with cornelians. Height 45
Museum of Oriental Art, Moscow

Pectoral amulet holder. Mid-19th century
Silver, gilt, stamped, chased, engraved, decorated with filigree,
 and set with cornelians. Height 20
Museum of Oriental Art, Moscow

Dish. 1974–75
By Ye. Sapayev
Kunia-Urgench
Clay, fired and painted underglaze. Diameter 29
Union of Artists, Moscow

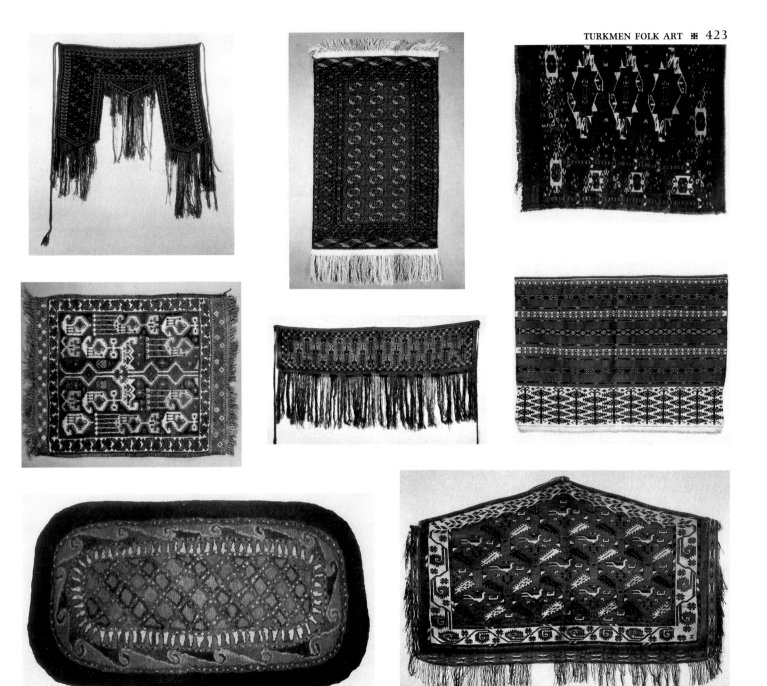

Overdoor hanging for a *yurta* tent. Mid-19th century
Tekke Turkmen
Pile-woven wool (natural dyes). 72 × 53
Ethnography Museum, Leningrad

Wall bag. 19th century
Tekke Turkmen
Pile-woven wool (natural dyes). 110 × 36
Ethnography Museum, Leningrad

Carpet. Early 20th century
Woollen felt (synthetic dyes). 202 × 115
Ethnography Museum, Leningrad

Hearth rug. Early 20th century
By O. Kurban and S. Setdarova
Tekke Turkmen
Pile-woven wool (natural and synthetic dyes). 86 × 129
Fine Arts Museum of the Turkmen SSR, Ashkhabad

Wall bag. 19th century
Ersari Turkmen
Pile-woven wool (natural dyes). 150 × 35
Ethnography Museum, Leningrad

Screen rug for the lower part of *yurta* tent entrance. Late
 18th or early 19th century
Pile-woven wool (natural dyes)
Museum of Oriental Art, Moscow

Wall bag. 19th century
Tekke Turkmen
Pile- and flat-woven wool (natural dyes). 112 × 79
Ethnography Museum, Leningrad

Cloth covering for a camel. 18th century
Tekke Turkmen
Pile-woven wool (natural dyes). 151 × 88
Fine Arts Museum of the Turkmen SSR, Ashkhabad

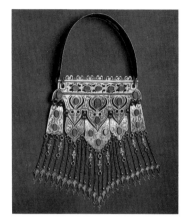

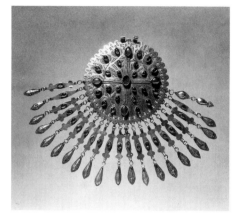

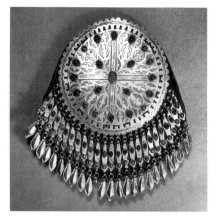

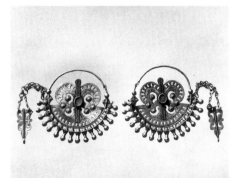

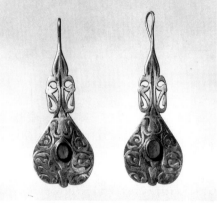

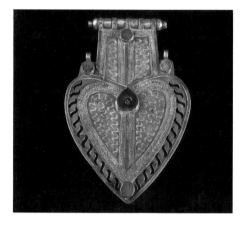

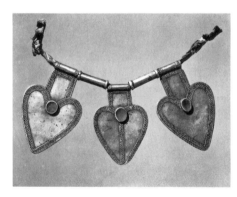

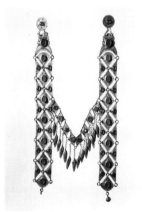

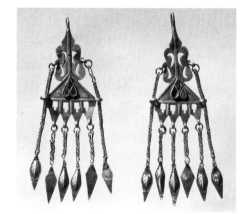

Breast ornament. 19th century
Silver, gilt, stamped, chased, and engraved, decorated with
 filigree, and set with cornelians. Length 44
Museum of Oriental Art, Moscow

Earrings. Early 20th century
Yomud Turkmen
Silver, gilt and carved. Diameter 11
Ethnography Museum, Leningrad

Ornament for plaits. 1900s
Village of Koine-Kasyr
Silver, decorated with filigree and set with cornelians. Height
 12 and 10
Ethnography Museum, Leningrad

Clasp for woman's robe. Early 20th century
Silver, gilt, stamped, chased, engraved, and set with
 cornelians. 11 × 9
Museum of Oriental Art, Moscow

Earrings. Early 20th century
Saryk Turkmen
Silver, gilt, chased, carved, and set with cornelians.
 Length 12.5
Ethnography Museum, Leningrad

Ornaments for plaits. 1940–50
Tekke Turkmen
Silver, gilt, engraved, chased, and set with glass and
 cornelians. Length 47
Ethnography Museum, Leningrad

Woman's breast decoration. Early 20th century
Tekke Turkmen
Silver, gilt, engraved, and set with cornelians and colored
 glass. 28 × 18
Fine Arts Museum of the Turkmen SSR, Ashkhabad

Ornament for plaits. Late 19th century
Silver, gilt, stamped, chased, engraved, decorated with filigree,
 and set with cornelians. Length 13
Museum of Oriental Art, Moscow

Temple pendants. Early 20th century
Tekke Turkmen
Silver, gilt, chased, pierced, and set with cornelians. Length 13
Ethnography Museum, Leningrad

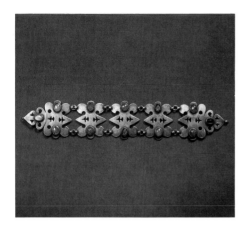

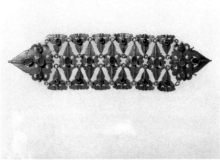

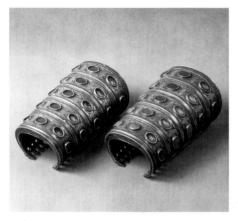

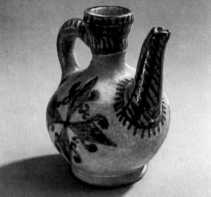

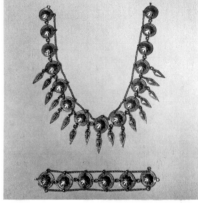

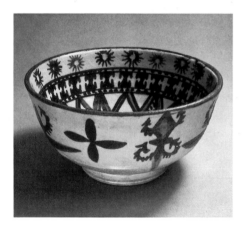

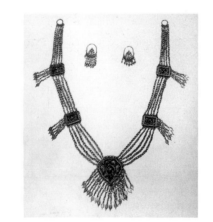

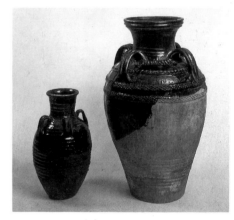

Ornament for woman's headdress. 19th century
Silver, stamped, pierced, and set with cornelians. Length 26
Museum of Oriental Art, Moscow

Woman's bangles. Mid-19th century
Silver, gilt, stamped, chased, engraved, decorated with filigree,
 and set with cornelians. Length 17
Museum of Oriental Art, Moscow

Bowl. 1977
By Ye. Sapayev
Kunia-Urgench
Clay, fired and painted underglaze. Diameter 19
Union of Artists, Moscow

Ornament for woman's headdress. 1900s
Village of Koine-Kasyr
Silver, stamped, pierced, decorated with filigree and
 granulation, and set with cornelians and glass. 40 × 11
Ethnography Museum, Leningrad

Jug. 1977
By Ye. Sapayev
Kunia-Urgench
Clay, fired and painted underglaze. Height 27
Union of Artists, Moscow

Necklace and earrings. 1970s
By Ye. Ivannikova
Ashkhabad
Silver, stamped, decorated with filigree and granulation.
 Length of necklace 43
Union of Artists, Moscow

Ornament for young girl's headdress. 1920s
Ersari Turkmen
Silver, stamped and set with cornelians. Length 35.5
Ethnography Museum, Leningrad

Necklace and bracelet (from the *Yakalyk* set). 1976
By A. Sakhatov
German silver, stamped and decorated with granulation.
 Length of necklace 36
Union of Artists, Moscow

Jugs. 1977
By Yu. Khaitmuradov
Kunia-Urgench
Clay, with applied details, fired, and glazed. Height 67 and 34
Union of Artists, Moscow

KIRGHIZ
Folk Art

The Kirghizians possess a rich and unique cultural legacy created throughout the centuries by nomadic herdsmen who inhabited the foothills of the Tien Shan and Altai mountain ranges. This land's picturesque scenery played an important role in the formation of the ornamentation and imagery in Kirghiz folk art. The rugged contours of mountain peaks, the smooth foothills, and the sun-drenched expanses of the steppes are still embodied in Kirghiz ornamental art with its characteristic unhurried rhythm and economy of color.

The *yurta* tents of Kirghiz *auls* stood like rows of mounds on the steppes or mountain pastures. Such dwellings had a sound design, each element of which had evolved over centuries. Even its hemispheric shape, reminiscent of an object from outer space, provides one of the sturdiest structures known to men.

The *yurta* tent was generally partitioned into a section where guests could be received and another for household and kitchen utensils; sometimes a separate place for sleeping was reserved. Mats woven of grass and colored woollen thread, decorated with a kaleidoscopic profusion of geometric designs, were used as screens.

An embroidered carpet (*tushkiiz*) was usually hung, like a stage wing, on the wall opposite the entrance. It was the focal point of the interior around which all the other *yurta* decorations were grouped. Felt and piled rugs, bags hanging from the walls, colored coverings on chests, various

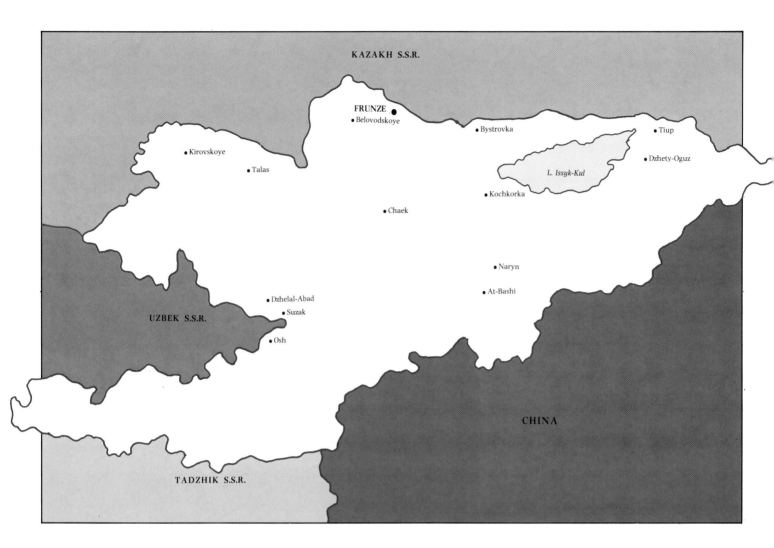

leatherware with stamped designs, carved wooden stands, and other hand-made objects performed useful functions and contributed to the overall decorative effect.

The chief materials used for making *yurtas* were wood and felt. The wooden framework was covered with felt rugs of different shapes and sizes. Felt was also used for flooring and in the making of various storage bags for clothes and utensils. Felt rugs were decorated with large-scale patterns either by pressing colored wool onto the surface before it was fully matted or by combining two felts of different colors cut so as to produce two mirror-image pieces with mosaic-like designs.

Shirdak felt rugs used as flooring were made all over Kirghizia, with the exception of some localities in the southwest of the republic. These rugs bear clear-cut large ornaments due, on one hand, to the folk artist's awareness of the rug's decorative purpose and, on the other, to the technical limitations precluding the use of small-scale designs.

The composition is based on the accentuation of two to four large repeating circles, quadrangles, rhombs, or crosses. The space between and within is filled with designs consisting of variously shaped curls vaguely suggesting plants or animals.

The impression of ornamental richness and compositional harmony that *shirdak* felts evince is to a large degree due to their contrasting colors. The most favored combinations are red and blue, and brown and orange.

Yurta **tent entrance curtain.** 1973
By A. Attokurova
Talas District
Pile-woven wool (synthetic dyes). 115 × 212
Fine Arts Museum of the Kirghiz SSR, Frunze

Hanging for partitioning off the kitchen. 1922
Kochkorka District
Plaited wool and reeds (synthetic dyes). 170 × 375
Fine Arts Museum of the Kirghiz SSR, Frunze

Hanging for partitioning off the kitchen. 1935
Frunze
Plaited wool and reeds (synthetic dyes). 158 × 280
Fine Arts Museum of the Kirghiz SSR, Frunze

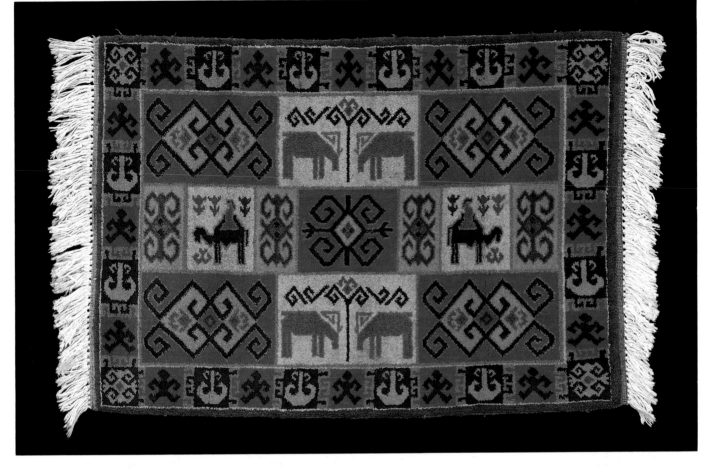

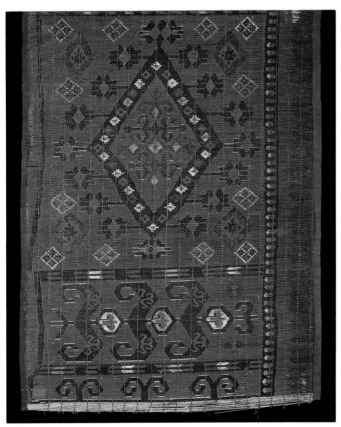

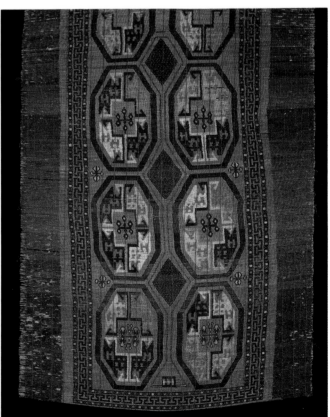

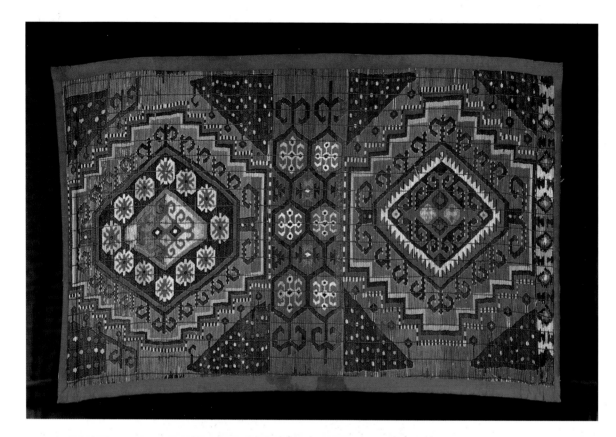

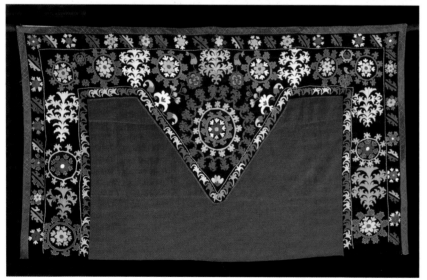

The decorative effect is enhanced by outlining the design with colored cord.

Although the decoration of all Kirghiz carpets basically follows the same lines, it does show some local variations. In the Tien Shan Mountains it is the most traditional. In the Talas Valley, where the neighboring southern parts of Kazakhstan have been an important influence, the predominant decorative motifs are highly formalized plants, although almond-like pat-

Hanging for partitioning off the kitchen. 1922
Pishpek District
Plaited wool and reeds (synthetic dyes). 161 × 288
Fine Arts Museum of the Kirghiz SSR, Frunze

Detail of wall hanging. 1935
By Z. Baidovletova
Issyk-Kul District
Velvet and cloth, embroidered in wool (synthetic dyes).
 Width 150
Fine Arts Museum of the Kirghiz SSR, Frunze

Detail of floor rug. 1937
By K. Isayeva
At-Bashi District
Mosaics of woollen felt (synthetic dyes). Width 155
Fine Arts Museum of the Kirghiz SSR, Frunze

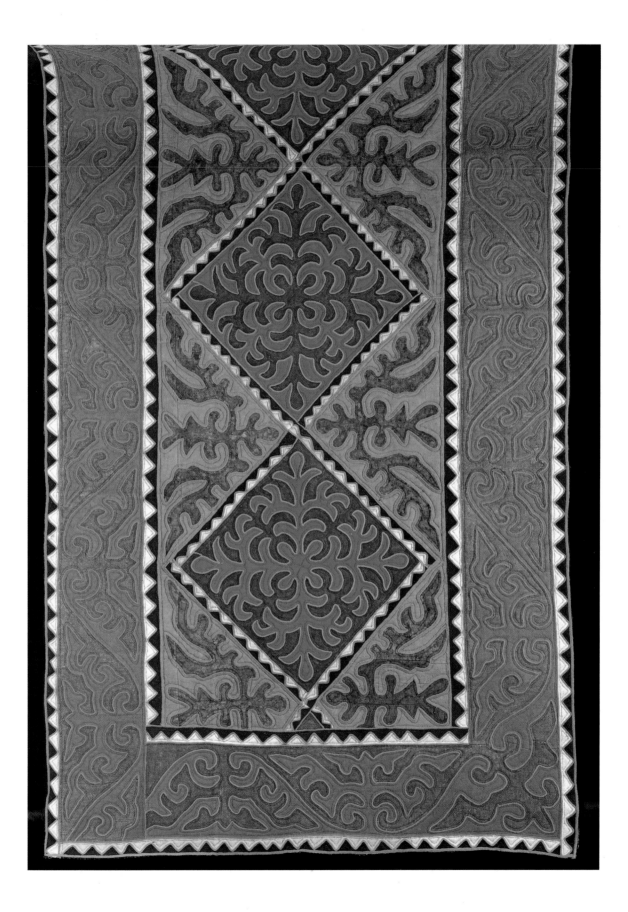

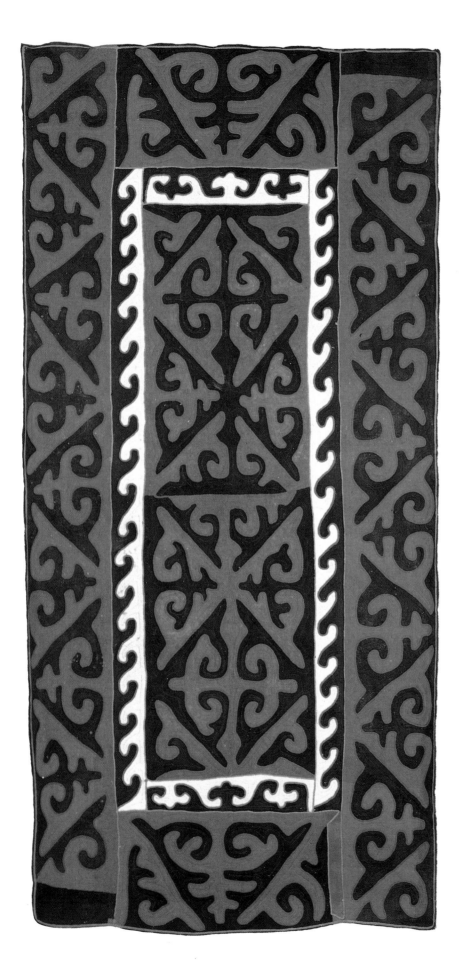

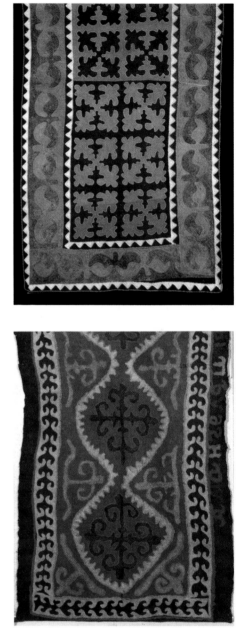

Floor rug. 1974
By S. Cholponbayeva
Kemin District
Mosaics of woollen felt (synthetic dyes). 150 × 320
Union of Artists, Moscow

Detail of floor rug. 1978
By K. Markatayeva
Chui District
Mosaics of woollen felt (synthetic dyes). Width 105
Fine Arts Museum of the Kirghiz SSR, Frunze

Detail of wall hanging. 1966
Kochkorka District
Woollen felt (synthetic dyes). Width 236
Fine Arts Museum of the Kirghiz SSR, Frunze

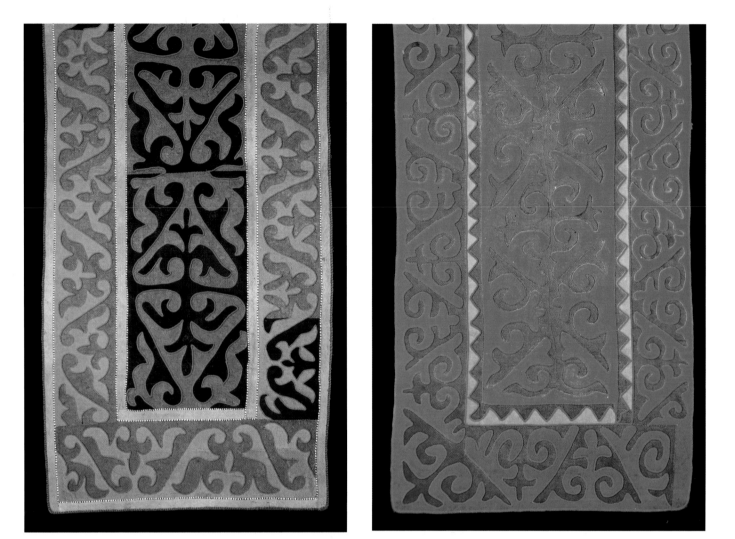

Detail of floor rug. 1960
By Bektursunova
Kemin District
Mosaics of woollen felt (synthetic dyes). Width 135
Fine Arts Museum of the Kirghiz SSR, Frunze

Detail of floor rug. 1966
By T. Abdyldayeva
Moskovsky District
Mosaics of woollen felt (synthetic dyes). Width 170
Fine Arts Museum of the Kirghiz SSR, Frunze

terns, presumably borrowed from Uzbek art, also occur. One of the oldest types of decoration used in Kirghiz felts is decorative stitching in camel-hair thread on a light or dark background.

The most characteristic features of Kirghiz pile-woven carpets are their clear-cut large-scale designs based chiefly on geometric motifs with distinct horn-like curls, their high pile (6–8 mm), and their color scheme in which reds and blues predominate, as they do in Kirghiz felts.

The best and most traditional examples of Kirghiz carpets are small-size pieces used for the storage and transportation of domestic utensils. They display greater freedom and expressiveness of design and more color harmony than large carpets. Their ornamentation is not so much the result of symmetry as of balance.

The Kirghizs' taste for large figured patterns with clear-cut outlines and contrasting color combinations is manifest in their embroidery and patterned weaving. Embroidered designs appear on all sorts of objects, adorning their *yurtas*, clothes, headdresses, and horse trappings. They are worked in colored wool and silk thread on leather, felt, and on woollen and cotton fabrics. In the second half of the nineteenth century, tambour embroidery on black velvet or red woollen cloth became their most characteristic type

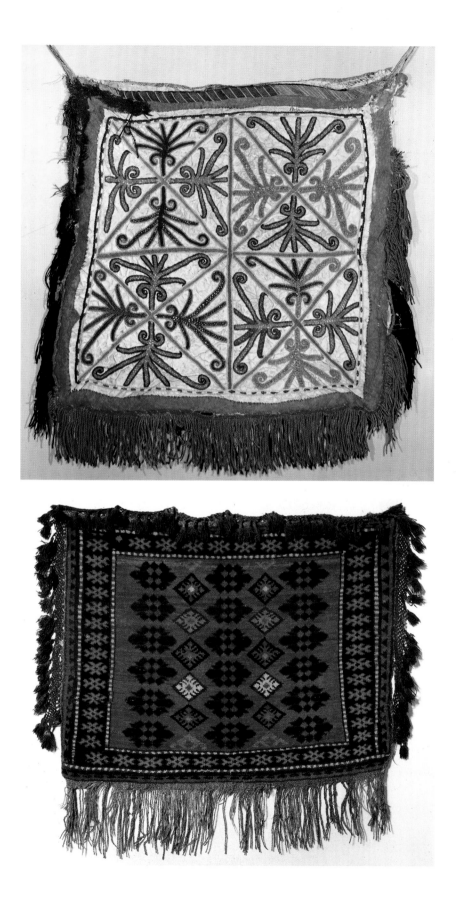

Wall bag. Late 19th century
Leather, with embroidery in cotton and wool (natural dyes).
 62 × 62
Ethnography Museum, Leningrad

Wall bag. Late 19th or early 20th century
Pile-woven wool (natural dyes). 102 × 77
Ethnography Museum, Leningrad

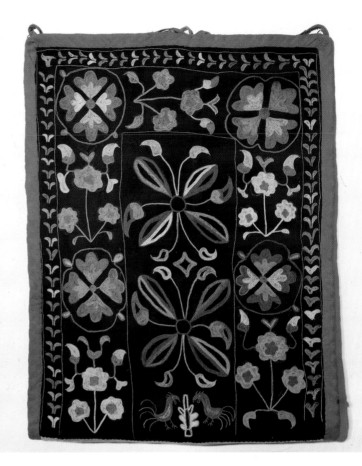

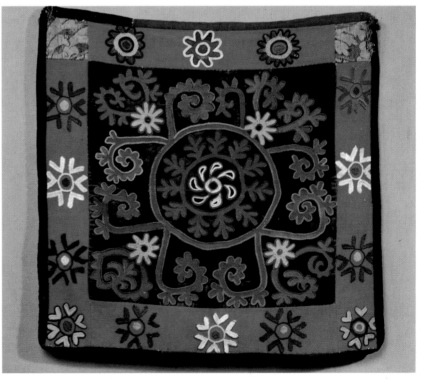

Bag for woman's headdresses. 1930s
Velvet, wool, cotton, silk, and felt, with embroidery (natural
 dyes). 112 × 64
Ethnography Museum, Leningrad

Wall bag. 1978
By B. Orazaliyeva
Osh Region
Velvet and cloth, embroidered in silk (synthetic dyes). 48 × 50
Union of Artists, Moscow

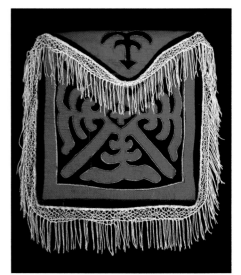

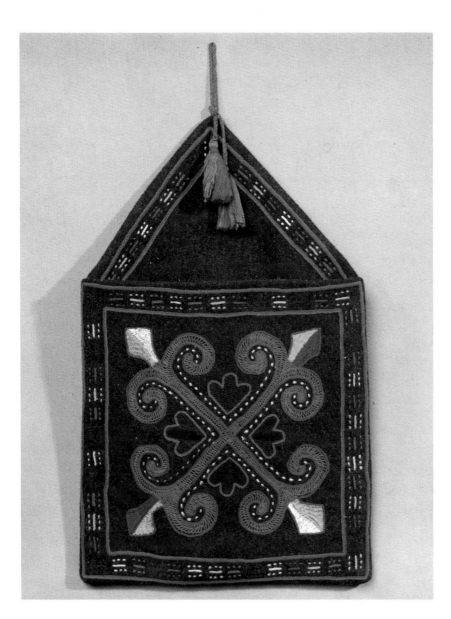

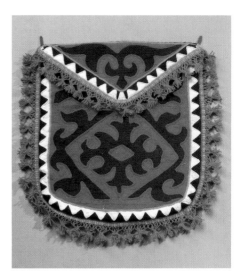

of needlework. Kirghiz riding habits, which include velvet skirts with tambour embroidery and men's suede trousers, are among their particularly decorative articles of clothing.

In recent years great attention has been paid to the making of embroidered *tushkiiz* panels, which are indispensable elements in the present-day home interior. In the past, *tushkiiz* hangings were made of felt and decorated with appliqué in red cloth or embroidery in colored wool.

If felting, weaving, and embroidery were considered women's handicrafts, metalwork, leathercraft, and wood carving were practiced by men. Fine carved designs can be seen on the lintels, frames, and doors of the Tien Shan *yurtas*. The ornamentation, formed by deeply incised grooves, unfolds in a smooth quiet pattern. The contrast between the grooves and the raised

Bag for mirror. 1976
By M. Asankulova
Woollen cloth, embroidered in mouliné thread (synthetic dyes). 20 × 13
Union of Artists, Moscow

Wall bag for crockery. 1950
Talas District
Wool, velvet, felt, with cotton appliqué (synthetic dyes). 90 × 116
Fine Arts Museum of the Kirghiz SSR, Frunze

Wall bag for crockery. 1970s
Wool, cotton, and felt (synthetic dyes). 54 × 54
Union of Artists, Moscow

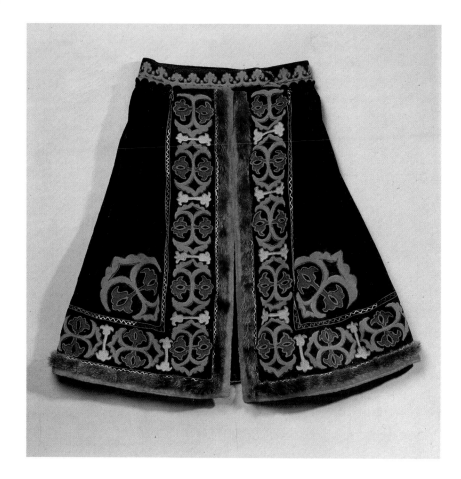

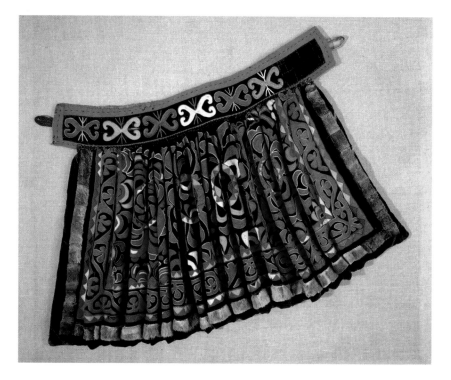

Skirt. 1978
By K. Dzhumaliyeva
Velvet, with fur trimming and embroidery in mouliné
 (synthetic dyes). Length 70
Union of Artists, Moscow

Skirt. 1926
By I. Kanetova
Tiup District
Velvet, fur, wool, cloth, and felt, with embroidery (synthetic
 dyes). Length 82
Fine Arts Museum of the Kirghiz SSR, Frunze

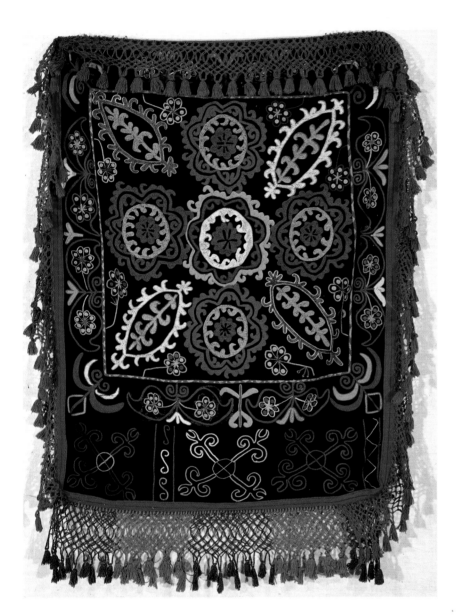

parts generates sharp light and shade effects causing the wooden objects to look almost as decorative as a felt rug.

Kirghiz leatherwork is related to their carving. Flasks for *kumiss* have the form of twinned scrolls and are covered with stamped designs. Stamping is also used to decorate leather pails, cases for cups, boxes, harnesses, and other objects. By varying their ornamentation and manufacturing techniques, for example combining stamped designs with colored leather or cloth appliqué, decorative stitches, or fancy-shaped metal plates, the craftsmen further enhanced the attractiveness of their articles.

Metalwork is also a highly developed art in Kirghizia. Stamping, chasing, and damascening are all techniques used in the making of harnesses,

Wall bag. 1978
By R. Kapoyeva
Kara-Bulak, Naryn Region
Velvet and wool, embroidered in silk (synthetic dyes). 86 × 67
Union of Artists, Moscow

Decorative hanging. 1975
By I. Yakubova
Osh Region
Cotton, embroidered in silk (synthetic dyes). 70 × 90
Union of Artists, Moscow

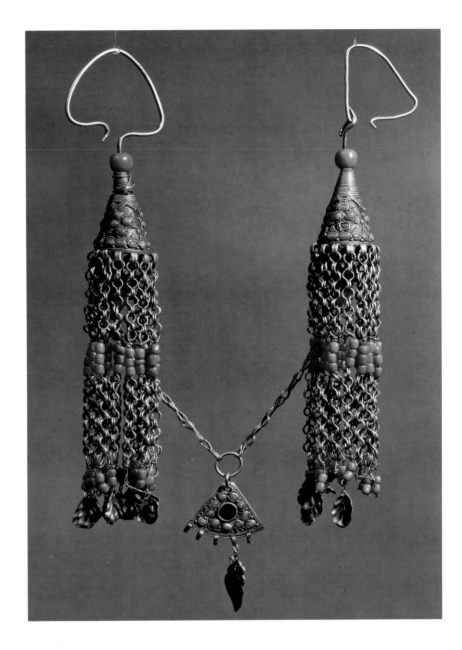

Neck and temple ornaments. Late 19th or early 20th century
Silver, stamped, decorated with granulation, and set with
corals and glass. Length 22
Ethnography Museum, Leningrad

while granulation, filigree, and insets of cornelian, turquoise, and coral decorate women's personal ornaments.

Kirghiz goldsmiths and jewelers do not favor jagged, angular outlines or fragmented forms. By contrasting lignt and dark colors, small and large details, plain and relief surfaces, they achieve a play of light that enhances the decorative quality and attractiveness of their jewelry.

Although Kirghiz folk art has much in common with the arts of the Turkmenians and Kara-Ḳalpaks, it is particularly close to Kazakh art, with which it shares not only its system of imagery but even its basic concepts of ornamentation and design.

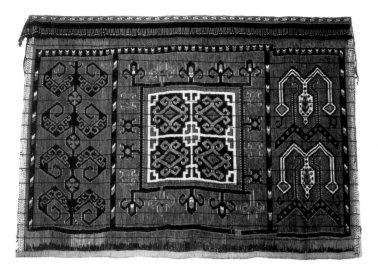

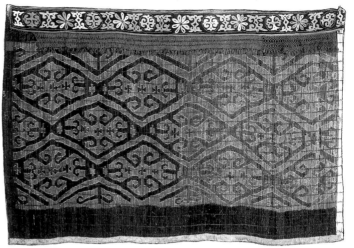

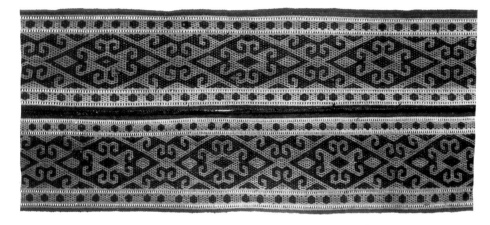

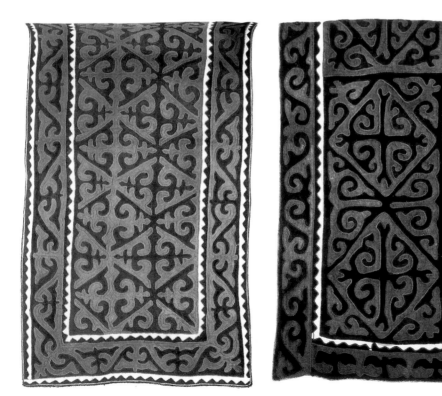

Hanging for partitioning off the kitchen. Late 19th century
Alai Valley
Plaited wool and reeds (natural dyes). 248 × 168
Ethnography Museum, Leningrad

Hanging for partitioning off the kitchen. 1931
By Adzhimudinova
Dzhumgal District
Plaited wool and reeds (synthetic dyes). 160 × 297
Fine Arts Museum of the Kirghiz SSR, Frunze

Band for fixing a *yurta* tent. 1900s
Pattern-woven wool and cotton (synthetic dyes). 1,500 × 27.5
Ethnography Museum, Leningrad

Detail of floor rug. 1965
By R. Aidraliyeva
Kochkorka District
Mosaics of woollen felt (synthetic dyes). Width 162
Fine Arts Museum of the Kirghiz SSR, Frunze

Detail of floor rug. 1966
By Kasarkulova
Talas Valley
Mosaics of woollen felt (synthetic dyes). Width 121
Ethnography Museum, Leningrad

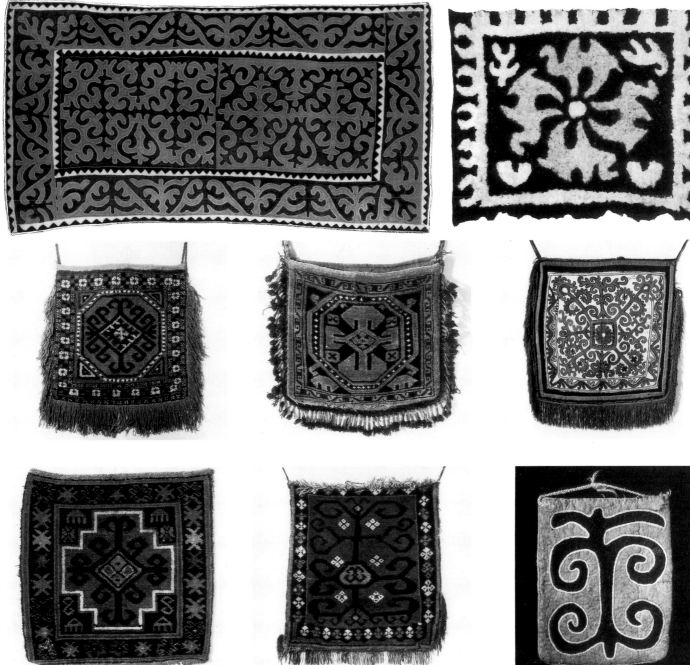

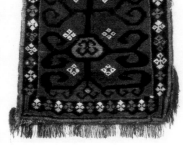

Floor rug. 1970s
Mosaics of woollen felt (synthetic dyes). 150 × 300
Union of Artists, Moscow

Wall hanging. 1970s
By U. Dzhumabai
Frunze
Wool and felt (synthetic dyes). 170 × 185
Union of Artists, Moscow

Bag for crockery and small articles. Late 19th or early 20th
 century
Fergana Region
Pile-woven wool (natural and synthetic dyes). 54 × 51
Ethnography Museum, Leningrad

Bag for crockery and small articles. Early 20th century
Fergana Region
Pile-woven wool (synthetic dyes). 50 × 53
Ethnography Museum, Leningrad

Bag for crockery and small articles
Alai Valley
Leather, cotton, and wool, embroidered in silk (natural dyes).
 50.5 × 50.5
Ethnography Museum, Leningrad

Bag for crockery and small articles. Early 20th century
Pile-woven wool (synthetic dyes). 50 × 50
Ethnography Museum, Leningrad

Wall bag. Early 20th century
Pile-woven wool (synthetic dyes). 92 × 88
Ethnography Museum, Leningrad

Wall bag. Late 19th century
East Alai
Mosaics of woollen felt, with plaited woollen trimming.
 87 × 32
Ethnography Museum, Leningrad

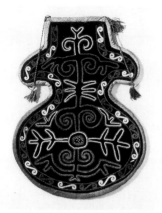

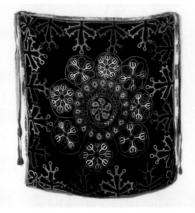

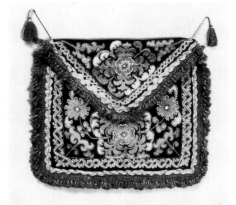

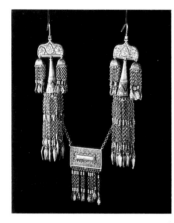

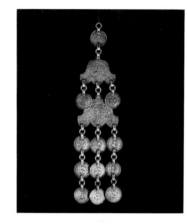

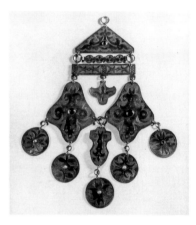

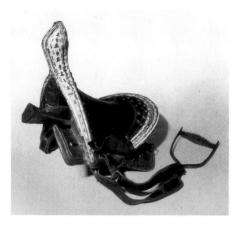

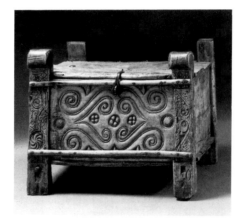

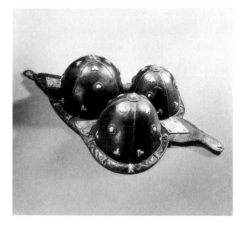

Case. 1930s
Suzak District, Dzhalal-Abad Region
Velvet and cotton, embroidered in silk (synthetic dyes).
 Height 46
Ethnography Museum, Leningrad

Earrings. 1900
Seven Rivers Region
Silver, nielloed and set with corals. 6.5 × 29.5
Fine Arts Museum of the Kirghiz SSR, Frunze

Saddle. Early 20th century
Leather and wood, with engraved metal and carved bone.
 Height 42
Ethnography Museum, Leningrad

Wall bag for hats. 1930s
Kurshab District, Osh Region
Velvet, with fur trimming and embroidery in cotton thread
 (natural dyes). 100 × 78
Ethnography Museum, Leningrad

Pendant for plaits. 1930
Dzhety-Oguz District
Silver, chased and engraved. 8 × 34
Fine Arts Museum of the Kirghiz SSR, Frunze

Box for provisions. 1939
Kirovskoye District
Carved wood. 40 × 39 × 51
Fine Arts Museum of the Kirghiz SSR, Frunze

Wall bag for crockery. 1957
By A. Bekboyeva
Naryn
Velvet, with embroidery (synthetic dyes). 54 × 19
Fine Arts Museum of the Kirghiz SSR, Frunze

Breast ornament. 1976
By Sh. Dairbekov
Frunze
Silver, chased, engraved, nielloed, and set with corals and
 chrysoprases. Height 11
Union of Artists, Moscow

Case for cups. 1870
Syr-Darya Region
Leather, with chased silver mount. 33 × 64 × 15
Fine Arts Museum of the Kirghiz SSR, Frunze

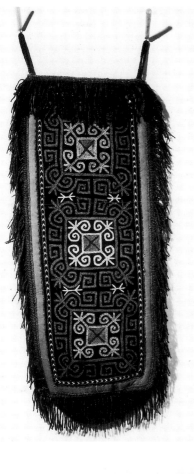

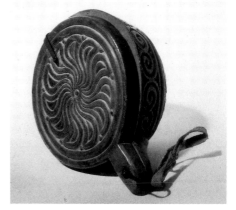

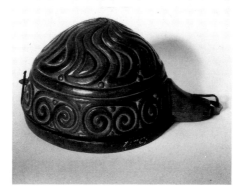

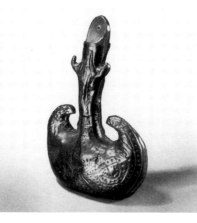

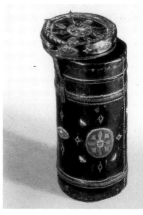

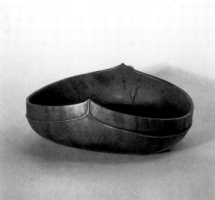

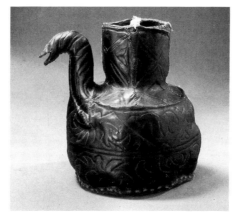

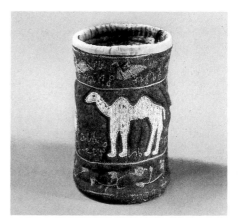

Case for *yurta* tent poles. Late 19th century
Taldyk Pass Area
Woollen felt, with embroidery (natural dyes). 87 × 32
Ethnography Museum, Leningrad

Case for cups. Late 19th century
Eastern Altai
Leather and carved wood. 17 × 21
Ethnography Museum, Leningrad

Case for cups. Late 19th century
Eastern Altai
Leather and carved wood. 17 × 21
Ethnography Museum, Leningrad

Vessel. 1935
Dzhety-Oguz District
Stamped leather. 20 × 21
Fine Arts Museum of the Kirghiz SSR, Frunze

Case for cups. 1925
Talas District
Stamped leather, wood, and silver. 16 × 31
Fine Arts Museum of the Kirghiz SSR, Frunze

Kumiss **dipper.** Early 20th century
Wood, chiselled and carved. 39 × 30
Ethnography Museum, Leningrad

Vessel for *kumiss*. 1935
Dzhety-Oguz District
Stamped leather. 28 × 43
Fine Arts Museum of the Kirghiz SSR, Frunze

Case for cups. 1939
Dzhumgal District
Felt, embroidered in woollen thread. 20 × 32
Fine Arts Museum of the Kirghiz SSR, Frunze

KAZAKH
Folk Art

In the past, numerous handicrafts had been highly developed in Kazakhstan. Some of these declined and became practically extinct when the previously nomadic Kazakhs were settled after the October Revolution of 1917. A large number of objects, hitherto essential for *yurta* life in the middle of the steppe, became redundant. Nevertheless, even nowadays Kazakhstan has interesting handicrafts, and its folk artists still produce traditional objects based on the people's ideals of beauty, their folklore, and their general outlook on life.

The relationship between Kazakh and Kirghiz folk arts in imagery and approach to ornamentation and design can be accounted for by the fact that the two nations have for centuries been nomadic or seminomadic. For this reason most of their crafts were connected with products from livestock raising. Women used wool and camel hair in felting, carpet-making, weaving, and in the making of bags for the storage and transportation of domestic utensils. Men were engaged in leathercraft, smithing, and wood and bone carving.

Like the Kirghiz dwelling, the Kazakh *yurta* was a thoroughly organized ensemble, in which every object performed a useful domestic function as well as pleased the eye with its exquisite ornamentation.

The most widespread Kazakh handicraft is felt rug-making. Some felts of Scythian date (fifth and fourth centuries B.C.), excavated by Soviet archaeologists in the Altai Mountains, give grounds to believe that the tradi-

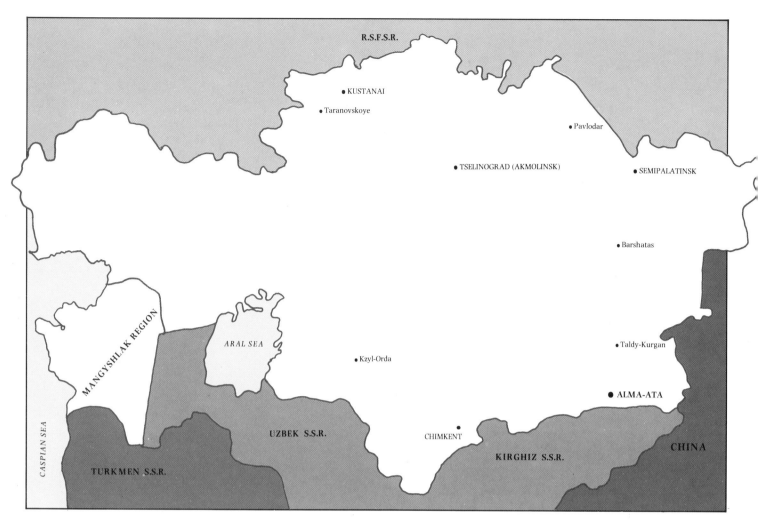

tions of this art can be traced to remote antiquity. In modern times, this craft is still thriving since felts are indispensable furnishings for Kazakh homes.

Kazakh felt rugs fall into three basic categories: rugs with appliqué decoration, rugs with a design of colored wool pressed into them, and rugs with mosaic-like patterns. The latter two techniques are the more complicated.

To make rugs with a design pressed into them, bits of colored wool or cut-out designs of thin felt are placed on a soft felt mat and pressed into it by rolling. Owing to the peculiarities of this technique, the outlines of the design become somewhat diffused, which produces an effect similar to color gradations in painting. Rugs of this kind lend a touch of warmth and cosiness to the interior.

Rugs with mosaic-like designs are known as *syrmaks* (in Kirghizia as *shirdaks*). To make a rug in two colors, the craftswomen work on two rugs simultaneously: the cut-out parts of the one form the design in the other, and vice versa. For greater strength all the elements are quilted. *Syrmak* rugs are mostly black and white, brown and white, red and white, or claret-colored and red, with the outlines heightened with red or brown cord. Rugs from the Seven Rivers region are made in deeper shades. At present, colored felt rugs are popular all over Kazakhstan.

The clear-cut curvilinear design in *syrmaks* is formed by rhythmically recurring large-scale lozenges, circles, and various single and twinned

Floor rug. 1957
By N. Umasheva
Chubartau District, Semipalatinsk Region
Mosaics of woollen felt (synthetic dyes). 237 × 120
Central Museum of Kazakhstan, Alma-Ata

Floor rug. 1976
By M. Alimova
Mosaics of woollen felt (synthetic dyes). 138 × 250
Union of Artists, Moscow

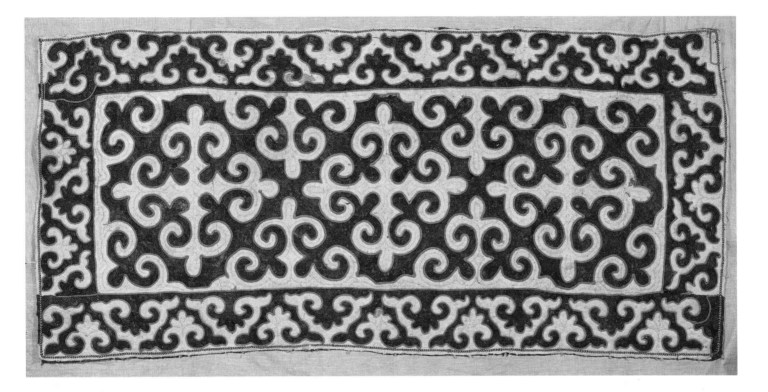

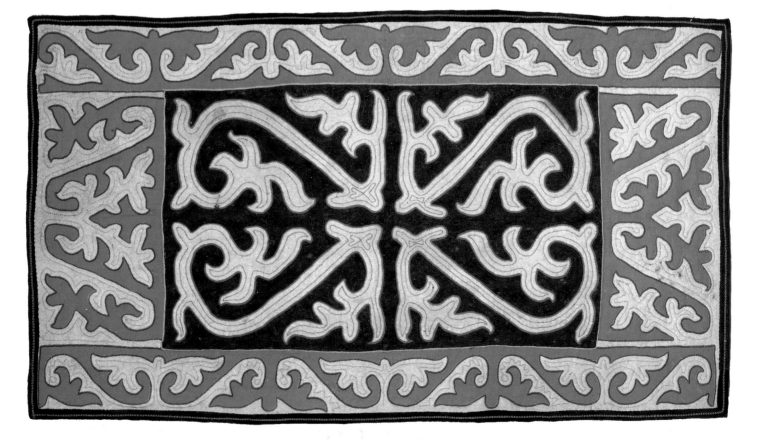

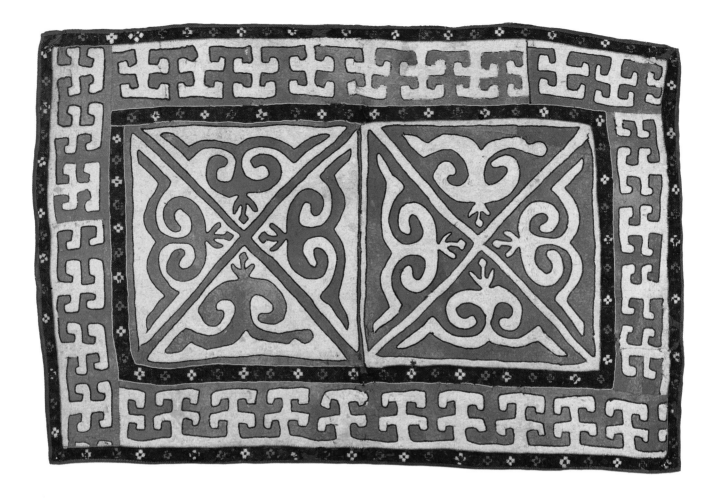

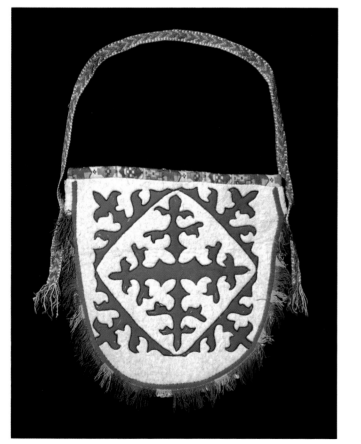

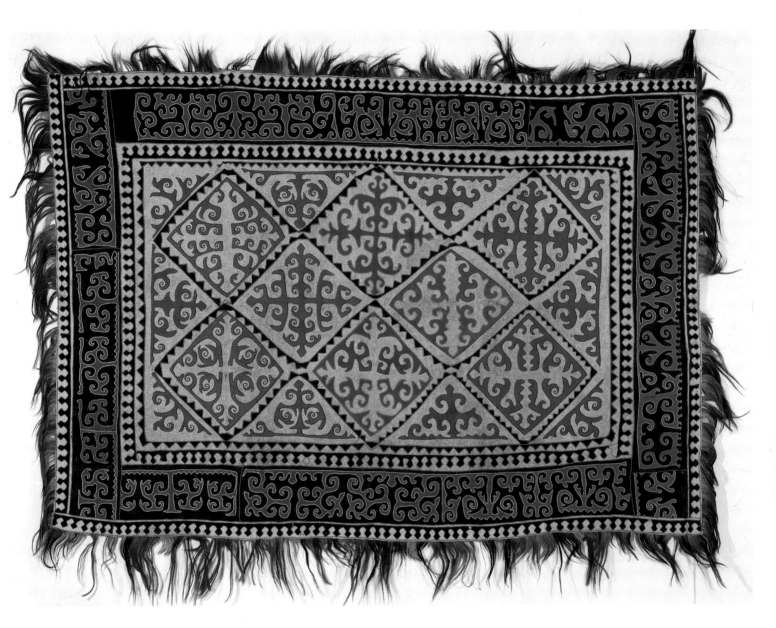

Floor rug
By Sh. Valiyeva
Taranovskoye District, Kustanai Region
Mosaics of woollen felt (synthetic dyes)
Central Museum of Kazakhstan, Alma-Ata

Wall bag for crockery. Early 20th century
Semipalatinsk
Woollen felt and cloth, with appliqué. 50 × 49
Ethnography Museum, Leningrad

Detail of floor rug
By Sh. Tabynbayeva
Kzyl-Orda Region
Woollen felt (synthetic dyes). Width 190
Central Museum of Kazakhstan, Alma-Ata

Floor rug. 1920
By U. Begimov and A. Begimov
Woollen felt and cloth, with appliqué (synthetic dyes).
300 × 200
Central Museum of Kazakhstan, Alma-Ata

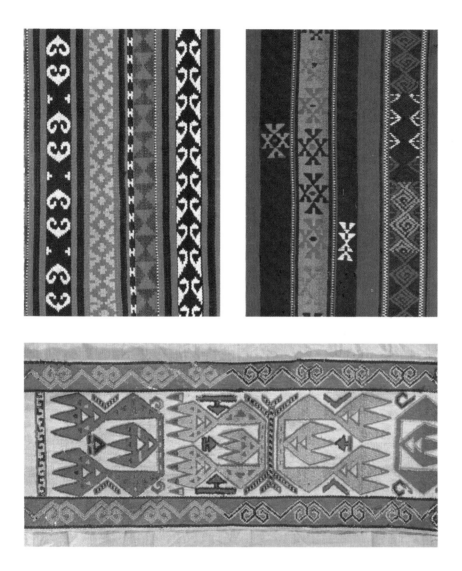

Detail of rug. Late 19th or early 20th century
Kzyl-Orda Region
Flat-woven wool (natural dyes)
Central Museum of Kazakhstan, Alma-Ata

Detail of rug. Late 19th or early 20th century
Kzyl-Orda Region
Flat-woven wool (natural dyes)
Central Museum of Kazakhstan, Alma-Ata

Band for fixing a *yurta* tent. Detail. Late 19th or early 20th
 century
Kzyl-Orda Region
Pile- and flat-woven cotton and wool (synthetic dyes)
Central Museum of Kazakhstan, Alma-Ata

scrolls suggesting horns or stylized plants. It is based on strict symmetry, and, despite its diversity, the composition is invariably flat, two-dimensional. No interwoven or overlapped patterns, which are characteristic of Uzbek and Tadzhik ornamental arts, are tolerated. The clarity and conciseness of silhouettes, the sparing use of color in ornamental elements, and a certain heaviness of design impart austerity and monumentality to the best examples of this Kazakh folk art.

The thematic range of ornaments found on felt carpets is exceedingly wide, but the majority of them are zoomorphic and plant-like. As in Kirghiz art, the motif of twinned horns, *kashkar-muyiz*, occurs with particular frequency.

There are certain differences in the artistic approach seen in large- and small-scale felt rugs. Large pieces have a more austere design and composition, and a more marked rhythm. Smaller rugs, on the other hand, show greater freedom of ornamental arrangement depending on the shape of the

Saddle-cloth. 19th century
Pile-woven wool (synthetic dyes). 101 × 66
Ethnography Museum, Leningrad

Palas. Early 20th century
Kzyl-Orda Region
Flat-woven wool and cotton (synthetic dyes)
Central Museum of Kazakhstan, Alma-Ata

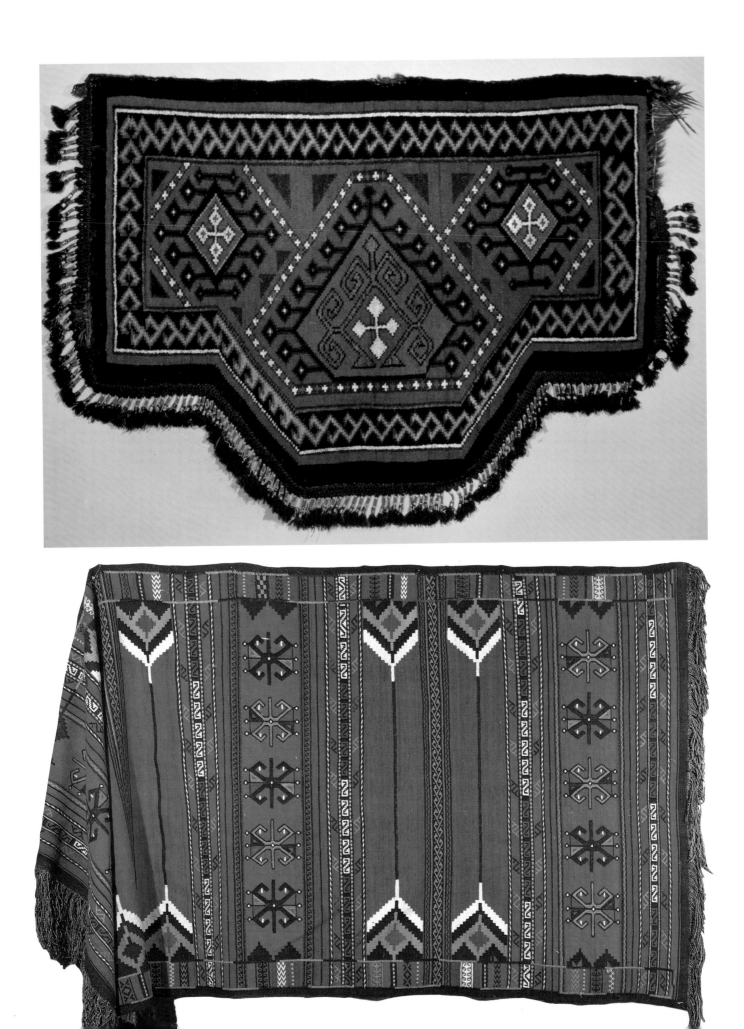

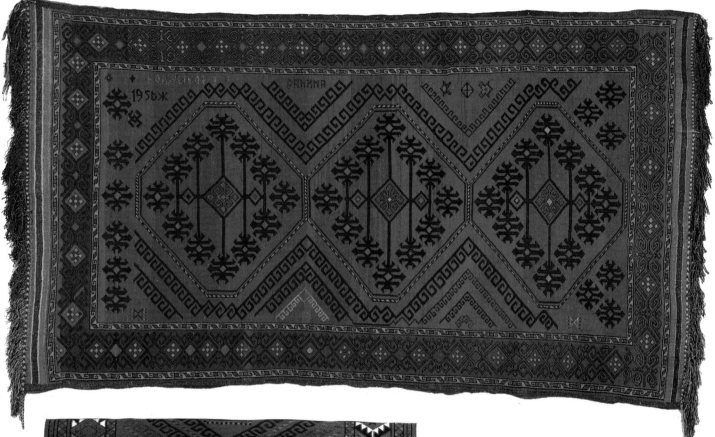

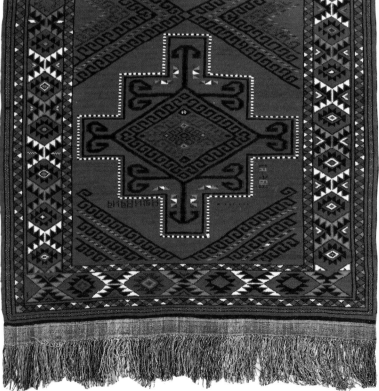

Carpet. 20th century
Pile-woven wool (synthetic dyes)
Central Museum of Kazakhstan. Alma-Ata

Yurta **tent entrance curtain.** 1960s–70s
Chimkent
Pile-woven wool (synthetic dyes)
Central Museum of Kazakhstan. Alma-Ata

Yurta **tent entrance curtain.** 1978
By U. Torenbekova
Pile-woven wool and cotton (synthetic dyes). 176 × 320
Ethnography Museum, Leningrad

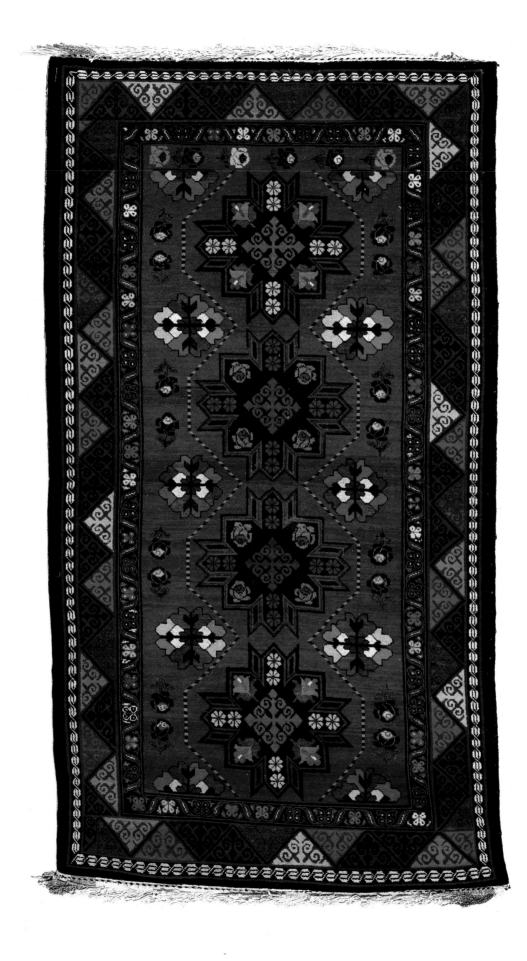

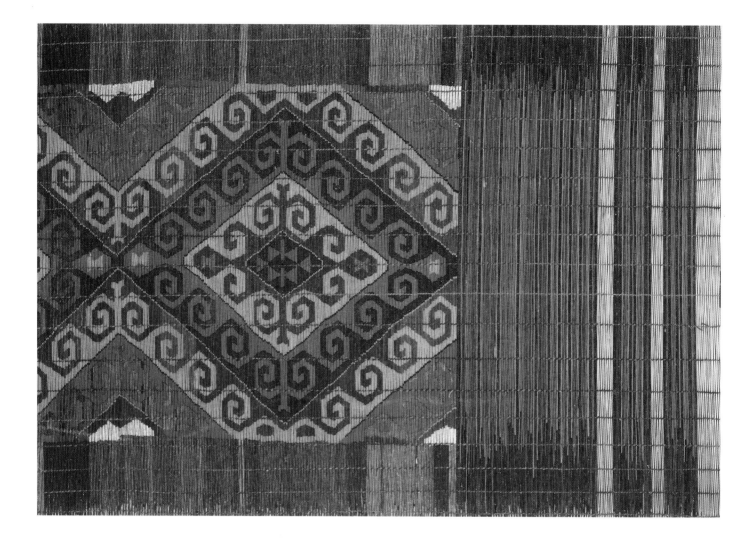

object. Thus, the decoration of saddlebags is subjugated to the shape of their roundish lower part. The entire space confined by this curved outline is skillfully filled with one well-balanced design. The decorative effect is heightened by a contrasting color combination.

Fabric weaving is also practiced throughout Kazakhstan. The predominant colors are red and blue, except for western Kazakhstan, where red and brown are fairly common. Plain dense fabrics for the groundwork of *palases* are woven in this area.

Fine taste and skill are shown by Kazakh women weavers of patterned mats, which are used today as screens and floorings.

Kazakh embroidery is decorative and varied. The *tushkiiz* wall hanging was usually made of felt and, apart from decorative purposes, was hung on the wall for warmth. Moreover, a *tushkiiz* was a requisite trousseau item believed to protect the bride from the evil eye and grant prosperity and happiness. The central field of the wall hanging is plain, but the wide border is richly embroidered in gold, silver, and beads. Insets of pearls, corals, silver discs, colored glass, and even gems were included in the sumptuous plant-like designs.

The style of embroidered decoration of *tushkiiz* wall hangings follows

Carpet. 1978
Alma-Ata
Reeds interwoven with wool (synthetic dyes). 608 × 145
Central Museum of Kazakhstan, Alma-Ata

Wall hanging. 1966
Tobler, Kosh-Agach District, Gorno-Altai Autonomous Region
Cotton, with embroidery (synthetic dyes). 135 × 230
Ethnography Museum, Leningrad

Detail of wall hanging. Late 19th or early 20th century
Pavlodar Region
Woollen felt, cloth, and velvet with appliqué (natural and
 synthetic dyes)
Central Museum of Kazakhstan, Alma-Ata

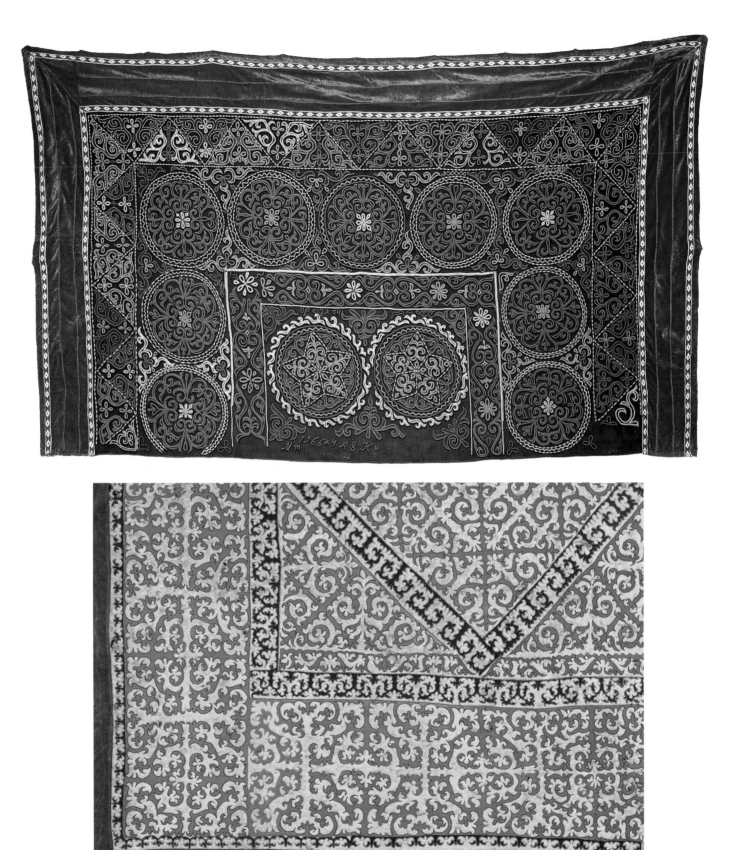

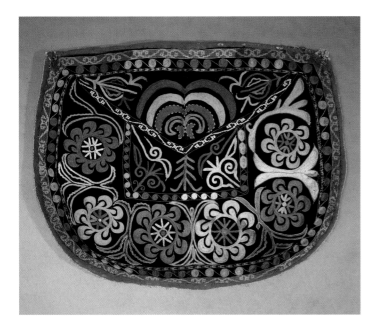

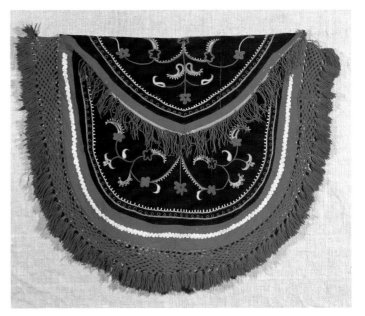

the same rigid age-old principles of the interior decoration of the *yurta* mentioned above: it is formalized and favors somewhat heavy, almost monumental forms. Embroidery was also widely used to trim clothing, especially riding skirts, men's hunting trousers, and headdresses for women and young girls.

Like most other peoples, the Kazakhs enhanced embroidered women's costumes with various personal ornaments. Their massive silver adornments in archaic shapes are magnificent in combination with the rest of the ensemble. Kazakh bridal headdresses (called *saukele*) are particularly luxurious. In the past, the entire headdress was made of silver foil, which was later supplanted by fabric with a large number of pendants.

Kazakh earrings, brooches, signet rings, bracelets, clasps, buttons, and necklaces set with large cornelians, colored glass, or even gems are remarkable for their fine chasing, niello, engraving, filigree, and granulated work, which create subtle nuances of color and rich effects of light and shade. Nearly every object proclaims its maker's skill and mastery of material.

Notwithstanding its characteristic dependence on large-scale, almost monumental, forms, Kazakh jewelry is marked by simplicity, precision of design, and ornamental congruity with the groundwork. The plant motifs often employed are traceable to the Tree of Life, an attribute of their ancestors' religion; the zoomorphic motifs are derived from the ancient nomads' totemistic beliefs, while their geometric designs are connected with their astral mythology. All these themes are expressed in highly generalized forms, remarkably forceful and majestic.

The Kazakhstan of solitary *yurta* tents is gone. A great many modern towns and urban-type settlements have recently emerged in the republic.

Wall bag for crockery. Early 20th century
Velvet and woollen felt, with embroidery (natural and
synthetic dyes). 60 × 78
Central Museum of Kazakhstan, Alma-Ata

Wall bag for crockery. Early 20th century
Alma-Ata Region
Woollen felt and velvet, with embroidery (natural and
synthetic dyes)
Central Museum of Kazakhstan, Alma-Ata

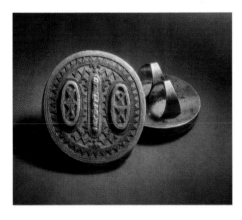

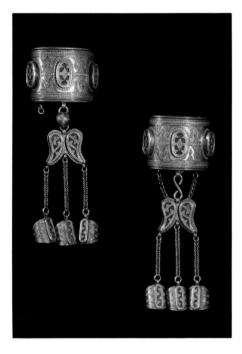

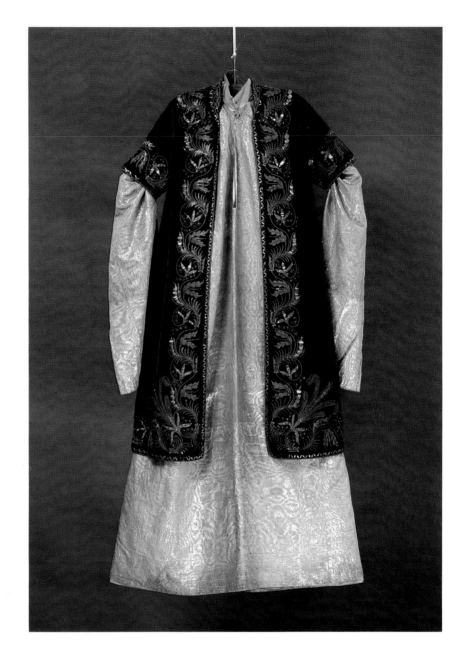

Signet rings. Late 19th century
Stamped silver, decorated with granulation and glass insets
Central Museum of Kazakhstan, Alma-Ata

Bracelets. Late 19th or early 20th century
Silver, decorated with granulation and set with cornelians
Central Museum of Kazakhstan, Alma-Ata

Dress and short-sleeved camisole. Early 20th century and
 mid-19th century
Ural Region
Brocade and velvet, embroidered in gold thread. 130 × 150
 (dress); 105 × 49 (camisole)
Central Museum of Kazakhstan, Alma-Ata

New layers of life are being superimposed on the ancient nomadic culture, although its traditions survive. *Syrmak* felt rugs are still made, and *tushkiiz* hangings still embroidered, even though now for purely decorative purposes. Their colors have become more contrasted, compositions and ornamental motifs more dynamic, and the artist's individuality more pronounced. But in all these objects, the past comes alive. Although new symbols and images appear in their decoration, these objects retain their distinctive national features and identity, formed in the course of many centuries.

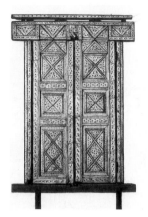

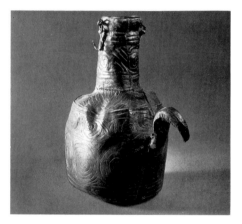

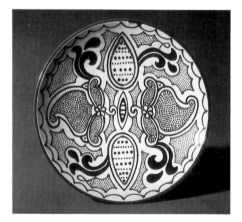

Yurta **tent door.** Late 19th or early 20th century
Akmolinsk (?)
Wood, inlaid with carved bone, engraved, and cloth.
 Height 148
Ethnography Museum, Leningrad

Box for provisions. Late 19th century
Ural Region
Wood, carved and tinted. 49 × 105 × 54
Central Museum of Kazakhstan, Alma-Ata

Dish. 1972
By V. Sotnikova
Alma-Ata
Clay, fired and painted underglaze. Diameter 31
Ethnography Museum, Leningrad

Bed. Late 19th century
Semipalatinsk Region
Wood, inlaid with carved bone, metal, and silver. 72 × 128
Central Museum of Kazakhstan, Alma-Ata

Box for provisions. Early 20th century
Pavlodar
Wood, carved and tinted. 47 × 87 × 46
Ethnography Museum, Leningrad

Fragment of horse-cloth. Second half of the 19th century
Taldy-Kurgan Region
Stamped leather and metal. 225 × 110
Central Museum of Kazakhstan, Alma-Ata

Head of bed. Late 19th or early 20th century
Wood, carved and painted. 95 × 38
Ethnography Museum, Leningrad

Teapot. Early 20th century
Alma-Ata Region
Stamped leather. 38 × 22
Central Museum of Kazakhstan, Alma-Ata

Detail of wall hanging. Early 20th century
Semipalatinsk
Woollen felt and velvet, with embroidery (synthetic dyes)
Central Museum of Kazakhstan, Alma-Ata

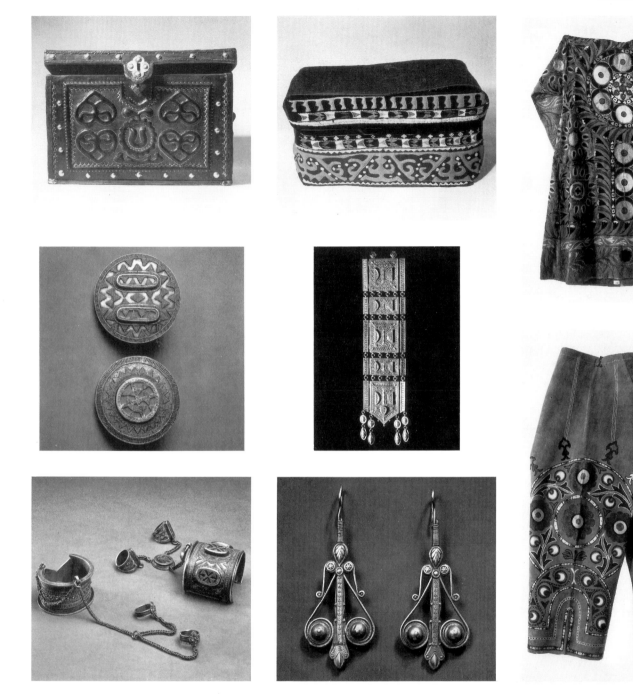

Miniature chest. Late 19th or early 20th century
Stamped leather, wood, and metal. 25 × 45
Ethnography Museum, Leningrad

Matchmakers' rings. 19th century
Stamped silver, with granulation. Diameter 4 and 4.5
Museum of Oriental Art, Moscow

Bangles. Late 19th century
Kustanai Region
Stamped silver, with filigree and granulation, and glass insets
Central Museum of Kzakhstan, Alma-Ata

Cover for a chest. Early 20th century
Village of Min-Bulak
Woollen felt and leather, with appliqué and embroidery
 (natural and synthetic dyes). 98 × 42
Ethnography Museum, Leningrad

Breast ornament. Mid-19th century
Mangyshlak Region
Silver, stamped, gilt, and decorated with granulation and
 niello
Central Museum of Kazakhstan, Alma-Ata

Earrings. Early 20th century
Silver, cast and chased. Length 5
Museum of Oriental Art, Moscow

Robe for festive occasions. Early 20th century
Cloth, embroidered in silk (natural dyes). 125 × 193
Ethnography Museum, Leningrad

Man's hunting trousers. Late 19th century
Suede, embroidered in silk (natural dyes). Length 96
Ethnography Museum, Leningrad

НАРОДНОЕ ИСКУССТВО
СОВЕТСКОГО СОЮЗА

Альбом (на английском языке)

Издательство "Аврора". Ленинград. 1990
По заказу фирмы Harry Abrams Inc., New York
Изд. № 1842
*Printed and bound in Italy
by Nicola Teti Editore - Milano*